W9-BKI-378

A NEW HANDBOOK OF

ITALIAN RENAISSANCE PAINTING

A NEW HANDBOOK OF

ITALIAN

HACKER ART BOOKS • NEW YORK • 1981

RENAISSANCE PAINTING

Laurence Schmeckebier

Second edition, revised, 1981

Library of Congress Catalogue Card Number 79–50409
International Standard Book Number 0–87817–253–X

Printed in the United States of America.

Table of Contents

Introduction

THE ESSENCE OF HISTORICAL ART CRITICISM is not the assembly of facts, but their understanding and interpretation. Jacob Burckhardt's famous characterization of Renaissance man as a creative individual "to whom all the things of this world become possible" reflects his own historical method as much as it does his interpretation of the period. His call for a structural history as a means by which names, works and their essential meanings would find their places within a total context is as important today as it was a century ago.

The Renaissance has always provided fascinating material and background for great theories and spirited interpretations. Many of these have become classics of literary and historical art criticism. Modern publication has produced a rich variety of illustrated monographs, special studies of individual artists, scholars and periods as well as total histories, some of them suited for use as textbooks, others intended primarily for the reference library or decorative home use.

With such an impressive panorama of specialized studies available to the young scholar, this book seeks to present, in as brief and concise a form as possible, the factual material on which these critical concepts and interpretations are based. Although there will always be debatable questions of selection, proportion and attribution, the aim here is to present the information and the problems rather than their solutions. On the basis of this material it is hoped that the suggestions made by way of comparative analysis will stimulate the student in the development of a deeper understanding of political and social as well as iconographical problems and relationships.

The book, first published in 1938 as *A Handbook of Italian Renaissance Painting*, was designed to meet "a crying need of students of the fine arts." Its appeal is still to the deeper study of formal and iconographical problems rather than to the generalized approach of the introductory art appreciation class. The author's use of this method during forty years of teaching has indeed been rewarding, and the many requests over the years from professional colleagues for a new edition would indicate a similar reaction among others.

There have been many changes, not only among the historic monuments themselves, but in the factual information about them and their subsequent interpretation. The devastation wrought by World War II and the great flood of 1966, balanced by a magnificent record of restoration and preservation, have brought about many new discoveries. The clarification of old problems and the idenfication of new ones have been recorded in an impressive array of publications, some of the most significant the products of British and American scholarship.

The program and scope of the book cover the period from the great age of Innocent III and Frederick II to that of Julius II and the subsequent reestablishment of imperial domination by Charles V in 1530. This study is conceived without illustrations, since the inclusion of the major works would only be duplicating what has already been published many times, and a total compendium of all works would make impractical the concept of a "handbook." The wide selection of illustrated paperbacks, monographs and scientifically prepared guides makes it possible for today's student to develop a library in accordance with his own special interests to supplement the institutional art library. A bibliography is included of the standard reference books, sources and the most recent discussions on scientific problems, along with useful historical and iconographical indices.

The author wishes to acknowledge his indebtedness to many friends and colleagues whose advice, criticism and suggestions have been so valuable. Among these it was Professors Wolfgang Stechow and Ulrich Middledorf whose encouragement made the original

book possible. To the library of the Kunsthistorisches Institut in Florence and the privilege of Dr. Middeldorf's friendly consultation while he was director there, he is again grateful. The generous grant of leaves of absence in 1960, 1968 and 1970 by Syracuse University has enabled the author to reexamine most of the important works both in Italy and in the European and American museums. As always, it is to Alexandra K. Schmeckebier that he owes his greatest debt for her professional expertise as librarian, archivist and art-historical critic.

Laurence Schmeckebier
Syracuse, New York

BOOK I.

THE
FOURTEENTH
CENTURY

1. Rome

DURING THE GREAT AGE of Pope Innocent III, Rome enjoyed a renewed period of world political and ecclesiastical importance rivaling that of early Christian days under Emperor Constantine. That rule ended in 1215, and Rome, despite the nominal control of the papal senators, went through a long period of turmoil and anarchy, particularly in the bloody Orsini-Colonna family feuds and the conflicts between the people and the nobility. The struggle between the papacy and the Hohenstaufen was ended by the death of Frederick II (1250) and the extinction of his successors, as well as by the introduction of the Angevin rulers into southern Italy. The political tension at Rome increased when the choice of a Gaetani, Boniface VIII, as Pope brought that family into collision with the Orsini and Colonna in 1294. The attempt of Boniface (i.e., in his bull *Unam Sanctam*) to extend the temporal power of the papacy, as Innocent III had done, caused the rebellion of the French King Philip, and the Pope's humiliation at Anagni in 1303 followed.

The period of French domination of the papacy, the so-called Babylonian Captivity, began in 1309, when Clement V, a Frenchman, moved the papal court to Avignon. Conditions at Rome during this period were chaotic. The Colonna and Orsini, the nobility and the people, together with imperial, Neapolitan and papal parties, engaged in constant strife. In 1339 the papal senators were expelled, and in 1343 a democratic government was established which gave way, from 1347 to 1348, to the Tribunato of the famous Cola di Rienzi. Then party warfare was renewed, and when Pope Urban V returned to Rome in 1367 he found it a desolate city, almost in ruins after a century of strife. Gregory XI ended the Babylonian Captivity in 1377, but his death (1378) was the signal for the break between French and Italian factions in the church. The result was the election of two Popes and the beginning of the Great Schism in the church, which lasted until 1417.

Extensive activity in the building and decoration of churches and palaces continued under the reins of Innocent III and his immediate followers through that of Boniface VIII. In these buildings, particularly in the fragmentary remains of fresco and mosaic decoration, one can trace the early transition from the Medieval, non-representational style to a more monumental type of figure representation reflecting a return to Early Christian forms.

The rich diversity of the background can be seen in several of the few remaining examples which reflect in varying degrees Ottonian-Romanesque, Byzantine and local traditions developed through the monasteries. Among these are the remarkable frescoes decorating the church of Sant' Angelo in Formis, near Capua, with Christ Enthroned, symbols of the Evangelists, the three archangels with St. Benedict and the patron (possibly Abbot Desiderius) holding a model of the church in the apse, scenes from the New Testament on the walls of the nave, Old Testament scenes along the aisles, and the Last Judgment on the entrance wall. The work was done, presumably, by craftsmen from the monastery of Monte Cassino, to which the church had been given in 1072 and whose abbot, Desiderius (1058-1086), is named on the portal as patron. A lively activity in the arts during the reign of Desiderius, who had imported craftsmen from Lombardy as well as Byzantium, and had maintained a strong tradition of manuscript illumination in what has been called a Benedictine style, is recorded by chroniclers. Frescoes related to this school of Monte Cassino, from about the same period or slightly later, are to be found in the crypt of Santa Maria del Piano in Ausonia and the Abbey of Monte Cassino (fragments from the Chiesa del Crocefisso in Cassino).

The impressive Byzantine-Romanesque compositional scheme, with its vigorous execution, appears much more refined, in the manner of the manuscript illuminators, in the frescoes decorating the lower church of San Clemente in Rome, executed ca. 1100 under Pope Paschalis II (1099-1118). The transition to a new type of monumental figure and decorative scheme appears strongly influenced by a renewed emphasis on Early Christian forms, as may be seen in the stiff Romanesque figures of a Madonna and Saints placed in decorative arcades in the apse mosaic of San Francesca Romana (second quarter of the 12th century) and the Christ and Virgin Enthroned with Saints in the apse mosaic of Santa Maria in Trastevere (1140-1148).

The close relationship in style to that of Christian Antiquity, as well as the fact that many of these basilicas are either copies or renovations of Early Christian churches, makes it difficult to ascertain whether the work is an original design or a restoration of an Early Christian mosaic remaining from the older structure. Hence this apse mosaic may be based on an Early Christian design (note the centralized position of Christ), with the figures of Mary and Innocent III possibly additions of the twelfth century. To the same period, though damaged and with much modern restoration, belongs the mosaic of the Enthroned Madonna with the Wise and Foolish Virgins on the façade of Santa Maria in Trastevere (executed under Eugene III, 1145-1153).

The growing influence of the Byzantine decorative style during the thirteenth century is reflected in the request of Pope Honorius III in 1218 to the Doge of Venice for Byzantine mosaic craftsmen to renovate the Early Christian mosaics of St. Paul's Outside the Walls, a work which seems to have been of major importance to the time (badly damaged in the fire of 1823 and restored). The character of the influence is best seen in the frescoes in the chapel of San Sylvester in SS. Quattro Coronati, done ca. 1246 under Innocent IV. The fresco represents the Last Judgment and scenes from the life of St. Sylvester and Constantine: Constantine gives the command to kill the children whose blood will heal his wounds; he is advised in a dream by St. Peter and St. Paul to seek the help of St. Sylvester, and he sends messengers to fetch him; they prostrate themselves at the feet of the saint on Mt. Soracte; Sylvester shows the portraits of St. Peter and St. Paul to Constantine; he baptizes the emperor; the emperor crowns Sylvester with the papal tiara; Constantine humbly leads the mounted Pope and his suite to Rome.

Aside from traditional Byzantine characteristics in the figure and drapery pattern and the elaborate ornamentation, there appears a quite un-Byzantine interest in realistic movement and dramatic gesture, suggesting an influence of French Gothic sculpture or miniatures as seen in the gestures of the wailing woman and the repetition of trotting horses. The general arrangement of Last Judgment and narrative scenes is likewise reminiscent of tympanum reliefs on the portals of Gothic cathedrals (Rheims).

Of about the same period and style are the frescoes in the Benedictine monastery (the Sacro Speco) in Subiaco, particularly in

the lower church and the chapel of St. Gregory. An inscription dates the frescoes of the chapel in the second year of Gregory's reign, hence 1228. (Gregory IX, 1227-1241, had been a friend of Francis and Cardinal-Protector of the Franciscan Order.) The important portrait of St. Francis, with the inscription *Fr. Franciscus*, may have been done "from life" when the saint had visited the abbey in 1218. The style of the portrait, however, corresponds to the other frescoes of the chapel executed in 1228 rather than to the earlier date. He is represented as a *frater* without a halo, hence it was probably done before his canonization in that same year.

A second series of frescoes, somewhat more Byzantine in character, was executed shortly before 1255 in the crypt of the Cathedral of Anagni. For the parallel with the Roman work, note particularly the Christ Enthroned with Saints. The series represents a rather involved painted encyclopedia of Biblical-Classical learning in the manner of the contemporary scholastics (cf. Honorius Augustodunensis), which, together with the strongly Byzantine character of the style, suggest a relationship with the court art of Frederick II.

Fragments of fresco decorations in the abbey of Grottaferrata (ca. 1272) reveal a general Byzantine character but also suggest a greater and more expressive movement in the figures and a more naturalistic handling of the forms as developed later by Cavallino.

This interest in nature and form as stimulated by French Gothic and Christian Antiquity, in contrast to the *maniera bizantina*, has a strong and significant parallel in the contemporary art of the Cosmati. A flourishing activity in sculpture and mosaic decoration was developed early in the thirteenth century by the elder Cosmas and Jacopo (signed decorations of the Cathedral of Città Castellana, 1210) and was continued by the younger branch of the family headed by Pietro Mellini and his sons, Cosmas II and Giovanni, in the latter half of the century. It was this Cosmas II who was called by Pope Nicholas to decorate the Cappella Sancta Sanctorum with mosaics representing an Enthroned Christ with Angels and Saints, and who signed them: *Mag. Cosmatus fecit hoc opus.* Arnolfo di Cambio (ca. 1240-1302) had already been in Rome in the service of Charles of Anjou before 1277, and had considerable influence on the younger sculptors, particularly the sons of Cosmas II, Deodato and Giovanni di Cosma. The emphasis on plastic form, the

Gothic curvature and grace of drapery, and the growing sense of relationship between sculpture, architecture and painting in mosaic or fresco are to be noted, both as parallels to and influences on the development of Roman painting before the Babylonian Captivity.

Characteristic works from this point of view are the signed tombs, by Giovanni di Cosma, of Bishop Guglielmo Durante (1296) in Santa Maria sopra Minerva, and of the Cardinal Gonsalvo Rodriguez (1299) in Santa Maria Maggiore with combined sculpture and mosaic, and especially the tomb of Matteo d'Aquasparta (d. 1302) in Santa Maria in Aracoeli, Rome, with an architectural framework and a fresco respresenting the Madonna Enthroned and Saints on the wall above the reclining sculptured figure on the tomb. While the tomb was executed by Giovanni, the quality of the fresco has often encouraged its ascription to Pietro Cavallini.

Jacopo Torriti (active ca. 1288-ca.1296) was the most conservative and Byzantine of the three important Roman artists of the period. Born probably in nearby Torrita, he became a Franciscan monk and was patronized chiefly by the Franciscan Pope Nicholas IV (1288-1292), from whom he received commissions to do the two apse mosaics for which he is principally known. That of San Giovanni in Laterano (1291) represents a jeweled cross, with the dove of the Holy Ghost, bust of the Savior, and angels above. Below are the four Rivers of Paradise, with drinking harts and lambs, which flow together into the River Jordan. To the left of the cross are Mary, St. Peter, and St. Paul, with St. Francis and the kneeling patron, Pope Nicholas IV. To the right are grouped John the Baptist with St. Anthony of Padua, St. John the Evangelist and St. Andrew. Below the whole apse mosaic are nine apostles and the kneeling portraits of Jacopo Torriti and his co-worker, Jacopo da Camerino, with the inscriptions: *Iacobus Torriti pictor hoc opus fecit* and *Frater Iacobus de Camerino socius magistri operis recommendat se misericordiae Dei et Meritis Beati Johannis*. From an inscription on the vault the bust figure of Christ is a copy of an Early Christian mosaic, as is probably the whole general plan of the mosaic into which the two Franciscan saints had been inserted by Torriti. The mosaic is completely worked over by modern restorations.

As in San Giovanni in Laterano, the composition of the apse mosaic of Santa Maria Maggiore (ca. 1296) is very likely based on

7

the fifth-century mosaic which was destroyed in the rebuilding of the apse by Nicholas IV. The adherence to the Early Christian model and Torriti's variation of it not only reflect the identity of stylistic interest of this period with Christian Antiquity, but also show the continued influence of Gothic principles. The mosaic represents the Coronation of the Virgin, enclosed in a mandorla, and hosts of angels on either side below. To the left of the throne are Saints Peter, Paul and Francis; to the right, Saints John the Baptist, John the Evangelist and Anthony. Before these groups kneel the patrons: Pope Nicholas IV in front of St. Peter, and Cardinal Colonna before St. John. The auxiliary scenes below the apse mosaic depict the Annunciation, the Nativity, the Death of the Virgin (with the kneeling figures of Torriti, his helper Jacopo da Camerino, and the patron Cardinal Colonna), the Adoration of the Magi and the Presentation in the Temple; these last two scenes are placed in iconographical concordance to the first two on the other side of the Death of the Virgin.

For the originality of Torriti's style, note the centralized composition of the Coronation and the scenes below it (i.e. the Death of the Virgin) in a manner reminiscent of Gothic tympanum sculpture, in contrast to the earlier mosaic of Santa Maria in Trastevere. Its conventional Byzantine character can be seen by a comparison with the contemporary mosaics of Kachrije Djami in Constantinople, whereby the more thoroughly integrated composition and rounded figures of Torriti's manner become evident.

Pietro Cavallini (active ca. 1273-1316/34). Concerning the life of Cavallini there are two dates of importance in documents: a *Petrus dictus Cavallinus de Cerronibus* is mentioned in a document in the archives of Santa Maria Maggiore in Rome in 1273, and in Naples on June 16, 1308, an agreement to pay him for his services is made by King Charles II of Anjou, which is then confirmed on December 15 of the same year by his son Robert: *pro magistro Petro Cavallino de Roma pictore de solvendis sibi gagiis.* A note by the painter's son, Giovanni, from about the middle of the century, mentioned his father as having lived to be a hundred. The mosaics in Santa Maria in Trastevere were presumably signed 1291. In addition to these, his work in Naples, the dates and the notes by Ghiberti and Vasari of his Roman works and of his work in Assisi after the papal bull of

1288, indicate the range and importance of the artist's activity.

The frescoes, attributed to Cavallini by Ghiberti, which decorated the walls of the nave of San Paolo fuori le Mura were destroyed in the fire of 1823, but are known through drawings executed in 1634 for Cardinal Francesco Barbarini and preserved in the Vatican. These were divided into two groups belonging to different periods: the first group on the left (north) wall of the nave was done in 1277-1279, during the reign of Abbot John VI (1270-1279), whose name is given as patron, and depicted scenes from the Acts of the Apostles. The second group, with scenes from the Old Testament, was done between 1282 and 1290 under Abbot Bartholomew (1282-1297), who is represented kneeling near a figure of St. Paul on the triumphal arch, and under whose extensive decorative activity Arnolfo di Cambio was also employed (i.e., the signed ciborium of 1285 in this same church of San Paolo). These scenes on the right wall were arranged in a concordance similar to Early Christian cycles, such as the clerestory mosaics of Santa Maria Maggiore.

The forty-two scenes of these two series are important, not only because iconographically they are based on Early Christian models, but also because of the stylistic change evident in the development from one to the other. The former still reflects the stiff and linear flatness of the Byzantine manner, while the latter shows a more lively movement and closer composition of figures, a more plastic modeling of forms, and a greater feeling of the third dimension. The combination of a more emotional feeling for reality (Gothic) and a greater sense of monumental form (Classic), as opposed to the traditional Byzantine stylization, is a direct parallel in painting to the reforms effected in sculpture only a short time earlier by Nicola Pisano.

The mosaics (1291) of Santa Maria in Trastevere reveal these same characteristics in a much more comprehensible form. They are placed around the apse below the earlier Coronation of the Virgin and represent scenes from the life of the Virgin: the Annunciation, Adoration of the Shepherds and the Magi, Presentation in the Temple, the Death of the Virgin and the medallion of the Virgin with the apostles Paul and Peter, who recommend to Her the kneeling patron, Bertoldo Stefaneschi. A comparison with Torriti's mosaic in Santa Maria Maggiore (e.g., the Death of the Virgin) will

demonstrate Cavallini's more dramatic composition, more plastically modeled figures and space, and their careful arrangement within the frame of the picture.

Cavallini's most impressive painted work is the fresco decoration of Santa Cecilia in Trastevere. The date of ca. 1293 is based on the relationship between Cavallini's Gothic baldachin details and Arnolfo di Cambio's tabernacle, dated 1293, in the choir. The walls of the interior were decorated with parallel scenes from the Old and New Testaments in traditional manner, while the entrance wall was covered with a tremendous Last Judgment. The fragments left on the side walls suggest poorer draughtsmanship, probably the work of helpers, while the undamaged sections of the Last Judgment reveal the solidity of form, the use of light in the modeling of the figures and, particularly, the richness of color that again bear out a renewed inspiration from classical models and justify Cavallini's position as the first great Roman artist since classical times.

Related to the frescoes of St. Cecilia are the damaged ones in the apse of San Giorgio in Velabro, Rome, which were probably ordered by Cardinal Jacopo Stefaneschi in 1295. A second series of frescoes is ascribed to him on the basis of the fact that Cavallini is listed as having worked in Naples (1308), and because of the similarity in style to the frescoes of St. Cecilia. These are the decorations, done either by him or at least by his helpers, of Santa Maria Donna Regina in Naples (Last Judgment, scenes from the Passion and the lives of St. Catherine, St. Elizabeth and St. Agnes). The general connection with the court of Naples is emphasized by the fact that this church was built by the queen, Mary of Hungary, who had supplied funds in 1308 and 1314, during—or shortly after—which time the frescoes must have been done. The church was consecrated in 1320.

Filippo Rusuti (active ca. 1288-1317/21) is known chiefly for his mosaics decorating the facade of Santa Maria Maggiore, which he was commissioned to do by the cardinals Jacopo and Pietro Colonna sometime shortly after 1288. Aside from this, there are only a few facts recorded: in 1308 he was called by Philip of France to decorate his palace at Poitiers together with his son, Giovanni, and Nicolo Demarchi; he is mentioned until 1317 and died before 1321. It is assumed that he was one of those participating in the decoration of

the upper church of San Francesco in Assisi. The decoration of Santa Maria Maggiore was probably intended as an extension of that done by Torriti in the apse at Colonna's request only a short time earlier. The figures represented are Christ in a mandorla surrounded by four angels in the center over the rose window, and saints on either side. Below are four scenes from the history of Santa Maria Maggiore: Mary appears to Pope Liberius and to John the Patrician instructing them to build the church, John tells the Pope of his vision, the miracle of the snowfall in August, and the laying of the cornerstone of the church. Due to the reconstruction of the narthex, the portraits of the patrons were cut off, but Rusuti's signature remains at the feet of the Savior (*Philippus Rusuti fecit hoc opus*).

The style of these mosaics reveals a direct development of those qualities noted in Cavallini's work and suggested in Torriti: a growing sense of reality, the plastic and more lively expression of figures, and particularly the more fully developed perspective through converging lines and the placement of figures.

2. Assisi

AFTER A TURBULENT PERIOD OF RULE BY CONRAD, Duke of Spoleto, and wars with nearby Perugia, Assisi was ceded to the Pope in 1198 and remained consistently Guelph throughout the thirteenth century. The importance of Assisi to Italian Art, however, is not so much political or economic as it is religious, for it was the center of the most powerful religious reform movement of the late Middle Ages, which served as a direct stimulation to the arts, particularly mural decoration, through the Gothic period and well into the Renaissance. This movement is rooted in the pure devotion and lyric mysticism expressed in the life, personality and work of St. Francis of Assisi (1182-1226). Its significance to the period can be noted in the rapidity with which the cult of St. Francis grew, his canonization within two years after his death (1228), the establishment of a shrine and parent monastery in Assisi over his grave that same year, and its continued popularity, both from the side of the official church and with the people at large, through the thirteenth century.

The church of San Francesco itself, begun in 1228 under the direction of Friar Elias of Cortona and consecrated in 1253 by Pope Innocent IV, is important as one of the first Gothic churches in Italy. Using the characteristic Gothic features of ribbed vault and pointed arch, its aesthetic form is much more related to the structural economy and simplicity of twelfth-century Cistercian architecture than it is to the structural complexity of orthodox Gothic churches of the north. The distinctive feature of this Franciscan Gothic, in contrast to the elaborate and spacious developed Gothic or the Puritanical Cistercian, is the emphasis laid on large wall spaces through a subordination of windows and the use of a single-aisled plan, so that the wall surfaces facing the nave are impressively visible. On these the stories of the Bible, as well as those of St. Francis,

could be taught and made understandable in visual form, in a manner similar to the sermons spoken by the friars themselves.

In varying degrees, the same character can be found in the architectural complexes of the other mendicant orders developed in the thirteenth century, notably the Dominicans, the Augustinians, the Carmelites and the Servites. As preaching orders devoted to active participation in the daily life of the people, rather than the cloistered retreats of the older systems, their appeal was to the larger numbers of middle-class society concentrated in the growing and increasingly prosperous cities. Their devotion to the doctrine of poverty and joyousness as a way of life was an integral part of both the acceptance and the remarkable growth of the mendicant orders in Italy, as well as throughout Europe.

The church of San Francesco in Assisi was certainly the most important, but a considerable number of mendicant churches, with their accompanying monasteries, appeared rapidly in other centers, following a fairly consistent program combining structural and aesthetic economy with large, classically contained and impressive spaces. Though not clearly definable as a ''mendicant style,'' this character may be followed in such churches as San Francesco in Bologna (founded 1236), the Dominican Santa Maria Novella (1279) in Florence, and Santa Croce in Florence. Santa Croce is important as an artistic center second only to Assisi, with a history going back to 1211-1212 when St. Francis himself had lived there. Various building activities are mentioned in 1225 and 1252 until the new structure was designed in 1294-1295, presumably by Arnolfo di Cambio.

Dates and names of artists at work on the decoration of San Francesco are not to be found in contemporary records. The attribution of frescoes to Torriti, Rusuti, Giovanni Di Cosma, Cavallini, Cimabue, Giotto and their respective schools is based on rather vague remarks by later commentaries, especially Vasari, and on modern stylistic criticism.

As already noted, the design of the architecture and its decoration in fresco was conceived as an organic whole. It is a double church, the lower level with its dark and massive, tomblike vaults, the upper with its light, more open and compactly balanced proportions, its single-aisled nave divided into four bays by decorated ribs.

The decoration appears to have begun shortly after the con-

secration of the church in 1253. A papal bull of 1288 by Nicholas IV, the former general of the Franciscan order (1274-1279) and later Pope (1288-1292), urged the continuation of the work. The stylistically late frescoes on one of the vaults with figures of "church doctors" seem to have been done in 1297, the year in which the doctors, as such, were so designated by Pope Boniface VIII. The total decoration seems to have been finished by the festival year of 1300, which drew so many pilgrims to Assisi.

The frescoes on the walls facing the nave of the upper church appear to have been planned as a unit and are from the Old and New Testaments, iconographically paired on either side of the vertical windows of the the clerestory, while the third and larger series depicting twenty-eight scenes from the legend of St. Francis occupies the main part of the nave wall and is divided into a triptych system within each bay. Significant here is the subordination of the series of Old and New Testament scenes and the emphasis on the history of St. Francis as the spiritual focus of the Christian story. For arrangement of the scenes see pages 16 and 17.

San Francesco of Assisi fresco

Upper South Wall (left) NEW TESTAMENT SERIES		Upper Register North Wall (right) OLD TESTAMENT SERIES	

UPPER REGISTER

r	The Annunciation	a	The Creation
s	The Visitation (destroyed)	b	The Creation of Adam
t	The Birth of Christ	c	The Creation of Eve
u	Adoration of the Magi	d	The Fall of Man
v	Presentation in the Temple	e	Expulsion from Paradise
w	Flight into Egypt (destroyed)	f	Adam and Eve at Labor (destroyed)
x	Jesus among the Doctors	g	Sacrifices of Cain and Abel (destroyed)
y	Baptism of Christ	h	The Murder of Abel

SECOND REGISTER

	South Wall		North Wall
z	The Marriage at Cana	i	Building of the Ark
aa	The Raising of Lazarus (destroyed)	j	Entrance of Noah into the Ark
bb	The Kiss of Judas	k	The Sacrifice of Isaac

cc	Scourging of Christ (destroyed)	e	Abraham and the Angels
		m	Jacob before Isaac
dd	Christ bearing the Cross	n	Esau before Isaac
ee	The Crucifixion	o	Joseph sold by his Brothers
ff	The Lamentation	p	Joseph and his Brothers in Egypt
gg	The Resurrection		

Entrance Wall

hh The Ascension q The Pentecost

LOWER REGISTER—ST. FRANCIS LEGEND

North Wall

1. St. Francis is honored by a poor simpleton of Assisi.
2. St. Francis gives his cloak to a poor man.
3. St. Francis' vision of the palace filled with arms for his soldiers.
4. St. Francis prays before the Crucifix of St. Damian, which tells him to repair his ruined church.
5. St. Francis renounces his father before the Bishop of Assisi.
6. Pope Innocent III in a dream sees St. Francis supporting the falling Church.
7. St. Francis receives the sanction of Pope Innocent III for the Rule of his Order.
8. The Vision of the Brothers wherein St. Francis is transported in a chariot of fire.
9. Fra Leone's vision of the thrones, with the exalted one reserved for St. Francis.
10. St. Francis prays and Brother Silvester expels the demons from Arezzo.
11. St. Francis offers to undergo the ordeal by fire before the Sultan.
12. St. Francis in Ecstasy.
13. St. Francis institutes the representation of the Holy Manger at Christmas in Greccio.

Entrance Wall

14. The Miracle of the Spring: St. Francis causes water to gush from a rock
15. St. Francis preaches to the birds.

South Wall

16. Death of the Knight of Celano.
17. St. Francis preaches before Pope Honorious III.
18. St. Francis appears to the Brothers at Arles while St. Anthony preaches to them.
19. St. Francis receiving the Stigmata.
20. Death and Ascension of St. Francis.

16

The general scheme of the apse and transept areas of the upper church, attributed largely to Cimabue and his shop, is a unified decorative and iconographical program reflecting the Franciscan theological emphasis (expressed in St. Bonaventure's *Legenda Maior*) on the Virgin as the major intermediary between Heaven and Earth, the heroic and militant St. Michael of the Apocalypse, and St. Peter and St. Paul as the two representatives of the Apostolic Mission. The central group in the apse is dedicated to the Virgin, with the Angel appearing to Joachim and the Birth of the Virgin in the lunettes, the Disputation in the Temple and the Marriage of the Virgin below these, and the Last Moments, Death of the Virgin, Her Assumption and the Virgin in Majesty on the lower level. The series in the left (south) transept is devoted to the Apocalypse, with St. Michael and the Dragon, St. John on Patmos, the Fall of Babylon, Christ in Judgment, the Four Angels, the Twenty-four Elders Adoring the Mystic Lamb and the large Crucifixion which is directly over the altar of St. Michael on the eastern wall.

The right (north) transept has the Christ Enthroned with symbols of the Evangelists and the Transfiguration in the lunettes, and on the walls the series dedicated to St. Peter and St. Paul: the Healing of the Cripple, the Healing of the Possessed, the Fall of Simon the Sorcerer and the Martyrdom scenes of St. Peter and St. Paul. Another large Crucifixion dominates the wall over the altar of St. Peter.

The vaults in the crossing are decorated with figures of the four Evangelists seated before symbolic representations of the four quarters of the world to which they brought the gospel: Ytalia,

Judea, Asia and Ipnacchaia (Greece). These are represented as medieval walled cities, of which the Ytalia, with the figure of St. Mark, can be identified as Rome, containing various recognizable buildings, such as the Palace of the Senators with the coat of arms of the Orsini family. This would suggest a relationship between Cimabue and the Orsini senators, notably Giangaetano Orsini, who as Nicholas III was Pope from 1277 to 1280, and hence might indicate a dating of the frescoes.

Corresponding to these are the Four Church Fathers in the first vault from the portal in the nave, and the decoration of the third vault with figures of Christ, Mary, John the Baptist and St. Francis. In keeping with the two altars of St. Michael and St. Peter with their Crucifixion scenes in the transepts, the large Triumphal Cross by Giunta Pisano was originally suspended above the freestanding altar of the Virgin directly in front of the crossing. The other vaults are decorated with gold stars against a blue background.

The stained-glass windows of the apse belong to the same period and represent concordant scenes from the Old and New Testaments. Those of the window on the left appear to be the work of northern craftsmen, possibly French or German, while those on the right seem to be more closely related to the art of Rome.

The frescoes are badly damaged, some beyond recognition, a condition which combines with the complete absence of documentary evidence to make the various problems of authorship and ascription by stylistic analysis most difficult. General factors to be noted, however, are the apparent stylistic development from the scenes of the north wall (Old Testament) to those of the south, and the quite clearly recognizable participation of a number of different artists who reflect, in varying degrees, the general breaking-up of the traditional Byzantine manner, as already noted in the contemporary decorations of Rome.

A relationship in iconographical arrangement, and possibly in style, may be noted between the Old Testament scenes and the lost frescoes of St. Paul's Outside the Walls. The comparison of the Kiss of Judas and sections of the St. Cecilia frescoes might further substantiate the participation of Cavallini in the work. Likewise, the stylistic character of some of the ''earlier'' scenes of the Creation series bears a general relationship to that of Torriti's mosaic in Santa Maria Maggiore (e.g., Creation of Eve, or the Birth of Christ). The

damaged fresco of the Creation of the World is frequently attributed to Filippo Rusuti, which is even more impressive when one sees the recently uncovered underpainting in red and ochre of the head of the Creator. In any case, these frescoes reveal a style related and parallel to the art of Rome at the end of the century, and form the connection and immediate background for the new form and lyric enthusiasm developed in the art of Cimabue and Giotto.

3. Florence

IN THE THIRTEENTH CENTURY, Florence was largely under Ghibelline control, since the violent Donati-Uberti family feud allowed for much imperial interference in the city government. In 1259, the Guelphs were reestablished, only to be defeated at Montaperti in 1260 by the combined forces of Siena, Pisa and Manfred of Sicily. The Ghibellines were restored upon the latter's death, and a more popular type of government developed, giving way in 1282 to the government of six Priors. The last years of the century were marked by the great struggle between the Blacks and the Whites, the latter party, imperial in character, being expelled in 1302, at which time Dante, a famous White, began his exile.

The Guelph government became embroiled with imperial forces and was defeated at Montecatini in 1315 and again in 1325. Internal upheaval led to the establishment of Charles of Calabria as despot in 1326, and a fifteen-year period of peace followed. War with Pisa in 1340 brought another change in government, and Walter de Brienne, Duke of Athens, was installed as commandant for ten months. A period of civil war between the nobility and the Popolo followed, and Florence suffered severely from its own political troubles as well as from the ravages of the Black Death and almost continuous war with Milan. The Chiompi revolt in 1378 and the Ricci-Albizzi feud increased the turbulence, and in 1382 the burghers and employers emerged as the rulers of Florence under the increasing power of such magnates as the Medici family.

The characteristics of the *maniera bizantina* in Florence can best be studied in the mosaics of the Baptistry, particularly the apse with the Madonna Enthroned with Prophets and Saints (ca. 1225ff.), and in the fresco fragments of San Miniato al Monte. The much-restored mosaic of the Last Judgment with Old Testament scenes in the vault of the Baptistry (ca. 1270-1300) was done by

Venetian and Florentine craftsmen in a scheme somewhat reminiscent of contemporary Roman nave decorations but broken up to fit the octagonal form of the vault.

Vasari speaks of many Byzantine craftsmen who were imported to decorate churches during the first half of the century. The various characteristics of local Florentine craftsmen, under the influence of Byzantine, Romanesque and neighboring schools such as Lucca and Pisa, can be followed in a number of alterpieces: the Crucifixion of ca. 1200 in the Uffizi, with its open-eyed, frontally placed *Christus Triumphans* and scenes from the Passion; a second Crucifixion of ca. 1250-1270 with the new Dead Christ type (*Christus Patiens*) used by Giunta Pisano (Accademia of Florence); the large St. Francis altar with twenty scenes from his life in Santa Croce, Florence, which is based on Bonaventura Berlinghieri's famous 1235 altarpiece in San Francesco, Pescia; the St. Magdalene altar, also a full-length figure, with eight scenes from her life, ca. 1260-1280, in the Florence Accademia; the St. Zenobius altar by the so-called Bigallo Master (from the small Crucifixion in the Bigallo gallery) with the enthroned saint, flanked by standing deacons and four scenes from his life, ca. 1250-1270, in the Opera del Duomo in Florence; an altar with the half-length figures of Christ, Mary and three saints by Melior Toscano (signed and dated, *Melior me pinxit A.D. MCCLX-XI*) in the Uffizi gallery; and a thirteenth-century Madonna Enthroned in the Accademia.

Coppo di Marcovaldo (active ca. 1250-ca. 1274) is the first identifiable artistic personality in Florence. He seems to have been born about 1225-1230 and is mentioned as a shield-bearer among Florentine conscripts involved in the war with Siena, and is assumed to have been among those imprisoned after the battle of Montaperti (1260). He executed a series of frescoes for the Cathedral of Pistoia between 1265 and 1269 (lost). A 1274 document contains a petition for the release of his son, Salerno, from debtors' prison so that he could assist his father on the completion of several panels for the same cathedral, one of which, a damaged Crucifixion, survives in the cathedral sacristy. An early work is the Madonna del Carmine in Santa Maria Maggiore, Florence (ca. 1250-1260), with its strictly frontal Mother and Child in flat relief based on the traditional Byzantine type of the *Nikopoia*. The rosettes and relief decoration suggest

the influence of goldsmithwork. A Crucifix of about the same period (ca. 1260) is attributed to him; it is now in the Museo Civico of San Gimignano. His most important extant work is the large Madonna del Bordone in Santa Maria dei Servi, Siena, which was done for the Servite order there in 1261, probably during his imprisonment by the Sienese after the battle of Montaperti. The panel has been considerably retouched, but is now restored, and has the signature *MC-CLXI Coppus de Florentia me pinxit*. The comparison with the earlier Madonna will show the freer movement and more lyric conception of the theme related to the newer *Hodegetria* type, a more refined technique paralleled in the similar Madonna by Guido da Siena and further developed in the Madonna panel (ca. 1265) in the Servite church of Orvieto, which is attributed to Coppo with reasonable certainty. A second work of similar style ascribed to Coppo is the Crucifix in San Domenico, Arezzo, which seems similarly related to the art of Giunta and the Pisans, but developed in a lively and more expressive form.

A number of works by minor talents reflect the same transitional character of the period. An example is the anonymous panel of St. Magdalene (formerly in the Abbey of SS. Annunziata and now in the Academy of Florence), with its tall figure of the saint and small side panels showing Byzantine features of doomed architecture and gold ground combined with new groupings of figures.

The much-restored mosaics of the Baptistry of Florence continue more strictly in the older tradition: the work originally began ca. 1225 (Frater Jacobus), is noted in documents again in 1271, payments are continued in 1288, and it is still mentioned as late as 1325. The artists listed are Apollonios, who had been at work on the mosaics of San Marco in Venice in 1279, Andrea Tafi, and, lastly, Gaddo Gaddi. A development of style which can be associated with these artists seems to go from the apse to the upper rows with the heavenly hosts, the scenes from the life of Joseph, the life of Christ and finally the life of St. John in the lower row. Out of this same school of mosaic workers appear those of San Miniato, Florence, which were done about 1297, and the apse mosaic of the Cathedral of Pisa, which was begun by the Florentine master, Francesco, and finished by Cimabue in 1301.

Cimabue (Cenni di Pepo, ca. 1250-1302), who is mentioned in

Dante's *Purgatory* (Canto XI, 91) and succeeding commentaries, is a significant example of the growing recognition of the artist as a creative and individual personality rather than the traditional anonymous craftsman. A few facts are given by the sources: in 1272 he is mentioned (*Cimabue pictore de Florentia*) in the archives of Santa Maria Maggiore as having served as a legal witness in Rome; in 1301-1302 he is in Pisa where he continues the work on the mosaic, begun by a *Magister Franciscus pictor de S. Simone*, in the apse of the cathedral and receives payment for ninety-four days' work. His full name and origin are given: *Magister Cenni dictus Cimabu pictor condam Pepi de Florentia de populo Sancti Ambrosii.* His work in San Francesco in Assisi is presumed to be between 1279 and 1284; and his name appears in a Florentine document of 1302, *heredes Cenni pictoris*, refering to an estate near Fiesole and indicating his death a short time before. That same year he is mentioned in another document as a member of the Pisan military society of the Piovuti.

Cimabue's activity in Assisi thus falls between his years in Rome and Pisa. Besides the fresco work of both the upper and lower church, a number of interesting, although sometimes disputed, altar panels reveal a consistent evolution of style: the Crucifix in the church of San Domenico in Arezzo seems to have been painted before his appearance in Rome, i.e., ca. 1265-1272, and has much of the strong expressive character of Coppo di Marcovaldo. The Crucifix in the Museo del Opera of Santa Croce, Florence (almost completely destroyed in the flood of 1966), because of its large size and the swaying, weightless quality of the figure, is later (ca. 1285-1288), and may be associated with the building of the new Franciscan church for which it was probably intended as a triumphal cross on the screen. The Madonna in Santa Maria dei Servi, Bologna (ca. 1287), and the Madonna from the church of San Francesco in Pisa (Ca. 1295-1300), now in the Louvre, Paris, when compared with the earlier Madonnas in Assisi and the Uffizi, appear rather stiff and archaic, indicating perhaps the participation of assistants.

The fresco in the lower church of San Francesco in Assisi uses the traditional iconographical scheme of the Madonna and Child Enthroned with angels and saints on either side. Its date is assumed to come at the end of Cimabue's acitivty in Assisi, i.e., shortly before 1284. It is consideraly damaged; St. Francis stands to the right and a

second saint, probably St. Anthony, was originally paired on the opposite side. Characteristics to be noted are, again, the more plastic modeling of drapery, which tends to reveal the solid form of the figure beneath, a greater brilliance of color, and a greater spiritual quality in the lyric expression of faces. This last feature can be clearly demonstrated, in spite of its retouched present state, by comparing the head of St. Francis with the earlier ''portrait'' of the saint on the walls of the Sacro Speco in Subiaco. Signed and dated frescoes (1284) by a Florentine, Corso di Buono, in the choir of San Giovanni Evangelista in Montelupo, show rather clearly the influence of Cimabue's Assisi style, particularly in the figures, and hence would suggest their completion before that date.

Related to the Assisi fresco, but developed into a truly monumental altarpiece, is the Madonna Enthroned with Angels and Four Prophets (Jeremiah, Abraham, David, Isaiah), formerly in Santa Trinità and now in the Uffizi Gallery of Florence (ca. 1285). Compositional features of a more strictly centralized arrangement of throne and accompanying figures, the gold background, and the even distribution of color based on the red, blue and gold of throne and figures of the central group reflect the traditional Italian-Byzantine form but are dramatized by the tremendous scale (12′ 8″ high) and the monumental clarity of the composition. The contrast between this and the more gentle, open composition of the contemporary Rucceilai Madonna by Duccio reveals the competition as well as the relationship between these two personalities and traditions.

The only definite, authenticated work of Cimabue is the apse mosaic, particularly the figure of St. John, in the Cathedral of Pisa, which had been begun by a Francesco di Simone Porte a Mare (who may possibly be the same Francesco who was entered in the Calimala guild of Florence in 1298) and which was worked on by Cimabue in 1301/2 and not completed until 1321. The heavily restored condition, together with the limitations imposed by the differences in technique, make the work of questionable value to the definition of the artist's personal style.

The damaged frescoes decorating the choir and transept of the upper church of San Francesco were unquestionably executed by Cimabue and, with their quite remarkable compositions and varying relationships with Rome, suggest not only the participation of the master, but also of an extensive group of helpers. As described

25

before (page 24), the total iconographical and decorative scheme appears to be a unified concept in accordance with both the structure and the function of the architecture. The prominence given to those key works of the choir may again suggest the importance of Cimabue as the artist responsible for the design. The focus of attention appears to be on the four Evangelists of the vault at the crossing, with—if one can judge from the existing fragments of color—a brilliant array of colors radiating through the choir and transept area.

A study of style, even from the fragments in their present mutilated condition, will show a more Byzantine character (hence related to the ''earlier style'' of Cimabue) in the Evangelist figures on the vaults over the crossing; the gradual breaking up of the traditional flat and decorated surfaces as shown in the frescoes of the choir (particularly the scenes depicting the Last Moments and Death of the Virgin, and the Virgin in Majesty), and the Apocalyptic scenes of the south transept; and the dramatic and well-integrated style revealed in the Crucifixion of the south transept. The remarkably vigorous and expressive treatment of faces, drapery and gestures is especially noticeable in the details of the crowd at the left and right, in spite of the deterioration caused by the oxidation of the white lead and the resulting reversal of values. When compared with this most important and effective work of the series, the Crucifixion in the opposite transept presents a quite different quality, and suggests Roman characteristics and origin which reappear in the other frescoes of that north transept.

Cimabue's position in this dramatic period of transition, obscured through lack of documentation and the fragmentary condition of surviving works, is most difficult to evaluate. The archaic and restrained handling of forms suggests the end, and perhaps culmination, of an Italo-Byzantine tradition. On the other hand, the agitated, even dramatic, action of faces and figures, and their organization into massive blocks in space, point to new developments appearing in the work of Giotto and Masaccio.

Giotto (Giotto di Bondone, ca. 1267-1337). The interpretation of the many literary sources on Giotto's life and work, as well as the identification of the undocumented works, has often been dependent on whether one considers the artist a revolutionary genius who

broke the ties of medieval conventionality and created a new monumental art based on the reality of the world about him, or whether one holds that his genius lay in the re-formation of traditional elements, which appeared in the styles of Cavallini, the Pisani, French Gothic sculpture and his own Florentine background, into a new spirit and expression. In either case, the personal accomplishment of Giotto as the "father" of Italian painting remains as a permanent monument. It is recognized as such by succeeding individualists, such as Masaccio and Michelangelo; it is denied by decorative stylists like the Sienese-Gothic of the fourteenth and the Florentine courtly painters of the fifteenth century. The relationship with tradition, the discovery of new forms and their perfection into a new style and new tradition can be followed through the fresco series of Assisi, Padua and Florence, and have their artistic parallels in the literary development of his contemporaries Dante, Petrarch and Boccaccio.

The sources and older commentaries give the following generally accepted data about the life of Giotto di Bondone. He was born in Colle di Vespignano in the Mugello valley near Florence, either 1267 or 1277, according to the interpretation given to Vasari's *sessanta* or *settanta* when he speaks of Giotto's age at his death. The date is probably the earlier, since in 1303 he is spoken of as *adhuc satis invenis*. Also according to Vasari, he was a pupil of Cimabue. Though there are many arguments to the contrary, he is assumed to have been at work on the decoration of San Francesco in Assisi during the '90s, and is mentioned by the chronicler Riccobaldo da Ferrara as having worked for the Franciscans in Assisi, as well as in Rimini and Padua. He was possibly in Rome before 1300, and certainly at various times before 1313. Between 1303 and 1310, he was at work on the Scrovegni Chapel in Padua. From 1307 on, he is mentioned intermittently as active in Florence, being listed in the guild of *medici e speziali* in 1327. Ghiberti names, among other works, a series of allegorical frescoes painted by Giotto in the Palazzo del Podestà (destroyed). From 1328 to 1333 he is listed in Napues and was named *Familiaris* at the court of King Robert. While there, he is said by Ghiberti and Vasari to have painted frescoes for Robert in the Castello Nuovo and the Castello d'Uovo a series of portraits of famous men and scenes from the Old and New Testaments in the church of Santa Chiara, which was built by Robert. In 1334 he was

again in Florence and was appointed directing architect for the building of the cathedral. The lower story of the campanile is generally accredited to his plan. Ghiberti credits him with the designs for the reliefs on the campanile which were executed by Andrea Pisano. Further documentary evidence indicates that Giotto had been active again in Rome (i.e., after the Padua work) and probably in Assisi, as well as in Rimini, Verona, Milan, Bologna and possibly Avignon. These, together with Petrarch's praise of the master as *Nostri Aevi Princeps*, as well as Dante's, in which Giotto appears to have surpassed the reputation of Cimabue, give some indication as to his widespread fame and recognition. He died January 8, 1337, and was buried with all honors in the Cathedral of Florence.

The frescoes associated with Giotto in the upper church of San Francesco in Assisi are the twenty-eight scenes from the life of St. Francis, beginning at the crossing on the right and continuing around to the crossing at the left. The total decorative scheme appears to be a unified and carefully planned iconographical program involving, as described above (pages 15-16), the combination of Old and New Testament scenes with those of St. Francis in a common theme of Salvation. The general coloration of the nave frescoes is somewhat subdued, compared with what must have been—if one can judge by the surviving fragments—the brilliant color of Cimabue's choir. The dramatic innovation, compared to the Rome-related upper scenes of the nave, was the almost life-sized presentation of the life of St. Francis on the main sections of the walls, with the stories given as a very free, personalized and spiritually realistic interpretation, based chiefly on St. Bonaventura's *Legenda Maior* (1261).

Among the general stylistic features to be noted in the series are: the composition of the scenes into triptychs within each bay of the nave; the simplified arrangement of figures as a well-modeled relief in the foreground with the suggestive landscape or architectural background stacked up decoratively as a surface pattern; the figures themselves composed not only as separate and autonomous scenes, but also with a continued left-to-right movement so as to connect the narrative from one scene to the next; the frequent interpolation of details which add to the associative charm of the story but are not integrated in a total composition and hence, by comparison with Giotto's later and more monumental works (Florence),

reflect the "youthful" style of the master; finally, in contrast to the older styles, the free and unconventional lyric spirit of the narrative which combines with these qualities to form what might be called a "Franciscan" style.

The impressive unity of the general plan of the St. Francis cycle indicates, in the total design and conception at least, the work of a single and dominating personality. Whether it was Giotto or one of a group of his followers or an unknown artist from Rome, Umbria or elsewhere, it is the subject of rich and stimulating controversy which defies general acceptance. With a few exceptions the chronology of execution appears to follow the chronological sequence of the story itself.

Of particular importance in this situation is the change in technical procedure, which appears to be an integral part of the stylistic evolution not only here in Assisi, but also in Rome and Florence, during the last decade of the thirteenth century. The medieval tradition of a combined technique of *fresco* (i.e., the pigment painted directly into the wet plaster) and *secco* (the pigment combined with a binder—tempera—applied on the plaster surface after it is dry) had continued since antiquity, and is described in the eleventh-century treatise by Theophilus. The process involved the drawing on the finished surface and the paint laid on over it. The succeeding areas of the wall being painted, the *pontate*, were determined by the platform of the scaffold on which the painter worked, as it was moved from upper to lower levels and along the wall. The *pontate* divisions can be seen in the Cimabue frescoes of the choir and in the Old Testament scenes of the nave (e.g., the Building of the Ark and the Creation of Eve in the first two bays from the transept).

The new attitude, with its greater emphasis on a more unified conception of figure, space, and composition, developed the drawing directly on the rough base coat of plaster, the *arriccio*, first with charcoal, then with a brush and red earth pigment (*sinopia*). The painting then proceeded on a day-by-day basis, with the final coat of smooth plaster, the *intonaco*, applied in patches small enough to be painted in one day (the *giornata*) while the plaster remained wet.

The advantage to the designer in this latter method is that he is able to achieve a freer expression in details as well as a greater unity to the total composition through the more rapid execution of the

drawing. With the overall design established, the painting of the smaller sections provides an equal degree of freedom and control, that is, if the execution of the work is carried out by the master himself. If it is turned over to assistants, the quality of the result depends on the talent and experience of the assisting craftsman. These patches can usually be seen by close examination of the San Francesco frescoes, varying from a half dozen in the scene of St. Francis Praying in San Damiano to over fifty in the Death of St. Francis. It is this total concept of ''drawing,'' by which is implied the overall idea and concept as well as the projection of that idea in visual terms on the given surface, that the Renaissance understood in the term *disegno*.

In general, the system of the *giornata*, with the dividing lines frequently woven into the design at the outlines of the forms such as figures, drapery or landscape, appears to begin with the Isaac scenes and continues through the Franciscan cycle. As noted before, the work on the upper levels of the nave seems to have been in process at the same time that Cimabue was working in the choir and lower church. The scheme followed the Roman practice, where the contemporary interest in the Early Christian frescoes and its emphasis on the wet plaster technique of the *giornata* is evident. The change in technical procedure appears to be a product of the new concept of a younger generation involved in the Franciscan cycle.

The most striking of these Old Testament scenes are the last four of the north wall, particularly the two Isaac stories. The artist, known as the Isaac Master, has long been distinguished by critics for his strong, individual character because of the sculptural compactness of his figures and their strict organization in space through its architectural framework. The organic integration of these forms into a dramatic and highly individual expression suggests an artist of Roman origin, but also indicates a close relationship, even an identity, with Giotto. A similar quality, evident at least in the design if not in the actual execution, is to be seen in the vault decorations of the Church Fathers, where the combination of figures with the surrounding furniture and equipment in a related perspective tends to unify the four vaults into a common domelike design.

Within this general scheme, a closer stylistic analysis will show variations which suggest the development of the master's style, as well as the hands of several quite different personalities at work with

him. The comparison of some of the early scenes on the north wall (e.g., St. Francis Gives His Cloak to a Poor Man) with later ones on the south wall (e.g., Preaching before Pope Honorius III, or Appearing to the Brothers at Arles) reveals the narrative concentration on the figures gradually enriched through greater modeling of the forms and their freer movement in space. Likewise, the comparison of such a scene as St. Francis Honored by a Poor Simpleton and the last three scenes on the south wall will reveal a stylistic point of view quite different from those mentioned. These show a greater interest in problems of space, the movement of figures more in space than along the surface, and the general predominance of architecture, with its tall Gothic proportions and spatial recession, over the figures. This style has been associated with a contemporary panel with scenes from the life of St. Cecilia (ca. 1304) in the Uffizi of Florence, and the artist therefore, has been named the ''St. Cecilia Master.''

The identification of Giotto's pupils and co-workers active in Assisi has been a vague and difficult problem. Sources and the older commentaries (Boccaccio, Sacchetti, Villani, Ghiberti and Vasari) give, among others, the names of Buffalmacco, Puccio Capanna and Stefano Fiorentino, of whom there are no authentic works extant, but to whom, as immediate followers of Giotto, a number of the Assisi frescoes have been attributed without clearly associating the names to the works. The frescoes of the lower church include the one group by a single master who decorated the four vaults of the crossing with allegories of the Franciscan vows (Poverty, Chastity, Obedience), a Glorification of St. Francis and the scenes from the youth of Christ, the life of Mary, the Crucifixion and three miracles of St. Francis in the north transept. The ascription to Puccio could be based on Vasari's note that he had executed frescoes of the Passion in the lower church of San Francesco and a St. Francis cycle in the choir of San Francesco in Pistoia (1343).

A second group is the decoration of the chapels of St. Magdalene and St. Nicholas. The St. Magdalene Chapel can be dated sometime after 1314, when the patron, Teobaldo Pontano di Todi (d. 1329), became Bishop of Assisi, while the other frescoes, representing scenes from the life of St. Nicholas, are associated with Napoleone and Gian Gaetano Orsini, and may be dated before 1316, when the latter became Cardinal, or possibly as early as 1306 or

1307, because of the relationship of figure designs with the dated (1307) retable in the Gardner Museum of Boston by Giuliano da Rimini. Many of the compositions of these scenes are directly influenced by Giotto's frescoes in Padua (e.g., the Raising of Lazarus, the Marriage at Cana, and the *Noli me tangere*), but are much inferior, both in total conception and in the execution of details.

Several works are associated with Giotto's Roman period. One is the fresco fragment, Pope Boniface VIII Announces the Holy Year in San Giovanni in Laterano, ca. 1300, of which a drawing indicating the total composition exists in the Ambrosiana of Milan. Two others are mentioned in the *Martyrologia Benefactorum Basilicae Vaticanae* as having been done by Giotto and given by Cardinal Jacopo Gaetano de' Stefaneschi to the basilica of St. Peter. They both appear to have been done about the same time, i.e., about, or possibly shortly after, the Holy Year, 1300. The St. Peter altar in the Vatican Pinacoteca, executed, presumably, for the high altar of Old St. Peter's, is a double-sided polyptych with the Christ Enthroned, St. Peter, Apostles and Angels, the Virgin and the martyr deaths of St. Peter and St. Paul. Due to the weak composition of the scenes and much overpainting, Giotto's own hand in the work is doubtful, but the strong character of the Madonna might be considered a connecting link between the fresco medallions of the Virgin in Assisi and in Padua.

The other work is the mosaic known as the *Navicella*, originally done for the atrium of the older basilica of St. Peter's and now extant in a restored and reduced form in the narthex of the present church. Early copies, without the Evangelists in the clouds, are to be found in the drawings in Chatsworth and Chantilly, and the fresco copy by Andrea da Firenze in the Spanish Chapel of Santa Maria Novella in Florence. From these one can recognize the strong, dramatic composition, balanced on either side in the foreground by the figures of Christ and Peter and the fisher. The dramatic interpretation of the theme might be noted in the movement of the waves, the excitement of the apostles, the asymmetrically composed full-blown sail and the genrelike motif of the fisher in contast to the terrified apostle Peter.

Sometime during this period (1300-1305), between Assisi and the Padua frescoes, Giotto painted an altarpiece and a fresco of the story of the Madonna, which was mentioned by Ghiberti and Vasari,

in the main chapel of the Badia of Florence. Of the frescoes only a few fragments remain, but these details, particularly the hooded head of a shepherd, reveal the freshness and expressive quality of the master. The much-discussed Badia polyptych representing the Virgin with St. Nicholas and St. John the Evangelist, St. Peter and St. Benedict was painted about the same time with the assistance of the shop.

Giotto's greatest work is the decoration of the Scrovegni Chapel in Padua. The chapel itself is a relatively small (67 ft. long × 28 ft. wide × 42 ft. high), one-aisled structure covered with a barrel vault and built by Enrico Scrovegni (dedicated on Annunciation Day, March 25, 1303, and consecrated March 25, 1305, to the Virgin Mary) as a family chapel adjoining his palace around the ruins of an ancient arena (hence the name Cappella dell' Arena). The palace was destroyed in the nineteenth century (1820). Enrico Scrovegni was the son of a wealthy usurer, Reginaldo, who was mentioned in Dante's *Inferno*, Canto XVII, 64-75. The modest character of the architecture with its emphasis on wall surfaces suitable for painting would suggest Giotto as the designer. The decoration of the nave was probably begun after the dedication in 1303 and may have continued beyond the consecration date of 1305. The frescoes were certainly finished by 1313, since they are mentioned in the *Compilatio Cronologica* by Riccobaldo Ferrarese and the *Documenti d'Amore* by Francesco da Barberino. The walls of the choir were decorated some time later by Giotto's followers.

The content includes a large God the Father with Angels as He dispatches Gabriel to the Annunciation on the triumphal arch, a Last Judgment on the entrance wall and thirty-seven scenes from the Lives of Mary and of Christ, with additional decorative figures and motifs. Of significance is the emphasis on the Virgin, to whom the chapel is dedicated, as well as Christ in the story of Salvation. The sources are to be found in the Apocryphal books of the New Testament (i.e., Gospel of St. James), as well as the pseudo-Bonaventura *Meditationes Vitae Christi* and Jacopo da Voragine's *Golden Legend*. These scenes are arranged in three registers of six scenes each, the lower two registers on the right being reduced to five because of the windows. For arrangement see page 34.

TRIUMPHAL ARCH (East Wall)
God the Father with Angels

TOP REGISTER
13. A & B. The Annunciation: Gabriel and Mary

North Wall (left)
7. Birth of Mary
8. Presentation of Mary in the Temple
9. The Wooers bring their Rods to the Temple
10. The Prayer of the Wooers
11. Marriage of the Virgin
12. Bridal Procession of Mary and Joseph

South Wall (right)
1. Joachim's Expulsion from the Temple
2. Joachim retires to his Shepherds
3. Annunciation to Anna of Mary's Birth
4. Joachim's Sacrifice
5. Joachim's Dream
6. Meeting of Joachim and Anna at the Golden Gate

SECOND REGISTER

East Wall
26. Judas accepts the Bribe 14. The Visitation

North Wall
20. Christ among the Doctors
21. Baptism of Christ
22. Marriage at Cana
23. Raising of Lazarus
24. Christ's entry into Jerusalem
25. Christ drives the Money-changers from the Temple

South Wall
15. Birth of Jesus
16. Adoration of the Magi
17. Presentation in the Temple
18. Flight into Egypt
19. Slaughter of the Innocents

THIRD REGISTER
East Wall
Painted Gothic chapels (*le cappelle segrete*)

North Wall (left)
32. Christ bearing the Cross
33. The Crucifixion

34. Lamentation over Christ
35. The Angels at the Sepulchre and *Noli me tangere*
36. The Ascension
37. Descent of the Holy Spirit

South Wall (right)
27. The Last Supper
28. Christ Washing the Feet of the Disciples
29. The Kiss of Judas
30. Christ before Annas and Caiaphas
31. The Flagellation of Christ

BOTTOM REGISTER

The Cardinal Sins (Grisaille Figures)	The Cardinal Virtues (Grisaille Figures)
Despair	Prudence
Envy	Fortitude
Infidelity	Temperance
Injustice	Justice
Wrath	Faith
Inconstancy	Charity
Folly	Hope

Entrance (west) Wall

The Last Judgment

DECORATIVE QUATREFOILS

The Brazen Snake
Jonah swallowed by the Whale
The Lioness with the Cubs
Elijah in the Chariot of Fire
Moses receiving the Ten Commandments
The Circumcision
Moses strikes Water from the Rock
Creation of Adam
The Children of the Prophets go to Elisha
Michael's Battle with Satan
Various Saints and Church Doctors

MEDALLIONS ON THE VAULTING

Christ with John the Baptist and three other prophets
Madonna and Child with four prophets—Daniel, Baruch, Malachi, Isaiah

Among the more important stylistic factors which could be pointed out are following: the almost Romanesque simplicity of the architectural design appears to have been dictated by the desire for mural decoration (as at Assisi), with solid walls, barrel vault and windows limited to the right wall and façade; the left wall was solid since it adjoined the palace; the comparison with a parallel French Gothic court chapel, the Sainte Chapelle in Paris (1243-1248), with its tall ribbed vaults and sheets of stained glass, illustrates the striking differences between the Northern and the Italian versions of the Gothic style, particularly with regard to the relationship of painting to architecture and the specific character of a tradition that dominates Italy during the succeeding centuries.

In design, color and illumination the interior of the Scrovegni chapel exhibits a unity far beyond what had been achieved in Assisi, where the long proportions of the room and its division into bays by ribs still gave predominance to the architecture over the decoration and its content. In the Arena Chapel, it is the painted decoration and its impressive content that has gained the supremacy. Color values vary according to their distance from the sources of light, i.e., the windows of the entrance wall and right side, and according to their distance from the beholder, i.e., in varying degrees from the lower to the upper rows of scenes. This attention given to the lighting, the simplicity of the figure design and the use of color values in the modeling of the forms combine to give the impression of actual plastic relief.

The same unity of concept is likewise evident when one analyzes the linear perspective. While it is not the ideal ''correctness,'' in the mathematical sense of the Quattrocento, the organization of figure and space through the use of stylized landscape and architecture serves as an organizing principle parallel to the color.

In this totality of *desegno* each composition is closed, with its various horizontal and vertical elements perfectly balanced, self-contained yet in movement, in a kind of inner architecture which complements the architectural plan of the whole. Of note in the design are the marbleized base panels, with grisaille figures between them as accents, and the vertical decorative bands in painted Cosmati-type mosaics, again with accents, in the quatrefoils containing Old Testament scenes.

Giotto's mastery of technique is demonstrated not only by the unending variations in color expression that he had worked out of such a limited medium, in contrast to the earlier frescoes in the choir and transept of San Francesco of Assisi, but also by the remarkable state of preservation. There is little damage by either time or restoration. The greater emphasis on true fresco, rather than the *secco* noted in the St. Francis cycle, is continued here, so that the major portion of the decoration is in the true fresco technique, with only limited use of *secco* in sections involving blue and green. There are very few indications of *sinopie* on the *arriccio*. The continuity of the Giotto tradition in technique as well as style has been preserved through the master's followers and was written down in handbook form (*Il Libro dell' Arte*) by Cennino Gennini, the pupil of Taddeo

and Agnolo Gaddi, Giotto's pupils.

As in Assisi, each scene is designed in a continuous left-to-right movement in keeping with the narrative sequence. They represent a constant solution of problems of dramatic content and monumental form that had appeared in the earlier work. Note, for instance, the use of realistic genre motifs to dramatize the scene, as the drinking burgher in the Marriage at Cana, the tender lyricism of such scenes as the Meeting of Joachim and Anna at the Golden Gate, the ominous tension of such scenes as the Last Supper and the Kiss of Judas, and the expressive pathos in the Crucifixion and the Lamentation over Christ. This last is a good example with which to demonstrate the fact that the expression is a matter not only of the content by of its enhancement by the abstract language of the moving forms and design. Similar subleties of dramatic content may be seen in the concordance of such scenes as the Raising of Lazarus and the Resurrection, the Flagellation of Christ and the Slaughter of the Innocents, or, indeed, the parallel scenes of the story of Joachim in the top row at the right and those of the Virgin at the left. It is in this light that Dante's characterization of the new age as *il dolce stil nuovo* should be interpreted.

Due to the decorative unity of the chapel and the remarkably short period of execution it is difficult to trace a chronological development of the work through stylistic analysis. At first glance it might seem that Giotto began with the Last Judgment and continued to the lower rows (Life and Passion of Christ), and the Life of Mary in the top rows. A simpler and more elemental type of composition and change in color pattern might support this theory. On the other hand, these same qualities can be accounted for by the distance of the top rows from the eye of the spectator. The more logical interpretation would be the continuous work on all four walls (i.e., including the Last Judgment and the triumphal arch) from the top down, in accordance with the convenient removal of the scaffolding. The change in concept from relatively simple compositions with fewer figures on the top register to the more complicated use of figures in dramatic situations involving massive forms in a thoroughly organized space, as seen in the middle and lower rows, should be understood as an integral part of the total design as well as the stylistic evolution of the separate units.

A final point is the stylistic relationship and parallel to the

sculpture of Giovanni Pisano. There is reason to believe that Giotto may have known Giovanni personally, since the latter had been commissioned by Enrico Scrovegni to do a marble Madonna for the altar of the Arena Chapel and was in Padua at the same time. The total style of Giovanni, moreover, has a certain combined Gothic lyricism, decorative verve and dramatic sense of reality that has its parallel in the murals of Assisi and Padua. The development of style, from the revival of classical forms in the later thirteenth century to their refinement under the influence of French Gothic principles, into a new spirit can be followed in the reliefs of the famous pulpits by Nicola and Giovanni Pisano (pulpits by Nicola in the Baptistry of Pisa, 1259, and Siena, 1268; those by Giovanni in Pistoia, 1298, and in the Cathedral of Pisa, 1302–1311), and form an interesting parallel to the development already traced in the painting of Rome, Assisi and Florence.

Of the many panels by Giotto mentioned by Vasari and Ghiberti, two pieces of consistent and highest quality are identifiable. One is the remarkable Crucifix in Santa Maria Novella, Florence, which is mentioned in a Florentine document of 1312 as being in that same church. It has long been famous, both for its relationship to the fresco Crucifixion of the Arena Chapel and as an important prototype for many similar crucifixes executed by his followers through the fourteenth century. Indeed, its freshness and vitality have led more recent criticism to the conviction that it is the work of the young Giotto, executed certainly before Padua and possibly before or during the Assisi frescoes, i.e., between 1290 and 1300. In comparison with the older Crucifixion type used by Cimabue and his contemporaries, note the gigantic size of the panel itself (5.78 meters high), the realistic consciousness of weight and the hanging body as compared with the swinging curve of the Byzantine manner, the modeled character of the form through drawing and the use of light as seen in the head and torso, even the clear but somewhat hesitant foreshortening of the legs from knee to hip. There is almost a sculptor's conception involved in the use of one nail for the feet rather than the traditional use of two which, through the overlapping of the forms, enriches the composition and deepens the expressive pathos.

Related Crucifixes, executed with the help of assistants, are those in the Museo Civico of Padua, ca. 1305/6, formerly in the

Scrovegni Chapel, and in San Francesco in Rimini, ca. 1300-1305. Although in a poor state of preservation, this latter work might indicate the presence of Giotto in Rimini during the years between his work in Assisi and Padua.

The other important panel is the large (3.25 × 2.04 meters) Madonna Enthroned in the Uffizi, which is noted by Ghiberti as being in the church of Ognissanti. Its date of execution is usually set around 1310, shortly after the Padua frescoes and contemporary with Duccio's Maestà (1308-1311), but before Simone Martini's fresco Maestà (1315) in the Siena Palazzo Pubblico, which seems related to it (cf. the kneeling figures).

In comparison with Cimabue's Madonna Enthroned, the style of the Ognissanti panel shows a more elemental simplicity of design and a correspondingly impressive modeling of the form in the manner of Giotto's own decorative figure of Justice in the Arena Chapel. Angel figures at the side do not look straight out at the beholder, but are turned in toward the Virgin, which again is not alone a matter of pictorial form, i.e., the relationship of modeled figures in the illusionary space, but also one of iconography. The traditionally hieratic conception of the Madonna in Majesty has been softened and made more human by the introduction of more poetic Gothic motifs, shown in the kneeling and standing pairs of angels on either side below, offering flowers, the crown and anointing vessel to the Virgin. The plastic dignity of the traditional Virgin Enthroned has thus been enhanced by the strong, simple form, yet is also enriched by the lyric attributes of other scenes associated with her (i.e., the Coronation and the Adoration). It is this latter idea which is continued and emphasized by Martini and Sienese. A related Madonna, originally of large size but not cut down and damaged, is that in the church of San Giorgio alla Costa in Florence. Its simpler and more tenative design would make it an earlier work, possibly of the Assisi period.

The late work of Giotto is represented by the fresco decoration of the four chapels in Santa Croce, Florence, as mentioned by Ghiberti. Of these the frescoes of the Cappella Giugni, with stories of the apostles, and the Cappella Tosinghi, with stories of the Virgin, have been destroyed, except for a damaged Assumption of the Virgin over the entrance to the latter chapel. The frescoes of the Cappella Peruzzi represent scenes from the lives of St. John the Bap-

tist and St. John the Evangelist: the Annunciation to Zacharias, Birth and Naming of John the Baptist, the Feast of Herod and Dance of Salome, St. John the Evangelist on Mt. Patmos, the Raising of Drusiana and the Ascension of St. John.

In the Cappella Bardi the frescoes represent six scenes from the life of St. Francis: St. Francis' Renunciation of His Father, his Appearance to the Brothers in Arles, Death of Francis, Pope Innocent III Sanctions the Rules of the Order, the Ordeal by Fire before the Sultan, and, lastly, the Vision of Brother Augustine and the Saint's Appearance to Bishop Guido of Assisi. The scene of St. Francis Receiving the Stigmata appears over the entrance wall. Separate figures in painted architectural niches represent Saints Claire, Elizabeth, Louis of Toulouse and Louis, King of France. The representation of Louis of Toulouse with a nimbus is significant in dating the fresco, since Louis was not canonized until 1317, and hence the work must have been begun after that date, perhaps even as late as 1330.

The frescoes of both chapels, particularly the Peruzzi, which were painted largely in *secco*, have a long record of deterioration, repainting and restoration, so that some critics have gone so far as to consider them practically lost. A recent program of careful restoration, however, shows them still impressive as compositions and a completion of the monumental form characteristic of Giotto's late style. This can be seen by the comparison of similar themes and compositions; for instance, the Raising of Drusiana and the Raising of Lazarus in the Arena Chapel; St. Francis Renouncing His Father and the same theme in the Assisi church; the Apparition at Arles as compared with the same theme in Assisi, or better, the Last Supper at Padua. They show a greater movement and compact grouping of figures, a deeper space composition through the architecture, and a greater integration of figures and design into a more centralized and monumental composition (note particularly the Raising of Drusiana and the Apparition at Arles).

The scale is also important, since the figures of the Arena series are about half life-size, while these are closer to full size. This centralization is one of the chief characteristics of the master's late style, yet the change may also have been a necessity due to the different character of the room in which they are painted: the scenes are superimposed one above the other on a vertical wall space, con-

sequently there is not the running narrative of the succession of scenes as in Assisi and Padua, and the compositions, although still to be read from left to right, are built more around a central vertical axis.

As at Assisi, the interior decoration of Santa Croce with its narrative scenes appears to have been a part of the whole original architectural design. The actual development of the work went piecemeal through the fourteenth century and, though not as obvious as at Assisi, there is some evidence of a unified iconographical plan. This is evident in the general humane character of the narrative, the emphasis on the stories of the Virgin and St. Francis, and the juxtaposition of Agnolo Gaddi's Assumption of the Virgin and Giotto's St. Francis Receiving the Stigmata on the center wall of the spacious transept facing the nave. According to the legend it was on August 15, 1224 (Assumption Day), that the saint went into retreat at La Verna, where on September 14 the vision of the Crucifix appeared and he received the Stigmata.

The history of Santa Croce goes back to the lifetime of St. Francis himself, who established a chapter outside the Porto San Gallo in 1211 or 1212. The legend of the Holy Cross, to which the church is dedicated and which became the theme of Agnolo Gaddi's decoration of the main chapel, is of special interest to the Franciscans, since they became custodians of the sacred sites in Jerusalem in 1333. The huge Gothic structure, with its expansive open space to facilitate the preaching function, was begun in 1294 by Arnolfo di Cambio, and was essentially completed by the middle of the fifteenth century.

In addition to those already mentioned, there are various altarpieces attributed to Giotto which are certainly products of his workshop. These include the early (Assisi period) St. Francis Receiving the Stigmata from the church of San Francesco in Pisa, now in the Louvre, Paris; the Coronation of the Virgin polyptych in the Baroncelli Chapel of Santa Croce, Florence (ca. 1328); the Madonna Enthroned with St. Gabriel and St. Michael, St. Peter and St. Paul, in the Pinacoteca Nazionale of Bologna (signed *Opus Magistri Iocti De Fiorentia* but certainly a shop piece); the Death of the Virgin in the Berlin-Dahlem Museum (possibly the same painting mentioned by Ghiberti as having been in Ognissanti); and the so-called Peruzzi polyptych, with which the Madonna in the National Gallery of

Washington, the St. Stephen in the Museo Horne in Florence, the St. John the Evangelist and St. Laurence panels in the Musée Jacquemart-André in Châalis, as well as others in the North Carolina Museum in Raleigh, may be associated.

Among the followers of Giotto, a distinction is to be made between those pupils and co-workers associated with the Assisi frescoes and those who carry on the Florentine tradition to a somewhat greater degree of individuality through the first half of the fourteenth century. The character of the Assisi group can best be studied in some of the scenes decorating the vaults of the lower church of San Francesco, particularly the Raising of Lazarus, the *Noli me tangere* and Flight into Egypt, which are obvious variations of Giotto compositions in Padua but lack the strength and integrated quality of the master.

There is some evidence that the Florentines were aware of this decline in the years that followed. Franco Sacchetti, in one of his novellas, tells the story in which Orcagna asks the question, "Who is the greatest painter beside Giotto?" One suggests Cimabue, another Stefano, then Bernardo and Buffalmacco, among others. Taddeo Gaddi replies that there have been good artists, but that painting appears to be on the decline and gets worse every day. Although the story was written about 1390, it is assumed that the conversation described would have taken place around 1360.

Taddeo Gaddi (ca. 1300-1366) was the most important of Giotto's immediate followers who maintained the tradition in Florence. He was presumably the son of the mosaicist Gaddo Gaddi, and both his work and reputation are extensively discussed in Vallani, Ghiberti, Vasari and Sacchetti's novellas. In 1341-1342 he is recorded in Pisa. Signed and dated panels of 1334 and 1355, notes in records of 1359, 1363 and 1366 connected with his activity on the building commission of the cathedral, and his death, probably in 1366, from the records of the guild of St. Luke, are the chief sources for dating his activity.

Taddeo Gaddi's most important work is the fresco decoration of the Baroncelli Chapel in Santa Croce, Florence, with scenes from the life of Mary, which was probably done shortly after the installation of the tomb of the Baroncelli family on the entrance wall in 1328. Besides the Madonna and Child in the fresco lunette over the tomb,

the scenes on the left wall represent the Expulsion of Joachim from the Temple, Annunciation to Joachim, Meeting at the Golden Gate, Birth of the Virgin, Presentation in the Temple and the Marriage of the Virgin. On the altar wall are the Annunciation, Visitation, Annunciation to the Shepherds, Nativity, Annunciation to the Magi and Adoration of the Magi. Figures of the Virtues appear in the vaults.

The comparison of these with parallel scenes in Giotto's Paduan cycle (e.g., the Meeting of Joachim and Anna, or Mary Ascending the Steps of the Temple) illustrates Taddeo's interest in more complicated architectural patterns, more lively movement of figures and realistic detail, the use of light as an expressive compositional element (e.g., the Annunciation to the Shepherds) and, in general, a greater love for lyric narrative. This is often associated with the writings of Fra Simone Fidate of Cascia, the Umbrian mystic who lived in Florence from 1333 to 1338 and whose *De Vita Cristiana* contains many descriptions which parallel the artist's painted narratives. From this period, too, comes the remarkable series of twenty-eight scenes (twenty-two quatrefoils in the Accademia of Florence, together with two scenes from the lunette, two in the Berlin-Dahlem Museum and two in the Munich Alte Pinakothek) from the Life of Christ and the Life of St. Francis, set in Gothic quatrefoils which originally decorated the doors of wooden cabinets in the sacristy (ca. 1330).

The signed and dated (1334) triptych of the Madonna and Child in the Berlin-Dahlem Museum is closely related to a triptych dated 1333 by Bernardo Daddi in the Museo del Bigallo in Florence, and reveals many of the same characteristics. Represented is the Enthroned Virgin with Two Kneeling Donors and Fourteen Saints, the Nativity on the left wing with St. Nicholas Rescuing Adeodatus from the Service of the Persian king, and on the right, the Crucifixion with St. Nicholas Restoring Adeodatus to His Parents.

Damaged but well-authenticated frescoes by Taddeo are to be found in the crypt of San Miniato al Monte in Florence (1341), in the Campo Santo of Pisa (fragments of scenes from the story of Job), and in the choir of San Francesco in Pisa (1342). The most monumental in scale is the giant fresco in the refectory, now the Museo, of Santa Croce, painted between 1330 and 1340 with a Last Supper and the mystical Tree of St. Bonaventure (*Lignum Vitae*).

Bonaventure's vision of the Crucified Christ, with St. Francis, St. Louis of Toulouse, St. Dominic, a kneeling patron in the robes of a Poor Clare, and himself as recorder at the bottom, is accompanied by parallel scenes of the Stigmatization of St. Francis and St. Benedict at Sacro Speco, St. Louis ministering to the Poor, and the Feast in the House of Simon. Both in concept and in composition, these scenes show a certain return to the dignified form of Giotto, and the Last Supper is particularly of note as the oldest surviving example of this popular type of refectory decoration. Later altarpieces are the polyptych with the Virgin Enthroned with Four Saints in San Giovanni Fuorcivitas of Pistoia, done between 1347 and 1353, and the Madonna and Child panel of 1355 from the church of San Lucchese in Poggibonsi, now in the Uffizi. This is interesting not only because it is authentically signed and dated (*Taddeus Gaddi de Florentia me pinxit MCCCLV*) but for its characteristic differences and similarity to Giotto's Ognissanti Madonna.

Bernardo Daddi (Active ca. 1312-1355) is another close follower in the Giotto tradition, with its realism and love of narrative detail. He is especially known for a considerable number of small portable altarpieces used for devotional purposes in homes and for travel. A son of Daddo di Simone, he is listed in the *arte dei medici e speziali* from 1312 on, and among the founders of the guild of St. Luke in 1339, along with Jacopo del Casentino. In 1335 he was at work on a Vision of St. Bernard for the chapel of the Palazzo della Signoria, and in 1347 he was paid for a Madonna in Or San Michele. The records of the guild mention his name for the last time in 1355.

A number of works bear his signature, *Bernardus de Florentia*: a Madonna of 1328 from Ognissanti in the Uffizi, another of 1334 in the Accademia of Florence, and a Crucifixion with Saints of 1348 in the Parry Collection of Highnam Court. The early work shows a simplicity and directness characteristic of Giotto, but there develops an interest in the expressive use of light and space which is a parallel, in a more restrained way, to that noted in Taddeo Gaddi. This can be seen especially in the dated (1333) tabernacle of the Madonna and Child with Two Donors and Saints, and on the wings, the Nativity and Crucifixion, with scenes from the life of St. Nicholas of Bari (Museo del Bigallo, Florence). An almost exact copy of this was made a year later by Taddeo Gaddi (Berlin-Dahlem Museum). A

large polyptych, of the Madonna Enthroned with Saints and scenes from the life of the Virgin in the predella, originally painted for the high altar of San Pancrazio in Florence, is in the Uffizi. The same quality of gentle lyricism appears in his Madonna and Child with Eight Angels, of 1347, for Orcagna's tabernacle in Or San Michele.

The early frescoes (ca. 1330) in the Cappella Pulci-Beraldi of Santa Croce, depicting scenes from the lives of St. Stephen and St. Laurence, have been ascribed to Bernardo by Vasari; this can be justified by comparison with the signed panels. They reveal these same characteristics of a realistic use of architecture for perspective and a free arrangement of figures in space, combined with a peculiarly sensitive and lyric quality, which can be traced back to the early Giotto shop (e.g., the St. Cecilia Master), and anticipates the new style of Orcagna.

Maso di Banco (active ca. 1343-1346); **Giottino** (active 1336-1369). The third of this group is incorporated in the relatively consistent work of what could be a single master but which has been divided between two different names and personalities in the documents. One master—Maso di Banco—is listed in the *arte dei medici e speziali* in 1343 and 1346, is praised by Villani and named by Ghiberti as a pupil of Giotto who had executed some sculpture on the Campanile of Florence and had painted frescoes in Santa Croce depicting the legend of St. Sylvester, a lost work for Santo Spirito and a Madonna in a tabernacle which had been placed in the square before Santo Spirito. The *Libro di Antonio Billi* (written 1500-1507), however, cites this last work as by Giottino. Vasari combines the works under a single master, Giotto di Maestro Stefano, called Giottini, whose birth he gives as 1324 but who is otherwise not definitely to be identified in the documents except that he is listed as a member of the guild of St. Luke in 1368. In 1369 he is called, with Giovanni da Milano and Agnolo Gaddi, to Rome to decorate the Lateran with frescoes. A fresco, now destroyed, on the façade of the Torre del Podestá, depicting the expulsion of the Duke of Athens from Florence (the duke was expelled in 1343, the fresco done the following year), is mentioned by Villani without the name of the painter and is described by Vasari as painted by Giottino.

The important work ascribed to Maso di Banco (or Giottino) is the decoration of the Cappella Bardi di Vernio in Santa Croce, which

was built in 1336 as a burial chapel for Gualtiero di Jacopo Bardi. The frescoes, painted ca. 1340, contain a Resurrection with the Kneeling Patron, on the wall over the carved tomb, and five scenes from the legend of St. Sylvester and Constantine. The fresco of the Entombment in the smaller niche to the right of Maso's Resurrection is attributed to Taddeo Gaddi. Significant features of Maso's style, to be seen particularly in St. Sylvester Raising the Two Pagan Priests, are the solemn and compact figures characteristic of Giotto's Padua frescoes, as well as the greater emphasis on the space and the abstract architectural forms of ancient Rome into which they are composed. While the design still continues the Giotto tradition, it has developed well beyond that seen in Daddi's slightly earlier decoration of the Pulci Chapel, and reflects, both in color and in design, somewhat the Sienese character of Ambrogio Lorenzetti. The same features are to be found in the Coronation of Mary fresco over the pulpit and the two scenes from the legend of St. Stanislas in the lower church of San Francesco in Assisi. Maso's hand can be recognized in the fresco fragments of heads decorating the Santa Barbara Chapel of the Castel Nuovo in Naples, which would indicate his collaboration with Giotto on the work for King Robert of Anjou. A similar character might be seen in the polyptych with the Madonna and Child with Saints Mary Magdalene, Andrew, Julian and Catherine in Santo Spirito, Florence, as well as the Lamentation panel in the Uffizi.

Pacino di Bonaguida (active 1303-1339) is first mentioned in Florentine documents as having terminated a shop association with an otherwise unknown artist, **Tambo di Serraglio,** and is registered in the *arte dei medici e speziali* from 1320 until 1339. The style is associated with Giotto and the St. Cecilia Master, as may be seen in the signed and dated (1310) polyptych with the Crucifixion, Mary and John, Saints Nicholas and Bartholomew on the left, Saints Florentius and Luke on the right, in the Accademia of Florence. A second panel is the richly detailed Tree of Life (Accademia, Florence), based on Bonaventure's *Lignum Vitae* as well as Revelation 22:2, with scenes from Genesis at the bottom, Moses and Saints Francis, Clare and John with scrolls above them, the Crucified Christ as the Tree of Life with twelve branches and scenes from His life, and the Virgin with Christ in Glory and the Heavenly Hosts at

the top. The miniature style of the pictographic scenes reveals a close relationship with manuscript illuminations of the period (cf. the series of thirty-two scenes from the Life of Christ, No. 643, in the Pierpont Morgan Library of New York).

Jacopo del Casentino (active ca. 1339-1358) is mentioned in the *Annali Camaldolensi* and by Vasari as having died at the age of eighty in 1358 in Pratovecchio. He is listed as one of the founders of the guild of St. Luke in 1339. Of the many works attributed to him the most characteristic, with its mixed Florentine (Daddi) and Sienese elements, is the altar with San Miniato and eight scenes from his life in the church of San Miniato al Monte, Florence, probably commissioned when the chapel of San Miniato was redecorated between 1335 and 1342. Others are the small signed triptych of the Virgin Enthroned with the Crucifixion, St. Francis Receiving the Stigmata, and the Annunciation in the Uffizi Gallery, Florence, the Madonna and Child with Angels and Saints John the Baptist and John the Evangelist in the tabernacle of the Palazzo dell' Arte della Lana in Florence, another Madonna triptych in the Kunsthalle of Bremen, and a Coronation tabernacle in the museum of Berne.

Puccio di Simone (active 1343-1362) appears in the records of the *arte dei medici e speziali* in 1343 and 1358 and seems to have died before 1362. His chief work is the signed polyptych of ca. 1348-1355 from the monastery of San Matteo in Arcetri, now in the Accademia, Florence. Represented is the Madonna and Child with Saints Laurence, Onuphrius, James and Bartholomew. The Madonna figure is almost totally repainted, but the style in general appears to be closely related to Daddi, i.e., the Parry polyptych.

Andrea Orcagna (ca. 1320-ca. 1368). The art of Andrea di Cione, called Orcagna, represents the sharpest break with the Giotto tradition, and the establishment after the middle of the century of a more clarified plastic as well as illusionistic style. His many-sided activity in painting, sculpture and architecture can be traced in numerous sources. He is entered in the stonemason's guild (*arte de' maestri di pietra*) in 1352, and in the *arte dei medici e speziali* he is mentioned for the first time in 1343. In 1347, he and his brother Nardo are

ranked below Taddeo Gaddi and a frequently mentioned but otherwise unknown ''Maestro Stefano'' on a list of artists considered for the execution of an altarpiece for San Giovanni Fuorcivitas in Pistoia. From a document of 1354, he received the contract for the painted altar in the Strozzi Chapel. Notes of 1356 and 1357 name him as *capamaestro* at work on the tabernacle of Or San Michele. In 1356-1357, and again in 1366 and 1367, he is also associated with Francesco Talenti on the building of the Cathedral of Florence. Between this time he worked (1358-1360) on the Cathedral of Orvieto, particularly the mosaics of the façade. Frescoes by him in the choir of Santa Maria Novella (later replaced by Ghirlandaio's frescoes), Santa Maria dei Servi, Santa Croce and the refectory of Santo Spirito are listed by Ghiberti, but were probably executed by the shop. His last work is the St. Matthew panel for Or San Michele, begun in 1367 and turned over to his brother Jacopo the following year for completion. He probably died, therefore, in 1368, although is wife is not mentioned as a widow until 1377.

Orcagna's most important painting is the signed and dated altar, begun in 1354 and completed 1357, for the Strozzi Chapel in Santa Maria Novella. The center panel represents a hierarchic Christ Enthroned in a mandorla, reaching for the Book of St. Thomas Aquinas at the left and the Key of St. Peter on the right, in a manner reminiscent of the medieval *traditio legis*. Behind these kneeling figures are the Virgin and St. John the Baptist commending them to the Lord, and to the extreme left and right are Saints Michael and Catherine, Paul and Laurence. The three predellas below represent the Office of the Mass by St. Thomas, the *Navicella* and the Death of Emperor Henry II with the salvation of his soul by St. Laurence.

Orcagna's stylistic position with regard to the Giottesque and Sienese traditions can be shown by comparison with similar themes (e.g., Giotto's enthroned figures on the St. Peter altar and the Ognissanti Madonna). The lyric motif of kneeling figures has been expanded to the full-sized devotional action in the Book and Key connection between Christ and the two kneeling saints. These are composed rather stiffly into a monumental pyramid which becomes the central theme and combines the traditionally separate panels. The central group is further dignified by the recommending saints with their gestures and the flanking pairs on either side into a sacred

conversation piece (i.e., the *Sacra Conversazione*), a simplified version of the sacred hosts accompanying the Enthroned used by the Sienese (as in Simone Martini's Maestà). The emphasis on the surface planes, the rich and luminous color (the gold brocades on St. Michael and St. Catherine) and strong contrasts (the blue against the gold and red of the central group and the red and blue contrasts of Paul's robes) enhance this hierarchic effect.

In sculpture, as in painting, Orcagna's work represents a similar break with the older Giottesque tradition, which had been maintained by Andrea Pisano, whose reliefs on the Campanile of Florence are based on the same planar decorative principles used by Giotto. It will be remembered that Andrea is said to have executed some of them after Giotto's designs and had indeed succeeded Giotto as supervising architect until 1343, when Francesco Talenti took over the position.

Orcagna's important work in sculpture is the tabernacle in Or San Michele, which he had worked upon from 1352 until 1360 and had signed as *Oratorii Archimagister*, 1359, with his self-portrait. The Madonna panel which it enclosed is that painted by Bernardo Daddi in 1347 to replace an earlier thirteenth-century miraculous Madonna which had recently been destroyed by fire. The reliefs by the master's own hand are the eight scenes from the life of Mary on the base and the fourteen reliefs of Virtues. The imposing array of prophets, apostles, patriarchs and angels combines to form a Mariological program comparable, in its way, to those of Northern Gothic portals. Quite in contrast to the Pisani tradition, the reliefs especially reveal a new realistic form whereby the painter's means of perspective and recession are used to give a clear illusion of space, in which the well-rounded figures move and act.

One of the most striking of Orcagna's works appears to have been the frescoes of monumental scale (ca. 7 meters high and 18 meters wide) representing, in the form of a vast triptych, the Triumph of Death, the Last Judgment and the Inferno, originally in the south aisle of Santa Croce. The fragments of these are preserved in the Museo dell' Opera of Santa Croce. Destroyed in the redecoration of the church under Vasari's direction in 1566-1584, the fragments show a power of characterization and almost brutal earnestness comparable to Traini's Triumph of Death in the Pisa Camposanto, from which the Orcagna composition was probably

derived. The fresco was mentioned as Orcagna's work by Ghiberti and Vasari, who had also identified Orcagna as the painter of the Pisa fresco. The grim realism of the subject is undoubtedly associated with the Black Death of 1348, but the work would probably have been done several years afterward, i.e., in the 1360s. What must have been a major project was Orcagna's decoration (ca. 1350) of the choir of Santa Maria Novella with frescoes depicting the Life of the Virgin, which were replaced by the Ghirlandaio frescoes in the fifteenth century. Several fragments with heads of prophets from Orcagna's work were recently recovered during the restoration of Ghirlandaio's frescoes, and reveal a remarkable strength of characterization.

Orcagna's position as an architect is less important and seems to have been confined largely to mosaics and interior decoration. However, his standing as a personality and the widespread activity of his shop would indicate his importance as the most significant artist in Florence during the middle of the century. The work of his two brothers should therefore be understood as essentially a part of the shop activity under Orcagna's direction.

Jacopo di Cione (active ca. 1368-1394), a younger brother of Andrea's, is chiefly known for the St. Matthew panel (Uffizi, Florence) which was begun by Andrea for Or San Michele and completed by Jacopo in 1368. Andrea's hand is probably to be seen in the total composition, as well as in the plastic design of the center figure of St. Matthew, while Jacopo betrays a softer, less forceful manner in the accompanying scenes from the life of the saint. Among the altarpieces attributed to Jacopo are the Coronation of the Virgin with Ten Saints, of 1373, and the polyptych of the Madonna and Child (1383), both in the Accademia of Florence. The curious fresco fragment in the Palazzo Vecchio of Florence, representing the Expulsion of the Duke of Athens from Florence, is sometimes attributed to Jacopo di Cione.

Nardo di Cione (active 1343-1366) is a second brother of Orcagna's and of considerably greater significance. He is traceable in documents of 1343, when he is entered in the *arte dei medici e speziali*, and 1355, as a member of the stone mason's guild, and again in 1363, when he received a contract for frescoes in the

50

Bigallo (lost). In 1364, he was listed as a member of St. Luke's guild. He died before May 16, 1366, when his brothers Andrea, Jacopo and Matteo inherited his property.

Nardo's chief work is the fresco decoration of the Strozzi Chapel in Santa Maria Novella, which, though often accredited to Orcagna, was ascribed to Nardo by Ghiberti. On separate walls of tremendous scale are represented the Last Judgment, Paradise, and Hell, the latter being a direct illustration of Dante's *Inferno* with its division into six horizontal strips which are, in turn, divided into smaller sections. The portrait of Dante himself is inserted in the lower left of the central group in the Last Judgment.

Distinctive features of the style are to be noted in the general massing of great numbers of figures and scenes over the large walls in which the figures (e.g., in the Paradise) are built up in planes, one behind the other, to produce a grandiose tapestry effect. The Mary and Christ on Gothic thrones appear in somewhat enlarged proportions to enhance the monumentality of the composition. The even tone, with its rich and luminous coloration, provides a decorative unity which again reflects the influence of the Sienese painters. The anatomical realism and expressive action of the nude figures in the Inferno anticipate the specialized studies of the anatomical figure in the fifteenth century. The dignity and abstract quality of its design would suggest the total plan to be the work of Orcagna, whereas the execution was Nardo's. The subtle movement and swaying of the figures, their combination into groups, and the delicate linear design of details appear to substantiate this distinction. The frescoes were probably executed at about the same time as the Strozzi altar, i.e., between 1354 and 1357.

Frescoes related to those of the Strozzi Chapel, and generally ascribed to Nardo, are the damaged ones in the Cappella Giochi e Bastari in the Badia of Florence, with scenes of the Flagellation, Ecce Homo, Road to Calvary, Suicide of Judas and others, and in the Cappella Steccuti in the Chiostro dei Morti (ca. 1360) of Santa Maria Novella, with scenes from the Life of the Virgin. The badly damaged frescoes, also painted in the early 1360s, of the Crucifixion and Last Supper in the refectory of Santo Spirito, attributed to Nardo and the shop, represent one of the earliest examples of monumental refectory decoration (cf. Taddeo Gaddi's fresco in the refectory of Santa Croce).

Andrea da Firenze (active ca. 1343-1370). Probably the most intellectual yet strongly Sienese of this new generation of painters is Andrea Bonaiuti da Firenze, who is listed in the *arte dei medici e speziali* in 1343, received a contract in 1365 to decorate the Spanish Chapel within two years, was a member of the cathedral building commission in 1366, and was paid in 1377 for frescoes painted in the Campo Santo in Pisa.

Particularly from the point of view of content and historical associations, the frescoes in the Spanish Chapel of Santa Maria Novella (1365-1367) are the most important since the great achievement of the Franciscan cycle in Assisi. In contrast to the lyric, emotional and personal appeal reflected in the story of St. Francis, this is a carefully thought-out statement of church doctrine from the scholastic point of view of the Dominicans. Its literary origin would seem to be the *Mirror of True Penitence* (*Spechio della vera penitenza*) by Fra Jacopo Passavanti (d. 1357), who had been prior of Santa Maria Novella and executor of the will of the project's patron, Buonamico di Lapo Guidalotti. Aside from Passavanti, other iconographical parallels which might have served as sources are to be found in Dante's *Paradiso*, Cantos 13-14, and the writings of Thomas Aquinas, as well as the Pisani pulpits and the reliefs on the Campanile of Florence.

Originally intended as a memorial chapel for the Cuidalotti family, the ''Spanish Chapel'' acquired its name in the middle of the sixteenth century, when Eleanor of Toledo turned it over to the Spanish colony in Florence as its religious center. In 1592, it was formally dedicated to the Spanish national patron, St. James of Campostella. The architecture itself has a certain massive monumentality which is an integral part of the decorative program. Designed probably by Fra Jacopo Talenti shortly after 1344, it has a square plan with heavy ribbed crossvaults dominating the space.

The various scenes and symbols comprising the general ''Glorification of the Dominican Order'' are fitted into this plan. On the entrance wall are scenes from the lives of St. Peter the Martyr and St. Thomas Aquinas. The altar wall opposite it (toward the north) has the Crucifixion in the center, the Procession to Calvary below at the left, and the Descent into Limbo at the right. The two side walls represent allegories of the Dominican Order as a part of the Church Militant and Triumphant.

The fresco on the right (east) wall is the symbolical Church Militant with the traditional features of the Christ in Glory, the Heavenly Hosts, the Mystic Lamb and symbols of the Evangelists almost lost in the elaborate allegorical narrative below. Quite in keeping with the Passavanti text is the presentation of the picturesque road from temporary joys to eternal bliss: to the right are courtly figures enjoying dancing, music and hunting (i.e., man with a falcon) as symbols of worldly pleasures; then penitence, represented by an old man at confession before a Dominican monk; St. Thomas pointing the way to Paradise; the Gates of Paradise with St. Peter and angels; and Paradise itself with its hosts of saints looking up to the Saviour.

Across the bottom from right to left are groups representing St. Dominic preaching to and converting the heretics, and the Enthroned Pope before the Church (a representation of the Cathedral of Florence based on a model of the church then in the process of building), surrounded by figures representing the entire temporal and ecclesiastical hierarchy of the church. At his feet are sheep (i.e.,Christians) which are protected by black and white dogs, the *domini canes* (the Hounds of God, i.e., ''Dominicans''), which are further identified by the black and white of the robes worn by members of that order. To the right, these dogs can be seen attacking the ''wolves,'' or heretics, who seek to destroy the sheep.

Much more stiff and hierarchic in theme and execution is the Glorification of St. Thomas on the opposite (west) wall. In the center of the top row is enthroned the Saint whose philosophical achievements form the most important contribution and clarification of medieval church doctrine. On either side are accompanying dignitaries of the Old and New Testaments: Job, David, Paul, Mark and John; then Matthew, Luke, Moses, Isaiah and King Solomon. Angels above carry symbols of theological virtues; below the throne are figures of defeated heretical philosophers: Savellius, Averrhoes and Arius. The symbolic figures in the choir stalls of the lower row are representatives of the Seven Theological Sciences (*left to right*): Civil Law—Justinian, Canon Law—Pope Clement IV, Gospel Law—Peter Lombard, Theological Faith—Dionysius the Areopagite, Speculative Theology-Boethius, Mystic Theology—St. John the Damascene, Polemic Theology—St. Augustine. Also portrayed are the Seven Liberal Arts: Arithmetic—Pythagoras, Geometry—

Euclid, Astronomy—Zoroaster, Music—Tubal Cain, Dialectic—Aristotle, Rhetoric—Cicero, Grammar—Priscianus, with their accompanying historical personifications.

In contrast to the horizontal continuity of the various episodes on the walls, the scenes decorating the four sections of the vault are organized in a vertical concordance with those immediately below them. Thus the *Navicella* (a variation of Giotto's mosaic in St. Peter's), as the traditional symbol of the salvation of the Church as Christ had saved Peter, is associated with the Road to Salvation and the Church Militant. The Pentecost, as a symbol of enlightenment, is associated with St. Thomas and the Church Triumphant. The Resurrection is above the Crucifixion on the altar wall, and the Ascension glorifies the miraculous events from the lives of the saints on the entrance wall.

The comparison of both form and content in this series with Giotto's decoration of Assisi or the Arena Chapel is fruitful from several points of view. The quality of color, the narrative addition of figures and groups over the large surface, as seen on the right wall, are quite Sienese in character and reveal much of the quiet, un-dramatic and "un-Giottesque" manner of Lorenzetti. Vasari had ascribed the fresco to Simone Martini. In contrast to the Sienese, however, there is a new religious earnestness reflected in both the very human didactic allegory told on the right wall and the hierarchic figures on the opposite one. This may be accounted for partly by the new religious spirit developed after the terrible plague of 1348, and partly by the nature of the Dominican character and teaching. The Dominicans were much more intellectual and scholarly. While organized as a mendicant reform order, their appeal was more to the intellect than to the emotions, as was the case with the Franciscans. This can be shown by the comparison of their leaders, St. Francis and the Dominican, St. Thomas Aquinas, with their contrasting emphasis on the personal and mystic experiences as opposed to the vast intellectual realm of theological thought.

The dignified simplicity and spiritual realism of Giotto's form has thus given way to a hierarchic and intellectual allegory which recalls the scholastic representations of the thirteenth century (e.g., the frescoes in the crypt of Anagni Cathedral). As a style, it is a logical continuation of the trend developed by Orcagna in the Strozzi altar and continued in the frescoes by him and Nardo in the Strozzi

Chapel. While there is a certain rigidity to the rather formal stacking of figures and scenes up the wall in a vertical and horizontal abstract pattern, there is also a new strength in the realistic characterization of details which adds power to the total didactic program.

The three well-authenticated frescoes of ca. 1377 by Andrea in the Campo Santo of Pisa are late works, and reveal a decorative massing of figures much more elaborate, and correspondingly weaker, than those in Florence. The scenes are taken from the life of the local St. Raynerius, the patron saint of Pisa: the young Raynerius enjoying the pleasures of the world; he enters the cloister of St. Vito, where Christ appears and blesses him; he embarks for Palestine, distributes his wealth to the poor, becomes a pilgrim and is presented to the enthroned Virgin; he prays forty days in a church of the Holy Land, resists the devil, and feeds the poor. The series was continued by Antonio Veneziano after Andrea's death.

Giovanni da Milano (active ca. 1350-1369). Quite distinct from the Sienese decorative manner of Andrea da Firenze is the new realistic art of the Lombard Giovanni. His name, Giovanni di Jacopo di Guido da Kaverzaio (from the town now called Caversaccio, near Como) appears for the first time in Florentine records as a master's assistant in 1350. In 1363, he was a member of the *arte dei medici e speziali* and is listed in the tax records of the same year, which indicates that he was established enough to own property. In 1366, he became a citizen of Florence. In 1365, he was commissioned by the Franciscans to decorate the Cappella Rinuccini in Santa Croce. The last record of him is in 1369, when he was called to Rome (with Giottino and Agnolo Gaddi) to paint frescoes (now lost) in the Vatican for Urban V.

Giovanni's early training, and the style of work done while he was in Milan, can only be inferred from scattered and damaged fragments of frescoes produced by contemporary Lombard artists (see below under Milan). Vasari describes him as a friend and pupil of Taddeo Gaddi, which is doubtful, though Taddeo's style was cartainly more sympathetic to him than that of Daddi, Orcagna or Andrea da Firenze. Three works are definitely ascribed to Giovanni: the signed altar (*Ego Joannes de Mediolano pinxi hoc opus. Frater Francesco feci dipingere questa tavola*) was executed for Frater Francesco in 1354 for the high altar of St. Barnabas in Prato, and is

now in the Pinacoteca Communale of that city. It represents the Madonna Enthroned with Saints Catherine and Bernard, Bartholomew and Barnabas. Below are the Annunciation, scenes from the lives of each saint (i.e., the Execution of St. Catherine, the Apparition of the Virgin to St. Bernard, the Annunciation, the Martyrdom of St. Bartholomew and the Martyrdom of St. Barnabas), and six scenes from the life of Christ in the predella. These scenes show something of an influence of Taddeo and perhaps Simone Martini (the Annunciation), but they also show a remarkably clear and well-rounded form and space composition which points more toward fifteenth-century styles (e.g., Gentile da Fabriano) than to the aging Giottesque tradition.

The most important work of the master is the fresco series in the sacristy of Santa Croce (the Cappella Rinuccini), which was contracted for in 1365 and represents scenes from the lives of the Virgin and Mary Magdalene. In many ways there is a strong resemblance to Taddeo's frescoes in the Baroncelli Chapel, as can be seen in the Meeting of Joachim and Anna, but in others a new and more Renaissance conception of form is clearly to be seen. An example is the Refusal of Joachim's Sacrifice, where the dramatic action is concentrated on the central three figures of the foreground, with groups of stately figures seen on either side and receding into the background through the arcades. The genre character of some scenes (Birth of Mary) likewise points to Renaissance interpretations (Fra Filippo Lippi). The scenes on the lower level on both sides are assumed to have been painted by a follower, either Giovanni del Biondo or an anonymous "Rinuccini Master." Among these, the Presentation in the Temple can be recognized as a free copy of Taddeo Gaddi's scene in the Baroncelli Chapel.

The same features may be noted in the Pietà in the Accademia of Florence, which was painted at the same time as the Santa Croce frescoes and signed *Io Govani da Melano depinsi questa tavola in MCCCLXV*. The strong modeling, richness of color, and careful, detailed execution are to be noted. His most fully developed style, following the same characteristics, can be seen in the altar wings with five panels of saints and numerous predella scenes in the Uffizi that were parts of a polyptych painted for the high altar of Ognissanti.

Giovanni del Biondo (active 1356-1392) was another of Orcagna's followers perhaps associated with Giovanni da Milano but

with a style which is much less refined in color and drawing. Born in Pratovecchio, he became a citizen of Florence in 1356. A signed Madonna tabernacle of 1377 is in the Pinacoteca of Siena, and an altar of 1392, also with signature, is in the Misericordia church of Figline. His hand is frequently identified in two of the frescoes by Giovanni da Milano in the Cappella Rinuccini (1365) in Santa Croce, for which he had painted the polyptych (dated 1379) of the Madonna and Child with Saints Francis, John the Baptist, John the Evangelist, Mary Magdalene and scenes from their lives in the predella.

Giovanni di Bartolomeo Cristiani (active 1370-1378) is, like Niccolò di Tommaso, another follower of Nardo, and comes from Pistoia. He was identified by Vasari as Giovanni da Pistoia, a pupil of Cavallini. Among his extant works are the signed and dated (1370) altar with St. John Enthroned, with eight scenes from his life, in the sacristy of San Giovanni Fuorcivitas, and frescoes in the narthex (1377/8) and chapel of the *Confraternità dei Rossi* in the Cathedral of Pistoia.

Niccolò di Tommaso (active ca. 1343- ca. 1405) is first mentioned in 1343 in the *arte dei medici e speziali*. In 1365, he is listed with a number of other artists, including Orcagna, in connection with a design for the façade of the Cathedral of Florence. The following year, he is named as a witness for the will of Nardo di Cione. From the records of the guild of St. Luke, one assumes his death to be about 1405. He is known primarily for the signed and dated (NICHOLAUS TOMMASI DE FLORE(NTIA) PICTO(R) A. MC-CCLXXI) altar of Sant' Antonio Abate in the Museo di San Martino in Naples, representing St. Anthony Abbot Enthroned with Four Angels and Saints Francis and Peter, John the Evangelist and Louis of Toulouse on the wings. Related to it are the frescoes in the former Antonite Convento del T in Pistoia with Old Testament scenes (Creation, Fall of Man, The Flood, Jacob and Esau) and a Last Judgment in a style which might be associated with that of Nardo di Cione and Giovanni da Milano.

Niccolò di Pietro Gerini (active 1368-1415) appears from the documents to have been a major representative of the restrained and standardized *maniera giottesca* in Florence at the end of the Tre-

cento. He is registered in the *arte dei medici e speziali* in 1368. In 1370, he was commissioned to execute his first known altar, the Coronation of the Virgin, for San Pietro Maggiore in Florence (now in the National Gallery, London). Both Jacopo di Cione and Niccolò di Tommaso are sometimes associated with its execution. A second altar of the same subject, with two prophets and ten saints, including St. John the Baptist, the patron saint of Florence, was done in 1373, probably with the assistance of Jacopo di Cione, for the Zecca Vecchia of Florence, and is now in the Accademia. In 1386, he received the commission for frescoes on the façade of the Bigallo, with the help of assistants (Ambrogio di Baldese), of which the middle section, representing members of the order of the Misericordia receiving Orphans, remains in the Sala del Consiglio of the Museo del Bigallo. He is active in Prato (frescoes in the Sala del Capitolo of San Francesco, representing the Crucifixion and scenes from the lives of Saints Anthony Abbot, Benedict and Matthew, ca. 1395) and in San Francesco of Pisa (damaged frescoes of scenes from the Life of Christ, 1392).

Other works with much of the same hard and stylized manner are the high altar of San Carlo dei Lombardi in Florence (Entombment and Ascension), the 1401 Coronation of the Virgin triptych from the high altar of Santa Felicità in Florence, now in the Accademia, the frescoes of the Pentecost and the Holy Trinity in Or San Michele, Florence (1408/9), and the frescoes of Christ Bearing the Cross, the Resurrection and Ascension in the sacristy of Santa Croce, executed ca. 1400 with assistants. These last had originally surrounded a Crucifixion by Taddeo Gaddi.

Antonio Veneziano (Antonio di Francesco da Venezia, active ca. 1370-1388). The chief work of Antonio Veneziano is in the Campo Santo of Pisa, but he is important to this new generation of Florentine painters as another revitalizing influence on the overworked combination of Giottesque and Sienese traditions prevalent in the city. Antonio is mentioned for the first time in 1370 as having received payments, with Andrea Vanni, for frescoes on vaults of the Cathedral of Siena. In 1374, he is entered in the *arte dei medici e speziali* of Florence. From 1384 to 1387, he received payments for the St. Raynerius frescoes in the Campo Santo of Pisa, where he is identified both as *Maestro Antone di Franciescho dipintore da*

Fiorenza (i.e., of Florence) and as *Magister Antonius pictor condam Francisci de Venetiis* (i.e., of Venice). Other payments made there were for frescoes in the cupola of the cathedral (1385) and an altarpiece in the organ chapel (1387), both of which are lost. The last mention of him is in 1388.

The only frescoes in Florence known to be done by him and mentioned by Vasari are the ruined fragments of a Descent from the Cross, Last Judgment, and Death and Ascension of Mary, of the tabernacle from Torre degli Agli (now in the Fortezza di Belvedere, Florence). In style, they appear to be early works, and are closely related to the Pisa frescoes. Those in the Campo Santo are a continuation of the St. Raynerius legend begun by Andrea da Firenze and represent: 1) Raynerius, sailing from the Holy Land to Messian, accuses the devil-inspired publican of mixing water with wine and separates them and he is received and dined by the clergy of Pisa; 2) the death and funeral of St. Raynerius; and 3) two of the miracles performed by calling upon the saint—the miraculous draught of fishes by Chiavallo and the liberation of Uguccione di Rinaldo after having been captured by the pirates.

Although damaged, the frescoes reveal a compositional unity and a new life, particularly in color and the play of light, that is not to be found in Florentine painting at this time. The relationship with contemporary Venetians, or possibly Altichiero, is much stronger, though a marked interest in the modeled form and its action is evident. Vasari gives Antonio as the teacher of Starnina, which is of significance insofar as Starnina was the teacher of Masolino and had considerable influence on him as well as Masaccio, Fra Angelico and the Early Renaissance.

Among the various altar panels attributed to Antonio are the early Madonna Enthroned with Angels in the Niedersächsische Landesgalerie of Hanover (to which belong the two small panels of the Annunciation in the Berlin-Dahlem Museum), a Madonna and Child in the Boston Museum of Fine Arts, and the Assumption of the Virgin in the Pisa Convento di San Tommaso. The signed and dated (1388) Flagellation of Christ in the church of San Niccolò Reale (now the Museo Diocesano) in Palermo is dedicated to the members of the Confraternità di San Niccolò, who are listed on the panel.

Agnolo Gaddi (active ca. 1369-1396) is the last in the direct line of the Giottesques. The son of Taddeo Gaddi, he is mentioned for the first time in 1369, supposedly as an assistant to his brother Giovanni, when he is called to Rome with Giottino and Giovanni da Milano to paint frescoes in the Vatican. In 1380, 1383 and 1386, he is listed in the records of the building of the Loggia dei Lanzi as having designed decorative statues (Faith, Hope, Prudence, Charity), which were executed by Jacopo di Piero Guidi and Giovanni d'Ambrogio. The next year, he designed, and afterwards painted, an apostle figure for the façade of the cathedral. In 1387, he is entered in the guild of St. Luke; the frescoes in Prato were done 1392-1395; and he died in 1396 while at work in San Miniato al Monte (probably on an altarpiece which was completed by his brother, Zenobi).

An otherwise little-known pupil of Agnolo was the aforementioned Cennino Cennini, the author of the craftsman's handbook (*Il Libro dell' Arte*), written probably in the 1390s, in which Giotto's technical methods were preserved for the instruction of artists. The fact that the continuance of the Giotto tradition was a conscious and deliberate one is shown not only by the comparison of the works themselves and the reverence shown the master in contemporary documents, but also by the work procedures of the shop, and was so stated by Cennino.

Agnolo's principal and best-known work is the fresco series in the choir of Santa Croce, which was executed probably ca. 1380, after the donation of the chapel in 1374 by Jacopo di Caroccio Alberti, and mentioned as painted by "Maestro Agnolo" in a document of 1395. He depicts eight scenes from the legend of the Holy Cross taken from the *Golden Legend* by Jacobus de Voragine:

1) The archangel hands Seth the branch from the Tree of Knowledge which he plants on Adam's grave.
2) The Queen of Sheba discovers the sacred wood of the Tree, which Solomon then orders to be buried.
3) The Jews take the wood from the magic pool and fashion the Cross out of it.
4) The Jew reveals to Queen Helena the burial place of the three crosses; the True Cross is discovered by the resurrection of the dead youth from a passing bier.
5) Queen Helena leads the procession with the Cross; they are met at the gates of Jerusalem by a worshipping crowd.

6) Theft of pieces of the Cross by the Persian King Chosroes and his followers; their flight from Jerusalem.

7) Heraclius defeats Chosroes in battle, having been told in a dream of his approaching victory.

8) The execution of Chosroes and Heraclius' triumphant and humble return to Jerusalem with the Cross.

The frescoes of the Castellani Chapel in Santa Croce (1383), depicting scenes from the lives of Saints Nicholas, John the Baptist, Anthony Abbot and John the Evangelist, were executed by pupils, principally Starnina, under Agnolo's direction. A third series of frescoes is that done 1394-96 in the Cappella del Sacro Cintola in the Cathedral of Prato, depicting scenes from the life of Mary and the Legend of the Holy Girdle. Of the three series, the two in Santa Croce appear more Sienese in character, with the narrative sequence of scenes and bright coloration but without either the decorative or coloristic unity which the early Sienese had. When compared with the work of Niccolò di Pietro Gerini and other contemporaries of the *maniera giottesca*, Agnolo's style is much more delicate and free. Though the figures are crowded, they are much looser in their composition, the landscape is more open in its recession into depth, and there is a tendency toward the use of light for space effects, though little integration of figures and space.

The Prato series seems more dependent on Taddeo's Baroncelli Chapel in Santa Croce, although the softer flow of the drapery and an ornamental quality of the color would suggest a relationship of this late style to Lorenzo Monaco and the International Gothic.

The only authentic altarpiece by Agnolo is that in the Cappella del Crocefisso in San Miniato, Florence, which he left unfinished when he died. Represented are the Annunciation, scenes from the Passion, the Ascension and the two Saints, San Giovanni Gualberto and San Miniato. Its style is related to the decorative manner of the Prato frescoes.

Gherardo Starnina (Cherardo di Jacopo, active 1387- ca. 1413) is perhaps the most important of the many artists in the group about Agnolo Gaddi toward the end of the century who represent the transition from the waning *maniera giottesca* to the new style of the fifteenth century. According to Vasari, he was born in 1354, was a pupil of Antonio Veneziano, and died in 1408. He was registered in

the guild of St. Luke as *Gherardo d iacopo Starna dipintore* in 1387. Between 1398 and 1401, he is recorded, at various times, at work in Toledo and Valencia in Spain where, however, no trace of paintings produced by him is to be found. By 1404, he was back in Florence, when he completed a series of frescoes for Santa Maria del Carmine, and a fresco (now lost) representing St. Dionysius and Angels in the Palazzo di Parte Guelfa. In February of 1409, he was commissioned to decorate a chapel in Santo Stefano at Empoli with frescoes, which are likewise not extant. A document of 1413 refers to the master as dead.

Starnina's greatest works, and stylistically, the most important monuments in tracing the development from Antonio Veneziano to Masolino and Masaccio, can be seen in the fragments of frescoes in the St. Jerome Chapel of Santa Maria del Carmine (1404) and the fresco decoration of the Castellani Chapel in Santa Croce. The fragments of the former show a remarkably plastic and impressive form, worthy of a Renaissance painter (e.g., St. Benedict and St. Anthony). The Castellani Chapel was founded in 1383, at the death of Michele de Vanni di Ser Lotto, and the scenes represent episodes from the lives of St. John the Baptist, St. Anthony and St. Nicholas. While Vasari ascribes the whole series to Starnina, an earlier document names Agnolo Gaddi as author.

The general style is quite uneven: the bright coloration and well-developed perspective of the frescoes justify Starnina's relationship with Veneziano, which Vasari mentions. Many of the compositional patterns are reminiscent of Agnolo Gaddi and the Giotto tradition, even a renewed study of Giotto's own works (e.g., the St. John on Mt. Patmos); while the new and more individual characterization of figures (e.g., the St. Anthony and St. Nicholas scenes), and their lively movement, suggest new features that are carried on in the work of his pupil Masolino, the early Masaccio and succeeding Renaissance painters.

The small enigmatic panel representing scenes from the lives of the Hermits (Thebais) in the Uffizi has been attributed to Starnina, and is interesting in its combination of small groups of figures in an extensive landscape, again indicative of the new spirit of the fifteenth century.

Spinello Aretino (Spinello di Luca Spinelli, ca. 1346-1410), who was born in Arezzo, probably about 1346, is another individual

master of this transitional group. Documents in Arezzo indicate that he was the purchaser of property in 1373 and, in 1375, was commissioned by the Confraternity of Santa Maria to decorate a chapel in Arezzo. In Lucca, in 1384, he received a commission from Don Niccolò da Pisa for an altarpiece which is probably identical with the documented altar (1385) for the convent of Monte Oliveto Maggiore near Siena. In 1387, he is mentioned in the testament of Benedetto degli Alberti in connection with frescoes for San Miniato in Florence and the Cappella di Santa Caterina in Antella. In 1391–1392, he was at work on frescoes in the Campo Santo of Pisa; he was active again in Arezzo in 1395–1396, and payments are recorded for the painting of processional banners in Arezzo in 1404. He is then recorded at work on frescoes in the Cathedral of Siena, in 1405, with his son, Parri. He continued there on frescoes for the Palazzo Pubblico (1407), and died in 1410.

Spinello's style in general shows a closer adherence to the Giotto tradition, with something of the Sienese character in the execution of detail. While Vasari names him, falsely, as a pupil of Jacopo del Casentino when the latter was in Arezzo, he was most likely trained in the shop of Agnolo Gaddi, and seems influenced by Andrea and Nardo di Cione more than by anyone else. This can be seen in the altar pictures rather than in the more dramatic, and less carefully executed, frescoes.

The earliest authenticated work is the Monte Oliveto altar, executed in 1384–1385 and signed *Spinellus de Aretio picsit*, the parts of which are now scattered in the museums of Harvard University, Budapest and Siena. Closely related to this, but further developed, is the signed and dated triptych (*Hoc opus pinxit Spinellus Luce Atitio. D.I.A.* 1391) with an Orcagnesque Madonna Enthroned with Four Saints, in the Accademia of Florence. An interesting later work is the dated (1401) altarpiece, representing the Coronation of the Virgin and Saints, from Santa Felicità (now in the Accademia, Florence), for which payments are listed in the convent records of 1399 as made to Niccolò di Pietro Gernini and Lorenzo di Niccolò as well as to Spinello. The central panel with the Coronation, again reminiscent of Orcagna, seems clearly to be the work of the superior Spinello, whereas the side panels may have been painted by Niccolò di Pietro Gerini.

His most important fresco series is the decoration (ca. 1387), for Benedetto degli Alberti, of the sacristy of San Miniato al Monte

with scenes from the life of St. Benedict. The other less-restored and better-preserved frescoes in the church of Santa Caterina in Antella (scenes from the life of St. Catherine) were done about the same time for the same patron, and are probably the best of Spinello's work. Those in the Sala di Balia (1408) of the Sienese Palazzo Pubblico (scenes from the Venetian campaign of the Sienese Pope, Alexander III, against the Emperor Frederick Barbarossa), the series in San Francesco of Arezzo, and those in the Campo Santo of Pisa (scenes from the lives of St. Ephesus and St. Potitus), show a strong relationship with Orcagna through an interest in the lively movement of figures, yet lack his capacity for the compositional and decorative unity of the whole. Fragments of a fresco series in Santa Maria del Carmine (scenes from the life of John the Baptist) indicate a remarkable power of expression, and suggest again the new strength of the younger artists of the fifteenth century (Masaccio).

4. Siena

SIENA REMAINED CONSISTENTLY GHIBELLINE during the first half of the thirteenth century. Commercial rivalry with Guelph Florence caused it to harbor Florentine Ghibelline exiles and to organize the forces which defeated Florence at Montaperti in 1260. In 1266, the fall of King Manfred at Benevento brought a decline in Ghibelline power. Florence defeated Siena, and Provenzano Salvi, the Sienese dictator, was murdered. Under the influence of Charles Anjou, Siena joined the Guelph league, and from 1277 to 1285 the Guelph party, largely middle-class, gained power. The rule of this commercial class led to comparative peace and with it a great patronage of the arts. The fourteenth century was marked by increasing resentment against the merchants and by the family feuds of the Solimbeni and Tolomei. In 1355, the city was given over to Charles IV of Germany, who instituted the government of the twelve (*Governo dei Dodici di Popolo*) under an Imperial Vicar. This government was overthrown in 1368, and a consulate established. In 1369, the Imperial Vicar, Malatesta Unghero, was deposed. Civil war, anarchy and unrest marked the rest of the century, and by 1400 the *popolo minuto* was in power.

The beginnings of the *stil nuovo* in Siena can be traced from its local traditions in a development parallel to that of Rome and Florence. In achitecture and sculpture, it is again Giovanni Pisano, active (1284-1295) as *capomaestro* on the façade and sculpture of the Cathedral of Siena, who incorporates the Classic and French Gothic principles into new forms that become a part of the local tradition and parallel the development in painting here in Siena, as well as in Florence and Padua. In Siena, it appears that the Gothic became the stronger influence, which may well have been due to the personal impact of Giovanni Pisano, who is assumed to have worked in France in the early 1270s.

Guido da Siena (active ca. 1270-1290). The first important work in this development is the large Madonna from San Domenico in the Palazzo Pubblico, which is signed, *Me Guido de Senis Diebus Depinxit Amenis quem xrs Lenis Nullis Velit Agere Penis Ano Di MCCXXI.* The panel was originally the centerpiece of a large triptych with a pediment containing a half-length Christ and Two Angels surmounting the Madonna panel (also in the Palazzo Pubblico), and twenty-four small scenes from the Life of Mary and the Passion of Christ on the wings. Of these, some twelve have survived in the museums of Princeton University, The Lindenau Museum of Altenburg, the Central Museum of Utrecht, the Pinacoteca of Siena and the Stroelin Collection of Paris.

There is clear evidence of later retouching of the Madonna panel, particularly in the faces, which appears to have been done in the early fourteenth century in the shop of Duccio. The resulting change in the character of the style, together with the incredibly early date, has led to considerable discussion, especially since the inscription appears to be genuine, at least of the fourteenth century. The possibility of an "L" having been removed, or an "L" after the MCC and an "X" after the XX being missing, would indicate a much more plausible date of 1271 or 1281. An alternate suggestion has been made that the 1221 date was added by the Dominicans at the time of the restoration as a commemorative tribute to the death of St. Dominic (Aug. 4, 1221). In any case, the later dating appears to be reasonable, since the painting reveals a character parallel to that of Coppo di Marcovaldo, perhaps a development of the style shown in Coppo's Servite Madonna of 1261.

A damaged polyptych representing the half-length Madonna and Child with Saints John the Baptist, John the Evangelist and Mary Magdalene in the Pinacoteca of Siena has a similar inscription, from which that of the San Domenico panel may have been taken. It appears to be an earlier work by Guido of the late 1370s. The gentle flow of line and the intimate gesture of Mother and Child appear related, but are much more developed and evident in the San Domenico panel. These two altars, together with the anonymous St. Peter altar (late 1280s) in the Siena Pinacoteca (sometimes ascribed to Guido) are significant in being the chief painted documents linking the older Romanesque form (e.g., the strictly frontal Madonna of 1200 in the Siena Cathedral Opera or the one in the Palazzo

Saracini, Siena) and the decorative refinements of the *maniera bizantina* to the masterpieces of Duccio and his followers.

Duccio (Duccio di Buoninsegna, active 1278-1319) is second only to Giotto as an artistic personality and influence on the development of trecento painting. Concerning his life, the first record noted in documents is in 1278, when he received payment for certain *cassoni*, or chest paintings. On April 15, 1285, he received a contract to paint a large (*tabula magna*) Madonna panel for Santa Maria Novella in Florence. Back in Siena, on October 8, 1285, he was paid for a painting—*propictura quan fecit in libris camerarii*— indicating either a miniature or a painted book cover. Several other payments similarly identified indicate continued activity, in what apparently were painted book covers, until 1295. The Maestà was ordered in 1308, finished in 1311, and carried to the cathedral by the townspeople amid great jubilation. Various notes in records (1295-1302) indicate that he was brought before the courts several times for debts and avoiding military service. He died in 1318 or 1319; his widow, Domina Taviana, and her seven children renounced all claims to his estate, which was probably nothing but debts.

Chronologically, the first work ascribed to Duccio is the small-sized Madonna with the Three Franciscans in the Pinacoteca of Siena. In spite of its damaged condition, it shows many of the traditional features of the Byzantine manner, but the hierarchic stiffness of the older *Hodegetria* type has been softened into a more kindly and human, yet still dignified, manner, reflected in the gestures of Mother and Child toward the kneeling figures. Likewise, the design has been softened and made more flowing in character.

Whether the Madonne Enthroned in the Rucellai Chapel of Santa Maria Novella is the same panel which Duccio painted in 1285 for that church or not is disputed, largely because Vasari praised it as Cimabue's; but the general tendency among historians has been in the affirmative. Stylistically, the panel appears as a development of the type seen in the Franciscan Madonna and a close parallel to the Uffizi Madonna of Cimabue, which was probably painted about the same time. The significant differences between the Cimabue and the Rucellai compositions reveal the new spirit and generation which Duccio represents. Although smaller in actual size (12 ft. 7½ in. high compared with 14 ft. 9 in.), the Cimabue appears taller and

more hierarchic in its effect, with its symmetrical composition dominated by the towering figure and throne and the network of gold highlighting the drapery. Duccio's throne is placed at an angle, with the kneeling angels suspended in space, the throne and figure slightly unbalanced with a modest freedom given through the movement as the Virgin holds the Child (compared to the traditional stylized gesture towards the spectator used by Cimabue). The folds of the drapery tend to follow the figure without the gold design, except for the border, which gently flows from the face to the bottom of the garment in a free and characteristically Sienese expressive line. The more intimate and human relationship between Mother and Child, the delicate movement of the figures and the gentle flow of the design suggest Gothic influences which, though used in a more conservative way by Duccio, also affected Giotto in his Ognissanti Madonna.

Duccio's greatest work, and, along with Giotto's decoration of the Arena Chapel, the most important monument of the whole fourteenth century, is the Maestà in the Cathedral Museum (Museo dell' Opera del Duomo) of Siena. The modest but curious Madonna degli Occhi Grossi by an anonymous Sienese painter of the thirteenth century, now in the same museum, is said to have been the original altar which Duccio's panel replaced. The huge panel was commissioned in 1308 with a detailed contract indicating that the altar should be executed without delay and by his own hand (*suis manibus*). It was completed three years afterward—apparently, from a note of 1310—under considerable pressure by the *operai*. Contemporary chronicles describe the elaborate celebration and festivities of the townspeople on June 9, 1311, when the work was transferred from his shop to the high altar of the cathedral. According to the chronicler, all shops were closed, church bells rang, while the Bishop and the populace, with music and fanfare, joined in a joyous procession to accompany the finished work. It was removed in 1506, later to be sawed up into many separate panels, so that while the main parts are, today, still in the cathedral museum, smaller panels are scattered in many different museums, such as the National Gallery of Washington, the National Gallery in London, and in the Frick and Rockefeller collections of New York.

The front side of the altar represents the Virgin Enthroned with accompanying hosts of angels and saints, of whom the four patron

saints of Siena—Ansanus, Savinus, Crescentius and Victor—are placed in the front row on either side of the Madonna. The signature *Mater sancta dei sis causa senis requiei sis ducio vita te quia pinxit ita* is inscribed on the base of the throne. About this are smaller panels with scenes from Her Life, including the predella with scenes from the youth of Christ insofar as they are associated with Mary (below), a row of half-length apostles, and those scenes (above) from Her life after the Saviour's death, with Her Coronation as the climax. The original back side of the altar was divided into small scenes from the life of Christ, with the Passion in the center, the Public Life in the predella below, and the scenes after the Resurrection in the panels above. The total number, including the rows of angels at the top, comes to some ninety-two panels.

A close examination of the separate panels reveals many variations in quality and style, which might again be interpreted as either a development of Duccio's own style or the assistance of pupils. The central figures framed by the richly decorated throne dominate the broad many-figured panel in an essentially conservative two-dimensional composition. The traditional Byzantine design is softened by the easy flow of the drapery and the deep luminosity of the color. The half-length apostle figures reflect a much stiffer Byzantine manner. Other panels show a greater development of space and sense of figure composition, as in the Last Supper or Christ's Entry into Jerusalem. Parallel to this goes a development in color sensitivity from hard contrasting colors to a greater emphasis on even and soft transitional tones. Some of the most remarkable are to be found in the faces, with their green shadows and warm highlights, and the drapery, especially in the two flanking figures of St. Catherine and St. Agnes at the ends of the middle row.

A more general analysis of Duccio's style will show the remarkable parallel, and contrast, to that of Giotto. The tremendous size and elaborate iconography are far beyond anything that Siena had produced in altarpieces up to that time and, as such, with the large number of individual miniature scenes, might be compared to the monumental sequence of fresco scenes which decorate the walls of the Assisi and Padua churches. But where Giotto's genius lay in the simplified and easily comprehended narrative and its dramatization through a more humanely realistic interpretation of the story, and his strong, monumental form, Duccio has retained the more

abstract character of the theme, rather than the realistic story. Iconographically, these themes are more in keeping with the Byzantine manner, as might be traced in Byzantine mosaics and miniatures. Duccio's genius lay in the soft, lyric character of his interpretation, as shown in the design and drapery and figure groups, and the subdued luminosity of his coloration. The hierarchic abstraction of the Byzantine and the lyric, spiritual character of the French Gothic styles are thus here combined into new forms. The comparison of such similar themes as Duccio's Three Women at the Grave and Giotto's Christ and Mary Magdalene in the Arena Chapel will demonstrate the iconographical and formal differences, not only of the respective artists, but also of the two dominating traditions, Sienese and Giottesque, of the fourteenth-century painting in Italy.

Among other works attributed to Duccio are the half-length Madonna and Child from San Michele in Crevole (Sienna, Museo dell'Opera del Duomo), which would be an earlier work related to the Rucellai Madonna, a Madonna Enthroned with Angels in the Kunstmuseum of Bern, and the design for the rose window in the choir of the Cathedral of Siena, the commission for which is mentioned in the documents (1287-1288) although the master's name is not given. Represented are the Death, Assumption and Coronation of the Virgin, Four Evangelists and Four Saints. The design, especially the Coronation, appears to be somewhat related to the Rucellai Madonna.

In contrast to the tradition of Giotto in Florence, the influence of Duccio's workshop seems to have been limited. His pupils appear to have been merely followers of his manner rather than creative personalities, as can be seen particularly in the work of Meo da Siena, Ugolino da Siena and Segna di Buonaventura.

Meo da Siena (Meo di Guido da Siena, active 1319-ca. 1334) worked mostly in Perugia, and had considerable influence on local painters there. He is chiefly known for the signed (*Hoc opus pinxit Meus Senensis*) Madonna and Child with Saints, with a predella containing twelve apostles, of ca. 1320, from the high altar of the abbey church of Montelabate, now in the Galleria Nazionale dell' Umbria, Perugia.

Ugolino da Siena (Ugolino di Neri, active ca. 1317-1327) is another Duccio pupil of whom little documentary evidence exists. A many-panelled altarpiece, originally on the high altar of Santa Croce in Florence (now lost), was said to have carried Ugolino's signature on its center panel, but several other panels belonging to it exist in the Berlin-Dahlem Museum and the National Gallery of London. Painted probably ca. 1321-25, they include three half-length figures of the apostles Paul and Peter, John the Baptist, plus an Entombment and Christ at the Column from the predella. Several other fragments are in the National Gallery of London. In both style and iconography, they are related to the Duccio Maestà. A polyptych with the Madonna and Six Saints in the Sterling and Francine Clark Art Institute of Williamstown, Massachusetts, is also attributed to Ugolino.

Segna di Buonaventura (active 1298-1331) is mentioned in Sienese documents between 1298 and 1331 as having received commissions for various altarpieces. In 1319 he is cited in Arazzo. Chief among his extant works are a Maestà in the Collegiata di Castiglione Fiorentino, a signed triptych with the Madonna and Child, St. Benedict and St. Sylvester, in the Metropolitan Museum of New York, and a large Crucifix in the Badia of Santa Fiora e Santa Lucilla in Arezzo (ca. 1319).

Related works by unknown masters under Duccio's influence are the Maestà in Città di Castello, and a Madonna altar in the abbey church of San Salvatore e San Cirino in Badio a Isola, which is sometimes attributed to Duccio as an early work.

Simone Martini (ca. 1284-1344) is of a different stature. Instead of remaining as a limited follower of local tradition, it is he who developed the Sienese style to international proportions.

According to Vasari, Martini was born in 1284. Although little is known of his artistic origin (Vasari gives Giotto as his teacher), he appears as a fully developed master when he painted the Maestà in the Sala del Consiglio of the Siena Town Hall in 1315. In 1317, he is recorded as a ''knight'' at the court in Naples, and at the request of King Robert he painted, in 1317, a panel of St. Louis, the brother of the king, who was canonized that year. Two signed altars

for Pisa and Orvieto were painted in 1320. During the following two years he was back in Siena, and was paid (Dec. 1321) to restore his own Maestà in the Town Hall. In 1324, he married Giovanna, the daughter of a painter, Memmo di Filipuccio. Various records list payments for many altarpieces and small decorations, probably by his shop, such as gilded ornaments and coats of arms (1327). In 1328 he painted the fresco of Guidoriccio in the town hall opposite his Maestà. In 1339, he and his brother Donatus were appointed *procuratores* of Ser Andrea di Marcovaldo, the rector of Santa Maria degli Angeli in Siena, to the *Curia Romana*, i.e., the papal court at Avignon, probably for the purpose of settling legal difficulties between the papal curia and local church properties. It was probably the following year that Simone, his wife and his brother left for Avignon. He remained there until his death in 1344. An indication of his fame, aside from the authenticated record of his own works and activities, is given in the sonnets and letters of his friend Petrarch, who praises a portrait he made of Laura and claims him to be an equal of Giotto.

The most significant works by Martini are probably the Maestà and the Guidoriccio frescoes of 1315 and 1328 in the Palazzo Pubblico of Siena, and the Annunciation in the Uffizi. The first is undoubtedly influenced by Duccio's Maestà—a Madonna Enthroned with hosts of angels and saints, among them the same four patrons of the city in the front row. But where the front panel of Duccio's altar was still more conservatively Byzantine, the spirit and form of Martini's rendition have grown within the sphere of the International (French) Gothic style, which may have been effected through the medium of French miniatures, as well as ivories and decorative sculpture of the Siena cathedral.

The characteristics of the style, which reflect the influence of Giotto as well as of Duccio, can be noted in the more graceful pose and draping of the Virgin, the Gothic throne upon which She sits, and the crown She wears, the elaborate decorative canopy overhead, the interest in space as noted in the perspective of both canopy and floor, the more loosely and gracefully grouped figures of the accompanying hosts, and the addition of the motif, noted in Giotto's Ognissanti Madonna, of angels kneeling at the foot of the throne offering gifts to the queenly Virgin. The tall proportions, open structure and architecturally linear character of the throne and canopy

tend to increase the effect of airy space above the figures, whose rhythmic movement and thin proportions complement the total mood.

The color, too, has an even, luminous decorative quality strongly reminiscent of Gothic tapestries of the North. It is painted largely in *secco* rather than the straight fresco, with a rich use of gold to enhance its effect. A verse which, in spirit and in actual meter, already shows the influence of Dante, is inscribed below and ends with an incomplete line naming Simone: *S.a man di Symone*. The decorative frame of the fresco contains twenty roundels with representations of the Saviour, the Evangelists, saints and prophets, two half-length figures personifying the Old and New Law holding scrolls with the Decalogue and Seven Sacraments, and didactic verses exhorting the spectator to a virtuous government in her city— The *Civitas Virginis*.

A more developed Gothic form appears in the large signed (*Simon de Senis me pinxit*) altar in the Museo di Capodimonte of Naples, with St. Louis of Toulouse enthroned, crowning his brother King Robert, in the central panel, and five predella panels representing scenes from the saint's life. The panel is not dated, but was certainly executed either at the same time or shortly after the canonization of the popular Franciscan bishop (1317), and it had political significance since, in honoring the saint, King Robert would enhance himself and the House of Anjou. St. Louis wears the simple Franciscan habit underneath his richly brocaded bishop's robe, so that the ideal of spiritual humility and heavenly grandeur is impressively maintained.

The two signed altars of 1320, however, show a reversion to the Duccio manner. The polyptych originally painted for the high altar of Santa Caterina in Pisa, the fragments of which are now in the Museo Civico of that city, represents a half-length Madonna and Saints. The polyptych for San Domenico of Orvieto, now in the Opera del Duomo there, with half-length figures of the Virgin and Saints, has likewise much of the sober, more monumental form of the older style. A related altarpiece with half-length Madonna and Child, St. Paul, St. Lucy, St. Catherine and St. John the Baptist, originally from Orvieto, is in the Gardner Museum of Boston.

Shortly after the completion of these two altars, probably between 1322 and 1326, Simone executed a series of frescoes in the

Chapel of St. Martin in San Francesco, Assisi. Represented are ten scenes from the life of St. Martin, a number of saints in pairs (including Saints Anthony and Francis, Mary Magdalene and Catherine of Alexandria, St. Louis of Toulouse and St. Louis of France, St. Clare and St. Elizabeth of Hungary) and a portrait of the donor, Cardinal Gentile de Montefiore (d. 1312), kneeling before St. Martin over the entrance arch. The donor had been titular cardinal of San Martino al Monte in Rome, appointed by Franciscan Pope Boniface VIII in 1298, and was buried in San Francesco of Assisi in the chapel dedicated to St. Louis of Toulouse, in whose honor the Naples altar was commissioned.

The legend of St. Martin was attractive to the Franciscans because of both his pious sympathy to the poor and his knightly bearing. The scenes represent, on the left wall, St. Martin Dividing His Cloak with the Beggar, his Dream of Christ Wearing the Beggar's Share of the Cloak, St. Martin Resuscitates the Dead Child, St. Ambrose's Dream of His Presence at St. Martin's Funeral, and at the top, the Funeral Ceremonies of St. Martin. On the right wall are parallel scenes, beginning at the bottom: the Investiture of St. Martin in the presence of the Emperor Julian, St. Martin Renounces the Sword, St. Martin Celebrating Mass at Albenga, St. Martin's Audience with the Emperor Valentian, and the Death of St. Martin.

The narratives, many of them closely related in composition to the predella scenes of the Naples altar, are told again with many figures and much factual detail, but with a general emphasis on a more spiritual and chivalrous content, whereby both the architecture of the chapel and its fresco decoration present a harmonious and coloristically well-integrated Gothic style. To the same project belonged, probably, the decorations of the St. Louis Chapel on the opposite side of the nave, which were destroyed when the chapel was repainted in the sixteenth century.

The fresco portrait of the *condottiere* Guidoriccio Ricci dei Foligni da Reggio was executed in 1328 (or shortly afterward) on the wall opposite the Maestà in the Palazzo Pubblico of Siena, in honor of his capture of Montemassi that same year, which is represented with a second captured castle, Sassoforte, in the background on either side of the mounted warrior. Interesting narrative and realistic details may be noted in the representation of the besieger's camp, the fluttering banners and the fences with pikes leaning against

them. The landscape itself is stylized in Gothic fashion, and against it the striding horseman is set off in sharp relief. The figure is probably a realistic likeness; its forward stride and flowing drapery are stylized into a graceful Gothic design. Effective, too, is the luminous black and yellow-gold of the figure as against the deep blue sky and the warm gray-brown of the receding landscape.

The triptych in the church of Sant' Agostino in Siena was executed about the same time, and shows an interest in the more unified composition, as well as an increased attention to realistic detail. Represented is the blessed Agostino Novello with four scenes of his miracles and two Augustinian saints.

Perhaps the finest and most famous single example of the Sienese Gothic style is the altar, with the Annunciation and Saints Ansanus and Giuletta, which was painted for the chapel of St. Ansanus in the Cathedral of Siena and is now in the Uffizi Gallery of Florence. Comparison with other examples of the same theme (e.g., Giotto's Annunciation in the Areana Chapel) reveals the unique qualities of grace and sensitivity which are Simone's and Sienese, along with an expressive movement and flow of design based not only on tradition, but also on careful observation of the figure. From the inscription (*Simon Martini et Lippus Memmi de Senis me pinxerunt Anno Domini MCCCXXXIII*) the panel was painted in 1333 by Simone and his brother-in-law Lippo Memmi. The duller coloration and design of the two accompanying saints seem to indicate the work of the inferior master, Lippo.

Simone's late work at Avignon brings him in close contact with the international traffic of the papal court. His chief works there are the lost fresco representing the battle of St. George with the Dragon, a fragment of the Savior with Angels in the narthex, and a fragment representing the Virgin with the kneeling Cardinal Jacopo Stefaneschi, all in Nôtre Dame des Domes in Avignon. Recent restorations have uncovered a series of preliminary drawings (*sinopie*) underneath the top layers of the fresco which reveal both Simone's expressive vitality and the working process. Of special significance is the new motif of the Virgin nursing the Child (the Madonna dell' Umiltà) which became popular in succeeding generations as an expression of the tender and intimate love of Mother and Child. Another example is the Madonna of Humility altar by Bartolomeo da Camogli, which is inscribed *Nostra Donna de*

Humilitate, signed, and dated 1346, in the Galleria Nazionale della Sicilia in Palermo.

A possible variation of the spacious St. George composition may be found in a miniature of the same subject, possibly by a pupil of Simone's, in the St. George Codex (Vatican Library, Rome), which contains a life of the saint written by the same Cardinal Stefaneschi. Simone's connection with miniature painting may be inferred from the miniature which he is said by Petrarch to have painted as the frontspiece for the poet's copy of Virgil, now in the Biblioteca Ambrosiana of Milan. Other works belonging to this later period in Avignon are the small signed and dated panel of 1342, representing Christ's Return from the Temple, in the Walker Art Gallery in Liverpool, and sections of a small polyptych containing a two-panel Annunciation, the Crucifixion and Deposition in the Antwerp Koninklijke Museum voor Schone Kunsten, the Procession to Calvary in the Louvre of Paris, and the Entombment in the Berlin-Dahlem Museum. These reflect the decorative grace and lyric idealism of this international style, but they also show a crowded compactness and attention to realistic detail characteristic of the fifteenth century. The Procession to Calvary is repeated with only slight variation, along with a copy of Taddeo Gaddi's fresco of the Presentation of the Virgin in the Baroncelli Chapel, among the miniatures of the *Très Riches Heures* of the Duke de Berry in Chantilly.

Lippo Memmi (active ca. 1317-ca. 1347) and his brother Donato, Simone's brother-in-law, are among the closest followers who had assisted Simone in his shop. Lippo is otherwise chiefly known for the large fresco variation of Simone Martini's Maestà which he and his father, Memmo di Filipuccio, painted for the Palazzo Comunale of San Gimignano in 1317, only two years after Simone had completed his. Compared with Simone's the figures here are heavier and more stiffly composed; in place of the kneeling patron saints, Lippo presents the single kneeling figure of the Podestà, Mino dei Tolomei, under whose regime the commission was given. It appears in poor condition, and had already been restored by Benozzo Gozzoli in 1467. Memmo di Filipuccio is also credited with the scenes of profane love, known and The Bed and The Bath, in Podestà's bedroom of the same building.

Some of the frescoes in the right transept of San Francesco in

Assisi, particularly the famous half-length figures of St. Francis and St. Clare, may possibly have been done by Donato, if not by Simone, about the same time as Simone's decoration of the St. Martin chapel. A number of altarpieces are attributed to Lippo which are of much finer quality, such as the Madonna del Popolo in the church of Santa Maria dei Servi in Siena, the Madonna altar (signed *Lippus de Sena*) in the Cathedral of Orvieto, and the Madonna Enthroned in the Staatliches Lindenau Museum in Altenburg.

Barna da Siena (active ca. 1350ff.) is another follower of Simone Martini who is mentioned by Ghiberti and Vasari but is otherwise difficult to document. His chief work is the fresco series of scenes from the life of Christ in the Collegiata of San Gimignano, in which some twenty-six scenes are arranged in three rows on one wall of the nave. Many of the compositional motifs are taken directly from the narrative scenes in Duccio's Maestà, while figure types are related to those of Simone Martini. Most important, however, is the clear definition of figures in an illusionary shallow space, like a relief against the background, and their rather forceful, dramatic action. The date of execution would appear to be around 1350-1355, though Vasari gives his death as 1380, resulting from a fall from the scaffold. The frescoes were finished by his pupil, Giovanni D'Asciano.

Matteo Giovanetto da Viterbo (ca. 1300-68/69) is the most important representative of Simone's followers in Avignon. Born around 1300 and mentioned in papal documents of 1322 and 1328, he appears at the papal court in Avignon for the first time in 1343, and continues there until 1366. He died in Rome ca. 1368/69. His frescoes in the papal palace at Avignon, in the Salle de l'Audience, contain some twenty life-size figures of Old Testament prophets, and in the chapels of St. Martial and St. John are scenes from the lives of those saints. Others are in the Carthusian monastery of Villeneuve-les-Avignon. They reveal the same combination of Sienese and French Gothic characteristics which were noted in Simone's Avignon work and which play a considerable role in the development of French easel painting of the fourteenth century.

Pietro Lorenzetti (active 1305-ca.1348) is probably the older of

the two brothers, and Ambrogio the more famous. The actual records of them in the sources are sparse. Pietro was born probably about 1280, is mentioned for the first time in 1305 as having been paid by the Siena Council of Nine for a painting, and was paid for an altar by Guido Tarlati, Bishop of Arezzo, in 1320. The only works on which both the brothers seem to have collaborated, and which is mentioned by older commentators, up to and including Vasari, are the 1335 frescoes of the Ospedale della Scala (lost after 1720). Vasari gives the signature as reading: *Hoc opus fecit Petrus Laurentii et Ambrosius eius frater MCCCXXXV*. As with Ambrogio, it is assumed that Pietro died of the plague in 1348.

A considerable number of altars by Pietro are signed and dated up to 1342. The most important of these is the polyptych of the Pieve di Santa Maria in Arezzo, done in 1320 for Bishop Tarlati (signed *Petrus Laurentii hanc pinxit dextra senensis*) representing a half-length Madonna between Saints John the Evangelist, Donatus, John the Baptist and Matthew, with other half-length saints, an Annunciation and the Assumption above. The style is that of a fully developed master, and contains a very human grace and spiritual dignity which has its origin in Duccio's Maestà, but has developed far beyond that master's relative stiffness in a manner parallel to Giovanni Pisano and considerably different from Simone Martini. An earlier panel of ca. 1315, in the Cathedral of Cortona, represents the Madonna Enthroned with accompanying angels in a composition reminiscent of Duccio, but the animation of the figures suggests the new forms of the Tarlati altar.

The chief authenticated altarpieces following these are: the Madonna del Carmine with St. Nicholas, the Prophet Elijah and Four Angels, formerly in the Confraternità di Sant' Ansano in Dofana (signed and dated 1329), now in the Pinacoteca Nazionale of Siena, with its vertically proportioned but rigidly symmetrical figure composition. To this altar belong a number of predella scenes, including Pope Honorius Sanctioning the Order of the Carmelites and four other scenes from the Carmelite legend, also in the Siena Pinacoteca Nazionale, which show a remarkable combination of narrative detail, rich, jewel-like coloration, and strictly formalized composition. The same character appears in the three panels of a polyptych of 1332 in the Siena Pinacoteca Nazionale. The Madonna

Enthroned with Angels, in the Uffizi Gallery of Florence, dated 1340, reveals the intimate grace of Mother and Child and the restrained movement of figures, combined with a kind of formal monumentality. So, too, is the Beata Umiltà, with scenes from Her Life, in the Uffizi, Florence, which, from its damaged inscription, is probably to be dated 1341. Two missing panels from this series are in the Berlin-Dahlem Museum. Finally there is the large triptych, signed and dated 1342, of the Birth of the Virgin, in the Museo dell' Opera del Duomo in Siena, with its formal composition of figures in a unified Gothic architectural space through the separate framed panels. All of these, particularly the last, show a gradual tendency to combine many plastically modeled (much more so than Simone's) figures decoratively into an integrated space and architecture in a specifically Sienese (i.e., Ducciesque) manner, yet related to that of Giotto's followers (i.e., Taddeo Gaddi).

The most important frescoes attributed to Pietro are those in the south transept of the lower church of San Francesco in Assisi depicting scenes from the Passion, from the Entry into Jerusalem to the Resurrection. These complete the series of the Birth and Youth of Christ depicted in the north transept. In style, they appear to be a development of that noted in the Carmelite predella of the Siena Pinacoteca, and are to be dated in the period immediately afterward, i.e., in the 1330s. The combination of narrative realism and decorative unity has led to a form of dramatic tension similar, not so much to the personal style of Giotto, but to that of Giotto's followers (Vasari had ascribed them to Giotto, Cavallini and Puccio Capanna). Indeed, comparison with some of his Florentine contemporaries (e.g., Taddeo Gaddi) might show the Sienese considerably stronger and more expressive. The half-length Madonna between St. Francis and St. John the Evangelist, particularly, shows this attempt to dramatize and decoratively unify the scenes, through the intent look of Mother to Child, the turning of the two saints toward the center, and the pointing gesture with the thumb of the Virgin toward St. Francis. In contrast to the isolation of figures noted in the Arezzo altar, the scene is composed into a *sacra conversazione* in a manner similar to that which Orcagna was to use later in Florence (Santa Marie Novalla altar).

A weaker variation of this, probably executed by pupils but

sometimes interpreted as an early work (i.e., ca. 1320), is the fresco representing the half-length figures of the Madonna with St. Francis and St. John the Baptist over the tomb of Cardinal Napoleone Orsini, in the chapel dedicated to St. John the Baptist. The most expressive and dramatic of the Passion series, certainly executed by Pietro, are the Descent from the Cross, which reveals a significant relationship to Giotto's Lamentation in the Arena Chapel, and the many-figured Crucifixion. Of particular interest, from both the iconographicl and the compositional point of view, is the Last Supper, with its elaborate narrative and descriptive detail, the genre motifs embellishing the scene, the use of light as both an iconographical and a compositional means of expression, the bright jewel-like coloration, and the combintion of figures and architecture in a hexagonal space. Related motifs can be found in Giotto (the Marriage at Cana) and Taddeo Gaddi (Presentation in the Temple).

Pietro's later work in Siena, still during the 1330s, includes frescoes in the church of San Francesco (Crucifixion and Entombment) and in Santa Maria dei Servi (Slaughter of the Innocents, the Feast of Herod and Ascension of St. John). Although in somewhat deteriorated condition, they reveal the consistent development of action in the figure groups. Several of the motifs, such as the Ascension of St. John, indicate a knowledge of Giotto's frescoes in the Peruzzi Chapel. The comparison of the two will demonstrate both the progressive development of style consistent with the period, and the unique quality of the Sienese artist's individual expression. The fresco series of four scenes from the life of Mary, which he executed in 1335 with his brother Ambrogio for the facade of the Ospedale di Santa Maria della Scala in Siena, was destroyed in the eighteenth century, although, from later copies and Ghiberti's description, some suggestion of their quality and design might be inferred from the Birth of the Virgin altar in Siena.

Ambrogio Lorenzetti (active ca. 1319-1348) is the younger and artistically more sensitive of the two brothers. The records concerning his life are few: the earliest mention of him in Florence is 1321; in 1327, he was first registered in the *arte dei medici e speziali* of Florence; in 1332 he was at work on panels with the legend of St.

Nicholas for San Procolo in Florence (mentioned by Vasari and Ghiberti). In 1335, besides the work with his brother on the above-mentioned hospital in Siena, he decorated the church of Santa Margarita in Cortona with frescoes which are now lost. Various notes and payments are listed in Siena until 1347, when he was a member of the Council. Since he is not mentioned after that, it is assumed he died in the great plague of 1348.

Ambrogio's most important work is the damaged fresco series (1337-1339) decorating the Sala della Pace in the Palazzo Pubblico in Siena (also called the Sala dei Nove, i.e., the Hall of the Nine who ruled Siena), with a unique program of allegories of Good and Bad Government and their Consequences. On the end wall opposite the window in the allegory of Good Government, with an enthroned figure of the Good Governor at the right with mace and the shield of Siena, flanked by six seated female figures of civic virtues, labeled as Peace, Fortitude and Prudence (to the left) and Magnanimity, Temperance and Justice (to the right). About the King's head hover half-length figures of the three theological Virtues (Faith, Hope and Charity), holding their corresponding attributes. At his feet is the Sienese town emblem of the wolf with the suckling Romulus and Remus (Siena had always considered herself associated with Rome). Below the king are the conquered enemies of the city being guarded by soldiers and being led before him.

On the left side of the huge fresco (ca. 14 meters long) is the second enthroned figure, that of Justice, with a half-length figure of Wisdom above, holding the Book of Laws and the Scales, which Justice balances with both hands, and in whose trays are winged figures of *Justitia distributiva* and *Justitia commutiva*. Of these, the one at the left leans forward to crown one kneeling figure and behead another, while that on the right hands a spear to one and money to a second. A cord is attached to the balance and is held by the seated Concordia below, who in turn hands it to a procession of twenty-four counselors moving toward the Good Governor at the right.

A band below the fresco bears the inscription, *Ambrosius Laurentii de Senis hic pinxit utrinque*, and an explanation of the symbolism, probably by the painter himself:

Questa santa virtu ladove regge	And these, gathered together for
Induce adunita lianimi molti	such a purpose,
Equesti accio riccolti	A common good for their master
Un ben comun perlor signor sifanno	undertake;
Loqual p[er] governar suo stato	Who, in order to govern his state,
elegge	chooses
Dino[n]tener giamma gliochi rivolti	Never to keep his eyes turned
Dalo splendor devolti	From the splendor of the faces
Dele virtu chetorno allui sistanno	Of the virtues which around him
P[er] questo contriunfo allui	stand.
sidanno	For this, with triumph are given to
Censi tributi esignorie diterre	him
Per questo senza guerre	Taxes, tributes, and lordships of
Seguita poi ogni civile effetto	lands;
Utile necessario edidiletto	For this, without wars
	Is followed then by civil result,
	Useful, necessary, and pleasurable.
	Wherever this holy virtue rules
	She induces to unity many souls;

The fresco on the long wall depicts the results of Good Government in the country and in the city. The former is represented by a rolling landscape with a winged *Securitas* hovering above with a scroll and a miniature gallows in her hands and numerous figures scattered over the roads and fields. The text reads:

Senza paura ognuom franco camini	Without feat, let each man freely
Elavorando semini ciascuno	walk,
Mentre che tal comuno	And working let everyone sow,
Manterra questa don[n]a i[n]	While such a commune
signoria	This lady will keep under her rule
Chel alevata arei ogni balia	Because she has removed all power
	from the guilty.

Similarly the panorama of the city, probably a realistic ''portrait'' of medieval Siena itself, depicts busy merchants, mounted nobility and dancing maidens in the streets and squares. Thus under Good Government peasants may till the land, merchants ply their trade, the youth may dance and the nobles hunt. The inscription below the fresco runs as follows:

Volgiete gliocchi a rimirar costei
Voi che reggiete che qui figurata
E p[er]sue cielle[n]zia coronata
Laqual se[m]pra ciascun suo dritto
 rende
Guardate quanti ben vengan da lei
E come e dolce vita eriposata
Quella dela citta dve servata
Questa vi[r]tu kepiu daltra
 rispre[n]de
Ella quard[a]e difende
Chi lei onora e lor nutrica e pascie
Da la suo lucie nascie
El meritar color coperan bene
E agliniqui dar debite pene

To gaze attentively at her who is
 here represented,
And for her excellence is crowned;
Who always renders justice to
 everyone.
Behold how many good things come
 from her,
And how sweet life is, and how
 full of repose
Is that of the city where is observed
This virtue, which more than any
 other shines.
She guards and defends
Those who honor her, and nour-
 ishes and feeds them.
The rewarding of those who do
 good,
And giving to the iniquitous due
 punishment.
Turn your eyes, you who are
 governing,

The allegory of Bad Government on the opposite side is dominated by the enthroned horned Tyrant holding the dagger and cup as instruments of murder, and surrounded by Pride, Avarice and Vainglory (above), Deceit, Treason and Cruelty (to the left), and Fury, Discord and War (to the right). At the feet of Tyranny lies the prostrate Justice and her broken scales. Finally the ruined fresco of the results of Bad Government represents robbers and raiding soldiers plundering houses and murdering people. A haggard old woman as Fear hovers above with the scroll:

P[er] volere elbenproprio i[n] questa
 terra
Sommesse la guistitia a tyrannia
Unde p[er] questa via
No[n] passa alcun se[n]ça dubbio
 di morte

Che fuor sirobba e dentro dele porte

For wanting his own good on this
 earth,
He subjected justice to tyranny;
Wherefore along this road
Because robbery is without and
 within the gates.
Passes no one without dread of
 death;

The text describing the effects of Tyranny is also given below:

Ladove sta legata la iustitia
Nessuno albe[n] comune giamay
 sacorda
Ne tira adritta corda
P[er]o convien che tirannia
 sormonti
La qual p[er] adempir la sua nequitia
Nullo voler ne operar discorda
Dalla natura lorda
De vitii che co[n] lei son qui
 co[n]gionti
Questa caccia color calben son
 pronti
E chiama ase ciascun camale
 i[n]tende
Questa sempre difende
Che sforda o robba o chi odiasse
 pace
Unde ogniterra sua i[n] culta giace
. .
. e p[er] effetto
Che dove e tirannia e gran sospetto
Guere rapine tradimenti en ganni
Prendansi signoria sopra di lei
E pongasi la mente e lo inteletto
In tener sempre a iusticia suggietto
Ciascun p[er] ischifar si scuri danni
Abbattendo e tirani
E chi turbar la vvol sie p[er] suo
 merto
Discacciate diserto
In sieme con qualunque sia seguacie
Fortificando lei p[er] vostra pace

Nor goes straight ahead for the
 right,
But is agreeable that Tyranny
 should rise;
Which, in order to carry out her
 wickedness
Is unwilling either to wish or do
 anything
Against the dirty nature
Of the vices, which with her are
 here joined.
She chases those who on the good
 are intent,
And calls to herself everyone who
 is planning evil.
She always defends
Him who uses force, or robs, or
 who might hate peace;
Wherefore every land of hers lies
 uncultivated.
. .
. and for effect
That where is tyranny and great
 suspicion,
Wars, rapines, treacheries, and
 deceptions
Gain the upper hand over her,
And use their minds and under-
 standing
To hold always everyone is sub-
 jection to justice
In order to avoid such dark injury,
By throwing down tyrants;
And he who wishes to disturb her,
 let him, according to his merits,
Be chased away and deserted,
Together with his followers, if he
 has any,
Fortifying her for your peace.*

84

There, where bound is Justice,
No one for the common good ever
joins together

The symbolism is continued in the borders of the entire series with medallions (damaged) containing representations of the seven liberal arts, the seasons and the planets.

General features to be noted about the series are, first of all, the elaborate allegorical content and its didactic use in propagating civic virtue, which is basically in the tradition of Simone's Maestà, but is translated from the strictly ecclesiastical idealism of that earlier work to a new form of secular symbolism. The interest in classic Roman motifs, and indeed in classic symbolism, has its parallel in Petrarch and the systematic theorists (St. Thomas Aquinas). Their development into a didactic program is evident in French Gothic sculpture and that of the Pisani, particularly Giovanni. From Vasari's description, a somewhat similar allegory of civic virtue must have been used by Giotto in his lost decoration of the hall of the Podestà in Florence, and related motifs are to be found in the allegories of Giotto's Arene Chapel (e.g., the dancing maidens and mounted nobles on the base of the *Justitia*).

There is evidence of the careful study of classic models for design as well as subject matter, in the form of reliefs, coins or sculpture in the round (e.g., the reclining figure of *Pax*). In total concept as well as specific detail, however, there appears a free and independent interpretation. The painstaking yet free romantic interest in realistic detail (strongly reminiscent of contemporary French miniatures) of the landscape, for example, is especially notable when compared to that in Simone's portrait of Guidoriccio. With the emphasis on the many well-executed figures and allegorical details, the compositional and dramatic unity of the total wall has correspondingly suffered. The artistic quality, however, is to be found in the decorative unity achieved through the relatively subdued luminous color fo the whole and the easy flow of linear design in both figures and the landscape, as well as architectural panoramas in the background. In this scheme the didactic content is an integral part of the basic artistic form, which becomes an important feature in later Trecento painting.

*Text and translation from George Rowley, *Ambrogio Lorenzetti,* 2 vols., Princeton, N.J., pp. 127-129.

Ambrogio's artistic development can be traced by a number of well-authenticated altarpieces. An early work, dated 1319, in the church of Sant' Angelo in Vico l'Abate represents the Virgin Enthroned in a hierarchic plastic manner, as close to Giotto as it is to the Sienese tradition. A second Madonna, in the Seminario Arcivescovile of Siena, shows a greater emphasis on the decorative curvature of the figures and a more intimate, tender mood through the motif of the Mother nursing Her Child. The two frescoes in San Francisco in Siena (1331), representing the martyrdom of the Franciscans before the Sultan in Ceuta, and St. Louis before Pope Boniface VIII being admitted into the Franciscan Order, show a greater interest in the handling of architecture and spatial problems, and are more closely related to the style of his brother Pietro (compare the Carmelite predella in the Siena Pinacoteca). Although the identity is often disputed, there are several sections of the altar which was mentioned by Ghiberti as having been painted for San Procolo in Florence in 1332, representing the Madonna and Saints Proculus and Nicholas, and four scenes from the life of St. Nicholas, now in the Uffizi Gallery. These likewise show the influence of Pietro's more linear and decorative style, which seems to have been developed before the frescoes of the Palazzo Pubblico.

An impressive Maestà of 1335-1337, in the Municipio of Massa Maritima, is based on the great Duccio composition, but is much more solidly packed with the hosts of figures and strengthened through the emphasis on the central pyramidal throne composition. Its content is enriched by the addition of the theological Virtues, *Caritas*, *Spes* and *Fides*. Angels hold the cushion on which the Virgin sits. The glowing color is further enhanced by rich jewelled and embroidered decoration, again anticipating decorative interests of later Sienese painters.

A simplified version of the Maestà theme is the recently discovered fresco lunette in the church of Sant' Agostino in Siena (1333-1335). The accompanying Saints Agatha, Catherine, Augustine, Batholomew, Mary Magdalene, Apollonia, Michael, Guglielmo Eremita and the patron are arranged freely in space about the central Virgin. A similar Maestà fresco, sometimes attributed to Ambrogio, is in the circular chapel of Montespiepi near San Galgano. Several remarkable preliminary drawings (*sinopie*) have been uncovered on the *arriccio* of this series.

Several panels of a polyptych of ca. 1340, originally in the con-

vent of Santa Petronilla in Siena, now in the Pinacoteca Nazionale there, reveal the composition of the Madonna and Child Enthroned with Saints Mary Magdalene and Dorothy as a single group with the adoring saints turned and gesturing toward the center, with a rich and luminous coloration as a unifying element.

The late work of Ambrogio is seen in the two signed and dated altars: one of 1342, representing the Presentation in the Temple (signed *Ambrosius Laurentii fecit hoc opus Anno Domini MCCCX-LII*), in the Uffizi, is especially notable for its finely executed Gothic detail, the simplicity and restraint of its figure composition, and the perfected, though not mathematical, linear perspective of its architectural setting. The other altarpiece is the Annunciation, signed *17 di dicembre 1344 fece Ambruogio Lorenci questa tavola*. . . . in the Pinacoteca of Siena, and it is notable, in contrast to the lyric grace of Simone Martini's Annunciation of 1333, for the rather heavy and cramped composition of the two figures, the uncertain use of perspective in the tiled floor alone, and yet the remarkably plastic and tense expression of the theme.

A number of interesting minor masters continue the Sienese tradition through the second half of the fourteenth century in a manner that closely parallels the development in Florence.

Lippo Vanni (active ca. 1341-1375) is known as the painter of a series of miniatures (1345) in the cathedral library of Siena, a triptych with an Enthroned Virgin and Saints of 1358 in the monastery of San Domenico e San Sisto in Rome, a fresco Madonna and Child with Saints Francis, John the Baptist, Catherine and Anthony, ca. 1370, in the Archepiscopal Seminary of Siena, and possibly the fresco depicting the battle of Val Di Chiana (1372) in the Sala del Consiglio of the Palazzo Pubblico of Siena. All of these are strongly under the influence of Ambrogio Lorenzetti.

Niccolò di Ser Sozzo Tegliacci (active ca. 1334-1363), like Lippo Vanni, continued an eclectic mixture of Simone Martini and the Lorenzetti. He was active (1336 ff.) as a book illuminator and has a number of altar panels in the Pinacoteca of Siena, the Museo Civico of San Gimignano, and the Museo Nazionale of Pisa.

Luca di Tommè (active 1355-1389) is mentioned by Vasari as a pupil of Barna, but his style follows in the Lorenzetti tradition

(Assumption of the Virgin, ca. 1355-1360, in the Yale University Gallery, New Haven, Conn., Crucifixion of 1366 in the Museo Nazionale of Pisa, and the 1367 polyptych with Mary, St. Ann, the Child and Saints in the Pinacoteca of Siena).

Niccolò di Buonaccorso (active ca. 1348-1388) is a follower of Simone Martini, although his chief concern seems to be the rich textural effects of costumes, as seen in the signed Marriage of the Virgin in the London National Gallery (signed: *Nicholaus Bonachursi De Senis Me Pnxt*), and the Crucifixion in the Galleria Nazionale dell' Umbria in Perugia.

Bartolomeo Bulgarini (active ca. 1345-1378), mentioned in the documents, is sometimes associated with the anonymous Maestro di San Pietro a Ovile, whose principal work is the Madonna and Child altar in the church of San Pietro a Ovile in Siena, and is related in style to Pietro Lorenzetti.

Andrea Vanni (ca. 1332-1414) is known not only as an artist but as a man of political affairs, having served on the city council of Siena and as envoy to Florence, Naples and Avignon, as well as being a friend of St. Catherine of Siena. His chief works are the fresco ''portrait'' of St. Catherine in the church of San Domenico in Siena, the triptych with the Crucifixion and Two Prophets (1396) in the Pinacoteca of Siena, the signed triptych with the Crucifixion in the Clark Collection, Williamstown, Mass., and the large altarpiece with the Madonna and Saints, ca. 1400, in Santo Stefano, Siena. The style appears largely dependent on the work of Simon Martini and possibly Lippo Memmi, as well as Barna.

Bartolo di Fredi (active ca. 1353-1410) shared a workshop with Andrea Vanni in 1353 and is traceable until his death in 1410. Among the numerous works attributed to him, the most important is a fresco series of twenty-six scenes from the Old Testament on the left wall opposite the New Testament cycle by Barna da Siena, in the Collegiata of San Gimignano (completed in 1367). The Triumph of Death fresco in the church of San Francesco in Lucignano appears to be somewhat earlier. Like Andrea Vanni, he is no outstanding creative personality, and his style is more dependent on that of the

Lorenzetti, particularly Pietro, though he was certainly influenced by Barna. His fresco series of scenes from the Life of Mary in the church of Sant' Agostino in San Gimignano was also done in the 1360s, and shows greater restraint in concept. In the style of his Adoration of the Magi in the Siena Pinacoteca, he is a forerunner of Gentile da Fabriano.

Giacomo di Mino del Pilliciaio (active ca. 1342-ca. 1396) is recorded as having executed a (lost) ceiling fresco in the Cathedral of Siena with Bartolo di Fredi in 1368. Characteristic works are the signed and dated Madonna del Belvedere (1363), in the Basilica di Santa Maria dei Servi in Siena, and a Maestà in the Pinacoteca of Siena.

Francesco di Vannuccio (mentioned in documents from 1361-1388) is another imitator of the Lorenzetti and Simone Martini, whose major surviving work is the signed (*Francischus Devannuccio Desenis pinsit hoc hopus MCCCLXX*) Crucifixion in the Berlin-Dahlem Museum.

Paolo di Giovanni Fei (active 1372-1410) was probably a student of Andrea Vanni and was influenced by Bartolo di Fredi. His style continues in the mannered tradition of the late Trecento in Siena, though there is evidence of a new interest in space and the realistic handling of figures. As the teacher of Sassetta and Giovanni di Paolo, he forms one connection with the new art of the next century. The characteristics of his style are to be found in the crowded composition of the Birth of Mary altar in the Pinacoteca of Siena.

Taddeo di Bartolo (ca. 1362-1422), a pupil of Bartolo di Fredi, is the most significant of this new generation of Lorenzetti followers whose interest in reality and renewed vitality transformed Sienese art from a provincial tradition to the broader level of the International Late Gothic style. His most important works are the Adoration of the Shepherds panel (1404) in the church of Santa Maria dei Servi in Siena, the extensive and realistically Dantesque fresco of the Last Judgment (ca. 1395) in the Collegiata of San Gimignano, the large triptych of 1401 in the Duomo of Montepulciano with the self-portrait of the artist (one of the earliest extant) as his patron saint,

the apostle Jude Thaddaeus, a fresco series of scenes from the Life of Mary in the chapel of the Palazzo Pubblico in Siena (1406-1407), along with allegorical frescoes of good and bad rulers of ancient Rome in the entrance corridor, which was painted some years later (1414). Damaged frescoes of scenes from the Life of Mary, related to these, are in the sacristy of the church of San Franceso in Pisa (1397). A number of remarkably well-preserved altars are in the Galleria Nazionale in Perugia, including the Madonna and Child with Saints and a signature, *Thadeus Bartoli de Seni pinxit hoc opus MCCCCIII.*

5. Minor Schools

WHILE THE CENTERS OF CREATIVE ENERGY in the late thirteenth and early fourteenth centuries appear to have been concentrated in Florence, Siena and Rome, with their extensions in Assisi, Padua and Naples, Rome soon deteriorated after the transfer of the papacy to Avignon in 1309, leaving the major developments in the hands of the Sienese and Florentines. Recognizing these influences, there appears a rich heritage in a number of smaller communities where material wealth, civic pride and practical though pious patronage provided a remarkable variety of artistic production.

Pisa

As a naval power rivalling Genoa and Venice, Pisa had participated in the First Crusade and had achieved control of Sardinia, Corsica and the Balearic Islands, as well as exerting considerable influence in the East. She was a leader among Ghibelline cities throughout the thirteenth and fourteenth centuries. This position was strengthened by struggles with the papacy in Sardinia and rivalry with Florence. While she joined in the war against Florence in 1228 and 1254, the city was largely occupied during this period with maritime rivalry with Genoa. Her defeat by Genoa at Meloria in 1284 put an end to Pisa's sea power and led to the removal of Ugolino della Gherardesca, the Ghibelline dictator of the city. In 1312, with the aid of Henry VII of Luxembourg, Pisa attempted to gain territory in Tuscany. Henry's death left the city without Ghibelline allies and brought the Imperial Vicar, Ugoccione della Faggiuola, to power. He succeeded in conquering Lucca and defeating Florence in 1315

at Montecatini. He was later expelled, and Castruccio Castracani succeeded him as lord of Pisa and Lucca. Through the latter part of the century the power of Pisa slowly declined, while the city was torn by the feud of the Raspanti and Gambacorti families. The latter came to power in 1369, and the end of Pisa as a political entity came when Jacopo d'Appiano sold the city to the Visconti of Milan in 1399. The final blow was struck in 1406, when the city was occupied by the Florentines.

As suggested before, the development of the new style in Pisa toward the end of the thirteenth century can best be followed in the sculpture of Niccolò and Giovanni Pisano (i.e., the above-mentioned pulpits), whereby the complex relationship and struggle between strong creative personalities and the contending Byzantine, Classical and French Gothic traditions is clearly evident.

Although difficult to prove because of the scarcity of surviving works and documents, it would seem that Pisa provided a major stimulus to the development of Tuscan and Florentine painting during the thirteenth century. However, a number of examples and individual artists can be listed wherein one can follow a basically Romanesque character, whose form may have local roots parallel to those of Pisan sculpture and architecture, which is then gradually loosened into a more decorative but still monumental Byzantine schema and then, in turn, reinterpreted in a more personal and dramatic way by individuals toward the end of the thirteenth century.

This can be seen in a number of well-known crucifixes. The oldest Pisan example appears to be the late twelfth-century Crucifix in the Museo Nazionale of Piza, with its life-size, open-eyed Christ figure, four-nailed, though he appears to be standing as a *Christus triumphans*. Three narrative scenes from the Passion appear on each side, while those of the Last Supper and the Washing of the Feet occupy the ends of the arms and the Pentecost is at the bottom, the Ascension at the top.

A later example of the early thirteenth century is the Crucifix which was formerly in the Cappella Maggiore of the Campo Santo (now in the Pisa Museo Nazionale) having a much more expressive character, with emphasis on the dead Christ (the *Christu patiens*), and the narrative scenes at the sides depicting the events after the Crucifixion. The pathos of the suffering Saviour and the change in

iconography, combined with the more active movement of both figure and design, suggest a stronger Byzantine character which persisted through the thirteenth century.

Similar examples of this older type of triumphal cross, which usually hung over the altar or was placed on the rood screen or bar separating the choir from the lay area in the church, are to be found in the damaged Crucifix, dated 1138, by a Maestro Gullielmus in the Cathedral of Sarzana, one with a damaged inscription indicating a date of 1187 and the artist's name, which has been interpreted as Alberto Sotio, in the Cathedral of Spoleto, and a third, also late twelfth century, in the Uffizi of Florence.

A Crucifix of the Dead Christ, with scenes depicting the Betrayal, Flagellation, Mocking of Christ, Road to Calvary, Crucifixion, Deposition, the Women at the Sepulcher on either side, together with Peter's Denial at the base and the Ascension at the top, was signed by Enrico di Tedesco (*Enricus quondam Tedici me pinxit*) and has a rather stiff, Romanesque quality, even though the main figure is the Dead Christ type and has the slight curvature of design. It is assumed to have been painted around the middle of the thirteenth century.

Giunta Pisano (Giunta di Guidotto da Colle, active 1202-1267) is the leading master of the period who is mentioned in a document of 1202, again in 1228, when he bought a house, 1236, when he dated a Crucifix (lost) with a kneeling portrait of Frater Elias of Cortona once in the lower church of San Francesco in Assisi, and 1267, when he is mentioned as deceased.

The San Francesco Crucifix is significant, not only because of its early date, but also as indicating the early fame of the Franciscan story (cf. also the Berlinghieri), the prominence of Pisan and Lucca artists outside their area, and the early patronage of Elias as head of the Franciscan Order.

There are three rather important signed works by Giunta extant: the Crucifix, formerly in the church of San Ranierino in Pisa, now in the Museo Nazionale there (signed, *Junta Pisanus me fecit*), that of Santa Maria degli Angeli near Assisi (signed, *Juncta Pisanus Capitini me fecit*), and a third Crucifix (signed, *Cuius docta manus me pinxit Junta Pisanus*) in San Domenico in Bologna. When compared with Enrico di Tedice's panel or the earlier one in the Museo

Nazionale of Pisa, the stronger, more personal and dramatic character of Giunta's style becomes readily apparent. The figure is more plastically modeled, the movement and design much more positive. While the devotional pathos of the dead Christ is strengthened, the narrative interest in the accompanying Passion scenes has given way to the most positive expression of single figures, such as Mary and John, at the terminals, and in the Assisi example, the figure of Christ in Benediction in place of the traditional Ascension. It is this type that is carried on in Florence by Cimabue.

Two other panels in the Museo Nazionale of Pisa are sometimes ascribed to Giunta, or at least to his school. One is the St. Anne Enthroned with the infant Mary on her lap, which, while composed in the traditional Byzantine manner, has much of the decorative finesse noted in Guido da Siena's Madonna. The other panel, formerly in the church of San Martino, Pisa, presents the Virgin Enthroned and twelve accompanying scenes from the story of Joachim and Anna. It appears to be later in style, with more carefully modeled forms but little interest in perspective, and might be related to the Rucellai Madonna. The comparison of these with the more rigid Pisan-Byzantine character of the Madonna in the Moscow Museum of Fine Arts will again show the specific line of development traceable within the local Pisan school.

The Campo Santo (1350 ff.). Pisan painting of the fourteenth century is a curious mixture of local and foreign elements. The important monument is the extensive fresco decoration of the Campo Santo, for which not only local artists were employed, but a considerable number of outside artists invited, among them Andrea da Firenze, Spinello Aretino, Antonio Veneziano and Barnaba da Modena.

The Campo Santo itself is a large cemetery, some 138 yards long and 57 yards wide (126 meters x 52 meters), near the cathedral, for which, according to tradition, fifty-three shiploads of earth were brought from Jerusalem for the hallowed ground. The impressive marble architectural enclosure was built in 1278-1283 by Giovanni di Simone. The frescoes cover the nearly thirty-foot walls facing the ambulatory, while arcades with elaborate fifteenth-century Gothic tracery open to the cloisterlike interior.

94

Francesco Traini (active ca. 1321-ca. 1365) is the most important master of the local school, whose somewhat Sienese character may possibly have been influenced by Simone Martini's stay in Pisa (1320). He is traceable in documents from 1321 to 1344, and his chief authenticated work is the signed altar painted for Santa Caterina of Pisa in 1345, now in the Museo Nazionale of Pisa, representing St. Dominic and scenes from his life. Related to this is the altar representing the Triumph of St. Thomas Aquinas, in the church of Santa Caterina, Pisa, which had been attributed to Traini by Vasari and which is identified in local documents with a date of 1363.

The decoration of the Campo Santo was begun shortly after 1350 with an Assumption of the Virgin (badly damaged) over the entrance portal. The most important single scene is the famous Triumph of Death, which Vasari attributed to Orcagna but is certainly the work of Traini. In form and content it is closely related, at least as far as the fragments show, to the fresco of the same subject which Orcagna painted in Santa Croce, and was probably done about the same time (i.e., ca. 1350). It is difficult, and indeed impossible in this situation, to distinguish stylistic priorities or influences, but from Orcagna's fragments it would appear that his emphasis was more on the abstract character of the overall design, whereas Traini, working on a larger space, had greater power in the expression of realistic detail. Frescoes of the same Triumph of Death theme, on a reduced scale, are to be found in the Sacro Speco near Subiaco and the frescoes by Bartolo di Fredi in San Francesco of Lucignano. Both are of the same time or slightly later.

The content, in keeping with the moralistic earnestness of the years after the great plague of 1348, may have been taken from the allegory of the "Three Living and the Three Dead" contained in the writings (*Le Vite de' Santi Padri*) of the Dominican monk Domenico Cavalca (1270-1342). Other expressions of the period related to the subject matter are to be sought among ascetics who were social and religious critics of the time, such as Giovanni dalle Celle, abbot of Santa Trinità in Florence (1351), and especially Jacopo Passavanti (prior of Santa Maria Novella from 1354 until his death in 1357), whose *Specchio di Vera Penitenza* preached the terror of hell and damnation. The theme of Death as a long-haired

female figure has a long history, from Greek mythology to Horace, and the terrifyingly realistic visual images are familiar from hell in the Last Judgments, such as *Nardo di Cione's* Dantesque fresco in Santa Maria Novella. Their development, in terms of both size and dramatic impact, can be seen, too, in the gigantic Last Judgment by **Taddeo di Bartolo** in the Collegiata of San Gimignano.

The various scenes within the composition depict, in the foreground, a procession of mounted nobility pausing before the three open coffins behind which the hermit Macarius warns of the *momento mori*. To the right, under a bower of trees, is a well-dressed group of courtly people enjoying music and stories, reminiscent of Boccaccio's *Decameron*. Contrasted with this is the terrifying figure of Death and demons fighting over the lost souls, while the crowd of leprous beggars and cripples implores for mercy and release from their miseries. The scene at the upper left depicts the quiet life of the hermit monks, secluded from the terrors of the world, again a variation of the contrasting *vita activa* and *vita contempletiva*.

The tone of the color and the decorative grace of the design, particularly of the musicians' group at the right, are reminiscent of the style of Ambrogio Lorenzetti (Palazzo Pubblico series). Indeed, the style is closely related to the Sienese-Florentine character of contemporary Florence, which accounts for the frequent attribution of the Pisan frescoes to Orcagna.

A badly damaged Crucifixion on the end wall had been traditionally attributed to Buffalmacco but has more recently been assigned to Traini with the assistance of Bolognese artists, with whom there appears an interesting relationship. Likewise by Traini is the large fresco of scenes from the Lives of the Hermits (the Anchorites of the Thebaid).

The large Last Judgment is also attributed to Traini and, in its newly restored state (now exhibited with the preliminary *sinopie*), is probably the most impressive painting of the series. For the first time Mary is enthroned with Christ, as an equal Judge, She on the side of the blessed, whereas He condemns the damned with dramatic power. Hell is extended into another full-sized wall, dominated by a gigantic and grotesque Satan and filled with an endless variety of terror-ridden expressions. The extraordinary size and descriptive realism of these scenes again suggest later Last Judgments, such as that by Taddeo di Bartolo in San Gimignano, and the new realism of the fifteenth century.

Aside from the frescoes depicting scenes from the life of St. Raynerius by Andrea da Firenze and Antonio Veneziano, the scenes from the lives of St. Ephesus and St. Potitus by Spinello Aretino, and the History of Job attributed to Taddeo Gaddi, the Campo Santo contains a weaker series of Old Testament scenes by Piero di Puccio (done 1389-1391). These, in a sense, form the transition to the fifteenth century, when the project was completed by Benozzo Gozzoli.

The Campo Santo and its mural decoration were heavily damaged by the tragic shelling and resultant fire in 1944 during the Second World War. However, in the process of restoration, the separation of the finishing coat of plaster from the rough under-layer revealed a remarkable series of red chalk drawings (*sinopie*) which were the original sketches used in laying out the composition before the final coat of plaster was applied for painting. These show a freshness and vitality, a direct and freely expressive quality, which frequently becomes lost in the technical process of executing the finished work.

Lucca

For the most part, Lucca had followed a Ghibelline policy, first under Pisa's control and then under Florence. In 1399, it purchased its independence from Charles IV, and remained so until 1530.

Berlinghiero Berlinghieri (active early 13th century) is the first representative of the local school of Lucca, paralleling the work of Giunta of Pisa and Guido of Siena. The oldest panel extant is the Crucifix in the Pinacoteca of Lucca, from the local church of Santa Maria degli Angeli, which is signed *Berlinghieri me pinxit*. The master is mentioned in a document of 1228 as having been born in Milan and having three sons: Barone, who is noted as having received a contract to decorate a room in 1244 and is mentioned in 1282 and 1284 as receiving commissions for altarpieces in Lucca churches which are now lost; Marco, who is mentioned as a painter of miniatures in 1250; and Bonaventura, mentioned in documents of 1240 and 1244, of whom the only certain painting is the life-size ''portrait'' of St. Francis in the church of San Francesco in Pescia, which is signed and dated 1235.

The elder Berlinghieri's Crucifix is of the open-eyed *Christus*

triumphans type, Romanesque in character but with a strong well-modeled central figure, and parallel figures of Mary and John on the apron of the cross in place of the traditional narrative scenes. Symbols of the Four Evangelists appear at the terminals of the arms, while the Madonna with angels is at the top, Peter's Denial at the bottom. It is to be dated between 1210 and 1220. On the basis of this, a number of similar works have been attributed to Berlinghiero, such as the Crucifix from San Donino, Lucca, now in the Palazzo Venezia, Rome; others are in the churches of Santa Giulia, Santa Maria dei Servi, and San Michele in Lucca, and one using the new *Christus patiens* type of central figure, in the Uffizi Gallery of Florence.

Bonaventura Berlinghieri's altar of St. Francis with six scenes from his life has a special interest because of the proximity of its execution (1235) to the death of the saint (1226). It is not a "portrait" in the sense that the Frater Franciscus in Sacro Speco (Subiaco) might be interpreted with its simplicity and directness associated with the character of the saint. Bonaventura's Francis has the strict and hierarchic austerity of the traditional Byzantine Christ in Benediction. The six scenes appear to be among the earliest representations of the Franciscan legend. A St. Francis Receiving the Stigmata of about the same time, also attributed to Bonaventura, is in the Uffizi Gallery of Florence.

Related in style to Bonaventura Berlinghieri, but somewhat later, is the signed St. Francis altar in the Museo di Castelvecchio of Verona by Margaritone d'Arezzo (ca. 1270), who is otherwise unknown except for an Arezzo document of 1262 and a Madonna retable with scenes of the Nativity and lives of the Saints John the Evangelist, Benedict, Catherine and Nicholas (signed *Margarit de Arito me fecit*) in the National Gallery of London.

Angelo Puccinelli (active 1350-1399) is the only name of any prominence during the fourteenth century in Lucca, where there is very little evidence of the strong creative activity so characteristic of Pisa and Florence. His chief work is the signed and dated (1350) Marriage of St. Catherine triptych in the Pinacoteca Nazionale of Lucca, which is the Simone Martini-Lippo Memmi tradition. Others are the altar with the Death and Assumption of Mary, signed and dated 1386, in the church of Santa Maria Forisportam in Lucca, and

the signed polyptych of the Virgin with Four Saints (1394) in the church of Varano.

Naples

The history and significance of Naples is of no great importance to the development of Renaissance painting, yet it does contain a number of interesting factors in the political and cultural relationship to the Byzantine Orient and Classical Antiquity. The predominantly Greek-Byzantine culture of Sicily and southern Italy in the Norman Kingdom under Roger lasted until 1194, when it was supplanted by the Hohenstaufen. In the first half of the thirteenth century a flourishing, particularly classical culture was developed about the court of Frederick II in Naples. With the conquest by Charles I of Anjou, a new dynasty and a new culture flourished again in Naples under Robert the Wise (1309-1343) that might be looked upon as more French and Gothic in character as compared to the imperial classic culture when the Hohenstaufen sought to sponsor.

Along with other famous men (e.g., Petrarch, who was crowned as poet laureate by Robert at Rome in 1341), most of the artists active at King Robert's court were imported from other cities: so there appeared Cavallini from Rome, Giotto from Florence and Simone Martini from Siena. A fourth artist from the north was Lellus of Venice, who signed and dated (1322) a Byzantine-like mosaic with the Virgin Enthroned with Saints Januarius and Restituta in the church of Santa Restituta in Naples.

Cavallini's frescoes in Santa Maria Donna Regina and the works by Giotto and Simone have already been noted. A number of names and mediocre works are extant, and represent a mixture of these various influences, from which that of Simone develops as the more dominant. The chief local master of the fourteenth century is Roberto di Oderistio, who became court artist to Charles II in 1382 and who signed a Crucifixion fresco in San Francesco at Eboli (near Naples): *Hoc opus pinsit Robertus de Oderisio de Napoli*. The important fresco series in the church of Incoronata, representing scenes of the Seven Sacraments and the Glorification of the Church by members of the royal family, are probably executed by Roberto

ca. 1360, and reveal a combination of Sienese and Cavallini characteristics.

Venice

The peculiar geographical position of Venice had made it one of the most important connecting links between the Byzantine Orient and Western Europe since the early Middle Ages. In the thirteenth century, under the Doge Enrico Dandolo, Venice played one of the leading roles in the Crusades and the conquest of extensive territories in the eastern Mediterranean. Her commercial domination of the Mediterranean, especially after the defeat of her chief rivals, the Genoese in 1380, the close connection with the Orient, and her relatively stable local government under the control of a Doge and a hereditary class of military nobles are significant to the development of her local artistic tradition.

The Byzantine tradition is, therefore, a more dominating influence in Venetian painting, and was kept alive, especially in the mosaic decoration of its Cathedral of San Marco, well into the fourteenth century. The mosaics of the Baptistry and the Cappella di San Isidoro in San Marco, executed probably under Doge Andrea Dandolo (1343-1354), reveal a mixture of Gothic and Byzantine elements in a manner suggestive of the new spirit. Altar panels are more closely allied to Byzantine icons and book illuminations. Tentative suggestions of an individual style in the early fourteenth century may be found, too, in the Descent from the Cross, a damaged fresco in San Benedetto Vecchio, Padua, and the relief of St. Donatus (1310) in the Basilica di Santa Maria e San Donato, Murano, with two well-painted kneeling patrons at the sides.

Paolo Veneziano (Paolo da Venezia, active ca. 1321-ca. 1362) is the first known personality and master of the Venetian school, whose works are dated from 1321. He was head of a shop which produced designs for windows and tapestries (1355) as well as paintings, and which included his brother Marco and his sons Giovanni and Luca. Among his important works are: the Paliotto (altar frontal) of Beato Leone Bembo, dated 1321, now in Dignano d'Istria, the Coronation of the Virgin (1324) in the National Gallery,

Washington, D.C., the polyptych with the Coronation of the Virgin, scenes from the Life of Christ and of St. Francis and the Four Evangelists, David and Isaiah in the Accademia of Venice, the signed and dated (1333) Death of the Virgin with St. Francis and St. Anthony, from San Francesco in Vicenza, now in the Pinacoteca Civica there, a large panel in the Museo Marciano of Venice, with half-length figures of Christ and Saints and seven scenes from the life of St. Mark, painted with the help of his sons in 1343-1345 and used as an altar frontal covering the Pala d'Oro, the signed and dated (1347) Madonna Enthroned with Angels in the Chiesa Parrocchiale of Carpineta (Cesena), the signed and dated (1358) Coronation of the Virgin in the Frick Collection of New York, and the polyptych of San Francesco and Santa Chiara in the Accademia of Venice. Although the quality of these panels varies, from which the assistance of his sons in the shop may be assumed, the general tendency is toward a refinement and graceful flow of the linear design and the softening of the inherited Byzantine forms, combined with a love for sumptuous detail, gold pattern and colorful decoration. All this gives a special character to Venetian Gothic as compared to the International Gothic style of the fourteenth century.

Lorenzo Veneziano (active 1356-1372) is a pupil of Maestro Paolo, and the outstanding master of the second half of the century. A group of altars reveals this gradual development of a highly decorative Gothic, more closely related with the international style, with its elongated figures and bright and luminous coloration characteristic of the Venetians. These are: the extensive polyptych of 1357, from Sant' Antonio Abate, representing the Annunciation, with the donor, Domenico Lion, and a number of saints in the total of eighteen panels, in the Accademia, Venice; the Mystic Marriage of St. Catherine with Music-making Angels of 1359; two panels representing St. Peter and St. Mark, signed and dated 1371; and an Annunciation with Four Saints of 1371, all these in the Accademia of Venice.

Another major altarpiece by Lorenzo is the polyptych of 1366, with the Death of the Virgin and Crucifixion with Saints, commissioned by Tommaso de' Proti and signed, *MCCCLXVI. Laurentius Pinxit Mesxs Dcebris*, in the Cathedral of Vicenza. Glowing color with delicate detail, combined with a hierarchic dignity, appear in

the signed altar of 1370 representing Christ giving the Key to St. Peter (Museo Correr, Venice). This was presumably the middle panel of a polyptych, of which four panels of saints were lost during World War II and a predella with the story of St. Peter remains in the Berlin-Dahlem Museum.

Rather Mediocre followers of Lorenzo are Giovanni Da Bologna (active 1360-1390), who painted the signed St. Christopher of 1377 in the Padua Museo Civico, and the signed Madonna dell' Umiltà altar, with kneeling members of the Confraternity of San Giovanni Evangelista and Four Saints, in the Venice Accademia, and Jacobello Di Bonomo, whose signed and dated, 1385, polyptych of the Virgin Enthroned with the Crucifixion and Saints is in the Municipio of Sant' Arcangelo di Romagna.

Padua

In the thirteenth century, Padua, as a Ghibelline city, joined with Verona and Vicenza in making the young Ezzelino da Romano captain of their forces. His abuse of the powers given him led to his tyranny over almost all northern Italy, with Padua his headquarters. Upon the death of Ezzelino in 1259, Padua adopted a republican form of government, which did not survive against the strong Carrara family who, in spite of interference from the Scaligeri of Verona, succeeded in gaining control of the city. By 1318, the family was firmly established, although nominally under the sovereignty of Venice. In 1356, Francesco Carrara supported King Ludwig of Hungary against the Venetians, and was later refused Venetian aid in his struggle with Gian Galeazzo for the city of Verona. As a result, Padua was taken by Milan, then retaken by Francesco Novello, who was confirmed as lord of Padua in 1392 under the sovereignty of Milan. The death of Gian Galeazzo encouraged Francesco to attack Milan, which sought aid from Venice. The Venetians repaid the treachery of Francesco in full by annexing Padua in 1405.

The claim of Padua to cultural preeminence in the Gothic period is based on its university, founded in 1222 by Frederick II, and the culture-loving house of the Carrara. Aside from the presence of Dante, many artists, including such famed personalities as Giovanni Pisano, Giotto and Altichiero were called in from the outside to do commissions.

Guariento di Arpo (active 1338-1368/70) is the outstanding local artist of the period, working both in Padua and in Venice. He painted a series of historical frescoes in the palace of the Carrara (now lost). The earliest works of his extant are the frescoes and wood panels (executed ca. 1340-1350) from the walls and ceiling of the destroyed (1769) Cappella dei Carraresi of the Palazzo del Capitano, now in the Museo Civico of Padua. The fragments include various badly damaged fresco scenes from the Old Testament and panels of the Saviour, Evangelists and, particularly, a half-length Madonna in an octagonal frame. The style shows a certain influence of Giotto from his Arena Chapel frescoes, but it likewise reveals many Byzantine characteristics, such as the elaborate costuming and decorating curvature of figures that is related to contemporary Venetian painting.

The fresco decorations in grisaille and color in the choir chapel of the Eremitani church were done shortly afterward. They were badly damaged in the 1944 bombing, which also destroyed the Mantegna frescoes. They depict a Christ Enthroned, scenes from the Passion, allegories of the ages of man and the planets, and scenes from the lives of St. Augustine, St. James and St. Philip. Although uneven in quality, they are more closely related to the Arena Chapel. A signed (*Guarientus pinxit*), painted Crucifix with the kneeling patron, Maria dei Bovolini, in the Museo Civico of Bassano, is based on the Giotto prototype. His late work and probably his most important single project, which was a major influence on Venetian painting, was the massive and many-figured Coronation of the Virgin fresco, painted on the main wall of the Sala del Gran' Consiglio of the Doge's Palace in Venice at the order of the Doge Mario Cornaro in 1365-1368. It had been badly damaged in the fire of 1577, and was covered by the great Paradise canvas painted by Tintoretto until 1903, when it was removed and reconstructed (now in the Palazzo Ducale). Another example of this late style is the impressive Madonna and Child altar in the Metropolitan Museum of New York.

Nicoletto Semitecolo (active 1353-1370 ff.) is a follower of Maestro Paolo and Guariento who had presumably assisted the latter with the frescoes in the choir of the Eremitani church. A Coronation of the Virgin in the Rohoncz Collection in Castagnola (Lugano) is signed and dated 1355. A date (1367) and signature (*Nicholeto*

Semitecholo da Venezia) on one of the panels identifies a series of four scenes from the life of St. Sebastian (Sagrestia dei Canonici del Duomo, Padua). In comparison with the more Byzantine-Venetian style of Guariento, these appear to have more of the naturalism of Tomaso da Modena and the Giotto tradition, parallel to Altichiero and Avanzo.

Giusto de' Menabuoi (also called Giusto Padovano, active ca. 1363-1400) is said to have emigrated from Florence, and may well have received his early training there. His work is contemporary with that of Altichiero and Avanzo in Padua, and in a sense it parallels the Sienese-Giottesque style in Florence of the same period. Chief among these are: the signed (*Justus pinxit in Medio Ano. Dñi. MCCCLXVII*) and dated (1367) triptych with the Coronation of the Virgin in the center, the Annunciation, the Nativity and Crucifixion on the wings, in the National Gallery of London, which is an interesting parallel to Daddi's Coronation in Berlin; and the fresco series in the Baptistry of Padua (1376-1378). The badly repainted frescoes in the Cappella di San Luca Belludi, in the church of Sant' Antonio in Padua, commissioned by the Conti family in 1382, depict scenes from the lives of St. Philip and St. James, as well as of Beato Luca Belludi.

While Giusto's early altarpiece appears closely related to the Florentine style (Daddi), the frescoes of the Baptistry are concerned with the larger problems of architectural decoration in much the same way as are the works of his Florentine contemporaries. Although there is some question as to whether or not he is actually the artist (the *Codex Anonimo Moreliano* quotes the original signature over the door leading to the cloister as *opus Joannis et Antonii di Padua*), they represent one of the most impressive projects of the entire second half of the trecento.

The building itself is a thirteenth-century Romanesque structure with a square plan, surmounted by a dome set on a drum supported by pendentives. In the center of the dome is the half-length figure of Christ, surrounded, in concentric circles, by angels and saints in Heavenly Glory, with a Byzantine-type full-length figure of the Virgin on the axis. Below it, around the drum, are scenes from the Old Testament. Evangelist symbols and Prophets occupy the

pendentives, and the stories from the New Testament cover the walls below, dominated by a large Crucifix. In the arch over the area which once contained the tomb of the patron, Fina Buzzaccarina is presented as donor to the Enthroned Virgin by patron saints. The polyptych on the altar, also attributed to Giusto, has the Madonna and Child Enthroned, the Baptism, scenes from the life of John the Baptist, and rows of Doctors of the Church and Protecting Saints of Padua.

Verona

Verona played its role in the Guelph and Ghibelline struggle, and was occupied as well by the famous family feud of the Montecchi and Capuletti. In the early thirteenth century, the noted Ezzelino da Romano established his tyranny over the city. His death in 1259 brought Verona under the control of the della Scala or Scaligeri dynasty. Verona's greatest period was during the reign of Can Grande della Scala and his nephew Mastino (1312-1351), when Padua, Vicenza, Brescia and Parma were brought under Veronese control. The gradual degeneration of the Scaligeri, following a series of fratricides among the heirs, led to the downfall of the city. In 1387, Gian Galeazzo Visconti of Milan subdued the city, and it remained under Milanese rule until 1403.

The art of Verona is closely associated with Padua and the Giottesque manner. This can be seen in the anonymous early frescoes of the San Fermo Maggiore in Verona: an Adoration of the Magi and Coronation of the Virgin above the arches of the chapels flanking the apse, and over the chancel, the kneeling portraits of the prior, Daniele Gosmerio, and the patron, Guglielmo Castelbarco (d. 1320). Among the artists whose names have survived is Turone, who signed the polyptych altar of 1360, *Hoc opus est Turonis*, representing the Holy Trinity and Four Saints in arcades, and a unique Coronation of the Virgin above the center, now in the Verona Museo di Castelvecchio. The fresco of the Crucifixion over the entrance of the same church of San Fermo Maggiore is often attributed to Turone.

Altichiero (Altichiero Altichieri da Zevio, ca. 1330- ca. 1395) is

the founder and greatest master of the Verona school, and probably the most significant of the entire Trecento in northern Italy. He was born ca. 1330 in Zevio, and, after working in Verona for some years, was called to Padua to work for the Carrara about 1370, and died about 1395. While Vasari speaks of him as having been a habitual visitor to the court of the della Scala in Verona, most of his activity is traceable in Padua. The decorations which he did in 1364 for the reception room in the della Scala palace in Verona are lost. The call to Padua by Francesco Carrara was probably for a similar decoration of his own palace with "famous men" (after Petrarch). These are lost, except for a single damaged portrait of Petrarch at his desk, in the Palazzo del Capitano in Padua. Another early work, which he did in Padua shortly after 1730, is the fresco decoration representing the Coronation and Annunciation above the tomb of Francesco Dotto in the Cappella Dotti of the Eremitani church.

Altichiero's two important works are the fresco series in the Cappella di San Felici, formerly San Giacomo, in the Basilica del Santo and those of the Oratorio di San Giorgio in Padua. For the first project the master received a payment in 1377, which may well indicate its completion. The elaborate decoration, built into a rectangular Gothic room covered by ribbed cross vaults and opening out on the nave, contains eight scenes from the legend of St. James (from the Golden Legend), a large and crowded Crucifixion, and the Virgin Enthroned, with St. Catherine and St. James presenting the kneeling patrons, Bonifacio Lupi and Caterina dei Francesi. On the vaults are twelve medallions with Evangelists, Church Fathers and Prophets.

The oratory of St. George was founded in 1377 by the brothers Raimundino and Bonifacio Lupi di Soragna as a family funerary chapel and completed in 1384. The frescoes were probably executed sometime toward the end of that period. Represented are scenes from the life of St. George, with the Madonna and kneeling figures of the donor and his family (on the left wall), scenes from the legend of St. Lucy and St. Catherine (on the right wall), the Annunciation, Adoration of the Shepherds and of the Magi, the Flight into Egypt and the Presentation in the Temple (on the entrance wall), and the Coronation and Crucifixion on the altar wall.

The style is undoubtedly developed under the influence of Giot-

to's works, but while it shows a great interest in realistic and dramative narrative, it is not lost in detail, as was the tendency with some of Giotto's Florentine followers. The actively moving figures are more closely integrated in the surrounding space, and to this purpose Altichiero used a most fully developed illusionistic landscape, and particularly the architectural settings forming a stage upon which the scene takes place. Like the contemporary Sienese-Florentines, he used an even mode of coloration in unifying the total compositions, rather than the elaborately detailed, contrasting colors with the glistening gold applications noted in the earlier work of the Venetians (note particularly the Crucifixion and the Battle of Clavigo scenes in the St. James series).

The frescoes are not all of the same quality, which suggests the help of assistants. This is substantiated by the fragment of a signature inscribed below the panel depicting the Funeral of St. Lucy: *Avantus Ve——.*, upon which uncertain basis the activity of a Jacopo Avanzo, possibly of Verona (from the *Ve——*) is assumed. The character of the St. Lucy series, somewhat different in style (i.e., more restrained and less dramatic) and inferior in quality, implies his participation as Altichiero's pupil.

Frescoes (ca. 1390) in the Cavalli Chapel of St. Anastasia in Verona indicate a later return to the master's home city, and represent the Virgin Enthroned in a Gothic hall, receiving the homage of kneeling members of the Cavalli family dressed in contemporary knightly costumes. Because of the remarkable quality of the color and the interest in space through landscape and architectural perspective, the work of Altichiero is of considerable significance to the development of fifteenth-century painting in northern Italy, as will be seen in the narrative form of Carpaccio and the more scientific Mantegna. Both in color and in composition, the influence of the frescoes, particularly those in the Padua Oratorio di San Giorgio, is certainly felt in Titian's early decorations of the neighboring Scuola di Sant' Antonio.

Modena

Modena became an independent city in the early part of the twelfth century and remained largely Ghibelline, in opposition to Bologna

and Reggio. It was defeated by Bologna at the Battle of Fossalta in 1249, then was taken over by Obizzio II d'Este of Ferrara in 1288. Under the rule of the Margraves of Este the subsequent histories of the two cities are closely related.

Tomaso da Modena (Tomaso Barisini, ca. 1325-1379) is the leading artist of this city from which a considerable number of names of artists are recorded in the fourteenth century but of whom practically no works are extant. Only a few faint traces of frescoes survive from what was once an extensive decoration of the interior of Modena's famous cathedral. Tomaso Barisini was born about 1325/6 and is mentioned in various local documents until 1349. He then appears in Treviso until 1358, and after a ten-year stay in Modena (1358/60, to 1366/68) the records are silent, which has led to the somewhat questionable assumption, based on his style and the existence of his paintings in Bohemia, that he was called to serve at the court of Charles IV in Prague (Bohemia), and would have remained there, probably, until his death in 1379.

Tomaso's artistic origins appear to be rooted in Bologna and the rich manuscript illumination tradition of that university city, as well as in the lively art of Vitale da Bologna. From the many Sienese motifs in his work, it can be assumed that he had seen the painting of Simone Martini and others in Siena and Assisi.

His chief work is the signed and dated (1352) fresco decoration of the Chapter House of San Niccolò in Treviso with forty saints and holy dignitaries of the Dominican order, each labeled with an inscription and seated in nichelike cells in varying positions of study and contemplation. Their combination of intellectual and spiritual activity, expressed in single figures, recalls the evangelists portraits in medieval gospels, and would parallel the representation of church doctors in Assisi and the Spanish Chapel. Both the idea and its realistic presentation appear, in more developed form, in the fifteenth-century representations of "Famous Men." They find a parallel, too, in the contemporary half-length figures of saints and church fathers painted by Theodoric of Prague in the castle of Karlstein. These, together with the work of Nicholas Wurmser, would tend to support the argument for the presence, or at least strong in-

fluence, of the Modena master at the court of Prague.

A second, less important series in Treviso, not signed but attributed to him, depicts the legend of St. Ursula, done for Santa Margherita and now in the museum there. The worldly, courtlike atmosphere of many of its scenes, and the appearance of new problems of light and perspective, point again toward new interpretations of the fifteenth century (e.g., Carpaccio).

Tomaso's late work is represented by two signed altars in Karlstein, Prague: a triptych (originally in the Chapel of St. Palmatius in Budnian near Prague), with the Madonna and Child between Saints Wenceslas and Dalmasius, and the panels of an altar representing the Virgin and an Ecce Homo. The general style has many Giottesque as well as Sienese characteristics to be noted in the love of narrative and realistic detail, and reflects again the common Byzantine background in a manner similar to Altichiero and the Paduan school. Whether Tomaso worked in Prague, or Theodoric had appeared in Treviso or Modena, remains an open question. The important fact, however, is the artistic contact between the Italian master and the court of Charles IV in a manner somewhat reminiscent of the earlier one between Avignon and Siena.

Barnaba da Modena (active ca. 1362- ca. 1383) worked mostly in Genoa, and follows somewhat later than Tomaso with a style closer to the Byzantine manner, yet with many of the more developed Gothic refinements of the Sienese. The first mention of him in documents is in 1362, when he is listed as a citizen of Genoa. In 1364, he was sat work on decorations (lost) for the Palazzo Ducale. He stayed there until 1380, when he was called to Pisa, where he went via Modena (to sell a house) to finish the St. Raynerius frescoes in the Campo Santo begun by Andrea da Firenze, but he did not execute the project. The last notice is 1383, when he was back in Genoa.

A group of signed and dated Madonna panels best exemplifies his rather consistent and unchanging style. The earliest is the Madonna Enthroned in the Frankfurt Städelisches Kunstinstitut (*Barnabas de Mutina pinxit in ianua MCCCLXVII*), done in Genoa in 1367. Similar Madonnas are in the Berlin-Dahlem Museum

(1367), in Turin (1370), and San Giovanni Battista in Alba (1377). Particularly characteristic is the highly refined tracing of folds with gold, the rich ornamentation, and the gentle modeling of forms in light tones of green and flesh colors.

Rimini

Rimini had remained under the domination of one family since the arrival of the Malatesta in 1216. Giovanni Malatesta was elected *podestà* in 1237 and his successor, Malatesta de Verucchio, became absolute in 1295. The family traditionally supported the Guelph cause, and managed to retain its power and prestige by a succession of wise marriage alliances.

The local school of Rimini reveals several distinguishable stylistic tendencies at the beginning of the fourteenth century. One is based on an older, more Byzantine-Gothic tradition, possibly that of book illumination associated with the neighboring university city of Bologna (such as the miniature of 1300 in the Cini Collection, Venice, signed by Neri da Rimini; others are in the Biblioteca Vaticana and the Museo Civico of Bologna). There appears to be a crossing of Assisi, Florentine and Roman influences here in Rimini which is associated with Giotto's visit, noted in the chronicle of Riccobaldo da Ferrara. The frescoes painted by Giotto for San Francesco in Rimini were presumably destroyed when the church was remodeled as the Tempio Malatestiano, and may have been done during the period between the Assisi and Padua projects. The Crucifix in San Francesco, frequently attributed to Giotto, may have been painted at the same time but certainly by assistants.

Guiliano da Rimini (active 1307-1346) shows evidences of this Giottesque background in his work. The signed and dated (1307) altar-frontal, formerly in the church of Urbania, near Urbino, representing the Madonna Enthroned Adored by Kneeling Women, possibly nuns of the Order of St. Clare, and flanked by eight saints in Cosmati-decorated arcades (now in the Isabells Stewart Gardner Museum, Boston) is the earliest panel extant.

Damaged frescoes by anonymous Rimini masters are in the Capella del Campanile of Sant' Agostino in Rimini (scenes from the Life of Mary), the Last Judgment from Sant' Agostino, now in the

Palazzo dell' Arengo, Rimini, and the choir frescoes of the Life of St. John the Evangelist, also in Sant' Agostino. They reveal the continuance of this Giotto tradition, which appears to have been directly inspired by his work, possibly even by Giotto's presence personally in Rimini. They were probably painted during the first two decades of the fourteenth century, and suggest a development in style from the more monumental Giotto type of composition to the decorative and narrative manner noted among the Giottesques in Florence, although they are conceived on a much grander scale.

A second style appears in the anonymous frescoes representing the Crucifixion with Christ Enthroned and Saints in the apse of San Pietro in Sylvis in Bagnacavallo, near Ravenna, and in the fresco series in the chapter house and refectory of the famous medieval abbey of Santa Maria di Pomposa. The latter series, once attributed to Giotto himself, is now assigned to **Pietro da Rimini,** who from the documents in the abbey, was working there between 1317 and 1320 under the local abbot, Henry, during the reign of Pope John XXII. Represented is an impressive Christ between Mary and St. John the Baptist, with St. Benedict and St. Guido. On either side, in a rather literal concordance, are the Last Supper and the Miraculous Supper of St. Guido, the distinguished abbot of Pomposa who, while entertaining the Archbishop Gebeardo of Ravenna, changed water into wine as he poured it for his guest.

The style (especially in the recently restored condition of the frescoes) reveals many Giotto characteristics, but the tall proportions and dignified figures are also closely related to those of Cavallini. An extraordinary coloration of light green, rose and blue reveals a vigor and sensitivity which uniquely complements these features in a remarkably integrated expression.

Further works belonging to Pietro are the signed and dated (1333) Crucifix in the Chiesa dei Morti in Santa Chiara, Ravenna, and the poorly preserved fresco fragment (the Last Judgment) from the church of San Niccolò di Iesi, now in the Convento di San Francesco in Montettone, signed and dated 1333. The further development of this combined Giotto-Cavallini style can be seen in the frescoes (damaged during World War II) of Santa Maria in Porto near Ravenna, begun after the restoration of the church in 1332 and continuing possibly as late as 1345.

Giovanni Baronzio (died ca. 1362) appears to be a less gifted

follower of Giuliano who had assisted Pietro in the decoration of Santa Maria in Porto and to whom parts of these frescoes may be attributed. The chief further works ascribed to him are the Giotto-type Crucifix of 1344 in San Francesco in Marcatello, and the signed and dated (1345) polyptych of the Madonna with Saints and scenes from the Life of Christ in the Galleria Nazionale delle Marche at Urbino.

The frescoes of scenes from the Life of Mary, Life of Christ and the Legend of St. Nicholas in the Cappellone di San Nicolò in Tolentino are frequently attributed to Baronzio. The scenes are accompanied by an elaborate array of Evangelists and Church Doctors reminiscent of the Spanish Chapel. Again, it is the clear definition of modeled forms and the surrounding space that reflect the Giottesque manner as it develops toward the middle of the century.

The transition to the Renaissance is seen in the 1408 altar of San Giuliano in Rimini by **Bitino da Faenza** (active ca. 1398-ca. 1427).

Bologna

The once many-towered city of Bologna became a free Commune in the early twelfth century, with a semirepublican form of government. In 1228, it cast out all of its nobles from office and introduced a republican system under a Council of Elders, much like that of Florence. It is the seat of the oldest university in Europe, founded in 1088, with a traditional emphasis on jurisprudence. It had joined the Lombard League and consistently opposed the Emperors (Frederick II's son Enzo, who was captured in the Battle of Fossalta in 1249, was kept as a life prisoner here). Through the local struggle between the Guelphs (the Geremei) and the Ghibellines (the Lambertazzi) the government remained predominantly Guelph. During most of the fourteenth century Bologna became the object of a great controversy between the Visconti of Milan, the Popes, who had long claimed it, and the powerful family of the Pepoli. In 1401, Giovanni Bentivoglio was chosen *principe* in an effort to make Bologna independent, but was soon displaced by Gian Galeazzo of Milan (1402) who, in turn, was succeeded by Cardinal Baldassarre Cossa, who established the closer control by Rome.

A local school of Bologna developed partly from Giuliano's school and partly under local traditions which might be followed in

manuscript illuminations from the thirteenth century on. Damaged frescoes of scenes from the Life of Christ and the Life of St. Francis in the refectory of San Francesco in Bologna were executed by Francesco da Rimini in 1330-1340 (now preserved in the Pinacoteca Nazionale of Bologna).

Vitale da Bologna (active ca. 1305- ca. 1361) is the first important artist. He had apparently assisted Giuliano da Rimini on the frescoes of Pomposa and had worked on frescoes (the large Last Supper, now in the Pinacoteca Nazionale) in the same monastery of San Francesco in Bologna. A number of altars by him exist, particularly the signed and dated (1345) Madonna dei Denti in the Museo Davia Bargellini, Bologna, and the late work of 1353 in San Salvatore, Bologna, representing the Coronation of the Virgin. In contrast to the gentle and relatively restrained style of the earlier Madonna, are the strong action and expressive design of the four panels with scenes from the Legend of St. Anthony Abbott from Santo Stefano, and especially the fresco decorations, formerly in the church of Sant' Apollonia di Messaratta, both in the Pinacoteca Nazionale of Bologna. Dramatic in size, as well as the action of figures, is this fresco series from Mezzaratta, now superbly installed with the preliminary *sinopie* of the undercoat in special large rooms of the Pinacoteca Nazionale. Represented are the Annunciation, Nativity and other scenes from the Life of the Virgin by Vitale and a number of his Bolognese followers.

These frescoes were presumably painted in the early 1350s. Before that, Vitale had painted a series of frescoes representing scenes from the life of St. Nicholas in the Cathedral of Udine (1348-1349) and in the abbey church of Pomposa (Evangelists and Doctors of the Church, scenes from the life of St. Eustace, begun 1351). A final late work attributed to him is the Adoration of the Magi, now in the National Gallery of Edinburgh.

In the work of Vitale's students and followers one can trace the continuance of this highly animated style on a more limited basis through the second half of the century. These include **Jacopino da Bologna** (active ca. 1350-1380), whose polyptych of the Coronation of the Virgin and dramatic battle scene, a fresco fragment representing the Victory of St. James at the Battle of Clavijo, are in the Pinacoteca Nazionale of Bologna; **Andrea da Bologna** (a polyptych of 1369 in the Palazzo Comunale of Fermo); **Jacopo da**

Bologna, Simone and **Cristoforo dei Crocifissi, Jacopo di Paolo** and **Lippo di Dalmazio.** Most of these had participated in the fresco program at Sant' Apollonia at Mezzaratta, sections of which (many of them signed) are now installed in the Pinacoteca Nazionale. To Andrea da Bologna is also attributed the fresco decoration of the Chapel of St. Catherine, with scenes from the life of the saint, and a kneeling portrait figure of Cardinal Egidio Albornoz in the lower church of San Francesco in Assisi (1368).

Milan

Milan was quite consistently Guelph in politics up to 1300. Three bodies politic ruled in the city, the Credenza of St. Ambrose (popular), the Molta (minor nobility) and the Credenza of the Consula (higher nobility). Their practical independence of each other led to faction and dispute, which brought about the rise of the Torriani (della Torre) in 1256. A revolt against their tyranny was led by the Archbishop Otto Visconti and the Ghibelline party, and in 1277 they were ejected. Matteo Visconti was later driven out by the Torriani, but the Visconti family was restored by Henry VII in 1311 and remained in power until 1447. Changing their policies to suit their own ambitious purposes, the Visconti broke with the Ghibellines and King Ludwig in 1327, and Azzo was made Signore. By 1400, the Visconti tyrants succeeded in securing control of Alexandria, Verona, Parma, Como, Bologna, Pisa, Siena and Perugia. Though cruel and rapacious, they were the chief patrons of the arts, particularly Azzo and Gian Galeazzo (the Visconti Viper). The latter inaugurated the work on the Cathedral of Milan and the Certosa of Pavia.

Although few tangible names of artists are definitely to be associated with extant paintings in Milan and Lombardy, there is a considerable number of works in which the consistent development from Byzantine to Giottesque and Sienese styles can be followed. Examples of the Byzantine manner are to be found in the fresco fragments decorating the large hall of the Rocca Borromeo, the former Visconti castle in Angera (Lago Maggiore), executed for the Visconti after 1314 and representing, among other things, battle scenes from the campaigns of Bishop Otto Visconti against

Napoleon della Torre. Of the same style are frescoes on the vaults of San Bassiano in Lodi Vecchio, dated 1323, and frescoes in San Francesco of Lodi, decorating the tomb of Antonio Fissiraga (d. 1327) and representing the funeral of the patron and again the patron accompanied by a bishop and St. Francis, kneeling before the Virgin.

The introduction of the Giottesque style might be accounted for by the supposed visit (mentioned by Vasari) of Giotto to Milan at the request of Azzo Visconti in 1334. However, the anonymous frescoes of 1327 just mentioned in San Francesco in Lodi already show an influence of Giotto, and those (scenes from the Life of Christ) in the apse of Sant' Abbondio, Como, and the fragments in the archepiscopal palace of Milan, executed under Bishop Biovanni Visconti (1342-54), bear evidence of the widespread influence of the style.

Giovanni da Milano, whose invigorating influence had been noted on Florentine painting after the middle of the century, represented an already well-developed individual school before his arrival in Florence, one might assume. But work of his Milan period, if any existed, has not been preserved. Neither can definite names of artists be attached to existing works, but a number of anonymous frescoes in scattered Lombard cities are the chief evidence of the strict, well-composed and linear style which flourished in Lombardy as a parallel to that of Orcagna in Florence and Altichiero in Verona and Padua.

The most significant among these works are: the frescoes (dated 1349) in the choir of the abbey church of Viboldone, near Milan, representing the Virgin Enthroned with Four Saints, and a fragment of the Last Judgment. Somewhat later are frescoes in the oratory of Solaro (Crucifixion and stories from the Life of the Virgin), executed shortly after the building of the church in 1366. The most important are those formerly in the oratory of Mocchirolo, now in the Pinacoteca di Brera of Milan (ca. 1365), representing the Crucifixion, the Marriage of St. Catherine, Christ in a Mandorla, and the Virgin Enthroned with the portraits of Stefano Porro (counselor to Galeazzo Visconti) and his family kneeling before her. Parallel to these are the frescoes decorating the church of Lentate, built in 1368 by Stefano Porro, and representing the Crucifixion, the Last Judgment, Resurrection, and the patron Stefano with his family

kneeling before St. Stephen and representing a model of the church. A further view into the art of Milan and the court of the Visconti may be had from the contemporary miniatures, such as those in the prayer book of Bianca of Savoy (ca. 1350-1378), by **Giovanni di Benedetto da Como**, whose style shows many parallels to the murals already noted.

BOOK II.

THE FIFTEENTH CENTURY: *The Early Renaissance*

The Fifteenth Century:

The Early Renaissance

1. Florence

FLORENCE BEGAN the fifteenth century free from outside domination and relieved of the danger from Milan after the end of the war in 1402. The republican government of the burghers developed into an oligarchy consisting of an aristocracy of wealth and was marked particularly by the rise of the Medici family. Cosimo de' Medici became, nominally, president of the republic in 1435, and with him begins the resplendent period of Medicean rule and patronage. An especially influential factor, and evidence of the broadening of the Florentine cultural horizon, was the formation of the Platonic Academy after the Council of Ferrara-Florence in 1439.

The triple alliance of Milan, Florence and Naples against Venice was supported by both Cosimo and Piero, his successor (1464-69), who also put down the attempted revolt of Luca Pitti. Piero was followed, in 1469, by Lorenzo the Magnificent. A major conspiracy of the Pazzi and Pope Sixtus IV against the Medici was suppressed by Lorenzo in 1478, but though the conspiracy failed, Sixtus incited Frederick of Naples against Florence, and the city was saved only by Lorenzo's dramatic trip to Naples to treat with Frederick.

As a result, Lorenzo became all-powerful in Florence, and the peaceful years which followed saw his court develop into one of the greatest centers of Italian learning and culture. The Platonic Academy was revived, and humanism became the fashion until the fanatical preaching and reform spirit of the Dominican monk

Savonarola began to sway the Florentines even before Lorenzo's death in 1492. When Piero, the incompetent successor of Lorenzo, submitted to the French invader Charles VIII, he was expelled, and a republican form of government was set up under the dominance of Savonarola (1494). His attacks on Alexander VI and the papal court, however, brought the interference of that Pope, and Savonarola was tried as a heretic and put to death (1498). The republic lasted until 1512, when the Medici were reinstated.

In the study of the total Italian Renaissance, the development of painting in Florence during the fifteenth century is undoubtedly the most complex and fascinating subject. The complexity lies in the multitude of artistic and scientific problems of expression arising out of a new approach to reality; the vast number of recorded individuals who, as artists and personalities, acquired a new social and cultural importance in contemporary life; the increased number of lay and ecclesiastical patrons, whose individual tastes and desires gradually took precedence over established convention; the tendency toward a grouping of styles in accordance with varying geographical, social and aesthetic conditions, as well as under the influence of dominating personalities; and, finally, the development of these styles through a series of successive generations during the century.

In Florence, these conditions were not new, but were evident, in varying lesser degrees, through the preceding century. A striking concentration on fundamental principles of form and expression appears in the work of strong creative personalities at the beginning of both centuries (e.g., Giotto and Masaccio), and the development of their successors is more or less conditioned by their respective accomplishments.

In surveying Florentine painting during the Quattrocento in accordance with these conditions, the works group themselves into four broad divisions: a clearly definable Gothic tradition, which related to the International late Gothic, as well as a survival of the Sienese-Florentine style of the preceding century (Masolino, Fra Angelico); a monumental style, headed by Masaccio and continuing through a series of experimental stages in form and perspective (Ucello, Castagno), color (Domenico Veneziano, Piero della Francesca), and movement (Melozzo da Forlì and Signorelli); a lyric, realistic style related to the Gothic, yet much more closely associated with nature and a more appealing romantic reality (Fra

Filippo Lippi); and, finally, the combination of these heterogeneous elements into a highly sensitive, stylized and decorative form during the last quarter of the century (Botticelli).

The Gothic Tradition

Lorenzo Monaco (ca. 1370-1425) is the first of these ''Gothic'' painters who stands out as belonging to the Early Renaissance, as distinct from such mediocre masters as Niccolò di Pietro Gerini, Lorenzo di Niccolò Gerini, Lorenzo di Bicci and Bicci di Lorenzo, who were mentioned before at the end of the Florentine Trecento. His original lay name was Piero di Giovanni before he became a Camaldolite monk in 1391, and he is registered in 1392 as subdeacon in the Convento degli Angeli in Florence. Dated altars and records of payments indicate a flourishing activity from 1399 until August 1422, when he was paid for an altar in San Egidio. Vasari says that he died in 1425 at the age of fifty-five; hence, he would have been born about 1370. A document of 1414 refers to him as *Lorenzo dipentore da Siena*, from which, together with the fact that his first authentic works show an already mature style, the assumption is drawn that his artistic education came from Siena, possibly in the shop of Bartolo di Maestro Fredi.

The earliest work attributed to Don Lorenzo (ca. 1395) is the damaged fresco in the Chiostro degli Oblati in Florence representing the Pietà, symbols of Christ's martyrdom and a number of kneeling figures (Mary and St. John), in which, along with Sienese influences, the characteristic features of Agnolo Gaddi's shop style are discernible. A dated panel (1404) with a Pietà similar to this is in the Academy of Florence.

Lorenzo's most important frescoes are those (executed 1420-1424) in the Cappella Bartolini in Santa Trinità, Florence, depicting scenes from the Life of Mary. The style, for example in the Meeting of Joachim and Anna or the *Sposalizio*, shows many Gothic features in the elongated figures and decorative sway of drapery, but also shows an attempt to articulate the composition by a rigid horizontal grouping of figures and the combination of their vertical poses with a predominantly vertical yet receding architectural background (cf. Taddeo Gaddi's Meeting of Joachim and Anna).

The two best-known altarpieces by Lorenzo are, first, the Adoration of the Magi (1420-1422) in the Uffizi, Florence, with its modeled, rhythmically swaying figures, stylized receding landscape and luminous, miniaturelike coloration which gives a certain emotional tone to the scene. The second altar, whose dignity and monumental unity somewhat recalls Orcagna's work, is the large Coronation of the Virgin (1413) in the Uffizi, from Santa Maria degli Angeli, with an inscription giving Zenobius Cecchi Fraschi as donor, with Lorenzo's signature and date: *(La)urentii Johannis et suorum monaci huius ordinis qui eam pinxit anno Domini MCCCX-III*. Three terminals at the top show the Christ in Benediction and the figures of the Annunciation, while the predella below depicts six scenes from the life of St. Benedict. A hole had been cut through the lower center of the altar, probably for a receptacle for the Eucharist.

Other altarpieces which show the development of his Sienese brightness and luminous color, combined with the new interest in the compositional unity of figures and space, are the Madonna and Child (1404) in the Museo della Collegiata of Empoli, the Coronation of the Virgin of ca. 1415 (National Gallery, London), which, with the two top wings in the Liechtenstein Gallery probably belonging to it, appears to be a reduced variant Uffizi Coronation, and the late Annunciation in Santa Trinità, Florence. The expressive use of light and the romantic atmosphere of many of the night scenes in the predellas are again part of the Gothic spirit in this new age.

Records from 1409 until 1413 indicate considerable activity by Lorenzo in miniature painting (i.e., those of the missal from Santa Maria degli Angeli in the Laurentian Library, 1409, and of the Antiphonary from Santa Maria Nuova in the Bargello, Florence), which is associated with a Camaldolese tradition going back to the Trecento. These, however, may be considered significant as parallel to the style of Lorenzo's later altarpieces, and not as the general source from which his style developed, as the study of his frescoes will show (i.e., the earlier Pietà in the Chiostro degli Oblati).

Gentile da Fabriano (Gentile di Niccolò di Giovanni Massi, ca. 1370-1427) represents a more cosmopolitan aspect of this early fifteenth-century Gothic. He was born in Fabriano ca. 1370, and was probably influenced by the local tradition to be seen in the work of **Allegretto Nuzi** (ca. 1315-1373), who had been registered in

the Florentine Compagnia di San Luca in 1346 and had painted a number of altarpieces in the Fabriano area (e.g., the large signed and dated 1369) triptych of the Madonna and Child with Saints in the Cathedral of Macerata). A follower of Nuzi's was **Francescuccio Ghissi** (active ca. 1359-ca. 1395), whose life-size Madonna della Pace in Sant' Agostino, Ascoli Piceno, and the signed altar of 1359 in the Palazzo Comunale of Fabriano, continue his highly decorated style. Both artists reveal a decidedly poetic and Umbrian character, with many recognizable Sienese and Giottesque elements, but with a rich ornamentation of gold, bright color and extensive detail.

Although his early history is vague, Gentile is recorded in Venice from 1408 to ca. 1414, where he received payments for a fresco in the Sala del Consiglio Maggiore of the Doge's Palace, depicting the naval battle of the Venetians against the forces of Otto III, later destroyed in the fire of 1577. Between 1414 and 1419 he was in Brescia, at work on the decorations (now destroyed) of a chapel for Pandolfo Malatesta. He left Brescia in 1419 for Rome at the invitation of Pope Martin V, but remained mostly in Florence, where he was registered in the Compagnia di San Luca (1421) and the *arte dei medici e speziali* (1422) and was active on commissions for various well-known families. Documents indicate that he was in Siena (1424, 1425) and Orvieto (1425), where he painted a still-existing Madonna in fresco for the cathedral. He was paid in 1427 for frescoes in San Giovanni in Laterano in Rome, which were later (1433) completed by Pisanello, and he died there that year.

Gentile's most important work is the Adoration of the Magi (1423) in the Uffizi, which was ordered by Palla Strozzi for his chapel in Santa Trinità, signed and dated *Opus Gentilis de Fabriano MCCCXXIII Mensis Maio*. Predella scenes represent the Virgin Adoring the Child, the Flight into Egypt (both in the Uffizi) and the Presentation in the Temple (Louvre, Paris).

The basic lyric and poetic character of the work is related to that of Simone Martini and Lorenzo Monaco, but much richer in its ornamental color, and painstaking in its detail and observation of nature. While the subject of the action, the Holy Family, to whom the Magi journey, is placed asymmetrically of the left side of the scene, the color composition is evenly balanced about the brilliantly costumed young king in the center. Careful and poetic observation of detail can be noted in the depiction of faces, birds and plants, the

figures and landscape receding in the distance, as well as the move-ment of forms in an illusionary space (e.g., the horses at the right). This is especially true of the predella scenes, particularly the Flight into Egypt, with its movement, panorama landscape and romantic use of light.

These same characteristics are developed with a certain courtly elegance in the second important altarpiece, namely, the signed and dated (1425) Quaratesi polyptych which was executed for the high altar of the church of San Niccolò Oltrarno in Florence. The center panel with the Madonna and Child and Angels is now in the Na-tional Gallery of London; the four panels belonging to it, with Saints Mary Magdalene, Nicholas, John the Baptist and George, are in the Uffizi. The rich brocades and meticulous detail of the drapery, to be noted especially in the figure of St. Nicholas, are set off by the brilliant gold of the background. The five scenes from the life of St. Nicholas of Bari from the predella are to be found in the Pinacoteca Vaticana in Rome and the National Gallery of Washington. Among the earlier works are the signed polyptych (ca. 1400) of the Corona-tion of the Virgin with Saints and predella scenes, formerly in Valle Romita (near Fabriano) and now in the Pinacoteca di Brera of Milan, and the handsome small-size Madonna Adoring the Child in the Pisa Museo Civico (ca. 1415).

Masolino da Panicale (Tommaso di Cristoforo Fini, 1383-ca. 1447) is perhaps the most significant connecting link between the late Trecento and the early Renaissance (i.e., Gaddi, Starnina and Masacio). He was born in 1383 in Panicale, and was listed in the Florentine *arte dei medici e speziali* in 1423. In 1424, he was paid for frescoes in Santo Stefano in Empoli, and in Florence, the follow-ing year, he is mentioned in connection with work in Santa Maria del Carmine. He was in the service of Cardinal Branda at Castiglione d'Olna at various times, painting frescoes there until after 1435. During that period he went to Hungary, probably in 1425, to decorate a chapel for Filippo Scolari (Pippo Spanno), the *condottiere* of Emperor Sigismondo. In a tax declaration by his father in 1427, he was indicated as working in Hungary, but by the summer of that year (July) he was back in Florence. He died probably about 1447. Aside from this, he had worked in Empoli and Rome (1428) and, ac-cording to Vasari, had been a pupil of Starnina and an assistant to Ghiberti.

Masolino's earliest work is probably the dated (1423), though not signed, Madonna in the Bremen Kunsthalle. Frescoes of the Virgin and Child with Angels, in the church of Santo Stefano degli Agostiniani in Empoli, and a Pietà, in the Museo della Collegiata of Empoli, are probably the ones listed in local records as paid for in 1424. Of about the same time are the Madonna and Child (the Madonna of Humility) in the Alte Pinacothek of Munich, and the two panels of a triptych (Santa Maria delle Nevi), probably the front and back of the center piece, painted for the Colonna Chapel in Santa Maria Maggiore, Rome, and now in the Museo di Capodimonte in Naples. These represent the Miracle of the Snow (i.e., Pope Liberius marking the location and groundplan of Santa Maria Maggiore in the freshly fallen snow) and the Assumption of Mary. Two panels in the Johnson Collection of Philadelphia, representing pairs of saints (Peter and Paul, John the Evangelist and Martin of Tours), as well as a second pair (St. Matthias and a Pope, possibly St. Liberius, St. Jerome and St. John the Baptist) in the National Gallery of London, are assumed to have been the original wings of the triptych. The solid modeling and stronger character of the London St. Jerome and John the Baptist panel tend to support its frequent attribution to Masaccio.

His work in the Brancaci Chapel of Santa Maria del Carmine in Florence was probably begun in 1424, and continued until his departure for Hungary in 1425. He must have worked again on them with Masaccio after his return in 1427. Of this extensive series, the destroyed frescoes of the vaulting, with figures of the Evangelists, and lunettes with stories of Peter, are assumed to have been primarily his, as well as the Fall of Man, the Preaching of St. Peter, and the greater part of the Raising of Tabitha and the Healing of the Cripple, parts of which were then completed by Masaccio. The frescoes of San Clemente in Rome reveal the same dual stylistic problem of Masaccio-Masolino (see below under Masaccio). The damaged fresco of the Madonna Enthroned with Angels in the church of San Fortunato in Todi was originally painted for the right entrance portal of the church, and has been transferred to the interior. It is documented by a record of payment in 1432.

In Castiglione d'Olona, the work is divided between the Collegiata, with scenes from the Life of Mary, the Palazzo Castiglione, with fragments of figures and a landscape, and the Baptistry (scenes from the life of John the Baptist). The first were done probably soon

after the consecration of the church in 1425, those of the Baptistry about 1435. The only genuine extant signature of Masolino's is that given on the scroll in the lower part of the Nativity in the Collegiata: *Masolinus de Flor(e)ntia pinsit.*

The study of Masolino's style through the foregoing works is complicated by their poor condition, but it reveals much of the lyric and narrative interest in a natural reality characteristic of the Gothic, in addition to a certain awareness of formal problems, that goes back to this teacher, Starnina (i.e., the modeling of forms, their monumental strength and orientation in space, as well as linear and aerial perspective). Note particularly the recession of the river landscape behind the figures of Christ and St. John the Baptist, and the architectural space-construction in the Feast of Herod frescoes of Castiglione d'Olona.

Yet the possibilities of new and dramatic integration of this reality and form into a monumental composition are nowhere accomplished. Beyond the products of his earlier period (i.e., the Pietà in Empoli or the Brancacci Chapel), executed under the influence of his ''pupil'' Masaccio, he does not develop, as comparison with the even less-articulated style (possibly influenced by Fra Angelico) of his later compositions in the Baptistry will demonstrate (note particularly the altar wall with the Baptism, St. John Preaching in the Wilderness, or the side wall with Herod's Feast).

The problem of separating and identifying the individual contributions of Masolino and Masaccio is one of the most complicated and controversial issues in the history of Renaissance painting and has its parallel, perhaps, in the similar confrontation of traditional and new forms noted in the Giotto-Assisi situation. The major works involving both artists, and the new developments of the fifteenth century, are considered in the discussion of Masaccio.

Fra Angelico (Guido, or Guidolino, di Pietro, 1387-1455) is often referred to as the ''last of the Gothic painters,'' which is applicable only insofar as the decorative use of many of his forms and colors can be associated with Lorenzo Monaco and the late Trecento tradition which he inherited. The style, however, is based not on the idealized and somewhat mannered representation of the traditional religious theme customary to the late Gothic, but rather on the pious and cloistered faith of a Renaissance individual to whom

religion had become a personal and almost mystic experience. From the character of this experience, which the beholder relives through his devotional pictures, comes the artist's name by which he is traditionally known, the "Angelic" Brother. Although by no means an inventor of new forms, as was the case with Masaccio, Donatello, Brunelleschi and their successors, Fra Angelico had the subtle gift of absorbing these new ideas without surrendering the traditional form and the devotional function which it served. In a sense, the problems and his artistic solutions form an intriguing parallel to the work of Ghiberti.

According to Vasari, he was born in 1387 in Vicchio di Mugello and entered the Dominican monastery of Fiesole with his brother Benedetto in 1407, becoming Fra Giovanni da Fiesole. Due probably to political difficulties after the Council of Pisa (1409) involved in the opposition of Gregory XII and Alexander V, whose election of the latter as Pope the local Dominican chapter would not recognize, the brothers of the monastery fled to the filial abbey of Foligno. After five years there they moved, probably driven by the plague of 1414, to Cortona, and finally went back to Fiesole in 1418, after the election of Pope Martin V and the end of the schism by the Council of Constance (1417).

Although there is some discussion about his early birth date and youth, it is assumed that Fra Giovanni accompanied these wanderings. From 1418 until 1436, he remained in Fiesole. In 1436 the chapter, including Fra Giovanni, was installed in the monastery of San Marco in Florence, which was being rebuilt (1437-1443) by Michelozzo at the request of Cosimo de' Medici. His activity there, chiefly on the fresco decorations, continued until 1445, when he was called to Rome by Pope Eugene IV to decorate the Cappella del Santissimo Sacramento (later destroyed by Pope Paul III); then he was requested by the new Pope Nicholas V, in 1447, to decorate the chapel known by his name. This last period was interrupted by a short stay in Orvieto during the summer of 1449 at work on the frescoes of the cathedral, and three years again in Fiesole (1449-1452), during which time he was elected prior of the abbey. He died in Rome in 1455, and was buried in the church of the Dominican monastery where he lived, Santa Maria sopra Minerva.

The work of Fra Angelico may be divided stylistically according

to the conditions and requirements of the three successive periods in Fiesole (1418-1436), Florence (1436-1445) and Rome (1445-1455). From the works extant, the first period seems to have been occupied largely by devotional altarpieces of small format associated mostly with the Virgin. Whatever frescoes may have been done are destroyed, except the large and impressive Crucifixion (ca. 1430) in the chapter house of San Domenico, Fiesole, which had long been neglected and was restored in 1955. The best-known of these altarpieces are, perhaps, the two small reliquaries of the Annunciation and Adoration of the Magi and the Madonna della Stella, both from Santa Maria Novella, now in San Marco, Florence, the two Coronation of the Virgin altars (San Marco and the Louvre), the Linaiuoli altar (San Marco), and the Last Judgment (San Marco). Another early work of this period is the triptych of the Madonna and Child with Four Saints in the church of San Domenico in Cortona, to which belongs the predella with scenes from the life of St. Domenic, now in the Museo Diocesano of that city.

The Madonna dei Linaiuoli is the first authentically datable panel, having been contracted for by the linen merchants in 1433. Its large size (2.60 meters x 2.66 meters) presents a special problem of scale, especially when compared with the small-sized altars with their miniature figures characteristic of this period. The original polychromed marble frame, after designs by Lorenzo Ghiberti, gives it even greater impact. Represented is the Madonna Enthroned with the Standing Child, surrounded in the immediate frame by music-making angels and St. Mark (patron saint of the guild), St. John the Baptist on the inside of the wings, St. Peter with St. Mark on the outside. Scenes of St. Peter preaching, the Adoration of the Magi, and the Martyrdom of St. Mark occupy the predella. Variations in quality, particularly in the predella and wings, indicate the work of assistants in its execution.

The two Coronations are of interest not only for their remarkably spiritual expression in the stylization of faces, the brilliant gold, and their light coloration, but also for the mastery of technical problems displayed in the drawing and modeling of the forms, their recession into a well-composed space both with and without the aid of a perfected linear perspective. In the Last Judgment may be noted the characteristic elaboration of Paradise as a romantic garden of eternal bliss, in detail and execution reminiscent of Northern Late Gothic miniatures, as opposed to the Hell, whose

dramatic possibilities are left unexploited. A later variation (ca. 1445), which had been cut up to form a triptych, is in the Berlin-Dahlem Museum.

The chief works of the Florentine period are the frescoes in San Marco, which are distributed in the cloister, chapter house and, particularly, the corridors and numerous cells of the upper story. Variations in quality, as in nearly all of the work of this highly productive period, indicate the aid of assistants in many of the scenes. The most impressive of these is the large Crucifixion in the chapter house—iconographically of especial interest through the choice of church representatives in a frieze before the white strip of the horizon: to the extreme left, the patron saints of the Medici, Saints Cosmas and Damian, and St. Laurence, then St. Mark (patron of the monastery), John the Baptist with the Virgin, Martha, Mary Magdalene and John. To the right of the Cross are kneeling Saints Dominic, Jerome, Francis, Bernard, Giovanni Gualberto and Peter the Martyr; while standing are Saints Ambrose, Augustine, Benedict, Romuald and Thomas Aquinas. Medallions with Dominican church dignitaries ornament the frame of the total fresco.

In artistic form and iconography, the fresco series of San Marco again offers new solutions to problems already noted in earlier mendicant styles, notably the frescoes of San Francisco in Assisi and the Spanish Chapel of Santa Maria Novella. While still motivated by the narrative didactic principles of the order, the scenes here have become intimate, personal and direct, with more of an isolated devotional character than the large dramatic or lyric sequences which Giotto and Andrea da Firenze used. The majority of the scenes are set in isolated cells or lunettes in corridors. They contain but few figures, in which monks or saints in Dominican habit are often included as spiritual companions for the cloister inmate (e.g., the lunette with Christ as a Pilgrim being welcomed by two Dominican monks; the half-length figure of St. Peter the Martyr with his gesture of silence; the Annunciation with St. Peter the Martyr; or the Coronation with six kneeling monastic saints; and the many Crucifixion scenes). The devotional spirit of the entire series may have its parallels in the sermons of Fra Giovanni Dominici, the heroic prior of Fiesole, and the sensitive design and delicate space proportions of Michelozzo's architecture, particularly the cloister of this same abbey.

The comparison of such scenes as the Coronation or the Annunciation with the Nativity, the Crucifixion with Four Saints, or the symbolic scenes of Christ's torture will show the remarkable differences between Fra Angelico's own work and that of his assistants. Again, the comparison of his Adoration of the Magi with that of Lorenzo Monaco will show the greater ease and freedom with which Fra Angelico handled the movement and placement of figures in a shallow stagelike space, and the specific character of his own "Gothic" style, as opposed to Lorenzo's.

The altarpieces of this period, e.g., the Deposition from Santa Trinità (with its three pinnacles representing the *Noli me tangere*, the Resurrection, and the Three Women as the Sepulcher, painted by Lorenzo Monaco) and the Lamentation (done with the help of assistants) in the Museum of San Marco, show a tendency toward the composition and grouping of larger numbers of figures, and an interest in recognizable Tuscan landscapes as background.

Fra Angelico's late work is mainly in the frescoes of Orvieto and Rome. As mentioned before, the fresco decoration for the Chapel of the Holy Sacrament, presumably painted as his first project in Rome, is lost, although Vasari described it as representing scenes from the Life of Christ, which contained a number of portraits of contemporaries, such as Pope Nicholas V, Emperor Frederick III, Ferdinand of Aragon and others.

While in Rome he contracted to spend the summer months of each year in Orvieto on decorations in the cathedral, which he did only the first year, and is recorded at work there from June 14 to September 28, 1447, with a group of assistants, including Benozzo Gozzoli. The frescoes painted were two vaults of the Cappella Brizio with the Christ Enthroned as Judge and a chorus of prophets. A more realistic manner in some of the figures has been interpreted as the work of Gozzoli. The chapel was later completed by Signorelli (1499 ff.).

The frescoes in the rather small (6.25 meters x 4.20 meters) Cappella Nicolina dei Santo Stefano e San Lorenzo in the Vatican depict the Four Evangelists in the vaulting, a series of eight bishops and saints in painted nich like tabernacles, six scenes from the life of St. Stephen in the lunettas, and five scenes from that of St. Laurence on the walls below. The first payment is recorded March 3, 1447, shortly after the accession of Nicholas V to the papal throne, and the

work probably continued until 1449, and again from 1452-55 after the master's return from Fiesole. The frescoes of the vaults and lunettes suggest the earlier period, while those depicting the St. Laurence scenes probably belong to the later one. Again, as in Orvieto, the more realistic handling of separate heads and figures suggests the work of Gozzoli (cf. the Evangelists Matthew and Luke on the vaults).

In general, the style shows a marked development over the San Marco frescoes, which may be interpreted from the point of view of Fra Angelico's own artistic development, the growing popularity of the new forms developed by Masaccio and the Florentine experimenters, and the iconographical and stylistic demands of the immediate surroundings involved in each place, i.e., the cloistered seclusion of the monastery as compared to the more worldly papal court. In depicting the various scenes, there is a greater interest in realistic detail, both in figures, landscape and architecture. Figures are more strictly and consciously composed, and the architecture, with its mathematical perspective, tends to become an integrated part of that composition. The use of light and shade to model figures and define them in space is another Florentine feature (D. Veneziano) which makes its appearance. Although the compositional problems are by no means solved, the work shows the gradual predominance of Renaissance forms, as well as the persistence of an unworldly Gothic piety noted in the friar's earlier style.

The third group of Fra Angelico's late period is that of thirty-five panels of the sacristy cupboards from SS. Annunziata (now in San Marco) in Florence depicting scenes from the Life of Christ. Painted between 1449 and 1452, they are executed mostly by assistants, among them Zanobi Strozzi, Alesso Baldovinetti and possibly Pesellino, after the master's own designs.

Masaccio and the Monumental Style

While the first significant works of the new monumental tradition appear in the third decade of the century, the artists themselves belong to a generation considerably younger than those of the contemporary "Gothic" group. Of all the fifteenth-century styles, it had the greatest capacity for internal growth and development. Not

only did its influence spread out into other schools beyond the geographical confines of Florence, but many outside artists were drawn into its local sphere. The depth and universality of expression accomplished by the great masters of the High Renaissance are to be understood on the basis of this monumental tradition.

Masaccio (Tommaso di Giovanni di Simone Guidi, 1401-ca. 1428), like Giotto a century before, stands at the threshold of the new era. Considering the importance of his work and its influence on other artists, there is remarkably little definite information about his life. He was born at Castello di San Giovanni Valdarno on December 21, 1401, and was registered in the Florentine *arte dei medici e speziali* in 1422 (therefore, one year before Masolino's name appears), and in the guild of St. Luke in 1424. Vasari names him as a pupil of Masolino. Vasari describes a lost fresco which he painted in the cloister of the Carmine, commemorating the consecration of the church (1422), which included portraits of Brunelleschi, Donatello, Masolino, Antonio Brancacci and others. Apparently he worked in Rome at two different times—once, perhaps, in 1423, and the second, later in 1427. His death in Rome occurred sometime in the fall of 1428. The 1424 registry indicates that he was back in Florence, shortly after which he was probably working in the Brancacci Chapel in collaboration with Masolino. On February 19, 1426, he received payment for an altar for the Chiesa del Carmine in Pisa. On July 27, 1427, he had made a tax declaration in Florence, so that his trip to Rome would come after that date.

In such a short span of life, it seems somewhat exaggerated to refer to ''early'' and ''late'' works of the master. Had he lived longer, the artistic products of this entire lifetime would normally be considered simply as ''early works.'' Yet the series of panels and frescoes associated with him show such a rapid development of form, and strikingly new solutions, as well as new problems, that, even when considered from the point of view of inexplicable ''genius,'' it seems incredible. This and the scarcity of recorded facts about the artist himself, his reasonably certain association with Masolino that is evidenced both in the literature (Vasari) and in their respective styles, the resultant conflict between two aesthetic points of view (i.e., Gothic and Renaissance) as well as two generations represented in the older ''teacher'' and younger ''pupil'' and, finally, the un-

disputed creative genius and personality of the younger man that is revealed in the work itself (i.e., especially the Tribute Money) are the basic factors making up the famous Masaccio-Masolino problem.

Masaccio's earliest and most striking panel in terms of this new point of view is the newly discovered triptych of the Madonna and Child with St. Bartholomew and St. Blaise on the left, St. Juvenal and St. Anthony Abbot on the right, in the church of San Giovenale in Cascia di Reggello, which is dated 1422. Comparison with Gentile da Fabriano and, especially, Masolino (e.g., his Bremen Madonna altar painted a year later) will show the remarkable difference in basic character, evident in the details with their loose freedom of the brushstroke as well as in the total composition of the figure, the modeling of its forms and the drapery over them. These show a constructive crudity and strength which is not to be found among his Gothic contemporaries in Florence, and certainly not to be expected from a youthful pupil of Masolino. Rather, it is more closely related to the sculptor's realism of a Donatello (e.g., the St. George figure and tabernacle executed for Or San Michele in 1415-1417), and reveals a return to the heroic spirit of Giotto (i.e., the Ognissanti Madonna).

The same spirit is developed and enhanced in the famous Madonna with St. Anne in the Uffizi Gallery of Florence. It was probably painted in 1424 or 1425 and was originally, according to Vasari, in the church of Sant' Ambrogio in Florence. Its character again recalls the Giotto Ognissanti Madonna, but where Masaccio had constructed his Giovenale Madonna into a nichelike throne and turned the two kneeling angels inward with their backs toward the spectator (cf. Giotto's kneeling angels in profile), here in the St. Anne altar he developed a more thoroughly integrated perspective with the space created by the figures as well as by the perspective of the throne. The monumental dignity of the Virgin is enhanced iconographically by the introduction of the protecting St. Anne and surrounding angels, somewhat reminiscent of the Coronation theme but constructed more into a functioning form and gesture rather than its inclusion by association. The projecting hand is foreshortened and seen from below, indicating again a kind of structural continuity evident in the figures of the Child, the Virgin and St. Anne. The rigid vertical composition of the figures and drapery, the plastic modeling of the forms in a three-dimensional throne, the rich color

based on the contrast of the deep blue of the Virgin set against a regal purple-red of St. Anne, and the impressive directness of the total composition, reflect again this new and personal attitude, which is not to be found in any of Masaccio's contemporaries.

The argument for the exception might be found in the problematical works of Masolino done during the same period (i.e., the Bremen Madonna, the Pietà in Empoli and the two panels in Naples), wherein these features appear in an isolated and unarticulated form. Indeed, a close examination of the separate figures of the St. Anne altar might support the argument that the Madonna and Child, together with the angel holding the drape on the upper right, were painted by Masaccio, and the inferior painting evident in the other angels as well as the St. Anne figure must be the work of Masolino. The persistent possibility is that these, together with the San Clemente frescoes, were done in collaboration by the two masters.

The damaged and much-restored frescoes in the Chapel of St. Catherine in San Clemente, Rome, were commissioned by Cardinal Branda Castiglione and executed probably at the very beginning of his 1425-1431 stay in Rome. Precisely to whom the commission was given is not known, but considering the fact that Masolino was older and continued to be closely associated with the cardinal at Castiglione d'Olona, one might assume it was to that master, and that Masaccio possibly did the major part of the work. An early date is also a possibility, since the cardinal had been in Florence in 1422 and might have arranged the commission with Masolino, or both artists, at that time.

The scenes represent a large Crucifixion on the altar wall, the Four Evangelists and the Church Fathers on the vaults (damaged) and Apostles in the quartrefoils on the entrance arch, five scenes from the legend of St. Catherine (left wall), and five from that of St. Ambrose (right wall), the Annunciation in the spandrels on the wall at the entrance, and a St. Christopher on the entrance pier at the left. The strongest of the series is probably the Crucifixion, with its masses of well-composed figures, modeled and effectively foreshortened, the broad and realistic landscape background (reminiscent of the Roman campagna), and the dramatically towering crosses in the center.

Other scenes show a similar consciousness of problems of

plastic form, carefully constructed perspective, and greater effectiveness through a simplified and dramatic content (e.g., the Miracle of the Wheel). That mere "consciousness," however, brings the work closer to the general art and attitude of Masolino. On the other hand, the simplicity and directness of the technique used, and the remarkably unified impression of the whole chapel, whereby the compositions are oriented in accordance with the room, the beholder and the lighting, are not Masolino characteristics and are in keeping with the young Masaccio's basic understanding of the totality of the design as well as the expression of the individual forms. It is this which relates him to the genuine Giotto, rather than the century-long Giottesque tradition.

Vasari says that the commission to decorate the Brancacci Chapel was first given to Masolino. In the records of Santa Maria del Carmine, Felice Brancacci's name is given, but no date, and the assumption is that the project was begun in 1424, after Felice had returned from a diplomatic mission to the East (1423).

The plan of the decoration appears to have been a unified program devoted to St. Peter. The order of the scenes, however, is not in historical sequence, nor do the individual stories adhere strictly to the literary sources. The size of the chapel is about 21 by 27 feet (6.96 meters x 5.38 meters). On the right wall are (on the upper level) the Fall of Man, the Raising of Tabitha and the Healing of the Cripple; below are the Liberation of Peter, Peter and Paul before the Proconsul, and the Crucifixion of Peter. On the left wall (above) are the Expulsion from Paradise, the Tribute Money, and below are Paul's Visit to Peter, the Resuscitation of the King's Son (i.e., the story of Theophilus from the "Golden Legend") and St. Peter in Cathedra. On the end wall (left of the altar) are St. Peter Preaching to the Multitude, and Peter Healing the Sick with His Shadow; on the right are St. Peter Baptizing and the Distribution of Property with the Death of Ananias.

The chapel had been renovated after a fire in 1771, so that the window at the end had been replaced by an altar, the lunettes on the side walls containing the Calling of the First Apostles (Peter and Andrew) and the *Navicella* as well as Peter's Denial and His Repentance on the upper level of the end wall were replaced by eighteenth-century decorations. The design of the individual scenes is determined in part by the total architectural space, with the relatively shallow

perspective on the first level and the deeper space oriented to the spectator in the upper register. The window in the end wall would have relieved the boxlike impression of the present room and furnished the light to which the color and light composition of the entire series was oriented. Both figure compositions and the perspective of the scenes on the end wall are likewise designed with this opening and light source in mind.

Of the frescoes still extant, the Fall of Man, the Sermon of Peter and, probably, the greater part of the double scene with Peter Healing the Cripple and the Raising of Tabitha are directly in line with the development of form already traced from the Bremen Madonna to the Miracle of the Snow panel and the San Clemente frescoes. Whether executed by Masolino, by the young Masaccio, or by both working in collaboration, they are markedly different in style from those which follow.

This difference can best be seen by the comparison of the most famous of all of Masaccio's works, which is almost universally accepted as painted by him, The Tribute Money, with the earlier scene of St. Peter Healing the Cripple and the Raising of Tabitha. First, it is to be noted that his later fresco is divided into two separate episodes in the narrative manner of the Trecento. These are dramatized through the sparing use of figures, their plastic modeling and their composition through light and perspective in a three-dimensional space. The two scenes are tied together by a mathematically unified perspective composed of a line of buildings in the background parallel to the picture plane and architectural wings on either side like a stage setting.

The figure composition on the two sides and groups is tied together in the center in somewhat obvious fashion, by the two strolling gentlemen in contemporary costume. They represent the two messengers who, according to the story (Acts 9), were sent from the deathbed of Tabitha to fetch Peter. Their costumes and compositional isolation would support the suggestion that they were possibly portraits (e.g., Giovanni and Lippaccio Brancacci). The similar design and lack of compositional integration appears in the gentlemen of the Banquet scenes in Masolino's Castiglione d'Olona decoration, which would strengthen Masolino's authorship here.

In contrast to this balanced composition of episodes, the dramatic story of the Tribute Money (from Matthew 17:24) is concentrated in the large and impressive central group with the tax col-

lector in his short tunic, back to the beholder, facing the Christ in his demand, and Christ, surrounded by His apostles, pointing to the water as He gives directions to fetch the shekel from the fish's mouth. The two auxiliary scenes of procuring the money and paying the collector are subordinated in triptych fashion on either side of the central group. The perspective is not only mathematically correct, but unified, and used as a means to an end, rather than a problem in itself, as in the foregoing fresco. It recedes in unbalanced fashion from the architectural structure at the right to the hazy distance at the left through a succession of overlapping planes in the hilly landscape. Aerial perspective through color and light is used to increase its effect, again not as an end in itself but as a means of defining the figures in the illusionary space and of heightening the dramatic effect of the scene.

A last feature might be noted in the elemental simplicity and hence greater freedom in spiritual expression afforded by the technique, which is based on a simple palette of red, blue and ochre used in true fresco manner, i.e., without the *a secco* (tempera) overpainting used by Giotto followers, described by Cennini and still used by Masolino in the Castiglione frescoes (as well as in those San Clemente and Brancacci frescoes frequently attributed to him). The areas identified by each *giornata* are large, swiftly painted with loaded brush, revealing Masaccio's characteristic freedom and asssurance. This can be seen especially in the tall figure to the right of the tax collector, which is often looked upon as the self-portrait of the artist, though it has also been identified as a portrait of the donor, Felice Brancacci.

The break in style of the Brancacci series may have been effected by Masolino's departure for Hungary (1425-1427). In any case, the remaining stories of St. Peter (all of which were taken from Matthew, the Acts of the Apostles and the "Golden Legend") appear more closely connected with the Masaccio point of view. The character of such details as the head of the cripple or the kneeling figure seen from the back in the Raising of Tabitha suggests the hand of Masaccio. Likewise, the dramatic and pentrating expression of the two figures in the Expulsion from Paradise (Masaccio) is a remarkable contrast to the stiff and archaic pose in the figures of the Fall of Man (Masolino), while the head of Christ in the Tribute Money seems to be clearly Masolino's.

Dramatic tension and monumental form govern the composi-

tions of St. Peter Baptizing and the St. Peter Enthroned, which is appended to the Resuscitation of the King's Son, and in which a number of figures were completed by Filippino Lippi (i.e., particularly, the four figures at the left and the eight men in the row behind). Two further scenes depict Peter with John distributing alms and healing the sick with their shadows, in which (particularly in the latter scene) light and shade and the diagonal perspective of the architecture are compositional means used to dramatize the magic power of the saint.

The stature of Masaccio as a creative individualist, which seems evident in the total plan of the series, is again evident in the analysis of both content and design. The story, as represented in the Tribute Money, for example, is not a literal repetition of the Matthew text, but is reconstituted in his own artistic terms, which is a phenomenon of his time rather than a legendary past. In a sense, it is a reversal of the process followed with Giotto in Assisi and Padua, where the new content of the Franciscan story contributed to the creation of new forms. Here it would appear that the discovery of new forms through the exploitation of light, perspective, the expressive head as well as the constructed figure, had created a new content, which had its affinity with the spirit of Giotto, but opened up entirely new possibilities not realized in the preceding century.

The identification of that content in terms of actual events and objectives is difficult, but nevertheless real. Felice Brancacci was a wealthy merchant and politician with overseas interests as well as Italian ones. The expanding economy of the Florentines needed peace and tranquility. Renewed hostilities with the aggressive Visconti in Milan had just broken out in 1424. A peace treaty with Venice was concluded in 1426, largely through the efforts of Pope Martin V, who had developed a vigorous program for the strengthening of the papal position in political affairs. New taxes were imposed (e.g., the *Castato* in 1427) and defended by the church. The identity of Peter and the Papacy, the *Navicella* as the Church of Christ, the Power of Faith through Peter's miracles and the appeal to the *libertas ecclesiae* evident in the Tribute Money all have their practical associations. There is no literal interpretation possible, which is the significant feature of Masaccio's achievement, but the church's responsibility and function is nevertheless clearly stated.

138

Two other authentic works belong to Masaccio's last years. One is the altarpiece commissioned by Giuliano di Colino degli Scarsi for Santa Maria del Carmine in Pisa, for which payments are listed in February and August, 1426. From this polyptych come the Madonna Enthroned with Angels in the London National Gallery, and other fragments, notably the figure of St. Paul in the Pisa Museo Nazionale, that of St. Andrew in the Lanckoronski Collection of Vienna, the Crucifixion in the Museo Nazionale di Capodimonte in Naples, the four small saints and the three predella scenes in the Berlin-Dahlem Museum, the Adoration of the Magi, the Martyrdom of St. Peter and that of St. John the Baptist, and scenes from the lives of St. Julian and St. Nicholas (done probably with the assistance of Andrew di Giusto).

With all due respect for the short period of time involved, it is revealing to trace the remarkable maturity developed within the four years since 1424, as can be seen in the comparison of the Madonna of the Pisa polyptych with that of the San Giovenale altar and the Madonna with St. Anne from Sant' Ambrogio. From the initially crude but strongly sculptured statement of the early work had grown a more firmly constructed, compact and heroic form in the Madonna with St. Anne. Here in the Pisa altarpiece, the figure and form of the Madonna appear relaxed, confident and more freely expressive. The architectural setting provided by the throne serves to enhance that freedom and monumentality. Much of the same purity and confidence of form appears in the small predella scenes and, especially, the Naples Crucifixion, with its foreshortened perspective of the Christ figure and the newly uncovered Tree of Life at the top of the cross. The Adoration of the Magi is especially revealing in showing Masaccio's character, even in such small format, when compared with Gentile's large and crowded Adoration in the Uffizi, completed only three years earlier.

The second late work is the fresco in Santa Maria Novella, Florence, of the Holy Trinity with the Virgin, St. John and Kneeling Donors. The composition was designed as a memorial monument for the tomb of the Florentine *gonfaloniere* Lenzi, who is represented with his wife as kneeling supplicants. The fresco had been covered by a large altarpiece by Vasari in the sixteenth century, then moved in 1861 to the entrance wall of the church and finally (1952) returned to its original setting with its recently discovered

painted skeleton beneath the altar level as a *memento mori* and the inscription: *IO.FV.QVEL.CHE.VOI.SETE: EOVEL CHISON VOI. ACO.SARETE* (What you are, I was also, and that which I am you will become).

The remarkably effective architectural design is often attributed to Brunelleschi, particularly the mathematically correct perspective of the coffered barrel vaulting, a motif which may have had its origin in the Classical-Romanesque designs of the Florentine Baptistry or San Miniato al Monte. The outer painted frame design has its parallel in Donatello's niche on Or San Michele, which formerly contained his statue of St. Louis. The figure of the Crucified Christ is a direct parallel to the realism of Donatello (e.g., the wooden Crucifix of ca. 1420 in Santa Croce as compared to the more elegant wooden Crucifix of ca. 1410-1415 by Brunelleschi in this same church of Santa Maria Novella).

Among other factors to be noted in this fresco is the use of perspective, again not as an end of itself, but as a means of enhancing the plastic and monumental effectiveness of the figures and the scene. The figures, both kneeling and standing, are all consistently about life-size, whereas they would have to considerably smaller if they were designed to fit into the scale of the architecture. While the surface of the wall is broken by the illusion created by the architectural perspective, the spectator is not drawn into the space, but the space is used to strengthen the figures. This orientation is further strengthened by the perspective of the vault, whose lines converge to a point of flight at the foot of the cross which is also at the eye level of the spectator. The slight foreshortening of the figures as they are seen from below at their respective levels, and the use of various geometrical patterns to hold them in suspense, demonstrate again the complete integration of form and content characteristic of Masaccio. These portraits of the kneeling donors are built into the composition in much the same way as the adoring angels of Giotto's Ognissanti Madonna and its Trecento successors, and mark the beginning of a new tradition of portraiture developing through the entire century.

Of more general interest at this juncture is the study of similarities and differences in approach to problems of form, function and iconography to be noted in contemporary architecture and sculpture. The great master of early Renaissance architecture is

Filippo Brunelleschi (1377-1446), whose aesthetically pure and mathematically well-integrated handling of space-forms and architectural design can be seen in the church of San Lorenzo (1421 ff.) as compared with the Gothic Cathedral of Florence (1296) or Santa Maria Novella (1278-1350), or in his façade of the Ospedale degli Innocenti (1419 ff.) in contrast to the spacious and unarticulated Loggia dei Lanzi (1376-1382).

In sculpture, a dramatic parallel may be found in the wool weavers' competition of 1401 for the bronze doors of the Baptistry, for which the respective interpretations of a common theme, Sacrifice of Isaac, submitted to the competition by Brunelleschi and Lorenzo Ghiberti, are still preserved in the Bargello of Florence. The fact that Ghiberti won the competition with his more conservative and graceful Gothic design is indicative of the persistence of that tradition, in contrast to the dramatic realism of Brunelleschi, which is much more in the spirit developed by the young Masaccio.

As Brunelleschi's succeeding efforts were confined largely to architecture, it was Donatello (1386-1466), the greatest of fifteenth-century sculptors, who incorporated the new approach to reality as well as problems of sculptural and decorative form in a manner parallel to Masaccio and his followers. This may be seen particularly in such strictly sculptural monuments as the St. George on Or San Michele (1415-1417), now in the Bargello, and the prophets on the Campanile of the Florence Cathedral (1416-1435).

Of particular importance in Donatello's work, as well as that of Brunelleschi, is the new understanding and stimulating influence of classical antiquity, which is paralleled in the exploitation of many classical motifs by Masaccio. As one reviews Masaccio's figure compositions, one recognizes many of the classical conventions, such as the pose of the ancient Venus de' Medici, used by Giovanni Pisano in the figure of Prudence on the Pisa pulpit, and by Masaccio in the composition of Eve in the Expulsion from Paradise. Likewise, the classical Dying Seneca pose is used in the famous shivering nude in the Baptism scene of the Brancacci Chapel.

In many of the heads (e.g., that of John and other apostles in the Tribute Money) one seems to recognize the portrait profiles of antiquity, such as those on Roman coins as well as portrait busts. The heads are lined up in a strictly horizontal band, as in classical reliefs (isocephalism), even though the figures are arranged in a semicircle

and the perspective used in creating the illusion of space would indicate otherwise. The classical nobility and power of the individual heads is combined with the solemnity of the standing figures in space to give a dramatic tension and presence, as can be seen in the sculptural form of Nanni di Banco's group of four life-size marble Martyrs (ca. 1413) on the façade of Or San Michele. In each case, the motif is used creatively as a means of strengthening the expression. As in the case of the Pisani more than century earlier, the works of classical antiquity became identified with reality as a means of developing the new rather than a revival of the ancient.

Paolo Uccello (Paolo di Doni, 1397-1475) is one of a group of artists following Masaccio whose interests are concentrated on the experimentation with specific "problems" of pictorial form. Unlike Masaccio or the Gothic painters, they do not deal with the reality of nature or of spiritual content, but more with the theoretical "reality" of pictorial structure and composition. In the beginning, these experiments are concentrated on relatively isolated problems of perspective, form and color. These, to be sure, are not new in themselves, since they appeared in many variations through the Trecento, but the renewed and specialized attention given to them in scientific laboratory fashion served to deepen and enrich the artistic expression of later generations.

In addition to those suggested, there are other contemporary relationships which might be elaborated upon. As mentioned above, the knowledge and use of a perfected mathematical perspective appears in the work of the engineer and architect Filippo Brunelleschi (1377-1446), with whom the architectural perspective in the background of Masaccio's Holy Trinity fresco is associated. The science of perspective and optics receives considerable attention in the teachings and writings of the physicist Paolo Toscanella and the mathematician Antonio Manetti (whom Vasari gives as a friend of Uccello). The interest in reality, in the deeper sense of the human figure as a functioning organism which is capable of scientific analysis, is further reflected in the contemporary sculpture of Donatello (also a friend of Uccello's), whose realistic study of the physical skeleton and anatomy, as well as human character and expression, is revealed in the prophet figures on the Campanile. Thirdly, the compositional possibilities of color are further realized by the

enrichment of the technique itself through the gradual introduction of oil as a medium (i.e., the combination of oil and tempera already suggested by Cennino Cennini and perfected by the Van Eycks in Flanders, and a closer observation of the effects of light and shade in nature. All of these factors are worked into an aesthetic system by Leon Battista Alberti in his "Treatise on Painting" (1435), which reflects both the influence of the classics (Plato, Euclid) and the general intellectual spirit of the time which found contemporary expression in the establishment of the Platonic Academy (founded in 1439 by Cosimo de' Medici).

The argument is frequently pursued, particularly in the study of Uccello, that the interest in the experiment, i.e., the scientific analysis of the optical or technical medium, outweighs the interest in the use of that medium as artistic expression. It appears in Vasari's description of a conversation between Donatello and Uccello over the design of a *mazzocchio*, a male headdress construction with an elaborate system of squares and facets drawn from different angles of perspective. Donatello's comment was that with these exercises Uccello was losing the substance for the shadow and that such things were more suitable for marquetry, i.e., the mechanical craftsman as opposed to the genuine artist. The answer to the argument, and the one which applies to this entire tradition of progressive artists from Masaccio to the end of the Quattrocento, is that expressed by the philosopher Gianozzo Manetti, whereby faith is identified with certainty, and the articles of religion may be as true as the fact that "a triangle is a triangle."

Paolo Uccello was born in Florence in 1397, the son of a barber and surgeon, Dono di Paolo. He served as an apprentice in Ghiberti's workshop from 1407 until about 1414, was entered in the Florentine *arte dei medici e speziali* in 1415 and in the guild of St. Luke in 1424. A testament of 1425, requesting that he be buried in his father's tomb in the church of Santo Spirito and bequeathing his probably inherited property to the hospital of Santa Maria Nuova, seems to have been written just before his departure for Venice, where he is said to have done a mosaic (now lost) of St. Peter on the façade of San Marco. By 1430, he was back in Florence, where records of tax payments and commissions indicate a continued activity there, including an application for design work in 1432 in the cathedral, which apparently was the reason for an in-

quiry to Pietro Beccanugi, the Florentine agent in Venice, as to Uccello's ability as a mosaicist.

A note in the *Anonimo Morelliano*, as well as in Vasari, mentions a trip to Padua, where his friend Donatello was to work, during which time (probably 1445) he is said to have painted a series of Giants (lost) in the Casa Vitaliani, which are important for their possible influence on the young Mantegna. Payments are listed in 1436 for the John Hawkwood fresco, and in 1443 for the cartoons for the stained-glass window and the execution of prophets' heads for the clock face, all in the Cathedral of Santa Maria del Fiore, Florence. In the early '50s he married Tomasa di Benedetto Malifici, some thirty-seven years his junior, who bore him two children. In 1451, he was asked to estimate the value of a tabernacle painted by Stafano d'Antonio for Santa Margherita a Montici, and in 1453 he is recorded as having painted a figure of Beato Andrea Corsini for the cathedral library. The payment of a small sum by the brotherhood of Corpus Domini in Urbino for work in 1467/8, together with a declaration of poverty before the tax magistrates recorded in 1469, are possibly indicative of reduced circumstances and a scarcity of important commissions available to him. He died in December, 1475, and was buried in the family tomb in Santo Spirito.

The equestrian fresco portrait of the *condottiere* John Hawkwood (Giovanni Acuto) is the first dated and fully documented work by Uccello (signed, *Pauli Uccelli opus* on the pedestal, with a dedication plaque: *Iohannes Acutus. Eques Britannicus. dux aetatis. suae cautissimus. et rei militaris. peritissimus. habitua est.*). Various dealings and payments by the *operai* are mentioned in connection with it from May until August, 1436, in the cathedral records.

Of particular note with regard to its style are the plastic character of the painting, with the gray-green grisaille of the figure against a dark red background, and the apparent inconsistent use of perspective, whereby the sarcophagus is foreshortened as seen from below while the mounted figure is seen in straight profile. This may possibly have been intended as a means of enhancing the monumental effect of the figure, as Masaccio had done in the Holy Trinity fresco.

The plastic form of the group may have been influenced by the

classical bronze statue of Marcus Aurelius, as well as North Italian equestrian tomb statues (i.e., that of Paolo Savello in Santa Maria dei Frari, Venice) during his trip to Venice, and he had certainly seen the ancient bronze horses on the façade of San Marco. The comparison with Simone Martini's Guido Riccio is interesting as contrasting important Sienese-Gothic and Early Renaissance interpretations of a similar theme. Of particular note is the isolation of the Uccello figure from scenic background and landscape, along with its rigid and sculpturesque modeling and design. The decorative border is a sixteenth-century addition.

The frescoes of the Chiostro Verde in Santa Maria Novella, now in the Forte di Belvedere Museum, appear to have been executed in two groups. The first, representing scenes from Genesis, including the Creation of the Animals, the Creation of Adam, Creation of Eve, and the Fall of Man and other scenes, were probably painted after his return from Venice in 1430 and before the John Hawkwood. Though badly damaged, they show the careful and detailed observation of nature characteristic of the Gothic painters in the tradition of Starnina, Gentile da Fabriano, even Pisanello, as well as the compositional interests of Ghiberti, with whom he had worked as an apprentice during the execution of the second pair of bronze doors. Their authenticity is supported by the early sources, notably Antonio Manetti, Francesco Albertini, the *Libro di Antonio Billi*, the *Anonimo Magliabechiano*, as well as Vasari.

Those of the second group were done some ten years later (i.e., ca. 1446). The dating is based largely on stylistic evidence, which is substantiated somewhat by Vasari's statement that the figure of Ham was a portrait of the painter Dello Delli, who is known to have been in Florence in 1446/8. Represented are the scenes of the Deluge and the Recession of the Waters in the lunette, and Noah's Sacrifice and Drunkenness immediately below it.

The frescoes, also badly damaged and painted in green grisaille (*terra verde*), show a more forceful use of architectural perspective, which can be readily seen by comparing the spread-out architectural "wings" of the Masaccio-Masolino fresco of the Raising of Tabitha. Related compositional features may be found in the double scene of Noah's Sacrifice and his Drunkenness, whereby the two separate groups are connected by an arbor of parallel horizontal lines whose illusionary effect of convergence, when seen from the side of the

room, tends to compose the two scenes in a fore- and background sequence.

The deep pace is dramatized by the active nude figures which struggle in the water and clamber up the walls of the ark, a motif which recalls the terror-stricken souls of Trecento Last Judgments (e.g., Francesco Traini in the Campo Santo of Pisa, or Taddeo di Bartolo in the Cathedral of San Gimignano), as well as the more sophisticated nudes disrobing in Masolino's Baptism in Castiglione d'Olona. Note, too, the forward stride of God the Father in the Creation of Adam, and His downward motion in Noah's Sacrifice. Although hardly visible in the present state of damaged fresco, the sharply foreshortened figures on the ground in the Deluge (i.e., the Recession of the Waters at the right) and the drunken Noah reveal an interest in the perspective of the figure parallel to that of space.

Thus the development from the Gothic interest in nature and decorative detail to the creative use of perspective in both figure and space reflects the impact of Masaccio's achievement, as well as the more gentle influence of Ghiberti. Similar characteristics, though difficult to see in their damaged condition, are to be found in the fresco fragments of Scenes from the Life of St. Benedict (also identified as "Stories of the Holy Fathers," i.e., The Thebais) in the church of San Miniato al Monte in Florence (ca. 1439), and the Nativity in the cloister of the former hospital of San Martino alla Scala in Florence (ca. 1446).

Ghiberti's influence might also be seen in Uccello's designs (for which payments are listed between 1443 and 1444) for windows in the drum of the cupola in the Cathedral of Florence, representing the Nativity, executed by Angelo Lippi, and the Resurrection, done by Bernardo di Francesco. The composition of the Resurrection is related to that of the same theme in Ghiberti's Paradise doors; its superior quality, in comparison to the other window, is due as much to better craftsmanship in execution as it is to Uccello's own possibly later and more perfected style. The four heads of prophets on the clock face of the entrance wall in the Cathedral of Florence were done about this same time (1443) and are remarkable for their strength in form and character (cf. Donatello's campanile heads and those of Masaccio in the Brancacci Chapel).

The famous Battle Scenes (in the Uffizi, the Louvre and the National Gallery of London) were done in 1456 or 1457 as decorations

for the Camera di Lorenzo in the Palazzo Medici, and are listed there in an inventory of 1492.

Represented is the Battle of San Romano (June 1, 1432), in which the Florentine troops, under the command of Niccolò da Tolentino, defeated the Sienese, led by Bernardino della Ciarda in alliance with the Duke of Milan, in a long, joustlike struggle. The decisive rout was accomplished only after fresh Florentine reinforcements, under Michelotto Attendolo da Cotignola, arrived to turn the tide. The three scenes were apparently designed, triptych-fashion, as a unit, with Niccolò on his prancing white steed at the head of a cavalcade of four knights at the left (the National Gallery panel), advancing hosts of Michelotto at the right (the Louvre panel), and the decisive battle, with the retreating Sienese and the unhorsed Bernardino della Ciarda struck by an enemy lance, in the center painting (Uffizi). The signature, *Pauli Ucieli Opus*, appears on the shield at the left in the Uffizi painting.

In many ways the San Romano group takes a key position in the development of Renaissance painting, with regard to both patriotic subject matter and the discovery of new artistic forms. Compared with Simone Martini's Guido Riccio and other Trecento battle representations, Uccello's is much more formal and abstract. The more sophisticated consciousness of form, and a resulting epic content, may have been stimulated by the new interest in classical reliefs, such as those on Hellenistic and Roman sarcophagi. The subject had continued as a live literary theme from the classical Virgil to Renaissance Tasso (''Jerusalem Delivered''), but the initial impact here was undoubtedly both personal and patriotic. Niccolò da Tolentino had been a close personal friend of Cosimo de' Medici's as well as a Florentine hero, which accounts for both this tribute and the portrait commission given to Castagno at the same time (1456).

Abstract and awkward though the style may appear, there are several significant features. In contrast to the dramatic use of perspective combining the background and the figures in the foreground noted in the Deluge fresco of the Chiostro Verde, there appears here a separation of the two picture planes by a wall of still life (i.e., the orange trees and rose bushes in the London panel). Figures are composed on a shallow stage where the illusion of space is achieved by the strong foreshortening of forms (i.e., broken lances, fallen warriors and horses) and the violent ''action'' of the

fighting warriors. The attempt to combine this movement with the sharp and linear definition of the foreshortened forms accounts for their wooden character. An uncommon (for Florence) coloration of rose, light blue and light ochre tones indicates a more abstract sense of color, possibly related to Venice. The finely painted detail in the harness, costumes and rosebushes seems related to the late Gothic painters, as does the impressive cavalcade motif (cf. Gentile da Fabriano's Adoration and Gozzoli's later Adoration of the Magi in the Medici Chapel).

A number of less important works are of interest in tracing Uccello's development as well as his handling of different problems. To the earlier period are ascribed the St. George panels in Paris (Musée Jacquemart-André) and the London National Gallery as well as the Crucifixion (Thyssen Collection, Lugano); their Gothic pattern is related, possibly, to the style of Don Lorenzo Monaco, as well as to Ghiberti. The group of five portraits in the Louvre (the so-called Founders of Florentine Art—Giotto, Uccello, Donatello, Antonio Manetti and Filippo Brunelleschi), if painted by Uccello, is related to the Masaccio-like prophet heads of the Florentine cathedral, but of a later date (ca. 1450-1460). To the late period belong the panel of The Hunt in the Oxford Ashmolean Museum, with its frieze of running figures related to the battle scenes, and the predella panels in the Galleria Nazionale della Marche of Urbino, which are assumed to have belonged to the altar that Uccello painted for the Corpus Domini brotherhood in Urbino, payments for which are mentioned in documents in 1467-1469. Represented are six episodes from the history of the Sacred Host, with various developments in the use of perspective and light which suggest the work of Piero della Francesca.

Andrea del Castagno (Andrea, or Andreino, di Bartolomeo di Simone, ca. 1421-1457) is the second of this group who developed, particularly, the plastic realism of figures noted in the work of Masaccio and Donatello.

Andrea was born in Castagno in the Mugello valley, probably about 1421, and was, according to Vasari's account, closely resembling his story of Giotto, a shepherd on his uncle's farm, when his artistic talent was discovered by Bernardetto de' Medici and he was brought to Florence. According to Vasari, he painted frescoes

on the façade of the Palazzo del Podestà in Florence (destroyed in the riots of 1494) depicting the enemies of the Medici, the Albizzi and other conspirators who had participated in the 1440 Battle of Anghiari against Florence, hung by their feet (*impiccati*), described by Vasari "in extraordinary attitudes, all different and very fine," and from this came the nickname *Andreino degli Impiccati*. Between that time and 1444, when he is recorded in Florence, Castagno went to Venice and executed cartoons for mosaics in the Mascoli Chapel in the left transept of San Marco and the signed and dated (1442) frescoes in San Zaccaria, Venice. In 1445, he was registered in the guild of St. Luke, and is recorded regularly at work in Florence until his death in 1457 (frescoes of the Cappella Maggiore in Sant' Egidio, and those in the Cappella di San Giuliano e Orlando Medici in SS. Annunziata, which are almost wholly destroyed).

The recently restored frescoes on the ribbed Gothic apsidal vaults of the Cappella di San tarasio in San Zaccaria, Venice, represent God the Father with Angels, the Four Evangelists, St. John the Baptist and St. Zachary, with ten medallions of prophets, and are signed by Andrea and Francesco da Faenza: *Andreas de Florentia et Franciscus de Faventia* and dated *MCCCCXLII M. Augusti*. Of these, the figures of the Evangelists and part of the frieze with putti seem to have been painted by Castagno, the rest in the more Fabriano-like manner of the Faenza master. They reveal a strong definition of the draped figure in the terms of Masaccio and Donatello in a manner uniquely Florentine and new to Venetian painting of that time. The Death of the Virgin mosaic (ca. 1443) in the Mascoli Chapel of San Marco in Venice may be attributed to Andrea, chiefly on the basis of the design, with its triangular composition of figures against a Brunelleschi-type architectural framework (cf. Masaccio's Trinity) and the characteristically well-modeled apostles, particularly the two on the left.

On his return to Florence, he made a cartoon for the Deposition window in the cupola of the cathedral which was paid for in 1444, the same time as the payments to Uccello are listed. Likewise datable is the altar panel representing the Assumption with St. Julian and St. Miniato in the Berlin-Dahlem Museum, which is assumed to be the one painted 1449/50 and commissioned by Leonardo di Ser Francesco Falladanzi for the church of San Miniato fra le Torri in

Florence. The figures of the two saints in this composition appear somewhat weak in comparison to the strong color and modeling, the sharp drawing and the twist of the central group. The dramatic figure of David with the severed head of Goliath, painted on a leather parade shield, in the National Gallery of Washington, is assumed to have been produced during this same period.

The dating of the major fresco projects by Castagno has been the subject of much discussion. The first Crucifixion, from the outer cloister of the Camaldolese Convento degli Angioli in Florence, may well have been an earlier work, even before his trip to Venice, and is associated with the design of the Crucifixion on Masaccio's Pisa altar as well as with his Trinity. A later Crucifixion, from an inner cloister of the Convento degli Angioli, also has the Virgin, St. John, St. Benedict and St. Romuald. Both are now in the Castagno Museum of Sant' Apollonia in Florence. The massiveness of the figures and the heavy modeling of drapery are again reminiscent of Masaccio's Trinity (cf. the St. John figures in each) and of the plastic realism of Donatello (i.e., the Santa Croce Crucifix).

Shortly afterward, i.e., after his return from Venice and before the Assumption, come the frescoes decorating the refectory of Sant' Apollonia representing the Last Supper, with the Crucifixion, the Entombment and the Resurrection above. The Last Supper is particularly significant as being the prototype for a number of renditions which became typical of the Quattrocento until Leonardo. As to its style, note the boxlike composition of the space occupying only a part of the total wall; the linear perspective in the designs of floor, ceiling and walls; the long table parallel to the picture plane, with the clearly drawn and plastically modeled figures, with polished gold halos in perspective, seated behind it (excepting Judas); the use of many classical decorative motifs in the pilasters and sphinx figures, reminiscent of Donatello; the use of light from windows at the right as an aid in the perspective of the room and the definition of figures; and, lastly, the bright coloration of the marble-incrusted walls against the subdued color of the figures. The three scenes above, though damaged, are lighter and more atmospheric in coloration, suggestive of Domenico Veneziano, and the figures are more loosely composed before the broad landscape background.

The usual dating of between 1445 and 1450 is suggested by a letter of 1445 from Pope Eugene IV to Abbess Cecilia Donati ap-

proving her plan for the enlargement of this Benedictine convent. The 1953 detachment of the deteriorated frescoes from the wall revealed the striking *sinopie* of the *arricio*, which are significant as being among the first so far discovered which are not the free sketches of the Trecento tradition, but are based on cartoons from which the drawing is transferred by pouncing chalk through the perforated outlines, both on the undercoat and on the final *intonaco.*

The fresco series of *Uomini famosi* painted for the Villa Carducci (later Pandolfini) in Legnaia, now in the Museum of Sant' Apollonia, Florence, is an important iconographical development as a secular variation of the *Sacra Conversazione* and devotional portrait groups common both to fourteenth-century painting (Giotto, Oderisio, Altichiero, Tommaso da Modena, and in the Visconti Palace, Milan), as well as to literature. Represented are nine figures, including three famous military leaders (Pippo Spano, Farinata degli Uberti and Niccolò Acciaiuoli), three famous heroines (the Cumaean Sybil, the half-length Queen Esther and Queen Tomyris), and three literary heroes (Dante, Petrarch and Boccaccio).

Characteristic features already noted in the Last Supper can be seen in the classical designs of the putti frieze, the bright coloration of the frames with their alternating green and red backgrounds in contrast to the brownish tones of the figures, the hard drawing and plastic modeling of the large portrait figures that form an interesting contrast to Masolino's portrait of Pippo Spano in the Feast of Herod fresco in Castiglione d'Olona or the two gentlemen in the Raising of Tabitha in the Brancacci Chapel. In contrast to these two, and to the typical Trecento form (e.g., Tommaso da Modena), the depiction of the figures as twisting and moving forward out of the frame is indicative of Castagno's attempt at greater vitality and monumental strength, an idea noted before with Donatello's figures on the Campanile or the St. George on Or San Michele.

The famous works of Castagno's last years are the fresco of the Trinity with St. Jerome in the Cappella Carboli and the fragment of the Saviour with St. Julian in the Cappella Gagliano, both in the church of SS. Annunziata, Florence (1454/5) and the equestrian portrait of Niccolò da Tolentino (1456) in the Cathedral of Florence. The Trinity is in a particularly good state of preservation, having been covered by an altar by Allori since 1553, and is interesting as a stylistic development over the same theme by Masaccio: note the

symmetrical composition with heads varying to either side on a central axis; the two female figures (possibly Saints Mary of Cleophas and Mary Magdalene) turning inward, instead of being placed in profile, and looking up to the Cross and God-Father group which hovers above the triangular space bounded by the three figures; and especially the ecstatic and tortured expression in the face of the central St. Jerome (cf. Donatello's Jeremiah on the Campanile).

The portrait of Niccolò da Tolentino (with the inscription on the base: *hic quem sublimem in equo pictum cernis Nicolaus est Tolentinus inclitus dux Florentini exercitus*) is likewise a logical development in form over that of Uccello's John Hawkwood, done twenty years earlier. This can be seen in the unified system of perspective and foreshortening used, whereby both figures and sarcophagus are equally seen from below, the greater integration in anatomy of both horse and rider, and the particular emphasis on movement in the forward stride and gesture of the two figures, the flutter of drapery, and the twisting of the horse's head outward, in contrast to the stiff profile of the Uccello group. A famous parallel development in sculpture may be noted by the comparison of Donatello's equestrian statue of Gattamelata (1447) in Padua with Verrocchio's Colleoni (1468/8) in Venice.

Domenico Veneziano (Domenico di Bartolomeo da Venezia, ca. 1410-1461) is the third of this group working under the influence of Masaccio and Donatello, but with more of an interest in color. He was in all probability born in Venice, and is recorded in Perugia in 1438, when he wrote a letter to Piero de' Medici in which he requested a recommendation to Cosimo in connection with an altarpiece about to be commissioned. The assumption is that he had been well acquainted with Cosimo and, hence, probably had been in Florence previously. Vasari says that he had painted a series of famous men in the Palazzo Baglioni of Perugia, which, from the ages of the men represented, seems doubtful. Between 1439 and 1445, he is listed in the hospital records of Santa Maria Nuova in Florence as having painted frescoes of scenes from the life of Mary, including many contemporary portraits, and at the same time Bicci di Lorenzo and Piero della Francesca are listed as assistants. Here, too, for the first time, the use of oil as a painting medium is mentioned, which substantiates Vasari's comment about Domenico being the first to

use the new method in Tuscany. In 1448, he was paid for two painted *cassoni* for Marco Parenti and Caterina Strozzi. In 1455, he rented a house in Florence, and, in 1457, rendered an evaluation of a painting by Pesellino. He died May 15, 1461.

Domenico's most important work is the signed altarpiece (ca. 1445) from Santa Lucia dei Magnoli in Florence (now in the Uffizi Gallery) representing the Virgin Enthroned with St. John the Baptist and St. Francis, St. Zenobius and St. Lucy. The signature (*Opus Dnici de Venetiis Ho. Mater Dei-Miserere mei—datum est*) is inscribed on the base of the throne. All five panels of the predella have been discovered in various collections and are definitely related to the altar in style, iconography and their corresponding dimensions: the Stigmatization of St. Francis and St. John the Baptist in the Desert, in the National Gallery, Washington, the Annunciation and St. Zenobius Raises the Boy Trampled by Oxen, both in the Fitzwilliam Museum of Cambridge, and the Martyrdom of St. Lucy in the Berlin-Dahlem Museum.

Concerning the style of the altar itself, note the use of architecture and perspective to effect a balance between decorative unity and the illusion of space (i.e., the tiled floor, the triptych arrangement of the hall-arcade, the shell niches in the background, and the vegetation behind the wall used to fill out the spaces under the arches) in a manner similar, yet quite different, from the point of view of decorative unity, from Uccello's perspective. The figures, in their realism and plastic modeling, are close to Castagno and Donatello, yet have a certain softness of expression quite contrary to those forceful personalities, and more reminiscent of Fra Angelico (cf. the St. Lucy figure). Most significant is the use of light and glowing color: light used as an aid to perspective in creating the illusion of space (cf. the diagonal shadow cast from the upper right), and color used both for its recession into the third dimension and for decorative unity. Light and luminous tones of green, blue, pink and white are used in a mixed technique of oil and tempera, which, together with the love for fine detail shown in the brocade and bishop's miter, and the similarity of St. Zenobius to the figure of St. Donatian in Jan Van Eyck's Van der Paele altar in Bruges, suggest an earlier and closer connection to the Van Eycks than is customarily conceded, where Antonello da Messina is regarded as the intermediary.

The other signed work by Domenico is the fresco from the

street tabernacle of Canto de' Carnesecchi in Florence, now transferred to canvas in the National Gallery of London. It represents the Virgin Enthroned, with God-Father above, and is signed *Domicas D. Veneciis P.* on the base of the Cosmati-decorated throne. Two small fragments of heads of saints, possibly Saints Augustine and Benedict, belong to the same tabernacle (also in the National Gallery). The figures show a resemblance to those of Castagno and, considering the similarity of the God-Father motif with that of Castagno's Holy Trinity in SS. Annunziata, a suggestion as to the date (i.e., ca. 1454/5) might be given as well.

Closely associated with Domenico is the detached fresco with two saints, John the Baptist and St. Francis, in Santa Croce, Florence, which might be compared with the same pair in the St. Lucy altar. The famous feminine profile portraits in the Poldi-Pezzoli Museum of Milan and the Berlin-Dahlem Museum are generally ascribed to Domenico on the basis of their color and the delicate clarity of their profile design (cf. the profile of St. Lucy in the Uffizi altar).

The tondo Adoration of the Magi in the Berlin-Dahlem Museum is generally accepted as an early work by Domenico, and is significant as one of the earliest of the circular-shaped panels popular in Renaissance painting, as well for as its incorporation of many Masaccio (cf. the Pisa polyptych Adoration) and Fra Angelico characteristics, i.e., the composition of many figures into a romantic landscape.

Piero della Francesca (Piero di Benedetto dei Franceschi, ca. 1420-1492) begins the new generation of the Umbro-Tuscan painters which flourishes after the middle of the century and reflects an integration of the various innovations produced by the foregoing group, as well as the development of new problems.

Also called Piero dei Franceschi in the documents, he was born in Borgo San Sepolcro, now Sansepolcro, near Arezzo, probably between 1410 and 1420. Although he may have been influenced at an early date by Sienese painters working in Umbria, such as Domenico di Bartolo in Perugia and Sassetta, who was in Sansepolcro in 1437, he was certainly connected with Domenico Veneziano, with whom he is recorded at work as assistant on the frescoes of Santa Maria Nuova, Florence, in 1439. Along with Domenico's color probably

came the acquaintance with Uccello's mathematical experiments in Florence during the same period. By 1442, he was back in Sansepolcro, where he is recorded as a member of the town council, and 1451 he worked in Rimini on the Malatesta fresco. The visit to Ferrara where Vasari says he was called by Borso d'Este, and where he painted frescoes (now lost) in the castle of the Este family, and in a chapel of Sant' Agostino, probably came during this period. About this time too, although there is no document to prove the fact other than the later record of a payment for work in the papal apartment and a damaged fresco of St. Luke attributed to him in Santa Maria Maggiore, must have come the frescoes which Vasari says Piero had executed in the Vatican for Pope Nicholas V (1447-1455) and which were destroyed under Julius II. In 1454, he is again recorded in Sansepolcro, commissioned to paint an altarpiece for Sant' Agostino, for which payments continue until 1469.

A damaged fresco in the town hall of Sansepolcro, a figure of St. Louis, was commissioned by the people of the town in honor of Lodovico Acciaroli (Acciajuoli) in 1460. By 1466, the famous frescoes in the choir of San Francesco in Arezzo were finished, since they are mentioned as completed in the contract for a processional banner (lost) which Piero was to paint in oil for the *Compagnia dell' Annunziata* that year. There appear to have been several visits to Urbino during the '60s: Giovanni Santi mentions him in 1469, when he was supposed to have painted an altar for the Confraternità del Corpus Domini (1468) for which Uccello was painting the predella scenes, and which was then turned over to Joos van Ghent (1473/4).

A number of commissions from the duke, Piero's dedication of his second book to the Duke Guidobaldo and his pupil Pacioli's reference to him as *assiduo famigliare* at the court indicate the close connection between the ducal house and the artist. A number of records of lost works and service with the city council bear evidence of his continued activity in Sansepolcro. In 1487, he composed his testament, in which he refers to himself as *sanus mente intellectu et corpre* which, together with the literary and artistic activity of his later years, would contradict Vasari's statement that he became blind at the age of sixty. He was buried on October 12, 1492, in the Badia of Sansepolcro.

Two significant works of his early period are the large polyp-

tych of the Misericordia of 1445, and the votive fresco portrait of Sigismondo Malatesta (1451) in the Tempio Malatestiano (San Francesco) in Rimini. The first was commissioned by the Confraternità della Misericordia in Sansepolcro, and remains today in the Galleria di Sansepolcro. The various panels of the polyptych (painted in tempera) include figures of Saints Sebastian, John the Baptist, Andrew and Bernardino with the Madonna in the center and the Crucifixion above, flanked by the Angel and Virgin of the Annunciation and Saints Benedict and Francis. The style shows the persistent conflict of Gothic and Renaissance principles in the three dimensionally designed figures against the traditional gold background. The predella and smaller panels are inferior in quality, and were probably executed by assistants, while the Madonna, with her protecting mantle eveloping the kneeling figures about her, follows the traditional scheme (e.g., Parri Spinelli in the museum of Arezzo, or Domenico di Bartolo in the Ospedale di Santa Maria della Scala in Siena). It also shows the master's own monumental development of the adoration motif used by Masaccio (St. Peter in Cathedral).

The general character and plan of the polyptych, as well as such panels as the Crucifixion, certainly reveal a knowledge of Masaccio's Pisan altarpiece. The execution of the work began in 1445, but must have extended over a number of years, since a payment made to Piero's brother, Marco, is recorded in 1461, and a development can be followed from the Masaccio-like sculptural form of the St. Sebastian and St. John the Baptist figures at the left to the softer light enveloping the figures of St. Bernard and St. Benedict at the right. The fact that Bernardino was not canonized until 1450, and is represented here with a halo, would support the chronology. The refined character-portrayal of the kneeling figures in the center panel, and their composition in an atmosphere around the grandiose figures of the Virgin, indicate the developed style of the mature master.

The fresco portrait of Sigismondo Malatesta is located over the door of the Relics Chapel of the Tempio Malatestiano. The duke is represented kneeling with his deerhounds before his patron, St. Sigismund of Burgundy, the group placed before a broad though much-restored landscape seen through the garlanded opening between the pilasters. Interesting stylistic features are the decorative

profile arrangement of the figures leading from the dogs at the right to the enthroned saint, who, however, is twisted about to a three-quarter view while still composed into the decorative scheme, thus facing both beholder and the portrayal donor; the contrast of figures on a narrow stage against the light and distant landscape background, whereby the central portrait is framed by the Renaissance pilasters and cornice (cf. Alberti's classical designs for the same church, 1447); the luminous coloration of the prince in yellow-gold brocade with red legs against the light blue background, the similar gold brocade covered by a purple and blue mantle, and the red hat of the saint, again set off from the background. The color system and the design are continued in the contrasting pair of hounds and the medallion at the right. The coat of arms of the Malatesta appears on the cornice, a representation of their castle on the medallionlike window at the right, with an identification (*Castellum Sismundum Ariminense MCCCCXLVI*) and the year in which the castle was built. The names and signature are below: *Sanctus Sigismundus. Sigismundus Pandulfus Malatesta Pan. F. Petri de Burgo opus MCCCCLI.*

Piero's well-known profile portraits of Count (since he became Duke only 1474) Federigo da Montefeltro and his wife, Battista Sforza, were presumably painted in 1465, or at least between 1461 and 1466, when the Carmelite monk Ferabò, of Urbino had composed a verse in which he speaks of the finished portrait. They are intended as companion pieces, facing each other in profile in a manner similar to portrait reliefs on contemporary medals (Pisanello and Sperandio). A realistic peculiarity of Federigo is the hooked nose, which he had broken, as well as having suffered the loss of his right eye, in a duel with Guidagnolo Ranieri in Urbino in 1450 (cf. other portraits of Federigo by Berruguete and in Joos van Ghent's Last Supper).

The color has much of the luminous and delicate tone of Domenico's profile portraits, but Piero has introduced, as in the Malatesta fresco, a landscape in the background with recognizably Umbrian characteristics and a loose atmospheric perspective. The continuity of the panorama through both pictures indicates again their composition as a diptych unit. On the reverse side of the panels are allegorical representations of the duke and duchess seated on classical triumphal chariots drawn by white horses and unicorns and

accompanied by allegorical virtues: Federigo is crowned by Fame, and accompanied by the Cardinal Virtues, Justice, Prudence, Fortitude and Temperance, while Battista is accompanied by the Theological Virtues, Faith, Hope and Charity. The Latin verses below praise his triumph and her virtues. The inclusion of Amor and the unicorns in the allegory refers to the marriage of Federigo with Battista Sforza in 1459.

Piero's most important work, and certainly one of the great monuments of Quattrocento painting, is the fresco series depicting scenes from the Legend of the Holy Cross decorating the choir of San Francesco in Arezzo. The commission was first given to the mediocre Florentine, Bicci di Lorenzo, by the Aretine burgher, Luigi Bacci. Only a few frescoes (begun in 1447), with Gothic figures of Saints and Evangelists against a starry background, were completed by him on the vaults before his death in 1452. Piero may have begun the work soon afterward, which the close stylistic relationship with the Rimini fresco, the numerous works produced during the same period, and the long delay in the completion of the Sant' Agostino altarpiece (1454-1469) may indicate. Reasonably certain from the aforementioned commission for the processional banner is the assumption that the frescoes were finished by 1466.

In the analysis of the style it is significant to note the particular selection of scenes and their juxtaposition in an original concordance for both didactic and aesthetic purposes, as against the literary sources which Piero may have used for the Legend of the Holy Cross (i.e., the "Golden Legend" by Jacobus de Voragine, possibly the apocryphal gospel of Nicodemus, and the writings of Honorius Augstodonensis), as well as the previous fresco series of the same subject by Agnolo Gaddi in Santa Croce and Cenni di Francesco in San Francesco in Volterra (1410). On the right wall, in three superimposed fields, which are separated by painted classical cornices, appear: 1) the story of the origin of the Holy Cross, with the aged Adam sending Seth for the healing oil from the Garden of Eden and Seth's return with the branch from the Tree of Knowledge, which he plants over Adam's grave; 2) the arrival of the Queen of Sheba and her suite, her recognition of the sacred wood of the Tree in the bridge, and her reception by King Solomon; and 3) the Battle of Constantine and Maxentius.

On the left wall appear: 4) the Emperor Heraclius' humble en-

try, with the recaptured Cross, into Jerusalem, where he is met by the worshipping crowd; 5) the Empress Helena having the crosses raised from their burial place on Calvary and discovering the True Cross by the miraculous raising of the dead youth; and 6) the Battle of Chosroes and Maxentius. On the back window wall are four more scenes: the raising of the Jew, Judas, from the well after he had revealed the burial place of the crosses, and the removal of the sacred wood from the bridge to Solomon's Temple (above); and, below, the Annunciation to the Virgin, and the Dream of Constantine, with the prophecy of his coming victory over Maxentius. Not associated with the legend are several separate figures of prophets (on the back wall), St. Louis (patron of Luigi Bacci), Mary Magdalene, and a blindfolded Amor.

Instead of the Gothic narrative sequence of one scene following logically upon another, as seen in Gaddi's Santa Croce frescoes, the scenes here are freely chosen and juxtaposed for both didactic and compositional reasons. Thus, the two battles against the heathen are correspondingly placed in the lower row, the two discoveries of the sacred wood in the middle panels, and the origin and salvation of the sacred wood (i.e., the Tree of Knowledge from the Garden and the Cross returned to the Holy City) in the lunettes. Likewise, the two Annunciations are juxtaposed on the end wall, even though the Annunciation to the Virgin has no connection with the legend, a fact which frequently encourages its interpretation as a representation of the Annunciation to St. Helena of her mission to discover the True Cross. Compositional parallels may have an iconographical connection, as in the decorative prominence given to the Tree and the Cross in the lunettes, yet often have none, as in the corresponding groups of figures in that same pair, the architectural backgrounds of the middle pair, and especially the two scenes (probably executed by assistants) on the back wall with the raising of the Jew and the removal of the wood. Among the assistants who might be identified is **Giovanni de Piamonte**, whose style (signed altar in Santa Maria delle Grazie in Citta di Castello, of 1456) seems closely related. In contrast to these, the paintings of the Dream of Constantine and the Battle of Constantine appear to have been painted by Piero himself.

The general technical condition of the frescoes is not good, although heroic attempts have been made to conserve them. Large sections, particularly on the right wall, have been damaged by

moisture, and earlier restorations recently removed. Some areas, such as the richly brocaded robe of King Solomon, were painted *a secco* and are badly flaked. The figure compositions were done on cartoons, some of them transferred to the *arriccio*, others transferred directly on the final *intonaco*. Sometimes a single cartoon was used for several figures, either repeated exactly or reversed.

The style, therefore, shows a persistence of the more abstract monumental form inherited from Piero's immediate predecessors, yet is not devoid of certain emotionally stimulating qualities associated with the late Gothic painters and Domenico Veneziano. Examples are to be found in the coloration (luminous blue, light green, yellow and varying tones of purple, red and pink) and use of light in the Dream of Constantine, reminiscent of similar ''night scenes'' by Lorenzo Monaco and Gentile da Fabriano (the Birth of Christ). Similarly, the luminous coloration, in the figures and flying banners of the battle scenes, as well as in the distant landscape in the Constantine-Maxentius battle, lends a certain emotional stress to the spiritual significance of those battles (i.e., Christian salvation) already suggested in the patriotic battle scenes of Uccello. Aside from the contrasting fury of actual battle in the Heraclius-Chosroes scene, and the bloodless victory of Constantine over Maxentius, both the iconographical element of the omnipotent Cross which Constantine holds out before him and the wooden character of the fighting figures in the friezelike Heraclius composition are to be understood from this point of view.

Further characteristics are to be noted in the contrasting use of perspective in landscape and architecture to enhance the dignity of the scene (cf. the middle panels and the Annunciation of the back wall), the sculpturesque simplicity of the figures, their predominantly vertical-horizontal composition, their careful postures, reflecting both the study of actual models and possibly the influence of early classical sculpture, and their rhythmic placement in varying profile, lost-profile and *en face* positions in the space (again reminiscent of Masaccio). The classic architectural design and motifs have their analogy in Alberti's elegant designs for the renovation of the church of San Francesco into a Temple Malatestiano (1450) in Rimini, where Piero worked in 1451. The compositional use of the lances reminds one of Uccello's battle scenes, yet also has an emotional value associated with the traditional Kiss of Judas theme (cf. Giotto

in the Arena Chapel), as well as with later battle and commemorative scenes of Tintoretto and Velasquez.

In general, it would appear that Piero's interests were not devoted to the decorative unity of the chapel walls as architectural design, but rather to the inner structure of figures and forms in the illusionary space, so that iconography and form create a spiritual and aesthetic unity which transcends the architectural setting. The size (about 11 ft. x 24 ft.) of the main scenes is about the same as Masaccio's Tribute Money (about 11 ft. x 23 ft.), yet the impression of the composition being much larger indicates something of this new and heroic power.

Its meaning in historical terms might be inferred from the contemporary fear of the Turkish advance westward after the fall of Constantinople, as expressed in Pope Nicholas V's Bull of September 30, 1453, in which he called for a crusade against the Sultan Mohammed II as the antichrist. The features of the victorious Constantine are those of the Byzantine emperor John Palaeologus (cf. Pisanello's medal with the head of the emperor), with its implication of a comparable victory under guidance.

A number of separate works of undoubted authenticity are often disputed as to their chronological position in Piero's development, i.e., whether they were done before, during or after the execution of the Arezzo series. The possibility of widely varying opinions where the works are not inscribed with dates is characteristic of the highly spiritual, impersonal and carefully calculated (hence relatively constant) quality of Piero's style, compared, for instance, with the more personal style and swift development of Masaccio.

One of these works is the Baptism of Christ in the London National Gallery, which was originally the center panel of an altar commissioned for San Giovanni Battista in Sansepolcro. Two wings were added by Matteo di Giovanni in 1465. Characteristic is the vertical and sculpturesque composition of the well-modeled figures and forms, the delicate luminosity of the color laid on in thin glazes, the use of reflections and light effects carefully observed from nature, as seen in the composition of the landscape space of the background (i.e., the reflections of figures in the mirrorlike water and the recession of color values in the landscape and the clouds). The "bather" motif of the disrobing catechumen at the right is related to that used by Masolino in the Baptistry of Castiglione

d'Olona. The style indeed shows many characteristics of both Masolino and Domenico Veneziano, which has led to the assumption that it may be one of Piero's earliest works (ca. 1440-1445). However, the compositional dignity of the figures, the atmospheric perspective and the light-filled landscape suggest the period closer to the beginning of the Arezzo frescoes (i.e., ca. 1450).

Similar features, with more monumental effect, are to be seen in the fresco of the Resurrection in the main hall of the Palazzo Comunale in Sansepolcro. The Resurrected Christ was used as the traditional Patron and Protector of the city. The posing of the figures, their careful construction in space and the handling of drapery over them (i.e., the Christ) again reflects the use of wooden or clay figures as models, a procedure which Vasari describes in connection with Piero and which was probably a common practice from Uccello on. The head of the sleeping guard in the center is traditionally (Vasari) considered a self-portrait of the artist. Parallel features may also be recognized in what appears to be a self-portrait in the Meeting of Solomon and the Queen of Sheba (second figure from the left). The generally accepted date for the Resurrection fresco varies between the late 1450s and 1465.

The curious Flagellation of Christ, formerly in the sacristy of the cathedral, now in the Galleria Nazionale delle Marche of Urbino, contains a group of three standing figures in the foreground at the right, while the flagellation scene itself is thrust in the background before the enthroned Pilate. The most common interpretation of the panel has been that the figures represent the half-brother of Duke Federigo, Oddantonio da Montefeltro, standing between his two favorites and advisers, Tommaso dell' Agnello and Manfredo dei Carpi, through whose treachery Oddantonio was murdered on July 22, 1444. The original inscription on the frame, *convenerunt in unum* (from Psalms 2:2 and Acts 4:26-27), is liturgically associated with the Flagellation, and hence it was assumed that the panel was painted for Federigo as a votive picture in memory of his half-brother. The symbolism of the Flagellation is also associated with the struggles and tribulations of the Christian Church, and the use of the subject here, with the seated figure resembling the Emperor John Palaeologus, may have a connection with the fall of Constantinople to the Turks in 1453. There is, however, no proof to justify either interpretation, and the figures

may indeed represent simply those who had conspired against Christ.

Piero's signature, *Opus Petri de Burgo Sancti Sepulcri*, is inscribed on the base of Pilate's throne. The clearly defined and impressive Renaissance architectural setting is related to the Arezzo frescoes (Meeting of the Queen of Sheba and Solomon, and the Annunciation), and the work would probably be dated about that time, i.e., the late 1450s. The figures, like those of the lunette with the story of Adam, reflect many classical poses (e.g., possibly, the Marsyas figure of Myron) used alike in the marble relief of the Flagellation (ca. 1425), ascribed to Donatello, in the Berlin-Dahlem Museum.

A famous fresco with an iconographically rare motif is the Madonna del Parto in the cemetery chapel of Monterchi, near Sansepolcro. The figure itself is an interesting variation of the Madonna della Misericordia and Annunciation compositions, but would be datable near the beginning of the Arezzo series.

A similar problem in dating appears in a much more inferior polyptych in the Galleria Nazionale dell' Umbria in Perugia, with the Madonna and Child with Saints Anthony, John the Baptist, Francis and Elizabeth, an Annunciation above, and three miracle scenes in the predella (St. Anthony raises a boy from the dead, St. Francis and the Stigmata, and St. Elizabeth rescues the boy fallen in the well) and two roundels with half-length figures of St. Clare and St. Agatha. The altar came originally from the convent of Sant' Antonio delle Moinache, and had been mentioned by Vasari, who noted the angel of the Annunciation who ''seems to have come from heaven.'' The pediment with the Annunciation appears to have been cut down from a larger size. The gold backgrounds of the saints' figures would suggest an early dating, but the figures themselves are more closely associated with the saints of the Sant' Agostino altarpiece (below) and would be painted by an assistant. The date would then be about 1470.

Another problem altar is the polyptych from the Chiesa degli Agostiniani in Sansepolcro, which apparently goes back to a commission by Angelo Giovanni Simone Angeli of October 4, 1454, and for which Piero received a final payment on November 14, 1469. A center panel, probably representing a Madonna and Child, is lost, but a substitute Assumption had been painted by a follower

of Perugino; this is now in the Galleria di Sansepolcro. The saints are scattered in various museums: St. Augustine in the Lisbon Museu de Arte Antiga, St. Michael in the London National Gallery, a saint, presumably St. John the Evangelist, in the Frick Collection, New York, and St. Nicholas of Tolentino in the Poldi-Pezzoli Museum in Milan. All of these, as well as the scenes from the predella (the Crucifixion in the Rockefeller Collection, New York, St. Apollonia in the National Gallery, Washington, Santa Monica and an Augustinian monk, both in the Frick Collection) show the active participation of shop assistants.

Three other altarpieces deserve mention. One is the Madonna di Senigallia of ca. 1470 from the church of Santa Maria delle Grazie, now in the Galleria Nazionale delle Marche of Urbino. A second is the later Nativity, now in the National Gallery of London. The characteristic alignment of statuesque figures is seen in the group of angels, but there is also a loosening of the composition reminiscent of Flemish painting, particularly Hugo van der Goes. The color likewise is much more atmospheric, as seen in the landscape which seems to have a Flemish character as well as something of a development of his own landscape interests. The unfinished appearance of the painting is due largely to drastic scraping down and over-cleaning of certain areas in early restorations.

By far the most important of the later altarpieces is the Ma donna and Child, with Saints, Angels and the Kneeling Federigo da Montefeltro, in the Pinacoteca di Brera in Milan. The votive picture represents the Madonna Enthroned with four angels behind, three saints on either side (Saints John the Baptist, Bernardino of Siena, Jerome and Francis, Peter the Martyr and Andrew), and the kneeling figure of Duke Federigo at the right. It was commissioned by the duke, presumably for the high altar of San Bernardino near Urbino, in memory of his wife, Battista Sforza, who died in 1472 shortly after the birth of their son and was buried in that church. The Madonna had been assumed to be an idealized portrait of Battista, the angels portraits of four of their daughters, and the Child that of his only son, Guidobaldo.

Aside from Piero's characteristic vertical composition of figures, the work shows the continued experimental character of perspective, light and color, and forms an interesting counterpart to Domenico Veneziano's St. Lucy altar. Note the inclusion of two

fragments of the cornice in the nave before the transept, the placement of the group in the crossing before the barrel-vaulted (cf. Masaccio's Holy Trinity) choir and apse, the protrusion from the apse of the shell from which hangs a luminous egg-shaped object which catches the light coming from the left transept. To these illusionistic means of defining the space through the architectural design (cf. Alberti's Sant' Andrea in Mantua) are to be added the color relationships of the pilasters and marble designs of the back walls to the vertical figures of the foreground. The painstaking detail with which the hands of the duke and several passages on his armor are painted has led to the assumption that the Fleming, Joos van Ghent, either completed or worked over the panel.

While the luminous egg presents a technical problem, suspended as it is from the shell in the background but catching the light so that its location appears considerably forward, almost even with the head of the Virgin, it has interesting iconographical implications as well. The egg as a symbol of fertility is common in Christian iconography, but in this case the large size indicated by the scale in the space makes it that of an ostrich egg rather than the ordinary one. The ostrich as a symbol of strength and piety had been a favorite emblem of Federigo, and appears both in his palace decorations and in manuscript illuminations executed under his patronage. Ostrich eggs were frequently used in reliquaries and hung in churches as a reminder of God's grace, a symbol of the Virgin Birth as well as the Resurrection. It is the legend of the forgetful ostrich who leaves her eggs and then returns that Durandus, in his *Rationele Divinorum Officiorum*, interprets in Christian terms as man who is illuminated by Divine Light, remembers his faults and returns to Him.

Piero's literary work is composed late in life (i.e., in the 1480s), and is incorporated in two treatises: one, in Italian, on perspective (*De prospectiva pingendi*), and the other, in Latin, on five regular bodies (*De quinque corporibus regolaribus*), which was dedicated to Duke Federigo, although his son Guidobaldo, who became ruler in 1482, is also mentioned in the introduction. These writings are significant, not only as theoretical counterparts to the scientific element of Piero's style, but also as a practical handbook written for pupils, and, as such, form a connecting link between the *Libro dell' Arte* of Cennini and the notebooks of Leonardo da Vinci. Many of

these theories and methodical directions are contained in the writings of Piero's pupil, Luca Pacioli (*Summa de Arithmetica*, Venice, 1494, and *De divina proportione*, Venice, 1509), and may have been the medium through which Albrecht Dürer became acquainted with Piero's treatises.

A number of panels used as coffer decorations, with city views in carefully developed perspective, are directly related to these studies and were executed either in his shop or at least under his influence (e.g., those in the Urbino Galleria Nazionale della Marche, the Walters Art Gallery of Baltimore, the Schlossmuseum of Berlin and the Staatliche Museen, Berlin).

Melozo da Forlì (1438-1494) is the most immediate of the Umbrio-Tuscan painters influenced by Piero della Francesca. He was born in 1438 in Forlì in the Romagna, the son of Giuliano di Melozzo degli Ambrogi. Records of his life are scarce, but he is recorded in Forlì in 1460 and seems to have been associated with Piero at Arezzo, was active in Rome possible in the early '70s, and was then at the court in Urbino with Joos van Ghent while the latter was there (1473-76). Payments for the library fresco of Sixtus IV in January, 1477, indicate the work was almost finished; hence he must have been back in Rome again by 1476. On December 14, 1478, he is listed in the Roman *Compagnia di San Luca*. With the exception of several trips to Forlì and Loreto, the greater part of his later career is associated with Rome. A number of payments are listed in the records, and are indicative of the rather important position of Melozzo in Rome at the time, e.g., the work for the Vatican library, done together with Antoniazzo Romano, 1480/81, and frescoes for Cardinal Stefano Nardini of Forlì in a chapel of Santa Maria in Trastevere, 1483/84, now lost.

The origins of his style can hardly be found in the work of a local school (e.g., Ansuino da Forlì), nor in the rich Romagna tradition of the previous century, but seem to be rooted in the delicate sense of color and mathematical mastery of forms in a constructed space characteristic of Piero's style. Though there is no documentary evidence to prove that Melozzo actually worked with Piero, there is no doubt of a stylistic influence which Melozzo actually worked with Piero, there is no doubt of a stylistic influence which Melozzo developed, particularly toward the freer movement of

figures as well as the mathematically constructed space. In this sense, too, he must have had some acquaintance with the theories of Alberti and the work of Mantegna.

To Melozzo's earliest work extant belong the two canvasses, representing St. Mark as Pope Enthroned, and as Evangelist Writing, in the basilica of San Marco, Rome. They were painted (in tempera) probably shortly after 1470 for Paul II and were apparently intended as processional banners. Although there is no documentary evidence to prove Melozzo's authorship, the strict frontal and profile positions of the saint, the sharp foreshortening of perspective, the heavy contours and finely executed color and detail are basic characteristics which the artist later develops.

There is likewise no document to prove either the length of his sojourn in Urbino or the exact work which he executed, except the slight mention of him in Giovanni Santi's rhymed chronicle. The work which he did in conjunction with Joos van Ghent and the Spaniard Pedro Berruguete for Duke Federigo, probably between 1473 and 1476, is the decoration of the small *studiolo* in the ducal palace with portraits of famous men from classical antiquity and the Old Testament as well as from the Christian era. The walls of the *studiolo* were decorated on the lower level with intarsia (i.e., panels inlaid with different colored woods) based on designs frequently attributed to Botticelli, but executed by Baccio Pontelli, representing various still-life themes of books, musical instruments, architectural vistas and allegorical figures. A similar room with intarsia decorations (ca. 1476-1480), presumably designed by Francesco di Giorgio and also executed by Baccio Pontelli, from Federigo da Montefeltro's palace in Gubbio, is in the Metropolitan Museum, New York.

The twenty-eight portraits of Famous Men were arranged in two rows over the intarsia decorations, in pairs, so that the figures turned towards each other in a kind of *disputatio* (e.g., Plato and Aristotle). Fourteen of them, along with the larger panel of the seated Federigo with his son Guidobaldo, are in the Galleria Nazionale delle Marche in Urbino: Boethius, Cicero, Homer, Euclid, Bartolo Sentinati, Hippocrates, St. Gregory, St. Ambrose, Moses, King Solomon, John Duns Scot, Pius II, St. Albert the Great and Petrarch. Those in the Louvre are: Plato, Aristotle, Ptolemy, Seneca, Virgil, Vittorino, Solon, Pietro d'Albano, St. Jerome, St.

Augustine, St. Thomas, Bessarion, Sixtus IV and Dante. Two of the surviving liberal arts panels are in the National Gallery of London: Allegory of Music, with Costanzo Sforza, and Allegory of Rhetoric with Cicero (or Quintillian). The two panels of Dialectic with the kneeling Duke Federigo, and Astronomy with Ptolemy (probably also a portrait), formerly in the Berlin Staatliche Museen, were lost in World War II.

The question of the foreign artists and their participation in these various projects has been the subject of considerably discussion. Joos van Ghent (Joos van Wassenhove) was born about 1430 and came from Ghent, where he is listed in the artists' guild in 1464 and was mentioned as guarantor for Hugo van der Goes in 1467. He is mentioned in sources for the last time there in 1468. He probably stayed in Rome during the intervening years, but the first mention of him in Urbino documents (as Giusto da Guanto) is February 12, 1473, when he was commissioned by the corporation of Corpus Domini to execute a large altar panel (his most important work) with the Institution of the Holy Sacrament (Last Supper). This included a number of contemporary portraits (the duke, his son and the Venetian ambassador to Persia, Caterino Zeno). The altar was completed October 25, 1474, with the financial help of the duke. It is for this same projected altar that Uccello had painted the predella with stories of the Profanation of the Host several years before (1468/9). The altar and predella are now in the Galleria Nazionale delle Marche in Urbino. Joos seems to have been one of the most active painters at the court; how long he remained there is not known, but from the records he stayed at least until 1476, possible as late as 1480.

Pedro Berruguete was born ca. 1450 in Paredes de Navas, Valladolid, Spain, and is presumed to have worked in Naples with Colantonio, the teacher of Antonello. He is recorded here in Urbino in 1477 as *Pietro Spagnolo pittore* and reappears in Spain after 1483, principally in Toledo and Avila.

Earlier criticism had assigned most of the *studiolo* panels to Melozzo, at least in their general design with its expertly handled perspective and new developments in figure and space composition. The completion of the work was certainly carried out by Justus, who was specifically requested to use the oil medium, and Berruguete. This can be seen in varying degrees in the different panels, in the glazing of colors, the fine, painstaking detail, and the interest in soft,

space-creating light, which is characteristic of the Flemish tradition. Recent criticism, however, has assigned more of the panels to Berruguete (e.g., the portrait of Federigo and his son Guidobaldo).

Melozzo's most famous single work is the "group portrait" representing the appointment of the papal librarian Platina (kneeling), as prefect of the Vatican by Pope Sixtus IV in the presence of other court officials (i.e., standing left to right: Giovanni della Rovere, Girolamo Riario, Cardinal Giuliano della Rovere and Raffaelle Riario). From the recorded payments, it was finished in 1477, and was painted in fresco originally on the wall opposite the entrance to the library, was later transferred to canvas, and is now in the Vatican Pinacoteca.

Its composition is dominated by the impressive architectural setting, with its heavy marble Renaissance piers and coffered ceiling, in which the relative subordination of the figures to the space (i.e., less than half) is complemented by the sharp foreshortening and low point of flight and horizon of the perspective, to the dignified enhancement of both the figures and the scene (cf. similar "votive" scenes by Masaccio and Piero). Significant to the coloration is the framing of the figure group in the gold rosettes and oak branch (of the Rovere family) designs against a blue ground on the piers at the sides and the coffered ceiling, the subdued color of the background, and the strong red, blue and white coloration of the figures. Both with regard to problems of form and to its courtly, monumental spirit, the fresco is an interesting independent parallel to Mantegna's more freely composed portrait decoration of the *Camera degli Sposi* in Mantua (1468-1474).

Melozzo's frescoes in the cupola of the sacristy of San Marco, in the Basilica della Santa Casa in Loreto, were probably painted in 1477/8 at the request of Cardinal Girolamo Basso della Rovere, whose coat of arms appears in the center of the cupola. Represented are eight angels swaying upward bearing symbols of Christ's Passion, a row of cherubim above, and eight seated prophets below, each holding a *cartello* with the text of his prophecy. Of the eight scenes from the Passion intended for the walls, the representation of Christ's Entry into Jerusalem is the only one completed. It is of interior quality and was probably executed by assistants, possibly Marco Palmezzano of Forlì, who had been active in the (lost) frescoes in San Biagio, Forlì.

The figures of the Loreto cupola are significant in being the first

attempt at freely swaying figures seen from below, whose rather awkward movement and foreshortening, independent of the architectural background, are combined to achieve the illusion of space. Likewise, the use of architectural, linear perspective in a unifying space illusion over a room (i.e., in a vault or dome) is attempted here for the first time and anticipates, with Mantegna's cupola of the bridal chamber in Mantua, a long tradition of Renaissance and Baroque ceiling decoration from Michelangelo and Correggio to Cortona and Tiepolo.

A further development of this cupola illusionism through the movement of figures is seen in the fragments of an Ascension fresco, painted, probably at the request of Cardinal Giuliano della Rovere, for the cupola of SS. Apostoli in Rome and finished before the consecration of the remodeled church in 1480. These fragments—of the ascending Christ surrounded by angels in the Palazzo del Quirinale, and heads of apostles and figures of putti and music-making angels in the Vatican Pinacoteca—show a continuous experimentation with the movement of figures defined by the overlapping and recession of planes and the fluttering of drapery. Iconographically associated with this element of empathy is the use of the music-making angel, whose active playing of the instrument calls for varying positions of the figure in a manner parallel to the anatomical studies of Signorelli and the Pollaiuoli. The color is consistently light and luminous, with a suggestion of impressionistic transparency shown in the painting of the halos with dots of gold, rather than the solid, platelike forms used by Castagno.

Along with Marco Palmezzano (1458/63-1539), who had assisted Melozzo on the Loreto frescoes and was best known for the fresco decorations in San Biagio e San Girolamo in Forlì (destroyed in World War II), a second follower of Melozzo and Piero is Donato Bramante (1444-1514), who became far more important as an architect than as a painter. His most important painting is the fresco decoration (1480/2) of the Casa Panigarola in Milan (fragments now in the Pinacoteca di Brera) with over-life-sized poet and warrior figures in illusionary niches executed largely in the plastic manner of Melozzo.

Luca Signorelli (Luca d'Egidio di maestro Ventura de' Signorelli, ca. 1441-1523), as the third Umbro-Tuscan, combines the

monumental style of Piero with the new problems of movement which were developed by Melozzo and by the Florentine artists of the same period (Pollaiuolo).

Signorelli was born in Cortona, probably about 1441, since Vasari mentions his age as eighty-two when he died, even though he gives the date of death falsely as 1521 when the actual date is registered as October 16, 1523. The beginnings of his style are not to be found in Cortona, since most of the local work was executed by foreign masters (Lorenzetti, Sassetta, Fra Angelico), but are probably in Arezzo, under the influence of Piero della Francesca. Both the style of his early work and Luca Pacioli's praise of him in the *Summa de Arithmetica* as *degno discipulo* of Piero indicate that he was probably an active pupil of the Sansepolcro master while the latter was at work on the San Francesco series.

Vasari mentions a number of early works in churches of Arezzo (e.g., Sant' Agostino and San Lorenzo, 1472, and a chapel in San Francesco), which are lost. A badly damaged fresco fragment of St. Paul in Città di Castello was painted in 1474, and another fresco *staccato* fragment of the Annunciation of about the same time is in San Francesco of Arezzo. By 1475, Signorelli was in Florence for a period of years, and came under the influence of the Verrocchio-Pollaiuoli group there. Beginning in 1479, he appears to have been quite active in the public affairs of his home town, Cortona, where he was elected to various political offices and even treated with Francesco di Giorgio in Gubbio (1484) in the attempt to hire him for the building of the Chiesa del Calcinaio near Cortona.

A considerable number of important outside projects, such as the frescoes in the Sagrestia della Cura in Loreto (ca. 1480) and the fresco panels in the Sistine Chapel (1482-83), took him away from Cortona. In 1491, he was in Florence in the capacity of counsel for the cathedral façade, and he executed several panels for Lorenzo Magnifico the following year. He was in Orvieto at various times (1499-1506), working on the decoration of the Cappella Brizio, which Fra Angelico began.

In 1506, he went to Siena, where he made cartoons for a floor mosaic in the cathedral (not executed) and took part in the fresco decoration of the Pandolfo Petrucci palace (executed largely by Girolamo Genga). He was called to serve Julius II, together with Perugino, Pinturicchio and Sodoma, in Rome, in 1508/9, and he

went there again in 1513, contacted Michelangelo, but failed to receive a commission from the Pope. In 1512, he was sent to Florence as ambassador of Cortona in honor of the return of the Medici, and after the trip to Rome remained in Cortona most of the time until his death in 1523.

An example of Signorelli's early work is the signed *(Opus Luce Cortonensis)* Flagellation panel in the Pinacoteca di Brera, Milan, which gives the basic elements of his style. It shows the luminosity of color, the use of light as a means of clarifying forms in the space (cf. the shadows cast from the legs), and the monumental composition of figures as developed by Piero in the Urbino Flagellation. The exaggerated movement of the nude scourging figures reflects the influence of the Pollaiuoli brothers (cf. the engraving of Fighting Nudes, ca. 1470), and such a grandiose pose and gesture as that of the warrior at the right suggests a new figure consciousness that is developed both by Signorelli and by other masters in later work of the century. With it belongs a Madonna and Child panel in the same museum, both of which, being the same size, probably served as a pair of processional standards for the church of Santa Maria del Mercato in Fabriano and must have been painted between 1470 and 1475.

The frescoes on the walls and cupola of the octagonal Sagrestia della Cura, in the Basilica della Santa Casa in Loreto, were painted about 1480, and represent eight seated Evangelists and Church Fathers with swaying angels playing musical instruments (in the cupola), and pairs of apostles, Christ and the Doubting Thomas, and the Conversion of Paul on the walls. Compared with Signorelli's altar pictures, these are inferior in quality, which may be due to participation of assistants (e.g., Bartolomeo della Gatta). When compared with the parallel cupola decoration by Melozzo da Forlì in the sacristy of San Marco in the same church, however, the design shows a different principle, whereby the figures are subordinated to the architectural framework, composed smaller, and made to recede into the darker space behind the triangular frames, as opposed to Melozzo's more forceful and freely composed figures separated from the decorative background.

The frescoes in the Sistine Chapel were executed shortly afterward (i.e., 1482/3), and begin with the completion of Perugino's Christ Giving the Keys to St. Peter, namely, the two apostles behind

Christ and the portraits of Alphonse of Calabria, the papal representative Giovanni de Dolci, and a third anonymous figure. Thereupon follow the Testament of Moses and the Battle of the Archangel Michael with Satan for the Body of Moses (latter fresco destroyed). The designs appear to have been made by Signorelli, under considerable influence of the Florentines, while the execution, as in Loreto, was carried out with the collaboration of Bartolomeo della Gatta (Don Piero Antonio Dei). The differences between the two hands, master and collaborator, can be seen by comparing the group of men with the seated nude figure in the center, which is certainly Signorelli's, and the group of women figures next to it on the right, which appear to have been painted by Bartolomeo.

The next major fresco project appears many years later, from about 1497 until 1501, when he decorated the cloister of Monte Oliveto Maggiore, Siena, with either rather weakly composed scenes, related somewhat to the Orvieto frescoes, from the life of St. Benedict, again with considerable collaboration by assistants. The series was continued later (1505 ff.) by Sodoma.

Signorelli's most important work is undoubtedly the decoration of the Cappella Nuova (also called the Cappella di San Brizio) in the Cathedral of Orvieto. Two of the vaults, it will be recalled, were painted by Fra Angelico in 1447, with a Christ Enthroned surrounded by the Celestial Hosts of a Last Judgment. The first contract, of April 5, 1499, called for the completion of the remaining unfinished vaults; the next year (April 23), a second contract was given for the further decoration, to be executed by his own hand, of the walls with scenes of the Last Judgment, the major part of which (from the recorded payments) was completed by 1504.

The continuation of Fra Angelico's and Gozzoli's frescoes of the vaults by Signorelli included the choirs of Apostles and Angels with symbols of Christ's Passion (the cartoons for which were probably left by Fra Angelico and used by Signorelli), Church Doctors, Martyrs and Virgins. The chapel itself is of rectangular shape, and is divided into two bays covered by Gothic cross vaults, between the ribs of which (i.e., in the triangular spandrels) these groups of Christ as Judge and the Celestial Hosts are painted. On the two sides of the altar wall, which is divided by the large center window, are scenes of Heaven and Hell, with the Dantesque motifs of Charon's boat and the flaming city.

On the side walls of the first bay from the altar are larger scenes with the Crowning of the Elect (left) and the Fall of the Damned (right). Facing the second bay are two more scenes of the same size, with the Preaching and Fall of the Antichrist (left) and the Resurrection (right). Around the arch, and on either side of the doorway on the entrance wall, are the Prophecies (by David and the Sibyls) and the Destruction of the World. A series of decorative frescoes below these scenes contains framed portraits of famous men of antiquity (supposedly Homer, Empedocles, Lucian, Horace, Ovid and Virgil) surrounded by medallions in grisaille with scenes freely chosen from Virgil's *Aeneid*, Horace's *Odes*, Ovid's *Metamorphoses*, and Dante's *Purgatory*.

Those less damaged, of this lower wall, and of particular iconographical interest, are:

1. Below the Heaven on the altar wall, the scenes from Dante's *Purgatory*, IX, XI.
2. Below the Hell on the right side of the altar wall, the scenes from Ovid's *Metamorphoses*, IV, particularly Perseus and Andromeda in the center.
3. Below the Crowning of the Elect, at the left, Dante, with scenes from the *Purgatory*, II-IV, and at the right the portrait of Virgil with scenes from the *Purgatory*, V-VIII.
4. Below the Fall of the Damned, the portrait of Ovid at the left, with scenes from his *Metamorphoses*, V, and at the right, the bust of Horace and scenes from his *Odes*, Books I, III, and from the *Metamorphoses*, X.

The other scenes about the portraits of Homer, Empedocles and Lucian on the remaining walls are hardly identifiable with any of these sources.

The end wall is damaged by a seventeenth-century altar; the niche cut into the lower section of the side wall contains a fragment of a pietà fresco, and figures probably of the Orvieto patron saints, Petrus Parens and Faustinus; on the arch are medallions depicting their martyrdoms. The arches about the three windows of the altar wall contain lute-playing angels, with male saints below them (probably Saints Brizio and Costanzo), and the Archangel Michael with the scales.

In the analysis of the style, it is significant to note, first, Signorelli's apparent originality in the interpretation of content, which is not based on the traditional representation of the Last Judg-

ment (i.e., Giotto's) but seems to be developed out of a didactic, more popular religious background similar to the moralistic representations of the Trecento after the Great Plague (cf. the Triumph of Death in Pisa).

The leading theme is the story of the Antichrist, with its warning against false preachers and prophets, and the destruction of the world, as it appears in the epistles of John (I John, 2), Matthew 24, and Revelations 2: 12. Other iconographical sources are to be found in Dante's *Divine Comedy*, ''The Golden Legend'' and the *Revelationes* of St. Birgitta. Possible influences or parallels appear in the general moralistic tendencies of the time, revealed in the popular sermons (Savonarola), the mystry plays, and the graphic arts (e.g., the Lombard woodcut series of the Antichrist of 1496). The penetrating, fanatical character of the content, the stagelike compositions of the scenes, and the strong, angular design of the figures might suggest the direct influence of these sources.

A second factor has to do with the adjustment of both form and content to the given space. Fra Angelico had placed the Enthroned Christ as Judge on the vault nearest the altar wall, intending, in all probability, to subordinate the scenes of Paradise and Hell, in the lyric manner of his altarpieces, around the lower walls of the room. In Signorelli's resulting composition, the emphasis goes with compelling force on the four scenes of the side walls, arranged in a more positive concordance of opposites (i.e., the Crowning of the Elect and Damnation; Resurrection and Fall of the Antichrist), as well as the parallel juxtaposition of opposing scenes on the same walls (i.e., the Fall of the Antichrist and the Crowning of the Elect on the left wall; the Damnation and Resurrection on the right wall). The divided frescoes on the smaller end walls (Prophecy and Destruction of the World; Heaven and Hell) serve more as connecting links than as centers of concentration, as the more traditional Last Judgment would require (i.e., particularly on the altar wall). In general, therefore, Signorelli's execution is less consistent with the architectural unity of plan suggested by Fra Angelico (and developed in Michelangelo's Sistine ceiling), but is more in line with the inner compositional structure of Piero's Arezzo frescoes.

The size of the room is impressive (13.42 meters long, 11.67 meters wide, 13.90 meters high). In proportion, the figures appear relatively small, but the scenes, in their overhead position above the

high wainscoting extending into the vaults, given an uncanny impression of extended space. The action, and indeed the total expression, is carried by the figures.

Of the countless other stylistic problems and comparisons which might be pointed out in these frescoes, the following are perhaps the most important: 1) the conservative character of the designs on the vaults which shows Signarelli's respect for the original plan and attitude of his predecessor (whom he also represents, along with his own full-sized self-portrait, in the lower left corner of the Antichrist fresco); 2) the remarkable contrast of these attitudes of two different personalities and ages, both intensely religious, yet one more lyric and romantic in character (cf. Fra Angelico's romantic emphasis on the Paradise theme) and the other more drastic and dramatically realistic in his terrifying emphasis on Hell and the *dies irae*; 3) the means by which this dramatic realism is presented, namely, through the movement of nude figures, which is strengthened by a new interest in anatomy developed by the contemporary Florentines (i.e., Verrochio and the Pollaiuoli), the modeling and foreshortening of forms in the space (Uccello), and especially the composition of these forms into compact and seething masses, with much of their spirit and psychological effect noted in the battle scenes of Uccello and Piero; 4) Signorelli's continuance of architectural designs of the room into his picture (cf. the painted columns "supporting" the corbels upon which the ribs of the vaults rest), hence increasing the stagelike vista into the scenes; 5) the dramatic use of perspective, seen in the sharp foreshortening of the Temple of Jerusalem (a stiff variation of Renaissance architectural designs, possibly Bramante's or Francesco di Giorgio's) in the Antichrist scene; 6) the use of figure perspective for similar reasons, as in the forceful recession of figures (i.e., the action inward from the right and outward at the left) in the End of the World over the doorway, and the dual composition of figures in flat relief, above, and in a deeper space, below, in the scenes on the side walls; 7) the strangely cool, yet penetrating character of the coloration, with its weird lavender figures of the devils and light blue, purple, green and ochre variations based on an even gray of the total tone; and 8) the remarkable series of chalk drawings (mostly in the Uffizi, the Louvre and the British Museum) done as sketches for the Orvieto frescoes, which show Signorelli's mastery of technical problems of "nature" (i.e., the nude model) as well as his power of personal expression.

The intriguing comparison of similar themes by Signorelli and Michelangelo, such as the pose and anatomical structure of standing or foreshortened figures (Bacchus), the action of massed figures (Battle of Centaurs, Battle of Cascina) is to be interpreted less as an influence of the young Florentine on the older Signorelli, as in the case of Masaccio, but more as revealing the new and dramatic solutions, by the new generation, to common problems of the late Quattrocento.

A number of easel and altar pictures will show Signorelli's artistic development from the early Flagellation to the Orvieto frescoes perhaps better than the Loreto and Sistine decorations. The dated (1484) altar of Sant' Onofrio in the Museo del Duomo of Perugia represents the Virgin Enthroned with Three Saints (John the Baptist, Laurence and Onuphrius) and the donor Jacopo Vagnucci, Bishop of Perugia, and was originally painted for the Chapel of St. Onuphrius in the cathedral. It has much of the poetric, lyric quality of the local tradition there (i.e., Perugino), with its tall, somewhat awkward yet symmetrically composed figures. Two preparatory drawings for the saints' figures are in the National Museum of Stockholm and the British Museum.

The signed Circumcision altar panel in the London National Gallery was painted for the Chapel of the Circumcision in the church of San Francesco in Volterra about 1492. Its composition seems to be based largely on that of Piero's Brera altarpiece, but the figure group is packed more closely together in a circular arrangement against the niche of the background, rather than across the front, thus giving more prominence to the space and the action. Details such as the book and vessel, as well as the tiled floor and play of light and shade from the figures, aid in this emphasis on the stagelike space. The figure of the Christ Child, with its softer modeling, had been repainted somewhat later by Sodoma.

The chief works of Signorelli's Florentine period associated with Lorenzo de' Medici and his circle between 1490 and 1495 are the Madonna with the Child and Shepherds tondo (1490) in the Uffizi, and the so-called "Pan," formerly in the Staatliche Museen of Berlin. The first is probably the panel of the Virgin with Two Prophets (in the medallions of the frame) mentioned by Vasari as ordered by Lorenzo (d. 1492), and is interesting for its composition of the main group (horizontal and vertical, yet also composed into the circular frame) and the enlivement of the landscape background

with nude ''shepherds'' in a romantic, pastoral setting and series of poses reminiscent of Classical-Early Christian shepherd scenes. A number of variations of this theme and composition were done about the same time, notably the Holy Family in the Uffizi and the tondo of the Virgin and Child in the Alte Pinakothek of Munich.

The ''Pan as God of Natural Life and Music'' was probably the canvas which was, according to Vasari, presented to Lorenzo by Signorelli, and must have been painted about 1490. Its content is associated with both the Boccaccio *Genealogia Deorum* and Sanazzaro's *Arcadia*, as well as the Virgil commentary by Servius (*Buccolica* 2, 31), and is also related to the poetry of Poliziano and Lorenzo Magnifico himself. Pan is enthroned in the center; to the left is the figure of the nymph, Syrinx; the remaining figures represent supposedly the four phases of human life—Love (youth at Pan's feet), Art (the flute player), Active Life (the gesticulating figure beside Pan) and the Contemplative Life (the old man at the right). Characteristic of the style is the subdued coloration, the cubistic modeling of the figures, their trancelike poses and symmetrical composition similar to the saints of the Perugia altarpiece. Signorelli's signature is inscribed on the little table on the staff held by the nymph: *Luca . Cortonen.* The painting was destroyed during World War II.

With a few isolated exceptions (e.g., the remarkably strong Portrait of a Jurist in the Berlin-Dahlem Museum, ca. 1500), Signorelli does not develop beyond his Orvieto frescoes. There were few monumental projects of that size available to him, and since he was unable to compete with Raphael and Michelangelo at Rome, his later activity is confined largely to altarpieces in smaller towns (Cortona, Orvieto, Arezzo, Città di Castello, etc.). Most of these were signed by the master but executed in his shop, with the collaboration of a considerable number of assistants and pupils, including two of his sons, Antonio and Polidoro, a nephew, Francesco, and a number of unimportant others (e.g., Turpino Zaccagua, Girolamo Genga, Papcello). Characteristic examples are the Lamentation in the Museo Diocesano in Cortona (signed and dated 1512), a Crucifixion in the Uffizi, the Communion of the Apostles (signed and dated 1512) and the Nativity of 1521, both in the Museo Diocesano, Cortona.

c. Fra Filippo Lippi and His Followers

A third group of Florentine painters appears under the leadership of Fra Filippo Lippi in approximately the same generation as Masaccio and the tradition which followed him. It is fully conscious of the technical and formal innovations which those early monumental theorists had produced, yet in spirit it is more closely related to the lyric romanticism of Fra Angelico and is antecedents in the Late Gothic tradition of the Trecento going back to Agnolo Gaddi. It is aware of the large and impressive forms of Masaccio, modeled as they are with color and light in space, but it puts new emphasis on drawing and the use of line in the total design of both figure and space. Particularly characteristic, too, is a continued careful observation of nature and detail, as in Gentile da Fabriano, with a gradually increasing interest in a more humanized narrative form of representation whose romantic spirit became especially appealing to the flourishing middle classes of Florentine society. However weak as a classification, the term ''realism'' is to be understood here in the more commonplace sense of recognizable and naturalistic representation, rather than the Platonic ''realism'' of the monumental tradition.

Fra Filippo Lippi (ca. 1406-1469) is the head of this tradition, which developed through Pesellino and Gozzoli and is closely associated in spirit, as well as in patronage, with middle-class Florence and the rising Medici.

Fra Filippo was born about 1406 in Florence, the son of a butcher, Tommaso di Lippo. Like his brother Giovanni, he became a novitiate of the Carmelite Order (ca. 1420) and took his vows June 18, 1421. He is listed among the members of the order until 1431, but not until 1430 with the title of painter (*dipintore*). Vasari describes him as having painted a fresco in *terra verde* of a pope confirming the new rules of the Carmelite Order in the cloister of Santa Maria del Carmine. Various trips to Pistoia, Siena and Prato are mentioned in the records. Apparently he was not at the monastery after 1431 for some years, though as late as 1441 he is still referred to as *frate Filippo del Carmine*. In 1434, according to Marcantonio

Michiel (i.e., the *Anonimo Morelliano*) and local records of payments, he was in Padua at work on frescoes in the church of Sant' Antonio.

Back in Florence, he was commissioned by the Capitani of Or San Michele on March 8, 1437, to execute an altar for the Cappella Barbadori in Santo Spirito, which is referred to in Domenico Veneziano's letter of April 1, 1438 to Piero de' Medici offering his services to paint an altarpiece and commenting on the great amount of work which good painters like Fra Filippo and Fra Angelico have to do.

A considerable number of commissions for altars is recorded in Florentine documents during this period. Besides, he was appointed by Pope Eugene IV in 1442 to the life-long position of rector of the church of San Quirico à Legnaia, and in 1450 was made chaplain of the convent of San Niccolò de' Frieri in Florence. Having been convicted of forgery in a case of indebtedness to his assistant Giovanni di Francesco, he was removed from his ecclesiastical offices, though in 1456 he was appointed chaplain of the convent of Santa Margherita in Prato. Other complaints of a more technical nature are frequently recorded against him, such as that of Antonio del Brancha, who brought suit in 1451 for delivering a commissioned altarpiece (lost) for San Domenico in Perugia which was not executed by his own hand.

His activity in Prato began in 1452, and he was already listed as the painter of the choir chapel in the cathedral when his pupil, Fra Diamante, received the first payment for him on May 29. It was probably shortly after his appointment as chaplain that he abducted the nun, Lucrezia Buti, and he is accused in 1416 of having a child by her (although the records, probably mistakenly, name her sister Spinella as the child's mother). That same year he and Lucrezia were released from their vows by Pope Pius II. By Lucrezia, Fra Filippo had two children, the painter Filippino Lippi (b. ca. 1457) and a daughter, Alessandra (b., 1465). The position of chaplain of that convent was taken over in 1466 by Lippi's pupil, Fra Diamante.

The records reveal considerable outside activity during this same period while he was at work on the Prato frescoes: for example, in 1454, he was called to Perugia to judge the newly completed frescoes of Bonfigli; and in 1457/8, he conducted a correspondence (one letter included a pen-and-ink drawing of the proposed triptych

in an elaborate Gothic frame) with Giovanni di Cosimo de' Medici concerning an altar, probably executed in Florence, which was given to the King of Naples. In 1458, he was commissioned to complete an altarpiece (now in London) begun by Pesellino for Santa Trinità in Pistoia, which was finished the next year and praised by the Bishop of Prato as *perfetta*. Only after threats and considerable pressure from his ecclesiastical superior (Bishop Donato de' Medici of Prato) were the frescoes finally completed, with Fra Diamante's help, in 1464. The fresco project in Spoleto was taken over in 1466; the actual painting was begun in September, 1468, and nearly completed by the time of his death (burial October 10, 1469), again with the help of Fra Diamante and Filippino. The final payment was made early the following year (February 23, 1470) to Fra Diamante.

Fra Filippo's teacher and the exact origins of his style are not clear, and have been the subject of considerable discussion, but his early works reveal a quite independent handling of the various influences of Gentile da Fabriano, Masaccio and Fra Angelico. Vasari's mention of Lippi in connection with the frescoes of the cloister of Santa Maria del Carmine would strengthen his relationship with Masaccio, which is logical since Lippi, as an eighteen-year-old novitiate in the monastery, certainly knew the young master and had watched the development of the Brancacci chapel project, if he did not actually participate as an apprentice. If the frescoes, now lost except for a significant detached fragment in the Forte di Belvedere Museum in Florence, were painted by Lippi, they would have to have been completed before 1434, when he is recorded in Padua, and after February 15, 1432, when Pope Eugene IV established the new and more liberal rules of the order.

The fragment reveals a Thebaid type of theme, similar to that of Starnina in the Uffizi panel, the Life of the Hermits fresco by Traini in the Pisa Campo Santo, and Uccello's frescoes in San Miniato al Monte, with groups of figures composed into the receding space of the landscape. The figures are conceived as large and voluminous forms with a certain bulkiness in the drapery which does not seem integrated with the figure underneath. A new note appears in the lusty, round-faced smile of the monk as he looks out at the spectator and counsels the kneeling neophyte.

There are several other works of uncertain authorship which reveal many of the same characteristics, notably the Madonna of

Humility from the Trivulzio Collection, now in the Castello Sforzesca of Milan, the Madonna Enthroned with Saints and Angels in the Museo della Collegiata in Empoli, and several of the frescoes decorating the Cappella dell' Assunta (ca. 1440) in the Cathedral of Prato (notably the Birth of the Virgin, the Presentation in the Temple and the Disputation of St. Stephen; the others are by Andrea di Giusto). As a group they show a strong and individual personality certainly influenced by Masaccio and rather close to Uccello, particularly in regard to the rounded forms and the hard drawing of both heads and figures.

However, when compared to Fra Filippo Lippi's later work, beginning with his Tarquinia Madonna, these paintings reveal a remarkably different style and character which is certainly not Lippi's. They have, therefore, been grouped together under the name of the "Prato Master," although there is a strong possibility that he may be identified with Domenico di Bartolo (ca. 1400-1444/6), the Sienese painter who is mentioned by Vasari as active in Santa Maria del Carmine and who had executed a painting for the high altar there. Figures by Domenico with similar peasant features may be seen in the 1433 Madonna and Child in the Pinacoteca of Siena, and the triptych with the Madonna and Saints with the Patron in the Fitzwilliam Museum of Cambridge. On the other hand, the quality of the drawing and modeled form has suggested the attribution to Paolo Uccello.

The clearest definition of Lippi's point of view, in contrast to that of Masaccio and the "Prato Master," can be seen in the dated (1437) Madonna Enthroned, formerly in the Museo Nazionale Tarquiniese of Tarquinia (near Viterbo) and now in the Rome Galleria Nazionale, which was probably commissioned by the Florentine archbishop (1435-37), Giovanni Vitelleschi. The general scheme of the figure in the throne and space is related to that of Masaccio's Pisa Madonna, but in Lippi's composition the figures interact much more with one another, the drapery has a greater continuity that is designed with closer attention to the figure underneath, the space is more open, and the interest in the line as a particular medium of expression is especially apparent, as seen in the flow of drapery over the figure and about the head. Of concern, too, is the inclusion of recognizable details of a domestic interior and the new, more naturalistically typed features of both the Madonna and Child.

The Annunciation in the Cappella Martelli of San Lorenzo, Florence, was done a short time later (ca. 1440) for Niccolò Martelli. It is interesting in that it is a double panel divided by pilaster, yet composed as a unit, as shown in the continuity of the kneeling angel behind the pilaster and the sharply foreshortened yet unified perspective. The representation of the standing Virgin, behind the lectern, as well as the plastically modeled standing angels, at the left, reflect the large forms of Masaccio, but also show a carefully detailed architectural perspective and an intimate study of nature, as seen in the still life and garden foliage (cf. Gentile da Fabriano). The predella was added later (ca. 1447), and depicts scenes from the life of St. Nicholas of Bari.

The altar with the standing Virgin, angels and the kneeling Saints Frediano and Augustine, in the Louvre of Paris, is documented by payments from the Capitani of Or San Michele in 1437 and was originally in the chapel of Gherardo Barbadori in Santo Spirito, Florence. The predella for it is in the Uffizi and contains three scenes: The Annunciation of the Virgin's Death, the Miracle of St. Frediano reversing the current of the river Sercio, and St. Augustine pierced by arrows as he looks at the Trinity. Also significant is the unified composition of the figures and space even though the traditional triptych division of the frame is used. Note the centralized and impressive standing position of the Madonna, which is enhanced by the perspective and circular grouping of angel figures around the throne behind her, and the composition of the saints, one slightly facing out, the other turning inward, kneeling before her in the well-defined space (cf. the Trecento solution of this same compositional problem in Orcagna's Santa Maria Novella altarpiece). With these features must be noted the continued careful execution of Renaissance decorative detail, the rich linear pattern developed in the drapery, and an increasing naturalism in the depiction of character faces.

Fra Filippo's best-known and most characteristic altarpiece is the Coronation altar in the Uffizi. It was commissioned in 1441 by Francesco Maringhi, Canon of San Lorenzo, for the high altar of the Benedictine convent of Sant' Ambrogio, of which he was also prior. The final payment for the completed altar was made June 7, 1447. Its composition is a logical development over that of the Louvre altar: the triptych frame appears wider and more horizontal in its

proportions, the central group is placed further into the background, behind a row of kneeling figures, the alternating rows of angels and saints with their decorative lilies are placed diagonally on either side of the throne, rather than around it, and the centralized perspective with its relatively high eye level and point of flight takes the dominant form of a pyramid about which the figures are arranged.

Two standing saints (St. Ambrose as patron of the convent, and St. John the Baptist, patron saint of the city of Florence) receive special emphasis on either side. The other saints are, from left to right: Saints Job, Martin, Clare, Laurence, and, in the center, St. Eustace and his wife, St. Theopistes, with their two sons, St. Agapitus and St. Theopistus. Fra Filippo's own self-portrait is, presumably, the second figure at the left, with his hand supporting his chin. That of the seventy-year-old Maringhi, who died in 1441, is at the right, indicated by the scroll with the words *is perfecit opus* inscribed on it. To be noted again is the emphasis on linear detail seen in the designs of headdresses, brocades, the many garlands and lilies, and the realistic character of facial types, which leads one to believe that many of the figures are actual portraits (note especially the figures in the immediate foreground. One of the panels from the predella, representing the Miracle of the Bees and St. Ambrose, is in the Berlin-Dahlem Museum.

Parallel to the style of the Coronation, though inferior in quality, is the Madonna with St. Bernard (i.e., the Vision of St. Bernard) in the London National Gallery, concerning which payments were registered for a panel over the door of the chancellery of the Palazzo della Signoria in Florence, May 16, 1447.

The character of Lippi's later and most mature period is to be found in the Prato frescoes and a number of small house altars. The finest of these is the tondo in the Palazzo Pitti, Florence, representing the seated Madonna and scenes with the Birth of Mary and the Meeting of Joachim and Anna in the background. The picture and its date are associated with a document of August 8, 1452, in which the artist is required to complete a tondo panel with a Madonna for Leonardo Bartolini by December of that year. The style shows a certain clarification and refinement of the more realistic head studies of the earlier period into a new facial type which became almost the established norm for later fifteenth-century painters (Botticelli). Various figure compositions and poses are crystallized here for the

184

first time (e.g., the moving basket-carrier at the right). A new language is given to perspective, which may be noted in the separation of the several picture planes and spaces that recede from fore- to middle- and background, and from the right of the Virgin to the left and right again. In keeping with this, the arrangement of figures and scenes into three receding groups and the choice of genre details reveal the intimate, romantic, and narrative character of this peculiarly realistic survival of the Gothic style.

A parallel to the Pitti tondo Madonna is the Adoration of the Magi of about 1455-1458, now in the Cook Collection of Richmond, with its elaborate parade of figures stretching deep into the landscape background and composed in accordance with the circular frame. Its romantic mood and detailed interest in nature form a remarkable parallel and contrast to that of Gentile da Fabriano's altarpiece of the same subject.

The frescoes in the choir of the Cathedral of Prato (1452-1464) represent figures of the Evangelists seated on clouds before a semicircle of angels against a starry background on the vaults, and scenes from the lives of St. John the Baptist and St. Stephen on the right and left walls. These, placed on the opposing walls, are arranged in narrative concordance: in the lunettes are scenes of the Birth of John, with Zacharias inscribing his name, and the Birth of Stephen, with the abducted child being given to a bishop at the right. In the middle zone are the scenes of John taking leave of his parents, with his preaching in the wilderness, and Stephen taking leave of the bishop after having been ordained as deacon, with his disputation with the Jews. The lower scenes represent the Feast of Herod, with Salome's Dance and the presentation of John's Head to Herodias, while opposite it is the Funeral of St. Stephen. The Stoning of St. Stephen and the Beheading of St. John, and single figures of St. John Gualbert and St. Albert the Great, are on the altar wall flanking the window.

Along with Piero's contemporary decorations in San Francesco of Arezzo, Lippi's series in Prato might be considered the most important of this middle period of the Quattrocento, since the frescoes contain the basic stylistic features developed in the broad compositions of Ghirlandaio, Botticelli and the later Florentines. The significant characteristics of style can be noted first of all in the compositional and iconographical concordance, whereby the simple birth

chamber, landscape and impressive architectural settings are placed in parallel fashion in the three zones. While told in narrative sequence, the stories are also juxtaposed didactically, as were Piero's scenes of the Holy Cross legend, although Piero had disregarded the narrative sequence in the interest of monumental impressiveness.

Another comparison, which demonstrates Fra Filippo's attempt to combine both the narrative and the monumental, is with Fra Angelico's scenes (likewise from the life of St. Stephen) in the chapel of Nicholas V. It is from this point of view, together with the architectural relationship of the superimposed scenes to the beholder, that the special (compositional and iconographical) emphasis is given to the lowest scenes, namely the "climax" of John's career in the Feast of Herod scene and that of Stephen in his impressive funeral.

Further points which might be noted are the chronological sequence of execution, probably beginning with the vaults and continuing downward to the best work in the lower scenes; the persistence of Gothic featues in the gold rays and starry heavens of the vaults; the stylized architecture and landscape of the two upper pairs of scenes; the decorative realism of detail in drapery and ornamentation; the realistic portrait character of the figures, especially in the Funeral of St. Stephen; the particularly unified composition of the Feast of Herod and the Funeral of St. Stephen. The isolation of Fra Filippo's own work from that of his pupils (especially Fra Diamante) is made difficult by the long period of time over which it was painted as well as by modern restorations.

The work on the frescoes actually began in May, 1452, after Fra Angelico had refused the offer by the cathedral officials and it was turned over to Fra Filippo Lippi. The Funeral of St. Stephen is signed *Frater . Filippus opus 1460*, but the date probably refers only to this fresco, since records of activity on the project continue until 1464. The coat of arms in the center of the Feast of Herod is that of the Prato merchant Francesco di Marco Datini (d. 1410), who founded the organization of the *Ceppo dei poveri* which supported the mural project.

A number of well-known altarpieces were executed by Fra Filippo Lippi and his shop during this period. One closest to the Prato frescoes, and painted in part by Fra Diamante, is the Funeral of St. Jerome in the Cathedral of Prato that was ordered by Gemignano In-

ghirami some time before 1460, possibly for the Oratorium di San Girolamo. The patron is represented kneeling before the bier, surrounded by lamenting monks. Above are God the Father, Christ and Angels with a Thebaid-like landscape in which appear the various scenes of Jerome in Prayer, Jerome Presenting His Translation of the Bible to St. Damasus, and the Nativity at Bethlehem, to which city Jerome returned before his death.

The signed Virgin Adoring the Child now in the Berlin-Dahlem Museum, was originally painted for the altar of the house chapel (decorated 1459 ff. by Benozzo Gozzoli) in the Medici palace and listed there in later inventories. The idea of an intimate devotional scene of the Virgin Mother kneeling in adoration before the Child is related to similar motifs of Lorenzo Monaco, as is the light and delicate coloration of the figures (particularly the light blue of the Virgin's mantle), and the dark, romantic background of the forest interior. Further details of interest are the subdued perspective in the rocky background, the delicate use of decorative gold dots about the rays from the Dove, the inclusion of the infant St. John with his scroll (Ecce Agnus Dei Ecce Qu...) and staff, and the presence of a praying saint, possibly St. Romuald, suggestive of Fra Angelico's mood and coloration. On the handle of the axe in the left foreground is the signature *Frater Philippus P.*

Two variations of this composition in the Uffizi reflect this romantic mood of Fra Angelico. One is the Adoration of the Child, with Mary and Joseph, the repentant Magdalene, St. Jerome and the hermit St. Hilarion. The altar came originally from the Annalena Convent in Florence, which was founded in 1453 by Anna Elena Malatesta. It was probably painted between then and 1455, when the convent was officially confirmed by Pope Calixtus III. The other was painted some ten years later (ca. 1463), commissioned by Lucrezia Tornabuoni for the hermit monastery of the Camaldolites (founded by St. Romuald) in the Casentino. A similar Fra Angelico spirit may be found in the two lunettes, possibly an original Medici commission of ca. 1457/58, now in the London National Gallery depicting the Annunciation and a group of seven adoring saints in a kind of *sacra conversazione*.

Several other altars are related in general design to the Tarquinia and Barbadori altars. The Madonna with Saints Cosmas, Damian, Francis and Anthony of Padua, in the Uffizi, from the Cap-

pella del Noviziato in Santa Croce, was probably commissioned by the Medici family about 1450. The predella scenes belonging to it were painted by Pesellino, and are in the Louvre and the Uffizi galleries. A Madonna and Child with Two Angels panel, in the Jules Bache Collection of New York, is the center of a triptych, to which belong the two wings with the Church Fathers (Saints Augustine, Ambrose, Gregory and Jerome), in the Accademia Albertina of Turin. Finally, the Coronation altar with Four Saints and Two Patrons (Gregorio Marsuppini and his son Carlo), in the Vatican Pinacoteca, was painted for the Cappella di San Bernardo in the monastery of Monte Oliveto in Arezzo sometime in the later 1440s.

The larger concept of the Enthroned Madonna with standing saints and kneeling patrons appears in two related altarpieces, notably in the triptych Madonna with Saints Laurence, Cosmas and Damian, kneeling patrons, and wings with Saints Benedict and Anthony, in the Metropolitan Museum of New York. The altar was commissioned by Alessandro degli Alessandri, a close associate of the Medici family (hence the inclusion of the Medici patron saints), who is represented with his sons in the foreground. According to Vasari, it was originally painted for the church in Vincigliata, near Fiesole, some time in the later 1440s. Both wings and the center panel had been cut down and restored, the center panel into a tondo which was later extended again to its original format. The same scheme appears in the later Madonna del Ceppo in the Galleria Comunale of Prato, representing the Virgin Enthroned with St. Stephen and St. John the Baptist, for which a payment is recorded on May 28, 1453. The Prato merchant Francesco di Marco Datini is represented with four officials of the Ospedale del Ceppo, which he had founded and for whose house the altar was painted.

The final phase of Fra Filippo Lippi's development appears in his very last years (1468-69) in Spoleto. The decorations cover the vault of the apse in the choir of the cathedral (the Coronation of the Virgin with Hosts of Angels and Saints) and scenes with the Annunciation, Death of the Virgin, and the Nativity on the walls below it. Their chief significance is in the total architectural design and the tendency toward a new space illusionism (the Coronation in the apse vault) suggestive of the later experiments of Melozzo. The execution is largely the work of pupils, which included the young Filippino

Lippi, but especially **Fra Diamante** (ca. 1430-ca. 1498), the Carmelite monk who, aside from the extensive participation in the frescoes of Prato and Spoleto, is known chiefly for the (lost) paintings under the portico in the Palazzo Pubblico of Prato (done ca. 1470, in honor of the *podestà*, Cesare Petrucci) and figures of Popes in the Sistine Chapel in Rome (ca. 1481).

Francesco Pesellino (Francesco di Stefano, ca. 1422-1457), though lacking the imposing character of his contemporaries, represents a historically important phase of this romantic mid-century style in his combination of elements from Masaccio, Fra Angelico, Fra Filippo Lippi, Uccello and Domenico Veneziano.

Pesellino was born about 1422, the son of a painter, Stefano di Francesco (d. 1427), and grandson of the Late-Gothic Trecentist, Giuliano d'Arrighi (1376-1446), called Il Pesello, whose general style was associated with that of Agnolo Gaddi. On the death of his father, he went, at the age of five, to live with his grandfather, and probably worked as pupil and apprentice with him. He is assumed to have worked with Fra Filippo Lippi in his early twenties. He married in 1442, and his name was listed in the Florentine guild of St. Luke in 1447. In 1453, he was associated in a shop with Piero di Lorenzo di Pratese and Zanobi di Migliore. In 1455, he was commissioned, by the Campagnia della Santa Trinità of Pistoia, to paint an altar, which was left unfinished when he died on July 29, 1457. His widow, Tarsia, was sued by Piero di Lorenzo for his share of the payment, though she received the full sum the following year. In July, 1457, an appraisal was recorded as having been made by Fra Filippo Lippi and Domenico Veneziano, indicating that the picture was about half finished. The altar was then taken to Prato to Lippi's shop for completion and finally delivered to Pistoia in June, 1460.

Pesellino's most significant earlier works are the five predella scenes in the Uffizi and the Louvre which he painted (ca. 1445) for Fra Filippo Lippi's Medici altarpiece of the Madonna with Saints Cosmas and Damian, Francis and Anthony of Padua (Uffizi). Those in the Uffizi represent St. Anthony causing the discovery of the miser's heart in his money chest during the funeral oration; the martyrdom of the two doctors, Saints Cosmas and Damian; and the Nativity. Those in the Louvre depict St. Francis Receiving the Stigmata and the Dream of the Deacon Justinian. Characteristic of

the style are its lyric devotional spirit and delicate simplicity of design, similar to Fra Angelico and Fra Filippo yet with much of the modeling of form and clarity of composition of Masaccio's manner (cf. Masaccio's Berlin Adoration of the Magi). Related to these, with somewhat more of Fra Fillipo's detail, are the predella panels with scenes from the life of Pope Sylvester in the Galleria Doria Pamphili, Rome, and in the Worcester Art Museum, Massachusetts.

Pesellino's last work (1455-1457) is the altar with the Holy Trinity, with St. James Major (the patron saint of Pistoia), St. Zeno (to whom the Cathedral of Pistoia is dedicated), St. Jerome and St. Mamas, in the National Gallery, London. Various scenes from the lives of each of the saints are represented in the predella (St. Mamas in Prison with the Lions, the Beheading of St. James, St. Zeno Exorcising the Daughter of the Emperor Gallienus). These were painted in Lippi's shop. The large forms and minutely painted detail of the center panel, with its Trinity group before a hilly landscape, seem less characteristic of Pesellino, whose extant works are generally of small format; yet the general design, and much of the fine execution, seem for the most part to come from his own hand. The head and face of God-Father and sections of the saints' figures are probably done by Fra Filippo and his assitants, who completed the work.

The major part of Pesellino's career, along with that of a considerable number of anonymous painters of the same period, seems to have been taken up with an even, shoplike production of small, decorative panels representing both religious and mythological scenes. They do not necessarily reveal strikingly new or original inventions in either content or composition, and hence it is often difficult to recognize and identify a personality in the work. Since one of the main purposes of these small panels was the decoration of elaborate wooden bridal chests, or *cassoni*, of the period, the name "*cassoni* painters" is generally applied to this anonymous group, whose style is closely associated with that of Pesellino. His particular frame as a master of animal representations, used so often in these decorations, is already evident in the praise accorded him in early sources (i.e., Antonio Billi, the anonymous "*Magliabecchianus*" and Vasari).

Pesellino's best-known *cassoni* panels are those in the Isabella Stewart Gardner Museum of Boston, representing allegorical Triumphs of Love, Charity and Death, and of Fame, Time and

Religion (from Petrarch); another group with scenes from the life of David in the Fogg Museum, Cambridge, the William Rockhill Nelson Gallery of Kansas City, Missouri, and the Museum of Le Mans; and finally the two late *cassoni* with the Triumph of David, from the Palazzo Torrigiani, now in the collection of Lady Wantage, Locking House, England. The earlier panels (Boston) again reveal much of the late-Gothic love of detail in costume and landscape, yet the figures are arranged in rigid horizontal and vertical groups, a miniature form of that which was later enlarged to monumental proportions by Piero in his Arezzo frescoes. The costume and profile designed suggest Domenico Veneziano (St. Lucy altar). The later panels in Locking House, with the cavalcades of prancing horses, are more active in composition and are certainly related to Uccello's battle scenes.

Giovanni di Francesco (ca. 1428-1459), whose style is related to that of the *cassoni* painters, was recorded in the Florentine painters' guild in 1446 and was active in Lippi's workshop in 1450. He has long been identified as the "Master of the Carrand Triptych." His chief work is the triptych of the Carrand Collection in the Bargello, Florence, representing the Madonna with Saints Francis, John the Baptist, Nicholas and Peter. A predella with scenes from the legend of St. Nicholas is in the Casa Buonarroti of Florence and has frequently been associated with this triptych. Both in style and in theme, they are related to the predella scenes presumably executed in the Lippi workshop for the earlier Annunciation altar in the Cappella Martelli in San Lorenzo, Florence. His only documented work is the fresco lunette of God the Father with Angels and Martyred Innocents in the Ospedale degli Innocenti in Florence, for which he received payments in 1459. There is also a Crucifix from Sant' Andrea a Brozzi in the Seminario Maggiore of Florence, and a dated (1453) altar frontal with St. Blaise in San Biagio a Petriolo near Florence. These reveal not only the continuing influence of Masaccio and the Florentine monumental painters of the mid-century, but also a parallel relationship with this romantic-realist, almost miniature style of the *cassone* decorators.

Benozzo Gozzoli (Benozzo di Lese di Sandro, 1420-1497) belongs to the same generation as Pesellino and carries on the Lippi tradition

almost to the end of the century. Although a realist associated with the middle class narrative tastes of the Florentine mid-century, he is also related to the Gothic tradition of Ghiberti and Fra Angelico. Indeed, he, too, is often called the last of the "Gothic" painters.

Benozzo, called Gozzoli by Vasari in the second edition of his "Lives," was born in 1420 in Florence, a date which is deduced from a tax declaration of 1480 in which he was registered as sixty years of age. In January, 1444, he signed a contract to work for three years as assistant to Lorenzo and Vittorio Ghiberti, who were then at work on the second pair of bronze doors for the Baptistry. At the end of that time, beginning March 13, 1447, he was registered in Rome as assistant to Fra Angelico on the decoration of the choir chapel of St. Peter's (destroyed), and accompanied him to Orvieto, during the summer of that year, to assist in the decoration of the Cappella Brizio.

His name appeared in Orvieto several times during the next two years, and he offered (in 1449) to complete the chapel, which apparently was refused. Between 1450 and 1452, he executed frescoes in the abbey churches of San Fortunato and San Francesco in Montefalco; in 1453, he decorated the church of Santa Rose in Viterbo with nine scenes from the life of Beata Rosa, which were destroyed in the seventeenth century, but are known through the copies of 1632 made by Francesco Sabatini (in the library of Viterbo). Documents of 1452 and 1455 indicate that he was in Rome, but whether he collaborated with Fra Angelico on the chapel of Nicholas V is not certain. Another document, of 1458, refers to him as "master" at work in the Vatican on various standards and banners, very likely in connection with the coronation of Pope Pius II.

He probably went to Perugia in 1456 to execute an altar for the Collegio Gerolimiano. Then he appears in Florence in 1459, beginning the frescoes of the chapel in the Palazzo Medici-Riccardi, which were commissioned by Piero de' Medici, and concerning which several letters explaining the work were written by Benozzo to Piero at his Careggi villa during the summer of that year. After the completion of these, he went (in 1463) to San Gimignano, where he remained for four years at work on the decoration of the choir of Sant' Agostino. The extensive fresco series along the north wall of the Campo Santo in Pisa took from 1468 to 1484, with one interrup-

tion—in 1483, when he went to Rome to decorate the chapel of Cardinal d'Estouville in Santa Maria Maggiore (frescoes now destroyed). A number of minor works were executed during his last years (the Cappella della Tosse of 1484 in Castelfiorentino, the tabernacle of 1483-1486 for Santa Maria in Borgo), and he died on October 4, 1497, in Pistoia.

Aside from the decorative and sculpturesque discipline which he may have derived from his apprenticeship with Ghiberti (cf. Uccello's earlier apprenticeship with the same master), Benozzo's early style is largely under the influence of Fra Angelico. However, a close examination of details in the Rome and Orvieto frescoes in which Benozzo assisted will reveal a marked difference, which can be seen in the harder modeling and stiff, more realistic characterization of figures and the detail of the Renaissance architectural backgrounds (cf. scenes in the Nicholas V chapel: the women at the left of St. Stephen Preaching, the mother and child in St. Laurence Distributing Alms, or the head of Decius in the scene of St. Laurence before Decius).

Likewise, comparison of Benozzo's chief altarpieces with those of Fra Angelico will show something of the latter's characteristic devotional lyricism, which then seems dissipated by an increasing emphasis on decorative and realistic detail in the more literal manner of Lippi. This can be observed in such altarpieces as the polyptych of ca. 1450, given to Pope Pius II by the town of Montefalco, now in the Vatican, representing the Virgin giving the Girdle to St. Thomas, and six predella scenes from Her Life; and the fresco (done shortly afterward) with St. Anthony of Padua and two kneeling donors, in the church of Santa Maria d'Aracoeli, Rome, which was originally a part of an elaborate decoration of the Cesarini Chapel in that church. Others would include the dated (1456) altar with the Virgin and Kneeling Saints (Peter, John the Baptist, Jerome and Paul) executed for the Collegio di San Gerolamo in Perugia at the request of its founder, Benedetto Guidalotti, and now in the gallery there; the Virgin and Child Enthroned with Angels and Saints, now in the National Gallery of London, commissioned by the Florentine Compagnia di San Marco in 1461; the altar of 1466 of the Virgin with the Marriage of St. Catherine and accompanying saints, in the Pinacoteca of Terni, signed and dated on the pedestal of the throne: *Opus Benotii de Florentia MCCCCLXVI;* and the signed altar of the

same year, representing the Madonna and Four Kneeling Saints, in the Collegiata of San Gimignano.

Gozzoli's activity in Montefalco began late in 1449 with a Madonna and Saints in the portal lunette, another on the inside right wall, a San Fortunato Enthroned, and the high altar mentioned before, all probably executed in 1450. The frescoes in the choir of San Francesco depict twelve scenes from the life of St. Francis, arranged in three superimposed rows. On the vaults and about the window are figures of illustrious Franciscan monks, dominated by a St. Francis in Glory; below the window are medallion portraits of Petrarch, Dante and Giotto (the latter with the inscription, *Pictorum Eximius Iottus Fundamentum et Lux*). A scroll on one of the pilasters contains an inscription which names the Franciscan Jacopo da Montefalco as the commissioner, Benozzo as master, and the date, 1452. The decorations in the St. Jerome Chapel in the same church, also done in 1452, contain a fresco polyptych on the altar wall, with a Virgin and Saints, flanked by scenes from Jerome's life (his flight from Rome and his extraction of the thorn from the lion's paw), and the Crucifixion with kneeling monastic saints (including Francis, Dominic and Jerome). On the vaults appear God-Father and the four Evangelists, and the inscription below the Crucifixion gives the date of completion as November 1452; hence, it was probably painted after the choir frescoes.

Aside from being Benozzo's first independent attempts at extensive full-sized mural decoration, they are badly damaged and repainted, and their artistic quality is difficult to judge. However, the comparison of these frescoes with those of Fra Angelico (San Marco and the Nicholas chapel) and Giotto (Assisi), whom he expressly honors with a portrait, reveals not only a certain spiritual sterility as against Angelico's lyric expressiveness, but also the suggestion of a new approach, from this somewhat realistic point of view, to an old problem of a monastic inspirational style (cf. Giotto's Franciscan series in Assisi, Andrea da Firenze's Dominican series in the Spanish Chapel, that of Fra Angelico in San Marco). The tendency to ''decompose'' both the composition and the content into apparently unrelated genre detail is thus a parallel to the same character noted in Fra Filippo Lippi's tondo with the Virgin in the Galleria Palatina, painted the same year. It shows much the same attempt at a narrative enrichment of content presented in monumental

194

form, instead of its subordination to predella scenes in Fra Angelico's altarpieces (cf. the scene depicting the Miracle of Greccio).

Benozzo's best-known work is the fresco decoration of the palace chapel in the Palazzo Medici, which was begun for Cosimo by Michelozzo (1396-1472) in 1444. The room itself is small, rather awkwardly proportioned, with a high ceiling and an extended altar-alcove at one end. The altar was originally adorned with the Nativity panel by Fra Filippo which is now in the Berlin-Dahlem Museum. The panel with the same subject in its place today is an early copy attributed to Neri di Bicci (1418-1493). The frescoes on the two walls of the alcove immediately facing the altar contain choruses of angels kneeling in adoration, standing and singing, gathering flowers in the verdant Paradise-landscape and enlivening the clouds and skies above. The three Magi, each with his respective cortege, are divided on the three remaining walls of the chapel, which, though separated, are composed together before a richly vegetated landscape panorama. The long cavalcade approaches from the distance over the hills at the right (i.e., when facing the altar), proceeds around the walls of the room, and departs again upward into the mountainous background of the left wall. On the remaining walls over the door-ways flanking the choir, which were originally the only entrances into the chapel, are two narrow fresco scenes with shepherds tending their flocks. Aside from the damage caused by the addition of windows and doorways, and the breaking of the walls at the left to make room for a stairway which cut the mounted patriarch in half (done in the seventeenth century, when the palace was taken over by Riccardi), the frescoes are in a remarkably good state of preservation, from the point of view of both color and general ensemble.

A number of observations will indicate something of the significance of the murals as historical documents of this distinctly Medicean age in Florence. In keeping with Benozzo's realistic characterization of faces, and his rich courtly costuming of figures, tradition has identified a number of them as actual portraits. Thus, the young king on a white horse approaching on the right wall is assumed to represent Lorenzo de' Medici; behind him, also mounted, is the aged Cosimo with Piero and Giovanni de' Medici. Benozzo's self-portrait is the only clearly identifiable, set back in the crowd at the left with the signature, *Opus Benotii*, on his cap. The

brilliantly robed king dominating the wall opposite the altar is identified as the Byzantine Emperor, John Palaeologus (cf. the medal by
Pisanello with profile portrait of the same emperor), the bearded
dignitary mounted on a mule in the third fresco as Joseph, Patriarch
of Constantinople. These identifications, together with the oriental
costumes (John Palaeologus and the decorative animals (e.g., the
cheetahs), may associate the murals with the famous occasion of the
Ferrara-Florentine Council of 1439, to which the Eastern Emperor
and Patriarch journeyed with great pomp to confer with Western
potentates in the attempt to unite the two churches and Christian
civilizations against the Turks.

Other comparisons may be noted in the relationship with Late
Gothic Adoration scenes (Gentile de Fabriano) whereby the
elaborate cavalcade of noble personages (cf. also those in the Trecento Triumph of Death in Pisa) is expanded by Benozzo in a more
worldly, impressive manner about three walls, with the object of
their adoration (i.e., the Virgin and Child) a separate entity in the
room, as an intimate devotional focal point for both the beholder and
the figures represented on the walls. The idea of such a festive and
courtly parade was a common fifteenth-century institution, such as,
for example, the festival presented on May 1, 1459, by Piero de'
Medici for the reception of Pope Pius II and Galeazzo Maria Sforza.
The landscape background has many characteristic Gothic stylizations, yet is a realistically recognizable view of the surrounding Arno valley, richly enlivened with plant and animal detail, particularly
hunting animals, which again are associated with the familiar Gothic
theme of nobility and the chase. Many of the architectural
monuments have been recognized, such as the many-towered town
of San Gimignano (left wall), the Medici castle of Cafaggiolo (right
wall) and the Medici villa of Careggi. The group ''reliefs'' of standing and singing angels are parallels to the sculptured reliefs of
Donatello and della Robbia.

As decorations, the murals have much of the luminous quality
of a tapestry, with the high horizon of the landscape, the filling in of
spaces with detail (cf. the tall cypresses, clouds and angels that cover
up open patches of sky), the general subdued coloration, in keeping
with the darkness of the room, and the particular emphasis on the
sparkle of gold and bright color in the trappings of the figures which
are composed into this subdued tapestrylike coloration. The com-

parison and analysis of the earlier (1432) Ghent altar by Jan and Hubert van Eyck with these various factors in mind will reveal many similarities and differences, which are of interest with regard both to iconographical motifs and to problems of "Renaissance" and "Gothic" in Italy and the North.

The decoration of the choir of Sant'Agostino in San Gimignano contains seventeen scenes from the life of St. Augustine. They were probably begun in 1463; the eleventh fresco (Augustine's Baptism by St. Ambrose) is dated April 1, 1464; and the seventh fresco, with Augustine's Departure from Rome, has an inscription with Benozzo's name, that of his patron, Fra Domenico Strambi, and the date, 1465.

Stylistically, the series shows a development of the more genre type of narrative seen in the Montefalco frescoes, but enhanced, in somewhat more dignified fashion, by conscious arrangements of figures and settings. Where the Medici Chapel seems influenced by the decorative pageantry of Fabriano, these involve more complicated problems of perspective and figure foreshortening in the manner of Mantegna. The seventh scene, for instance, of Augustine departing for Milan, is an arrangement based on the Medici series, but more simply composed, and framed in more' monumental fashion by standing figures on either side. The sixth scene, representing Augustine Teaching Philosophy and Rhetoric in Rome, reveals this same arrangement of standing figures on either side with seated figures around the enthroned Augustine in pyramidal composition (cf. Fra Filippo), yet the pair at the left is placed before the seated pupils, while that at the right is placed behind, in order to unbalance the composition in the narrative left-to-right continuity of the series, and still preserve a centralized grouping.

As contrasted with the Medici frescoes, the perspective of architecture and landscape here serves more to increase the dignity of the figure group (note the adjustment of the architectural designs, i.e., the niche, pilaster, and spaces between them, to accent the figures) rather than to draw the spectator's attention into an illusionary distance or relate the figures dramatically in that space (cf. also the Funeral of St. Augustine). The interest in classical decorative motifs (e.g., the pilasters, medallions, putti, etc.) is again a pronounced feature characteristic of the period.

An interesting votive fresco of St. Sebastian as Protector of the

People was painted during the plague of 1464 for the altar of that saint in Sant'Agostino, San Gimignano. St. Sebastian is represented standing on a pedestal, his cloak held by angels to protect the crowds of kneeling inhabitants of San Gimignano (cf. other variations of this same motif, e.g., Piero's Mater Misericordiae in Sansepolcro) and to catch the arrows of God's wrath directed against them. God the Father is represented above in the act of loosing the arrows of punishment; before Him kneel the Saviour and the Virgin, who intercede in behalf of the sinners below. The composition has many features (i.e., the upper half) associated with the traditional Last Judgment, and its combination with a semi-realistic votive theme and content is characteristic of this particular group of artists.

The greater part of Benozzo's later life was taken up by the decoration of the north wall of the Camp Santo in Pisa with some twenty-five large fresco scenes (badly damaged in World War II), mostly from the Old Testament. The payments began January 9, 1469, and are recorded almost regularly until May 1, 1485, to a number of otherwise unknown assistants as well as to himself. (Noah's Drunkenness, 1470; Curse of Ham, Tower of Babel, 1471; Abraham and the Priest of Baal, 1472; Abraham's Journey to Egypt, 1473; The Fall of Sodom, the stories of Isaac and of Jacob, 1474; then the two frescoes with the story of Joseph, 1478; from 1479 to 1482, the stories of Moses, ending with the Brazen Snake; the last scenes with Joshua crossing the River Jordan, David and Goliath, and the Visit of the Queen of Sheba to Solomon, paid for in 1485). The style continues the emphasis on detailed genre scenes in large format, the splitting up of figure compositions and space perspective in accordance with the separate episodes of the story in a manner closely resembling the late Trecentists about Agnolo Gaddi and the pre-Renaissance painters of Florence.

d. Florentine Painting of the Later Quattrocento

Alesso Baldovinetti (1425-1499) is the oldest of a new group and generation of artists that make up a curiously heterogeneous, yet recognizable, style of the late Florentine Quattrocento, and out of which Leonardo da Vinci develops as the leading creative personality of the High Renaissance. Psychologically, the art appears to be rooted in the tradition of Fra Filippo Lippi and the Realists; its

realism, however, tends toward a deeper understanding of nature and its organic structure as a means of artistic expression. To this end, the artists make use of the scientific experiments which Masaccio and the early Florentine monumental painters produced, but they do not lose sight of the emotional quality of Fra Angelico nor of the necessity for comprehension and the more human, natural appeal which the broader base of middle-class patronage required. In view of this complex and many-sided situation, the tendency among the artists is to specialize in particular problems in a manner similar to the early Quattrocento without, however, the sense of monumental form and dignity which accompanied that first contact with "nature" and the classical tradition.

Baldovinetti was born in Florence, probably on October 14, 1425 (from tax declarations and the note in Francesco Baldovinetti's *Memoriale*), and is entered in the Florentine guild of St. Luke in 1448. Aside from his *Ricordi*, or journal, which began in 1449, there are few documentary records of his life. Apparently from the above-mentioned memoirs of a relative, Francesco Baldovinetti (1477-1545), he came from a respected patrician family that is traceable to the early thirteenth century in Florence between 1448 and 1453, but there is no factual evidence to prove he was actually a pupil or assistant of Fra Angelico, who was there in 1449-1453 and had directed that project. In 1454, he took over a contract from Castagno to paint an Inferno in Santa Maria dei Servi, Florence (lost).

A number of works were executed in Florence after 1460, including the fresco of the Nativity in the cloister of SS. Annunziata (1460-1462), the completion of fresco scenes from the life of Mary in Sant' Egidio (1461, begun by Domenico Veneziano, the fresco decoration (an Annunciation, Prophets, Evangelists and Church Fathers) of the burial chapel of Cardinal Jacopo di Lusitania of Portugal (d. 1459) in San Miniato al Monte (1466-68), the altar for Sant' Ambrogio, and an extensive project for Santa Trinita begun in April, 1470, at the request of Bongianni Gianfigliazzi. This latter included the Trinity altar in the Accademia, and a series of frescoes for the choir, in which Vasari speaks of a "Meeting of the Queen of Sheba and Solomon" and a number of fine portraits (total fresco destroyed except for four damaged prophet figures). According to his journal, Baldovinetti had executed many designs for stained glass

windows and mosaics, such as stained glass windows for San Martino in Lucca and Sant' Agostino in Arezzo (1481). He is also recorded as active on mosaics (lost) on the façade of the Cathedral of Pisa (1461), the restoration of those in San Miniato al Monte (1481, 1483), and the Baptistry of Florence (1491). He died August 29, 1499, and was buried in San Lorenzo.

The three panels in the Museo di San Marco, Florence, were painted ca. 1448 for the cupboard doors in the sacristy and represent the Baptism of Christ, the Transfiguration and the Wedding at Cana. At first glance, they suggest the lyric stylization of Fra Angelico, but closer examination reveals a certain spiritual indifference (note the lower figures in the Transfiguration) and a particular interest in color problems closely related to Domenico Veneziano. This interest seems to be largely technical in character, as is shown in the rich luminosity of local color and various notes in his journals on experiments with oil as a medium.

The two panels in the Uffizi, representing the Virgin surrounded by Saints and the Annunciation, were probably executed between 1455 and 1460 and include stylistic elements of both Fra Angelico and Filippo Lippi. The former panel comes from the Medici villa of Cafaggiolo, and includes the favorite Medici patron saints: St. John the Baptist, Saints Cosmas and Damian, St. Anthony Abbot, St. Francis, St. Peter the Martyr, St. Julian and St. Laurence. In it can be recognized various design ideas, such as the brightly colored carpet upon which the Virgin is seated, the arrangement of kneeling figures in lost profile as a means of producing the space illusion, the accompaniment of standing saints on either side of the Virgin before a tapestry, with cypresses and vegetation decorating the sky above it, which are all related to similar altarpieces by Fra Angelico. The more intimate and naturalistic character of Lippi's art is reflected in the fact that the Madonna is seated among the conversing saints rather than enthroned, and in her rather motherly attitude of adoration toward the Child in her lap (cf. Piero's votive altarpiece in the Pinacoteca di Brera). A variation of the central group is the three-quarter-length Madonna and Child before a landscape, now in the Musée Jacquemart-André in Paris.

The Annunciation is a large panel, painted about the same time for San Giorgio sulla Costa in Florence. In many ways it seems to be a correction of Lippi's altar of the same subject in San Lorenzo and a

development of Domenico Veneziano's St. Lucy altar: the background is divided off into flat planes of flowers, garden wall and cypresses; the principals of the scene are framed by the arcades; the total proportions of frame, figures and architecture are lengthened into a more vertical composition; and the scene itself is given new life by the emphasis on movement, as can be seen in the inward rush of the angel and the responsive gesture of the Virgin, while at the same time retaining the dignified vertical pose of the figures.

The damaged fresco of the Nativity in the Chiostrino dei Voti of SS. Annunziata, executed 1460/62, is significant in its subordination of figures to the setting and landscape: the Child lies on the ground, the Virgin adoring Him (as in Lippi's Nativity), while shepherds are approaching at the right. A certain monumental effect is given in the contrast of the towering tree and ruins of the immediate foreground with the distant landscape, which seems to be a direct representation of the Arno Valley. The unified tone and recession of the color suggests, again, the influence of Domenico Veneziano and the parallel of Piero della Francesca. Related to this composition is the mosaic of inlaid wood (intarsia), representing the Nativity, in the sacristy of the Cathedral of Florence, executed by Giuliano da Maiano after Baldovinetti's designs of 1463.

Perhaps Baldovinetti's finest and best-preserved single panel, done about the same time (ca. 1460), is the Madonna Adoring the Child, now in the Louvre, Paris. The motif of a personal and intimate adoration is a variant of that noted in the Cafaggiolo and Jacquemart-André Madonnas, but formalized in new sense by the placement of the seated figure behind a balustrade on which the Child rests. The background is open, but, in contrast to the similar figure-and-landscape compositions of Piero and other contemporaries, the color here has a more delicate and luminous quality, a tonal unity and technically more detailed execution.

The fragments of later works are of inferior quality and in bad state of preservation. A major project was the decoration of the Portuguese Chapel in San Miniato al Monte, Florence, which was designed in 1460-1466 by Antonio Manetti for the tomb of the Cardinal of Portugal (d. 1459). Baldovinetti's frescoes (1466-1473) include an Annunciation on one wall, with figures of Evangelists and Church Fathers in the spandrels of the square vaulted chapel. From Vasari's account, the frescoes (begun 1471) in Santa Trinita of

Florence must have been his major and most impressive work; their high quality, however, can hardly be discovered in the ruined fragments of prophets still extant. The same is true of the very realistic and heavily composed Holy Trinity with St. Benedict and St. John Gualbert panel of 1470-1471, now in the Accademia of Florence, which was painted for the high altar of the Gianfigliazzi family chapel in Santa Trinita. The altarpiece representing the Madonna with Saints and Angels, in Sant'Ambrogio, Florence, was commissioned by the prior, Domenico Maringhi, in 1469, for the high altar of that church. A hole was originally left in the center of the panel for a receptacle of relics. Payments were made in 1484 to Baldovinetti's pupil, Graffione, who is probably responsible for the center group of the Virgin Adoring the Child, painted in to fill up the opening.

The Pollaiuoli (Antonio, 1429-1498; Piero, 1443-1496) represent not only a new phase in the development of realism, with their concentration on the anatomical structure and decorative movement of the human figure, but also a new correlation of the various arts on a shop basis, which included the execution of sculpture, goldsmith work, textiles and engraving, as well as painting and design.

Antonio Del Pollaiuolo (Antonio di Jacopo d'Antonio Benci del Pollaiuolo) was born in Florence, probably on January 17, 1433. The date of his birth is derived from a cadastral declaration of 1457 made by his father, Jacopo, in which the ages of his sons are given, though the inscription on his tomb in San Pietro in Vincoli, Rome, indicates a birth date some five or six years earlier. According to Vasari, he learned the goldsmith's craft from Bartoluccio's stepson, Lorenzo Ghiberti, and Vittorio Ghiberti, on the later bronze doors of the Baptistry. It is reasonably certain that he worked as a goldsmith in the shop of his father, Jacopo d'Antonio (ca.1399-1480). In 1459, together with Pietro di Bartolommeo Sali, Antonio opened a shop on the Via Bacchereccia near the Ponte Vecchio. Benvenuto Cellini mentions his association with Maso di Finiguerra, for whom Antonio had executed designs for metal work.

Apparently, Antonio's activity as a painter developed in close association with the goldsmith work in the same shop. In 1473, he is recorded in the *Compagnia di San Luca* as a ''goldsmith and

painter.'' In a letter of 1494, he mentioned three large canvases, representing the Deeds of Hercules, which he had painted thirty-four years before for Lorenzo de' Medici, and on which he was assisted by his younger brother, Piero. A number of documents indicate that he lived in prosperous and highly respected circumstances: he bought houses and property in Quarata, near Pistoia (1467), in San Michele Berteldo, and in Florence (1481), and a vineyard at Castello. In Florence, his name appears at the head of the list of painters in 1472; he served on a commission to estimate the value of the metal ball on Brunelleschi's cupola on the cathedral (1468); and he was requested to value the reliquary made by Jacopo da Pisa for San Gimignano in 1481.

With his brother Piero, he went to Rome in 1484 for the purpose of executing the bronze tomb for Pope Sixtus IV. Afterwards, he took part in the competition for the façade of the Florentine cathedral (1491), and a letter of 1494 mentions a commission he had accepted to execute a bronze bust of the *condottiere* Gentile Virginio Orsini, and proposes to do in its stead a bronze equestrian statue of the same man. Whether it was executed or not is not known. The last work is the tomb of Pope Innocent VIII, completed shortly before Antonio's death (February 4, 1408). He was buried with his brother in San Pietro in Vincoli, and the monument with their portraits was done by Andrea Bregno. A cadastral declaration of 1480 mentioned a first wife, Marietta; his testament of 1496 gives a second wife, Lucrezia Fantoni, and two daughters as heights. On February 14, only a few days after his death, the Signoria of Florence charged its representative in Rome, Domenico Bonsi, to collect outstanding debts due on commissions in the interest of the surviving family of this *celeberrimo scultore.*

The importance of Antonio's bronze and goldsmith work lies in its origin as a minor art (parallel to the *cassoni* paintings) produced on a shop basis to suit the decorative idiosyncrasies and the sophisticated taste of a wealthy urban society, and in his development of it to new and monumental proportions. This can be followed in the chief sculptures still extant, which were designed and executed by Antonio: the base of the Crucifix reliquary from the Baptistry of Florence, now in the Museo dell'Opera, done in 1457-1459 in collaboration with Milano di Domenico Dei; the small bronze group of Hercules and Antaeus in the Museo Na-

zionale del Bargello of Florence, executed probably before his departure for Rome in 1484 and listed in the Medici inventory of 1494; the terracotta bust of a youthful warrior, also in the Bargello; and the bronze tombs of Pope Sixtus IV (executed 1484-1493) and Pope Innocent VIII (1494-1498), the former in the Grotte Vaticane of the Vatican, the latter in St. Peter's.

Of these, the tomb of Sixtus is the most significant, with its expressive and realistic head, its use of a more monumental catafalque form, rather than the traditional flat grave plaque, its rich allegorical program in the reliefs representing the seven Virtues and ten Liberal Arts, and, above all, the technical perfection of the bronze high relief decorating the tomb. The tomb of Innocent is less effective, but it is interesting as the first example of a wall tomb with the figure of the deceased appearing as alive and enthroned in a niche above the sarcophagus, his hand raised in blessing. The face of the reclining figure appears to be taken from a death mask. Another phase of this development is to be inferred from Antonio's desire to execute an equestrian state of Orsini, and the designs for a similar statue of Francesco Sforza, which Vasari mentions and with which the drawing in the Munich Staatliche Graphische Sammlung is sometimes associated (cf. the equestrian figures of Verrochio and Leonardo).

The famous copper engraving of Ten Fighting Nudes is perhaps the best single work in which to study Antonio's style. Note the figures composed in two layers before a thickly vegetated, tapestry-like background, the two in the center almost symmetrically arranged with one arm upraised wielding a sword, the other grasping a chain over which they appear to be fighting, in poses similar to Piero della Francesca's Flagellation figures in the Urbino panel. The other pairs to the left and right in the foreground, and the four across the background, show the stylization of movement into a decorative pattern, whereby the action or battle itself is absorbed in the abstract pattern (note the comparative insignificance of the chain, as a focal point over which the warriors are supposed to be fighting). The anatomical structure of the figures, while probably based on the actual dissection of cadavers, shows an artistic exploitation of the muscular forms into similar decorative patterns; their design is an interesting contrast to the later nudes of Signorelli (Orvieto), in which the muscular planes are used in the movement of forms in three dimensions rather than the surface movement as given here.

The engraving is the only signed one (*Opus Antonii Pollaioli Florentini*). A number of variations based on Antonio's designs are to be found in engravings by Lucantonio degli Uberti and Johannes de Francfordia (woodcut).

This analysis of anatomical form in the interest of a new decorative movement through the human figure is the chief feature of Antonio's painting. Especially noteworthy are the damaged frescoes of dancing nudes in the Villa la Gallina at Arcetri, near Florence, which were probably painted soon after the purchase of the villa by the Lanfredini (one of whom, Giovanni, was known to have been a friend of Lorenzo de' Medici) in 1464. Not only the decorative movement, but the genrelike motif itself, of nude dancers, seems related to antiquity, possibly Greek vase paintings or sculpture, as well as to Donatello's dancing putti on the pulpit of Prato or the *cantoria* in the Museo dell'Opera, Florence. The three canvases, representing the Deeds of Hercules, done by Antonio for the Medici palace in 1460, must have been on the same order as these, and represent development, both in style and in iconography (i.e., the classical theme), of the battle-scene decorations executed by Uccello only a few years before the same palace.

A characteristic interest in the small format related to the so-called minor arts (engraving and goldsmith work) may be noted in the small size and miniaturelike color and execution of the two Hercules panels in the Uffizi (Hercules Killing the Hydra, Hercules and Antaeus, this latter being related to the bronze group in the Bargello). These two, together with a third (lost) panel of Hercules and the Numidian Lion, may possibly be small variations of the large canvases which he had painted in 1460 for Lorenzo de' Medici, and must have likewise been done in the early '60s. Again it is a battle theme, expressed through muscular nude figures and distorted grimacing faces. The Hercules Killing the Hydra, especially, with the decorative swing of the best, the lion's skin, and the pose of Hercules himself (cf. the central figure of the Fighting Nudes engraving) shows the particular elasticity and strength of expression of which Pollaiuolo's design is capable. In keeping with the practice of his contemporaries (i.e., Baldovinetti and Piero della Francesca), the figures are placed before a broad valley landscape. The coloration is extremely fine and detailed, with an emphasis on luminous local color patches reminiscent of the miniaturist.

Several other well-known panels, certainly executed by Antonio himself, reveal interesting variations of these problems. The Apollo and Daphne, now in the National Gallery of London, was painted in the 1460s, probably for the small end of a *cassone*. Not only are its detailed execution, its movement and its elaborate design characteristic, but it already suggests a certain identification of Christian and Pagan iconographical themes on the basis of common artistic problems (cf. the elements of movement in figures and the unified design noted in Baldovinetti's Annunciation in the Uffizi). Another pagan variation of this is the Abduction of Deianira, formerly in the Jarves Collection, now in the Yale University Art Gallery, New Haven.

The Martyrdom of St. Sebastian (National Gallery, London), painted in 1475 for the Cappella Pucci in SS. Annunziata, Florence, is a larger panel whose six figures of executioners, grouped in varying poses about the saint, reveal not only the more stylized design of Antonio's later work, but also a more narrative elaboration of the theme characteristic of Lippi, whereby the action of the figures in the space is used as the means of their unified composition. Its color is less local and detailed, composed on a more unified tone of the brown underpainting, with a greater illusion of space through aerial perspective (note also the high horizon). The David in the Berlin-Dahlem Museum, an early work, offers an illuminating stylistic comparison with similar themes and figure-poses that form part of the Florentine tradition through the Quattrocento (cf. Donatello's St. George, Castagno's Pippo Spano, the David statues of Donatello, Verrochio and Michelangelo).

Less forceful in execution, but stylistically well-authenticated, at least with regard to the Pollaiuolo shop, is the early altar panel, with the Communion of St. Mary Magdalene, in the Palazzo Vescovile of Colle Val d'Elsa, which shows particularly the strong influence of Castagno. The decoration (1466) of the Cappella di San Jacopo (i.e., that of the Cardinal of Portugal) in San Miniato, where Baldovinetti had painted frescoes of the Annunciation and Evangelists, and in which Piero had assisted his brother, comprises the altar panel representing St. James between Saints Eustace and Vincent, in the Uffizi (painted in large part by Piero), and the damaged frescoes of two angels actively pushing back curtains on the lunette of the altar wall.

Of Antonio's designs for embroideries (the cartoons of which are lost but the finished works for the most part are still extant, two projects are most important: the first is the set of some thirty-six embroideries for four liturgical robes for the Baptistry of San Giovanni, depicting scenes from the life of John the Baptist, now in Museo dell'Opera in Florence, the cartoons for which were begun in 1466 when payments were made by the Florentine Mercanzia. The execution, by a number of craftsmen including Paolo di Bartolommeo da Verona and others from France and Flanders, took until about 1480. The second embroidery is an altar hanging, commissioned in 1475 by Pope Sixtus IV for San Francisco in Assisi (still in the treasury of San Francesco), representing the kneeling Sixtyus before St. Francis, with the oak branches and garlands of the Revere family in the background. Its style shows a greater emphasis on larger, more plastic forms, as opposed to the smaller figure groups and architectural settings of the earlier cartoons.

A fresco fragment of a kneeling St. Jerome from San Domenico in Pistoia (recently detached and now in the Forte di Belvedere Museum, Florence) had long been attributed to Antonio. Its clear and forceful drawing, as well as its monumental architectural setting, had stimulated attributions to Piero della Francesca and Domenico Veneziano, yet its action recalls the late work of Castagno (the St. Jerome) or Botticelli (St. Augustine).

Piero del Pollaiuolo (Piero di Jacopo d'Antonio Benci del Pollaiuolo, 1433-1496) was Antonio's youngest brother, whom Vasari mentions as a pupil of Castagno, but who was probably more influenced by his elder brother and Baldovinetti than by anyone else. He was born in 1443, and had assisted his brother (from Antonio's letter of 1494 to Orsini) on the Medici canvases of 1460, on various *nielli* in his shop, and on the altarpiece for the chapel of the Cardinal of Portugal in San Miniato in 1466. His first independent project was the decoration of the council chamber for the Mercanzia with numerous allegorical figures (1469/70). He lost a competition to Verrocchio, the next year for an altarpiece in the Cappella di San Bernardo in the Palazzo Vecchio. A cadastral declaration of 1480 indicates the Piero kept a studio separate from his brother's. The Coronation altar for Sant'Agostino in San Gimignano was finished in 1483; the next year, he accompanied Antonio to Rome to assist

on the execution of the bronze papal tombs. He died there in 1496, and was buried in San Pietro in Vincoli.

Piero's chief work, and the only clearly authenticated one (signed and dated: *Piero del Polaiuolo Fiorentino, 1483*), is the altar panel, now in the choir of Sant'Agostino in San Gimignano, which was commissioned by Fra Domenico Strambi, the same patron who had hired Benozzo Gozzoli to decorate that church some twenty years before. Represented is the Coronation of the Virgin, with cherubim with the Chalice, encircled by music-making angels and adored from below by kneeling saints (Fina, Gimignano, Nicholas of Tolentino, Augustine, Jerome and Nicholas of Bari). Characteristics of the style are the tall proportions of the figures (cf. Baldovinetti), the hard and relatively stiff drawing, and the passive lack of expression on faces, which are quite a contrast to the vital drawing and expressiveness of Antonio. Color is hard but well modeled, and the whole composition shows somewhat more of a desire for special values (cf. the angels). Using this altar as a basis for comparison, the two figures flanking St. James in the Uffizi panel of 1466 (especially the St. Eustace) would seem to be the work of Piero, while the St. James is certainly painted by Antonio.

The enthroned allegorical Virtues in the Uffizi—Charity (1469) and Faith, Hope, Temperance, Justice and Prudence (1470)—reveal the same tall proportions with a particularly short torso, the heavily painted and modeled drapery, and the round, expressionless faces noticed in the Coronation. The preliminary drawings, one of which, for the Charity, is extant on the back of that panel, were probably done by Antonio. Other works attributed to Piero are the Annunciation now in the Berlin-Dahlem Museum, with its bright and heavily painted palace ornamentation and the distant panorama of Florence and the Arno valley through the windows in the background; the stiffly posed bust portrait of Gian Galeazzo Sforza in the Uffizi, which is listed in the Medici inventory of 1510; and the fresco of St. Christopher now in the Metropolitan Museum of New York, which has often been identified with the lost fresco on the façade of San Miniato fra le Torre, Florence, mentioned by Vasari, Antonio Billi and the *Codex Magliabechianus*.

Andrea del Verrocchio (Andrea di Michele di Francesco Cione, 1435-1488) is a parallel to the Pollaiuoli as a craftsman and the

master of an extensive workshop whose many-sided activity shows a similar expansion to works of monumental proportions. His greatest accomplishments are in the field of sculpture; his significance to painting, aside from the continued emphasis on movement and the anatomically composed figure, lay in his influence on the younger generation of artists (Leonardo, Lorenzo di Credi, Perugino, Botticelli).

Verrochio was born in 1435 in Florence, the son of a brick and tile maker, and served his apprenticeship, supposedly, with the goldsmith Giuliano Verrochi. As an architect, he was paid in 1461 for designs submitted in a competition for a chapel in the Cathedral of Orvieto, but was not awarded the contract. He received the commission for the bronze Christ and St. Thomas group on Or San Michele in 1465, and in 1467 executed his first definitely known Medici commission, namely the tomb of Cosimo de'Medici in San Lorenzo, Florence, at the request of Piero. From then on he did a large number of works, including standards, tombs, reliefs, small statuary, candelabra, ornaments and even purely mechanical projects (the casting of the bronze globe in 1468-1471 for the top of the cathedral dome) for the Medici and the Rucellai, as well as for civic organizations. In 1479, he received the commission from the Signoria of Venice to execute the bronze equestrian statue of Bartolommeo Colleoni (d. 1475), the model for which was done in Florence and transported to Venice in 1481, but which was not cast until after his death by Leopardi di Ferrara; the statue was set up in 1496. Verrocchio's will was made on June 25, 1488, and he died in Venice before October 7 of that year, when Lorenzo di Credi brought his body back to Florence for burial in Sant'Ambrogio and took over the shop.

Certainly his most important work is the statue of Colleoni, which, in the development of Verrochio's own style as related to contemporary taste, holds a position roughly comparable to Antonio Pollaiulo's tomb of Sixtus IV (1484-1493). As an equestrian statue it follows in the tradition of Donatello's Gattamelata (1446-1453) in Padua and the painted memorial figures by Uccello and Castagno of 1436 and 1456, and may possibly have been influenced by the bronze horses of antiquity on the façade of San Marco in Venice. Its emphasis on anatomical structure, the dramatic action of the combined horse and rider, and the resultant total unity of the monumen-

tal group, while still retaininig the minute decorative detail of the shop craftsman, are characteristics which are found in both sculpture and painting of the period.

Verrocchio's stylistic character can be studied in the following authentic pieces of sculpture: the group of Christ and the Doubting Thomas on the exterior of Or San Michele, commissioned by the Merchants' Guild, the *Mercanzia*, probably in 1465, and completed in 1483; the bronze David of 1476 in the Museum Nazionale del Bargello of Florence, and the Winged Putto with the Dolphin in the Palazzo Vecchio, both of which were executed for the Medici villa at Careggi (ca. 1465) and are listed in the inventory of 1496; the bronze tomb of Piero and Giovanni de'Medici (1472) in the Sagrestia Vecchia of San Lorenzo; the tomb (1476-1483) of Cardinal Niccolò Forteguerri in the Cathedral of Pistoia, the competition for which Verrocchio had won through the favor of Lorenzo de'Medici; the Beheading of St. John the Baptist, a silver relief done in 1480 for the altar of San Giovanni and now in the Museo dell'Opera del Duomo in Florence; and, lastly, the Colleoni monument.

The one painting which, although not documented, is generally accepted as Verrocchio's, and which was left unfinished to be worked over later by Leonardo, is the panel with the Baptism of Christ in the Uffizi, originally painted (ca. 1470) for the Vallombrosian Abbey of San Salvi near Florence. The comparison with earlier variations on the same theme (e.g., Masolino's Baptism in Castiglione d'Olona and Baldovinetti's panel in San Marco) will show Verrocchio's attempt to crystallize the movement of anatomically constructed and animated figures into some sort of monumental form, without the columnar rigidity noted in Piero della Francesca's London panel. Note the standardized pose of the two main figures, combining movement and rest (i.e., the walk and arm gesture, particularly of John). The pose of John is the same one used, to more monumental effect, in the bronze Christ and St. Thomas group on Or San Michele.

Characteristc of Verrocchio is the craftsmanly pedantry of anatomical (cf. the muscles and veins of St. John) and landscape detail, the conscious balancing of stage wings, seen in the palm tree and rock formations at the sides, and the hard stylization of facial types (cf. the similar face of Christ in the bronze St. Thomas group on Or San Michele). A drawing of an angel's head with perforated

outlines in the Uffizi is an example of the stencillike patterns which may have been used for such a composition (cf. the head of the second angel at the left).

A remarkable difference in technique and expression may be noticed in the head of the first angel, in contrast to the harder features of the one just behind it, as well as in certain more atmospheric passages in the landscape background and in the softer modeling of the Christ figure. These sections seem to be painted in an oil technique over an unfinished layer of tempora; the masterful handling of the brush and more spiritual expression, especially in the angel's head, suggest Leonardo da Vinci. This is substantiated further not only by Vasari's mention that Leonard painted a part of the picture but also by the mention, in the *Memoriale* of Albertini, of an angel in the church of San Salvi (where the Baptism is known to have been), painted by Leonardo. A famous Madonna and Child panel in the Berlin-Dahlem Museum is attributed to Verrocchio on the basis of its similarity with the marble Bust of a Lady in the Museo Nazionale del Bargello of Florence. In its detail and animated design, it forms an interesting development over Baldovinetti's Madonna in the Louvre. A variation executed by the shop is to be seen in the Madonna and Child with Two Angels in the National Gallery of London.

Lorenzo di Credi (Lorenzo d'Andrea d'Oderigo, 1459-1537) continued the Verrocchio shop and its stylistic tradition, little affected by the changing styles of his contemporaries among the Florentine painters of the High Renaissance.

He was born in Florence, probably in 1459 (from his age given in a tax declaration), of a family of goldsmiths. By 1480, he had entered Verrocchio's shop, and probably continued several of the works left there (e.g., the Forteguerri monument) when Verrocchio went to Venice. Verrocchio's will of 1488 requests that Lorenzo continue the work on the Colleoni monument, which, however, Lorenzo turned over to the Florentine sculptor, Giovanni d'Andrea di Domenico, and which was then given to Leopardi di Ferrara by the Venetia Signoria. Aside from a number of relatively unimportant works, Lorenzi is listed in Florentine documents as one of the artists concerned (1504) with the site of Michelangelo's David, as arbiter and judge concerning the mosaics submitted by Davide

Ghirlandaio in a competition (1505), and on various disputes involving the work of Fra Bartolommeo (1507) and Davide Ghirlandaio in the Palazzo Vecchio. As a restorer, he had worked over the panel of Fra Angelico in San Domenico, Fiesole, and the frescoes of John Hawkwood (Uccello) and Niccolò da Tolentino (Castagno) in the Cathedral of Florence. He died in 1537.

Lorenzo's manner can perhaps be best studied in the Venus canvas, originally in the Villa Medici at Cafaggiolo, now in the Uffizi. It is interesting as the only pagan subject of Lorenzo's that has survived (Vasari describes the profound influence of Savonarola and Lorenzo's destruction of his own works with pagan subjects in the famous Fire of Vanities of 1497). The naturalistic pose and facial type (cf. Verrocchio), the dull coloration, heavy modeling of the forms and uninspired design are typical characteristics that form a remarkable contrast to the elegance and sensitivity of Botticelli's Venus compositions.

The chronology of Lorenzo's works is difficult to follow, since few of them are dated, and they reveal little basic development, although certain formal arrangements common to the Florentine High Renaissance (cf. Fra Bartolommeo) are noticeable. Several of the most important datable works are: The Madonna Enthroned with the Child between St. John the Baptist and St. Donatus of Arezzo, in the Cappella del Sacramento of the Cathedral of Pistoia, which he completed after Verrocchio had left it unfinished in 1485; the Madonna Enthroned with San Giuliano and San Nicola, painted in 1493 for the Mascalzoni Chapel of Santa Maria Maddalena dei Pazzi in Florence (now in the Louvre); and the Madonna with Four Saints, in Santa Maria delle Grazi in Pistoia, paid for in 1510. The same pedantic naturalism and heavy modeling can also be seen in a considerable number of other works attributed to him, notably the Annunciation, with its spacious interior and grisaille scenes of the Creation of Eve, the Fall of Man, and Expulsion from Paradise, in the Uffizi; the Madonna and Child (ca. 1485) and the Adoration of the Child, in the National Gallery of London; the tondo Adoration of the Child in the Berlin-Dahlem Museum; the Adoration of the Shepherds (ca. 1510), from Santa Chiara, in the Uffizi; and two male portraits, one presumably a portrait of Pietro Perugino, in the Uffizi, and another, supposedly a self-portrait of 1488, in the National Gallery of Washington. A tondo Madonna Adoring the Child with

the Infant St. John and an Angel is in the Metropolitan Museum of New York.

Cosimo Rosselli (1439-1507) is the oldest of another group of Florentine painters whose art develops parallel to that of the Pollaiuolo-Verrocchio shops, yet is more closely allied to the decorative mural compositions of Fra Filippo Lippi.

Cosimo was born in 1439, in Florence, and in 1453, he entered the shop of Neri di Bicci (1419-1491), son of Bicci di Lorenzo, who himself is historically unimportant but who had conducted a large shop and produced many works for provincial churches in an eclectic, naturalistic manner considerably inferior to that of Fra Filippo. Characteristic of these is the fresco of 1455, with San Giovanni Gualberto and Ten Saints, in the Cloister of San Pancrazio, Florence. Otherwise, Bicci is chiefly known for his *Libro di Ricordi*, kept from 1453 to 1475 (MS. now in the Uffizi).

Cosimo left the Bicci shop in 1456, the same year in which Benozzo Gozzoli came to Florence. Although there seems to be some stylistic relationship between the two, there is no actual evidence available in the documents that Rosselli worked with Gozzoli. In 1459, he was commissioned to paint an altarpiece, which is now lost, for the Scali Chapel in Santa Trinita; between 1462 and 1466, there are the badly restored frescoes representing the four Evangelists in the vault and Saints Leonard and John the Baptist, a Sybil and Prophet, and a Christ as Saviour, in the Cappella Salutati in the Cathedral of Fiesole; and in 1465/6, a lost Birth of Christ in the Cathedral of Pisa. The first dated work is the 1471 altar with St. Anne, now in Berlin; in 1473, he listed as *Provveditore* in the guild of St. Luke, and a fresco was painted in the cloister of SS. Annunziata before June 1475. On October 27, 1481, he signed a contract in Rome to work on the frescoes of the Sistine Chapel. Recorded back in Florence by November 25, 1482, he continued at work on many projects, including shop products of the minor arts, and served on various commissions (as counsellor on the cathedral façade, 1491; as arbiter in a suit between Vittore Ghiberti and his sons, 1496; and as a member of a commission with Gozzoli, Perugino and Fillippino to estimate the work of Baldovinetti in Santa Trinità). He made his will in 1506, naming the sculptor Benedetto da Maiano as executor, and died in January, 1507.

The comparatively early panel by Cosimo (dated 1471), in the Staatliche Museen of Berlin, represents the Virgin, St. Anne and the Child with Saints George, Catherine, Mary Magdalene and Francis, and contains a number of stylistic features which he may have inherited from the eclectic manner of his teacher: the Virgin appears somewhat related to the style of Benozzo Gozzoli; the stiff and well-rounded figures and the remarkably composed architectural setting seem to be influenced by Castagno. The Annunciation of 1473 (Louvre), with its pairs of saints (Saints John the Baptist, Anthony Abbot, Catherine and Peter the Martyr) in niches at the sides, likewise shows, in its eclectic way, an attempt to compose figures and architecture into some sort of monumental unity. The fresco of about 1476, in the cloister of SS. Annunziata, representing the monks clothing St. Philip Benizi with the white robes of the Servite Order, reveals a development of that type of figure composition with the architectural and landscape background for monumental and decorative purposes. The peculiar set of proportions used in the relationship of figures to the space recalls the Adoration of the Shepherds fresco by Baldovinetti in the same cloister, while the elaborate detail of some parts (e.g., the cart of the Virgin) suggests Verrocchio. The entire artistic problem involved, with its architectural wings and figure groups at the sides and the perspective recession in the center, is somewhat reminiscent of similar problems attempted by Masolino in the Brancacci Chapel (the Raising of Tabitha fresco) and the Baptistry of Castiglione d'Olona.

Rosselli's most important works are the frescoes of the Sistine Chapel, which were contracted for (together with Perugino, Ghirlandaio and Botticelli) on October 27, 1481, and due to be completed by March 15, 1482. Of the total ten frescoes required, only four were finished by January of that year, and Rosselli must have completed those allotted to him shortly afterward, since he is recorded back in Florence in November 1482. The chapel itself was consecrated on August 15, 1483. The frescoes executed by Rosselli with the assistance of Piero di Cosimo are: 1) the Sermon on the Mount, with the additional episodes of the descent from the mountain and the healing of the leper; 2) the story of Moses, with the episodes of his receiving the Ten Commandments on Mt. Sinai, his descent of the mountain carrying the tablets and followed by Joshua, the worship of the Golden Calf by the Israelites and Moses breaking

the tablets; and 3) the Last Supper, with its semi-circular table, elaborate Renaissance hall, two pairs of portrait figures at the sides and the smaller predella-like scenes between the pilasters on the walls representing Christ in the Garden of Gethsamane, the Kiss of Judas and the Crucifixion—these three probably executed by Piero di Cosimo or another assistant. Characteristic of the style are the division of the scenes into a number of different episodes, the attempt to unify the separated groups through a common landscape or architecture, and Rosselli's particular emphasis on unrelated color patches and gold decorations. Of the long series of Popes represented here on the walls of the Sistine Chapel, the figures of Popes Dionysius and Callixtus are generally attributed to Rosselli.

Rosselli's later painting reflects the influence of his contemporaries with whom he had worked in the Sistine Chapel. The most important of these, influenced largely by Botticelli and Ghirlandaio, are the frescoes representing the Miracle of the Sacrament, with the Church Fathers on the vaults and the angels around the tabernacle, in the Cappella del Miracolo of Sant' Ambrogio in Florence, executed in 1485-1486, during which time Fra Bartolommeo is listed as assistant. A second work is the altar representing the Virgin Enthroned with the Child and the Infant St. John, with Saints James and Peter, in the Accademia of Florence, painted in 1492-1495 for the Cappella Salviati in Santa Maria Maddalena dei Pazzi (cf. similar altar compositions by Filippino Lippi). The influence of Filippino and Ghirlandaio may also be noted in the many-figured composition of his last authentic work, the Coronation of the Virgin of 1505, executed for the Giglio Chapel in Santa Maria Maddalena dei Pazzi and still there.

Francesco Botticini (Francesco di Giovanni Botticini, 1446-1497) is another pupil of Neri di Bicci whose shop character is closely associated with Verrochio and Rosselli.

He was born in Florence, in 1446, entered Neri's studio in 1459, and is mentioned in the *Ricordi*; then, in 1469, he is listed as one of a commission to estimate the value of a painting by his master. He is recorded as a member of the *Compagnia dell' Arcangelo Raffaello* associated with Santo Spirito in Florence, executed an altar for the Pieve in Empoli; he died on July 22, 1497. A son, Raffaello (1477-ca.1520), carried on his style, which then became

modified by the refinements of Perugino and Ghirlandaio.

The chief authenticated works of Botticini are the two tabernacles in the Museo della Collegiata in Empoli. One is the Tabernacle of St. Sebastian,, with a marble figure of the saint by Antonio Rossellino in the center and two angels with donors on the side wings with scenes from the life of St. Sebastian in the predella. The other is the Tabernacle of the Holy Sacrament, with the two wings containing figures of St. Andrew and St. John the Baptist and a predella with scenes of the Crucifixion of St. Andrew, the Betrayal of Christ, the Last Supper, the Agony in the Garden, the Feast of Herod and the Beheading of John the Baptist, which was contracted for by the *Compagnia di Sant' Andrea della Veste Bianca* for the Pieve at Empoli in 1484 and set up in 1491 (though apparently not completely finished, since Raffaello worked on it later). The Last Supper, particularly, shows some relationship with Castagno. The St. John the Baptist, in its pose and linear character, is related to figures by Verrocchio and Botticelli. The famous panel of Tobias and the Three Archangels in the Uffizi is attributed to Botticini on the basis of the Empoli altars, and, in its hard drawing and coloration, is a significant parallel to Verrocchio's Baptism.

Domenico Ghirlandaio (Domenico di Tommaso Bigordi, called Ghirlandaio or Grillandajo, 1449-1494) marks the completion of the naturalistic narrative style of Fra Filippo Lippi in monumental form, and is perhaps the most popular representative of the Florentine cultural scene during the late Quattrocento.

Ghirlandaio's major works include: 1) the fresco with St. Jerome, St. Barbara and St. Anthony Abbott, in the church of Sant' Andrea in Cercina, near Florence; 2) the Madonna della Misericordia with the portraits of the Vespucci family and the Pietà below it, in the Vespucci Chapel of the church of Ognissanti, Florence (1472-1473); 3) the frescoes of the Baptism and the Madonna Enthroned with Saints Sebastian and Julian, in Sant' Andrea, Brozzi, near Florence (ca. 1475); 4) the frescoes, in the Cappella di Santa Fina in the Collegiata of San Gimignano (1475), representing the Vision and Funeral of St. Fina, and the figures of the Evangelists, Prophets and Church Fathers in the vaults (these probably executed by Mainardi); 5) the fragmentary decorations of philosophers and prophets, executed ca. 1475 with his brother Davide for the library

of Pope Sixtus IV in Rome; 6) the damaged fresco (ca. 1476) of the Last Supper, in the Badia of Passignano; 7) the lost decorations (1477-1478) of the burial chapel of Giovanni Francesco Tornabuoni, in Santa Maria Sopra Minerva in Rome, described at length by Vasari; 8) the frescoes, again with the help of assistants, in the Badia of Settimo (1479), San Donato at Polverosa (1480), and a destroyed Last Supper in the Camaldolite monastery in Florence; 9) the famous frescoes (1480) of the Last Supper, in the refectory, and St. Jerome, in the nave (formerly in the transept), of Ognissanti, in Florence; 10) the decorations of othe Sistine Chapel in Rome, undertaken (contract October 27, 1481) with Botticelli, Rosselli and Perugino, of which the Calling of the First Apostles, a Resurrection (later destroyed), some six of the Pope figures (particularly the St. Victor), and probably the Drowning of Pharaoh (sometimes associated with Cosimo Rosselli) are executed by Ghirlandaio and his helpers; 11) the large St. Zenobius Enthroned with St. Laurence and St. Stephen together with figures of classical Roman heroes (Brutus, Mucius Scaevola and Camillus in one arch, and Decius, Scipio and Cicero in the other), in the Sala dei Gigli in the Palazzo Vecchio, Florence, painted mostly by members of Ghirlandaio's shop, probably Benedetto and Davide (1482-1484); 12) the scenes from the life of St. Francis, in the Sassetti Chapel of Santa Trinità (1485), with the portraits of Francesco and Nera Sassetti; 13) Ghirlandaio's most important work, the decoration of the choir of Santa Maria Novella with scenes from the lives of the Virgin and John the Baptist for Giovanni Tornabuoni to replace the damaged frescoes by Orcagna (contract of September 15, 1485, listed the scenes to be represented and required their completion within four years of the commencement time, which was to be in May 1486).

A number of mosaics were executed by the shop, such as the Annunciation for the Porta della Mandorla (1490) of the Cathedral of Florence, as well as designs for the façade of the cathedral. Also in this late period (ca. 1491) were executed the designs and drawings of the *Codex Escurialensis*, which include studies of nature, architectural scenes and city views, and studies of classical sculpture, as well as innumerable decorative motifs probably copies by pupils from Ghirlandaio's own drawings. On Domenico's death, January 11, 1494, the shop was continued under Davide's direction.

The origin and individual character of Ghirlandaio's style

are difficult to identify, but may be studied in the early works. Verrocchio's influence is apparent in the animated poses of the figures in the Brozzi frescoes, particularly that of St. Sebastian. The Baptism of Christ in the same church appears to be based on Verrocchio's panel in the Uffizi, perhaps through a compositional study from Verrocchio's shop in which Ghirlandaio is assumed to have worked. The stiff drawing of the kneeling portrait figures in the Vespucci frescoes suggests Castagno (cf. also Piero della Francesca's Misericordia Madonna); the gentle character and tall proportions of his Madonna della Misericordia are reminiscent of Baldovinetti. The increasing toward the strong modeling of figures, and their composition in space through the use of color and light, has its origin in Masaccio.

Ghirlandaio's solution to the traditional problems of a narrative genrelike content in a monumental composition is given in the St. Fina frescoes of San Gimignano, particularly the Funeral scene. The chapel itself has the distinct architectural completeness and unity in the Quattrocento design of Giuliano da Maiano and the sculptural decoration by Benedetto da Maiano, particularly the altar of St. Fina (1475). The comparison with Lippi's frescoes in Prato, and Gozzoli's funeral scene in Sant' Agostino in this same town, will show the greater ease and dignity with which Ghirlandaio is able to combine figures and architecture into a monumental Lamentation theme as well as a natural and recognizable scene (cf. the gentle, realistic faces and poses, the well-known towers of San Gimignano in the background at the sides). The Announcement by St. Gregory of St. Fina's Death, on the opposite wall to the right, has a comparable serenity through the clean surfaces of the architectural interior, the landscape vistas through the window and doorway, and the diffused light which permeates the scene. Its romantic mood is suggested by the inscription of St. Gregory's words to Fina given on the framed panel hanging on the back wall: *PARATA ESTO FILIA QUIA DIES SOLENNITATIS MEAE AD NOSTRUM ES VENTURA CONSORTIUM CUM SPONSO TUO PERENNITER PERPANSURA* (Be ready, my daughter, for on the day of my festival you will be taken into our company and remain there with your [beloved] bridegroom forever).

The Last Supper (dated just below the feet of Christ, MCCC-CLXXX) in the refectory of Ognissanti is based on Castagno's composition in Sant' Apollonia. Similarities may be seen in the alignment of Christ and the eleven disciples behind the table, John leaning on His shoulder, and Judas separated in front of the table. The characteristic "corrections" of the earlier form are to be noted in the greater feeling of space and life produced by the more prominent filed floor and perspective in the foreground, enclosed by the U-shaped table, the freer modeling and movement of figures in the space through the use of light and shade (note the shadows cast from the left arm of the table and on the wall behind the figures), the greater and more conversational animation through the naturalistic gestures of the apostles, the carefully observed embroidery of the tablecloth and still life on the table, the parapet wall with the open sky, birds and trees showing behind it, and, particularly, the closer relationship of the mural composition with the architecture into which it is built, i.e., the composition of the scene with the vaulting and the fact that the Last Supper covers the entire wall, rather than the several scenes and boxlike arrangement used by Castagno. In its present restored condition, with its luminous coloration, the fresco seems to be largely the work of Domenico himself. For the most part it is painted in true fresco, with *secco* used only in details. The head of Christ had been repainted in the seventeenth century. A variation of this Last Supper, executed by the shop, decorates the refectory of the Convento di San Marco in Florence.

The fresco of St. Jerome (dated 1480) in the same church of Ognissanti was moved along with its counterpart, the St. Augustine by Botticelli, from the old monks choir to its present location in the nave in the sixteenth century. It is interesting iconographically, in keeping with the humanistic mood of the period, for its interpretation of the saint as a studious scholar (cf. similar contemplative portraits of earlier periods, e.g., Tommaso da Modena) seated in his study with an elaborate and naturalistic still life of scholarly attributes about him. Its love of detail and observation of nature again recall the scholarly atmosphere of Duke Federigo's *studiolo* and the association of the Flemish tradition involved there.

Of Ghirlandaio's frescoes in the Sistine Chapel (1481-1482), the scene representing the Calling of the First Apostles, with the blessing of Peter and Andrew in the center, Christ preaching to the

two fishermen at the left (in the middleground) and their coming to the shore at the right, is the most famous. Characteristic is the narrative sequence of scenes with the important one in the center, the arrangement of figures in frieze-like groups, the realistic characterization of faces (probably portraits of members of the Florentine colony in Rome), and the detailed depiction of the river landscape with its atmospheric recession into the distance, by which the contrast to the similar compositional scheme in Masolino's Baptism of Christ in Castiglione d'Olona is especially evident.

Ghirlandaio's two most important fresco projects in Florence are those of the Sassetti Chapel probably begun late in 1482 and completed by January 1st, 1486) in Santa Trinità, and the choir of Santa Maria Novella, which was contracted for on September 1, 1485, even before completion of the Sassetti series (the choir chapel was opened December 22, 1490). The Sassetti chapel frescoes depict six scenes from the life of St. Francis; on the left wall at the top, St. Francis Renouncing His Father, below it St. Francis Receiving the Stigmata. On the altar wall, Pope Honorius Sanctions the Rules of the Order, and the Raising of the Child from the House of Spini. On the right wall is the Ordeal by Fire before the Sultan, and the Funeral of St. Francis. On the quadripartite vault are the figures of four sibyls, with Augustus and the Tiburtine Sibyl and the Sassetti coat of arms over the entrance.

On either side of the altar wall, flanking the altar with its Adoration of the Shepherds panel (also painted by Ghirlandaio in 1485 for this altar), are kneeling fresco portraits of Francesco Sassetti and his wife, Nera Corsi. Below them are the inscriptions, *XV Decembris* and *A.D.M.CCCCLXXXVI* (which had once been altered to read 1485). Domenico's own hand is to be seen in the Resuscitation of the Child (with its view of the Piazza Santa Trinità in the background and portraits of Maso degli Albizzi, Agniolo Acciaiuoli, Palla Strossi and, at the extreme right, the artist's self-portrait), and especially in the scene of the Pope Sanctioning the Order. Aside from the dignified posing of figures and their composition, the attempt to animate the traditional Franciscan theme (cf. Giotto's series in Assisi and Santa Croce, as well as Gozzoli's in Montefalco) with recognizable contemporary associations can be seen in the architectural vista in the background (the Florentine Piazza della Signoria with the Palazzo Vecchio and the Loggia dei Lanzi) and the portraits: at the right, Lorenzo Magnifico between

Francesco Sassetti and Antonio Pucci; at the left, Sassetti's three sons; and ascending the steps in front toward Lorenzo, the poet Angelo Poliziano accompanied by Lorenzo's sons, together with Matteo Franco and Luigi Pulci. The subtle juxtaposition of the parallel scenes of Poliziano ascending the steps toward Lorenzo, and St. Francis ascending the steps of the papal throne, have their counterpart in the implied content, i.e., the scientific-humanistic cultural atmosphere about Lorenzo and his court as a parallel to the Franciscan humanism sponsored by Pope Honorius of the earlier epoch. The other frescoes appear to be carried out largely by Davide and Mainardi on Domenico's designs.

The Santa Maria Novella frescoes decorate the three walls of the chancel (i.e., the Cappella Maggiore). These replaced the frescoes depicting scenes from the life of Mary by Orcagna, commissioned in 1350. Ghirlandaio's scenes from the life of Mary on the left wall include the Expulsion of Joachim from the Temple, Birth of Mary, Mary Ascending the Steps of the Temple, *Sposalizio* (Marriage of the Virgin), Adoration of the Magi, Slaughter of the Innocents, and, in the lunette, the Death and Assumption of Mary. The right wall contains scenes from the life of St. John the Baptist: The Angel Appears to Zacharias, the Visitation, Birth of St. John, Zacharias Inscribing John's Name, John Preaching in the Wildnerness, the Baptism of Christ; and, in the lunette, opposite the Assumption of Mary, is the Feast of Herod. The altar wall contains the damaged frescoes of the Coronation of the Virgin in the lunette, the Murder of St. Peter the Martyr, and St. Dominic burning Heretical Writings, on either side of the window, and the portraits of the patrons, Francesco Tornabuoni and his wife, Francesca Pitti. The four Evangelists decorate the vaults.

Included in this project, designed by Ghirlandaio but executed in his shop, are the stained-glass window of the Madonna della Cintola with the Circumcision and the Founding of Santa Maria Maggiore, and Saints, and the altarpiece (ca. 1494), which was dismantled in the nineteenth century. The central front panel of this, with the Madonna in Glory and Saints Dominic, Michael, John the Baptist and John the Evangelist, together with the single figures of St. Laurence and St. Catherine of Siena on the wings, are in the Munich Alte Pinakothek. The back panel with the Resurrection is in the Staatliche Museen of Berlin.

Perhaps the best of the fresco scenes (and one of the latest), ex-

ecuted very likely by Domenico himself, is the Birth of Mary, which also has the signature *Bighordi-Grillandai* on the decorative panels of the back wall. Others of comparable quality are the Expulsion of Joachim, the Visitation and the Birth of John. Various characteristics of the total style which might be noted in relationship to earlier works of this tradition, not only by Ghirlandaio but also going back to Gozzoli and Fra Filippo Lippi, are: the emphasis on highly decorative and impressive architectural settings with their classic and contemporary associations (cf. Giuliano da Sangallo); the rhythmical distribution of figures and groups in these settings; the growing tendency to emphasize movement in the figures, which is due not alone to the subject matter (i.e. the Expulsion of Joachim) but also as an integral part of the total design, as can be seen in the design of drapery, pose of figures and their group compositions; the inclusion of familiar architectural or landscape vistas, such as the court and façade of the Innocenti Hospital in the background of the Expulsion of Joachim, and the panorama view of Florence as seen from San Miniato al Monte in the Visitation; the inclusion of various genre motifs for compositional purposes (e.g., the two figures peering over the wall in the Visitation, used in a manner similar to the Flemish painters, such as Van Eyck's Madonna with Nicholas Rolin in the Louvre); the persistence of portrait figures, such as the self-portrait, those of his father and brothers in the Expulsion of Joachim from the Temple, the elegant portrait of Giovanna degli Albizi, wife of Lorenzo Tornabuoni, in the Birth of John scene, and that of Ludovica, daughter of Giovanni Tornabuoni, with her attendants in the Birth of Mary scene. Along with the many assistants who worked with Ghirlandaio, Michelangelo and Francesco Granacci are sometimes assumed to have taken part in this project.

A number of alterpieces by Ghirlandaio and his shop show a development of his comparatively impersonal style parallel to the frescoes. Two rather stiffly composed earlier panels, both painted by his own hand (ca. 1479), are in the sacristy of the Cathedral of Lucca (the Madonna Enthroned with Saints Clement, Sebastian, Peter and Paul), and the Madonna Enthroned with Saints Catherine, Stephen, Laurence and Fina from the monastery of San Girolamo in Pisa, now in the Museo Civico there. The altar in the Uffizi (1482/3) of the Madonna Enthroned with Angels, Saints Dionysius Areaopagita, Thomas Aquinas and the kneeling St. Dominic and

Pope Clement, from Santa Maria in Monticelli, shows a more individual characterization of figures and a livelier composition similar to the murals. The predella appears to have been painted largely by Bartolommeo di Giovanni.

His best-known panel is the Adoration of the Shepherds, in the Sassetti Chapel of Santa Trinità, painted by himself (with the exception of the cavalcade in the background) for that altar in conjunction with the mural decoration and dated 1485. The realistic characterization of the shepherds, particularly, is probably influenced by Hugo van der Goes' triptych of the same subject, which had been finished in 1945 for Tommaso Portinari and set up in the hospital of Santa Maria Nuova in Florence the two will demonstrate Domenico's typical arrangement of figures and background (with its classical ruins) in decorative planes similar to the mural compositions.

The later altars, done mostly by the shop, contain more elaborate and animated figure compositions related to the murals. These include the Coronation of the Virgin with Kneeling Saints, in the Municipio of Narni, finished in 1486 for the Abbey of San Girolamo there; the tondo with the Adoration of the Magi, in the Uffizi, dated 1487; the same subject in the Pinacoteca of the Spedale degli Innocenti in Florence, dated 1488, for which the contract specified that it should be painted entirely by his own hand (though the small scene of the Slaughter of the Innocents in the background and the predella appear to have been painted by pupils, i.e., Bartolommeo di Giovanni); and the late Visitation, in the Louvre, which is dated 1491 and was painted for the chapel of Lorenzo Tornabuoni in Santa Maria di Cestello, this was left unfinished by Ghirlandaio at his death and was completed by his brothers.

The more important artists active in Ghirlandaio's shop, to whom many of the inferior sections of both frescoes and panels are attributed by stylistic analyses, include his two brothers, Davide (1452-1525) and Benedetto (1458-1497), the anonymous Master of St. Sebastian (so-called after the panel of St. Sebastian and St. Roch in Pisa), to whom a large part of the Drowning of Pharaoh, in the Sistina, is attributed, Bartolomeo di Giovanni (sometimes identified as ''Alunno di Domenico''), and Sebastiano Mainardi (1460-1513). Ridolfo Ghirlandaio (1483-1561), Domenico's son continues in Florence largely under the influence of his father's shop and Fra Bartolommeo, e.g., the murals (1514) in the Cappella dei

Priori in the Palazzo Vecchio, and the Lamentation in Sant' Agostino, Colle Val d'Elsa (1521).

Sandro Botticelli (Alessandro di Mariano Filipepi, 1445-1510) represents a refinement of the lyric romanticism developed by Fra Filippo Lippi, expressed in terms of the movement of figures and linear design inherited from Verrocchio and the Pollaiuoli. In spirit and patronage, he is directly associated with the poetry and humanistic thought of Lorenzo Magnifico and his immediate circle.

Botticelli was born in 1445 (from the tax declarations of his father), the youngest son of a leather curer, Mariano di Vanni di Amedeo Filipepi. The name "Botticelli" comes from that of his eldest brother, Giovanni, who was called *Il Botticello* or "little barrel." Apparently, he was first apprenticed to a goldsmith, then (ca. 1464) to Fra Filippo Lippi (Vasari, Antonio Billi), and finally worked with Verrocchio (1467), which assumption seems justified by the stylistic character of the Fortitude which he is listed in the *Ricordanze* of Benedetto Dei as having painted for the Mercatanzia in 1470. His name is entered in the *Compagnia di San Luca* in 1472; in 1474, he went to Pisa to paint a trial fresco in the Campo Santo and an Assumption of the Virgin for the Cappella dell'Incoronato in the cathedral which he did not finish. Shortly afterward, probably in 1475, he painted an Adoration of the Magi fresco in the Palazzo Vecchio with many portraits of the Medici; then, in 1478, after the Pazzi revolt, he painted figures of the executed conspirators on the walls of the Bargello, as well as a portrait of the murdered Giuliano (both destroyed after the flight of the Medici from Florence). In 1480, he painted the fresco of St. Augustine in the church of Ognissanti in competition with Ghirlandaio (cf. the St. Jerome).

During 1481-1482, he was at work on the frescoes of the Sistine Chapel in Rome; then, with Ghirlandaio, he contracted to decorate the Sala dell' Udienze in the Palazzo Vecchio with frescoes, which were not carried out (except for Ghirlandaio's St. Zenobius frescoes). In 1491, Botticelli was a member of a commission, which included Lorenzo di Credi, Ghirlandaio, Perugino and Baldovinetti, to consult on designs for the cathedral façade. That same year, he was commissioned, together with members of the Ghirlandaio shop, to design mosaics for the Chapel of St. Zenobius in the cathedral; these were finished in 1515 by Davide.

The change away from pagan subjects and toward a more mystical abstract style during his later life is often accounted for by the death of Lorenzo Magnifico in 1492 and the influence of Savonarola, which was even increased after the monk's execution in 1498. The diary of Botticelli's brother Simone mentions him as a faithful (though probably not active) follower of the fanatical reformer. In 1499, he is mentioned for the first time in the *arte dei medici e speziali*; after 1500, he seems to have produced few works, at least none that are extant, nor traceable in the documents. His name appears in various records, such as those of the *Compagnia di San Luca* and the commission of 1504 charged with the placement of Michelangelo's David. He owned a villa of considerable size outside the Porta San Frediano and is praised in a poem of 1503 by Ugolino Verino (*nec Zeuxi inferior pictura Sander habetur*). A letter of Francesco Malatesta to Isabella d'Este recommends him as an excellent painter and one willing to work, which indicates that Botticelli, unlike Perugino and Filippino, who had been approached to execute commissions for the Marchesa of Mantua (for whom Francesco Malatesta was acting as agent), was not overloaded with commissions. He died May 17, 1510.

Although there are many panels, particularly Madonna and Child altars, which are attributed to Botticelli during the early years of his career, the first documented work is the enthroned Fortitude in the Uffizi, executed in 1470 for the council chamber of the *Arte della Mercanzia* and intended as decoration either for the backs of seats or for ornamental wainscoting. It is one of the series of Virtues contracted for by that guild with Piero Pollaiuolo and mentioned in most of the early sources, including Albertini's *Memoriale* of 1510, the *Anonimo Gaddiano*, the *Codex Magliabecchiano*, and Vasari. Its style shows the close relationship with Verrocchio in the detailed, goldsmith character of the armor and the ornamentation on the throne (cf. Verrocchio's tomb of the Medici). The figure has the same long-bodied proportions as the other six panels (also in the Uffizi) of the series executed by Piero Pollaiuolo, but lacks the latter's awkwardness and limited articulation in gestures and the drapery design. The facial type is reminiscent of that used by Fra Filippo Lippi (cf. the Coronation in the Uffizi), yet already has something of one lyric melancholy and expressiveness that characterize most of Botticelli's figures.

Other works of this first period which reveal the origins and in-dividual character of Botticelli's style are: the Adoration of the Magi tondo (ca. 1470-1472), which Vasari had seen in the Casa Pucci and which is now in the National Gallery of London. Its composition ap-pears to be based on the similar Adoration by Fra Filippo now in the Cook Collection of Richmond. The two small panels of ca. 1470 in the Uffizi, representing Judith and her Servant with the Head of Holofernes, and the Discovery of Holofernes' Body, reveal a par-ticular interest in the movement of striding figures and dramatic composition (cf. Antonio Pollaiuolo's compositions in the em-broideries in San Giovanni). The St. Sebastian now in the Berlin-Dahlem Museum was finished, according to the *Anonimo Gad-diano*, in January 1474 for Santa Maria Maggiore. The pose of this St. Sebastian appears to be a variation of Verrocchio's Christ in the Uffizi Baptism, but the scientific interest in anatomical structure is here subordinated to a delicate smoothness of textures. The inter-pretation of the theme is related to Antonio Pollaiuolo's Sebastian, painted a year later (1475), in its placing of the martyr figure above the eye level of the beholder. In contrast to Pollaiuolo, however, note the more balanced pose of the figure, and the emphasis laid on the devotional spirit of the theme as an accomplished fact rather than on the physical action of the martyrdom itself.

The inclusion of contemporary portraits in a number of his religious compositions follows in line with the Lippi tradition, as it does in the work of Ghirlandaio. The chief example is the Adoration of the Magi panel, originally in Santa Maria Novella and now in the Uffizi, which appears to have been painted about 1478 (although many historians have assumed an earlier date, i.e., 1474-1477, which would be well before the Pazzi revolt of April 26, 1478) for the merchant Giovanni di Zanobi del Lama and which included a number of portraits of the Medici family (Vasari). The figure kneeling immediately before the Child is assumed to represent the aged Cosimo de' Medici, the second of the kneeling kings is possibly Piero, and the third his brother Giovanni. Others are identified as Lorenzo (with the sword at the extreme left), next to him Agnolo Poliziano and then Pico della Mirandola. The tall, yellow-robed figure at the extreme right, looking out, is traditionally given as a self-portrait of Botticelli. The figure in profile just above him is

Lorenzo Tornabuoni, the bearded Giovanni Argiropulo is just in front of them, toward the center, the bareheaded figure above him, looking out, is presumably Filippo Strozzi, and the tall, handsome figure standing behind the kneeling Giovanni de' Medici is Giuliano.

The compositional features associated with Fra Filippo Lippi and Botticelli's London Adoration are to be noted in the balanced pyramidal grouping of figures receding to the Holy Family at the top of the background, and the bright and unevenly distributed patches of local color. The curious combination of stiffly posed and conversationally animated figures is composed in blocks on either side, yet with the leading participants freely spaced in the center. The greater emphasis on the space and the looser composition of the smaller and more animated figures around the central group is the special feature of the slightly later (1481-1482) variation in the Adoration of the Magi panel now in the National Gallery of Washington.

A number of portraits were done by Botticelli at about this same time (ca. 1478). One is the portrait of Giuliano de' Medici in the Berlin-Dahlem Museum, possibly based on a drawing used for his portrait in the Adoration. Variations are to be found in the Accademia Carrara of Bergamo, the National Gallery of Washington, and the Louvre in Paris. The Portrait of a Man with the Medal of Cosimo the Elder, in the Uffizi, is assumed to be an earlier work of ca. 1474. The various female portraits (e.g., in Berlin, Frankfort and Richmond) are often identified as Simonetta Cattaneo, the wife of Marco Vespuccia and the mistress of Giuliano, on the basis of their similarity with an allegorical portrait by Piero di Cosimo in Chantilly labeled *Simonetta, Ianvensis, Vespuccia*. Their significance lay not only in the romantic associations connected with the subjects (Simonetta died in 1476, at the age of twenty-three, Giuliano was murdered in the Pazzi revolt of 1478) and the poems of Poliziano praising them, but also in Botticelli's artistic stylization into the strange, poetic and melancholy type that he used, with many variations, in his allegorical compositions.

The cassone panel of Mars and Venus, now in the National Gallery of London (probably painted in 1476-1478, though frequently assumed to be later, i.e., ca. 1485-1486), has been interpreted, in this connection, as an allegory of the lovers. Giuliano had

been crowned as victor in the tournament given in his honor in 1475, in praise of which Poliziano was commissioned to write the *Giostra*, and he is here represented as the sleeping Mars disarmed by satyr-cupids, while Simonetta as Venus reclines beside him. A characteristic feature of the involved iconographical problem here is the association with classical antiquity as well as with contemporary poetry. The theme and many of the motifs have analogies in Lucian's description of the Marriage of Alexander and Roxanna, as well as in classical reliefs. Other interpretations stress the idea of love (based on Ficino), and the influence of Venus as *humanitas* on Mars as the symbol of war. The wasps at the right have been suggested as referring to the Vespucci family, who may have commissioned the painting. A similar problem and composition appears in the Venus, Mars and Cupid panel by Piero di Cosimo in the Berlin-Dahlem Museum.

The greatest of Botticelli's works, and two of the most famous pictures of the entire Italian Renaissance, are the Birth of Venus and the Primavera (Allegory of Spring), both in the Uffizi gallery, and are directly related to the personalities and idea of the humanist circle surrounding the Medici. Chief among these was Marsilio Ficino, founder and head of the Platonic Academy, whose *Theologia Platonica* (completed 1472, published 1482) sought not only a marriage of religion and philosophy but also the spiritual identity of Christ and Plato. Under the original patronage of Cosimo, the circle at the Villa Careggi included Lorenzi Magnifico, Angelo Poliziano, Giovanni Cavalcanti, Cristoforo Laudino and, later, Pico della Mirandola. One of the younger enthusiasts was Lorenzo Magnifico's cousin, Lorenzo di Pierfrancesco de' Medici(1463-1507), with whose newly acquired (1477) Villa di Castello the Botticelli paintings are associated.

The Primavera panel was painted about 1478, the Birth of Venus (on canvas) probably later (ca. 1485), while the Minerva and the Centaur, also on canvas and belonging to the same group, was painted ca. 1483, immediately after Botticelli's return from Rome, where he was working on the frescoes in the Sistine Chapel. The content of these much-discussed allegories appears to be free interpretation of various classical and contemporary romantic-allegorical poems that were popular in the humanistic circle of the Medici. These include Ovid's *Metamorphoses,* Marianus Capella's *Mar-*

riage of Mercury and Philosophy, the *Mythologicon* of Fulgentius, with its introduction describing the author's inspiration by the muses (i.e., Calliope) who bring him a maid, Flora, *petulantia floralis*, accompanied by the youthful Urania and the aged Philosophy; Lorenzo Magnifico's own poems, inspired as they were by Dante and Virgil; Angelo Poliziano's *Orfeo*, and especially his *Giostra*, which describes, in particular, the garden and palace of Venus.

Whether there was a definite iconographical program associated with this literary background which the painting illustrates is indeed doubtful. In keeping with the humanist's spirit, the central theme is essentially a devotional one whose allegorical associations are subordinated to the expressive function of the abstract form. The same type of problem in a more simplified form, appeared in the iconographical associations of the suspended egg in Piero della Francesca's Brera Madonna. In the case of the Primavera, it is the Calliope (i.e., Spring), with the Amor above her, Mercury pushing back the clouds with his staff and the three Graces on one side, and on the other side Flora fleeing before Zephyrus (or Urania, Flora and Philosophy). In the Birth of Venus, it is the myth of the wind-driven Goddess of Love in a shell landing on the flowered shores of Cyprus to be robed by the waiting nymph (cf. Poliziano's *Giostra*, stanzas 99-102, describing the reliefs by Vulcan in the palace of Venus). Poliziano called the place of landing Porto Venere, where Simonetta was born, thus again associating the theme with that personality. Another interpretation is based on the myth, as told by Hesiod, of the birth of Venus from the foam of the sea generated when Cronus threw in the severed genitals of Uranus, and it thus becomes an allegory of the birth of Beauty through the union of Idea and Matter.

With regard to the composition, note Botticelli's decorative stylization of movement, not only in the grouping of the figures but also in the highly refined patterns of the drapery and hair, the slightly unbalanced triptych composition (i.e., in the Primavera) with the red-robed figures of Venus in the center and Mercury at the left side, the otherwise subdued coloration with its dull green, tapestrylike forest background and delicate transparent grays in the drapery and flesh tones of the figures, the miniaturelike execution of detail in the flowers and foliage, in spite of the large size of the panel, and the persistence of certain traditional figure motifs, such as the dancing

nymphs (cf. Ambrogio Lorenzetti) and the classicial Venus pose (cf. Giovanni Pisano and the Eve by Masaccio), in which the peculiarly original and expressive quality of Botticelli's art is especially apparent. A comparison has frequently been made between the three-part composition of the Birth of Venus and the traditional Baptism of Chrtist scene (e.g., Verrocchio), wherein the relationship and unique ness of Botticelli's expressive form is again characteristic. One of the many variations (some possibly destroyed during the Savonarola reform) of the Venus figure, painted after that of the Birth of Venus, is now in the Berlin-Dahlem Museum.

The third allegory associated with the Villa di Castello and Lorenzo di Pierfrancesco de' Medici is the Minerva and the Centaur canvas in the Uffizi (ca. 1482-1483). Its content has been variously interpreted: as a political allegory alluding to Lorenzo Magnifico's successful trip to Naples to conclude the peace treaty for Florence (1480), or as a mural allegory in which Minerva, representing Wisdom, leads the Centaur—the half-man and half-beast—as the baser nature of mankind. In this sense, it becomes another tribute to Florence and the cultural achievement of Lorenzo and his circle. The decorative use of the laurel and the Medici symbol of interlocking rings on the figure of Minerva, as well as her inspirational power as stressed by Ficino, tend to substantiate both personal and political associations.

The two detached frescoes now in the Louvre, Paris, representing Lorenzo Tornabuoni Presented to the Seven Liberal Arts, and Venus with the Graces Offering Gifts to a Girl, were originally loggia decorations in the Villa Lemmi, near Careggi, which belonged to the Tornabuoni family. They had long been interpreted as an allegory commemorating the wedding of Giovanna degli Albizi and Lorenzo Tornabuoni, which took place in 1486 and hence would be closely associated in spirit with Poliziano and the classics mentioned before. The identity of the girl as Giovanna is doubtful, however (cf. the portrait in Ghirlandaio's Visitation in Santa Maria Novella), so that the association is by no means certain. The style would indicate the same period, possibly as early as 1480, but their quality is considerably inferior. They are badly damaged in their present state, so that their attribution to Botticelli has often been justly doubted.

Botticelli's frescoes, executed in close competition with Ghirlandaio, show his own district and emotional quality as com-

pared with the more phlegmatic representational style of the latter artist. This can be seen in the fresco of St. Augustine in the church of Ognissanti in Florence, executed about 1480, at the same time as Ghirlandaio's St. Jerome. These were originally painted, probably as gifts of Giorgio Antonio Vespucci, on either side of the entrance to the monks' choir, and were later (1564) transferred to the nave. Both are seated in their cells, surrounded by the various books and instruments of the scholar, reflecting, in both mood and attitude, the artists' acquaintance with Jan van Eyck's St. Jerome, then owned by Lorenzo de' Medici. The positive action of the figure, the more sensitive drawing, and the subtle use of light to enhance the spiritual quality of the design are specific features which one recognizes as Botticelli. The inscription suggests the mood of scholarly retreat: *Sic Augustinus sacris se tradidit ut non mutatum sibi adhuc senserit esse locum.*

The Sistine Chapel decorations (1481-82) comprise three elaborate compositions: The first is the story (Exodus 2) of the Youth of Moses (at the right Moses slays the Egyptian and flees Pharaoh's wrath, and at the left he leads the Exodus from Egypt; in the center, he draws water from the well for the flock of the daughters of Jethro and drives away the shepherds; and in the background, he removes his shoes and beholds the vision of the Burning Bush). The second is the Purification of the Leper (Leviticus 14), with four episodes of the Temptation of Christ above in the background, the façade of the newly restored hospital of Santo Spirito in the center, and groups of spectators at the sides, including Cardinal Giuliano della Rovere (Julius II) and Girolamo Riario (extreme right). The third is the Punishment of Korah, Dathan and Abiram (Numbers 16), with the punishment of Korah and his followers for their rebellious offering at the altar, the blasphemer being led to be stoned at the right, and, at the left, the disappearance of Dathan and Abiram in the earth, under Moses' curse. A number of the papal figures in the chapel are attributed to Botticelli or to his design, particularly those of Stephen, Marcellinus and Sixtus II.

Comparing the development in the three frescoes, one will find a change from the grouping of figures into various episodes which are freely arranged on different levels in an asymmetrical landscape (Youth of Moses) to their more unified composition through action and excited gesture. He then seeks to overcome their isolation in the

total composition by the use of architectural scenery (cf. the triumphal arch and ancient Roman ruins in the Punishment of Korah, Dathan and Abiram). Filippino Lippi is said to have been among his assistants on the work.

Botticelli's famous altarpieces form a direct parallel to the spirit of his literary allegories, and reveal the same development from the less-articulated form inherited from Fra Filippo Lippi to the agitated excitement of his later style: 1) the Madonna and Child with Two Angels, ca. 1468-1469, in the Galleria Nazionale di Capodimonte of Naples, with its figure types and composition close to those of Lippi's Madonna panels as well as to Verrocchio's; 2) the Madonna with the Child and St. John (Madonna del Roseto, ca. 1468-1469, in the Louvre; 3) the Madonna dell' Eucarestia, ca. 1471-1472, with the grapes and wheat as symbols of the eucharistic bread and wine, in the Isabella Steward Gardner Museum of Boston; 4) the two famous tondos in the Uffizi, the Madonna with the Pomegranate (ca. 1482) and especially the Magnificat (Coronation of the Virgin with the words *Magnificat anima mea dominum* inscribed on the book, ca. 1485), with their circular composition of figures; and 5) the three larger and more spacious altarpieces. One is in the Berlin-Dahlem Museum (the Madonna Enthroned with Saints John the Baptist and John the Evangelist, painted in 1485 on commission from Giovanni d'Angolo de' Vardi for the Bardi Chapel in Santo Spirito). The other two are in the Uffizi: the San Barnaba altarpiece (the Madonna Enthroned with Angels and Saints Catherine of Alexandria, Augustine, Barnabas, John the Baptist, Ignatius and Michael), done ca. 1487-1488 for the abbey church of San Barnaba; and the San Marco altarpiece representing the Coronation of the Virgin with Saints John the Evangelist, Augustine, Jerome and Eligius, painted in 1488-1490 for the Chapel of St. Eligius in San Marco, Florence. The five scenes of the predella for this San Marco altar depict St. John on Patmos, St. Jerome in His Study, the Annunciation, St. Jerome in the Wilderness, and St. Eligius restoring the Horse's Leg. The Annunciation, painted in 1489-1490 for the church of Santa Maria Maddalena dei Pazzi, now in Uffizi, is an interesting variation of the theme and figure composition so common to this group, going back to those of Fra Filippo Lippi and Baldovinetti.

Botticelli's illustrations to Dante's *Divine Comedy* were begun

in about 1485, or possibly earlier, for Lorenzo di Pierfrancesco de' Medici, and were no doubt left unfinished at that patron's flight from Florence in 1497. They were executed in silver point on parchment, although some of them have gone over with pen while others were colored by another hand. Of these, eighty-eight were in the Berlin Kupferstichkabinett before World War II, and eight are in the Vatican Library. The page with the illustrations to the 28th Canto of the *Paradise* contains Botticelli's signature. The representations closely follow the content of the text; the style reveals a poetic delicacy and a restraint which are still within the classic linear form of the Primavera and Birth of Venus paintings, rather than the violent excitement of his later work.

Of Botticelli's late period, the Calumny of Apelles (ca. 1485-1500), in the Uffizi, the Pietà of 1496-1498, in the Munich Alte Pinakothek, and the Nativity of 1500, in the London National Gallery, are perhaps the most signficant. The first is taken from a description by the classicial Lucian, repeated by L. B. Alberti (*De Pictura*), of a picture by Apelles in which a prayerful young man is dragged by Calumny, whose head is being crowned with flowers by Reason and Deceit, and who in turn is being led before the enthroned judge by Envy. Ignorance and Suspicion whisper accusations into the ass's ears of King Midas, the judge, while at the opposite side, to the left, stand the old woman in rags as Remorse and the tall nude figure of Truth. The use of an impressive architectural setting, with its Renaissance figures in niches (cf. Donatello and Castagno), as a means of holding the figure composition together, as well as the excited movement and gesticulation of the figures, is reminiscent of the Sistine frescoes (the Punishment of the Rebels), but much more intense. The tragic moral content is in keeping with the Savonarola epoch. The same baroque form of excitement and dramatic pathos is to be found in the Munich Pietà.

The Mystic Nativity in the London National Gallery contains a long inscription in Greek alluding to the troubles in Italy (the invasions of Louis XII in North Italy and of Cesare Borgia in Romagna in 1499), the woes of the Apocalypse, and the hope of salvation, with the date and Botticelli's signature:

ΤΑΥΤΗΝ . ΓΡΑΦΗΝ . ΕΝ . ΤѠὶ . ΤΕΛΕΙ . ΤΟΥ . Χ . ΣΣΣΣΣ . ΕΤΟΥΣ . ΕΝ . ΤΑΙΣ . ΤΑΡΑ(Χ)ΑΙΣ . ΤΗΣ . ΙΤΑΛΙΑΣ . ΑΛΕ ΑΝΔΡΟΣ . ΕΓѠ . ΕΝ . ΤѠὶ . ΜΕΤΑ . ΧΡΟΝΟΝ . ΗΜΙΧΡΟΝѠὶ . ΕΓΡΑΦΟΝ . ΠΑΡΑ . ΤΟ . ΕΝΔΕΚ / ΑΤΟΝ

. ΤΟΥ . ΑΓΙΟΥ . ΙѠΑΝΝΟΥ . ΕΝ . ΤѠἰ . ΑΠΟΚΑΛΥΨΕѠΣ . BᵃⁱΟΥΑΙ . ΕΝ .
ΤΗἰ . ΛΥΣΕΙ . ΤѠΝ . Γ . (Κ)ΑΙ . ΗΜΙΕΣΥ . ΕΤѠΝ . ΤΟΥ . ΔΙΑΒΟΛΟΥ .
ΕΠΕΙΤΑ . ΔΕΣΜΟΘΗΣΕΤΑΙ . ΕΝ ΤѠἰ . ΙΒᵃⁱ . ΚΑΙ . / ΒΛΕΨΟΜΕΝ .
(ΣΑΦ? . . .)ΝΟΝ . ΟΜΟΙΟΝ . ΤΗἰ ΓΡΑΦΗἰ . ΤΑΥΤΗἰ .

(I Alessandro painted this picture at the end of the year 1500 in
the troubles of Italy in the half time after the time according to the
11th chapter of St. John in the second woe of the Apocalypse in
the loosing of the devil for three and a half years then he will be
chained in the 12th chapter and we shall see clearly[?] . . . as in
this picture.)

Represented is an apocalyptic vision, the Virgin adoring the
Child, the kneeling Magi and Shepherds on either side, angels
holding the crown and olive branches kneeling on the roof and danc-
ing above, and three pilgrims being received by angels below (in
poses reminiscent of Fra Angelico's figures in San Marco), while
evil spirits flee before them into the rocks. The content and inscrip-
tion, though damaged, seem to indicate an allegory on the martyr
death of Savonarola and his companions, as well as the Christmas
message from Luke: *Gloria in altissimis Deo, et in terra pax
hominibus bonae voluntatis* (Luke 2: 14).

Filippino Lippi (ca. 1457-1504) continues the decorative styliza-
tion and lyric sentiment of Botticelli's middle period to a form of
mannerism which again parallels, in many respects, the late Gothic
mannerisms of a century before.

He was born in Prato, probably in 1457, the son of Fra Filippo
Lippi and the nun Lucrezia Buti. His early training began with his
father and Fra Diamante, and he was paid on December 31, 1469,
for his part in the work on the Spoleto frescoes. In 1472, he was
registered in the Florentine guild of St. Luke as associated with Bot-
ticelli. A document of 1478 indicates that he had a dispute with Fra
Diamante over the possession of a house in the parish of San Pietro
Maggiore that was a part of Filippino's inheritance. Whether or not
he actually assisted Botticelli on the Sistine Chapel decorations is
doubtful, though he is known to have worked on lost frescoes of
Lorenzo Magnifico's Villa dell'Ospedaletto near Volterra. In
December 1482, he was commissioned to execute, but probably did
not undertake, the decoration of the large hall of the Palazzo della

Signoria in Florence, a commission which first had been given to Perugino.

In 1484, he was commissioned to complete the frescoes of the Brancacci Chapel left unfinished by Massacio. He was awarded a contract on April 21, 1487, to decorate the Strozzi Chapel in Santa Maria Novella; the next year, he bought a house in Prato and made a trip to Rome, where he was presented to Cardinal Oliviero Caraffa. On the recommendation of Lorenzo the Magnificent, he received a commission from Caraffa to decorate his chapel in Santa Maria sopra Minerva (September 21, 1488). The next year (May 2), Filippino wrote a letter to Filippo Strozzi promising to begin the frescoes for him that summer, but apparently he was still in Rome on January 15, 1491, when he offered from there a design in the competition for the façade of the Cathedral of Florence. On January 1, 1497, he was one of a commission to estimate the frescoes of Baldovinetti in Santa Trinità, and in the same year he married Maddalena di Piero Monti. Payments for the Strozzi work began on November 27, 1500, and the decorations were probably finished in 1502, when he signed the fresco of the Raising of Drusiana.

A number of altarpieces commissioned by patrons outside Florence (i.e., Rome, Prato, Pavia, Bologna), as well as the invitation, in 1503, from King Matthias Corvinus of Hungary (for whom he had painted two panels in 1488) to come to that country, indicate something of the reputation Filippino had acquired. On January 1, 1504, he was one of the commission, along with Giuliano da Sangallo, Cosimo Roselli, Leonardo da Vinci and Bernardo Bandinelli, to decide the placement of Michelangelo's David. He died on April 18, 1504, was buried in San Michele Visdomini, and left three sons, of whom Giovanni Francesco is mentioned in Benvenuto Cellini's autobiography as a friend and goldsmith, and Roberto is referred to by Vasari as a pupil of Rustici.

Filippino's early works show a closer relationship to Botticelli than to his father or Fra Diamante. Two of these, executed between 1480 and 1485, are the altar with the Annunication and Two Saints (St. John the Baptist and St. Andrew) before a landscape with a view of Florence, now in the Galleria Nazionale di Capodimonte of Naples; and the altarpiece representing four saints (Saints Roch, Sebastian, Jerome and Helen) in the church of San Michele in Lucca. The general poise and grace of the figures, the facial types, and the

expressiveness of the hands (particularly in the Lucca panel) are specifically Botticelli in character. Two others, probably earlier, are the Coronation of the Virgin of ca. 1475, now in the National Gallery of Washington, and the Adoration of the Magi (ca. 1475-1480), now in the National Gallery of London.

His first documented altarpiece is that representing the Apparition of the Virgin to St. Bernard, commissioned by Pietro di Francesco del Pugliesse for the Chiesa delle Campora a Marignolle near Florence, set up in 1486 and now in the Badia of Florence. The donor is represented in the lower right-hand corner; the Virgin and angels are said to represent his wife and children. Some of the figure types, such as the angels, and the lyric, melancholy spirit of the scene, are still reminiscent of Botticelli, but the elongated proportions of the figures, the brighter coloration, and the new emphasis given to the detailed setting (i.e., the fantastic rock formations built up around the figures) are new features which Filippino tends to develop in his later work. The comparison of this panel with the contemporary frescoes of Ghirlandaio and Botticelli (i.e., the St. Jerome and St. Augustine) as an interpretation of the saintly scholar will demonstrate again the peculiar character of Filippino's style and that of this late period of the Quattrocento.

The completion of the Brancacci frescoes in Santa Maria del Carmine, left unfinished by Masaccio, began (1484) with a number of figures and some of the background of the Raising of the King's Son (i.e., the four portraitlike men at the extreme left, the boy and the eight men and the child in a row at the right). According to Vasari, the young Francesco Franacci had posed as model for the figure of the kneeling boy. A number of the standing figures about the cathedra of Peter are attributed to him. Certainly by Filippino's hand are the two narrow frescoes with St. Paul Visiting St. Peter in Prison and St. Peter's Delivery by the Angel, St. Peter and St. Paul before the Proconsul, and Peter's Execution. The artist's self-portrait is assumed to be the head at the extreme left of this latter fresco. Significant about the style of this series is the use of light and the simplicity and dignity of figures and composition, which Filippino seems to have absorbed from the monumental form of Masaccio.

In the frescoes which followed, Filippino loses both the lyric earnestness of Botticelli and the monumental dignity of Masaccio.

The damaged and considerably restored decorations of the Caraffa Chapel in Santa Maria sopra Minerva, Rome (1489-1493), contain an Annunciation on the altar wall, with the kneeling patron, Cardinal Caraffa, recommended to the Virgin by St. Thomas. Above it is the Assumption of the Virgin, with groups of apostles on either side. On the lunette of the left wall is St. Thomas's Vision of the Miraculous Cross, and below it is the Triumph of St. Thomas Aquinas. The Four Sibyls (Tiburtina, Hellespontica, Delphica and Cumana), executed largely with the assistance of Raffaellino del Garbo, decorate the vaults.

Various compositional features which might be noted are, first of all, the strikingly baroque character of the compositions, with the prominence given to a spacious and elaborately detailed architectural setting (the Triumph of St. Thomas); the extravagant movement and excitement of figures, especially noticeable in the swinging angels about the Virgin in the Assumption (cf. the problems of space and movement as worked out by Melozzo da Forlì); the attempt to combine and humanize traditional themes, as seen in the combination of the Annunciation with the presentation of a donor to her; and a certain artificial intellectualism (i.e., the Triumph of St. Thomas), which is not a matter of the subject alone, but can be seen in the obvious prominence given to the various books and inscriptions (cf. the composition with that of Gozzoli's St. Augustine Teaching, in San Gimignano; the theme with the Gothic Triumph of St. Thomas, in the Spanish Chapel of Santa Maria Novella, by Andrea da Firenze).

The third important fresco project by Filippino, and the end of his stylistic development, is the decoration of the Strozzi Chapel in Santa Maria Novella, Florence. The contract was made April 21, 1487, but the work probably did not begin until 1500, when the first payment was recorded (November 27), and it must have been completed at the time that he signed and dated the Drusiana fresco on the triumphal arch at the right: *A. S. MCCCCCII Philippinus di Lippi faciebat*. Represented are scenes from the lives of St. John the Evangelist and St. Philip: on the right wall is the Miracle of St. Philip, in which he curses the serpent in the Temple of Mars and causes it to come out from under the pagan altar, while the deadly stench from the beast kills the king's son. Above it in the lunette is the Crucifixion of Philip. On the opposite wall is the Resuscitation of

Drusiana by St. John, and in the lunette above it, the Martyrdom of St. John by being boiled in oil before the Emperor Domitian. On the altar wall are grisaille decorations with Caritas, Fides and other allegorical figures. The stained glass of the Madonna with St. John and St. Philip was executed from Filippino's design. On the vault appear figures of Adam, Noah, Abraham and Jacob.

Many of the same stylistic characteristics noted before in the Caraffa Chapel are here developed more elaborately, namely, the predominance of a highly mannered architectural setting with its combination of ancient Roman and Renaissance motifs, the rich and detailed ornamentation (Benvenuto Cellini professed great admiration for Filippino's sketches, which Giovanni Francesco had in his possession), the increased emphasis on excitement and movement of the figures, and a certain realism of action, which may be seen in the mechanically realistic way in which the cross is being raised, and in such motifs as that of the soldier protecting one of the executioners from the hot fire with his shield in the Martyrdom of St. John.

Perhaps Filippino's best-known altarpiece is that of 1496, representing the Adoration of the Magi, executed for the monks of San Donato a Scopeto (now in the Uffizi) and signed on the back: *Filippus me pinsit de Lippis Florentinus addi XXIX di Marzo*. It was for this altar that Leonardo had begun his early Adoration of the Magi, which was never finished. The style reveals much of the manneristic excitement and realistic detail already noted in the murals, and is an interesting comparison with the similar composition of Leonardo's unfinished panel (ca. 1480, in the Uffizi), as well as with the famous Portinari Altar of Hugo van der Goes.

The fresco decorations (dated 1498) representing the Madonna with St. Anthony Abbot and St. Margaret, St. Stephen and St. Catherine, of the street tabernacle of Canto a Mercatale, now in the Galleria Communale of Prato, are remarkable for their simplicity and almost Gothic expressiveness. The other late signed altarpieces (the Mystic Marriage of St. Catherine, in San Domenico, Bologna, 1501; the St. Sebastian with Saints John the Baptist and Francis, 1503, in the Palazzo Bianco in Genoa; the Madonna with Saints Stephen and John the Baptist, 1503, in the Galleria Comunale of Prato; and the Deposition, formerly the high altar of SS. Annunziata and now in the Accademia of Florence, that was left unfinished at his death and completed by Perugino) again show much of the same

baroque spirit and form with something of the Umbrian sentimentality (i.e., Perugino).

Raffaellino del Garbo (ca. 1470-ca. 1525) is one of several unimportant and rather enigmatic personalities who belong in this circle. He is often confused with a number of other names (Raffaello di Carlo, Raffaello Capponi or Raffaello dei Carli) with whom he is probably identical. Born ca. 1470, he was, according to Vasari, an assistant to Filippino on the Caraffa frescoes, and is registered in the *arte dei medici e speziali* as ''Raphael Bartolomei Nicolai Capponi pictor nel Garbo'' on November 15, 1499, and in the guild of St. Luke as ''Raffaello di Bartolomeo del Garbo'' in 1503 and 1505. He is credited with having painted most of the Sibyl frescoes in the vaults of the Cappella Caraffa in Santa Maria Sopra Minerva, in Rome, under Filippino Lippi's direction. His chief works might be considered the Resurrection altar in the Accademia of Florence, which seems closely related to Filippino, and the Madonna and Child with Saints Francis and Zenobius and Two Kneeling Donors, signed ''Raphael de Caponibus'' and dated 1500 (Uffizi). He died, supposedly, in 1524 (Vasari).

Jacopo del Sellaio (1442-1493) was originally a pupil of Fra Filippo Lippi, according to Vasari, and is recorded in the guild of St. Luke in 1472, and had a shop on the Piazza San Miniato fra le Torri with Filippo di Giuliano in 1480. A large number of small devotional house altars and cassone panels reveal variations of motifs by Botticelli, Ghirlandaio and Filippino. A signed Annunciation of 1472 with a predella containing the Nativity and Saints Martin and Sebastian is in the church of Santa Maria delle Grazie, in San Giovanni Valdarno, and another of 1473 is in Santa Lucia dei Magnoli, in Florence. A St. Sebastian of 1479 is in the collection of Yale University in New Haven. His chief work was, perhaps, the Pietà with St. Jerome and St. Frediano, now in the Staatliche Museen of Berlin, commissioned in 1483 by the Compagnià di San Frediano detta la Bruciata for their chapel in the church of San Frediano (destroyed in 1945). A characteristic combination of Ghirlandaio and Botticelli features may be seen, too, in the Crucifixion with the Virgin, Mary Magdalene, Saints John, Frediano, Catherine, Sebastian and Laurence, along with Tobias and the Angel, still in the sacristy of San Frediano, Florence.

Piero di Cosimo (Piero di Lorenzo, 1465-1521) holds a unique position, in this poetic-romantic group of painters associated with the Medici, through his particular emphasis on light and color as a means of expression. He represents the beginning of a new generation of outspoken colorists which develops in Florence during the early Cinquecento (cf. Fra Bartolommeo, Albertinelli, Andrea del Sarto, Pontormo, Branciabigio and others). He has been much discussed by critics as a significant and enigmatic figure, not only as an artist in his own right but also as a transition from the fifteenth to the sixteenth centuries in Florence.

The documentary records of his life are few. His real name was Piero di Lorenzo (called ''di Cosimo'' after his teacher, Cosimo Rosselli), and he was born in 1462 (from tax declarations by his father in 1470 and 1480 giving his son's age), the son of a painter and goldsmith, Lorenzo Chimenti. In 1480, he entered Rosselli's workshop, and accompanied him to Rome to assist on the Sistine Chapel decorations the following year. In 1504, he was a member of the commission to decide the placement of Michelangelo's David, and in 1514, he was charged with the design and direction of a Triumph of Death parade in Florence. Vasari states that he died in 1521 and was buried in San Pier Maggiore, though at another place he says that Piero lived to be eighty years old. There is no other evidence, however, to prove that he lived until 1542.

Piero's early work and style can best be seen in the distinctive sections of various frescoes in the Sistine Chapel which are attributed to him. Vasari suggests that he had painted the landscape background of Cosimo Rosselli's Sermon on the Mount. Related to this more lively manner are the scenes from Christ's Passion, seen through the windows above the Last Supper, the landscape of the story of Moses, and the Passage through the Red Sea (which, however, is also attributed merely to Ghirlandaio's shop). Piero's closer observation of nature, his interest in the play of light and shade, his freer application of paint and the particular atmospheric use of even and luminous green, blue and violet tones are features quite distinct from the pedantic manner of his teachers, Rosselli and Ghirlandaio, and seem to be developed on the inspiration of the Portinari Altar by Hugo van der Goes.

A considerable number of hardly datable cassoni and other

240

decorative panels, with allegorical or mythological scenes, begins to appear during the period in which Lorenzo Magnifico and his circle flourished. Their production seem to continue, regardless of Savonarola and the revolutionary reforms, well into the next country. The best known of these are: the Mars and Venus, in the Berlin-Dahlem Museum (cf. Botticelli's panel of the same subject); the Battle of the Centaurs and Lapiths (from Ovid's *Metamorphoses*, 12), in the National Gallery of London; the three companion panels representing allegorical scenes of the Stone Age (i.e., the Hunting Scene and the Return from the Hunt, in the Metropolitan Museum of New York, and the Forest Fire, in the Ashmolean Museum of Oxford); the cassone panel with Perseus and Andromeda, in the Uffizi, which, from a 1589 inventory of the Uffizi, was painted by Piero from a drawing by Leonardo (hence must have been during Leonardo's second stay in Florence, i.e., after 1500); the two cassoni panels representing the myth of Prometheus and Epimetheus, in the Alte Pinakothek of Munich and the Strasbourg Museum; the so-called Death of Procris, in the National Gallery, London, in which (note the contrast between this and the Berlin Mars and Venus) the softer and less rigid composition, and more atmospheric coloration, are characteristic of Piero's later style that is closely associated with Leonardo.

A number of these, particularly the panels of the Stone Age series, in the Metropolitan and Ashmolean, together with the Fall of Vulcan, in the Wadsworth Athenaeum, Hartford, Connecticut, and the Vulcan and Aeolus, in the National Gallery of Ottawa, have been associated with the decoration of a *studiolo* commissioned by Francesco del Pugliese in 1486.

The earliest authentic altar panel by Piero is the Madonna Enthroned with Angels and Saints (Saints Catherine of Alexandria and Rose of Viterbo kneeling, and the standing Peter and John the Evangelist), in the Pinacoteca del O Spedale degli Innocenti, Florence, mentioned by Vasari as ordered by the head of that institution. Done in the early 1490s, it reflects many of Filippino's mannerisms, but also has a deep and rich coloration reminiscent, again, of Hugo van der Goes as well as of the *sfumato* of Leonardo. More in the spirit of the High Renaissance, though inferior in quality, is the Immaculate Conception with Saints Francis, Jerome, Bonaventure,

Bernard, Augustine and Thomas Aquinas, in the church of San Francesco in Fiesole, that has a false date of 1480 and appears to have been painted much later.

The best-known portraits by Piero belong in this later period. One is that of Simonetta Vespucci, who is allegorically idealized as Cleopatra, labeled with its prominent inscription, in the Condé Museum of Chantilly. Two others are the striking portraits, in the Rijksmuseum of Amsterdam, representing Giuliano da San Gallo, the architect, and Francesco Giamberti, his father. Both are mentioned by Vasari as being in the house of Francesco da San Gallo.

2. Siena

AT THE BEGINNING OF THE FIFTEENTH CENTURY, Siena, like many of the other smaller city republics, came under the control of Gian Galeazzo Visconti of Milan. Upon his death in 1402, the city put itself under the protectorate of Florence, retaining most of its own republican form of government. It remained consistently Ghibelline, had been visited by the Holy Roman Emperors Sigismund and Frederick III, and maintained close contact with the Aragonese court at Naples, as well as with those of Milan and the North. Its subsequent history closely parallels that of Florence until 1490, when Pandolfo Petrucci established his Signoria over the city.

Unlike that of Florence, Sienese painting of the fifteenth century is more deeply rooted in its own Gothic tradition, with the stylized figures, gold backgrounds and heavy ornamentation that had been carried on through the late Trecento by Barna da Siena, Taddeo di Bartolo and Paolo di Giovanni Fei. Although fully aware of the great accomplishments in Florence, it is not concerned with the theoretical problems, the disciplined study of nature, nor the popular appeal involved in the large-scale fresco projects of the Florentines, but rather with the more intimate and personal expression and appeal which has its parallel in the court art of northern Europe.

Sassetta (Stefano di Giovanni, ca. 1400-1450) was probably the most influential of the early Sienese painters of the Quattrocento. Called Il Sassetta, he was a son of Giovanni di Consolo of Cortona. He is assumed to have been educated in Siena, and is recorded in the guild of painters in 1428. There are various records of

payments for work from 1440 on, including processional banners for the cathedral, a lost San Bernardino for Santa Maria della Scala in Siena, and a fresco commission (1447) for the Coronation of the Virgin for the Porta Romana in Siena, which was finished by Sano di Pietro after his death. His style, though deeply rooted in the Sienese Trecento tradition, seems likewise closely related to the rejuvenated Gothic which was flourishing in Florence at the same time in the work of Gentile da Fabriano, Pisanello and, particularly, Masolino.

The first of Sassetta's documented works is the polyptych which was painted between 1423 and 1426, commissioned by the *Arte della Lana* for their chapel near the former church of San Pellegrino in Siena. Fragments in scattered museums include the Last Supper and the Flagellation of St. Anthony, in the Siena Pinacoteca, a Miracle of the Sacrament, in the Bowes Museum, Barnard Castle, a St. Thomas Aquinas before the Crucifix, in the Vatican Pinacoteca, and a St. Thomas in Prayer, in the Budapest Museum (Szépmüvészetimuzeum).

A second altar is the Madonna of the Snow, which was commissioned in 1430 for the Cappella di San Bonifazio in the cathedral by the widow of a former *operaio* of the cathedral, Madonna Ludovica, and was completed in 1432 (signed, *Stefanus de Senis pinxit*). The central panel and predella are now in the Contini-Bonacossi Collection, Florence. The altar represents the Madonna and Child with Angels, and Saints John the Baptist, Peter, Francis and Paul. The seven panels of the predella present scenes from the Miracle of the Snow (i.e., the founding of Santa Maria Maggiore) that form an interesting contrast to the almost contemporary interpretation of the same subject by Masaccio. To it also belonged the Virgin of the Annunciation, in the Yale University Art Gallery, and a companion Angel, in the Museum of Massa Marittima.

The dated triptych (1436) of the Madonna and Child with St. Jerome and St. Ambrose, in the Basilica dell'Osservanza in Siena, has a stronger emphasis on Gothic proportions and ornament, and is sometimes attributed to a separate anonymous master, known as the "Master of the Osservanza." The polyptych of the Madonna and Child with Saints Nicholas, Michael, John the Baptist and Margaret, in the church of San Domenico in Cortona, was painted ca. 1433/4 and, though not documented, is generally attributed to Sassetta.

A Birth of the Virgin altar, formerly in the Collegiata of As-

ciano and now in the Museo d'Arte Sacra there, has a rather involved perspective system running through the three main panels, with separate scenes of the Madonna and Child Flanked by the Death and Funeral of the Virgin attached above. It presumably had a predella below. A Pietà, in the Dijon Museum, and a Virgin Taking Leave of the Apostles, in the Berenson Collection of Harvard University in Settignano, appear to belong to this predella group. The date is assumed to be about 1436.

Notable features of the style, in general, are the long proportions of figures, the facial types and rich ornamentation, that are still reminiscent of Simone Martini and the early Sienese, while the distribution of figures, and unified composition of linear perspective through the several panels of the main scene, reflect the new era (cf. the similar Nativity by Paolo di Giovanni Fei). The general character is intimate and direct, more closely associated with the predella or miniature than with the larger format of the Florentine production (cf. the Adoration of the Magi in the Palazzo Seracini in Siena with the similar compositions of Gentile da Fabriano, Lorenzo Monaco and Masaccio).

A major project, which extended over a number of years (1437-1444), was the polyptych for the high altar of San Francesco in Sansepolcro devoted to the life of St. Francis. The front panels present an Enthroned Madonna and Child with Angels flanked by St. Anthony and St. John the Evangelist (in the Louvre), while the back has St. Francis in Ecstasy with the Blessed Raniero Rasini and St. John the Baptist (Berenson Collection, Settignano). The altar remained in its original position until 1752 when it was dismantled and the various fragment dispersed over the years to a number of private collections. The accompanying scenes from the life of St. Francis constituted an extensive series of small panels, including a Miracle of the Blessed Raniero Rasini (which probably belonged to the predella), in the Staatliche Museen of Berlin, the Mystic Marriage of St. Francis, in the Musée Condé in Chantilly, and seven other scenes in the London National Gallery.

A considerable number of separate panels attributed to Sassetta are to be found in the Yale University Collection in New Haven, that of Count Guido Chigi Seracini in Siena, the Metropolitan Museum in New York, the Fogg Art Museum of Cambridge, Massachusetts, the Detroit Institute of Arts, the Berlin Staatliche

Museen, and others. Problems of attribution and participation have included related masters, such as Sano di Pietro and the Osservanza Master, as well as other followers.

Sano di Pietro (Asano di Pietro di Mencio, 1406-1481) is one of Sassetta's pupils, who are best known for their prolific production of small and highly expressive devotional altarpieces as well as miniatures. The record of his activity in Siena begins in 1428 and continues for many years, indicating the flourishing activity of a large shop producing technically superb but standardized compositions in small devotional panels, as well as frescoes triptych of the Coronation of the Virgin, in the Palazzo Pubblico of Siena, executed in 1445 (partly done by Domenico di Bartolo); sections of the fresco fragment of a Heavenly Host with Musical Angels and Prophets begun by Sassetta and completed by Sano; the fresco of St. Bernardinus, probably painted to commemorate his canonization by Pope Nicholas V in 1450, in the Siena Palazzo Pubblico; a St. Jerome in Prayer, in the Pinacoteca of Siena; a Madonna and Child with Four Angels, in the Basilica di Osservanza in Siena (also frequently attributed to Sassetta); and a number of miniatures, e.g., those of the antiphonary in the Cathedral of Siena, 1470.

An altarpiece known as the St. Anthony Abbot polyptych of 1444 has been variously attributed to Sano di Pietro and the so-called Osservanza Master, as well as to Sassetta. Indeed, there is good argument that the Osservanza Master and Sano di Pietro are to be identified as the same artist. A fragment of the central panel with the figure of St. Anthony is in the Louvre, while the scenes from his legend are in the Yale University Art Gallery (St. Anthony Tempted by a Demon in the Form of a Woman, St. Anthony's Flagellation), the Berlin Staatliche Museen (St. Anthony at Mass), the National Gallery of Washington (St. Anthony Distributes His Money to the Poor, St. Anthony Leaves the Monastery, the Meeting of St. Anthony and St. Paul the Hermit, and the Obsequies of St. Anthony), and the Robert Lehman Collection of New York (St. Anthony and the Porringer).

Giovanni di Paolo (Giovanni di Paolo di Grazia, 1403-1482/3) is another of Sassetta's better-known pupils, was mentioned as a painter in Siena as early as 1423, and was entered in the painters'

guild in 1428. Records of various payments appear, including one in 1447 by the brotherhood of San Bernardino to him and Sano di Pietro for an altarpiece. In 1450, he was paid for two illuminated books commissioned by the Spedale della Scala.

His development can be followed from dated works beginning as early as 1426 with the Pecci polyptych, which included a Madonna and Child with Music-making Angels (in the Propositura of Castelnuovo Berardenga, near Siena), saints on the side panels (two of them, St. Domenic and St. John the Baptist, in the Siena Pinacoteca) and several scenes in the predella (the Resurrection of Lazarus, Road to Calvary, the Deposition and Entombment, in the Walters Art Gallery of Baltimore, and a Crucifixion, in the Lindau Museum of Altenburg). A variation is the Madonna and Child, now in the Hirsch Collection of Basel (1472), which, like the Pecci Madonna, shows the strong influence of Gentile da Fabriano, who had been working in Siena (1425-1426) on his Madonna dei Notai (lost).

His most important altarpieces might be considered the large Crucifixion of 1440, in the Pinacoteca of Siena, signed *Hoc opus Johannis Pauli de Senis pinxit MCCCCXXXX*; the famous last Judgment, (also in the Pinacoteca of Siena), a late work particularly significant because of its relationship to both Gentile da Fabriano and Fra Angelico's Dantesque Last Judgment; the Flight into Egypt, Presentation in the Temple and the Crucifixion, in the Siena Pinacoteca, which belonged to the Fondi Polyptych of 1436; the large Christ Suffering and Christ Trimphant of 1426-1430, from the church of San Niccolò al Carmine in Siena, now in the Pinacoteca; the Assumption of the Virgin, in the Collegiata of Asciano (1470-1475), with its predella scenes representing St. Benedict Promulgating His Rule, the Communion of St. Magdalene, the Virgin Taking Leave of the Apostles, the Death of the Virgin, St. Galganus at Montesiepi, and the Vision of St. Bernard, in the Siena Pinacoteca, which would indicate the probable identity of the saints on the side panels of the polyptych; the Madonna and Saints with the Pietà, in the Cathedral of Pienza (1463); the polyptych of an Assumption (1475), formerly in the church of San Silvestro near Staggia, now in the Siena Pinacoteca.

Several interesting series of panels which probably belong to the middle period are those depicting scenes from the life of St.

Catherine, in the Stoclet Collection of Brussels, and the scenes (1447-1449) from the life of John the Baptist, in the Chicago Art Institute. The four scenes of a similar life of St. John, which undoubtedly belonged to a single predella, are in the National Gallery of London. A remarkably human and personal interpretation of the Triumph of Death appears in a miniature of an antiphonary of about 1450 in the Biblioteca Comunale of Siena, with its representation of a terrifying equestrian figure of Death charging a single martyrlike figure of a man in prayer.

There are several features of the style of Giovanni di Paolo which place him in a rather unique position in the development of the period: the strange and expressive facial type used is a realistic variation of the traditional Sienese-Byzantine form; the unique designed worked out in profile figures and patterned landscapes (cf. the early works of Uccello, i.e., before 1436); the lyric spirit and love of detail in the Last Judgment (cf. the Paradise) suggesting Fra Angelico, as does the active gesture of Christ as Judge (cf. Fra Angelico's Christ, in the Orvieto chapel, and the motif as used by Michelangelo); and, finally, there appears a curious observation of the effects of light, which again is associated with the innovations of Gentile da Fabriano (cf. the use of gold to produce the effect of sunlight in the Flight into Egypt.)

Domenico di Bartolo Ghezzi (ca. 1400-1445/7) is the first representative of the new realism emanating from Florence and taking root in Siena. Born ca. 1400 in Asciano, he was, according to Vasari, a pupil of Taddeo di Bartolo. He was first registered in the Sienese artists' guild in 1428, and was paid, in 1434, for a sketch of the enthroned Emperor Sigismund, which was supposedly used for the pavement design in the cathedral. He is recorded as having executed frescoes (lost) for the sacristy of the cathedral in 1435-1439. Earlier signed works, such as the Madonna now in the Pinacoteca of Siena (1433), the Madonna now in the Johnson Collection, Philadelphia (signed and dated: *Dominicus de Senis me pinxit anno 1437)* and the polyptych with the Madonna and Saints (1438), in Perugia, show a crossing of Florentine (i.e., Masaccio-Masolino) and Umbrian (i.e., Ottaviano Nelli of Fabriano) stylistic elements.

Domenico di Bartolo's chief works, and the first important frescoes of the century in Siena, are those in the Pellegrinaio of the

hospital of Santa Maria della Scala in Siena, commissioned in 1441 by the record of the hospital, Giovanni di Francesco Buzzicchelli, and completed in 1444. They represent realistic, almost genre, scenes of the Sanctioning of the Order by Pope Celestinus II, the care of the sick, the distribution of alms, marriage of the foundlings, the building of the hospital annex and a Madonna della Misericordia. The style reveals a well-developed linear perspective, an emphasis on ornamental detail, bright color and a certain combination of courtly dignity and realistic genre in the composition of figures. Many of these features recall the work of early Masaccio followers in Florence, e.g., the Prato Master. A pupil, **Priamo Della Quercia**, is recorded as having assisted him on this series.

Vecchietta (Lorenzo di Pietro, ca. 1412-1480) represents the Sienese transition from the Neo-Gothic of Sassetta and Giovanni di Paolo to the new realism which flourished through the third quarter of the century. Where the first two might be understood as parallels, successively, to Masolino and Fra Angelico in Florence, Vecchietta would take a position parallel to the combined genre-realism of Gozzoli and the shop productions of the Florentines during the same period (i.e., Pollaiuolo).

Lorenzo di Pietro, called Il Vecchietta, was born in Castiglione d'Orcia (Siena) about 1414, was a pupil of Sassetta, and was active as a goldsmith, architect and sculptor, as well as a painter. His work as a sculptor in bronze, developed under the influence of Jacopo della Quercia and Donatello, is perhaps more outstanding than his painting (cf. the bronze tabernacle in the Cathedral of Siena, 1462-1472).

In 1429, he collaborated with Sano di Pietro on an Annunciation in the Cathedral of Siena. Two years later he painted frescoes (1441) as part of the decoration of the large hall (the Pellegrinaio of the Ospedale della Scala in Siena), representing the Ladder of Paradise (i.e., the Foundlings' Ascending to Heaven), which has a large number of figures composed into an elaborate architecture. In 1446-1469, he painted the (damaged) Last Judgment in the sacristy of the same hospital, which is interesting for its horizontal division into an upper and a lower half, and the restrained dramatization of the scene.

Between 1449 and 1453, he decorated the apse and vaulting of

the Baptistry in Siena with frescoes of many figures of Apostles, Prophets and Sibyls, similarly composed into an architectural or landscape framework giving the illusion of space as well as decorative unity. While the earlier frescoes show more of the overall decorative interest through the use of color and architecture, in the manner of Domenico Veneziano and the Florentines, those of the Baptistry have a more brutal and personal expression in the individual figures. The two life-size frescoes in the Palazzo Pubblico, Siena, representing St. Catherine of Siena and the Madonna della Misericorida (the former executed, according to the inscription, in 1461 to commemorate the canonization of the saint that year by Pope Pius II) reveal a more monumental style, undoubtedly related to his own work in bronze, done at the same time for the cathedral.

Several altarpieces, although more conservative in character, show something of the development from the isolated figures and gold backgrounds of the Gothic to the more intimately connected and plastically modeled figure and space compositions of the Renaissance: the altar with the Madonna with Six Saints (Saint Bartholomew, James, Eligius, Andrew, Laurence and Dominic), 1457, in the Uffizi, and the triptych, signed signficantly with the identification as sculptor, *Opus Laurentii Petri scultoris de Senis*, in the Cathedral of Pienza, representing the Assumption of the Virgin with Saints, 1461 (cf. the similar Assunta by Giovanni di Paolo in the Collegiata of Asciano). This altarpiece was one of a series, commissioned by Pope Pius II in 1461-1462 for the new Cathedral of Pienza, designed by Bernardo Rossellino, including work by Giovanni di Paolo, Sano di Pietro and Matteo di Giovanni.

Of special interest, too, are Vecchietta's illustrations to Dante's *Divine Comedy* (London, British Museum). The manuscript was presumably illuminated between 1438 and 1444 for Alfonso of Aragon by both Giovanni di Paolo (the *Paradise*) and Vecchietta (the *Inferno* and *Purgatory*).

Matteo di Giovanni di Bartolo (ca. 1435-1495) was probably born in Sansepolcro some time before 1435, and appears in Siena before 1453, when he is associated with Giovanni di Pietro in the operation of a shop. He had probably worked with Vecchietta, and he is recorded as having decorated the Chapel of San Bernardino in the Cathedral of Siena (now destroyed).

In a number of altarpieces, one can follow his development from a naturalistic style, under the influences of Vecchietta, to the rather vertical and monumental style of Piero della Francesca, and, finally, to a more active and dramatic form parallel to that of the later Florentines (Pollaiuolo). The first of these is the polyptych, in Sant' Agostino in Asciano, representing the Madonna and Saints, painted about 1460. Of about the same time (i.e., in the 1460s) are the side wings, pilasters and predella of the triptych in the Cathedral of Sansepolcro, the central panel of which, i.e., the Baptism of Christ, in the National Gallery, London, was executed by Piero della Francesca. Whether Matteo had any direct or personal connection with Piero is not known, but the solidity of the figures has much of the character of the Umbrian master, while the general type is still in the Sassetta-Vecchietta tradition.

A remarkable example of this combination of characteristics is the Assumption of the Virgin, in the National Gallery of London, painted originally for the church of Sant' Agostino in Asciano in 1474. Two of the side panels are presumed to be the St. Augustine and St. Michael now in the Collegiata of Sant' Agata in Asciano. The dramatic figure of St. Thomas reaching for the Virgin's falling girdle, and the fluttering action of the music-making angels, reflect the contemporary interest in the active figure and design in Florence, while the spacious and sensitive landscape, and the tall, well-modeled figure of the Virgin, with her modestly expressive features, are in the mood of Piero della Francesca.

The clear disposition of the figures and perspective, and the Renaissance ornamentation, are to be noted in the Madonna and Saints altar of 1470, signed: *Johannis de Senis Pinxit MCCCCLXX*, in the Siena Pinacoteca. In the 1477 Madonna delle Nevi altar (signed and dated: *Opus Matei de Senis MCCCCLXXVII*, in the Siena Pinacoteca, a larger number of saints and angels are crowded about the enthroned Madonna in typical Sienese fashion, but the total group is given a coloristic unity which is strongly reminiscent of Duccio's Maesà, and may have been inspired by Piero's coloration. The Assumption of the Virgin (1487), on the high altar of Santa Maria dei Servi, in Sansepolcro, is likewise significant for its luminous coloration.

Among the later works there are a number of variations of the Massacre of the Innocents, which is of special interest,

iconographically since its appearance may have been inspired by the contemporary sack of Otranto and the massacre of its inhabitants by the Turks in 1480. At the same time it reflects compositionally the new interest in the physical movement of figures and dramatically exciting scenes (cf. Antonio Pollaiuolo). The chief works of this group representing the Massacre of the Innocents, in which a gradual intensification of dramatic action may be noted, are: the panel in Sant' Agostino, in Siena, 1482; that of the Museo Nazionale of Naples, with its signature and date, retouched, but probably done in 1488; the pavement in the Cathedral of Siena (together with the figure of the Samian Sibyl), executed from his designs, 1483; and the altar in Santa Maria dei Servi in Siena, 1491. The frieze of the Siena pavement is most remarkable for its many centaurs, wrestless and battling warriors, inspired by classical antiquity (vase paintings or sarcophagi) but corresponding to the combination of dramatic physical action and decorative taste of the late Quattrocento (cf. Pollaiuolo, Leonardo, Michelangelo).

Guidoccio Cozzarelli (1450-1516) is one of the pupils and followers of Matteo di Giovanni. A number of his signed and dated works exist, namely, the Baptism of Christ, of 1486, in San Bernardino, Sinalunga, the Madonna and Child with St. Jerome and the Blessed Giovanni Colombini, of 1482, in the Pinacoteca of Siena, and the attributed but certain Annunciation and Flight into Egypt, in the National Gallery of Washington. He also executed miniatures, such as those of the antiphonaries in the Piccolomini Library of Siena.

Benvenuto di Giovanni (1436-1518), another pupil of Vecchietta's, was the son of Giovanni di Meo del Guasto, and is first recorded in 1455, when he was at work on the frescoes of the Baptistry of Siena, undoubtedly as an assistant to Vecchietta. A considerable number of signed and dated works reveal no great individual innovations, but are of interest as a Sienese parallel not only to the Pollaiuolo-Verrochio tradition in Florence, but also to that of Crivelli in Venice. The most characteristic of these is, perhaps, the triptych (1475) of the Madonna Enthroned with Musical Angels and Saints, signed *Opus Benvenuti Iohannis de Senis MCCCCLX-XV*, in the Pinacoteca of Siena (note particularly its bright and or-

nate coloration, the clear modeling of forms and hard contours). A signed triptych of the Madonna and Child with St. Peter and St. Nicholas, of 1479, is in the National Gallery of London, and a later Adoration of the Magi is in the National Gallery of Washington.

The later work appears to be much closer to the art of Crivelli: the Madonna Enthroned with Angels and Saints, and the Pietà in the lunette, in San Domenico, Siena (1483); the Assumption of the Virgin, in the Metropolitan Museum, New York, signed *Opus Benvenuti Johannis de Senis MCCCCLXXXXVIII*; and a last Madonna altar, in 1509, in Santa Lucia in 1483-xx85 in the Cathedral of Siena, representing the Tiburtine Sibyl and the Expulsion of Herod, are to be understood in connection with the similar designs (Massacre of the Innocents) by Matteo di Giovanni of the same time. Benvenuto's son, **Girolamo di Benvenuto** (1470-1524), continues the same manner well into the sixteenth century (cf. the Madonna Enthroned with Saints, of 1508, in the Siena Pinacoteca).

Francesco di Giorgio Martini (1439-1502) is the most important Sienese artist of the fifteenth century, and the only one who attained a reputation outside his own locality in any way comparable to the great personalities of the Renaissance (e.g., Alberti and Leonardo).

He was born September 22, 1439, and is first recorded in 1464, when he, as a sculptor, received payment for a bronze relief from the company of San Giovanni Battista della Morte. At the same time, he was paid as an engineer concerned with the water system of the city. He married in 1467 and again in 1468, this time to the sister of Neroccio dei Landi. That year, with Neroccio, probably who had been a pupil with him in the shop of Vecchietta, he opened a shop on a partnership basis, but after a disagreement, in which Vecchietta and Sano di Pietro acted as arbiters, the association was dissolved in 1475. Two years later, he entered the service of Duke Federigo of Urbino as a military engineer, though he is referred to in the contemporary documents, including *Giovanni Santi*, as *dipintore*. He was an enthusiastic student of ancient ruins, according to Giovanni Santi, and was interested in their conservation as well as in the use of classical motifs for cassoni and other decorations.

In 1479, he was active as a painter for Federigo's ally, the Duke of Calabria, and the following year again was in Urbino as architect,

engineer (chiefly on fortifications) and even serving on diplomatic missions for the duke. Through Signorelli, he became associated with the design of the church of Santa Maria della Grazie al Calcinaio, outside Cortona, in 1484, and after the next year he was active on various engineering projects for the city of Siena, such as to Milan, to consult on the dome of the cathedral, and, with Leonardo, to Pavia, on the reconstruction of the cathedral there. He appeared in Naples, and then took part in the competition for the design for the façade of the Florentine cathedral (1491). In 1498, he was named directing architect of the Cathedral of Siena. He died in 1502 at San Giorgio a Poppaiano.

Of Francesco's works, the most important sculptures are probably the two bronze angels, commissioned in 1489, which flank the tabernacle by Vecchietta over the high altar of the Cathedral of Siena. The one certain architectural plan accredited to him is the church of Santa Maria delle Grazie al Calcinaio, at Cortona. Aside from many drawings of figure compositions and engineering projects reminiscent of Leonardo, and a number of book illuminations executed during his early period (those of 1463 and 1466, the Museum of the Osservanza), there are several important altarpieces by his hand in the Pinacoteca of Siena: an Annunciation, done before 1472, with its long-proportioned figures, sharply foreshortened perspective and double row of columns; the Adoration of the Child by the Virgin, St. Joseph and two kneeling saints who were originally St. Benedict and St. Thomas Aquinas, but whose attributes were changed in the eighteenth century to have the figures represent the Beato Ambrogio Sansedoni and St. Bernardinus. The altar is signed *Francis.Georgii.pinxit* and was painted in 1475 for the monastery of Monte Oliveto. Its general design suggests Verrocchio, but the composition is especially related to that of Baldovinetti's Nativity in SS. Annunziata in Florence.

The large Coronation of the Virgin, in the Siena Pinacoteca, was commissioned by the monks of Montoliveto di Chiusuri in 1471, and contains the kneeling figures of St. Catherine and St. Sebastian along with rows of saints, Church Fathers and monks of the Olivetan order. Significant about the Coronation panel is its stiff and formally centralized composition, with Christ in the central axis, the many-figured arrangement in an oval from the floor in the foreground up to the angels and seated saints behind the throne at

the top, the continuance of this three-dimensional composition in the circular movement of the sharply foreshorted God-Father at the top, the similar interest in a more abstract emotional expression in the hard drawing and design of the figures, which seems to be inspired by Antonio Pollaiuolo. A glance at the actively battling nudes of the Osservanza miniatures (the Labors of Hercules) will show the certain influence of Pollaiuolo at that early date.

Whereas the Coronation was painted in tempera in strong, contrasting colors, the Adoration of the Child shows a mixed technique with oil. Its color is softer, more unified in tone, the figures are more easily and gracefully composed (notice especially the two angels at the right, one casually leaning on the other's shoulder), and a distant landscape appears behind the ruins in the background. A later altarpiece representing a similar Adoration (San Domenico, Siena) has an almost classic architectural setting, in the form of a triumphal arch ruin, across the background, with small landscape vistas and a circular temple reminiscent of Brunelleschi's *laterna* on the dome of the Cathedral of Florence. The figures, especially those of the shepherds at the right, are composed in a more agitated and decoratively stylized manner, like Botticelli. Francesco is also credited with the designs of the pavement in the Cathedral of Siena depicting the Liberation of Bethulia and the Story of Jephthah (1483).

Neroccio di Bartolommeo Landi (1447-1500) was also a pupil of Vecchietta's, had conducted a workshop from 1469 until 1475 with his brother-in-law, Francesco di Giorgio, and is recorded at work for the Duke of Calabria, for the town of Lucca, and on many local projects in painting and sculpture from that time until his death in 1500. The most important examples of his sculpture are the marble tomb of Tommaso Testa Piccolomini (d. 1483), Bishop of Pienza and Montalcino, in the Cathedral of Siena, and the wood statue of St. Catherine (1474) in the Oratorio di Santa Caterina in Fontebranda, Siena.

The character and development, if any, of Neroccio's painting can be noted in a number of altar panels which reveal the essentially conservative devotional nature of the local Sienese style that follows in a direct line from Simone Martini to the end of the Quattrocento. The first of these is the triptych of 1476, in the Pinacoteca of Siena,

255

signed and dated *Opus Nerocci Bartolommei Benedictis de Senis MCCCCLXXVI*, representing the Madonna with Saints Michael and Bernardinus. Although Neroccio had worked in the same shop with Francesco di Giorgio, their styles have little in common. Note the bright gold backgrounds, the delicate tone and coloration, the simple design, particularly in the Madonna, the elaborately armored yet sensitive figure of Michael. The best of the later altars, with their larger proportions and more monumental compositions, are the Madonna with Six Saints, Saints Peter, Sebastian, John the Baptist, Sigismund, Bernardinus and Paul, signed and dated *Opus Nerocii de Senis MCCCCLXXXXII* (1492), in the Siena Pinacoteca (note especially the crowded composition of the figures and the ornate Renaissance throne), and the large altarpiece with the Madonna and Saints Peter and Sigismund, Ansanus and Paul, together with God the Father and six cherubim in the lunette above, in the choir of SS. Annunziata in Montisi, fully signed and dated 1496.

Neroccio is also credited with another of the pavement designs in the Cathedral of Siena, namely that of the Hellespontine Sibyl, 1483, a book cover for *gabella* (tax account) records, representing the Virgin Recommending the City of Siena to Christ, with the inscription on the scroll which she holds: *Hoc est Civita Mea*, and the coats of arms of the executors (1480) in the Archivio di Stato there. Two late works, associated in style with Luca Signorelli, are in the National Gallery of Washington: the Claudia Quinta (ca. 1495), one of a series of Famous Men and Women of the type painted by Castagno for the Villa Carducci, and the handsome Portrait of Young Lady, of ca. 1490, which once had been considered a portrait of Alessandra Piccolimini.

3. Perugia

PERUGIA HAD BEEN REMARKABLE through the fourteenth century for its independence, democratic rule and predominantly Guelph policies. The *Stato populare libero e guelfo*, however, terminated in 1403 with the expulsion of the Raspanti and the government's being taken over by Braccio Fortebracci and a subservient magistry of priors. The city came under the control of the papacy in 1424 and, though there were many factional disputes, the absolute sovereignty of the church was recognized. In 1425, Fra Bernardino of Siena came to Perugia, and, as a reformist, exercised a great popular influence. From that time until 1486, Perugia suffered eight different times from the plague without intermission, but most severely during the years 1460-1468. From 1450 on, the growing influence of the Baglioni family appeared, which was rivaled by that of the Oddi, and a continual and bloody series of family feuds ensued. In 1488, a Council of Ten was established, with the Baglioni in control, which continued amid disastrous civil wars until Rome took possession of the city (1506).

The development of a local style in Umbria, and in Perugia in particular, is a close parallel to that of Siena in its conservative adherence to the traditional Gothic style in the manner of Gentile da Fabriano. The new spirit of the Quattrocento is not felt until the middle of the century, largely under the influence of Domenico di Bartolo and a more realistic interpretation of Fra Angelico (i.e., Benozzo Gozzoli). As in Siena, the tradition still remains devotional in spirit, and does not appear interested in "problems" of artistic form and representation; hence the clear separation of the local masters, even though influenced by the Florentines (as was

Perugino), from the so-called Umbro-Tuscan group (i.e., Piero della Francesca, Melozzo da Forlì and Luca Signorelli) described in the chapter on Florence.

Giovanni Boccati (Giovanni Boccati da Camerino, ca. 1420-ca. 1480) is probably the first important artistic personality in Perugia, and, though by no means founder of the school, is certainly one of the early contributors to its own local style. He was born in Camerino and became a citizen of Perugia in 1445, and his activity is traceable through a number of dated works in Perugia, Camerino and surrounding towns.

His chief work, and the earliest extant, is the signed and dated Madonna del Pergolato with Saints and Musical Angels, signed *Opus Iohannis Bochatis de Camereno*, which was executed in 1447 for the Oratorio of the Confraternità di San Domenico, Perugia (now in the Galleria Nazionale dell' Umbria there). The style of the panel reveals, perhaps, the influence of Domenico di Bartolo, but it also shows a close relationship with Fra Filippo Lippi (Coronation of the Virgin), as seen in the pyramidal composition of Virgin, marble throne and kneeling saints in the center, with the singing angels and other saints grouped around it. The stiffness of the figures, however, and a certain naturalism (cf. also the predella scenes representing St. Thomas, the Taking of Christ, the Road to Calvary, the Crucifixion and St. Peter the Martyr) suggest the influence of the early Gozzoli. The Madonna dell' Orchestra, from San Simone del Carmine, Perugia, in the same museum, again shows Sienese characteristics with its elaborate ornamentation and tall proportions. Later works by Boccati are the Coronation, in the church of Castel Santa Maria near Camerino (1463), the Madonna and Saints, in the Museum of Budapest (1473), and the banner of the Pietà, signed *P. Domini Filippi Elci Johannes Bochacii de Camereno fecit 1479*, in the Galleria Nazionale dell' Umbria, formerly in Santa Maria degli Angeli in Perugia.

Benedetto Bonfigli (ca. 1420-1496) may possibly have been a pupil of Boccati's. He is first mentioned in 1445, when he was commissioned to pain an altar for the monastery of San Pietro in Perugia (lost). In 1450, he is recorded as *Maestro Benedetto de Perugia dipintore* in the service of Pope Nicholas V. After August 1453, he

is back in Perugia, and is commissioned, on November 30, 1454, to decorate the first half of the Cappella dei Prior in the Palazzo dei Prior with fresco scenes from the life of St. Louis of Toulouse and a Crucifix over the altar. These were evaluated by Fra Filippo Lippi on September 11, 1461, and on his favorable report a second contract was given for the completion of the series. The execution of these continued intermittently, with the aid of Bartolomo Caporali, and were not finished at his death, July 8, 1496.

Bonfigli's most important work is this fresco decoration of the Cappella dei Priori with scenes from the life of the youthful Franciscan bishop, St. Louis of Toulouse: 1) Louis consecrated as Bishop by Pope Boniface VIII (1296); 2) the Miracle of the finding the merchant's lost gold in the belly of the fish after a storm at sea; 3) the Funeral of St. Louis; 4) the Siege of Perugia by Totila; 5) the two scenes depicting the transference of the saint's body to San Pietro and again to San Lorenzo.

With regard to the style, the influence of the late Fra Angelico (or early Benozzo) seems especially apparent in the Consecration of Louis as Bishop (cf. the Consecration of Stephen as Deacon, in the Vatican, by Fra Angelico, executed only shortly before). The composition of the Funeral of St. Louis (perhaps the finest of the series) is based on the similar funeral scene by Lippi in Prato, which is repeated so many times by later artists of the Quattrocento. Significant here, in contrast to Lippi, is the particular interest given to architectural setting at the expense of the figures and their emotional expression, which is a characteristic markedly developed in the later frescoes. Both of these seem to have been done before Lippi's evaluation in 1461. The architectural views are realistic and recognizable; to be noted are the interior of San Pietro in the Funeral scene, and the panorama of Perugia from Sant' Ercolano in the Transference of the Body of the Saint, which are stylistically interesting parallels to the romantic naturalism of Lippi and Benozzo (cf. also Ambrogio Lorenzetti's fresco panoramas). The coloration is much more refined and unified in tone than was that of Boccati, and may have been inspired by Piero della Francesca.

Bonfigli is also well known for a particularly popular local specialty, the processional banner, or *gonfalone*. The theme is usually the representation of the Virgin, Christ, or a saint as Protector of the city and its inhabitants against Death, the Plague and other misfor-

tunes, in the manner of the Misericordia Madonnas (cf. Gozzoli's St. Sebastian as Protector, in Sant' Agostino, San Gimignano). A number of these are dated and follow the development of Bonfigli's later art toward a harder, ornate and more stylized form (cf. the Madonna, in San Francesco al Prato, Perugia, 1464; the Christ with San Bernardino, in the Galleria Nazionale dell' Umbria of Perugia, 1465; the Madonna of 1472, in Corciano; and that of 1476, in San Fiorenzo, Perugia).

Among the altarpieces, the earliest one surviving is probably the Adoration of the Magi, with its predella containing the Baptism, the Crucifixion, and St. Nicholas of Bari Rescuing the Three Innocent Men, in the Galleria Nazionale dell' Umbria (formerly in San Domenico of Perugia). It was mentioned by Vasari and was painted ca. 1453. While there are certain characteristics of Gozzoli already apparent, the major influence seems to be Boccati and Gentile da Fabriano. The numerous other and later altars produced in his shop with the aid of Caporali show the elaborate ornament (with the particular use of gold), classic architectural settings and figure types related to Gozzoli (cf. the Annunciation with St. Luke of ca. 1460, and the triptych of the Madonna and Saints executed for San Domenico, 1467, both in the Galleria Nazionale dell' Umbria).

Bartolomeo Caporali (ca. 1420-ca. 1505) is assumed to have worked in the shop of Bonfigli and to have painted the two panels of Bonfigli's San Domenico triptych, or at least parts of them, since he is recorded as having received half the payment for it. This largely Gozzoli manner, which then develops under the influence of Fiorenzo di Lorenzo, may be seen in the signed and dated (1469) fresco of the Assumption of the Virgin with Saints Juliana, Benedict and Bernard at the base, and God the Father above, formerly in the convent of Santa Giuliana in Perugia, and the Pietà fresco from the same convent of 1486. Both of these are preserved in the Galleria Nazionale dell' Umbria, as are the fragments of a signed and dated (1487) altarpiece, painted for the Cacciatori in Santa Maria Maddalena, in Castiglione del Lago.

Fiorenzo Di Lorenzo (ca. 1440/5-1522/5) might be considered the transition from the older style of Bonfigli, developed under the influence of Lippi and Gozzoli, to the lyric, decorative art of Pinturicchio and Perugino. He was born some time between 1440 and

1445, in Perugia, is registered in the guild lists from 1463 on, and was probably a student of L'Alunno (Niccolò di Liberatore, ca. 1430-1502), who was born in Foligno and developed under the influence of Gozzoli, the Vivarinis and Carlo Crivelli (cf. the Banner of the Annunziata, signed *Societas Anuntiate fecit hoc opus A.D.M.CCCCLXVI*, from Santa Maria dei Servi di Colle Landone, now in the Perugia Galleria Nazionale).

Fiorenzo is traceable in a number of documents referring to works that are now lost. One altarpiece, in particular, was contracted for in 1472, by the Silvestrines of Santa Maria Nuova in Perugia, and again, after some negotiations, in 1487, and a third time in 1491, when the date for the delivery of the work was set for 1493. The polyptych in the Perugia Galleria Nazionale dell' Umbria, representing the Madonna in Clouds with Angels and Four Saints, is assumed to be this altar. The gold backgrounds and stiff composition of the figures go back to the earlier Perugia tradition; the Madonna type (cf. the tall proportions and facial type), as well as the fluttering design and movement of the angels at her feet, resemble the contemporary Florentines, particularly Verrochio. Likewise, Florentine in spirit and form is the Adoration of the Shepherds, from the church of Santa Maria di Monteluce of Perugia, now in the Galleria Nazionale there.

The earliest work, with features more characteristic of L'Alunno and Caporale as well as Florentine, is the Guild of Justice triptych with the Madonna and Child, Kneeling Angels and Saints and the Dead Christ surrounded by the Virgin, Saints and Guild Members (ca. 1460-1470), from the Oratorio di Sant' Adrea or della Giustizia, now in the Perugia Galleria Nazionale. The only certain work of Fiorenzi is the signed and dated (*Florensius Lauren/tii Perusinus MCCCCLXXXVII*) frame of a niche, in the Perugia Galleria Nazionale, representing St. Peter and St. Paul at the sides and the Madonna and Child with Angels and Cherubim above the niche. Its style appears to be a development over the previous altar toward the more voluminous drapery, the stylized figure poses and movement, characterstic of Perugino, and certainly influenced by him. A fresco of the Madonna della Misericordia, formerly in the hostel of Sant' Egidio of the Collegio della Mercanzia, now in the Perugia Galleria Nazionale, originally had a date (1476) and signature.

Associated with the art of Fiorenzo and his shop, which in-

cluded Perugino, is a series of eight small panels now in the Galleria Nazionale of Perugia, originally used with the Banner of San Bernardino as part of a niche decoration, probably in the Oratorio of San Bernardino. They depict various scenes of the Miracles of St. Bernardinus: The Healing of the Daughter of Giovanni Antonio da Rieti, with an inscription on the arch indicating a completion date of 1473 (*S.P.Q.R. Divo Tito Divi Vespasiani Filio Vespasiano Augusto A.D. MCCCCLXXIII Finis*), Healing of a Blind Man, Imprisonment and Liberation of a Youth, Healing of a Paralytic, Healing of Nicola da Prato's Son, who had been gored by a bull, St. Bernardinus Raises the Stillborn Son of John and Margaret of Basel, Captain Giovanni Antonio Tornano is attacked and wounded, then healed by St. Bernardinus, the Healing of a Wounded Man.

The identification of the style has involved considerable discussion. The panels had once been assigned to Fiorenzo di Lorenzo, but different characteristics of design, such as the Alberti-type architecture and the figure compositions, have suggested a separate ''Master of Urbino''; others suggest Bonfigli, Caporali, Perugino and Pinturicchio. One possibility is that the general design of all the panels had been done by Perugino, and their execution carried out by the separate shop assistants. Their importance, however, lies in the collection of many stylistic characteristics, such as the spacious architectural and landscape settings, the subordination of figures to the space, and the delicate stylization of movement in the figures. These features are then developed and elaborated upon by Pinturicchio and Perugino, in a manner parallel to the development in Florence.

Perugino (Pietro di Cristoforo Vanucci, ca. 1450-1523) is the most important of the Umbrian masters. As formal decoration, his style is a parallel to that of Ghirlandaio; its lyric and emotional expressiveness is close to that of Botticelli; and while, in spirit and form, his art is rooted in the local tradition of Perugia, it develops on the same stylistic plane as the other great masters of the late Quattrocento.

He was born in Castello della Pieve about 1450, which is inferred from Giovanni Santi's mention of him in his *Cronaca Rimata* as the same age as Leonardo, although Vasari implies his birth year as 1445. His artistic origins and early training are not definitely

known; as a youth, he probably worked in the shop of Fiorenzo di Lorenzo who, in turn, had been influenced by Verrocchio. He could have worked with Piero della Francesca, as may be inferred from his knowledge of perspective and peculiar coloration, as well as by Vasari's mention of his having executed frescoes (now lost) in the churches of Sant' Agostino and Santa Caterina in Arezzo as an assistant of Piero. Vasari also says that Perugino had worked with Leonardo and Lorenzo di Credi in Verrocchio's shop.

In any case, he was probably in Florence during the late 1460s and is registered in 1472 in the Florentine guild of St. Luke as *Pietro di Cristofano da Perugia*. If one assumes the eight panels of the legend of San Bernardino to be the combined work of Perugino and Pinturicchio in the shop of Fiorenzo di Lorenzo, he would have to have been back in Perugia by 1473, when one of them is dated (*1473 finis*). It is certain that he was at work in Perugia by 1475, when he finished the frescoes (destroyed) of the Sala del Consiglio in the Palazzo dei Priori, and probably remained there until after 1478, when he signed and dated the fresco of St. Sebastian in the parish church of Cerqueto, near Perugia.

In 1479, he was in Rome, at work for Sixtus IV on the choir frescoes of St. Peter's, which represented a Madonna Enthroned in Clouds Adored by Saints and which were destroyed with the demolition of the church. Although nothing is known about them save the insufficient sketch made by Giamcomo Grimaldi, the style may possibly have been similar to that of the contemporary frescoes of Melozzo da Forlì executed for SS. Apostoli. With some interruptions, he remained in Rome until 1482, at work on the Sistine Chapel decorations, the contract for which he had signed October 27, 1481, though probably he had begun the work already before the Florentine artists were called to Rome. In 1482, in Florence, he was commissioned to paint frescoes in the Palazzo della Signoria, which were then turned over to Filippino Lippi. On one of his various trips to Rome, he signed a contract with Antoniazzo Romano (1484), and together they executed, with assistants, many processional banners, coats of arms and decorations for the coronation ceremonies of Innocent VIII.

During the decoration of the Sistine Chapel, Perugino was already looked upon as one of the foremost artists of Italy, and his subsequent prolific activity was divided largely between Perugia,

Florence and Rome, relatively unaffected by the political and artistic changes that were taking place, particularly in Florence (Savonarola) and Rome (Julius II). In Florence, he was a member of the commission appointed to judge the designs for the new façade of the cathedral (1491). In Venice, he received a contract (August 14, 1494) to decorate the Sala del Gran Consiglio, which was not carried out, and later, in 1513, Titian offered to do the project. In 1497, he estimated, together with Benozzo, Filippino Lippi and Rosselli, the frescoes of Baldovinetti in Santa Trinità. It was during the years 1499-1503 in Perugia, when he was producing some of his best work, that the young Raphael worked with him as assistant. In 1508, along with the great masters of the new era (i.e., Raphael and Michelangelo), he was called to Rome by Julius II, but he decorated only the ceiling of the Stanza dell'Incendio in the Vatican.

Through his very last years, he continued actively at work, mostly in Perugia and the neighboring provincial towns of Umbria, and died in either February of March, 1523, of the plague, in Fontingnano. The next year (October 6, 1524), his widow offered a canvas by him representing Venus, Mars and Vulcan to the Marchesa Isabella d'Este, who refused to buy it—a fact which, though in itself insignificant, is somewhat indicative of the fading popularity of the great masters of the last quarter of the Quattrocento before the new generation of the High Renaissance (cf. the similar fate of Signorelli, Botticelli and their contemporaries).

Of the large number of documented and attributed works belonging to Perugino, a few will suffice to demonstrate his artistic form, his historical position and his personal development. The first undoubted fresco is the St. Sebastian, in the parish church of Cerqueto, which is signed and dated, *Petrus Perusinus, P.A. MCCC-CLXXVIII*, and beside which the damaged figures of St. Roch and St. Peter are barely visible. Its pose and facial type are influenced by the traditional form of Fiorenzo di Lorenzo (cf. his Sebastian in the Perugia Galleria Nazionale). The freer stance, the more organic understanding of the nude figure and its effective, almost sculpturesque modeling, however, are features related to the Verrocchio shop. When compared with the metallic hardness of color and design in Fiorenzo's Sebastian, the color here is softer, and the light aids in the modeling of the form. There is a more effective perspective used, in which the figure is placed on a pedestal before a column above the

beholder's eye level (cf. Pollaiuolo's St. Sebastian). Perugino's development can be followed in a series of later variations of this popular theme, such as the St. Sebastian now in the Louvre, ca. 1494, the fresco in the church of San Sebastiano of Panicale, which is signed (*Petrus de Castro Plebis pinxit*) and dated 1505, and the panel, in the Galleria Nazionale of Perugia, from San Francesco al Prato, 1518.

The frescoes of the Sistine Chapel (1481-1482) originally comprised six large scenes, of which the Discovery of the Infant Moses, the Assumption of the Virgin and the Birth of Christ on the altar wall were later removed to make way for Michelangelo's Last Judgment (cf. the drawing by a pupil, in the Albertina, Vienna). On the side walls are the remaining scenes, depicting the Baptism of Christ, the Journey of Moses from Egypt, and Christ giving the Keys to St. Peter. In the execution of these, according to Vasari, Perugino had the help of a number of assistants, particularly Pinturicchio, whose hand may be seen in the landscape backgrounds and smaller figures of the first two, though the general designs and the main figure groups (e.g., John and Christ in the Baptism) were certainly done by Perugino himself.

The finest of the series is undoubtedly the Christ Giving the Keys to St. Peter scene, with Christ and St. Peter as the central group, the apostles arranged in a friezelike relief on either side, and additional scenes of the Tribute Money (Matthew 22) to the left, and the Attempt of the Jews to Stone Christ (John 8) on the right in the background. Among the contemporary portraits identified are the self-portrait (fifth from the right in the foreground), the architect Giovannino de' Dolci beside him to the right, and that of Alphonse of Calabria at the extreme left. Sixtus IV's exultant emulation of Solomon is reflected in the inscriptions: *Imensu (m) Salamo / Templum tu / hoc Quarte / Sacrasti Sixte Opibus / Dispar / Religione / Prior.*

As to the style, note the stylized poses (cf. those of Verrocchio) and rhythmical grouping of the foreground figures, the spacious square, with its sharp foreshortening, clear disposition of figures in their animated pattern, and the monumental effect of the architecture through the balancing of the octagonal temple and two Roman triumphal arches (cf. the Arch of Constantine) that forms a remarkable contrast to the similar attempt to use architecture in

Botticelli's fresco in the same series. It is in this fresco that Perugino matches, and in many ways surpasses, the attempts of the other great Quattrocentists of the same chapel toward a monumental decorative form. It is in this connection, too, that the Bernardino panels of 1473 are important as a possible early work of Perugino, containing many original motifs that are here developed to a perfected form.

The three large frescoes, composed as a triptych in the chapter room of the former Cistercian monastery in Florence, now Santa Maria Maddalena dei Pazzi, were begun in 1493 and unveiled on April 29, 1496. Mary Magdalene kneels at the foot of the Cross in the center piece, at the left is the Virgin with the kneeling St. Bernard Tolomei, and at the right is St. John the Evangelist with the kneeling St. Benedict. The reduced proportions of figures to the landscape (except for the towering Crucifix in the center), the luminous coloration of the sky and landscape background, and the entranced expression and pose of the figures, together with the simplicity of their composition, make this one of the noblest examples of this romantic style.

The somewhat damaged frescoes decorating the audience chamber of the Collegio del Cambio in Perugia were begun in 1499, and the main frescoes, at least, were probably completed in 1500 (from the *MD* on one of the pilasters in the Prophet and Sibyl fresco). Payments, however, extended from January 25, 1499, to June 15, 1507, which was probably due to the continuation of the work by assistants. The general iconographical program with its collection of Famous Men, and classical and religious allegory, appears to be related to Ghirlandaio's frescoes in the Sala dei Gigli in the Florentine Palazzo Vecchio, and may have been further developed in collaboration with Francesco Maturanzio, the Perugian humanist and classical scholar. On the elaborately decorated ceiling are medallions of the seven planets and the signs of the Zodiac (cf. the woodcuts in the *Astrolabium planum in tabulis ascendens*, ed. Johannes de Spira, Venice, 1494). On one wall are the frescoes illustrating Civic Virtue, with seated personifications of Wisdom and Justice, and the standing figures of three classical heroes for each below them (Fabius Maximus, Socrates, Numa Pompilius, Furius Camillus, Pittacus, Trajan), while on the other wall are Courage and Temperance, again each with three classical heroes (Lucius Sicinius,

Leonidas, Horatius Cocles and Publius Scipio, Pericles, Quintus Cincinnatus). On the end wall appear the Transfiguration, the Adoration of the Child (these representing, respectively, parallel religious allegories of Faith and Love), and God-Father with the Prophets Isaiah, Moses, Daniel, David, Jeremiah, Solomon and the Sibyls—the Erythrean, Persian, Cumaean, Libyan, Tiburtine and Delphic. Isolated figures of Cato (as Civic Virtue) and a self-portrait of Perugino in an illusionistic frame and an inscription on the shield below (*Petrus Perusinus Egregius.Pictor. . . . Perdita si Furerat Pingendi/ his Rettulit Artem/ si nusquam inventa est/ hactenus ipse dedit*) complete the decoration.

The artistic quality of the figures varies considerably due to the work of assistants, including Raphael, to whom the Fortitudo is often attributed. The elaborate designs of the single figures suggest the mannerisms of Filippino Lippi and other masters of the late Quattrocento, particularly in Florence, while the composition is based on the consistent alignment of figures on two levels against the open space.

Perugino's late frescoes show a continued repetition of formalized figure poses and group compositions in which, characteristically, the difference between his own painting and that of his many assistants can hardly be recognized. Characteristic of these are the fresco medallions, on the ceiling of the Stanza dell' Incendio in the Vatican (ca. 1508), and six saints (Saints Maurice, Placid, Benedit, Romuald, Benedict the Martyr and John the Martyr) added by Perugino, in 1521, below Raphael's fresco of the Holy Trinity, in the church of San Severo, Perugia.

Like his frescoes, Perugino's finest altarpieces were done during the earlier period. Their expressive character has much of the romantic appeal and intimacy of the small devotional altar which is expanded into monumental proportions, as can be seen especially in the fresco in Santa Maria Maddalena dei Pazzi. The most important of these are: 1) the early Adoration of the Magi, in the Perugia Galleria Nazionale, painted about 1475 for the church of Santa Maria dei Servi in Perugia, which reflects the influence of Piero della Francesca; 2) the Galitzin Triptych, in the National Gallery of Washington, with the Crucifixion, Mary and John in the center panel and St. Jerome and Mary Magdalene on the wings. The painting was commissioned, probably about 1485, by Bartolomeo Bar-

toli, Bishop of Cagli, and occupied the altar of Nome di Dio in the church of San Domenico in San Gimignano; 3) the large Albani Polyptych, completed in 1491 for Cardinal Giuliano della Rovere (later Pope Julius II), now in the Albani-Torlonia Collection in Rome, representing the Nativity, Crucifixion, Annunciation and Four Saints (Michael, John the Baptist, Jerome and George); 4) the two very characteristic Madonna Enthroned with Saints panels, in the Uffizi (1493), and Sant' Agostino, in Cremona (1494); the Vision of St. Bernard, in the Munich Alte Pinakothek, ca. 1494, which is closely related to the two foregoing altars in its combination of figures, space and architecture, yet in which the style is especially expressive of the mystic theme represented; 6) the equally expressive Pietà of 1494, using the same compositional scheme of figures framed by the architecture (Uffizi Gallery), and a second Pietà, signed and dated 1495, with its many-figured composition set in an open landscape, painted for the convent of Santa Chiara, Florence, and now in the Galleria Palatina of Florence; 7) the large polyptych of San Pietro, painted 1496-1498 for the high altar of the Benedictine church of San Pietro, Perugia, of which the central panel of the Ascension and lunette with God the Father are in the Musée des Beaux Arts of Nantes, predella scenes with the Adoration of the Magi, the Baptism and the Resurrection are in the Musée des Beaux Arts of Rouen, and a group of half-length figures of various saints are in the Galleria Nazionale dell' Umbria, Perugia, and the Vatican Pinacoteca; 8) the Enthroned Madonna with Six Saints, ca. 1498, formerly in Santa Maria delle Grazie, now in the Palazzo Communale of Sinigaglia; 9) the *Sposalizio* of ca. 1504, in the Musée de Peinture of Caen, which is of interest for its composition related to the Sistine fresco of Christ Giving the Keys to St. Peter and as a parallel to the similar *Sposalizio* (signed and dated 1504) painted by Raphael; 10) and, finally, the chief work of his late period, the large polyptych of Sant' Agostino in Perugia, of which some twenty-four panels are scattered in the museums of Lyons, Toulouse, Grenoble, Strasbourg, Birmingham, (Alabama), and Perugia. Painted on both sides (i.e., front and back of the altar, facing nave and choir), the chief scenes represent the Baptism with God-Father above (front), the Adoration of the Child with the Pietà (back), and accompanying Saints and Evangelists in separate panels. The execution was probably begun in 1512 and completed after his death by pupils.

Perugino's mythological pictures are unimportant in themselves but interesting historically as a weak parallel to Piero di Cosimo. One is the Triumph of Chastity, in the Louvre, painted on canvas for the Marchesa Isabella d'Este of Mantua in 1504. An Apollo and Marsyas (Louvre) is also attributed to him on the basis of the d'Este canvas.

A number of portraits are of special interest, not only because of their intrinsic quality but also as antecedents to those of Raphael just a few years later. These include the self-portrait, in the Uffizi Gallery, which has been attributed variously to Lorenzo di Credi and even to Raphael. It is also intepreted sometimes as a portrait of Verrocchio (cf. similar self-portraits in the frescoes of Christ Giving the Keys to St. Peter and the Perugia Cambio). Its date would appear to be ca. 1500. Somewhat earlier is the portrait of Francesco delle Opere of 1494, also in the Uffizi, with its inscription, *Timete Deum*, on the scroll in his hand.

Pinturicchio (Bernardino di Betto di Biagio, 1454-1513), represents in contrast to the strict horizontal and vertical compositions of Perugino and Ghirlandaio, a parallel with the later more colorful and highly decorative manner of Filippino Lippi and Piero di Cosimo.

Called Il Pinturicchio (from his diminutive size) or Il Sordicchio (for his deafness), he was born in 1454 (Vasari) and may possibly have worked with Perugino in the shop of Fiorenzo di Lorenzo. The first artistic activity definitely associated with him is that as assistant to Perugino in the Sistine Chapel (1481-1482). In 1481, he was entered in the painters' guild in Perugia; he bought property in Perugia, in 1482 and 1484, and in 1484, he was at work on the decoration of the Cappella Bufalini in Santa Maria in Aracoeli, Rome. In 1485/6, he was paid for smaller works in the convent of Monteluce in Perugia. In 1486, he was called by Innocent VIII to paint a large Madonna for a tabernacle and to decorate part of the Belvedere in the Vatican with landscapes and architectural views ''in the manner of the Flemings,'' as Vasari says (both works now lost except for lunette fragments in the Belvedere, with the date 1487). From then until his death, December 11, 1513, the greater part of his activity was in the service of the Popes at Rome. This was interrupted, at various times, by extensive commissions, mostly executed with the help of assistants, in Orvieto, Spello and Siena, as

well as frequent stays in his home town of Perugia. His later years seem to have been made miserable by his own physical infirmities and by the faithlessness of his wife Grania, which is reflected in his testament and other documents.

Pinturicchio's early development may be followed in the San Bernardino panels of 1473, the frescoes of the Sistine Chapel (1480-82) and those in Santa Maria in Aracoeli (1484). How much he had to do with the actual painting of the San Bernardino panels is not known, but their style is of significance as being characteristic of the group about Fiorenzo di Lorenzo, from which Perugino, as well as the younger Pinturicchio, developed. The two panels generally attributed to him are the Healing of the Paralytic, and the Imprisonment of the Young Man and His Liberation by San Bernardino. His participation in the Sistine Chapel decoration as assistant to Perugino is assured by Vasari, who says he received one-third of the payment. The style, however, is not easily distinguished from that of Perugino, but it is assumed that the greater part of the landscape and the smaller figures of the backgrounds in the Story of Moses, with the Exodus and Circumcision, and the Baptism of Christ, are painted by Pinturicchio (cf. the parallel assistance given to Cosimo Rosselli by Piero di Cosimo), as are the many fine portrait figures at the sides.

The frescoes in the Cappella Bufalini of Santa Maria in Aracoeli represent the Four Evangelists, in the vaults, and scenes from the life of San Bernardino: his glorification, on the altar wall (Christ in Glory above, with Saints Bernardino, Louis of Toulouse and Anthony of Padua below), and others depicting the Apparition of the Crucifix to him, the Investiture of San Bernardino, San Bernardino in the Wilderness, and the Funeral of San Bernardino. The Glorification is especially interesting because of its Umbrian emphasis on the landscape and the subordination of figures to the space. In comparison with the similar theme of Christ in Glory with Saints, by Perugino, the more subdued coloration in dull purple and green, the greater emphasis on the decorative movement of figures and drapery, and the general filling-up of empty spaces with manneristic designs, become evident as characteristic Pinturicchio features.

Pinturicchio's major works are the frescoes, particularly on the lunettes, of the Borgia apartments in the Vatican, which were painted between 1492 and 1495, with the aid of assistants, for Pope Alexander VI. They are divided according to subject matter: the

Hall of Mysteries (Annunciation, Adoration of the Magi, Nativity, Ascension, Descent of the Holy Ghost, Assumption of the Virgin, and the Resurrection with the votive portrait of Alexander VI); the Hall of Saints (the Visitation, Saints Anthony and Paul the Hermit in the Wilderness, the Martyrdom of St. Sebastian, St. Susanna and the Elders, the Flight and Martyrdom of St. Barbara, and the Disputation of St. Catherine); the Hall of the Seven Liberal Arts (with the enthroned figures of Grammar, Geometry, Dialectic, Arithmetic, Rhetoric, Astronomy and Music).

The frescoes of stylistic importance, in this series, which are assumed to have been executed more or less by Pinturicchio's own hand, are the Disputation of St. Catherine, the Visitation, the Martyrdom of St. Barbara, the portrait of Alexander VI in the Resurrection, and that of the donor (possibly the papal treasurer, Francesco Borgia) in the Assumption. In composition, the elaborate all-over decoration, the subordination of figures to the landscape or architectural space, the effective balancing of figure groups, and the mannered stylization of movement are characteristic features (cf. Filippino Lippi). Iconographically, the whole series is interesting as representative of the papal court of this pre-Julian era (i.e., Sixtus IV to Alexander VI), whose narrative realism and involved symbolism might be compared, on the one hand, with the Gothic allegorical decorations of the Spanish Chapel in Santa Maria Novella, Florence, and, on the other hand, with the High Renaissance decorations of Raphael (the Stanzas) or Michelangelo (the Sistine Ceiling).

The frescoes in the apse of the Cappella Eroli, in the Cathedral of Spoleto, were painted in 1497, and represent and altarlike composition on the circular wall with the seated Madonna and Child, St. John the Baptist and St. Laurence before a spacious landscape. A half-length Christ in the Tomb appears below, and God the Father with Angels and Cherubim covers the apse above.

The frescoes in the Cappella Baglioni of Santa Maria Maggiore, in Spello, were painted in 1501 for the papal protonotary, Troilo Baglioni (who became Bishop of Perugia that year), and represent four enthroned sibyls—Eritrea, Europea, Tiburtina and Samia—on the vaults, the Annunciation, the Adoration of the Shepherds and Christ among the Doctors, on the walls. The self-portrait of the artist, with the date 1501 and signature (*Bernardus Pictoricius Perusin[us]*, is to be found on the right of the Annunciation. The

best scene is probably that of Christ among the Doctors, with the decorative monumental use of the temple in the background (cf. Perugino's Christ Giving the Keys to St. Peter, in the Sistine Chapel).

The next year, 1502, Pinturicchio was commissioned by Cardinal Francesco Piccolomini (who became Pope Pius III in 1503) to decorate the cathedral library of Siena with frescoes depicting scenes from the life of his distinguished uncle, Aeneas Sylvius Piccolomini (Pope Pius II). These were begun in 1503 and completed in 1508. The series contains the following scenes: 1) the departure of the young Aeneas Sylvius, as secretary to Cardinal Capranica, for the Council of Basel, with the recognizable port of Talamone in the background. 2) Aeneas at the court of King James I of Scotland. 3) Aeneas, at the court of the Emperor Frederick III, receives the poet's crown of laurels from the enthroned Emperor. 4) Aeneas kisses the foot of the enthroned Pope Eugenius IV in the presence of the College of Cardinals, with the scene in the background of the Pope ordaining Aeneas to the priesthood after his reconciliation. 5) The meeting of the Emperor Frederick III and Eleonora of Portugal, whose marriage Aeneas had negotiated. The background represents a recognizable view of the Siena landscape outside the Porta Camollia, where the meeting took place, with a column bearing the coats of arms of the two families, and portraits of Alberto Aringhieri (wearing the black robe with the Maltese cross), Andrea di Nanni Piccolomini, and his wife, Agnese Farnese. 6) Aeneas Sylvius receives the cardinal's hat, as titular Cardinal of Santa Sabina, at the hands of Pope Calixtus III. 7) Aeneas, as the newly consecrated Pope Pius II, is carried into the church of San Giovanni Laterano. 8) Pope Pius II holds an assembly at Mantua with the Patriarch of Constantinople and various princes to organize the crusade against the Turks. 9) The canonization of St. Catherine, with the enthroned Pope blessing the body of the saint above, and the assembled crowd below, including portraits of Raphael, Pinturicchio and two Dominican Friars, presumably Fra Angelico and Raimondo of Capua, the confessor and biographer of St. Catherine. 10) The aged Pope Pius II arrives at Ancona to encourage the ill-fated crusade against the Turks, with, presumably, the portrait of Pandolfo Petrucci at the left.

During the same period, the frescoes over the entrance to the

library representing the Coronation of Pius II, with the dedication, *Pius III. Senen, Pii II. Nep. An. MDIII. September XXI. Apert. Electus Suffrag. VIII October Coronatus est,* and the scenes from the life of St. John the Baptist, in the Cappella di San Giovanni, were painted. A significant feature of the library decorations, aside from the monumental space proportions already noted in the earlier works, is their brilliant coloration and the narrative character of the content, which is reminiscent of Gozzoli but which reveals a greater interest in the figure composition as such rather than in the narrative. The best-known scenes are the Departure of Aeneas Piccolomini for the Council of Basel, and the Meeting of Frederick III and Eleanora of Portugal, with its figure composition reminiscent of the traditional *Sposalizio* as well as of the Visitation.

A number of stylistically unimportant altarpieces were executed during his late period, such as the Virgin and Saints, contracted for on March 24, 1507, by the Franciscans of Sant' Adrea, in Spello, and executed for the most part by a pupil, Eusebio da San Giorgio. The Virgin is seated on a Renaissance throne with a landscape background and the standing Saints Andrew, Louis of Toulouse, Francis and Laurence to the left and right. Angels and cherubim fill in the spaces above, and the child St. John is seated at the foot of the throne. The two important independent works by Eusebio da San Giorgio (ca. 1465/70-ca. 1539) are the 1508 Adoration of the Magi altar, in San Pietro, Perugia, with its mixed Raphael and Pinturiccio characteristics, and the signed and dated (1512) Madonna with Four Saints, in the church of San Francesco in Matelica.

A final project was the decoration of the reception hall of the Palazzo del Magnifico in Siena, commissioned by Pandolfo Petrucci in 1508 and painted by Pinturichio, Signorelli and Girolamo Genga. Fragments of the frescoes (now detached, on canvas), depicting mythological scenes, are in the National Gallery, London: Signorelli's Triumph of Chastity, and the Coriolanus Persuaded by his Family to Spare Rome (which has also been attributed to Genga), and Pinturicchio's Return of Prisoners, in the Pinacoteca of Siena, were designed by Signorelli but probably executed by Genga. Twenty-two detached fresco fragments from the ceiling by Pinturicchio have been reassembled, as replica of their original setting, in the Metropolitan Museum of New York.

4. Urbino

THE FAMILY OF MONTEFELTRO had been nominal rulers of Urbino even before Dante's time. The outstanding political and cultural personality of the fifteenth century was the great *condottiere* and humanist, Federigo da Montelfeltro, who, after marrying his daughter to Giovanni della Rovere, the nephew of Pope Sixtus IV, was confirmed as Duke by the Pope (1474). As a soldier, patron of the arts, humanist and founder of the great Urbino library, Federigo's position in Urbino is comparable to that of the Medici in Florence. He was succeeded in 1482 by his son Guidabaldo, husband of Elisabetta Ganzaga. In 1502, Guidobaldo was expelled by Cesare Borgia, and fled to Venice. On the death of Pope Alexander VI and the fall of Cesare, he returned to power in Urbino and reestablished his court of scholars and artists, among whom Castiglione, the envoy of Guidabaldo to the court of Henry VII of England and author of The *Courtier*, was perhaps the most famous.

Urbino's chief claim to eminence in the history of Renaissance painting is the patronage given to Piero della Francesca, Melozzo da Forlì and Joos van Ghent during the third quarter of the fifteenth century. Although Raphael was born here, his style was determined more by Perugino than by that of his father or any others of the local school.

Giovanni Santi (ca. 1435-1494) is the chief local master, perhaps more important as the father of Raffaello Santi and as the author of a rhymed chronicle (dedicated to Duke Guidobaldo), with its many comments on contemporary artists in Italy, than as a painter himself. A friend of Piero della Francesca and Melozzo da Forlì, he

appears to have been well acquainted with painting in Umbria and Flanders, and, from his remarks, seems to have taken a particular interest in perspective.

His stiff and provincial style can be followed in a group of altars and sacred conversation pictures: the earlier Visitation in Santa Maria Nuova, Fano, signed *Johannes Santis de Urbino pinsit*, and the signed Madonna and Saints, in Santa Croce, both of which were probably painted about 1485 and reflect a certain combined Flemish and Umbrian romantic interest in the landscape (particularly the Visitation), which may have been inspired by Joos van Ghent. The later works show a greater attention given to the architectural framework and setting, as well as to the enlivenment of figures, after the manner of Melozzo da Forlì and Perugino: the Madonna and Saints of 1489, with the kneeling members of the Buffi family, in the Galleria Nazionale delle Marche of Urbino; a much-restored Martyrdom of St. Sebastian and the Madonna with Saints and the kneeling Count Olivo Pianiani, 1489, in the Urbino Galleria Nazionale, formerly in the Franciscan monastery of Montefiorentino (cf. Piero della Francesca's Madonna altar with the kneeling Duke Federigo); and the later (1491) fresco of the Madonna and Saints, in San Domenico in Cagli, with its more decorated Renaissance throne and setting.

Timoeteo Viti (ca. 1469-1523) is the chief representative of the more decorative and manneristic style of the late Quattrocento in Urbino after Giovanni Santi. He was probably born in Ferrara, had worked, between 1491 and 1495, in Bologna, with Francesco Francia, and appears to have been permanently settled in Urbino in 1501, when he married a Gerolama di Guido Spaccioli, working for both Guidobaldo and Cesare Borgia after the latter's succession in 1502. An Annunciation, with a full-length standing Virgin flanked by Saints John the Baptist and Sebastian, is in the Pinacoteca di Brera in Milan. His chief works are probably the altarpiece with St. Thomas Becket and St. Martin adored by Guidobaldo da Montefeltro and Archbishop Arrivabene, in the Galleria Nazionale delle Marche in Urbino, and the late signed (*Timothei de Vite Urbinat opus*) panel of the high altar of San Michele in Cagli, representing the *Noli me tangere*, with St. Michael and St. Anthony Abbot.

5. Rome

DURING THE EARLY YEARS OF THE FIFTEENTH CENTURY, Rome and the papacy were occupied with attempts to end the Great Schism. A series of councils was held, and in 1417 the schism was ended by the election of Martin V as Pope. By 1443, under his rule and that of his successor, Eugene IV, the papacy had regained much of its lost prestige abroad, and the Popes were the absolute rulers at Rome. A number of outstanding scholars and personalities follow them on the papal throne, notably Nicholas V (1447-1455), the founder of the great Vatican library, and Pius II (1458-1464), the famous humanist Aeneas Sylvius Piccolomini. Toward the last quarter of the century there appears a renewed expansion of worldly power, as well as cultural enlightenment, through the patronage of learning and the fine arts in competition with the various courts of Florence, Urbino and the other cities. The rules of Sixtus IV (Francesco della Rovere, 1471-1484) and of Alexander VI (the famous Roderigo Borgia, 1492-1503) are notorious for their political conspiracies, murders, seizures of territory and intrigues withoutside powers for their own political gain. Yet it is they, particularly Sixtus IV, who inaugurate the most distinguished development of Renaissance art and architecture.

The problem of a local artistic tradition in Rome is a close parallel to that of Urbino, although on a much larger scale. The artists called upon to execute either altarpieces or decorative projects were, for the most part, outsiders, such as Gentile da Fabriano (for Martin V), Fra Angelico and Benozzo Gozzoli (for Nicholas V), Melozzo da Forlì, Signorelli, Botticelli, Ghirlandaio, Perugino, Cosimo Rosselli, and the younger group of Piero di Cosimo, Filip-

pino Lippi and Pinturicchio—all of whom, especially this younger group, were gathered by Sixtus IV and were further retained by his successors (cf. Pinturicchio and Alexander VI).

The Sistine Chapel

A review and analysis of the style of these masters working together on the concordance histories of Moses and Christ in the Sistine Chapel will reveal the intermixture of many regional and aesthetic traditions. There is also a unity, which is not a matter of artistic form or decorative style alone, but one content and its realistic and recognizable associations, for which Pope Sixtus IV, as patron, was directly responsible. Aside from the general interest of Sixtus IV in humanism and learning, as shows in his development of the Vatican library, it is significant that he himself was a Franciscan and had granted great favors to the Franciscans and other mendicant order in the promotion of their missionary and charitable activities.

As a Renaissance Pope and the successor to Martin V, Eugene IV and Nicholas V in the program of reestablishing the traditional preeminence of the papacy after the Schism, Sixtus IV's interest was in the consolidation of both temporal and spiritual power in the papal throne. The struggle for power in the fifteenth century was far different from the traditional Guelph and Ghibelline contest with the emperor. At this time, it was defense against the antipapal decisions of the various Councils of Constance, Florence and Basel in their attempt to limit the Pope's temporal as well as ecclesiastical power.

The general iconographical program of Sixtus IV's decoration of the papal chapel appears to be determined by the renewed doctrine of papal supremacy, by which the pope, as *Vicarius Christi*, derives his authority directly from Christ through His gift of the keys to Peter, the first Bishop of Rome, rather than through the Church. The selection of the scenes sought to strengthen the doctrine of personal leadership by juxtaposing the history of moses and Christ, as representatives of the Old and New Testaments, in an original concordance. Although there are no documents specifically defining the content, the attitude appears to be essentially the same as that outlined in Leonardo Bruni's letter to the committee of the *Arte de Calimala* concerning Ghiberti's bronze Doors of Paradise, namely that the

scenes be both *illustri* and *significanti*, i.e., they should tell the story and be meaningful.

The architect of the chapel is not recorded, although Vasari gives the name of Baccio Pontelli as active on this and many of Sixtus IV's projects. It was built on the site which had been used for that purpose since early times, and the previous buildings had been enlarged by both Pope Martin and Pope Nicholas as the papal *cappella magna*. Its inside dimensions were 40 x 13.6 meters, with a height of 20.7 meters. The decorative scheme was divided into three levels separated by heavy cornices, with painted curtains carrying the Rovere emblem (the oak) in the lower, the middle zone with the fourteen frescoes separated by vertical Corinthian pilasters, and an upper zone with the windows and full-length portraits of the thirty martyred popes, from Linus to Eusebius, in illusionary niches between them. The ceiling had been a plain blue with gold stars (later removed for Michelangelo's frescoes), and the floor was a mosaic of colored marble. The choir screen, also part of the original design, divided the room in half, but was moved in the sixteenth century to provide more room at the altar end.

The contract for the fresco decorations is dated October 27, 1481, between Giovannino de' Dolci as papal representative and the artists Perugino, Ghirlandaio, Cosimo Rosselli and Botticelli. Signorelli was added later probably late in 1482 to execute the last of the Moses series. The chapel was consecrated on August 15, 1483, so that most of the work must have been finished by that time.

The chapel was dedicated to St. Mary of the Assumption, and the west (altar) wall was dominated by a large altarpiece of the Assumption by Perugino, with his frescoes of the Finding of Moses on the left and Nativity on the right (later removed, along with the papal portraits of Linus and Cletus, to make way for Michelangelo's Last Judgment). Perugino's Assumption may well have been a fresco, rather than an altar panel, on the order of the Virgin and Saints with a kneeling figure of the pope, which he had painted (1479) in the apse of the Cappella del Coro of St. Peter's (destroyed in the building of the new church). A drawing now in the Vienna Albertina, presumably from Perugino's workshop, was apparently done after the altarpiece and gives a general idea of its design.

The order of the remaining scenes, and their concordance, is as follows:

Left (South) *Wall*:
LIFE OF MOSES

Right (North) *Wall*:
LIFE OF CHRIST

1. **The Journey of Moses**, with the Institution of the Circumcision (Genesis 17); the Meeting of Moses and Jethro (Exodus 18)—Pinturicchio.

1. **The Baptism of Christ**, with John the Baptist Preaching in the Wilderness (Matthew 3, Luke 3) —Perugino, Pinturicchio.

2. **Moses Slays the Egyptian**; he waters the flocks of Jethro; his Departure for Egypt (Exodus 2-4) —Botticelli.

2. **The Temptation of Christ**; the Cleansing of the Leper (Matthew 4, Leviticus 14)—Botticelli.

3. **Crossing of the Red Sea** (Exodus 14)—Cosimo Rosselli.

3. **The Calling of Peter and Andrew**; Healing of the Leper (Mark 1)—Chirlandaio.

4. **Moses Giving the Law to the Israelites**; Adoration of the Golden Calf; Punishment of the Idolators (Exodus 19, 31-34)—Cosimo Rosselli.

4. **The Sermon on the Mount** (Matthew 5-8)—Cosimo Rosselli.

5. **The Punishment of Korah, Dathan and Abiram** (Numbers 16)—Botticelli.

5. **Christ Giving the Keys to Peter** (Matthew 16); the Tribute Money (Matthew 22); Stoning of Christ (John 8, 10)—Perugino.

6. **The Last Acts of Moses**: Appointment of Joshua; Moses Reads the Law; Death of Moses (Numbers 27, Deuteronomy 29, 31-34) —Signorelli.

6. **The Last Supper**; Christ in Gethsemane; Kiss of Judas; Crucifixion (Matthew 26-27)—Cosimo Rosselli.

7. **Burial of Moses** (Deuteronomy 34); Archangel Michael Defending His Body against the Devil (Epistle of Jude)—Matteo da Lecce.

7. **The Resurrection** (Matthew 28)—Matteo da Lecce.

The nature of the concordance and the exact interpretation of the content in practical terms of fifteenth-century politics have been the subject of considerable discussion and controversy. The Crossing of the Red Sea, for example, has been associated with the defeat

of Alphonso of Calabria by the papal forces, led by Roberto Malatesta, at the Battle of Campo Monto, on the day of the Feast of the Assumption, as well as the identification of specific figures in the painting, such as the portraits of Alphonso on the white horse in the sea and Roberto Malatesta with Virginio Orsini, his captain, at the left. The Punishment of Korah has been related to the revolt in the College of Cardinals of Andrea Zamonetic, Archbishop of Krain in Austria, against Sixtus, his attempt at a crusade against Rome and its corruption, his calling of the Council of Basel in 1482, his imprisonment, and his final suicide.

The sacrificial scene occupying the central position in Botticelli's Temptation of Christ reflects the eucharistic significance of His victory over the devil in the form of the Old Testament blood sacrifice, which, in turn, is associated with the New Testament Last Supper. The temple in the background complements the sacrificial scene as the Temple of Solomon, but it also has its New Testament connotations in its resemblance to St. Peter's. On the other hand, this same scene has long been interpreted as a representation of the Cleansing of the Leper (from Leviticus 14), and the structure in the background as a representation of the newly restored hospital of Santo Spirito under the patronage of Sixtus IV.

The accurate rendering of detail in the Arch of Constantine as well as its monumental form serve not only to dramatize the composition and subject in the Punishment of Korah and the rebels, but also as a symbol of divine leadership, in this case of Aaron, which is indicated in the inscription (from the Epistle to the Hebrews): *Nemi sibi assum / at honorem nisi / vocatus a Deo / tanquam Aaron.* The same idea appears in Perugino's Christ Giving the Keys to St. Peter, with a monumental temple flanked by triumphal arches and an inscription, associating Solomon and Sixtus, Solomon's Temple and the Christian Church (though not necessarily the specific form of the new St. Peter's): *Imens(M) Salmo templum tu hoc quarte sagrasti Sixte opibus dispar religione prior.*

Portraits of contemporaries are frequently identified in the murals, such as: Giovanni Basso della Rovere, papal chamberlain, in the Baptism of Christ (at the right with a white napkin, and Girolamo Riario, husband of Caterina Sforza (extreme right, with staff), in Botticelli's Temptation of Christ. In the Calling of the Apostles: Giovanni Tornabuoni, papal treasurer (third head from

right), Guid' Antonio Vespucci (at extreme right), Rainaldo Orsini, Archbishop of Florence (beside Christ).

The importance of Sixtus IV's mural program is not only as a background for Michelangelo's revolutionary accomplishment of the ceiling and Last Judgment, but also as the culmination of a long series of projects involving an implied political and intellectual, as well as religious, content. In some cases they are associated with organizational policy, i.e., the "mendicant styles"; in others, they are matters of personal conviction by either artist or patron, or both. Nevertheless, they make interesting comparisons: note especially Giotto in Assisi, Andrea da Firenze in the Spanish Chapel, Masaccio in the Brancacci Chapel, Fra Angelico in San Marco, Benozzo Gozzoli in Montefalco, and Ghirlandaio in the Sasseti Chapel of Santa Trinità.

Antoniazzo Romano (Antoniazzo di Benedetto Aquilio, active 1461-ca. 1508) is the only local personality of any significance in Rome; his style appears somewhat Umbrian in character, possibly developed from Fiorenzo di Lorenzo or the early Perugino, and influenced by Melozzo da Forlì.

Little is know about his life, but his activity is recorded in documents extending from 1461, when he was commissioned by Alessandro Sforza (for whom Melozzo had executed a similar commission the same year) to make a copy of the miraculous Madonna of Santa Maria Maggiore, through a considerable number of mediocre decorations and altarpieces, until his death sometime after 1508, when he wrote a codicil to his will on April 17, and before 1512, when he is mentioned as deceased.

Chief among these recorded works (most of which are lost) are: the two chapel decorations in SS. Apostoli, executed in 1464-1465 for Cardinal Bessarion; frescoes in Santa Maria della Consolazione, finished 1470; collaboration with Domenico and Davide Ghirlandaio on decorations of the Vatican Library, 1475, and others for the same place, for which payments are registered to Antoniazzo and Melozzo da Forlì in 1480 and 1481; in 1484, he was at work with Perugino on banners and various festive decorations connected with the coronation of Innocent VIII; in 1491, he executed the much-repainted frescoes in the castle of Virginio Orsini in Bracciano; and

he was hired again to execute decorations for the coronation ceremonies of Alexander VI in 1492.

Antoniazzo's most important decoration extant is that in the apse of Santa Croce in Gerusalemme, painted some time shortly after 1492, when Cardinal Mendoza planned the work, representing a Christ Enthroned in a mandorla and a series of scenes from the Legend of the Holy Cross. The composition of figures showed something of the style of Melozzo and Signorelli; the emphasis on the romantic landscape and the predominance of the space over the figures are Umbrian in character (cf. Pinturicchio). Other frescoes, of inferior quality, are those (the Crucifixion and Saints, 1482) in Santa Maria sopra Minerva, in Rome.

A group of well-authenticated altarpieces reveals Antoniazzo's mediocre style, which seems largely inspired by Melozzo. The Madonna with St. Francis Receiving the Stigmata and St. Anthony of Padua (signed *Antonius de Roma depinxit 1464*), from San Antonio del Monte, now in the Pinacoteca of Rieti, has many Gothic features (cf. the gold backgound) reminiscent of the early work of Piero della Francesca. A similar triptych, of 1467, is in San Francesco of Subiaco. The Madonna Enthroned with Saints and kneeling portrait figures (the Madonna della Rota, in the Pinacoteca Vaticana, shows a tendency, however stiff, to compose many figures into more unified pyramidal form (ca. 1472). Others (Palazzo Venezia, Rome, and Cathedral of San Clemente, Velletri, 1486) show a gradual attempt to enliven the composition through a slight sway of the figures and more voluminous drapery, after the manner of Perugino and his contemporaries. This is especially evident in the fresco Crucifixion and Four Saints, on the fourteenth-century Gothic ciborium of San Giovanni in Laterano. The Annunciation, in the Isabella Stewart Gardner Museum of Boston, formerly in Santa Maria degli Angeli, near Assisi, has frequently been attributed to an anonymous ''Master of the Gardner Annunciation'' as well as to Fiorenzo di Lorenzo.

Among Antoniazzo's followers are his two sons, **Bernardino** and **Marcantonio**, the latter of whom is best known for his triptych with the Resurrection (1511) in the Pinacoteca of Rieti, and **Saturnino dei Gatti** (1463-ca.1512), whose polyptych with the Madonna and Child is in the Museo Nazionale of Aquila. A parallel to him

and head of the neighboring school of Viterbo, is **Lorenzo da Viterbo** (ca. 1437-1476), whose style is influenced by Gozzoli and Piero della Francesca (cf. Lorenzo's frescoes of scenes from the life of Mary, in the Cappella Mazzatosta in Santa Maria della Verità in Viterbo).

6. Venice

THE POLICY OF TERRITORIAL EXPANSION on the mainland, which Venice had followed during the second half of the fourteenth century, was continued into the fifteenth, particularly under the Doge Francesco Foscari. It was abruptly changed when Constantinople fell to the Turks in 1453, and although the League of Lodi was formed in 1454, most of the burden of defending the eastern trade routes fell on Venice alone. In 1478, Euboea was lost to the Turks, who then attacked Italy itself, concentrating on Friuli. Their diversion to southern Italy, and the attack on Otranto in 1480, though startling to the rest of Italy, temporarily relieved Venice of that outside pressure. She supported Charles VIII of France when he invaded Italy in 1494, but then formed, with the Pope, Milan and Spain, the league against him that brought about his retirement to France the next year. However, her policy was changed again when she actively supported the expedition of Louis XII which resulted in the fall of Milan and Naples in 1500. The results of her treacherous policy on the mainland, the renewed wars with the Turks, and the effects of the new trade route discoveries were to be felt by Venice through the next century in the gradual decline of her political and economic power.

Niccolò di Pietro (active ca. 1394-1430) is the first Venetian master in whose works can be followed the transition from the Byzantine-Gothic tradition of Maestro Paolo and Lorenzo Veneziano to a rejuvenated Gothic style that developed in the wake of Gentile da Fabriano. Little is known about his life, except that he was the son of a painter, and had executed a panel for San Pietro in

285

Castello, in Veronia (now lost), which had a signature, *Nicolaus filius magistri Petri pictor pinxit hoc opus Veneciis*. He is also known as Niccolò di Paradiso, from the location of his early home near the Ponte del Paradiso.

There are two important works by Niccolò: one is the signed and dated (1394) altarpiece (. . . *Nicholas filius Magistri Petri pictoris de Veneciis pinxit hoc opus qui moratur in chapite pontis Paradixi*), in the Accademia of Venice, representing the Virgin Enthroned with Music-making Angels and the donor, Vulciano Belgarzone of Zara, at her feet. Its style, when compared with that of earlier Venetians (e.g., Lorenzo Veneziano), shows a certain intimacy and naturalism characteristic of the new era even before the appearance of Gentile in Venice. The second is the Madonna dei Miracoli, executed in 1409 for Francesco degli Amandi (wings with Saints James and Anthony, lost), in the Accademia of Venice, in which the more graceful handling of drapery suggests something of Gentile's manner.

Of the works of famous outside artists active in Venice, particularly in the Doge's palace, the large fresco by Guariento of Padua, representing the Coronation of the Virgin, executed in 1365-1368, was the first. Gentile da Fabriano is first mentioned in Venice in 1408, when he executed an altarpiece (lost) for Francesco Amadi. Between then and 1414, he painted the Battle of Savore (i.e., the naval battle when the Venetians, led by Doge Ziani, were victorious over Otto, son of Frederick Barbarossa). A third master was Pisanello of Verona, who is recorded as active in Venice between 1409 and 1415 and again in 1420-1424, and had painted a similar mural in the Doge's palace representing Otto pleading with his father, Emperor Frederick Barbarossa, for the peace of Venice. Both of these were destroyed by fire in 1577.

Jacobello del Fiore (ca. 1370-1439) is the first of the local Venetians in whom the influence of Gentile is clearly perceptible. He was born probably about 1370, the son of Francesco del Fiore. In 1400, his name is recorded as a witness to a will, and he is designated as a painter. After 1409, he appeared in the regular service of the Signorie, and was director of the painters' guild in 1415.

Jacobello's earliest extant painting is the large tempera panel, originally in the Magistrato della Viastema, representing the Lion of

St. Mark (now in the Palazzo Ducale), signed and dated 1415 (*MCC-CCXV die primo Maii Jacobellus de Flore pinsit*). Its large size, in comparison to earlier works, is significant in that it is probably the first attempt at a large decorative project in tempera, possibly in imitation of fresco. His most important work is the triptych (signed *Jacobellus de Flore pinxit 1421*) in the Accademia of Venice, originally in the Magistrato del Proprio of the Palazzo Ducale, representing Justice seated on a throne of lions between the Archangels Michael and Gabriel. The decorative curve of figures and draper, and the rich ornamentation, are suggestive of Gentile's influence (cf. the Coronation of the Virgin in the Brera, Milan).

A third work is the Coronation of the Virgin, in the Accademia of Venice, formerly in the Cathedral of Ceneda, originally signed and dated 1438. The composition appears to be a reduced variation of the Coronation and Paradise fresco which Guariento had painted in the Doge's palace. Other altars of consistent quality are the triptych of the Madonna della Misericordia between St. John the Baptist and St. John the Evangelist (signed and dated 1436), in the Accademia of Venice, the Justice Enthroned with Two Martyrs, in the Municipio of Chioggia (1436), and the polptych with scenes from the life of St. Lucy and the figures of St. Anthony Abbot and St. Lucy on the back, in the Museo of Fermo.

Michele di Matteo da Bologna (active 1420-1462) is one of several other recorded artists whose style represents a continuance of the Gothic tradition under the influence of Gentile da Fabriano, Pisanello and Jacobello. His most important work is the polptych with the Madonna Enthroned, with St. Helen and other saints, and scenes from the Legend of the Holy Cross on the predella (signed *Michael Mathei de Bononia f.*), in the Accademia of Venice. Fragments of a signed polptych, with the Coronation of the Virgin and Saints, are in the Pinacoteca Nazionale of Bologna.

Michele Giambono (Michele di Taddeo Giovanni Bono, active ca. 1420-1462) comes from a family of painters (a grandfather, *quondam Maestro Zambon*, is mentioned in 1391, as is his father, Taddeo di Giovanni Bono) and is himself recorded on a number of commissions (e.g., the carved altar of Sant' Antonio e San Daniele, in Friuli, near Udine, done in 1441 with Paolo d'Amadeo). In 1453

he was consulted, together with Jacopo Moranzone, with regard to an agreement between Donatello and Gianantonio concerning the bronze status of the latter's father, Gattamelata. In 1447, he was commissioned to paint a Coronation of the Virgin (i.e., a Paradise), which is now in the Accademia of Venice, for the church of Sant' Agnese. This painting bears the false signature of *Joannes et Antonius de Muriano F. MCDXL* and is a free copy of the same theme by Giovanni d'Alemagna and Antonio Vivarini in the Ognissanti chapel of San Pantaleone (Venice).

The other important work done by Giambono is the group of mosaics (begun 1444) in the Cappella della Madonna dei Mascoli of San Marco, Venice, representing the Virgin, Isaac and David in medallions on the vault and scenes from her life on the walls. Of these, the first row, namely the Birth of the Virgin and her Presentaiton in the Temple, with their gentre details and elaborately decorated style, appear to have been done at an earlier date, still in the Gothic tradition of Gentile, while the later scenes (the Visitation and Death of the Virgin) appear to have been executed after the middle of the century, probably by Antonio and Barolomeo Vivarini, under the influence of a more scientifically minded generation (cf. the sharply modeled figures and emphasis on architectural perspective and settings with Castagno, Donatello or Mantegna). A polyptych with the Madonna Enthroned and Saints James, George, Jerome, John the Baptist, Peter and Paul, with a group of half-length saints above, painted by another and inferior hand, is in the Museo Civico of Fano. An equestrian figure of Crisogono, in the church of San Trovaso in Venice, that had formerly been attributed to Jacobello del Fiore, shows much of the same crossing of Gothic decorative design and Renaissance sense form noted before.

Giovanni d' Alemagna (known also as Giovanni Tedesco, Giovanni Alemanno and Giovanni da Murano, active ca. 1440-1450) is the first of a new generation of artists whose emphasis on plastic form and linear design continues in the Murano tradition of the Vivarini and Crivelli and is a parallel to the art of the third quarter of the century in Padua and Florence.

Giovanni's origins are unknown, but a document of 1447 indicates his German descent by referring to the altar of San Pantaelone in Venice, which was painted in 1444 by *Zuane et Antonio*

de Murano, as *per manus ser Johannis theotonici pictoris.* In the earlier documents he appears as *Zuane da Murano,* later as *Johanes Alamanus.* There are no works extant which were painted by Giovanni alone; his collaboration with Antonio Vivarini appears to have begun in 1441, when an altarpiece with a standing St. Jerome, flanked by St. Mark and St. Ambrose, with a half-length Madonna and Child above with St. John the Baptist and St. Anthony of Padua, is recorded as having been painted by them for the church of Santo Stefano in Venice (with which the polyptych, signed *Giovanni et Antonio Viavrini* with the date *1441,* in the Vienna Kunsthistorisches Museum, is identified). His own hand, however, can be recognized in the works painted in collaboration, by the more delicate color and tone and the more carefully executed detail, which might be associated with contemporary German painting, possibly the school of Cologne.

Antonio Vivarini (Antonio da Murano, ca. 1415-ca. 1476/84), the brother-in-law of Giovanni d'Alemagna, is the oldest of a productive family which originally came from Padua and settled in Murano, where Antonio was born. His style appears to have been developed from the tradition of Gentile da Fabriano, Pisanello and Jaobello, is influenced by the romantically inspired Giovanni, and, after the latter's death (1450), develops into the more plastic style of his brother Bartolomeo.

An early polyptych representing the Madonna and Child, with Saints Nicholas, Simeon, Francis and James, and, above, the Pietà, with Saints Mary Magadalene, Christopher, Anthony Abbot and Catherine, signed and dated *(1440 Anthonius de Murano pinxit hoc),* was painted by Antonio alone for the Cathedral of Parenzo, where it remains, and is related to the manner of Gentile. The partnership of Antonio and Giovanni is assumed to have begun with the San Girolamò altar of 1441 mentioned above. In 1447, both of them went to Padua, where they executed an altar representing the Nativity with Saints Francis, Bartholomew, Nicholas of Tolentino and Anthony of Padua for the church of San Francesco Grande in that city, which is mentioned by Ridolfi and Sansovino and has been identified with the polyptych now in the National Museum of Prague, formerly in the castle of Konopischt, Czechoslovakia (signed and dated, *MCCCCXLVII Christoph. D Ferara intaia Antonio da*

Mra e Johae Alaman p.). The next year they were commissioned to decorate the Cappella Ovetari in the Eremitani church in Padua, of which only the ornament of the ceiling remained, until its destruction in 1944.

The chief authentic works which are signed and dated by the two artists are: 1) the three altars in the Cappella di San Tarasio in the church of San Zaccaria, Venice, notably that representing St. Sabina in the center with Saints Jerome and Achilles and half-length figures of Saints Margaret and Catherine at the sides, an angel with the scroll—*Hic est sanguinis Xpi*—at the top (signed and dated, *Johannes et Antonius de Muriano pinxerunt 1443 M October hoc opus. . . .*) of which the more delicate figure of Sabina is attributed to Giovanni's hand. 2) The considerably restored Coronation panel of 1444 with the Four Evangelists, the Four Church Fathers and masses of angels, prophets and saints, in the Cappella degli Ognissanti of San Pantaleone, Venice. The composition is built in the manner of Guariento's fresco and the 1438 altar by Jacobello, but it is remarkable for its plastic modeling of the enthroned central group as against the massed figures of the background (a quality attributable to Giovanni and not taken over by Giambono in the copy which he made three years later). The signature, *Xpofol de Ferara i[n]taia Zuane e Antonio de Murane p[i]nse 1444,* indicates the Cristoforo de Ferara had executed the now lost frame of the altar. 3) The most important work of the two masters is the Madonna Enthroned with the Four Church Fathers, in the Accademia of Venice, painted in 1446 for the Scuola Grande della Carità, and signed, *M 446 Johanes Alamanus : Antonius D. Muriano.* Significant factors to be noted are the graceful design and dignified pose of the Virgin (certainly painted by Giovanni), the more spacious composition of the figures, the elaborate, goldsmithlike ornamentation of the Gothic niche and surrounding walls, and the decorative foliage that appears behind the screenlike walls. In surveying the general evolution of Quattrocento painting, it is interesting to compare, in this connection, the peculiar stylistic relationship, on the one hand with northern contemporaries (e.g., Stefan Lochner), and on the other with those of Florence and central Italy (i.e., Gozzoli).

The later works which Antonio executed independently after Giovanni's death are considerably inferior, and are characterized by their vertical figure proportions and hard drawing, under the in-

fluence of his brother, Bartolomeo: the Pesaro Polyptych, now in the Vatican Pinacoteca, formerly in the church of the Confraternità de Sant' Angonio in Pesaro, signed and dated 1464–*Antonius. de Murào. Pixit.* It contains eight saints (Saints Sebastian, Christopher, Venantius and Vitus on the lower level, and half-length figures of Saints Jerome, Peter, Paul and Louis of Toulouse on the upper level) and a Pietà surrounding the wooden figure of St. Anthony. A second polyptych, also signed as his own (*Ant.o de Murano 1467*), was executed for the convent of Santa Maria Vetere di Andria; sections are now in the Museo Provinziale of Bari (Saints Louis of Toulouse and Anthony of Padua, Francis and John the Baptist, St. Clare and a Pietà and the Convento di Santa Maria Vetere in Andria (Saints Bernardinus and Augustine).

Bartolomeo Vivarini (ca. 1432-ca. 1491) developed the realistic Gothic style of his elder brother Antonio into a more sculpturesque form closely associated with the followers of Squarcione in Padua (Mantegna). A considerable number of signed altars and legal records indicate a continued activity from about 1450 until his last signed triptych of 1491 (Bergamo, Accademia Carrara).

The work of Bartolomeo's first period, done in collaboration with Antonio, is more closely related to the Gothic ornateness and grace that Antonio had acquired during the preceding decade from Giovanni d'Alemagna. The most important of these is the polyptych, in the Bologna Pinacoteca Nazionale, executed in 1450 at the order of Pope Nicholas V for the Certosa di Bologna, and signed *Anno domini MCCCCL Hoc op. inceptum fuit et perfectum Venetiis ab Antonio et Bartolomeo Fra. ib [Fratribus] de Murano*. Represented is the Madonna Enthroned with Saints Louis of Toulouse, Jerome, Nicholas and John the Baptist, with (above) the Dead Christ, Angels and half-length figures of Saints Peter, Gregory, Augustine and Paul. The more vigorous modeling and characterization of such figures as St. John the Baptist or St. Jerome, in contrast to the other saints, possibly indicates the hand of the younger brother, while the more lyric character of the Madonna and the Christ figure above suggests Antonio (cf. also the polyptych in the convent of St. Euphemia on the Island of Arbe [Island of Rab, Dalmatia], signed by both brothers and dated 1458).

The works signed by Bartolomeo alone begin with the panel of

the Beato Giovanni da Capistrano (signed, *Opus batholomei de Murano 1459*), in the Louvre of Paris, in which the realistic characterization and carefully modeled drawing reflect the growing influence of Mantegna. Iconographically, the subject is interesting for its emaciated face and austere type-resemblance to the contemporary San Bernardino. John of Capistrano (1386-1456) was a Franciscan monk (a pupil of Bernardino at Siena) who was famous as a reform preacher and, with the Hungarian Johann Hunyadi, had led the Christian forces in defeating the Turks at Belgrade in 1456, to which the Crusader's banner and inscription allude.

The two altarpieces of this period, which rank among the finest he produced, are the Madonna Enthroned between Saints Andrew, John the Baptist, Dominic and Peter, signed and dated 1464, now in the Accademia of Venice and originally in the Cappella di Ca' Morosini in the church of Sant' Andrea della Certosa (cf. Mantegna's San Zeno altar). The second is the famous Madonna and Saints of 1465, in the Galleria Nazionale di Capodimonte in Naples, with its Renaissance throne, ornate garland, elaborate brocades and expressive figure types. The standing Saints Augustine and Roch, Louis and Nicholas, are arranged on either side of the throne in a single space rather than on the separate panels of the polyptch, before a rose arbor, while the half-length saints (Saints Dominic, Catherine, Peter the Martyr and Mary Magdalene) hover on clouds to fill up the sky.

Bartolomeo's late style shows a more forceful, realistic and somewhat ponderous striving for monumental form, with which is coupled a decorative brilliance of color and a pedantic emphasis on linear detail, as seen in the treatment of muscles, drapery and architectural ornamentation. The most important of these signed and dated works are: the 1473 triptych in the church of Santa Maria Formosa in Venice, with the Madonna della Misericordia surrounded by kneeling donors in the center panel, the Meeting of Joachim and Anne on the left, the Birth of the Virgin on the right. The altar was commissioned by the parish priest, Andrea da Sole, who is represented among the kneeling patrons. The Enthroned St. Augustine of 1473, with Saints Dominic and Laurence, formerly part of a large polyptych, in the church of San Giovanni e Paolo, Venice, is the only work of Bartolomeo's mentioned by Vasari, and was considered by Ridolfi to be his best. The triptych in Santa Maria

dei Frari in Venice, 1474, represents St. Mark Enthroned with Music-making Angels and Saints John the Baptist and Jerome, Paul and Nicholas, arranged in the stiff and impressive manner of Mantegna. Even heavier, in its ponderous effect, is the polyptych (1477), in the Accademia of Venice, representing St. Ambrose Enthroned blessing the kneeling members of the Scuola dei Tagliapietra, for whom the altar was originally painted, with Saints Louis of Toulouse and Peter, Paul and Sebastian in the accompanying panels.

Quirizio da Murano (Quirizio di Giovanni da Murano, active 1461-1478) is one of a group of followers of Bartolomeo Vivarini and Giovanni d'Alemagna whose name appears in documents from 1461 to 1478. His chief known works are the signed and dated (1462) polyptych with St. Lucy, with a kneeling nun as patron and six scenes from the life of St. Lucy, in the Pinacoteca dell' Accademia dei Concordi in Robigo; and the signed Christ Giving the Sacrament to a Kneeling Nun, in the Venice Accademia.

Fra Antonio da Negroponte (active second half of the fifteenth century) is otherwise unknown and unrecorded in documents, but his one work, the Madonna Enthroned in the Cappella Morosini in San Francesco della Vigna, Venice, is signed, *Frater Antonius de Negropon pinxit*. In its grace and jewellike ornamentation, it appears most closely related to Bartolomeo's Madonna of 1465, in Naples, and though it is not dated, it appears to have been painted some time after that, possibly about 1470.

Carlo Crivelli (ca. 1430/5-1495) represents, in a sense, the completion of the Vivarini tradition; yet, stylistically, he is one of the most peculiar personalities in the Venetian Quattrocento. He was born in Venice, apparently the son of a painter, Jacopo Crivelli, and had probably worked in the shop of the Vivarini. The first record of his is in 1457, when he was fined and imprisoned for the rape of the wife of Francesco Cortese. He seems to have left Venice immediately after serving his sentence, since he is not mentioned in any Venetian documents thereafter. From his style, it is presumed he had spent considerable time in Padua, and from the distribution of his works, the greater part of his activity must have been in the small towns of

the Marches, though he appears in Zara, Dalmatia (1465) and An-
cona, and he can be followed in Fermo (1470), Massa Fermana,
Ascoli Piceno (where he owned a house from 1473-1478),
Camerino, Macerata and Fabriano. It is know that he received the
title of *Miles* in 1490, from Ferdinand II of Capua and, by 1493, he
added the title of *Eques Laureatus* to his signature.

Crivelli's development of the hard draughtsmanship, clear
modeling of forms, the rich and realistic elaboration of detail which
he may have learned from the Squarcione school of Padua of about
1450 (as did his contemporary, Mantagna), can be followed through
a large number of works to a decidedly mannered style in the last
decade of the century. One of the first works is the Madonna Adored
by Angels Bearing the Instruments of Christ's Passion, in the
Museo di Castelvecchio of Verona, painted in the early 1460s and
signed *Opus Karoli Crivelli Veneti*. The Madonna type is similar to
that of Bartolomeo Vivarini (cf. the Naples Madonna); the attempts
at foreshortening and the rounded modeling of forms suggest
Mantegna.

Two signed polyptychs, one, of 1473, in the Cathedral of
Ascoli Piceno, and the other, of 1476, in the National Gallery of
London (the Demidoff altar), composed of thirteen panels of full- and
half-length figures in three tiers, originally in the church of San
Domenico in Ascoli Piceno, show the traditional Murano-Venetian
type of many-paneled altar with the Madonna in the center and the
Pietà above. Although the characteristic sharpness and modeling of
forms appear, the arrangement is much the same as the earlier works
of the Vivarini, except for the significant dramatization of the Pietà
scene above the Virgin (e.g., in the Ascoli altar), in contrast to the
lyric interpretation of the angel with the scroll in the St. Sabina altar
by Giovanni d'Alemagna and Antonio Vivarini in San Zaccaria, or
the direct placement of a half-length Dead Christ in the Tomb, as in
the Antonio Vivarini polyptych of 1464 in the Vatican. From this
point of view is to be understood the importance of Crivelli's many
dramatic and expressive Pietà representations, one of the finest of
which (1485) is that in the Boston Museum of Fine Arts, formerly
in the Panciatichi Collection of Florence.

The transition to the more active and dramatized figures, their
emphasis on realistic expression almost to the point of affectation,
and the freer composition of the figures in space, can be seen in a

group of later altarpieces. The triptych of 1482, with the Virgin and Saints Peter and Dominic at the left, and Saints Peter the Martyr and Venantius at the right, originally in the Cathedral of Camerino and now in the Pinacoteca di Brera of Milan, easily represents a transition from the older to the newer style in its closed composition and balanced relationship of figures to frame (note particularly the elegant figure of St. Venantius at the right holding a model of the city). The predella of this altar contains half-length figures of Saints Anthony Abbot, Jerome, Andrew, James, Bernardinus and Nicodemus, in two panels now in the Pinacoteca di Brera, while the two small panels with the Angel and Virgin of the Annunication, belonging to the upper part, are in the Städelisches Kunstinstitut of Frankfurt. A Resurrection for the center pinnacle is in the Abegg-Stockar Collection of Zurich.

The composition of this Annunciation, for example, is expanded into an elaborately detailed, spacious and richly decorated Annunciation of 1486, now in the National Gallery of London. Action, compactness and a more unified composition of space and figures is evident in the Madonna and Saints altar, in the Berlin-Dahlem Museum, which is composed as a single panel without the traditional separataion of saints and Madonna by the framework, and is enlivened by the changed motif in which she graciously presents the Key to St. Peter while the saints look on in a kind of *sacra conversazione*, rather than the ordinary plan of isolated standing saints. The diversity of character in the saints—besides St. Peter are St. Emidius, bishop and patron saint of Ascoli, St. Francis, St. John of Capistrano (the crusader against the Turks), St. Louis of Toulouse, St. Bonaventure and the Franciscan monk Giacomo della Marca—tends to complement the mood of the sacred conversation theme. The altar was painted, probably in 1488, for the church of San Pietro degli Osservanti in Camerino.

The most important work of his last period is the large Coronation of the Virgin with Saints George, John the Baptist, Catherine of Alexandria, Venantius, Francis, Sebastian and music-making angels, together with a lunette panel of the Pietà which belonged to it, now in the Pinacoteca di Brera, Milan. From documents the painting was ordered February 9, 1493, for the church of San Francesco in Fabriano, and is signed *Carolus Crivellus Venetus Miles pinxit MCCCCLXXXXIII*. Characteristic are the reduced proportion of

figures to the space, the elaboration of detail in the allover tapestry-like pattern and the late Quattrocentist sylization of movement (i.e., the running angels at the top). The Madonna della Candeletta, in the Pinacoteca di Brera, with the inscription, *Karolus Chrivellus Venetus eques laureatus pinxit*, of which side panels with Saints Peter and Paul, Jerome and Augustine are in the Galleria dell' Accademia of Venice, was probably painted at about the same time.

Vittorio Crivelli (active ca. 1481-1501) is a younger brother of Carlo; his chief works are the polyptych (Madonna and Saints, with Christ and the Twelve Apostles in the predella) of 1487, in San Giovanni Battista in Torre di Palme, the signed and dated (1489) polyptych of the Madonna with Saints Peter and Paul, in Santa Maria del Pozzo, and the triptych of the Madonna with Saints Michael, Gabriel, Emidius and Anthony Abbot, signed and dated 1490, both in Monte San Martino, near Macerata.

Pietro Alamanno (active ca. 1470-1498) came originally from Austria, and was active principally in the Marches, producing rather weak variations of Crivelli's works. His best-known altar is the polyptych of the Madonna with Saints Stephen, Augustine, Emidius and Maurus, signed and dated 1489, from Santa Maria della Carità, Ascoli Piceno, now in the Seminario there.

Antonello da Messina (Antonello di Giovanni degli Antoni, ca. 1430-1479) really belongs to the history of painting in southern Italy, but is one of the most significant figures of the Venetian Quattrocento because of his connection with the Flemish tradition of the Van Eycks and his supposed introduction of their technique of oil painting, so important to the later development of Renaissance painting in Venice.

Antonello was born in Messina in about 1430, the son of a sculptor, Giovanni di Michele degli Antoni. Concerning his artistic origins, little is known, but he seems certainly to have come into contact somehow with work of the northern painters of the Van Eyck tradition. Whether it was through the local school of Naples or whether he had been to Spain where a Flemish tradition had also developed, or even whether there was a possible direct connection with the Flemings in Bruges, are all questions which have

stimulated historical speculation, but have found no justification in any of the documents.

One possibility is suggested in a letter of 1524 written by Pietro Summonte, a knowledgeable Neapolitan humanist of the early sixteenth century to the Venetian Marcantonio Michiel, in which a certain Colantonio is mentioned as one of the leading artists of the time of King Alfonso and one who had mastered the painting manner of the Flemish artists. Actually, a panel of St. Jerome by Colantonio, formerly in the Franciscan church of San Lorenzo in Naples and now in the Museo Nazionale di Capodimonte there, has many Van Eyck features that would support the relationship. Indeed, there is a note by Bartolomeo Facio indicating that a similar composition, one wing of triptych, by Jan Van Eyck, was in the collection of King Alfonso of Aragon in 1456, and this may be a free variation of it.

Antonello may have studied, or had some contact, with him in Naples. In any case, there are records, in 1457, of his being in Messina, where he hired an assistant, Paolo di Ciacio, for his shop, and in Calabria, where he was commissioned to paint a banner for the brotherhood of San Michele dei Gerbini in Reggio Calabria. In 1460, he was again in Calabria; from 1461 to 1465, he is recorded in Messina. From 1465 to 1473, there is no record of him, with the exception of a dated Ecce Homo picture of 1470, which was seen in Palermo in the seventeenth century, was later in the Zir Collection of Naples, and is apparently identifiable with the one now in the Metropolitan Museum of New York. From its history, it is assumed that it was painted in southern Italy. In 1475-1476, he is recorded in Venice, where he painted an altar (part of which, a Madonna, is identified with the one in Vienna) for San Casciano. In 1476, he is also recorded at the court in Milan and, toward the end of that year, was back in Messina, where he died in 1479. His son, Jacobella, is also recorded as a painter in Messina.

Antonello's importance to his contemporaries of the fifteenth century, and to the development of Renaissance painting in general, is due to his sharp observation of nature, whether the object be landscape, architecture (particularly interiors) or decorative details; his interest in light as a means of giving a more palpable life to that nature; and his use of the oil technique as a more adequate medium for its representation. While Antonello's origins are of interest, the most significant point is that in spirit, as well as in style, his art is

related to the Van Eyck tradition, and that the new interest in light and color (and with it the oil medium) was a vital problem to both older and younger artists in Italy during this decade (i.e., the 1460s and 1470s), as has been seen in the work of Piero della Francesca, Baldovinetti, and Verrocchio, and was continued by Leonardo da Vinci (cf. Verrocchio's Baptism of Christ).

There are many works attributed to Antonello with varying degrees of certainty, but the earliest authentic painting is the Christ as Salvator Mundi, of 1465, now in the National Gallery of London, which is signed on the *cartellino*: *Millesimo quatricentessimo sexstage/simo quinto viije Indi Antonellus Messaneus me pinxit*. It is painted in oil and clearly shows many Flemish characteristics, both in style and in technique (cf. the God-Father in the Ghent Altar).

The relatively small format, the luminosity of color and jewel-like detail, and the interest in light as a means of modeling the forms three dimensionally in space are characteristics which are to be found in the other best-known works of Antonello's early, pre-Venetian, period: the signed and dated (1473) San Gregorio polyptych, in the Museo Nazionale of Messina, which was commissioned by the Abbess Cirino for the church of Santa Maria extra Moenia in Messina. The altar was badly damaged in the earthquake of 1908. The central panel contains the Madonna Enthroned, Saints Gregory and Benedict on either side, an Annunication on the upper level flanking what was probably a Pietà in the center. In spite of the damage, the glowing color and the sensitive use of light are clearly evident in the details. The Ecce Homo (1473), in the Piacenza Museo Nazionale, has a signature on the *cartellino*, *Antonellus Messaneus me pinxit*, and a date which appears to be 1473. A considerable number of variations, in different museums, are attributed to him on the basis of this and the London Salvator Mundi.

Also in this pre-Venetian group is the Annunciation of ca. 1474, in the Syracuse Museo Nazionale di Palazzo Bellomo, which was commissioned August 23, 1474, by Giuliano Manjuni for the church of Santa Maria Annunziata in Palazzolo Acreide. Although damaged, its rich quality has attracted comparisons with Petrus Christus and Piero della Francesca. The inspiration for its unique character may well be the Annunciation (ca. 1440-1445) in the church of Sainte Madeleine in Aix-en-Provence by an anonymous master who is sometimes associated the Colantonio. Variations are

to be seen in the Virgin Annunciate panels of the Munich Alte Pinakothek, ca. 1473, and Palermo, Galleria Nazionale, ca. 1475. Finally there is the remarkable Crucifixion, signed *1475 Antonellus Messaneus me pinxit* in the Musée Royale des Beaux Arts, Antwerp, which has the clear coloration, luminous landscape, technical precision and miniaturist's detailed execution which are certainly close to Van Eyck's Crucifixion.

The comparison of this Antwerp Crucifixion with a second, signed (though the signature has been retouched) rendition of the same subject, also dated 1475, but painted after the one in the National Gallery of London, reveals an atmospheric softness and lyric character in the latter which appears to be an influence of the Venetians. Another version of the Crucifixion with an even stronger Van Eyck character, certainly an earlier work, is in the Muzeul de Arta in Bucharest, formerly in Sibiu, Romania. Some time after his stay in Venice, he also executed the St. Sebastian now in the Dresden Staatliche Gemälde Galerie, which, though not signed, is certainly painted by Antonello and, in its sharply foreshortened architecture and rounded forms, reflects the influence of Mantegna (cf. also Pietro della Francesca, with his monumental form, and especially the soft use of light and color). The motif of the reclining, foreshortened warrior to the left is probably taken from Mantegna's Eremitani frescoes (St. Christopher).

Antonello's specific influence on the Venetians is not so clearly evident. The fact that Bartolomeo Viavrini's St. Augustine in Venice was painted in 1473, and in the oil medium, discounts the assumption that Antonello introduced that medium to the Venetians, since his dated works of the same year indicate that he was probably in southern Italy, and there is no evidence to prove that he was in Venice before 1475. However, Antonello's use of light and shade, not only as a means of modeling forms and defining them in an illusionary space, but also as an emotional expression in itself, seems to have had considerable influence on the later Venetians, as will be seen in the work of Giovanni Bellini and Alvise Vivarini, which distinctly separates them from the Murano tradition of the elder Vivarini.

One of the Antonello's most characteristic works, and the type which might well have exerted a more general influence on the Venetians, is the famous St. Jerome in His Study now in the Na-

tional Gallery of London. The emphasis on a spacious architectural interior with its careful depiction of still-life, various animals, including Jerome's lion, figures and objects bathed in luminous light, creates a mood thoroughly in keeping with the Van Eyck tradition and puts the emphasis on the spiritual and scholarly aspect of the saint, rather than on the personal and dramatic character (cf. the contrasting intepretations by Ghirlandaio and Leonardo da Vinci in Florence).

The Jerome panel was described in the *Anonimo* by Marcantonio Michiel in 1529 as being in the home of Antonio Pasqualino in Venice. It has been variously attributed to Van Eyck, Memling, and others, but its assignment to Antonello seems certain. Its quality suggests the later period of the mature master, but the relationship with Colantonio's Jerome and the Van Eyck triptych in the collection of King Alfonso may well indicate the earlier, pre-Venetian, period.

A well-known and important problem picture is the so-called Pala di San Cassiano, a large altarpiece commissioned by the patrician Pietro Bon for the church of San Cassiano in Venice (1476). In the course of the seventeenth century it disappeared, until 1659, when fragments identified as Giovanni Bellini's turned up in the collection of Archduke Leopold William in Brussels. From these, David Teniers had made engravings which were published in his *Theatrum pictoricum* (1660). Three of these fragments, with the Madonna and Child and half-length figures of Saints Nicholas of Bari and Mary Magdalene, Ursula and Dominic, have survived in the Vienna Kunsthistorisches Museum.

The original composition appears to have been an imposing group of eight saints bracketed by well-modeled figures of St. George and St. Sebastian, with the Madonna Enthroned. An architectural setting with tiled floor, domed ceiling and a barrel vault provided an impressive and open space through which light filtered to create the mood of a *sacra conversazione*. Variations of this scheme appear in a number of Venetian and north Italian altarpieces of the late fifteenth century, as can be seen especially in Alvise Vivarini's Belluno altarpiece, formerly in the Berlin Kaiser Friedrich Museum (destroyed in 1945).

Antonello's portraits are significant not only for their relationship with the Flemish realism and character portrayal, but also in

their position with regard to the development of the Renaissance portrait in Italy. The emphasis on a more plastic and personal, yet dignified, characterization of the sitter, with head in three-quarter view and eyes fastened on the beholder, is in keeping with the general realistic tendencies of this period going into the last quarter of the century. Among the best of these are the Portrait of an Unknown Man, painted ca. 1470, now in the Philadelphia Museum of Art, that in the London National Gallery (ca. 1473), the so-called Hamilton Portrait of 1474, and that of a Young Man, with signature and date, 1478, along with an inscription: *Prosperans modestus esto infortunatus vero prudens*—(Be modest in good fortune, but wise in misfortune)—in the Berlin-Dahlem Museum, that of a *condottiere*, in the Louvre (1475), and particularly that of a Milanese citizen, signed and dated 1476, formerly in the Tribulzio Collection, now in the Museo Civico of Turin (cf. Jan Van Eyck's portrait in London and also Piero della Francesco's portrait of Federigo da Montefeltro).

Alvise Vivarini (1445/6-1503/5) is the youngest member of the Vivarini family, and the one who represents the transition from the hard and linear style of the Murano group to the luminaristic manner of Antonello and Giovanni Bellini.

He is supposed to have been born about 1445 or 1446, the son of Antonio Vivarini, and probably worked in the shop of his uncle, Bartolomeo. In 1476, he is registered in the Scuola Grande di Santa Maria della Carità, from which he was expelled in 1488 for lack of interest in the institution. Various records indicate that he was active on paintings for the decoration of the Sala del Maggior Consiglio in the Ducal Palace of Venice (1488-1492) and painted a processional banner (1501) for the Scuola Grande di San Marco, of which he had been a member since 1492.

Alvise's early work seems to have been influenced more by Bartolomeo than by his father. This is shown in his earliest work, the polyptych of 1476, formerly in the convent of Montefiorentino Piandimeleto and now in the Galleria Nazionale delle Marche in Urbino. The five-panel altar represents the Madonna with the Sleeping Child and Saints Francis, Peter, Paul and John the Baptist, and is signed and dated *1476 . Ludovcvs . Vivarinus Murianen Sis. P.* The tall proportions, hard drawing and careful modeling of the figures

which are packed closely to the frame are the characteristic features to be noted.

A second altar, dated 1480 and signed *Alvixe Viva/rin. P. MC-CCCLXXX*, representing the Madonna and Six Saints (Louis of Toulouse, Anthony of Padua, Anne, Joachim, Francis, Bernardinus of Siena) in a *sacra conversazione* (formerly in San Francesco in Treviso and now in the Galleria dell' Accademia in Venice), shows the influence of Antonello and Giovanni Bellini, with its freer composition of figures, use of light and softer coloration.

Perhaps Alvise's finest and most important work was the altar, formerly in the Kaiser Friedrich Museum of Berlin, representing the Madonna Enthroned with Six Saints (Saints George, Peter, Catherine, Mary Magdalene, Jerome and Sebastian) with music-making angels, which was originally in the church of Santa Maria dei Battuti de Belluno and was destroyed in 1945. The dating is questionable, but it appears to be a later work, sometime after 1485, and is a free variation of Antonello's Cassiano altarpiece, as well as being related to Giovanni Bellini's San Giobbe altar (ca. 1480-1485). Aside from Bellini's music-making angels, it reveals many of the late Quattrocento compositional features already noted among the contemporaries, notably the impressive architectural setting to which the figures are subordinated, the tendency to group the figures into a pyramidal form, though in strictly vertical poses, and the interest in light. The same idea is developed in the later Madonna and Four Saints altar, in the Staatliche Museen in Berlin, painted in the 1490s and influenced by Cima da Conegliáno.

Alvise's last work is the altar representing St. Ambrose Enthroned with Saints Sebastian, John the Baptist, George, Liberalis, Gregory, Francis and Jerome, with music-making angels and a Coronation of the Virgin in the balcony above the vault, in Santa Maria dei Frari, Venice. From an inscription which is no longer legible, the altar was begun in 1503 by Alvise and finished by his pupil, Marco Basaiti, who is probably responsible for the figures of St. Sebastian and St. Jerome. The more elaborate architecture, the larger numbers of figures, their livelier movement and the continued exploitation of light and color to model the forms and create a unifying atmosphere are characteristic elements suggestive of the sixteenth-century style.

Jacopo Bellini (ca. 1400-ca. 1470) was the head of another impor-

tant artist family in Venice that developed parallel to the Vivarini and established the tradition which dominated the great artists of the sixteenth century.

Jacopo was born about 1400, the son of a plumber, Niccolò Bellino. He was a pupil of Gentile da Fabriano, and probably accompanied him to Florence, where he is mentioned for the first time in documents as involved in a law suit in 1423. By 1428 he was back in Venice, and that year he married Anna Rinversi of Pesaro, who made a will in 1429, shortly before the birth of her first child (Gentile). In 1436, he painted a large fresco of the Crucifixion (destroyed in the eighteenth century), in the Chapel of San Niccolò, for Bishop Guido Memmo in the Cathedral of Verona. In 1437, he became a member of the Scuola di San Giovanni Evangelista, and was active with his sons, Gentile and Giovanni, on an altar (1490, lost) in the Cappella Gattamelata in Sant' Angonio, Padua. He was at the court of Ferrara in 1441, when he won a competition over Pisanello for a portrait of Lionello d'Este. By 1443, he was back in Venice, married his daughter, Nicolosia, to Andrea Mantegna in 1453, and did decorations, with the help of his sons, in the Scuola di San Marco in 1466 (lost in a fire of 1485).

Of Jacopo's paintings, two are most significant. One is the early Crucifixion, painted on canvas and signed *Opus Jacobi Bellini*, now in the Museo Civico (Castelvecchio) of Verona. Its uncertain anatomy, the simple composition of the over-life-sized figure before a plain background, and the Gothic curvature of the design, indicate its early dating and suggest a parallel to Fra Angelico's work of the San Marco period.

The other is the famous half-length Madonna and Child, now in the Uffizi, which appears to be the latest of a group of similar panels, now in the Accademia of Venice, in the Milan Pinacoteca di Brera (1448), and in the Palazzo Tadini in Lovere. Remarkable features are the rather severe vertical composition, the careful drawing and modeling of the figures (cf. Mantegna, as well as his own drawings), and especially the richness of its coloration, which (in tempera) is laid on in loose, impressionistic patches suggestive of a minute mosaic.

The most interesting works of Jacopo's extant are the two sketch books (ca. 1450), one in the British Museum and the other in the Louvre, containing altogether some 230 drawings in pen and ink and silverpoint. These represent numerous iconographic themes,

both classical and Christian, many realistic studies of animals, costumes, landscapes, architectural settings and details (many of which are taken from classical antiquity), and countless artistic experiments in perspective, figure foreshortening, action and figure composition. The sketch books (of which the Paris codex appears to be the more finished and best preserved), therefore, parallel, in a general way, the new experiments that were going on in Padua and Florence at about the same time, i.e., toward the middle of the century. The date of 1430 and the signature (*De mano De M. S. Jacob Bellino Veneto, 1430, in Venetia*) on one of the pages are later additions (cf. the similar and less effectively executed drawings of Pisanello).

Gentile Bellini (1429-1507) continues the patriotic tradition of narrative-historical painting associated with the Doge's palace that was begun in the early part of the century by Gentile Da Fabriano and Pisanello.

He was born in 1429, the son of Jacopo Bellini, and worked with his brother as assistance to his father on the lost decorative projects in Padua and Venice. The earliest record of him is 1465, when he signed the portrait of Lorenzo Giustiniani. In 1466, he was commissioned by the Scuola Grande di San Marco to paint two canvases with scenes of the Exodus of the Israelites from Egypt. He was knighted (*eques*) and made a count of the Palatinate (*comes Palatinus*) in 1469 by Emperor Frederick III. In 1474, he was given permanent charge of the preservation and repair of the paintings in the Sala del Gran Consiglio in the Doge's palace. Vasari and Sansovino describe decorations, representing the Battle of Pope Alexander III and the Emperor Frederick Barbarossa, painted by Gentile and Giovanni in the same council chamber, which were destroyed in the fire of 1577. In 1479, an envoy of the Sultan Mohammed II made the request to the Signoria of Venice for the services of a painter, and Gentile was chosen to go to Constantinople. He sailed September 3 of that year, to return in November 1480. From the contemporary accounts and the conferring of the title *Bey* the Sultan, it is assumed that he enjoyed high respect at the eastern court. From 1480 until his death there are a number of legal records and contracts which indicate a continued residence in Venice and patronage by the ruling officials there, as well as several portrait

commissions from the Duke of Mantua. He was buried February 23, 1507, in the church of SS. Giovanni e Paolo.

Gentile's earliest works appear to be the organ shutters in the Museo di San Marco, done ca. 1464 and representing Saints Mark, Theodore, Jerome and Francis. The first two present life-sized figures (signed, *Gentili Bellini*) before barrel vaults in an impressive manner close to Mantegna's monumental use of figures and perspective in the Eremitani frescoes and the St. George (Venice), done in 1464. The other two saints before landscapes are less effective in their execution.

The portrait (signed, *MCCCCLXV opus Gentilis Bellini Veneti*) of the famous Venetia patriarch, the Blessed Lorenzo Giustiniani (d. 1455), in the Accademia of Venice, is interesting iconographically as a representation of the thin, emaciated, saintly type so frequent in this period (cf. San Bernardino and San Giovanni di Capistrano). Stylistically, the canvas shows a much more individual character than the Mantegnesque manner of the organ shutters, as can be seen in the neglect of color for a very hard and rigidly stylized profile design. Other profile portraits attributed to him on the basis of this peculiar style are the two now in the Museo Correr in Venice (Doge Francesco Foscari and Doge Giovanni Mocenigo) and that of Doge Andrea Vendramin now in the Frick Collection, New York.

Gentile's most famous and authentic portraits are: that of Sultan Mohammed II, in the National Gallery of London (with a retouched inscription and date but probably done in 1480, before his return to Venice), which, in spite of its damaged condition, shows much of Gentile's sharpness and refinement of design. The other work is the late, signed portrait of Caterina Cornaro, Queen of Cyprus, now in the Museum of Budapest, which is significant not only for its striking naturalism but also for its greater interest in the rounded form as well as the refinement of design.

Two signed Madonna altars exist: one in the Berlin-Dahlem Museum (signed, *Opus Gentilis Bellinus*, on the frame, however), which appears to be an earlier and inferior work; the other is the Madonna from the Mond Collection in the National Gallery of London, with the signature, *Opus . Gentilis . Bellini . Veneti . Equitis .*, from which the approximate date of 1469 is drawn, since he was first knighted at that time. Of special interest here is the somewhat

oriental character of the elaborate brocade of the Madonna's robe.

Gentile's most important and extensive works are the three large canvases, in the Accademia of Venice, which were originally in the Scuola di San Giovanni Evangelista and which represent Miracles of the Relic of the Holy Cross. The first (1496) is the Large Corpus Christi procession on the Piazza di San Marco (signed, *MC-CCCLXXXXVI Gentili Bellini Veneti equitis crucis a more incensus opus)*, in which the actual event represented, though hardly noticeable in the impressive scene, is the story of the Brescian merchant Jacopo Salis who sinks to his knees at the sight of the relic, implores, and is mercifully granted the miraculous cure of his sick son. The style is significant to the Venetian tradition for its interest in recognizably realistic settings and figures (cf. Ghirlandaio and Gozzoli) to which the narrative content is subordinated. A number of portraits in the crowd, including the Doge and various magistrates, are identified by Ridolfi.

The second of the series represents the Rescue of the Relic from the water (when it fell into the canal before San Lorenzo), which was effected, after several futile attempts by others, only by Andrea Vendramin, the guardian of the Scuola di San Giovanni Evangelista. The retouched signature gives the date of 1500 (note also the portrait of Caterina Cornaro among the court ladies at the left). The third canvas represents the miraculous healing of Pietro dei Ludovici (ca. 1501), and the last is the Preaching of St. Mark in Alexandria, painted for the Scuola di San Marco (in the Pinacoteca di Brera, Milan), which was begun by Gentile in 1504 and finished by his brother Giovanni. Aside from the somewhat monotonous regularity and strictness of the design and composition, one chief characteristic of the rich luminosity and unified tone of the color.

Giovanni Bellini (also Giambellino, ca. 1430-1516) has been considered since his own time as the greatest of the Venetian Quattrocentists and the dominating influence on the leaders of the sixteenth century, i.e., Giorgione and Titian.

He was born in Venice in about 1430, the younger son of Jacopo Bellini, and worked with his father and brother Gentile on the large decorative projects in Padua (1460) and Venice (i.e., the Scuola di San Girolamo, 1464). There is some discussion in the literature about the date and legitimacy of Giovanni's birth, since

his mother had made a will in 1429 in anticipation of her first child and then, in a will of 1471, shortly after Jacopo's death, left all her property to *"Gentile et Nicolao filiis meis et Jacobi equaliter."* Gentile and Nicolosia were the heirs and Giovanni was left out, which led to the speculation that Giovanni might not be her son or might be older than Gentile. Since they are referred to together, and were leading artists of Venice, the assumption has been that Giovanni was the younger, born sometime after 1430. The record of their activity in the Cappella del Gattamelata in Padua reads *Jacobi Bellini Veneti Patris ac Gentilis et Joannis Natorum Opus MCCCCLX*, with Gentile listed first of the two.

In 1453, his sister Nicolosia married Mantegna. In 1471, he is recorded as maintaining a studio with his brother, In 1479, he succeeded Gentile in the official position of conservator of paintings in the Palazzo Ducale when the latter left for Constantinople, and at the same time continued the cycle of decorations, done with Gentile, depicting scenes from the campaigns of Pope Alexander III against the Emperor Frederick Barbarossa (lost in the fire of 1577). That year he was also appointed *Sensaria*, or broker, at the Fondaco dei Tedeschi. A number of legal documents and many dated works indicate his continued residence in Venice.

In 1496, he entered into correspondence with the Marchesa Isabella Gonzaga of Mantua with regard to paintings for her library and is mentioned in documents of the Este family in Ferrara. On the death of Gentile (1507), he completed the latter's large canvas for the Scuola di San Marco. The interesting comment by Albrecht Dürer in a letter to his friend Pirkheimer (February 6, 1506) to the effect that Giovanni was very old but still the best painter indicates something of the respect in which he was held even at that age, which is also shown in the number of commissions he received and the great influence he had on pupils and the younger generation. He died on November 29, 1516, and was buried with his brother in SS. Giovanni e Paolo.

The work of Giovanni Bellini shows, perhaps more clearly than that of any of his Italian contemporaries, the gradual stylistic evolution from the carefully drawn, scientifically conceived manner (i.e., in anatomy and perspective) of the second half of the Quattrocento (Verrocchio, Mantegna), to the monumental and emotionally inspired art of the High Renaissance, with its ever-increasing emphasis

on light and color, freely moving forms and spacious compositions. Stylistically, he does not run into a blind alley, as do so many of the parallel Quattrocentists in Florence and Rome (Botticelli, Perugino, Lorenzo di Credi), but the works of his late period are closely associated with the early style of his pupils and the great masters of the following generation.

Among the best works of his early period, which show the direct influence of his brother-in-law Andrea Mantegna is the Agony in the Garden (London, National Gallery). While its general arrangement is related to that of Mantegna's panel of the same subject (also in the National Gallery), it has a marked simplicity of composition, with a more open space, and a greater emphasis on light and the emotional effect of its flooding of the landscape (cf. the motif of the sunrise), rather than the linear clarity and articulation of both figures and landscape which Mantegna uses. It is difficult to specify a date, but the Bellini panel appears to have been painted about 1465, and the Mantegna slightly earlier. Related to both is cetainly Jacopo Bellini's drawing of the same subject in the London sketchbook, and Mantegna's predella panel, with the praying Christ figure in the reverse position for the San Zeno altar, which is datable ca. 1457-1459 (now in the Tours Musée des Beaux Arts).

The two panels of the Crucifixion and Transfiguration, of about 1460, in the Museo Correr, Venice, possess many of the same characteristics. Similar differences in the lyric emotional expression might also be noted in the early Pietà themes, especially the famous one in the Pinacoteca di Brera of Milan, with its highly sensitive drawing, large and simplified areas of form and drapery, and the cool grayed coloration, which is remarkable contrast to the different point of view expressed in Mantegna's Dead Christ. In its simplicity of linear design and luminosity of color, it is perhaps the finest of Bellini's early works. The inscription on the parapet below reads *Haec fere quum Gemitus Turgentia Lumina Promant Bellini Poterat Flere Joannis Opus* (''When these swelling eyes evoke groans this work of Giovanni Bellini could shed tears,'' translation, Prof. Charles Brink). The date is unsure, but it would probably come between 1465 and 1470.

Later variations of this Pietà composition are those in the Museo Civico of Rimini, which may have been the one mentioned by Vasari as in the sacristy of San Francesco, executed for Sigis-

mondo Malatesta (d. 1468), and the large brush drawing on panel in the Uffizi of Florence. Although signed, the Pietà in the Venice Accademia has been attributed to various followers as well as to Bellini. Its stylistic relationship with the Baptism of Christ in the church of Santa Corona in Vicenza would date it about 1500. The sweeping landscape with its architectural panorama, as well as the poetic handling of the subject groups, suggest the northern Pietà type of the *Vesperbild*. The background buildings have been identified as the Basilica of Vicenza, the old façade of the cathedral and the sanctuary of Monte Berico, although they have also been identified as Ravenna (the cylindrical campanile of Sant' Apollinare and the church of San Vitale) and a panorama of the Natisone valley at Cividale.

The earliest of Giovanni's large-scale altarpieces is probably the Polyptych of St. Vincent Ferrer in the church of SS. Giovanni e Paolo in Venice. Represented are standing figures of St. Vincent Ferrer, the famous Dominican preacher and penitent, with St. Christopher and St. Sebastian on either side, the Pietà and Annunciation above, and three scenes from the life of St. Vincent Ferrer in the predella below. Though there has been considerable discussion about its attribution to Giovanni, the altar is mentioned by Francesco Sansovino in 1581, which may be based on Marcantonio Michiel, and it was probably painted for an altar being built in 1464 in the Scuola of St. Vincent Ferrer. The general form of the polyptych is significant as suggesting the transition from the elaborate Gothic to the Renaissance, particularly in its framing as well as its composition, and in its relationship with Mantegna (the San Zeno altar, 1459) and Antonello da Messina (the polyptych of St. Gregory, 1473).

One of the last works of this early Mantegnesque period is the Pesaro Altar, with the Coronation of the Virgin with Saints Paul and Peter, Jerome and Francis, in the Museo Civico of Pesaro, formerly in San Francesco there. An Entombment whose composition is a characteristic variation of the Pietà groups mentioned above, in the Pinacoteca Vaticana, formed the apex of the original altar. It is signed but not dated and is assumed to have been painted in the 1470s, perhaps 1475. Note the domination of the saints' figures over the central group, the monumental character of the scene as a *sacra conversazione*, the luminous color and atmospheric character of the

309

recognizable landscape with a Renaissance frame in the background, as well as in the predella scenes below. The painting medium is oil on panel. These predella scenes are of special interest because of their spacious landscape backgrounds: St. George and the Dragon, the Conversion of St. Paul, Crucifixion of St. Peter, the Nativity, the Penitent St. Jerome, and St. Francis Receiving the Stigmata, and St. Terence holding a model of the contemporary (built 1474) Rocca Costanza in Pesaro. Eight small panels of saints in illusionary niches occupy the pilasters on either side.

The particular emphasis on light and color in the landscape for their emotional effect is continued in two altar panels painted shortly afterward (ca. 1480), namely, the Transfiguration, in the Museo Nazionale di Capodimonte, Naples, with the Tomb of Theodoric and the Campanile of Sant' Apollinare in Ravenna represented among the buildings in the background to the right of Christ, and the Resurrection, of ca. 1479, with its nude soldier below and a castle represented in the distant background (possibly Monselice), now in the Berlin-Dahlem Museum, originally in San Michele di Murano.

The same mood is expressed in the remarkable panel of St. Francis Receiving the Stigmata, of ca. 1480, now in the Frick Collection, New York. The careful observation of its forms, the rich luminosity of the color, and the subtle use of light in unifying both the figure and the surrounding forms, seem to create a quiet devotional ecstasy through the painter's medium, rather than through the actual representation of the Stigmata (cf. the St. Francis Receiving the Stigmata in the predella of the Pesaro Altar).

The contrast between the Pesaro Altar and the large Madonna Enthroned with Saints Francis, John the Baptist and Job at the left, and Dominic, Sebastian and Louis of Toulouse at the right, in the Galleria dell' Accademia of Venice, formerly in the church of San Giobbe, reveals a fully rounded and perfected style. Note the easy grouping of the saints in triads to the left and right, the prominence given to the Madonna Enthroned above the groups, the pyramid of three angels playing musical instruments, at the foot of the throne, the spacious and richly decorated apse interior in which the figures are placed, and, especially, the use of light, not only to model the figures in the space but also to give a unified coloristic and emotional tone, to which, iconographically, the representation of musical instruments is related. The panel was probably painted in the late

310

1480s, certainly before 1490. It is mentioned by M.A. Sabellicus in his *De Venetae Urbis Situ* (first edition ca. 1489/90, and in the 1493 chronicle of Marin Sanudo. The theme of the enthroned Madonna with a *sacra conversazione*, set in a monumental church interior, seems to be related to Antonello's altar painted for the church of San Cassiano. In this case, the key figures are St. Sebastian and St. Francis, who turns with an expressive gesture to the spectator.

During this same period, Giovanni painted the votive altarpiece, in oil on canvas (1488), of the kneeling Doge Agostino Barbarigo before the Virgin, with Saints Mark and Augustine and angels, which was originally listed in the palazzo of the donor, and then, at his death in 1501, was transferred to the church of Santa Maria degli Angeli in Murano. It is now in San Pietro Martire, Murano (cf. the same architecture and fortifications in the distance at the right as noted in the landscape background of the Pesaro Altar). The triptych with the Madonna and Four Saints, in the church of Santa Maria dei Frari in Venice (signed *Iohannes Bellinus F. 1488*), was completed the same year. Represented are Saints Nicholas and Benedict, in the foreground on either side, with two others, probably St. Peter and St. Mark, behind them. Of special interest is the retention of the traditional scheme of a triptych with a heavy frame, into which the monumental figures are composed (cf. Giovanni d'Alemagna's altar in San Zaccaria and Mantegna's San Zeno altar), and the probable influence of both Bellini's and Mantegna's compositions on Dürer in the Munich Four Apostles. A second factor is the interest in the movement of the Christ Child, with its striding pose, and the more active poses of the two puttilike angels at the base of the throne.

Bellini's allegorical panels appear to have been painted, or at least begun at, about this time. The foremost of these is the Sacred Allegory, in the Uffizi, showing the Madonna with Saints on a terrace before a lake and mountainous landscape. The content has been traditionally interpreted as a representation of earthly Paradise, taken from the allegorical poem, *Pélerinage de l'âme*, by Guillaume de Deguilleville, a Cistercian monk who lived in the first half of the fourteenth century. Other interpretations stress the theme of a *sacra conversazione* involving the discussion between Mercy, Truth, Justice and Peace on the theme of Salvation through the Incarna-

tion, based on Psalm 84, or again a more simplified, but still unexplained, "meditation" on the theme of Paradise. The figures of St. Job and St. Sebastian appear to be almost identical with the same saints in the San Giobbe altar, and would suggest the date of the painting's execution as being about the same, or possibly a short time afterward.

The five small panels in the Accademia of Venice represent moral allegories that go back to classical antiquity of contrasting good and evil, associated with the use of the mirror: *Comes Virtutis, Fortuna Amoris, Vana Gloria, Servitudo Acediae* and the blindfolded Nemesis as the central figure. Stylistically, they reflect a consistent interest in a romantic mood associated with the technical use of light and atmospheric color, particularly through the landscape. These are, presumably, the panels mentioned in the testament of the painter Vincenzo Catena (dated April 14, 1530), and served originally as decorations for a *restello*, or lady's dressing-mirror. Both in style and in iconography, they offer interesting comparisons with contemporary works of Botticelli and the *cassoni* painters of Florence.

Of the many small devotional altars by Bellini representing the Madonna and Child, the most famous is the Madonna degli Alberetti (i.e., the Madonna of the Trees), in the Accademia of Venice, signed and dated 1487. Its style is closely related to the type of Madonna and soft atmospheric texture noted in the Frari and San Giobbe altars of about the same time.

Bellini's portraits show a development from an earlier style that is closely associated with the half-Flemish manner of Antonello da Messina, as can be seen in the 1474 (hence before Antonello's arrival in Venice) portrait of Jörg Fugger in the collection of Conte Contini-Bonacossi in Florence, which was not signed, but dated on the back of the panel *adi XX di Zugno MCCCCLXXIIII*. In contrast to the pious and restrained character of this work is the Renaissance elegance and dignity of the famous bust portrait of the Doge Lenardo Loredan, in the London National Gallery, which is signed, on the *cartellino, Iohannes Bellinus*, and which appears to have been painted at the beginning of his reign, about 1501/2.

The most significant single work of Bellini's late period is the large Madonna Enthroned with Saints Peter, Catherine, Lucy and Jerome, signed and dated (1505), in the church of San Zaccaria,

Venice. The comparison with the earlier *sacra conversazione* altars will reveal the typical characteristics of this new period in the broader and more monumental proportions of the figures (cf. especially St. Peter and St. Jerome), the subordination of these figures to an impressive space and architecture, the increased use of light, and a shimmering coloration in giving a romantic mood to the devotional scene. With regard to the artistic problems involved, it is useful to compare the similar motifs and different solutions used by Piero della Francesca in his Brera altarpiece, such as the throne before a niche with the piers and cornices showing at the sides in the foreground, the lamp hanging from the vault, with a purpose similar to Piero's hanging ostrich egg, and the landscape fragments visible through the arches at the sides, in contrast to Piero's closed interior.

The Baptism of Christ, in the church of Santa Corona, Vicenza, painted between 1500 and 1502 for Giovanni Battista Graziano Garzadori, who had just returned from the Holy Land, is a slightly earlier parallel to the San Zaccaria altar, with its mountainous landscape and evening atmosphere as a setting, rather than the vaulted interior. Giovanni's last completed altarpiece is the St. Jerome between St. Christopher and St. Louis of Toulouse, in San Giovanni Crisostomo in Venice, which was commissioned by Giovanni Diletti in his testament of 1494, but not finished until 1513. In a composition reminiscent of the traditional Madonna Enthroned altars, with a framing arch or vault to enclose it, the seated figure of St. Jerome is here enthroned on a rock, turned in profile, with a wilderness landscape opening the vast space behind him. The two figures of the standing St. Christopher and St. Louis occupy the narrow stage below in the foreground, modeled in color and light almost as sculpture (cf. Titian's St. Mark altar in Santa Maria della Salute).

A number of legendary and allegorical works during this last period show the development of new compositional forms that seem to originate in the aged Giovanni's shop and are worked out by pupils and followers; hence, their attribution to Giovanni, or any number of his important assistants, varies considerably. The most important of these is signed and dated (1514) Feast of the Gods, formerly in the Widener Collection of Philadelphia and now in the National Gallery of Washington, which was painted for Alfonso d' Este of Ferrara and for which the final payment was made on November 13, 1514. The subject is the bacchanalian feast honoring

Priapus as narrated in two well-known passages in Ovid's *Fasti* (1, 391-440; 6, 319-348), and the work was intended for Alfonso's studio, where he later added several Bacchanals by Titian. Many parts of the canvas are certainly not painted by Bellini; the landscape at the left, especially, is generally recognized as the work of Titian. Not only the prominent landscape and forest setting, to which the figures are subordinated, is to be noted, but also the increased emphasis on the movement of figures and their decorative organization, which becomes a significant factor of the sixteenth-century style. The panel depicting the Assassination of St. Peter the Martyr, now in the National Gallery of London (often doubted and attributed to Basaiti), is another well-known example, with its interest in the action of figures yet composition still in the horizontal-vertical manner of the late Quattrocento.

Cima da Conegliano (Giovanni Battista Cima da Conegliano, ca. 1459-ca. 1517) is one of a group of interesting but less important pupils and followers of Giovanni Bellini who were active in and around Venice. He was born ca. 1459 in Conegliano, and appears to have worked in Vicenza for some years (1488), then is recorded in Venice after 1492. He was buried in Conegliano some time in 1517 or 1518. His style is rather stiff and provincial when compared to that of Bellini, under whose influence he developed, though it also has many characteristics similar to Alvise Vivarini or Bartolomeo Montagna. One of his earliest works is the Madonna under a Trellis with Saints Jerome and James, in the Palazzo Chiericati (Museo Civico) of Vicenza, dated 1489 and closely related, though somewhat heavy and awkward, to Giovanni Bellini's altars of the same period. The 1494 Baptism of Christ, in San Giovanni in Bragora, Venice, shows a greater interest in a soft atmosphere, and a predominant landscape similar to Giovanni's later altar of the same subject in Santa Corona, Vicenza.

The late works of Cima reveal a greater interest in luminous coloration, tempered with even tones of gray and ochre, and larger, more active figure compositions in either landscape or architectural settings: the Madonna under the Orange Tree with Saints Louis of Toulouse and Jerome, in the Accademia, Venice (signed *IOA.BAPT.CONEGL.*); the 1501 altar with Helen and Constantine and predella scenes from the Legend of the Holy Cross, in San

Giovanni in Bragora, Venice; the 1504 Incredulity of Thomas, in the National Gallery, London; and the late Tobias with the Angel between St. James and St. Nicholas of Bari, in the Accademia of Venice, again showing, as in the late Bellini, the prominence given to an atmospheric landscape into which the figures are composed.

Marco Basaiti (active ca. 1496-1530) was probably born in Friuli, and worked with Alvise Vivarini and possibly with Giovanni Bellini. His chief works are the Calling of the Sons of Zebedee, signed and dated 1510, the Christ in the Garden of Gethsemane, with Saints Dominic and Mark, Louis and Francis standing on the tiled floor on either side of the central arch which frames the Garden Scene (signed and dated 1516), and the late (1520) St. George and the Dragon, all three of which are in the Accademia of Venice. Characteristically, they show the same emphasis on the landscape as did the late work of Giovanni and Cima, and use many of the same compositional motifs. Compare, for instance, Giovanni's St. Jerome, in San Giovanni Crisostomo, with Basaiti's Gethsemane, whereby not only Basaiti's harder drawing and modeling are evident, reminiscent of Alvise Vivarini (cf. the standing saints in the foreground), but also a certain manneristic handling of figures and drapery which might be looked upon as a parallel to the Florentines of the late Quattrocento.

Vincenzo Catena (Vicenzo di Biagio, active ca. 1480-1531) is somewhat younger than the two foregoing artists, and was probably a pupil of Alvise Vivarini; he then came under the influence of Giovanni Bellini and finally that of Giorgione. The early work in the manner of Vivarini can be seen in the Madonna with St. John the Baptist and St. Jerome (ca. 1500), in the Accademia of Venice. The Bellini style is best exemplified in the Madonna with Two Saints and the Kneeling Doge Leonardo Loredan, in the Museo Correr, Venice, painted between 1505 and 1510, and composed after the manner of Giovanni's votive picture in San Pietro Martiro in Murano. A late work, such as the Christ Appearing to St. Christina (1520), in Santa Maria Mater Domini, Venice, has much of the romantic spirit and coloration of Giorgione. A late, signed Portrait of a Man, in the Kunsthistorisches Museum of Vienna, is also noteworthy, as an example of the more completely Renaissance concept.

Jacopo de' Barbari (known in Germany also as Jakob Walch, ca. 1450-1516) is interesting, in this connection, as an international personality, who developed in Venice, under the influence of Alvise Vivarini as well as that of Giovanni Bellini, and then, in about 1500, entered the service of the German Emperor Maximilian at Nuremberg. From 1503-1505, he was court painter to Frederick the Wise of Saxony and was active in many other ducal courts in Germany as well as in the Netherlands, where he served as court painter to the Stadholder Margaret at Antwerp. The work shows some stylistic relationship with Albrecht Dürer, possibly a mutual influence (Dürer's first trip to Venice was in 1494), as well as, later, with Lucas Cranach. The chief work executed before 1500, while he was still in Venice, is the Madonna with Saints John the Baptist and Barbara, and the donor, Caterina Cornaro, Queen of Cyprus, now in the Berlin-Dahlem Museum. Best known, perhaps, are his still-life paintings (e.g., in the Alte Pinakothek, Munich, 1504), the Sparrowhawk, in the London National Gallery, and his portraits (e.g., the Portrait of Henry of Mecklenburg, 1507, in the Mauritshuis of The Hague, and the Portrait of a Gentleman, with a pair of nude lovers on the reverse, in the Berlin-Dahlem Museum), as well as his graphic work.

Lazzaro Bastiani (ca. 1430-1512) is the oldest of a second group of painters, active in Venice during this last quarter of the fifteenth and first quarter of the sixteenth centuries, which continues the narrative decorative style under the influence of Gentile Bellini. He had probably been originally a pupil of Bartolomeo Vivarini, and later developed the decorative manner of Gentile. He is also significant as the teacher of Carpaccio. Characteristic examples of his work are: the lunette with the Madonna, Saints John the Baptist and Donatus and the donor, Giovanni degli Angeli, in the church of SS. Maria e Donato, Murano, dated 1484; the signed (*Lazarus Bastianus. Pincxit*) altar of St. Veneranda Enthroned with Saints, formerly in the abbey church of Corpus Domini; and the Crusader Filippo de' Massari bringing the Relics of the Holy Cross to the Scuola di San Giovanni Evangelista, of ca. 1500, both in the Accademia of Venice.

Benedetto Diana (Benedetto Rusconi, active 1482-1525) is a second follower of Gentile Bellini and pupil of Lazzaro Bastiani, who is

best known for his *sacra conversazione*-type altar of the Madonna Enthroned with Saints Jerome, Benedict, Justina and Magdalene, in the Accademia of Venice.

Marco Marziale (active ca. 1492-ca. 1507) likewise remains a somewhat provincial follower of Gentile. He had been employed on decorations in the Doge's palace, and had worked for a time in Cremona. His chief works are the signed Circumcision altar of 1500, in the National Gallery, London, with portraits of Tommaso and Doralice Raimondi with their son Marco, the Supper at Emmaus scenes in the Accademia of Venice (1506) and the Staatliche Museen of Berlin (1507), as well as the Madonna Enthroned with Saints Gall, John the Baptist, James and Bartholomew (signed and dated 1507), in the London National Gallery.

Giovanni Mansueti (Giovanni di Niccolò, active 1485-1527) painted a number of altarpieces, such as the signed St. Jerome, and a Deposition, both in the Accademia Carrara of Bergamo, and the Madonna with Saints and Donor, in the Accademia of Venice. But his most important works are the two canvases depicting scenes of the Miracles of the Holy Cross: the Healing of Benvegnudo's Daughter and the Miracle in Campo San Lio (which is signed and dated 1494), in the Accademia of Venice. They originally formed part of a series in the Scuola di San Giovanni Evangelista, and from the transition from Gentile Bellini to Carpaccio.

Vittore Carpaccio (1460/65-1526) is the greatest of the Venetian historical painters and, along with Giovanni Bellini, is the second connecting link between the Byzantine-Gothic-Early Renaissance decorative tradition and the High Renaissance of Titian and Tintoretto.

Little is known concerning his life. He was born between 1460 and 1465, probably in Venice (although it has been argued that he or the family may have come from Capodistria), and had been a pupil of Lazzaro Bastiani. His name appears in various legal documents of 1472 and 1486, and his first dated work is in 1490 (St. Ursula Arriving in Cologne). A number of payments are recorded for work in the Doge's palace in 1502 and again in 1507, when he assisted Giovanni Bellini on the decoration of the Sala del Maggior Consiglio

in the Palazzo Ducale (destroyed in the fire of 1577). In 1511, he wrote a letter to Francesco Gonzaga of Mantua, offering to sell a large canvas at whatever price the patron should name; this was brought, apparently, since such a painting of a View of Jerusalem was listed in the Gonzaga inventory of 1627. In 1508, he, along with Lazzaro Bastiani and Vittore Belliniano, was asked to judge the frescoes of Giorgione on the Fondaco dei Tedeschi. Earlier the same year, he competed with Benedetto Diana for the commission, which he lost to Diana, to paint a *gonfalone* for the Scuola della Carità. In 1523, he is mentioned as a witness to the will of a Maria Contarini, and in 1526, he is mentioned as deceased.

Carpaccio's chief works are the four great decorative series which were done on large-sized canvases for the various Scuole of Venice. The first and most important of these is that depicting the Legend of St. Ursula (from the "Golden Legend" of Jacobus de Voragine), which was painted 1490-96/8 for the Scuola di Sant' Orsola (now destroyed) and is now in the Accademia of Venice. The first of the series (St. Ursula arriving at Cologne) is signed *Op. Victoris Charpatio Veneti MCCCCLXXXX M. Septembris*. The scenes represent, in their narrative order: 1) the ambassador of the pagan English king before King Maurus of Brittany, requesting the hand of the King's daughter Ursula for the English prince; 2) the ambassadors taking leave of King Maurus; 3) the English ambassadors presenting the answer of King Maurus to their king; 4) Ursula dreams of her Martyrdom at Cologne; 5) the English prince bids farewell to his father, meets Ursula, and they both take leave of King Maurus on their way to Rome; 6) their arrival at Rome and reception before the Castel Sant' Angelo by Pope Cyriacus; 7) their arrival at Cologne, which was besieged by the Huns; 8) the Martyrdom of Ursula and her followers by the Huns, and her funeral; 9) St. Ursula in Glory with God-Father above and the kneeling Virgins and followers about her.

With regard to the formal analysis of the series, note the traditional Gothic character of the lyric narrative translated into quiet and monumental decorative composition, parallel, in a sense, to that of Perugino (Christ Giving the Keys to St. Peter) or Pinturicchio; the similar use of recognizable, i.e., Venetian, backgrounds and settings in the landscape, city view or architectural interiors; the arrangement of elegantly costumed figures in horizontal decorative

planes (cf. Gentile Bellini and the similar compositional methods of the Sistine Chapel frescoes); Carpaccio's coloration, which is perhaps the most outstanding feature, whereby the brilliance and richness of local color patches, strengthened by contrasts (cf. the bright brocaded costumes, tapestries and architectural or landscape backgrounds) are combined with an even and unifying tone and luminosity, particularly through the soft use of light (cf. the grayed and linear character of Gentile's compositions); the peculiar iconographical use of light as a means both to the narrative and to the mood of a scene (cf. the Dream of St. Ursula, or the Ambassadors Taking Leave of King Maurus). An interesting iconographical and stylistic comparison is afforded by the similar representations of the St. Ursula legend on Hans Memling's Shrine of St. Ursula, finished in 1489, in the Hospital of St. John, Bruges.

The problem of stylistic evolution within the St. Ursula series presents difficulties, but it is possible to follow the change from a more tentative and unresolved handling of space and the figure compositions, as seen in what appears to be the earliest, the Arrival in Cologne, dated 1490, to a pronounced interest in the action of figures and their recession into space, as seen in the Martyrdom and Funeral of St. Ursula, dated 1493, and again to the use of light as an expressive medium (the Dream of St. Ursula), and, finally, the integration of these features into a rich and mature composition, such as that of St. Ursula and the Prince Taking Leave, which has the date 1495. The Reception of the English Ambassadors appears to be the last in the series, completed, probably, between 1496 and 1498. Some of the canvas had been cut down, probably in the process of removal from one building to another, in the seventeenth century, and again after the suppression of the order by Napoleon in 1810 (note particularly the Dream of St. Ursula). A number of figures have been identified as portraits of contemporaries or donors, such as figure at the left, in the Reception of the English Ambassadors, which may be Pietro Loredan. Those near him may be members of his family. The coat of arms on the base of the column in the Martyrdom scene is that of the Loredan family; the kneeling donor at the right is probably Eugenia Caotorta, wife of Nicolò Loredan.

The second cycle (1502-1507) was executed for the Scuola di San Giorgio degli Schiavoni, which had been confirmed in 1451 by the Venetian Council of Ten as a foundation of Dalmatians living in

Venice and dedicated to their patron saints, George, Tryphon and Jerome. The building and setting are essentially the same as originally designed, except that the scenes were removed from the large room on the upper story to their present location on the ground floor during the renovation of 1550-1565. Represented are scenes from the lives of Saints George, Tryphon and Jerome: 1) St. George Fighting the Dragon; 2) He Brings the Captive Dragon into the City and Slays it; 3) St. George Baptizes the Princess He Has Saved and Her Parents; 4) St. Tryphon (patron of the city of Cattaro) Drives the Demon from the Possessed Daughter of the Emperor Gordianus; 5) Christ Calling Matthew as His Disciple (dated 1502); 6) Christ in the Garden of Gethsemane; 7) St. Jerome Brings the Tamed Lion to the Monastery While the Terrified Monks Flee; 8) St. Augustine's Vision of St. Jerome; 9) Burial of St. Jerome.

The dates or the chronological order of execution of these canvases are of less significance than in the previous St. Ursula cycle, since there is a considerable variation in the quality, which would indicate the participation of pupils (e.g., St. Tryphon and the Daughter of Gordianus). The best of them show the continuous narrative in a form of strip composition in the foreground, against a landscape or architectural background, with the integration into a local composition through the use of a rich and luminous coloration (e.g., St. George and the Dragon). Other special qualities which might be noted are the Mantegna-like character of some scenes, such as the foreshortened forms in the St. George Fighting the Dragon or the Gethsemane; the many oriental costumes and motifs, possibly influenced by Gentile Bellini, but more probably taken from Erhard Reuwich's woodcut illustrations to Bernhard von Breydenbach's *Peregrinationes in Terram Sanctam* (i.e., the account of his journey to the Holy Land), published in Mainz, 1486; and, particularly, the St. Augustine's Vision of St. Jerome, with its subordination of figure to the space, careful observation of still life detail, and the use of light as an artistic means as well as an iconographical attribute, as in the Dream of St. Ursula (cf. the varying interpretations of St. Jerome by Botticelli, Leonardo da Vinci, Dürer's engraving and Ghirlandaio's St. Augustine).

The scene of St. Augustine's Vision of St. Jerome has traditionally been interpreted as a St. Jerome in his Study, but recent studies have suggested that it represents St. Augustine, to whom St.

Jerome spoke in a vision through an all-enveloping light. The inclusion of the bishop's crozier and mitre on the altar in the background, rather than the cardinal's hat associated with Jerome, would support the theory. A similar theme appears in the visions of St. Augustine represented in the choir of Sant' Agostino in San Gimignano by Benozzo Gozzoli.

The third series is that depicting scenes from the Life of Mary for the Scuola degli Albanesi, which was done about the same time (the Annunciation is dated 1504), and which represents the Birth of Mary (now in the Accademia Carrara in Bergamo), Mary Ascending the Steps of the Temple and the *Sposalizio*, in the Brera of Milan, the Annunciation and Death of the Virgin, in the Cà' d'Oro, Venice, and the Visitation, in the Museo Correr, Venice. The quality of these scenes, however, is considerably inferior to that of the other two series, and they appear to have been done with the help of assistants.

The last series, also vastly inferior through their stiff compositions and hard coloration, was painted ca. 1511-1520 for the Scuola di Santo Stefano in Venice and represents: 1) the Ordination of St. Stephen and His Six Companions (dated 1511), in the Berlin-Dahlem Museum; 2) St. Stephen Preaching in Jerusalem, in the Louvre of Paris; 3) the Disputation of St. Stephen, in the Pinacoteca di Brera of Milan; and 4) the Stoning of St. Stephen (dated 1520), in the Staatsgalerie of Stuttgart. A fifth scene, representing the Trial of St. Stephen, has been lost, but is known through a drawing in the Uffizi of Florence.

Of the separate altars and canvases by Carpaccio, one of the most important is the canvas (ca. 1494/95) executed for the Scuola di San Giovanni Evangelista (now in the Accademia of Venice) about the same time as the Ursula series, to which it corresponds stylistically as well. It belonged to the cycle of Miracles of the Relic of the Holy Cross, painted for that order by Gentile Bellini, Lazzaro Bastiani, Benedetto Diana and Giovanni Mansueti. The scene illustrates the healing of one possessed of the devil by the Relic held by Francesco Querini, Patriarch of Grado (on the balcony at the left), which act is lost in the lively and colorful picturesqueness of the Grand Canal scene.

Among the various devotional pieces, two associated with the Passion of Christ had long been identified as by Mantegna through

false signatures. One is the Meditation on the Passion panel, with the figures of St. Jerome and St. Job on either side of the enthroned Dead Christ in the Metropolitan Museum of New York. Its devotional content is based on the Book of Job, as indicated by the Hebrew inscription "My Redeemer Liveth. . . . " (Job 19: 25), which had been interpreted by St. Jerome as prophesying the Resurrection of Christ and was further discussed in the sermons of San Lorenzo Giustianiani. It may be an early work, painted ca. 1490, when one considers the close relationship in drawing and composition to Mantegna and Giovanni Bellini.

The second painting is the considerably larger canvas of the Entombment of Christ, now in the Berlin-Dahlem Museum. Its combination of a Pietà theme, with the Body of Christ resting on a marble bier in the foreground, with figures opening the grave at the left and the mourning women with St. John at the right in the background, along with the seated figures of Job, would indicate a later date, possibly ca. 1505. Again, some of the figures are reminiscent of Mantegna and Giovanni Bellini, as well as of Carpaccio's own later work, such as the Death of the Virgin in the Scuola degli Albanesi series.

The artistically less important altarpieces, belonging mostly to the late period, are the Presentation in the Temple, with the signature and date (*Victor Carpathius M.D.X.*), in the Accademia of Venice, formerly in the church of San Giobbe there; San Vitale Mounted, with Saints James and John the Baptist, Valeria and George on either side and Saints Andrew, Peter, Gervase and Protase on the arcade above, with the Virgin and Child in the clouds (signed and dated 1514), in the church of San Vitale, Venice; the Meeting of Joachim and Anna at the Golden Gate, with Saints Louis of Toulouse and Ursula (1515), in the Accademia; and the Madonna Enthroned with Saints Zachary, Joseph, Roch, Sebastian, Nazarious and Louis (signed and dated, 1516), in the Chiesa Concattedrale dell' Assunta of Capodistria.

There are several works that appear to be variations of individual canvases in the Scuole series. One is the panel of St. Ursula Taking Leave of her Father of ca. 1500, in the London National Gallery, which has also been interpreted as St. Ursula Meeting Her Bridegroom and The Landing of Caterina Cornaro at Cyprus. Although there is no reason to associate the subject matter, the

composition is based on that of St. Ursula and the Prince Taking Leave of Their Parents in the St. Ursula cycle. Another such variation is the St. George Fighting the Dragon canvas (signed and dated, 1516), in San Giorgio Maggiore, Venice, which is a rather weak shop version of the same scene in the Scuola di San Giorgio series.

Of special interest to the study of Carpaccio is the considerable number of drawings which have been preserved, particularly in the collections of the Uffizi, the British Museum, the Albertina in Vienna and the Louvre in Paris, as well as in many private collections. These reveal an endless variety of figure poses and compositions, which from the basis for shop production in much the same way as did the Jacopo Bellini drawings noted before. They also show a highly sensitive and personal character, not only in the study of nature and the individual costumed figures, but particularly in the interpretation and development of certain specific themes, such as St. Augustine's Vision of St. Jerome, the Dream of St. Ursula, and the various compositional studies for altarpieces which are often far more expressive than the finished work completed by the shop.

7. Padua

PADUA AS A POLITICAL ENTITY ended with its annexation by Venice in 1405. Its importance as a cultural center was carried on by its university, which became one of the strongest influences on the development of Humanism and the revival of Antiquity in northern Italy.

The art of the first half of the fifteenth century was dominated by the tradition of Altichiero and Avanzo of Verona. Toward the end of the second quarter, a new style developed, apparently under the influence of the Florentine realists, of whom Uccello (between 1425 and 1430) and Donatello (1443-1453) were active at various times in Padua and Venice.

Francesco Squarcione (1397-ca. 1468) is the local leader of the new school and the head of an extensive workshop operating in Padua. Two significant works are attributed to him with certainty. One is the polyptych with St. Jerome, St. Anthony Abbott, St. John the Baptist and two female saints, in the Museo Civico in Padua (executed between 1449 and 1452). The second panel is the Madonna and Child, in the Berlin-Dahlem Museum (signed *Opus Squarcioni Pictoris*), which, like the St. Jerome altar, shows the plastic modeling, the interest in movement of figures (Donatello), and the realistic ornamentation of the Florentines.

Besides Mantegna, and the Venetians already mentioned, a considerable number of minor masters appear to have been assistants in Squarcione's shop.

These include **Ansuino da Forlì**, who, with **Bono da Ferrara** (active ca. 1442-ca. 1461), painted the St. Christopher frescoes (particularly the St. Christopher Preaching and St. Christopher Carrying the Infant Christ, which is signed by Bono) in the Cappella Ovetari

of the Eremitani church in Padua. To Bono also belongs the signed (*Bonus. Ferariensis. Pisani. Disipulus*) panel of St. Jerome in a Landscape of ca. 1451, which is reminiscent of Piero della Francesca as well as of Pisanello, to whom this panel has sometimes been attributed.

Niccolò Pizzolo (active ca. 1421-1453) had been an apprentice in Donatello's workshop as well as in Squarcione's, and had participated in the Eremitani project. His chief and authentic work is the terra-cotta altar of the Madonna and Saints in the church of the Eremitani, Padua.

Marco Zoppo (Marco di Antonio di Ruggero, ca. 1433-1478) was born in Cento, had been apprenticed to Squarcione (ca. 1453), and was active in Bologna and Venice as well as in Padua. Characteristic works are the Pietà panels, in the National Gallery of London and the Museo Civico of Pesaro, and the St. Jerome, in the Pinacoteca Nazionale of Bologna.

Gregorio Schiavone (Giorgio di Tomaso Ćiulinović, 1436/7-1504) was born in Dalmatia and was apprenticed to Squarcione in Padua between 1456 and 1459. In 1462, he is recorded in Zara, and after 1463 he spent most of his time in Sebenico (Dalmatia). His major works reflects the influence of Fra Filippo Lippi as well as of Squarcione, as can be seen in the polyptych with the Madonna and Child (signature on the *cartellino Opus Sclavoni. Disipuli. Squarcioni.S.*) and panels with Saints Anthony of Padua, Bernardinus, John the Baptist, Peter the Martyr, Jerome, Catherine Sebastian and Cecilia, and the Pietà. Also by Schiavone is the signed Madonna and Child with Two Angels panel, in the Berlin-Dahlem Museum, which is the centerpiece of a triptych which was formerly in San Francesco in Padua, while the two wings are now in the cathedral of Padua.

Andrea Mantegna (Andreas Blasii Mantegna, 1431-1506) is the most famous of these pupils, and the most important Renaissance master of northern Italy outside Venice. His style includes much of the formal realism of his Florentine contemporaries, who had contributed considerable new life and vitality to the Paduan tradition, as

well as the Venetian decorative tradition, which is traceable to his father-in-law, Jacopo Bellini, and in turn to Gentile da Fabriano. What is perhaps most significant is that Mantegna represents a closer relationship with classical antiquity than any single painter of his generation.

He was born in 1431 in Isola di Carturo between Vicenza and Padua, and was the son of Biagio Mantegna, who apparently died at an early date, since the son was adopted by Squarcione and entered as apprentice in his shop in 1441. In 1448, he was awarded free citizenship in Padua, and in the same year he executed several of his earliest works, including a lost altar for Santa Sofia, which was signed and his age given at seventeen years. In 1454, he married Nicolosia, daughter of Jacopo Bellini, and two years later he dissolved his contract with Squarcione, to whom he had been bound since 1448. In 1456, he also went to Verona, where he was commissioned to paint a large triptych for San Zeno. At that time, a correspondence began with Lodovico Gonzaga, Margrave of Mantua, who invited him to his court, to which Mantegna agreed on the promise of a title of nobility and a family coat of arms. By 1458, he was on Lodovico's payroll as a member of the household, and in a document of 1459 Lodovico refers to him as *egregium virum Andream Mantegnam pictorem de Padua, carissimum familiarem nostrum, quem ad servicia nostra nuper duximus*, and grants him a family coat of arms, which appears in the dome of the Sant' Andrea Chapel in Mantua. From that time on, he appears to have been steadily in the service of the Gonzaga; in 1463, he was mentioned as a daily guest at the court.

Of the many decorations he executed in the various castles of the Gonzaga, only those in the Bridal Chamber of the Castello di Corte in Mantua remain. He visited Florence in 1466, and the next year was in Pisa on commissions for Lodovico. In 1471, he visited Cardinal Francesco Gonzaga in Bologna, and during the following years was in Mantua in the company of Leon Battista Alberti, Poliziano, and other well-known humanists at the Gonzaga court. Alberti drew up the plans for the church of Sant' Andrea in 1472; at the same time, Poliziano's *Orpheus* was first performed in Mantua. Something of Mantegna's own standing as a scholar and humanist is reflected in a letter written by Cardinal Francesco to his father on the eve of his return to Mantua in 1472, in which he an-

ticipates showing his collection of ancient cameos and bronzes to the Master Andrea. A continued and somewhat conceited interest in worldly wealth and honor is recorded in documents: he uses the titles *eques, miles auratus*, and even *comes palatinus* frequently; he classes himself with Alberti among the greatest scholars and artists in Italy (1478); and after much struggling for funds, he built himself a house in Mantua with *Ab Olympo* inscribed over the entrance to his studio. In 1484, he offered his services to Lorenzo de' Medici but was refused; then, ca. 1488, he was called to Rome by Pope Innocent VIII to decorate a chapel of the Belvedere (destroyed 1780). In a testament of 1504, he willed a sum of money for the decoration of a chapel on his designs in Sant' Andrea, Mantua, which was given him as a family chapel by Cardinal Sigismondo Gonzaga and in which he was buried up on his death, September 13, 1506.

The most important work of Mantegna's early period is the fresco decoration of the Cappella Ovetari (almost completely destroyed by bombs in 1944 and now partially restored) in the church of the Eremitani in Padua. A sum of money was set aside in his testament of January 5, 1443, by Antonio Ovetari, for decorations in his chapel depicting scenes from the lives of St. James and St. Christopher. He died in 1448, and on May 16 of that year the exact directions for the procedure were recorded. Giovanni d'Alemagna and Antonio Vivarini were called to paint the entrance arch and the vaulting (the Four Evangelists in medallions with angels and foliage decorations), which were to be finished by 1450. Giovanni died in 1450 and Antonio apparently discontinued the work, although he received a payment in 1451. The second part, the apse, was given over to Niccolò Pizzolo and Andrea Mantegna. In his absence, Andrea's brother, Tommaso, signed the contract and Niccolò apparently proceeded with the work, since at that time Andrea is recorded at work on commissions for the Santa Sofia altar (1448) and a number of portraits (now lost), including one of Lionello d'Este (1449). Although definitive attribution is difficult, Niccolò's frescoes are probably the God-Father, Saints James, Peter, Paul and Christopher in the vaulting of the apse, the medallions of the Four Church Fathers, and the scenes depicting the Calling of James and Andrew, the sons of Zebedee, and the Preaching of James, as well as the Assumption of the Virgin behind the altar. Payments of smaller amounts began on July 16, 1449, to Andrea,

and it is possible that these last scenes were executed by both artists in collaboration. Thereupon follow, by Mantegna alone, the four scenes on the left wall: the Baptism of Hermogenes by St. James, James Condemmed to Death by Herod Agrippa, James Blesses a Follower on the Way to His Execution, and the Execution of St. James. These appear to have been executed, in that order, from 1449 to 1452. In 1452-1454, Mantegna painted the damaged Martyrdom of St. Christopher and the Removal of his Body on the opposite wall. The two remaining scenes on this wall were painted by Bono da Ferrara and Ansuino da Forlì: the St. Christopher Bearing the Child, reminiscent of Piero della Francesca, was probably done by Bono, and the St. Christopher Preaching by Ansuino. By January, 1457, the entire project was apparently completed.

In the analysis of the style it is significant to note that Squarcione is not mentioned in any of the documents connected with this chapel. His position seems to have been that of a business director of a flourishing shop, rather than its creative leader. The new style appears in the work of **Niccolò Pizzolo** (active ca. 1421-1453) who had been a pupil of Fra Filippo Lippi on the decorations of the Padua Palazzo del Podestà (1434) and had assisted Donatello on the altar of Sant' Antonio (1446-48), and who also was well-acquainted with the Venetian (Vivarini) tradition. This can be seen in the clear and forceful articulation of the medallions of the Church Fathers (somewhat reminiscent of Uccello's prophet heads in the Cathedral of Florence) in comparison with the Evangelist medallions by Giovanni and Antonio da Murano on the vaults (cf. also the iconographical motif of Apostle or Church Father as scholar in his study with those of the Trecento, i.e., Giotto in Padua and Tommaso da Modena in Treviso). A possible relationship of Niccolò's figures in the vaulting to Castagno's frescoes in the Cappella di San Tarasio (1442) in San Zaccaria, Venice, might be noted.

Further points of interest, particularly in Mantegna's frescoes, are the logical development and perfection of the style that can be followed from Giovanni's and Antonio's work through Mantegna's scenes in the chronological order given above; Mantegna's use of perspective as a dramatic means of expression, as well as for the illusion of space similar to the Florentine realists (cf. the similar stage-like architectural design and sharp foreshortening in the mosaic of the Death of the Virgin, in the Cappella dei Mascoli in San Marco,

Venice, and in Jacopo Bellini's drawing of Christ Brought before Pilate, in the Louvre); the adjustment of the perspective in accordance with the room and the spectator's eye level so that, for example, the foreshortened floor of the lower scenes is not shown; the tendency to compose the separate scenes together, which changes, however, from the more decorative method, shown in the balancing of forms and spaces in the earlier St. James scenes, to a more logical and mathematically realistic manner, which can be seen in the unified perspective of the two St. Christopher scenes; the strong classical influence shown in the architectural settings, decorative designs and figure costumes; the tendency toward a realism of action, which can best be noted in such details as that of the executioner of St. James, whose coat rips as he swings his mallet, or the soldier pushing the crowd with his spear.

During the period between the Ovetari frescoes and those of the Camera degli Sposi in Mantua, Mantegna executed some of his finest altarpieces. The first is the St. Luke altar, in the Pinacoteca di Brera, representing St. Luke Enthroned at His Lectern, the Pietà with St. Mary and St. John above him, and half-length figures of Saints Daniel of Padua, Jerome, Augustine and Sebastian on the upper row, while standing figures of Saints Scholastica, Prosdocimus, Benedict and Justina of Padua are on the lower level in separate panels on either side of the studious St. Luke. The panel was contracted for by the monks of Santa Giustina in Padua, finished and paid for on November 18, 1454. Its style is close to the traditional form of the Venetians (cf. the 1450 altar of Antonio and Bartolomeo Vivarini in Bologna, originally in San Francesco in Padua); the figure of St. Justina at the right, however, has a monumental dignity which might well have been inspired by classical models.

The famous San Zeno altar, which is in its original location in the church of San Zeno in Verona, was contracted for by the Papal Protonotary Gregorio Correr, probably as early as 1455, and may have been the cause of Mantegna's legal difficulties with Squarcione, which ended in the breaking of his apprentice agreement with his teacher through a Venetian court on January 2, 1456. After some pressure from Lodovico Gonzaga, who wanted him in Mantua, the altar was finished in 1459. Represented is the Madonna Enthroned with four saints on either side: Saints Peter, Paul, John the Evangelist and Augustine on the left, and Saints Benedict, Laurence,

Zeno and John the Baptist on the right. Three predella scenes are in the Louvre (the Crucifixion) and in the Musée des Beaux Arts in Tours (Christ in Gethsemane and the Resurrection) and have been replaced on the altarpiece by copies. The triptych is significant in being another early attempt to organize the traditional three-or-more-piece altar form with the enthroned Madonna and separate saints into a compositional unit. As such, it affords an interesting comparison to related altarpieces, such as Domenico Veneziano's St. Lucy altar, in the Uffizi, and Fra Filippo Lippi's Barbadori altar, in the Louvre, as well as to the bronze and marble high altar executed by Donatello for the church of Sant' Antonio in Padua just a few years earlier.

The idea had already been developed by Mantegna in the Eremitani frescoes, was not used in the St. Luke altar, and is achieved here through the recession of the saints in rows on either side toward a center point in the background, and by the elaborately decorated architecture with its classical reliefs and continuous landscape showing between the piers. The unified composition of figures around the enthroned Madonna suggests the theme of the *sacra conversazione*, which became particularly popular in the second half of the century. Remarkable here is the difference in the linear clarity, the heavy ornamentation, the brightness of the gold and color, and the hard and minutely detailed local coloration as opposed to the soft and even tone of Giovanni Bellini's altars (i.e., that in the Frari church) by which the devotional mood of such a ''sacred conversation'' seems more adequately conveyed. The composition of the predella scenes has much of the monumental effect of the Eremitani frescoes, in spite of the small format required by their position on the altar (cf. also the similarity in many of the detail motifs as well as the general composition, particularly in the St. James scenes).

Out of this group developed a series of panels which have been variously dated as belonging to this same period or extending over a number of years. Among these are the St. Sebastian, in the Kunsthistorisches Museum, Vienna, signed in Greek on the pier at the left, TO EP Γ ON TOY AN Δ PEOY. as a work of Andreas (ca. 1458); the St. George, in the Accademia of Venice (ca. 1468); the portrait of Cardinal Lodovico Mezzarota, in the Berlin-Dahlem Museum, which was painted in Mantua, probably at the time of the Council of Pope Pius II held in that city, 1459-1460; and the Christ

in Gethsemane, in the London National Gallery (ca. 1470), signed *Opus Andreae Mantagna*, which is based on one of the drawings in Jacopo Bellini's sketchbook and which is related to the same subject on the San Zeno predella (cf. also Giovanni Bellini's Gethsemane scene). Because of its simpler composition and the more restricted use of space, this last Gethsemane has frequently been interpreted as an early work, i.e., before the San Zeno predella, possibly as early as 1450.

The frescoes of the Camera degli Sposi in the Palazzo Ducale of the Gonzaga in Mantua were probably begun shortly after his return from Florence and Pisa in 1468; and, from the inscription held by the putti over the doorway, the work was finished in 1474. The room is rather small and square, with a flat vaulted ceiling. On the wall over the fireplace are represented the margrave, Lodovico Gonzaga, seated with his wife, Barbara, and members of his household, including his secretary at the left (supposedly Marsilio Andreasi), to whom he turns with a letter, his sons, Cardinal Francesco (the portly figure to the right), Gian Francesco (standing behind Barbara), and Rodolfo Gonzaga (standing before the pier in the center). About the mother are grouped the younger children, including the eldest daughter, Susanna (a cripple); behind her stands the handsome Dorothea; a child with the apple (Paola) leans on her lap at the left, and the youngest son, Lodovico (who was named Bishop of Mantua by Pius II), stands in front of Cardinal Francesco.

One chief significance of the fresco is the fact that it is a group portrait representing the proud members of a bourgeois-noble family in a manner historically paralleled by the group portraits of Florentine families painted by Benozzo Gozzoli (Medici Chapel), Botticelli (Adoration of the Magi) and Ghirlandaio (Santa Trinità), as well as Melozzo's group portrait commemorating the appointment of Platina (in the Vatican Pinacoteca). The fresco to the left on the entrance wall has a connotation similar to Gozzoli's Medici Chapel in its representation (without religious content, however) of the meeting of the father, Lodovico, and his son, Cardinal Francesco of Bologna, on the occasion of the latter's return from Rome to Mantua on August 24, 1472. Included in this scene are the portraits of Gian Francesco again (profile between Lodovico and Francesco), the young Lodovico, whose hand is held by the Cardinal, Federigo Gonzaga, at the extreme right, and, supposedly, a self-portrait of

Mantegna, second from the right. The profile to the left of Mantegna (i.e., third from the right) is assumed to be Angelo Poliziano, and the next one, in front of the tree, Leon Battista Alberti. A third scene, on the other side of the door, represents the hunting train of Lodovico (cf. the same theme in Gozzoli's fresco).

While some of the frescoes are badly damaged, it is interesting to note the decorative continuity of the landscape background, such as that on the entrance wall, and especially the coloristic unity of the walls. The general tone is a rich and luminous green-red-gold combination, similar in effect to a tapestry, an all-over pattern against which the heavy forms are plastically modeled. The color does not have the shining transparency of true fresco, as is characteristic of the contemporary Florentines, but appears to be heavily overpainted *a secco*, in an attempt at a greater richness of coloration, in the tradition of the Venetians.

The ceiling of the room is elaborately decorated in grisaille with many garlands, classical motifs and, especially, a series of eight medallions held by putti containing bust portraits of Roman Emperors. In the center of the vault is the famous dome decoration, with its foreshortened balustrade, illusionistic sky and figures of putti and women peering down into the room over it (cf. the decorative form as a development of that noted on the vaults of the Ovetari Chapel; also the later attempts, i.e., 1477/8 and 1480, by Melozzo and Signorelli in Loreto). In the history of ceiling and vault decoration, this is the first attempt to exploit the new experiments in illusionistic perspective and its unified composition on the ceiling as well as on the walls of a room.

A famous canvas related to this ceiling decoration, and done about the same time (though kept in the artist's possession until his late years), is the Pietà, in the Pinacoteca di Brera in Milan. Its extraordinary foreshortening and restrained coloration (painted in tempera) are related to the foreshortened putti on the balustrade of the ceiling fresco. Its remarkable realism and powerful effect may be associated with the dramatic use of perspective noted among the Florentine experimentalists, as well as with Mantegna's own frescoes in the Ovetari Chapel.

A third large project, which is one of the most striking examples of the Renaissance interest in antiquity from a decorative point of view, is the series of nine cartoons of the Triumph of Caesar,

now in the Hampton Court Palace. These cartoons (paper on canvas) were probably begun in 1482. Their execution was interrupted by the trip to Rome in 1488-90, and they were completed in 1492, when they were hung up on the walls of the theater, the Camera dei Trionfi of the Castello Corte, and framed by painted pilasters, probably in the manner of the fresco decorations in the Camera degli Sposi. The crowded, tapestrylike form of decoration of the cartoons is related to that of these frescoes. In 1494, Isabella d'Este, wife of Gianfrancesco Gonzaga, is known to have shown the decorations to Giovanni de' Medici in the same theater. Later (1506) they were removed to a newly built palace near the church of San Sebastiano by Gianfrancesco. In 1629, they were purchased from the Duke of Mantua by King Charles I of England.

The theme, which was probably chosen by the patron rather than by the artist, is a reflection of the popular fashion of triumphal processions and festivals which was noted in Florence as part of the inspiration for Gozzoli's Medici Chapel decorations. As such, it is pagan and decorative rather than religious (cf. the fact that while the Medici representations were for a chapel, these were for a theater and are likewise done at a later date, almost parallel to the Savonarola revolution). The theme is perhaps more directly comparable to Florentine *cassoni* paintings, inspired as they are by both classical literature and decorative friezes (cf. the frequent appearance of classical triumphal processions as well as the more traditional and Gothic theme of the hunting parade). The sources here are not in the classical decorative motifs alone, but also in such literary descriptions as those of Suetonius (*Lives of the Caesars*) and Appian (*Triumph of Scipio*).

A closer study of the separate scenes of the series will show a division in style between the first three and the last six, which is probably due to the interruption of his two-year stay in Rome. The later scenes show a definite influence of the Roman environment in the introduction of new motifs (e.g., Trajan's Column and the triumphal arch), as well as a clearer and more spacious composition of figures.

The most important late work is the decoration of Isabella d'Este's (the wife of Gianfrancesco Gonzaga) *studiolo* in the Castello, for which she had already begun to collect the separate canvases before 1497, when Mantegna's Parnassus was probably

finished. Then followed the Triumph of Virtue over Vice, and the Triumph of Comus and Mercury, which was begun by Mantegna and finished by Lorenzo Costa. Others included the canvas by Perugino, and lost ones by Costa and Correggio. These canvases, especially the Parnassus and Triumph of Virtue over Vice (now in the Louvre), are interesting not only as iconographical parallels and a remarkable contrast in form to Botticelli's mythological scenes, but also as reflecting the common stylistic changes at the end of the century, namely, the subordination of figures to the space, a tendency toward a more atmospheric coloration, and a new emphasis on the movement of figures.

Many of the same features may be observed in other late works. The atmospheric quality of the color is evident in the decorations which Mantegna designed for his own burial chapel in the basilica of Sant' Andrea in Padua. Of these, the Holy Family was painted by his own hand (1505/6), while the Baptism of Christ and the four figures of the Evangelists were completed (1516, according to the inscription) by pupils, after his designs.

The grisaille canvas of The Triumph of Scipio (the Introduction of the Cult of Cybele at Rome), depicting the arrival of the goddess at Rome and welcome by Claudia Quinta and Scipio, was commissioned by Francesco Cornaro (who claimed to be a descendant of Scipio) some time before 1505, and must have been finished before he died, in 1506. The general scheme and many of the details have much in common with the Triumph of Caesar series, but show an increased interest in the movement of figures and the use of light and shade to strengthen the friezelike high relief.

The Madonna della Vittoria, in the Louvre, was promised as a vow by the *condottiere* Francesco Gonzaga, on the occasion of his battle with the French, under Charles VIII, at Fornovo, in 1495, and finished on the first anniversary of that victory, July 6, 1496. Of iconographical interest is the imploring attitude of the kneeling warrior, in contrast to the traditional rigidity of a votive portrait, and the friendly gesture of the Madonna in answer to him. This, together with the movement and gestures of the other figures, and their composition into a unifying pyramidal form (cf. Leonardo da Vinci's Adoration of the Magi in the Uffizi), is already a part of the typical sixteenth-century style (cf. Titian's Pesaro Madonna, Correggio's Madonna with St. Francis, in Dresden).

Mantegna's copper engravings are of particular interest, for the general development of Renaissance art, as a parallel to Antonio Pollaiuolo, and for the understanding of Mantegna's own style, in that they show the masterful energy and clarity of his draughtsmanship. A considerable number are attributed to him or his followers. The best known, and generally conceded to be executed by his own hand, are the two Bacchanals (one with the wine vat, the other with Silenus) and the two Battles of Sea Gods (one with the tritons, the other with sea-centaurs), which were probably executed about the same time as the Triumph of Caesar decorations (i.e., in the 1480s), to which they are stylistically related (cf. Pollaiuolo's engraving of Battling Nudes). To the later period belong, largely on the basis of the greater technical perfection of the work, the Resurrected Christ between St. Andrew and Longinus, and the famous Entombment. The figure of St. John, in the latter, is taken from the Crucifixion scene of the San Zeno predella, now in the Louvre, which indicates the persistence of certain stylized motifs often over a long period of years.

8. Verona

LIKE PADUA, VERONA was annexed to Venice in 1405, after the short rule of the Milanese under Gian Galeazzo, and its subsequent history, like that of most of the other surrounding cities, follows that of Venice.

Stefano da Zevio (Stefano da Verona, ca. 1375-ca. 1450) represents the transition from the late Trecento to the early Quattrocento in a flourishing tradition based on the school of Altichiero. His style has many of the characteristics of the International Gothic, but while it continues the tall Gothic proportions and the graceful curvature of figure and drapery, it also manifests a tendency to model the forms and give them a renewed life and naturalistic expression. Details are chosen for their romantic, lyric associations, and are executed with a miniaturist's delicacy that is related on the one hand to the lyric decorative art of Gentile da Fabriano, and on the other to contemporary French or Flemish miniatures (cf. also Giovanni d'Alemagna).

The chief works of Stefano are the fresco Madonna with Saints Anthony Abbott, Bartholomew, John the Baptist and Isaiah, in the lunette over the outside portal of San Giovanni in Valle, Verona, which appears to be early and still strongly under Altichiero's influence. The Madonna with the Carnation, surrounded by Adoring Angels, in the Galleria Colonna of Rome, has many Gentile da Fabriano characteristics. The dated (1435) Adoration of the Magi, in the Pinacoteca di Brera, Milan, is generally considered his most important and authentic work, whose design and detail seem related to French miniatures. Finally, there is the delicate Madonna in the Rose Garden (Madonna del Roseto), formerly in the convent of San Domenico, now in the Museo Civico of Verona, whose color and

mystic mood seem reminiscent of Northern painting (e.g., the School of Cologne).

Pisanello (Antonio do Puccio Pisano, ca. 1395-1455) is the greatest master of the school of Verona. As a representative of the lyric-Gothic style of the earlier Quattrocento, and in his many-sided activity in the principal art centers of Italy, he is both a parallel and a successor to Gentile da Fabriano.

He was born in Padua, the son of a cloth-maker named Puccio di Giovanni di Cereto, who had originally come from Pisa and later lived in Verona; there, Pisanello received his early training, in the tradition of Altichiero, possibly from Stefano da Zevio. In 1415, he is recorded in Venice, and between 1420 and 1424 he executed the fresco of Otto before the Emperor Frederick Barbarossa, in the Sala del Gran Consiglio of the Palazzo Ducale (destroyed in 1577), where Gentile had also painted his Naval Battle of the Venetians against Otto III. His subsequent activity as a decorator and medallist took him to most of the principal cultural centers of Italy besides Verona. He was in Mantua in 1422. In 1425, he is recorded in the service of the Gonzaga. From 1431-1432 he was at work in Rome, completing the frescoes of scenes from the Life of St. John the Baptist, in San Giovanni in Laterano, which were begun by Gentile. In 1435, he gave a portrait of Julius Caesar to Lionello d'Este at Ferrara and is recorded there again in 1438/9, when he had occasion to execute the portrait medallion of the Byzantine Emperor John Palaeologus. In 1439, he was again with the Gonzaga; the next year, he is recorded in Milan. In 1441, he competed with Jacopo Bellini in executing a portrait of Lionello d'Este, wherein Bellini was successful. About 1445, he executed lost frescoes in the castle of Mantua. In 1447, he was in Rimini, and the next year he was called to Naples and the court of King Alfonso. In between, he is recorded, at various times, in Verona, especially in the years 1433 to 1438.

Aside from his activity as a medallist, which seems to have been his chief calling at the ducal courts, there are a few works extant which show the remarkable combination of a close observation of nature, an almost poetic romantic spirit, some of the Gothic decorative stylizations, and also many of the Renaissance problems of modeling and figure foreshortening. Most of the work is done in the second quarter of the century, and would broadly parallel the

Gentile-Fra Angelico-Gozzoli group flourishing in Florence at about the same time.

Although the Madonna Enthroned, in the Palazzo Venezia, Rome, is often attributed to him, Pisanello's earliest certain work, which has also been attributed to Stefano da Zevio and is certainly related to his style, is the Madonna della Quaglia (Madonna of the Quaoi), in the Museo di Castelvecchio in Verona. A second is the fresco Annunciation over the Brenzoni tomb in San Fermo, Verona, probably done in the period immediately before the trip to Rome, possibly as early as 1425. Of particular note are the tall and graceful Gothic proportions of the figures, the realistically tender resignation of the Virgin in Her pose and gesture, and the addition of nature details reminiscent of Northern miniatures. The fresco over the entrance arch to the Cappella Pellegrini in the church of Sant' Anastasia in Verona (now in the Museo di Castelvecchio) depicts the story of St. George and the Princess, and is interesting iconographically in that it ignores the dramatic possibilities (i.e., St. George Killing the Dragon) in favor of a romantic genre scene which, in spite of its many-figured composition, is given a certain quiet monumentality reminiscent of Piero della Francesca's later frescos in Arezzo. The crowding of the forms and the detailed ornamentation are related to Gentile (cf. the Uffizi Adoration of the Magi); the profile figure of the princess has a particular though somewhat more worldly elegance, comparable to Domenico Veneziano's St. Lucy or the female figures by Piero in the Arezzo series.

A large number of Pisanello's drawings have been preserved, particularly those of the *Codex Vallardi* in the Louvre. They are remarkable for the vitality of their execution as well as for the sensitive and detailed observation of nature, which is an interesting contrast to the more compositional and theoretical point of view reflected in the drawings of Jacopo Bellini. Particularly of note are the detailed studies of the head of the Princess, the ragged and decomposed hanged men (the *impiccati*), the oriental figure and head types, and the equestrian studies.

At about the same time (i.e., before 1438), he painted the Vision of St. Eustace, now in the London National Gallery, with its Uccello-like, brightly shining mounted figure before a dark forest interior filled with animals in the manner of Northern tapestries or miniatures. Also in the National Gallery is the late work represent-

ing Saints Anthony Abbot and George and the Vision of the Madonna between them, which is inscribed *Pisanus Pi* and was painted ca. 1447/8.

Among the various portraits attributed to Pisanello are those of Ginevra d'Este (Louvre, Paris), Lionello d'Este (Accademia Carrara in Bergamo), the Emperor Sigismondo (Kunsthistorisches Museum, Vienna) and the Portrait of a Lady now in the National Gallery in Washington. The numerous cast medals, usually inscribed *Opus Pisani Pictoris*, are significant documents of Renaissance "famous men," such as those of Filippo Maria Visconti (Castello Sforzesco in Milan), Lionello d'Este and John Palaeologus (Cabinet des Médailles in the Bibliothèque Nationale of Paris) and those of Alfonso of Naples. Most of these were executed between 1438 and 1448/9.

Francesco Benaglio (ca. 1432-ca. 1492) is one of a number of minor Veronese artists of the second half of the fifteenth century who represent a stylistic development parallel to that of the Venetian school and are dependent largely on Mantegna and the Vivarini. His large altar of the Madonna and Saints, in the choir of San Bernardino in Verona (1462), is a coarse variation of Mantegna's San Zeno altar.

Francesco Bonsignori (ca. 1455-1519) combines stylistic elements of Mantegna and Alvise Vivarini, as can be seen in the 1484 Madonna and Saints, now in the Museo di Castelvecchio of Verona, and the late (1519) altar with the Martyrdom of Saints Blaise and Juliana, in the church of SS. Nazaro e Celso in Verona.

Domenico Morone (1442-ca. 1518) was a pupil of Benaglio and is best known for his more historical scenes in the manner of Jacopo and Gentile Bellini, such as the Battle of the Gonzaga and the Buonacolsi, dated 1494, in the Palazzo Ducale of Mantua, and the fresco decoration of the chapel of St. Anthony in San Bernardino, Verona, with scenes from the life of St. Anthony, dated 1503.

Francesco Morone (1474-1529) is the son of Domenico, and tends toward a more emotional and decorative elaboration of these forms (cf. the Crucifixion of 1498, in San Bernardino, Verona; the Madonna and Saints altar of 1503, and especially the sacristy frescoes, of later

date, in Santa Maria in Organo, Verona, representing the ascending Christ and half-figures of Popes and Olivetan monks).

Giovanni Maria Falconetto (1458-1534), an architect as well as a painter, is interesting for his highly decorative style somewhat in the manner of the Umbro-Tuscan painters (Melozzo), as can be seen in the decorations (1493) of SS. Nazaro e Celso in Verona, and the panel with Augustus and the Tiburtine Sibyl, in the Museo di Castelvecchio of Verona.

Liberale da Verona (ca. 1445-ca. 1526) is the most dramatic and baroque of this late group developed on the basis of Mantegna. He began as a miniaturist in Verona, then worked from 1467 to 1476 in Siena at the Cathedral and Monte Oliveto, and later in Florence and Venice. He appears to have been back in Verona after 1492. Characteristic of him are the Pietà, in the Alte Pinakothek of Munich (1489), the Adoration of the Magi, in the Cathedral of Verona, and the Death of Dido, from Virgil's *Aeneid* (ca. 1494), in the London National Gallery.

9. Vicenza

DURING THE FOURTEENTH CENTURY, Vicenza had freed itself from the rule of Padua only to be taken over by the Scala family of Verona and then in turn by the Viconti of Milan. With the death of Gian Galeazzo, the city was annexed by Venice, and remained consistently a part of the Venetian republic, in spite of the claims of Emperor Sigismund to the city and the desultory war waged over its possession by Venice and the Emperor during the fifteenth century.

Battista da Vicenza (active 1404-1437/8) is the first of the fifteenth-century painters in Vicenza who developed largely under the influence of Altichiero (i.e., the polyptych of Sant' Agostino of 1404, that of San Giorgio di Velo d'Astico of 1408, and the Madonna and Child of 1412, in the Museo Civico of Vicenza).

Bartolomeo Montagna (ca. 1450-1523) is the greatest master of the new style which developed in the second half of the Quattrocento under the influence of the Venetians. He appears to have been active, in his early years, in Verona, Padua and Venice, and his style reflects the influences of the leading masters in those cities, namely Mantegna, Gentile and Giovanni Bellini, and possibly Alvise Vivarini. By 1490, he is referred to as a *celeberrimus pictor* and, after 1496, is recorded regularly in Vicenza. The development of his style parallels, in a general manner, the evolution already followed in the work of his Venetian contemporaries, and can be seen in a number of his dated altarpieces: the Madonna with St. Sebastian and St. Roch, of 1487, in the Accademia Carrara in Bergamo, the Christ Appearing to Mary Magdalene, of 1492, formerly in the church of San Lorenzo in Vicenza and now in the Berlin-Dahlem Museum, the Pietà, of 1500, in the basilica of Monte Berico near Vicenza, the Madonna and Saints (1499), in the Pinacoteca di Brera, Milan, and the late Madonna with Saints, in Santa Maria in Vanzo, in Padua.

Giovanni Buonconsiglio (called Marescalco, active ca. 1495-1537) is one of a number of younger followers of Montagna in Vicenza who is also closely associated with the Venetians in style. His work reveals an increased interest in softer coloration, in smaller figures, and a slightly manneristic enlivenment of the figure compositions, largely under the influence of Giorgione (cf. the earlier Pietà, in the Museo Civico of Vicenza; the altar representing St. Sebastian with St. Roch and St. Laurence, in the church of San Giacomo dell' Orio, Venice; Christ with St. Jerome and St. Liberalis, in Santo Spirito, Venice; and the Assumption fresco, in the Cathedral of Montagnana).

10. Milan

THE DEATH OF GIAN GALEAZZO VISCONTI in 1402 brought about the near breakup of the duchy of Milan. The weak rule of his two sons, Giovanni Maria and Filippo Maria, who succeeded him, paved the way for the rise of the Sforza family. The great *condottiere* Francesco Sforza married Bianca, the daughter of the last Visconti, Filippo Maria. Upon the latter's death in 1447, a republican government was set up, the so-called Golden Ambrosial Republic. This lasted only until 1450, when Sforza, who had been given the post of *condottiere*, took control of the duchy, and his title of Duke was confirmed that same year at the Peace of Lodi. Of the Sforza dynasty, Francesco and Lodovico il Moro are the most outstanding. The latter ruled for the boy heir, Gian Galeazzo, and dispossessed him in 1480. Lodovico's marriage to Beatrice d'Este (1491) marked the beginning of a splendid court rivaling those of Mantua, Florence and the other famous centers of culture. The place of Bagnolo with Venice, Naples and Florence, in 1484, had brought an interim of peace and material prosperity.

In 1493, Milan and Venice supported Charles VIII of France against Naples, and in 1494, Lodovico, now Duke after the death of Gian Galeazzo, encouraged the French invasion of Italy. He then joined the new alliance made by Pope Alexander VI against the French, but ended by making a separate peace with Charles. His treachery to both parties was repaid in 1498, when a new French invasion under Louis XII forced him to flee to Germany. Lodovico was restored in 1499, but only briefly, for with the return of the French, he was captured and taken to France, where he died in 1508.

Michelino da Besozzo (Michelino Molinari da Besozzo, active 1394-1442) is one of the few names recorded in Milan during the early fifteenth century in what appears to have been a flourishing

local school, drawing artists from the provincial towns of Lombardy and from northern France and Flanders or the lower Rhine. They were active on miniatures and tapestry decorations associated with the ducal courts, as well as on the building and decoration of the Milan cathedral. Michelino is recorded at work in Milan, between 1394 and 1442, on frescoes, miniatures and stained glass, but few actual works are definitely attributable to him. One, however, is the small Late-Gothic altar with the Madonna and Saints Catherine, Anthony and John the Baptist (The Marriage of St. Catherine), in the Siena Pinacoteca, which seems related to Stefano da Zevio as well as to the German School of Cologne. A badly damaged fresco in the Palazzo Borromeo in Milan, sometimes ascribed to Michelino, suggests something of an elegant, courtly style, with its narrative-romantic content and intimate observations of nature associated with northern tapestries and parallel, in a provincial way, to the school of Verona (cf. Pisanello's frescoes in Sant' Anastasia).

Leonardo da Besozzo (active 1428-1488) is the son of Michelino, and continued this style in Naples, as seen in the Coronation fresco in the Caracciolo Chapel in San Giovanni a Carbonara in Naples (1428).

The **Zavattari** family (**Cristoforo**, recorded 1404-1407; **Franceschino**, 1417; **Ambrogio**, 1456-59; **Gregorio Di Franceschino**, 1479) is known particularly for the elaborate fresco decoration of the chapel of Queen Theodolinda in the Cathedral of Monza, depicting some thirty scenes from the legend of Queen Theodolinda. Most of the work was done ca. 1444 in the manner of Michelino and Pisanello.

Vincenzo Foppa (ca. 1427-1515) might be considered the founder of the Milanese school and a parallel to Andrea Mantegna and Giovanni Bellini in the development of the Quattrocento style. He was born in Brescia, may possibly have worked in the shop of Squarcione in Padua, and is recorded, at various times, in Pavia, Genoa, Milan and Brescia. His earliest dated work with a signature (*Mensis Aprilis Vincencius Brixensis pinxit*) is the Crucifixion of 1456, in the Accademia Carrara, Bergamo, which shows a Mantegnesque emphasis on an architectural frame and a dramatic twist to the

figures, but also a fantastic and atmospheric landscape background which seems vaguely reminiscent of the miniature tradition of Flanders (Van Eyck). A more monumental form is developed in later works, such as the fresco Martyrdom of St. Sebastian, and the Madonna with Saints John the Baptist and John the Evangelist of 1485 (both frescoes in the Pinacoteca di Brera, Milan). The late Pietà, in the Brera, combines Foppa's somewhat melancholy pathos with dramatic action in a manner particularly characteristic of the late Quattrocento (cf. the same theme as represented by Mantegna, Botticelli, Perugino).

The curious combination of these elements of solidly composed and clearly drawn figures, their action, and the colorful use of architecture and landscape in the backgrounds with a distinctly Lombard character, is seen in the frescoes representing scenes from the Life of St. Peter the Martyr, particularly St. Peter Healing a Young Man and the Martyrdom of St. Peter, in the Cappella Portinari in the church of Sant' Eustorgio, in Milan. The chapel was designed in 1462 by Michelozzo, so that the frescoes were probably executed a short time thereafter.

Bernardino Butinone (ca. 1436-1507) who came from Treviglio, is a contemporary and possibly a student of Foppa's; his most important works, painted in collaboration with Bernardo Zenale, are the polyptych of 1485, in the church of San Martino in Treviglio, and frescoes of scenes from the Life of St. Ambrose, in the Cappella Griffo of San Pietro in Gessate, Milan (1492/3). Butinone's own character can be seen in the solid and clearcut forms of the Madonna and Saints altar, in the Palazzo Borromeo of Isolabella, as well as in the triptych (1484) of the Madonna with Saints Bernardinus and Vincent, in the Pinacoteca di Brera.

Bernardo Zenale (ca. 1436-1526) also came from Treviglio and was active as an architect in Bergamo and on the Cathedral of Milan, as well as being a painter. The Treviglio polyptych with the Madonna, the Resurrection and Saints, which he painted with Butinone, shows some differences in execution: the Madonna figure, those of St. Martin and the Beggar, St. Anthony, and St. Paul reveal the bright colors, the sharply contrasting patterns and the separation of figures from the surroundings, which are attributed to Butinone. Other

figures, such as those of St. George, St. Catherine, and St. Mary Magdalene, are less wooden and more unified through the restrained use of color and light. More distinctly his own is the triptych with the Madonna Enthroned, in Sant' Ambrogio in Milan (1494). In general, the styles of both artists, as they evolve, show the common problems of combining plastic form, the illusion of space and the rich decoration noted among the contemporary Quattrocentists of the other schools. The solutions attempted by this group follow their own development, then become affected by the new art of Leonardo da Vinci and his circle, which flourished under Lodovico's patronage during the last quarter of the century.

Borgognone (Ambrogio di Stefano da Fossano, called Bergognone or Borgognone, ca. 1445-1523) is another pupil of Foppa who begins with a very hard and unarticulated, yet lyrically inspired style in his early work and develops to a slightly more lively expression, using the active gestures, movement of figures and atmospheric effect still relatively independent of Leonardo and the Cinquecentists. He was active chiefly in Milan, and in 1488-1495 is recorded at work in the Certosa di Pavia. The more significant of his altarpieces include: the Madonna Enthroned with Saints and Kneeling Donor, ca. 1480, in the Pinacoteca Ambrosiana of Milan, and several altars now in the London National Gallery (the two panels of a triptych dated 1501, with Christ in Gethsemane, and Christ Bearing the Cross, and the Madonna with Saints Catherine of Alexandria and Catherine of Siena, which came from the Certosa di Pavia). Also in the National Gallery are two smaller Madonna and Child panels, an early one of ca. 1480 and a later altar of ca. 1488, which shows a recognizable Certosa buildings in the background.

The late fresco of the Coronation of the Virgin, in San Simpliciano, Milan, and the detached fresco of the same subject from the apse of Santa Maria dei Servi of Milan, now in the Pinacoteca di Brera, show a remarkably soft and luminous color quality.

Vincenzo Civerchio (ca. 1470-1544) is another of Foppa's pupils who carried on his style in Brescia (cf. the Pietà of 1504, in Sant' Alessandro, Brescia; the Annunciation, and the St. Francis altar in the Accademia Carrara, Brescia).

Andrea Solario (ca. 1460-ca. 1522) is one of a younger generation more closely associated with Alvise Vivarini and the influence of Antonello da Messina than with the older Foppa group, and hence is stylistically more compatible with the art of Leonardo. He appears to have been a pupil of his brother, the architect and sculptor Cristoforo Solario, with whom he went to Venice before 1495. By 1496, he was back in Milan, and was active on local commissions as well as on outside calls, notably the decorations of 1507-1509 in the castle of Gaillon in Normandy, for Cardinal George of Amboise (lost). An early dated work (1405) in the Pinacoteca di Brera represents a half-length Madonna with Joseph and St. Jerome in the general manner of Alvise, and was originally painted for San Pietro Martire in Murano. The color and modeling are suggestive of Antonello. The half-length Christ, in the Cook Collection in Richmond, is also modeled after Antonello. The signed (*Andeas D. Solario. f.*) and dated portrait of Giovanni Cristoforo Longono (1505), in the National Gallery, London, is a remarkable development of Antonello's directness of character portrayal toward the more freely composed manner of the High Renaissance under Leonardo's influence. His earlier portrait of a Man with a Pink, also known as A Venetian Senator, comes from the Venetian period, possibly even before the Murano altar, and has a definite Antonello-Flemish character. The later work shows a greater emphasis on the movement and unified composition of figures, a greater emotional appeal through light and color, as seen in the Madonna of the Green Cushion, in the Louvre, and the Rest on the Flight into Egypt, of 1515, in the Museo Poldi Pezzoli, Milan.

Bramantino (Bartolomeo Suardi, ca. 1470-1536) might be considered the last of the Milanese Quattrocentists in that, while the major part of his activity is in the sixteenth century, his style is, in principle, still bound by the previous tradition and represents a romantic and somewhat manneristic phase parallel to that in Florence and Rome. He was originally a pupil of Butinone in Milan, then came under the influence of the Umbrian architect, Donato Bramante (hence the name ''Bramantino''), who had been active in Bergamo in frescoes of Famous Men in the Palazzo del Podestà (ca. 1477) as well as on other fresco decorations and architectural

designs in Milan (note the fresco fragments of Democritus, Heraclitus and several other figures in the Brera, formerly in the Casa Panigaroli, in Milan). He remained in Milan until about 1508, when he was active in Rome, probably called through Bramante's influence, on decorations for the Vatican. By 1513, he was back in Milan, and in 1525 was named court painter and architect by Francesco Sforza II. The Adoration of the Child, in the Pinacoteca Ambrosiana of Milan, is an early work (before 1500), related to the style of Butinone; likewise, the Philemon and Baucis, in the Wallraf-Richartz Museum of Cologne. During the period after the departure of Leonardo from Milan and before he left for Rome, Bramantino executed a number of fresco projects (e.g., the ruined frescoes in Santa Maria delle Grazie) and cartoons for tapestries of the Months of the Year (new in the Castello Sforzesco of Milan). One of the most characteristic works after his return from Rome is the Crucifixion (ca. 1518), in the Pinacoteca di Brera, which shows a peculiar mathematical stiffness in perspective and foreshortening, as well as a curious romantic mood, expressed through the subordinated proportions of figures to the space, the detailed, almost Flemish landscape in the background, and the luminous atmospheric coloration. Other late works are the Flight into Egypt, of 1522, in Santa Maria del Sasso in Locarno, and the Madonna with Saints, in the Pinacoteca Ambrosiana, Milan.

11. Ferrara

FERRARA HAD BEEN NOMINALLY RULED by the Este Family as early as the twelfth century. In 1329, the house was formally invested with the city by the Pope, and developed into one of the most important in Italy during the fifteenth century. Niccolò III became Margrave in 1441, and in 1470, Borso was created Duke by Pope Paul II. In 1482, Pope Alexander VI attacked Duke Ercole I, hoping to secure Ferrara for his nephew, but the intervention of Naples prevented his success. Ferrara continued to flourish, with an excellent financial system which allowed great expenditure in the support of a princely and sumptuous court. Friendship between the Sforza, Medici, Estensi and Aragonese families provided a powerful alliance against Venice. The Peace of Bagnolo in 1484 produced an interval of peace which aided the development of cultural and artistic activity at the court of the Estensi, as it did for the other great families during that period.

Cosimo Tura (also called Cosmè, ca. 1430-1495) is the first important master of the Ferrara school, which is closely associated with the patronage of the court and is stylistically under the influence largely of Mantegna and Piero della Francesca. He was born in Ferrara and probably worked in the shop of Squarcione in Padua. He is recorded in Ferrara from 1451 on, receiving a regular salary as court painter to the dukes Borso and Ercole I. In the sharp linear modeling of figures and the clear definition of space, based on the work of the Squarcione shop, he is a parallel to Mantegna; in the distortion of forms, however, and the more nervous and agitated design, he is much more related to the dramatic expression of Crivelli.

A number of altarpieces reveal his characteristic handling of the common stylistic problems of his generation. These include: the

Madonna with Saints Jerome and Apollonia, from Santa Maria della Consolazione (ca. 1462), in the Musée Fesch of Ajaccio (Corsica); the St. Maurilius altarpiece (ca. 1470), from San Giorgio fuori le Mura, Ferrara, of which two tondi representing the Condemnation and Execution of St. Maurilius are in the Pinacoteca of Ferrara (the probable appearance of the lost central panel, with the standing figure of St. Maurilius and two kneeling donors, is to be seen in a woodcut from the *Leggenda de Sancto Maurelio*, Ferrara, 1489); the Roverella altar, also from San Giorgio fuori le Mura, with the Madonna Enthroned and Music-making Angels and Tables of the Ten Commandments in Hebrew (ca. 1474), in the London National Gallery, to which belong the panel of Saints Paul and Maurilius with the kneeling Nicolò Roverella, in the Galleria Colonna, Rome, wht fragment of St. George, in the San Diego Fine Arts Gallery, and the lunette with the Pietà, in the Louvre of Paris; that of St. Anthony of Padua, from San Nicolò in Ferrara (1484), now in the Galleria Estense in Modena; the lost polyptych from San Luca in Borgo near Ferrara (from which there are two panels of St. Christopher and St. Sebastian in the Berlin-Dahlem Museum); fragments of a 1484 polyptych: St. James (in the Musée des Beaux Arts, Caen), St. Anthony of Padua (the Louvre), and St. Dominic (the Uffizi); and the fragments of another polyptych, ca. 1484, from San Giacomo in Argenta: St. Louis of Toulouse (New York, Metropolitan Museum); St. Nicholas of Bari (Musée Municipal, Nantes); Madonna and Child (Accademia Carrara, Bergamo); and the Pietà (Kunsthistorisches Museum, Vienna). The clear drawing and dramatic expression of the St. Jerome in Penitence, with a kneeling patron and a monk in the background (National Gallery, London), is another late work, related to the Modena St. Anthony.

The organ door decorations in the Museo della Cattedrale of Ferrara, painted in 1468-1469, represent the Princess with St. George Killing the Dragon on the outside, and the Annunciation on the inside. They are of interest because of the characteristic combination of hard drawing and excited figure action, as well as the architectural setting (in the Annunciation scenes) decorated with classical figures. The Pietà (ca. 1472), in the Museo Correr, Venice, is one of a type reminiscent of Northern *Vesperbild* sculpture groups, of which there is a variation in the Chicago Art Institute.

Several elaborate decorative projects were painted by Cosimo,

such as the allegorical scenes in the library of the castle of Mirandola for Count Francesco I Pico (1465-1467) and the chapel of the castle of Belriguardo near Voghiera (1469-1472), which are now lost. The fresco decorations of the Hall of the Months (Sala dei Mesi) in the Palazzo Schifanoia in Ferrara are still partially preserved, though in a damaged condition. The scenes represent allegories of the months based on medieval astrological calendars, such as that of the Arabian astrologer Abû Ma' schar and the *Astronomica* of Manlius, involving the Signs of the Zodiac, the Labors of the Months, twelve great Deities of Olympus (i.e., the ''Triumphs'' of Juno, Neptune, Minerva, Venus, Apollo, Mercury, Jupiter, Ceres, Vulcan, Mars, Diana and Vesta), and twelve Virtues, along with contemporary events featuring Duke Borso. In their elaborate combination of history, mythology and poetic allegory, with recognizable events and personalities, they thus form a parallel to the contemporary court art of Florence, Urbino, Mantua and the other intellectual centers.

They were executed between 1469 and 1471, probably from designs and under the direction of Cosimo Tura. The actual painting of the September and some of the other sections of the north wall have been attributed to him, while on the east wall the sections of March, April and May were painted by Francesco del Cossa. Those of June, July and August on the north wall were probably painted by Antonio Cicognara, and some of the heads and figures of the north wall next to June have been attributed to Baldassare d'Este.

Baldassare Estense (ca. 1437-ca. 1504) came from Reggio Emilia, and was active in Milan (1461-69) and as court painter and medallist in Ferrara, as well as in his home city. Chief among the paintings, particularly portraits, attributed to him, is the group portrait of Uberto de' Sacrati with his wife and son Tommaso, in the Alte Pinakothek of Munich. The participation in the Fresco decoration of the Palazzo Schifanoia seems to be limited to sections of the north wall of the Hall of the Months.

Francesco del Cossa (ca. 1435-ca. 1477) was born in Ferrara and probably was a pupil of Cosimo Tura. He is recorded in Ferrara in 1456 and in 1470, then appears to have been active in Bologna (1482) and again in Ferrara after 1487, when be became court

painter to the d'Este family. Along with Cosimo, he seems to have been influenced largely by the Squarcione shop, Mantegna and Piero della Francesca. His participation in the fresco decoration of the Hall of the Months is the subject of considerable discussion; some critics have attributed the entire series to him, but it seems clear that the Apollo, Venus and Minerva sections on the east wall were certainly painted by him.

A single panel representing an Allegory of Autumn, in the Berlin-Dahlem Museum, probably belonged to a similar series of representations of months and seasons of the year. Its monumental poise and character show a strong Umbrian influence (Piero della Francesca), as do a number of altarpieces. The most important among these is the Pala dei Mercanti, in the Pinacoteca Nazionale of Bologna, representing the Madonna Enthroned with Saints Petronius and John the Evangelist and a Kneeling Donor, Alberto de' Catanei, dated 1474 and signed *Fraciscus Cossa Ferrariensis F.*

A second altar (1473) is the Griffoni Polyptych, formerly in the Griffoni chapel in San Petronio in Bologna, of which the central panel, representing St. Vincent Ferrer, is in the London National Gallery, the two side panels of St. Peter and St. John the Baptist are in the Pinacoteca di Brera in Milan; several other panels, presumably the Crucifixion, St. Lucy and St. Florian in the National Gallery of Washington, belonged to it. The predella with scenes from the Life of St. Vincent Ferrer, in the Vatican Pinacoteca, is also considered to have belonged originally to this altarpiece.

Ercole de' Roberti (Ercole d'Antonio de' Roberti, also known as Ercole da Ferrara, ca. 1450-1496) is one of a series of less important painters, largely under the influence of Cosimo Tura, who reveal the typical features of the last quarter of the century. His chief work is the Madonna Enthroned with Saints Anne and Elizabeth kneeling beside her, and Saints Augustine and Piero degli Onesti standing on either side (Pinacoteca di Brera), which was painted in 1480 for the church of Santa Maria in Porto, in Ravenna. Although he was certainly working in the Manner of Cosimo Tura and Francesco del Cossa, there is a strong influence of Giovanni Bellini and the Venetians. This may be seen by noting the lyric simplicity of its composition and the use of a softer coloration, as opposed to the similar

themes by Cosimo (e.g., the Roverella Altar) and Francesco del Cossa. Several works ascribed to Roberti show new variations on the common emotional appeal of the period, such as the two predella scenes of the Kiss of Judas and the Way to Golgotha, in the Dresden Museum, with their manneristic emphasis on dramatic action, and the detached fresco fragment of a Mary Magdalene, from the lost decorations of the Cappella Garganelli in San Pietro in Bologna (now in the Pinacoteca Nazionale of Bologna). The contrast between Ercole's early and later work can also be seen in the two panels, the early Madonna and Child and the later John the Baptist, in the Berlin-Dahlem Museum.

Lorenzo Costa (ca. 1460-1535) is the last of this Ferrara-Bologna group, and represents the transition to the broader Cinquecento style. A pupil of Cosimo Tura and Francesco del Cossa, he appears to have been influenced both by Ercole de' Roberti and by the Venetians (Alvise Vivarini), as well as by Francia, with whom he became associated in Bologna. Later, he went to Mantua, and became court painter to Francesco Gonzaga on the death of Mantegna (1506).

A number of important works show his development under these influences and circumstances. The early fresco Madonna Enthroned with the group portrait of the Giovanni Bentivoglio Family (1487), in San Giacomo Maggiore, Bologna, is significant not only in the development of the Madonna altar, with its tendency toward a larger number of figures, but also as a group portrait related, on the one hand, to the traditional *Mater Misericordiae* and *sacra converszione* themes, and, on the other, to the more genre and bourgeois family portrait of the Renaissance (cf. the Medici portraits by Gozzoli, Botticelli and Ghirlandaio, and the Gonzaga portraits by Mantegna). Compared with the works of these Florentine masters, however, the artistic character here is stiff and provincial. Another early altar, dated 1492, is the Madonna and Saints, in San Petronio, Bologna, which is more Venetian in character. The work of the Bologna period shows a greater interest in space through the use of landscape rather than architecture: the Coronation, 1501, in San Giovanni in Monte, Bologna, and the frescoes which he painted with Francesco Francia (1506), depicting scenes from the lives of St. Valerian and St. Cecilia, particularly the Conversion of Valerian, in

the oratory of St. Cecilia, Bologna. The work of his later period in Mantua shows the more involved and manneristic compositions of active figures in a romantic landscape, e.g., the allegorical Kingdom of Comus, which was begun by Mantegna and completed by Costa in 1511/12 for the studiolo of Isabella d'Este, and the late (1525) Madonna and Saints altar in the church of Sant' Andrea in Mantua.

12. Bologna

THE CITY OF BOLOGNA was released from the rule of the Visconti tyrant Gian Galeazzo by his death in 1402; for the republican government set up soon failed and the control fell into the hands of the Bentivoglio family. The outstanding personality was Giovanni Bentivoglio, who held the city from 1462 until 1506 in spite of the claims of the papacy. At that date it came under the control of Julius II, and remained papal territory until the end of the eighteenth century.

Francesco Francia (Francesco Raibolini, ca. 1450-1517) is the most important local personality among artists of the Quattrocento in Bologna. He began as a goldsmith and medallist; then, as a painter, he formed a partnership with Lorenzo Costa and continued almost steadily in Bologna. His most important early work is the Madonna with Saints, Lute-playing Angel and the Donor, Bartolomeo Felicini (1494), in the Pinacoteca Nazionale of Bologna, which is closely related to Costa's style, yet has a softer and more sentimental expression. A series of altarpieces for local families shows a development of this romantic sentimentality, which then became somewhat mannered under the influence of Raphael: note the 1499 Madonna with Saints and Angels, in the Cappella Bentivoglio in San Giacomo Maggiore, in Bologna; the Adoration of the Child with Bentivoglio as donor, 1499; the late Entombment, in the Museo Nazionale of Parma; and the Pietà of 1515, in the Museo Civico of Turin. Weak frescoes of 1506 are in the Oratory of St. Cecilia in Bologna, depicting the Marriage of St. Cecilia with Valerian and the Burial of St. Cecilia.

A number of insignificant followers continued Francia's style in Bologna, notably his two sons, **Giacomo** and **Giulio**, and **Jacopo Boateri**. Another pupil, **Amico Aspertini** (1475-1552)

carried this involved and decorative style into the sixteenth century in a manner somewhat parallel to Pinturicchio, as seen in the Adoration of the Magi and the small monochrome scenes from the Myth of Dionysius and Galatea, in the Pinacoteca Nazionale of Bologna, and the fresco decorations in San Frediano in Lucca (1509).

Related schools associated with this Milan-Ferrara-Bologna group are those of Cremona, Pavia and Vercelli. **Boccaccio Boccacino** (1464-1524) is the most important Quattrocento artist in Cremona. He came from Ferrara, but was influenced by the Venetians, having been in Venice (1496), and was active in Genoa, Milan, Ferrara, then mostly in Cremona after 1506. His chief work is the fresco series of Christ Enthroned, in the apse, the Annunciation, on the triumphal arch, and scenes from the Life of Mary, in the nave, of the Cathedral of Cremona (1506-1519).

Pier Francesco Sacchi (1485-1528) came from Pavia but was active mostly in Genoa: the altar of St. Anthony the Hermit with Saints Paul and Hilarion (1516), in the Palazzo Bianco, Genoa, and the Madonna and Saints altar (1526), in Santa Maria di Castello, Genoa, both show a characteristic combination of Flemish and Foppa influences.

Eusebio Ferrari (ca. 1470-ca. 1533) appears to have been the founder of an artistic Quattrocento tradition in Vercelli, which continues in Piedmont with **Defendente Ferrari** (born in Chivasso ca. 1490), who is recorded with dated works from 1510 until 1535 (e.g., the Adoration of the Child, 1519, in the Cathedral of Ivrea; the Madonna and Child triptych, in the Museo Civico, Turin), and **Girolamo Giovenone** (1490-1555), whose signed triptych of 1527 with the Madonna and Child with Saints and Donors, in the Accademia Carrara of Bergamo, is characteristic of the late Quattrocento forms which continue well into the sixteenth century.

The artistic parallel in Modena is **Francesco de' Bianchi Ferrari** (1460-1510), as seen in the altar, Madonna Enthroned with St. Jerome and St. Sebastian, in San Pietro, Modena, and in the Crucifixion and Annunciation panels in the Galleria Estense of Modena.

In Parma it is **Filippo Mazzola** (ca. 1460-1505), the father of

Parmigianino, who developed in the manner of Giovanni Bellini and Antonello da Messina and is known for his portraits as well as altarpieces: the Baptism of Christ (1493), in the Cathedral of Parma, and the Conversion of Paul, in the Museo Nazionale of Parma.

BOOK III.

THE SIXTEENTH CENTURY:
The High Renaissance

The Sixteenth Century
The High Renaissance

THE HIGH RENAISSANCE in Italy tends to restrict itself politically as well as artistically to roughly the first quarter of the sixteenth century. It is characterized by the gradual absorption of the various ruling families and cultures in the local city-states into the larger imperialistic ambitions of the rival French and Spanish dynasties. Against these contending forces, the Italian states, with their growing national consciousness, put up a losing battle under the aggressive but contested leadership of the papacy. The end of the period might be marked by the sack of Rome (1527), the taking of Florence and the setting up of an hereditary dukedom of the Medici (1530), and the seizure of Milan, all by Spain and the imperial troops of Charles V.

The development of painting in this period, and especially of that which, as a style, may be genuinely understood as High Renaissance in the light of its political and economic background, is

limited broadly to the same period of the first quarter, or at most the first third, of the century. The style is no longer characterized by a many-sided complexity of local traditions, aesthetic problems and experiments, or personal tastes of worldly minded patrons, nor by the traditional requirements of a religious art. It is dominated by strong personalities, in whose creative expression these isolated problems of tradition, artistic form, religious or pagan content, and even the requirements of the patron are welded into new and highly individual styles. The various ''schools'' that develop are based largely on these personalities, rather than on shop traditions; hence, one is accustomed to think in terms of these individuals, rather than of the geographical localities from which they come.

To the High Renaissance belong five outstanding personalities, whose works represent not only a logical development of the new style and the persistence of many regional characteristics, but also a reflection of political and economic conditions which, in a sense, govern their production. Leonardo da Vinci is the oldest of these, and the major part of his artistic works was produced even before the turn of the century. Michelangelo's most extensive work in painting —the ceiling of the Sistine Chapel—was completed in 1512, and the other projects that are comparable to it—the tombs of Julius II and the Medici, and the Cathedral of St. Peter's—remained ideals and fragments that were never realized. Raphael was the most prolific and representative of the Renaissance in his balanced integration of all its formal and ideological problems into a monumental decorative style. Titian, in a sense, remained a recluse whose long development was largely a matter of his own personal growth and choice, and whose production was relatively independent of the vicissitudes of politics. Correggio, the youngest of the group, already marks the transition to the new style and expression of the following period.

While this discussion is confined primarily to the first quarter of the century, the study of some of the individual artists (i.e., Michelangelo and Titian) must of necessity be extended to cover their total lifetimes. With the vast literature and rich critical material available on each artist, the emphasis here is on the important works, the factual information associated with them, and suggestions for critical comparisons.

1. Florence

THE REPUBLIC ESTABLISHED IN FLORENCE in 1494 lasted, under the direction of Piero Soderini and an able assistant, Niccolò Machiavelli, until 1512, when the Medici were restored with the aid of the papacy and the Viceroy of Naples. Lorenzo II, who was also made Duke of Urbino in 1516 by Pope Leo X, ruled until 1519, when a series of cardinals governed as representatives of the Medici child heirs. The sack of Rome by the Spanish-Austrian troops led Florence to expel the Medici representatives in 1527, and a republic was again established. This remained until 1530, at which time Pope Clement VII, a Medici, made peace with Emperor Charles V and incited him to attack Florence. The devastating siege of Florence followed, and upon the surrender of the city, Alessando il Moro was made hereditary Duke of Florence. This tyrant, the supposed illegitimate son of Clement VII, was murdered in 1537, and Cosimo I became absolute ruler. Cosimo I, a descendant of the brother of the older Cosimo, the *Pater Patriae*, was then made Grand Duke of Tuscany by Pius V and established his territory on a flourishing and independent basis.

Leonardo da Vinci (1452-1519) is the first of the High Renaissance painters in Florence. While his art is deeply rooted in the shop psychology of the Florentine Quattrocento (i.e., Pollaiuolo and Verrocchio), it is his technical and theoretical mastery of the manifold problems of a chaotic reality that makes him the founder of a new style and form which is as applicable to science and

philosophy as it is to painting. In his dramatic crystallization of this new integration of form and content, he takes a position in relation to the sixteenth century which is comparable to that of Masaccio to the fifteenth.

Leonardo was born April 15, 1452, in the provincial town of Vinci, near Empoli, the illegitimate son of a notary, Piero di Antonio da Vinci, and a peasant girl named Caterina, who later married Acattabriga di Piero del Vacca, and he was brought up in the home of his well-to-do grandparents in Vinci. Sometime in 1469, he moved to Florence, and entered the shop of Verrocchio, where it is recorded as late as 1476, when he was brought to court on a charge of sodomy. He is registered in the *Compagnia di San Luca* in 1472. Later, several independent commissions for altarpieces are recorded, including one for the San Bernardo chapel of the Palazzo Vecchio in 1478, which was apparently not carried out. Two paintings of the Virgin are recorded, including one for the San Bernardo chapel of the Palazzo Vecchio in 1478, which was apparently not carried out. Two paintings of the Virgin are mentioned on a drawing of 1478, and two paintings of the Virgin Mary are recorded in 1478. In 1479, he did a drawing of the hanged figure of Bernardo di Vandini Baroncelli, the assassin of Giuliano de' Medici in the Pazzi conspiracy. In 1481, at the time that he was at work on the Adoration of the Magi, offering his services as a technician and engineer, and—at the end of the latter—also as an architect, sculptor and painter. He was called, most probably to execute the equestrian monument to Francesco Sforza, and went to Milan sometime in 1482, since he is last recorded in Florence on September 28, 1481, when he received a payment from the monks of San Donato, and the contract with the *Confraternità della Madonna della Concezione* in Milan for an altarpiece (the Madonna of the Rocks) was signed April 25, 1483.

At the court of Lodovico in Milan, Leonardo's universal genius was applied to almost every conceivable activity. Aside from painting, he was active as a musician, an engineer and a decorator; he designed and organized many of the popular and elaborate festivals, such as the pageant of *I Paradiso* in 1487 and the *Giostra* of Gale-

azzo Sanseverino in 1491, celebrating the double wedding of Lodovico il Moro to Beatrice d'Este, and Alfonso d'Este to Anna Sforza. During this period, most of his *Trattato della Pittura* must have been written. From July 1487 until January 1488, payments are recored for work on a model for the tambour and dome of the cathedral of Milan. In June 1490, he was employed with the Sienese, Francesco di Giorgio, as consulting engineer on the restoration of the Cathedral of Pavia, and later on the one in Piacenza. Fresco decorations of about 1498 included those of the Sala delle Assi (a vast interwoven vine decoration, much restored), in the Castello of Milan, the Last Supper, in Santa Maria delle Grazie, and others in the castles of Pavia and Vigevano (destroyed). Portraits are recorded of Cecilia Gallerani and Lucrezia Crivelli (lost). The casting of the equestrian statue of Francesco Sforza, which he must have been working on since 1483, failed, and the model was put on display in the court of the castello at the time of the wedding of the Emperor Maximilian and Bianca Maria Sforza in 1493. It was destroyed by the invading French in 1499. In December of that year, Leonardo left for Mantua, where he did a portrait drawing of Isabella d'Este. In March 1500, he is recorded in Venice as a military engineer, and by April 24 he was again in Florence.

Of his activity in Florence, considerable information is given in the correspondence of March and April, 1501, between Isabella d'Este and Fra Pietro da Novellara: Isabella expected a picture by him which she never received, and he was active with pupils on a number of commissions. He did a great deal of theoretical work in mathematics, on models of various mathematical forms, and anatomical studies on cadavers in the hospital of Santa Maria Nuova. In the summer of 1502, he entered the service of Cesare Borgia, and made a tour through the Romagna to study various engineering works and visit the swamp-reclamation project in Piombino, as well as the cities of Arezzo, Urbino, Rimini and Casena. A letter of Cesare Borgia, dated August 14, 1502, instructs commandants of garrisons to show their fortifications to this engineer and architect. By March 1503, he was back in Florence, after which time he probably began the portrait of Mona Lisa del Giocondo, and the

frescoes in the Palazzo Vecchio. In 1504, he was a member of the commission to decide where Michelangelo's statue was to be placed. In 1506, he received a three-months' leave of absence from the Signoria of Florence to enter the service of Charles d'Amboise, the French Governor of Milan. At the end of this time, Charles wrote for permission to extend this leave.

In Milan, he was at work on the equestrian monument of Gian Giacomo Trivulzio, which was never finished and is known only through drawings. He remained in Milan until the fall of 1507, then went to Florence. A letter of April 23, 1508, to the Governor of Milan states that he has two Madonnas finished for the King of France. Payments of a stipend from the king began in July 1508, and he moved to Milan again before September 1508, probably driven by the difficulties of Michelangelo's enmity and legal suits by his brothers in Florence. There, he continued his studies in hydraulics and aeronautics, as well as anatomy, with Marc Antonio della Torre. He remained in Milan until September 24, 1513, when he left for Rome, accompanied by his pupils Melzi, Salai and Lorenzo. Leo X was elected Pope May 11, and by December 1 of that year Leonardo as working with the architect Giuliano Leno on projects in the Vatican, in the midst of the various rivalries and antagonisms at the court of Leo. In August 1516, he did certain measurements on San Paolo, Rome, and paintings for Baldassare Turini of Pescia (now lost) were also done at this time. After that he left for France, and by May of the next year he was making his home in the castle of St. Cloud near Amboise. There, on October 10, 1517, he was visited by Cardinal Luigi of Aragon, to whom he showed a portrait of a young lady which he had painted for Giuliano de' Medici; also a young St. John, and the St. Anne pictures. He was, nevertheless, more active on festival decorations and engineering, such as the plans for the canal of Romorantin, than on his painting. Leonardo wrote his testament on April 23, 1519, and died May 2. He was buried in the cloister of St. Florentin in Amboise (now destroyed).

The earliest fairly definite works by Leonardo that were executed during the period of his apprenticeship with Verrocchio are the dated (1473) landscape drawing in the Uffizi collection, and the additions he made to Verrocchio's Baptism of Christ (ca. 1470) in the Uffizi, one of the angels of which was mentioned by Francesco

Albertini, in his *Memoriale* of 1510, as having been painted by Leonardo. The careful observation of detail in the landscape drawing is characteristic of Verrocchio and that Florentine group, but comparison with other typical landscape backgrounds of paintings during the period will show Leonardo's capacity to render the landscape as a space enlivened by atmosphere, rather than a mass of minutely observed detail. This more unifying and expressive element of atmosphere is what distinguishes Leonardo's work in Verocchio's Baptism. This can readily be seen in the more spiritual expression given to the head at the left in comparison with the second angel's head, and the other additions made in oil on the original (probably unfinished) tempera panel, namely sections in the landscape of the background, such as that immediately behind the first angel's head and to the right of the central figure. Also, there are parts of the nude figure of Christ which have much the same unified and atmospheric quality, though it is not so evident as in the angel's head.

The two small Annunciation panels in the Louvre and the Uffizi, although often disputed and variously ascribed to Verrocchio and Lorenzo di Credi, are probably the work of Leonardo during this early period, i.e., before 1478 or 1479, while he was still in Verrocchio's shop. A detail drawing for the angel's sleeve in both panels is in Christ Church in Oxford. Of the two panels, however, the Uffizi example, from the Monte Oliveto monastery outside Florence, is probably the earlier, executed ca. 1473-1475 in Verrocchio's shop with Leonardo's collaboration, which can be seen in some of the sections such as the drawing of the drapery and the composition of the Madonna figure. The design on the base of the lectern is closely related to that on the sarcophagus of Verrocchio's Medici tomb (ca. 1472) in San Lorenzo, Florence. The Louvre panel was part of the predella of the Madonna and Child with Saints John the Baptist and Donato altarpiece, produced in the Verrocchio shop for the Cathedral of Pistoia between 1475 and 1485. The altar was painted, for the most part, by Lorenzo di Credi, as was probably this panel, but the conception, with its emphasis on light and the more unified composition of the figures, and their integration with the space and landscape, appears to be Leonardo's. Another panel from this predella, representing St. Donatus and the Tax Collector, painted by Lorenzo do Credi, is in the Worcester, Massachussetts, Art Museum.

A second period begins with the Adoration of the Magi panel in the Uffizi, which was commissioned in March 1481, by the monks of San Donato a Scopeto for the high altar of their abbey church outside the Porta Romana (destroyed 1529). The panel was left unfinished, with only the brown underpainting, when Leonardo left for Milan in 1482. The commission was finally carried out by Filippino Lippi in 1496 with another panel of the same size and subject (now in the Uffizi). In the analysis of its form, the following factors might be noted: 1) the many separate drawings (especially in the Uffizi, Louvre and Windsor collections) made as preliminary studies of single nude figures, groups of figures, drapery, perspective and character studies of heads; 2) the symmetrical position of the Virgin and Child in the foreground (in contrast to Botticelli's placement in the background of the scene) at the top of a triangular composition of light patches against a drak background; 3) the dramatic arrangement of moving figures in concentric circles about the Virgin, with their varying expressions of doubt, amazement, scrutiny and devotion, as opposed to the tender yet dignified motherly character of the Virgin (cf. the elegantly posed figures of Botticelli or Gozzoli in their Adoration scenes); 4) the dramatization of the traditional procession in the background into groups of galloping horses and men (cf. Gentile da Fabriano's Adoration or the procession in that of Gozzoli); 5) the subordination of figures to space, as is characteristic of the later Quattrocento, but with the clear attempt, visible even in the unfinished state of the painting, to organize figures and space through the use of action, perspective, light and color; 6) finally and perhaps most important, the dramatic realism of content, which in spirit is more closely related to Antonio Pollaiuolo and Donatello (the reliefs in Padua) than to Verrocchio or any other contemporary. It is this personal and realistic dramatization, in which the essential meaning of the traditional religious theme is made apparent and convincing to the beholder, that connects Leonardo with the bourgeois tradition of Fra Filippo Lippi and at the same time establishes the new tradition of the High Renaissance.

For the study of Leonardo's later work as well as, indeed, that of his contemporaries and followers, the Adoration panel, with its associated drawings, provides something of a repertoire or at least an introduction to the vast number of motifs and visual ideas used later with endless variations. This can be followed in single figures, such

as the dignified, thoughtful figure at the left, the graceful figure and face of the Madonna, the expressive gestures of hands, figures and groups, the actions of horses and the space-creating as well as compositional exploitation of light and linear perspective.

The panel of St. Jerome, in the Pinacoteca Vaticana, was done about the same time, i.e., ca. 1481, and is likewise unfinished, with only the brown underpainting. It was lost for a long time, and was discovered early in the nineteenth century in an antique dealer's shop in Rome with the head cut out; this was later accidentally discovered in the possession of a shoemaker, and replaced in the original panel. Significant is the dramatic and spiritual intensification of the subject to the point of an almost pathological ecstasy (cf. the St. Jerome representations of Castagno, Ghirlandaio, Carpaccio). Leonardo's scientific knowledge of anatomy, as well as his genius for physiognomic distortion, is used as a means of achieving this end. Note further the composition of the background, a form of cavern which opens into lighter spaces behind either side of the figure; also the rough sketch of a Renaissance church façade at the right, somewhat suggestive of Santa Maria Novella.

Leonardo's first work in Milan is the altar with the so called Madonna of the Rocks (in the Louvre), originally painted on wood and later transferred to canvas. The theme and composition is a development of that used by Fra Filippo Lippi in his Adoration of the Child Altar, which he painted for the Medici Chapel. It is elaborated, however, into a complex situation whereby the infant St. John adores the Child and is blessed in return the two being composed under the tenderly protecting arms of the Virgin, whose extended left hand gives an added accent to the Child (cf. the same gesture in Mantegna's Madonna della Vittoria), while the angel looks out at the beholder and points to the action of the infant St. John. The composition is likewise based on a romantic interior: a dark and rocky cavern, in this case, instead of the forest interior used by Lippi. The figures are composed in a trianguar, nichelike fashion, with the Virgin and her outspread arms forming the back of the group, the light used to accent and model the forms against the darkness. In their surface and spatial pattern they are composed on two diagonals (i.e., the triangle) that are continued in the light openings of the cavern background to left and right in a manner already suggested in the St. Jerome panel.

A second version of the Madonna of the Rocks is the panel in the National Gallery of London. Its inferior quality may be noted in the harder coloration and less masterful handling of light and shade, and the less expressive character in the facial types (cf. the heads of the angel and the Virgin, the ineffective rendering of the Virgin's outstretched hand in the London example). Irrespective of "quality," the compositional differences are significant: in the London panel, the angel does not point, nor does he look out at the beholder; the figures are not composed into an apselike pyramid with their complex interchange of glances and unity through the atmosphere, but rather into a flatter and more decoratively conceived surface pattern against which the rocks and forms of the background appear more sculpturally modeled than that of the Louvre picture.

The history of the two pictures, their relationship to Leonardo and the significances of their varying styles can be explained on the basis of a number of documents. On April 28, 1480, the Confraternità della Concezione della Beata Virgine Maria ordered a large three-piece altar frame from Giacomo del Maino for San Francesco in Milan, which was finished on August 7, 1482. On April 25, 1483, the organization contracted with Leonardo, together with his pupils Ambrogio and Evangelista de Predis, for the painting, in which all details of content, colors and payments were carefully stated, and the work was to be finished by December 8 of the same year. Several years thereafter, in an undated letter, Leonardo applied to Duke Lodovico to appoint a commission of experts to appraise and revalue the work, claiming he was not being paid enough for it. The letter is signed by Leonardo and Ambrogio, not by Evangelista (who died ca. 1490), and Lodovico is addressed as "Duca di Bari," hence the letter must have been written before 1494, in which year he became the Duke of Milan. The Duke, as "judge," may have bought the picture himself with the purpose of giving it to Emperor Maximilian, from whom he was seeking favors. A second letter, March 9, 1503, was sent by Ambrogio in the name of the absent Leonardo to the French ruler of Milan, Louis XII, asking for another reconsideration and money. A final contract was made on April 27, 1506, in which the artists agreed to finish the work for an extra payment of 200 Lire. Ambrogio signed the receipt for the payment October 23, 1508.

The history of the Louvre picture is vague, although it is

definitely traceable in the royal collections of France since 1625, when it was mentioned by Cassiano del Pozzo in Fontainebleau, and in 1682, when it is listed in Le Brun's catalogue of Louis XIV's collection. As to its previous history, it may have been acquired by Louis XII, or again, it may have been given to Francis I by Leonardo himself. It may also be identical with a famous altarpiece mentioned in the *Anonimo Magliabechiano* and by Vasari as having been given to Emperor Maximilian by Lodovico and sent to Germany, later to be inherited by Emperor Charles V. The London panel remained in the church of San Francesco until the eighteenth century, when it was transferred to the Hospital of Santa Caterina alla Ruota, from which it was bought by an English painter, Gavin Hamilton, in 1785, and then came into the collection of the National Gallery. The two original wings of lute-playing angels by Ambrogio de Predis remained in San Francesco until 1798, when they became a part of the Meizi collection in Milan, and then were acquired by the National Gallery of 1898.

From this documentary evidence and the analysis of the pictures themselves it appears that the Louvre example was executed first, between 1483 and about 1494, largely by Leonardo's own hand, and was even at that time considered the superior work. The second (London) version was begun shortly afterward and completed in 1508, planned and begun by Leonardo but executed in large part by Ambrogio. The two versions, therefore, are significiant in noting not only the difference between the work of the master as compared with that of his pupils, but also the development of Leonardo's own style from the direct and emotionally compelling earlier work to the cooler and more reserved stylization of the later period.

Leonardo's famous Last Supper, in the refectory of Santa Maria delle Grazie, in Milan, belongs stylistically between these two versions of the Madonna of the Rocks, and represents the completion and perfection of those formal and iconographical problems begun in the Adoration of the Magi. The fresco was begun, probably, in 1495, on completion of Montorfano's fresco of the Crucifixion on the opposite wall of the refectory. A letter of June 29, 1497, from the Duke to Marchesino Stanga, his superintendent of buildings, requests him to hurry up the completion of Leonardo's fresco so that the decoration of the other walls might begin. It was finished by 1498, when Luca Pacioli, in his *Divina Proportione* (which is

dedicated to the Duke of Milan, February 8, 1498), mentions the Last Supper as a famous and much-admired work.

The damaged condition of the fresco in its present state goes back to the time of its execution. Matteo Bandello, the novelist and Dominican monk whose uncle was prior of the convent of Santa Maria delle Grazie, gives an eye-witness account of Leonardo's working methods, describing long periods of intensive work on the wall alternating with periods of study and contemplation. For the sake of a slower drying medium and more adequate and refined transitions of light and shade (*sfumato*), he experimented with a combination of fresco, tempera and oil. As early as 1517, Antonio de' Beatis had noted the poor technical condition of the mural. Vasari saw it in 1556, and could hardly recognize the figures. Careful restorations were begun in 1726 by Bellotti, and have been continued to the present day. A door was chopped through the wall by the monks in the eighteenth century for direct entrance into the kitchen, and during the French occupation of 1796-1815, under Napoleon, the refectory was used as a magazine and stable by the French troops. With all these factors taken into consideration, however, the original is still a remarkably impressive piece of work.

Of the many compositional and iconographical problems and stylistic comparisons involved, the following might be considered the most essential: 1) the common Quattrocentist interpretation of the theme as a memorial, i.e., a monumental representation of the last meeting of the Master with His disciples, suitable to the refectory of the monastery—an interpretation, however, which Leonardo dramatizes by Christ's announcement of Judas's treachery (cf. the older symbolical method used by Castagno and Ghirlandaio in isolating Judas in front of the table; also other attempts at the enlivenment of the scene through the movement of figures, the theme being changed to the Institution of the Sacrament as in Fra Angelico and Joos van Ghent); 2) the compositional unity of the wall through the action of the figures, which appears motivated by Christ's statement and gesture, the rhythmical division and organization of the figures into four groups of three, separated from the central figure of Christ (cf. the genre movement of figures in Ghirlandaio's Last Supper); 3) the expressive language and rhythmical organization of faces and hands (cf. Leonardo's Adoration of the Magi and his interest in physiognomic distortion as an ex-

ercise in dramatic expression shown in his drawings); 4) the use of a straight table parallel to the wall, rather than a U-shaped form (Ghirlandaio), and the placement of Judas with his face in the shadow behind the table rather than in front of it, hence an emphasis again on the monumental and decorative unity of the figure group; 5) the setting off of the table from the background by the contrast of light against dark, and the linear perspective of the floor, ceiling and side walls, which continues the lines of the refectory room (cf. again the use of perspective as a dramatic means in the tradition of Mantegna and Masaccio; 6) the three windows opening into the landscape of the background reminiscent of that decorative motif as used by Ghirlandaio and especially by Cosimo Rosselli (the Sistine Chapel); 7) the compositional unity of figures and space through the converging lines of perspective in the head of Christ, and the accent given to His head by the window frame and light coloration of the landscape.

As with the Adoration of the Magi, a considerable number of drawings of heads, drapery details and figure compositions are extant (Windsor Collection) which show Leonardo's remarkable contact with reality, his continual experimentation in the expression and organization of forms. A much-repainted pastel sketch of the head of Christ, in the Pinacoteca di Brera, probably not done by Leonardo, but an early copy by a pupil of either the cartoon or the finished original, suggests something of the indescribable expression of that famous central figure (cf. also the engravings after the Last Supper, such as that by the eighteenth-century Raphael Morghen). One of the best literary interpretations of Leonardo's Last Supper, frequently quoted in modern biographies, is perhaps to be found in Goethe's essay, ''Joseph Bossi über das Abendmahl'' (*Kunst und Altertum*, 1818).

The panel with St. Anne, Mary and the Child, in the Louvre, was apparently begun soon after Leonardo's return to Florence in 1500. Vasari describes a cartoon of that subject which had probably been commissioned by the monks of SS. Annunziata and which had caused great popular admiration. A letter of April 3, 1501, written by the monk Pietro da Novellara to Isabella d'Este, describes the cartoon in detail. This cartoon is now lost, but from the description it is assumed to have been a preliminary study for the Louvre panel, as are many compositional sketches and studies of details which were

done about the same time. It is generally assumed that the actual execution of the painting did not take place until Leonardo's second stay in Milan (i.e., 1507-1512). The assumption is somewhat justified not only by the more developed style, but also by the number of replicas made after it by pupils in Milan, and the fact that Leonardo kept the panel in his own possession and carried it to France, where it was seen by Cardinal Luigi d'Aragona and Antonio de Beatis in 1517.

The panel is for the most part done by Leonardo himself; its effect is somewhat changed by the later additions to the panel on either side of the figures. The theme and composition offer an interesting comparison with the same subject by Masaccio: note, in contrast to Masaccio's rigid and hierarchic vertical compositon, the free and easy movement of the figures (one seated on the lap of the other) in opposite directions, yet integrated into an organic composition; the emphasis on the forms on a central axis, with the landscape receding in two directions from it as in the St. Jerome (cf. the apsidal grouping of figures around a space in the Madonna of the Rocks); the introduction of a very human and natural play motif, whereby the Child pulls the ears of the lamb, the Mother reaches out to restrain Him, and Anne smiles benignly at the top of the group. Significant, too, is Leonardo's use of light and an evenly rich, subdued color scale in the modeling and atmosphere, which lends a unifying tone to the scene. While the plastic composition and modeling of the group is characteristic of the earlier style, the somewhat mannered smile is more in the idealized spirit of the later Milan period (cf. the smile of the Mona Lisa).

The cartoon of the Virgin and Child with St. Anne and the Infant St. John, in Burlington House, London, is related to the Louvre panel, but was executed earlier, probably in 1498 while he was still in Milan. It is significant, in contrast to the structural and classic interlocking of the figures in the Louvre panel, in its search for a balanced form through the aligning of figures in relief fashion, demonstrating again Leonardo's key position in clarifying the new classic style.

The famous Mona Lisa, in the Louvre, is a portrait of the twenty-four-year-old daughter of a Florentine burgher, Antonio Maria di Noldo Gherardini, and the wife of a respected citizen of Florence, Francesco del Giocondo. It was probably begun soon after

Leonardo's return from the Romagna in 1503, and is said by Vasari to have taken four years, and even then was not finished. The panel was seen in Leonardo's collection in St. Cloud by Antonio de Beatis and Cardinal Luigi in 1517, and remained in the collections of Fontainebleau, Versailles and the Louvre until 1911, when it was taken out of the frame and stolen, only to turn up again in Florence to 1913. The panel had been cut down: Raphael's copy, the pen drawing of 1505/6 in the Louvre, gives the columns of the loggia on either side of the picture in its original state.

As one of the finest of Renaissance portraits, the panel offers an interesting comparison with the earlier examples noted before, such as the brilliant coloration and profile design of Domenico Veneziano's portrait in Berlin, the more atmospheric color of Piero della Francesca's profile of Battista Sforza, and the modeled form of Bellini's Doge Loredan. The solidly modeled bust form bears a relationship to the elegant bust portraits in late fifteenth-century sculpture (Desiderio, Rossellino) and is composed with the landscape background through the light and atmosphere. The famous ''smile'' has something of the expression of classical Venus or Aphrodite figures, and had been used frequently in late fifteenth-century sculpture, and is continued hereafter as a more of less archaic mannerism, particularly by Leonardo's followers in Milan. The poor technical condition, often exaggerated, may be due in part to Leonardo's experiments with the oil medium, but more to the many layers of varnish that have been applied it its preservation.

From the contemporary records, a considerable part of Leonardo's activity must have been concerned with portraits. Because of overpainting and their poor technical condition, the authenticity of many of those surviving has been doubted. Among those identified is that of Cecilia Gallerani, Lodovico's mistress (known as the Lady with an Ermine), in the Czartoryski Museum of Cracow, which must have been painted during Leonardo's early years at Milan. Cecilia became Lodovico's mistress in 1481, and the ermine is a symbol associated with him. The portrait was praised in a sonnet by the court poet Bellincioni, and is mentioned in a letter of 1498 from Cecilia to Isabella d'Este. The profile Portrait of a Lady, possibly Anna Maria Sforza, in the Milan Pinacoteca Ambrosiana, is sometimes attributed to Leonardo's pupil, Ambrogio de Predis. The Portrait of a Musician, also in the Ambrosiana, had been identified

with Atalanta Migliorotti because of a 1482 drawing inscribed with his name. It later has been associated with Franchino Gaffurio, who was director of the Milan cathedral choir after 1482, although there is again no certainty to the identification. The famous La Belle Ferronnière, so-called because of the fashionable Lombard headband, in the Louvre Museum, had once been identified as a portrait of Lucrezia Crivelli, and may have been one of the portraits which Pietro da Novellara mentioned in 1501 as being worked on by assistants. In this case, it may be Boltraffio. In any case, it still is to be dated ca. 1495 in Milan.

The portrait of Ginevra dei Benci, in the National Gallery of Washington, is probably an early work, possibly done as a wedding portrait, since she was married in 1474. The panel had been cut down about eight inches at the bottom, so that the protrait was originally about half-length with hands, as suggested in a drawing in the Windsor Collection. The reverse of the panel has a garland of laurel and palm encircling a sprig of juniper (*genevra*) which would support the association with the name of the subject. The painting was mentioned in the *Libro di Antonio Billi* and the *Anonimo Gaddiano* as well as by Vasari, so that in spite of its earlier attribution to Lorenzo di Credi, the general acceptance as a work of Leonardo's appears to be sound.

Among the various attributions from this early period there are two altarpieces of interest. One is the much-repainted Madonna with the Vase, in the Munich Alte Pinakothek. It was probably painted in Verrocchio's shop and has a close relationship with the composition and Madonna's pose in the alterpiece of the Cathedral of Pistoia, which had come from Verrocchio's workshop and was completed by Lorenzo di Credi (1478-1485). The other is the so-called Benois Madonna (originally on panel, later transferred to canvas) from the collection of Léon Benois, now in the Hermitage Museum of Leningrad. These two Madonnas are sometimes identified as the two Virgin Marys referred to on Leonardo's drawing of 1478 (Uffizi Collection) with the inscription: ...*bre 1478 inchominciai le 2 Vergini Marie* (...ber 1478 I began the 2 Virgin Marys). The remarkable free and active composition appears in a related drawing from the same period in the Louvre Cabinet des Dessins, which was certainly the basis for the developed painting (cf. also the many other

Madonna and Child drawings in the British Museum, Windsor Castle and the Uffizi).

Among the later and less important works is the panel of John the Baptist in the Louvre which is mentioned in the *Anonimo Magliabechiano* and was seen in 1517, along with the Mona Lisa and the Virgin with St. Anne, in St. Cloud, by Cardinal Luigi and Antonio de Beatis. From the drawing of the same pointing hand in the *Codex Atlanticus*, it was probably painted about 1509. Its quality is inferior to the earlier work, and it is assumed to be one of his latest paintings, mostly done by pupils (cf. the mannered smile as well as the somewhat trite gesture).

Leonardo's painting of Leda and the Swan is another subject of much discussion. Its existence is assumed by the studies among his drawings as well as the records of the *Anonimo Gaddiano* and Lomazzo (although it is not mentioned by Vasari), and it had probably been taken to France. Such a painting, presumably Leonardo's, was seen by Cassiano del Pozzo in Fontainebleau, in 1625, and then was lost. Aside from the drawings, Leonardo's composition may indeed have been only a cartoon, but there are many copies, including those among Raphael's drawings, as well as paintings by Leonardo's followers such as those in the Galleria Borghese and the Galotti Spiridon Collection, Rome. Its importance is more iconographical than stylistic, since it provides a pagan variation of the mystery of creation, which is then developed in more sensuous terms by later renaissance artists (e.g., Correggio). The idea of a Venus-type figure combining action and repose in its *contrapposto* composition was attractive to both Raphael and Michelangelo, as well as to the Mannerists of the following generation.

The fresco of the Battle of Anghiari was begun in 1503, after Leonardo's return from the Romagna, for the Sala del Gran Consiglio of the Palazzo Vecchio in Florence, and commissioned by the Signoria through the *gonfaloniere*, Piero Soderini. Payments for it are recorded until October 15, 1505. In the spring of 1504, the Signoria requested that the cartoon be finished by February, 1505. Leonardo stopped work on it and petitioned for leave in 1506, and the damaged (largely through Leonardo's technical experiments with oil and fresco) and unfinished mural was finally taken down (1557) and replaced by the present ones by Vasari. Aside from the many preliminary drawings of fighting horses and men by Leonardo,

a reasonably accurate impression of the original fresco can be had from the anonymous copies by Florentines in the Uffizi and Casa Horne (both of which were probably done before the destruction of the fresco), the engraving by Lorenzo Zacchia dated 1558, and the famous drawing by Peter Paul Rubens, which was no doubt done on the basis of either copies of this type or engravings. Of all these, the Rubens drawing is the most useful, even though it is not taken from the original, because of its dramatic power and the remarkable identity in spirit of the two artists.

Represented is a patriotic subject taken from the Florentine war with Milan, the heroic battle of the Florentine soldiers against the superior forces of Filippo Maria Visconti, fought June 29, 1440, near Anghiari. Significant, in contrast to the frieze-like battle scenes as represented by Uccello, Piero della Francesca (his Arezzo frescoes) or the sarcophagi reliefs of antiquity, is Leonardo's choice of a dramatic incident out of the battle panorama, namely the struggle of a few warriors for possession of the banner. This may have been a matter of historical fact, since, according to the chronicles, the victory was accomplished at the moment when the standard was captured. On the other hand, the huge size (the original cartoon was ca. 8 x 20 meters) of the wall would require, from his point of view, such a concentrated action to achieve a compositional unity. By means of the limited number of figures, he is able more effectively to master the dramatic action of forms and groups through their anatomical structure, as can readily be seen in the numerous anatomical drawings and studies of horses and men; note, by contrast, the more abstract approach in the compositions of Uccello and Piero della Francesca. As to the composition, note the parallelogram and oval design of the figure group, the plastic modeling of the forms through movement, foreshortening, and light and shade. The motif of the rearing and fighting horse and rider is related to Leonardo's designs for his Sforza monument, and is evident in Raphael's later use of the group in the panorama Battle of Constantine in the Vatican. Michelangelo's parallel composition of the Bathing Soldiers is again a significant and contemporary contrast.

Leonardo's two equestrian statues, though known only through his designs, are intimately associated with his own style as well as with the development of the Florentine tradition from the fifteenth to the sixteenth centuries. As in painting (i.e., the Adoration of the

380

Magi), the Sforza monument demonstrates Leonardo's key position in the develoment of the new point of view in sculpture. Plans for the monument to Francesco Sforza were apparently begun in 1483-1484, soon after Leonardo settled in Milan, then were dropped, and were taken up again in 1490 (from a note on one of Leonardo's drawings), after fruitless inquiries has been made in Florence by the Milanese authorities for a master able to assist in the work. The model was finished by 1493, and was displayed with great admiration in the court of the Castello during the festivities celebrating the marriage of Bianca Maria Sforza and the Emperor Maximilian. The project was abandoned in 1494, when the bronze collected for the casting was diverted to Ercole d'Este for cannon. During the invasion of 1499, the model was used as a target by the French archers, and it later disintegrated.

The concept of the equestrian monument goes back to Donatello's Gattamelata and Verrocchio's Colleoni as a vigorous forward-striding figure. But the various drawings (Windsor Collection) indicate its reinterpretation from a striding to a rearing horse-and-rider group, sometimes combined with a small, crouching figure as a symbol of a defeated enemy. The idea appears in his own drawings for the Adoration of the Magi, but also has a tradition in classical sculpture (i.e., battle reliefs as well as gems) and the previous projects in Milan, as is seen in Filarete's illustration for a monument to Gian Galeazzo Sforza in his *Trattato dell' Architettura*, ca. 1460-1465, and Pollaiuolo's drawing for the Gian Galeazzo Sforza monument in the Graphische Sammlung of Munich.

The plans for the Trivulzio monument, again never executed but to be studied through the drawings in the Windsor Collection, were probably begun soon after Leonardo's return to Milan in 1506/7, the figure of Marshal Trivulzio as conqueror of Milan probably being intended to displace the idea and monument of Francesco Sforza. The various possibilities of the striding and rearing horseman appear, but the emphasis seems to be on the more complex group, related this time to that of the Anghiari scene. The content is likewise changed, in that the group is placed on a high and elaborate architectural pedestal, decorated with allegorical chained figures and containing an open space for a sarcophagus and the reclining figure of the deceased. The design is therefore no longer an equestrian monument, as understood in the Quattrocento tradition,

but a tomb or shrine which is conceived more in the architectural terms of the High Renaissance. In plan as well as in many of the motifs (cf. the ''chained slaves''), the Trivulzio monument appears to be closely related to Michelangelo's tomb of Julius II, and is therefore one of the connecting links between the Early and the High Renaissance.

The nature of Leonardo's influence as a personality and the creator of a school and tradition can further be studied in his *Trattato della Pittura*, most of which was written during the first period in Milan for the instruction of his pupils. In its personal and empirical approach to art and nature, it forms a characteristic parallel and contrast to the technical directions given in Cennini's *Libro dell' Arte* and the mathematical theory of Piero della Francesca. The large body of drawings, most of them bequeathed to his pupils, with scientific notes and data and mechanical inventions, as well as compositional ideas, is to be understood from the same point of view, namely as a source book of ideas which might be further worked out in mechanical, scientific or artistic form. These again bear evidence of the fact that the most fundamental characteristic of Leonardo's art and creative personality is the indissoluble unity of scientific and artistic *invention*, based on the study of nature.

Fra Bartolommeo (Baccio della Porta, 1472-1517) is the first of the Florentine school who, though not a creator of style, reflects the influences of leading personalities, such as Leonardo, and the new spirit of the period (i.e., Savonarola and the republic in Florence).

Bartolommeo et Sancti di Paulo di Jacopo popolo di San Felice, as his full name is recorded, was born in Florence on March 28, 1472, the son of a native of Genoa who owned a house near the Porta San Pier Gattolino, from which the name Baccio della Porta comes. With Mariotto Albertinelli, his close friend, he entered the shop of Cosimo Rosselli in 1485, and in 1492 the two artists established a studio in Bartolommeo's father's house. Their partnership was broken several times; in 1496/7, deeply impressed by the sermons of Savonarola, Bartolommeo burned all his paintings not of strictly religious content in the famous *Bruciamenti delle vanità*. In 1498 he contracted to paint a Last Judgment for Santa Maria Nuova, which he left unfinished in 1500 to enter the Dominican monastery in Prato; he then lived in San Marco of Florence as Frate Bartolom-

382

meo, and until 1504 remained in retirement, active mostly on drawings and small works. In 1505, he was appointed director of the painters' workship in San Marco. In 1508, he made a short trip to Venice and, on his return the next year, established a flourishing shop in San Marco, again in partnership with Albertinelli. This was dissolved in 1512, and Fra Bartolommeo carried on with but a few assistants, among them **Fra Paolino del Signoraccio** (1490-1547) and **Giovanni Sogliani** (1492-1544). In 1514, he went to Rome, and came under the influence of Raphael and Michelangelo. In July of that year, ill with malaria, he retired to the country place of the Dominicans, Pian' di Mugnone. He was active in Lucca for a short time in 1515, and then back in Florence, where he was honored by an invitation of Francis I to come to Paris and by a visit of Pope Leo X to his studio in San Marco. He died of malaria in Pian' di Mugnone, on October 31, 1517.

Fra Bartolommeo's development through this series of influences can be followed with a few significant examples. An early work of 1497 in the Cathedral of Volterra—an Annunciation done in conjunction with Albertinelli—and the damaged fresco of the Last Judgment from Santa Maria Nuova (1499-1501), now in the Museo di San Marco, which was completed by Albertinelli, show many of the decorative mannerisms of Rosselli, Filippino Lippi and the late Quattrocento, without the dramatic motivation of Leonardo's figure and drapery movement. The portrait of Savonarola in San Marco has much of the character of Perugino heads. The first contract taken after his retirement to San Marco was the Vision of St. Bernard, in the Accademia of Florence (contracted 1504, finished 1506). The comparison with Perugino's earlier version of the same subject shows Bartolommeo's interest in figures and their movement, without the decorative limitations of an architectural framework and setting. The scene is placed before an open landscape; the Virgin and the crowd of angels hover in midair, and in spite of their sweeping movement, the total scene and composition has a certain stillness and devotional mood reminiscent of Fra Angelico and the quiet atmosphere of San Marco (cf. the popular Northern parallel to this inspirational theme in the St. Luke Painting the Virgin by Roger van der Weyden. The same spirit is evident in the *Noli me tangere* (1506), in the Louvre, and the fresco of Christ as Pilgrim (1506/7), in San Marco. The compositional scheme of

the Vision reappears later in Raphael's Sistine Madonna, as does that of the Last Judgment in the Disputà.

The altars painted after the trip to Venice take on larger and more monumental proportions, simpler and more articulated compositions, with which he combines a luminosity of color that is partly Venetian and partly related to Piero di Cosimo (the God the Father with Saints Magdalene and Catherine altar, in the Pinacoteca Nazionale of Lucca, 1509, with its new interpretation of Fra Angelico's devotional mysticism; the 1509 Madonna Enthroned with St. Stephen, St. John and the Venetian Lute-playing Angel at the foot of the throne, in the Cappella del Santuario of the Cathedral of Lucca). At the same time there appears an interest in larger numbers of figures and the Venetian motif of the niche behind the Madonna, such as the dated (1512) Marriage of St. Catherine altar—the Pitti Pala—in the Accademia of Florence.

After the trip to Rome, the influences of Raphael and Michelangelo are apparent in the conscious use of dramatically swaying figures and drapery, the more organically interpreted contrapposto, and an emotional stress that tends rather more toward an affected pathos than toward the romantically inspired expression of the early work. The best example is perhaps the Resurrected Christ of 1516, in the Galleria Palatina (Palazzo Pitti), Florence, with its pose and gesture reminiscent of Verrocchio's Christ of the bronze group on Or San Michele. Fra Bartolommeo's most famous single work is the somewhat Leonardesque Pietà (1516), also in the Palazzo Pitti (cf. the larger figures and simpler, monumental composition, the rich and soft coloration against a dark background in contrast to Perugino's rendition of the same subject). Of special interest are Fra Bartolommeo's drawings (Uffizi Collection), which show a strength and versatility as well as a sensitity not often so evident in his paintings.

Mariotto Albertinelli (1474-1515) is a less-gifted pupil of Cosimo Rosselli, and for the most part is stylistically dependent on Fra Bartolommeo. Soon after the establishment of the studio with Fra Bartolommeo, he left for a short time and worked alone in the Medici gardens doing drawings from classical models (1494). When his partner entered the monastery, Albertinelli continued the work on the Santa Maria Nuova Last Judgment. His most productive period

took place between 1509 and 1512, in the San Marco studio; however, a great deal of his work of that time appears to have been done from his partner's drawings. His early work is represented by the Annunciation of 1497, in the Cathedral of Volterra, done in collaboration with Fra Bartolommeo. Certainly his most important single panel is the Visitation of 1503, with its predella scenes of the Annunciation, the Nativity and the Circumcision, in the Uffizi gallery. In its simple and impressive emphasis on the two important figures framed by an open arcade behind them, it forms a remarkable contrast with such narrative and scenic decorations as those of Ghirlandaio (cf. the Visitation in Santa Maria Novella). Parallel to it is the Trinity, in the Accademia of Florence, which is probably based on a cartoon by Fra Bartolommeo. A later work, showing an attempt at greater space and light effects, is the Annunciation of 1510, also in the Florentine Accademia.

Giuliano Bugiardini (1475-1554) was a pupil of Albertinelli's as well as Ghirlandaio's and Piero di Cosimo's. For a time, he had assisted Michelangelo on the ceiling of the Sistine Chapel. The large Martyrdom of St. Catherine, in the Cappella Ruccellai of Santa Maria Novella, Florence, and the Marriage of St. Catherine with Saints Anthony of Padua and the Infant St. John, in the Bologna Pinacoteca Nazionale, show again the major characteristics of the new Late Renaissance and Mannerist styles.

Francesco Granacci (1469/70-1543) had worked in Ghirlandaio's shop and was one of those called to assist Michelangelo at the beginning of the work on the Sistine ceiling. His character as another of these workmanlike, rather mediocre artists who represent the transition from the late Quattrocento to the High Renaissance and then Mannerism, under the influence of the great masters, can be seen in his Madonna della Cintola (1508/9) and the Assumption of the Virgin with Saints Bernardo degli Uberti, Fidelis, John Gualbert and Catherine (ca. 1512-1514), both in the Accademia of Florence.

Ridolfo Ghirlandaio (1483-1561) carried on the extensive Ghirlandaio workshop and may properly be considered still within the Quattrocento tradition. Yet his production continues well into the sixteenth century in an ecclectic combination of Piero di

Cosimo, Raphael and Leonardo characteristics. The earliest dated (1503) altar is the Madonna and Child with Saints Francis and Mary Magdalene, and is closer to Piero di Cosimo. Later work, such as the Pietà with Saints Jerome, Nicholas and John the Baptist, in the church of Sant' Agostino of Colle Val d'Elsa (1521), and the Madonna with Saints, in the Museo Civico of Pistoia (1528), shows the recognizable poses, gestures and motifs from Raphael, Fra Bartolommeo and Leonardo.

Franciabigio (Francesco di Cristofano, 1482-1525) had been a pupil of Piero di Cosimo, then worked, along with Bugiardini, as assistant to Albertinelli, and later worked with Andrea del Sarto on the frescoes of the Chiostro dello Scalzo and SS. Annunziata, as well as the Medici villa at Poggio a Caiano. His style is largely dependent on theirs as well as on Raphael's, as can be seen in the Annunciation, in the Galleria Sabauda of Turin, the Raphaelesque Madonna del Pozzo (1508), in the Accademia of Florence, the *Sposalizio*, in SS. Annunziata (1513), and the Last Supper fresco, in San Giovanni della Cala (1514) in Florence. The grisaille frescoes of the Benediction of St. John by Zachary and the Meeting of Christ and St. John, in the Chiostro dello Scalzo (1518), and the Triumph of Cicero (1521), in Poggio a Caiano, are strongly under the influence of Andrea del Sarto.

Andrea del Sarto (Andrea d'Agnolo, 1486-1531) is the greatest colorist of the Florentine High Renaissance and the parallel to Fra Bartolommeo as the chief representative of that local school.

Andrea, or as he is more fully identified in a dowry document of 1518, *Andreas Angeli Francisci vocato Andrea del Sarto populi Sancti Marci de Florentia pictor*, was born in Florence July 16, 1486, the son of a tailor (*sarto*) named Agnolo di Francesco, began as an apprentice to a goldsmith and then (according to Vasari) worked with Andrea Barile and Piero di Cosimo. In 1508, he is registered in the *arte dei medici e speziali*. That same year, he set up a studio with Franciabigio and, in 1509, received his first important commission, the decoration of the entrance court of SS. Annunziata which had been begun by Cosimo Rosselli. In 1515, he was at work, together with the architect Jacopo Sansovino, on the festival decorations in honor of the entrance of the Medici Pope, Leo X, into

Florence, particularly (according to Vasari) on the decoration of a temporary wooden façade for the cathedral. On September 1, 1516, he married Lucrezia del Fede, whom he used as a model for many of his altarpieces and compositions (cf. the portrait of her in the Prado of Madrid). In the spring of 1518, he was called to France by Francis I, but returned to Florence the following year. Vasari says he had made trips to Rome and Venice, which are not otherwise recorded. In 1521, he was at work on fresco decorations involving classical allegories devised by Paolo Giovio to parallel Medici history (e.g., Caesar Receiving Tribute) in the Villa Poggio a Caiano for the Medici, at the same time as Pontormo and Franciabigio. These were left unfinished at the death of Leo X and were not completed until 1570 (by Alessandro Allori). He made his testament on December 27, 1527, and died in Florence, September 29, 1530.

Andrea's most important early work is the fresco decoration of the Chiostricino, or entrance court, of the Servite abbey of SS. Annunziata in Florence, for which he contracted in 1509 to continue the series of scenes from the life of San Filippo Benizzi originally begun by Cosimo Rosselli. The first scene, of Filippo kneeling to receive the roles of the Order, was done by Rosselli; the other five scenes (San Filippo clothes a Leper; the punishment of those who had mocked the Saint; San Filippo heals the maiden possessed of the Devil; the Resuscitation of the dead youth at the bier of San Filippo; the Healing of the sick with the garments of San Filippo) were painted by Andrea, probably with the aid of Franciabigio, the last one being dated 1510.

The style shows an attempt to combine active figures into centralized compositions in an extended space in the manner of Leonardo's Adoration of the Magi, yet many of the compositional schemes are based on those of late Quattrocento narrative painters, e.g., the two last-named funeral scenes, which are based on Ghirlandaio's Funeral of St. Francis, in Santa Trinità. The awkward mannerisms of Fra Bartolommeo's Last Judgment are recognizable, and the figure drawing appears to be influenced by Leonardo, or more probably by the early Florentine, Raphael.

The more fully developed style which is associated with the classic High Renaissance (Raphael) appears with the fresco of the Adoration of the Magi in the same cloister (1511). Iconographically significant is the change of the theme to what is really the ''arrival''

of the Kings' procession rather than the actual Adoration (cf. the varying emphases in the same subject by Gentile da Fabriano, Gozzoli and Botticelli). While the procession and arrival do call for a movement from right to left, there is at the same time a tendency to balance the compositon and organize the figures into an imposing atmospheric space and landscape. The famous fresco of the Birth of Mary (1514), also in SS. Annunziata, might be considered the perfected solution of these problems of movement and balance, figures and space, organized into an impressive monumental form. With this the space is an interior scene, rather that the exterior landscape of the Arrival of the Magi; the content itself is concerned with the genre details rather than with a monumental group and situation (cf. Albertinelli's Visitation). The comparison with Ghirlandaio's Nativity scenes in Santa Maria Novella will demonstrate both the iconographical continuity and the formal differences (i.e., late Quattrocento as opposed to High Renaissance) of the two artists and styles.

Andrea's frescoes in the Chiostro dello Scalzo (near San Marco in Florence) were probably first begun in 1512, then continued in 1515-1517 (from payments listed in the books of the *Compagnia*), and again after his return from France from 1522-1523. Represented are scenes (painted in grisaille) from the life of St. John the Baptist and the four Cardinal Virtues. The first group of these (the Preaching of John, John Baptizing, and his Arrest) as well as the allegorical figures of Charity and Justice, were painted during the first period, 1515-1517. The remaining ones (the Annunciation to Zachary, the Birth of John, Dance of Salome, the Death of John, the Presentation of His Head at the Feast of Herod, together with the Hope and Faith) belong to the later period, 1522-1523. The Visitation is the last, painted in 1526.

Many of the group compositions stem from the late Quattrocento, e.g., the Baptism of Christ group from Verrocchio's panel. What is particularly noteworthy is the development of more plastic, muscular and energetic figures (cf. that of the executioner in the Beheading of John), largely under the influence of Michelangelo. Combined with this is the balanced organization, after the manner of Raphael, of fewer figures in a well-composed space—a unity of the separate and plastically modeled figures and space being achieved through the use of light and the single tone of the grisaille. In its

combination of narrative content and monumental form, the series may be looked upon as the completion of the compositional experiments of Piero della Francesco (Arezzo) and Luca Signorelli (Monte Oliveto).

The true character of Andrea's interpretation of Michelangelo is not to be seen in the muscular build of single figures alone, but morein the composition of those figures within the frame and space. The best example is the late (1525) Madonna del Sacco fresco over the door of the inner cloister (Choistro dei Morti) of SS. Annunziata. A characteristic iconographical feature is the choice of a genre scene, the Rest of the Holy Family on the Flight into Egypt (cf. the traveler's sack on which Joseph leans), as the theme for a monumental composition (cf. the Birth of Mary). The seated Madonna has something of the character of one of Michelangelo's sibyls (the Delphic); the composition is closer to that of the lunettes over the windows of the Sistine Chapel, but is much more freely composed both within the frame (cf. the reduced proportions of the figures) and in its orientation to the beholder (cf. the raised position of the fresco over the doorway above the spectator's head, and the foreshortening of both figures and perspective from below). Most important, it is the rich and luminous coloration that differentiates Andrea's individual style as against that of Michelangelo and Raphael.

The large fresco of the Last Supper (1526), in San Salvi, Florence, is another of Andrea's finest works. The animation of the figures and their composition behind the long straight table is certainly reminiscent of Leonardo's fresco in Milan; but the reduced proportion of figures to the room, the subdued movement of the apostles, the decentralization of the composition by the lack of light contrasts and perspective about the Christ, are still within the fifteenth-century tradition. The unity of the space through light, and again, Andrea's almost Venetian coloration, lend a dignified and monumental mood to the scene that not only reflects the spirit of the High Renaissance, but also suggests something of the decorative festivity of the later sixteenth century (cf. Veronese).

Of Andrea del Sarto's many altarpiecees, the best known is probably the 1517 Madonna delle Arpie (so-called from the decorative harpies at the base of the throne), in the Uffizi Gallery. Aside from the easily recognizable features of the classic style (i.e., the statuesque movement and contrapposto of the figures, the

balanced pyramidal composition), the panel is distinct in its unified tone (the *sfumato* of Leonardo) and its rich coloration which is related both to Piero di Cosimo and the contemporary Venetians. The same year, he painted the Disputation of the Trinity, with Saints Sebastian, Augustine, Laurence, Peter the Martyr, Francis and Mary Magdalene, in the Palazzo Pitti, with its actively gesturing saints in a form of *Disputà*, i.e., a serious theological discussion, but also retaining something of the lyric conversational spirit of the traditional *sacra conversazione*.

In style, both altarpieces parallel that of the Birth of Mary fresco in SS. Annunziata. An early panel (1513) is the Annunciation, in the Palazzo Pitti, which is interesting for its stylistic parallels to the earlier frescoes (the Arrival of the Magi) and also in its compositional development over the earlier works of Fra Bartolommeo (the *Noli me tangere* and the Vision of St. Bernard). In spirit, however, there are many features that are close to Quattrocento versions of the theme, such as the standing Virgin in Baldovinetti's Annunciation, the the genre motif of the figures peering over the balustrade used in Ghirlandaio's Visitation in Santa Maria Novella and again in his frescoes, both in SS. Anunziata and the later Last Supper. Late altarpieces, such as the Assumption and the Pietà (1524), in the Palazzo Pitti, and the Sacrifice of Isaac, in the Dresden Gemäldegalerie, show a gradual increase in dramatic gestures that suggests the manneristic style of the following generation (cf. the Pietà with that of Perugino).

Pontormo (Jacopo Carrucci, 1494-1557), another of Andrea del Sarto's pupils, belongs to the younger generation representing the new style of the Mannerists: note especially the Visitation fresco (1516) in SS. Annunziata and the series of five frescos of scenes from the Passion (ca. 1522-1527) in the Certosa di Val d'Ema (Certosa del Galuzzo) near Florence.

2. Siena

IN THE SIXTEENTH CENTURY, Siena carried less political and artistic importance than it did in the fifteenth. The political upheavals in Florence gave Siena a chance, in spite of local despots and the pressure of Papal and Spanish imperial intervention, to preserve, with the aid of the French, something of a republican government. An attack on the city by the Viceroy of Naples was repulsed, but it finally fell, with great loss of life and property, to Cosimo I in 1555 and thereafter remained under the control of Florence.

Sienese painting had never regained the national standing it had once had in the fourteenth century. The artistic talents of the fifteenth century, with the possible exception of Francesco di Giorgio and the sculptor Jacopo della Quercia, had attained little more than local significance, and even then outside artists were called in to execute the more extensive projects of the late period (cf. Perugino, Signorelli and Pinturicchio) for the Piccolomini and Pandolfo Petrucci.

Sodoma (Giovanni Antonio Bazzi, called Il Sodoma, 1477-1549) is the only outstanding personality active in Siena who might be considered a stylistic parallel to the great masters of the High Renaissance in Florence and Rome.

He was born in 1477 in Vercelli, near Milan, the son of Giacomo di Antonio Bazzi, a local shoemaker. In 1490, he entered the shop of **Giovanni Martino Spanzotti** (ca. 1456-ca. 1527), a Vercelli follower of the provincial North Italian Gothic court style, to be noted in his signed triptych in the Galleria Sabauda in Turin, and the 1509/10 Baptism, in the Cathedral of Turin. Sodoma is recorded in Spanzotti's shop until 1497. His whereabouts after that are not known; possibly he worked in Milan under the influence of the Leonardo school, but in 1501 he was invited to Siena by agents of the bankers Spanocchi, and is recorded there, and in the im-

mediate surroundings, from that time until 1508. That year, under the sponsorship of Agostino Chigi, he was commissioned to decorate the ceiling of the Stanza della Segnatura in the Vatican. About 1510, he decorated two rooms and the façade of the palace of Sigismondo Chigi in Siena. In 1512, back in Rome, he executed his most important work, the decoration of the upper chamber of the Villa Farnesina, for Agostino Chigi, the papal treasurer to Julius II. In 1515, he stayed with another patron, Jacopo d' Appiano, prince of Piombino, and the next year, with a letter of introduction from him, met Lorenzo de' Medici in Florence. About 1516, he was knighted by Pope Leo X, and in 1518 he wrote several letters, signing himself, *Jo. Antonices Sonona Eques Senis*, to the Duchess of Mantua and the Duke of Ferrara, offering his services. For the most part, his subsequent activity was restricted to Siena, although he made trips to Florence (1527 ff.), Piombino (1538), Volterra (1539/40), Pisa (1540/43) and Lucca (1545). He died on February 14, 1549, in Siena.

The character of Sodoma's early style can best be seen in the Deposition, in the Pinacoteca of Siena, which was painted (1502) soon after his arrival in Siena, for the Cinozzi Chapel in San Francesco. The choice of theme is historically interesting in that it affords ample opportunity for the action of a large number of figures, their decorative arrangement before a spacious background, as well as many possibilities for dramatic pathos, such as in the figure of Mary Magdalene and the group of the swooning Virgin (cf. the similar tendency to change the Pietà into an Entombment scene as done by Mantegna and Raphael). The style shows many late Quattrocento Umbrian characteristics, as, for instance, the landscape and the decorative flutter of drapery (cf. Pinturicchio), which are also used in the Deposition begun by Filippino Lippi for SS. Annunziata and finished by Perugino ca. 1505 (Uffizi).

The fresco series of thirty-one scenes from the life of St. Benedict, in the monastery of Monte Oliveto Maggiore, near Siena, was originally begun by Signorelli in 1497, and then left unfinished when that artist took up the decoration of the Cappella Brizio in Orvieto. Payments to Sodoma began in 1505 and continued until 1508 for the work on a total of twenty-five, which belong chronologically at the beginning of the narrative. Compared with the altar panel in the Pinacoteca of Siena, the style of these scenes is

awkward, and appears to be an attempt to combine the heavy figures of Sicnorelli's narrative with the imposing scene and movement of the Umbrian Pinturicchio, who at that time had been working on the frescoes of the Piccolomini library in Siena. An interesting detail, showing something of Sodoma's extravagant personal character, which Vasari describes, is the self-portrait in the third fresco, richly garbed in a gaudy costume that had been given him by the monastery, previously left by one of the brothers, a Fra Giovanni Ambrogio da Milano, upon his entrance into the order.

The change to a fully developed and conscious High Renaissance style under the influence of Raphael can be seen in his most important work, the frescoes of Agostino Chigi's bedroom in the Villa Farnesina, Rome (1512-1514). Represented are romantic scenes from classical antiquity: Alexander receiving the family of the conquered Darius, and the wedding of Alexander and Roxane (i.e., as a bridal bedroom scene) taken from Lucian's description in his *Herodotus* of the painting by Aëtion. The pagan love theme is therefore a variation of those appearing in the small panel and *cassoni* decorations of the Medici circle in Florence during the late fifteenth century, here expanded to monumental mural proportions, with the modeled forms, many-figured composition and the use of light and dark characteristic of the Raphael school (cf. the problem of the monumental narrative as presented by Andrea del Sarto in his contemporary Birth of Mary). The smaller scenes depict the Forge of Vulcan, and Alexander with Bucephalus.

The decorations of the Oratorio di San Bernardino in Siena with scenes from the Life of Mary (Presentation of Mary in the Temple, the Visitation, the Coronation of the Virgin, and the Assumption, with Saints Anthony of Padua, Francis and Louis) were begun, with the aid of his pupils, Girolamo del Pacchia and Beccafumi, in 1518, and not completed until 1532. The greater emphasis on the plastic forms, their balanced composition and unified tone are characteristic features of this later style. The frescoes of 1526 in the Cappella di Santa Caterina in San Domenico, Siena, reveal the elements of the late style, too, with its swaying figures and tendency toward a more emotional ecstatic expression (note the Stigmatization of St. Catherine and the contrast with the group of the fainting Virgin in the early Deposition Siena). About the same time, he painted the famous processional banner for the Confraternità di San Sebastiano

(1525), now in the Palazzo Pitti, representing St. Sebastian (note the exaggerated contrapposto of the Apollo-like figure, the ecstatic expression, the introduction of the angel holding the crown of martyrdom, the decorative spread of the nude figure, the tree and the angel in a pattern before a light and luminous valley landscape). Later and less important works are the frescoes of the three local patron saints— Ansano, Vittorio and Beato Bernardo Tolomei—in the Sala del Mappamondo in the Siena Palazzo Pubblico (1529-1534), those of the Cappella degli Spagnuoli (1530) in Santo Spirito, Siena, and the Sacrifice of Isaac, of 1542, in the Cathedral of Pisa (cf. Andrea del Sarto's version of the same theme in Dresden).

Baldassare Peruzzi (1481-1537) is important chiefly as an architect, but as a painter he was probably a pupil of Sodoma and influenced by Pinturicchio. His style tends largely toward a more manneristic form of decoration, and belongs within the limitations of the Late Renaissance. Among his major works are the more Quattrocentist ceiling and wall decorations in fresco of the choir of Sant' Onofrio in Rome (1504); the fresco decorations of the Ponzetti Chapel, in Santa Maria della Pace in Rome, with scenes from the Old and New Testament and a Madonna with St. Bridget and St. Catherine and the kneeling donor, Cardinal Ponzetti (1516-1517); the fresco of Augustus with the Sibyl, in the church of Fontegiusta in Siena (1528); and the ceiling decorations in the Villa Farnesina in Rome.

Girolamo del Pacchia (1477-ca. 1535) is a combination of Sienese and Florentine influences, as can be seen in his Assumption of the Virgin, in Santa Maria del Carmine, Siena, and the Coronation of the Virgin, in the church of Santo Spirito, Siena.

Domenico Beccafumi (called Mecarino, 1486-1551) represents again the mannerism of the Late Renaissance, as seen in his fresco decorations (done with Sodoma and Girolamo del Pacchia) of the Oratorio di San Bernardino, in Siena, and the fresco ceiling decorations (1529-1535) of heroic scenes from Roman history in the Palazzo Pubblico, Siena. With his emphasis on color and light, rather than form, and his somewhat mystical, anticlassical style, he is a parallel to Rosso and Pontormo.

394

3. Rome

THE DECADENT REGIME of Alexander VI and his son, Cesare Borgia, at the beginning of the sixteenth century brought a reaction which, in 1503, placed a della Rovere on the papal throne as Julius II. As head of the church and the dominating influence in Italy's new national and imperialistic political program, as well as a patron of art and learning, Julius ranks as a parallel to the other great political leaders of sixteenth-century Europe, namely Charles V and Francis I. As a personaltiy, too, he reflects much the same individualistic character as the great contemporary artists whom he patronized, particularly Michelangelo; but, in contrast to the artistic subservency of painter to patron, as was noticeable in the ''court'' style of Sixtus IV and Alexander VI, Julius allowed greater respect for the artist's individuality and freedom of expression (cf. Michelangelo and the design for the Sistine Chapel).

Political and cultural development went hand in hand. In the interests of an expanding papal state, Julius organized the League of Cambrai against Venice in 1508, and the Holy League against the French in 1511, then continued the policy of playing off the French and Spanish invaders against each other, with the result that at the end of his rule the papacy was in a stronger political position than it had been since the days of Innocent III. What Julius had begun in the patronage of the arts was continued by his successor, Leo X (1513-1521), and that golden age came to an abrupt end during the reign of Clement VII with the sack of Rome in 1527 by the Spanish imperial armies. After the coronation of Charles V as Emperor in Bologna in 1519, there began the period of Spanish-Austrian—i.e., imperial—domination of Rome and all Italy, and with it came the new struggles of the papacy against the contending forces of the Reformation and Counter-Reformation.

With regard to the art of the High Renaissance in Rome, the

chief characteristic is the dominance of the style by outstanding personalities. These were not native Romans, but importations from central Italy. In the analysis and description of the work produced in Rome during this period, it is significant to bear in mind: 1) that the two leaders, Raphael and Michelangelo, originate in two different geographical regions and artistic traditions, i.e., Umbria and Florence; 2) that they themselves represent two remarkably contrasting psychological types—one a more socially minded, worldly and balanced personality, the other a dynamic and almost pathological recluse; 3) that they are both influenced by Leonardo, but while Raphael develops the more formal and decoratively organized features of his art (i.e., related to his later style), Michelangelo concentrates on the spiritual and dramatic expression of Leonardo's earlier work; 4) that one, Raphael, is several years younger than the other, and represents the viewpoint of a younger generation, which, at least in this particular period of tense competition between personalities, is of considerable significance to the understanding of the complex relationship between individual and historical style (i.e., style as a personal expression of a creative individual as opposed to style as a broader reflection of the taste of patron or contemporary society); and lastly, 6) that, different as the two artists are, they both represent a certain universality of viewpoint which is primarily aesthetic, not scientific, as was the case with Leonardo, which is reflected in their active participation in all the arts—painting, sculpture, architecture, poetry, etc.—the like of which had not been seen since the days of Giotto and the early Trecento. The history of criticism, and indeed the entire interpretation of the Italian Renaissance, has varied in accordance with the emphasis laid on these contrasting principles: Classic and Baroque, Classicistic and Romantic.

Raphael (Raffaello Sanzio, 1483-1520) represents the most perfect balance of the countless and many-sided problems of artistic form that had been experimented upon, developed and enriched through the preceding century. What can be said about the perfection of form can likewise be said of the philosophical equilibrium with which he handled the traditional problems of iconography, whether they dealt with the devotional altarpiece, monumental decoration (the Stanzas), history (tapestries) or classical mythology (Villa Farnesina). And in

his integration of form and iconography he not only reflects the culture of Julius II and particularly of Leo X, but also fulfills the philosophical as well as political ideal of the High Renaissance in the rebirth and reestablishment of Rome to its ancient glory (cf. the parallel ambitions of the age of Constantine and that of Innocent III).

Raffaello Santi, or Sanzio, was born April 6, 1483, in Urbino, the son of the painter Giovanni Santi (Giovanni di Sante di Piero, ca. 1435-1494), who in his time had been active at the court of Duke Federigo da Montefeltro. Raphael's early training in the artist's craft probably began in the shop of his father and Pietro Perugino, who was active at various times in Urbino from 1493-1499. When the latter was called to decorate the Cambio in Perugia in 1499, the young Raphael very likely accompanied him as assistant. A document of December 10, 1500, indicates that Raphael, with Evangelista di Pian di Meleto, was commissioned to paint an altarpiece of the Coronation of St. Nicholas of Tolentino for the Church of Sant' Agostino in Città di Castello that was completed the following year. In the fall of 1504, he went to Florence with a letter of recommendation (the authenticity of which, however, has been questioned) dated October 1, 1504, from Giovanna Feltria to the Florentine *gonfaloniere*, Pietro Soderini.

He remained in Florence four years and was active on a number of altar commissions which reflect the influence particularly of Leonardo and Fra Bartolommeo. Probably late in 1508, he went to Rome (Vasari says he was called through the influence of his fellow Umbrian, Donato Bramante, who as architect had just begun plans for the new cathedral of St. Peter's). The next year, he was given the title of *Scriptor brevium* by the Pope, and was at work on the fresco decoration of the Stanza della Segnatura. This was finished by August 1511, and the same year he began the Stanza d'Eliodoro (a Ferraran envoy mentions the *due camere* which Raphael was painting, in a letter of July 12, 1511, to Isabella d'Este) which in turn was finished in 1514. After this came the Sala dell' Incendio, finished in 1517.

At Rome, particularly during the pontificate of Leo X, Raphael's activity expanded in many directions, and he appears to have been the center of a considerable group of artists and intellectuals at the papal court, so that as a personality his identification with the *Cortegiano* of his friend Baldassare Castiglione may be

justified. The number of commissions for portraits, altarpieces and large decorative projects increased steadily with each year, with a corresponding increase in the participation of many asisstants. Chief among the larger decorations, aside from the Stanzas, are: 1) the prophet Isaiah, in Sant' Agostino, Rome, done ca. 1512 for the prelate Johann Gortiz of Luxemburg and later much restored by Daniele da Volterra; 2) the fresco of the Four Sibyls, in the Cappella Chigi of Santa Maria della Pace, ca. 1511/12-1514; 3) the dome mosaics of the Cappella Chigi in Santa Maria del Popolo, done 1514-1516 for the same Agostino Chigi by the Venetian, Luigi de Pace, after Raphael's designs; 4) the decoration of the destroyed corridor connecting the Vatican with the Belvedere; 5) the London cartoons for the tapestries, 1515-1516; 6) the decoration of the bathroom of Cardinal Bibbiena in the Vatican, 1516; 7) the fresco decorations of the Villa Farnesina, 1517-1519; 8) the frescoes of the loggia on the upper story of the Vatican, ca. 1517-1519; 9) the sketches and cartoons for the Sala di Constantino, 1518-1519.

Raphael's activity as an architect began with his appointment by Pope Leo as directing architect of St. Peter's after the death of Bramante in 1514, and that year a model was made by Barile from his designs. His architectural style, largely influenced by Bramante, can be followed in a series of buildings in Rome after his designs; the Cappella Chigi in Santa Maria del Popolo, 1512; the Villa Madama, begun in 1515 and continued by Giulio Vidoni-Caffarelli; and the Palazzo Pandolfini in Florence, 1516-1520. In 1519, shortly before he died, Raphael took measurements and made plans, aided by Andrea Fulvio, the scholar and author of *Antiquitates Urbis*, for the reconstruction of ancient Rome and its ruins. According to a breve of August 27, 1515, Leo had appointed Raphael prefect of antiquities in Rome, which is significant in this connection, as is Raphael's consistent archaeological interest in antiquity, as reflected in his decorative motifs. Raphael died April 6, 1520, and was buried with all honors in the Pantheon.

Traditionally, Raphael's career is divided into the three periods of his activity, in Perugia (1500-1504), Florence (1504-1508) and Rome (1508-1520). Although a rigid demarcation of "periods" is not justified either by documents or by the work, his style develops correspondingly under the successive influences of Perugino, Leonardo and Michelangelo. The discovery and understanding of

the genuine Raphael, however, is not to be found in obvious influences as such, but in the character of his interpretation. The stylistic analysis of his many-sided activity may be approached both as a chronological succession of works from one years and period to the next, and as a continuity of form that is stabilized by the limitations of iconography and decorative purpose.

Among the various early works that have been attributed to Raphael is the *gonfalone* or processional banner ordered by the Confraternity of the Holy Trinity in Città di Castello on the occasion of the plague of 1499. Two badly damaged canvases, now in the Pinacoteca of that city, represent the Creation of Eve and the Holy Trinity with the kneeling Saints Sebastian and Roch. Though they resemble Perugino's manner, they might also be associated vaguely with Timoteo Viti, who had been active in Urbino after 1495 (cf. the similar Trinity by Viti in the Pinacoteca di Brera). The first major commission of the youthful apprentice was the altar representing St. Nicholas of Tolentino treading on the devil and being crowned by God-Father, for the chapel of Andrea Baroncio in Sant' Agostino in Città di Castello, which was ordered December 10, 1500, from Raphael and Evangelista di Piandimeleto (a former pupil of Giovanni Santi) and paid for on September 13, 1501. The original panel had been sawed in pieces and lost, except for three fragments: the head of an angel, now in the Pinacoteca Tosio Martinengo of Brescia (where it had long been attributed to Timoteo Viti), the head of Mary, and the figure of God-Father with the crown, now in the Galleria Nazionale di Capodimonte of Naples.

Aside from the single figure of Fortitude, and possibly the head of Horatius Cocles, in Perugino's Cambio frescoes, the best example of Raphael's most Peruginesque style is the Crucifixion of 1503, from the Mond Collection, now in the National Gallery, London. It was painted for the Cappella Gavari in San Domenico in Città di Castello and is his first inscribed work: *RAPHAEL . URBIN . AS . P.* The inscription over the altar in San Domenico reads *Hoc Opus Fieri Fecit Dnicus Thome de Gavaris . MDIII.* In the comparison of this panel with Perugino's Crucifixion in Santa Maria Maddalena del Pazzi, or that in Sant' Agostino, Siena, note the peculiarly spiritual, poetic quality which is more pagan and classical in character and which distinguishes Raphael from Perugino.

This significant, though at first glance slight difference in

character can be recognized in some of Raphael's early and small-sized panels. One is the so-called Vision of a Knight, in the London National Gallery, which in theme may be a variation of the classical Hercules at the Crossroads, related to the woodcut of the contending Virtus and Voluptas in Sebastian Brand's *Stultifera Navis* (Basel, 1497). The allegory has also been interpreted as a Neoplatonic Dream of Scipio, based on Cicero's *Somnium Scipionis*, with the women (Pallas and Venus) bearing the three attributes—book, sword and flower—signifying intelligence, strength and sensibility. A companion piece of about the same size is the Three Graces panel, in the Musée Condé in Chantilly. The relationship of size and theme suggests that they may have been designed together (though not necessarily in the form of a diptych) in a characteristically Renaissance allegory of Virtus and Amor. Its composition is based on the classical theme, as seen in the famous Praxitilean sculpture group in the Siena Museo dell' Opera Metropolitana. A pen-and-ink drawing, punched for transfer to the Vision of the Knight, is also in the London National Gallery. Although the two paintings have frequently been assigned to the early Florentine period, they seem more certainly to have been painted while Raphael was still in Perugia (i.e., ca. 1504).

The same Perugino-oriented, though distinctly independent, character can be noted in the more integrated drawing and vitality of the two panels representing St. George and St. Michael Killing the Dragons, in the Louvre, the St. George and the Dragon, in the National Gallery of Washington, and, above all, in the lyric naturalism of the early Madonnas, such as the Solly and Diotalevi Madonnas, in the Berlin-Dahlem Museum, and the Madonna Conestabile della Staffa, in the Hermitage Museum of Leningrad. The same is true of the St. Sebastian panel in the Accademia Carrera in Bergamo.

The Coronation of the Virgin, in the Pinacoteca Vaticana, reflects a more perceptible break with the Perugino manner. The painting, originally on wood and later transferred to canvas, was commissioned in 1502 by Maddalena degli Oddi for the family chapel in San Francesco in Perugia. The three beautifully preserved panels of the predella represent the Annunciation, the Adoration of the Magi and the Presentation in the Temple (note the clarity of their compositions as compared with Perugino's predella scenes of the same subjects belonging to the altar in Sata Maria Nuova, Fano,

1497). The comparison of his works with similar representations by Perugino, e.g., the Ascension (or rather, the Madonna in Glory) with Saints, in the Pinacoteca Nazionale of Bologna, of ca. 1500, or the Coronation of the Virgin with Saints, of 1502, from San Francesco al Monte in the Galleria Nazionale of Perugia, will show Raphael's adherence to the rigid division of upper and lower stories in the figure composition; but it also shows the combination and enrichment of the two themes by introducing the open sarcophagus and St. Thomas with the Girdle in the lower half of the composition. The sarcophagus and the active grouping of the apostles about it allow a more unified formal composition as well as a tangible and understandable spiritual content.

The most significant work of Raphael's early period is the *Sposalizio*, in the Pinacoteca di Brera of Milan, which is signed, *Raphael Urbinas*, over the center arch of the temple, and dated 1504, and was originally ordered by Filippo degli Albezzini for the altar of St. Joseph in the church of San Francesco, Città di Castello. It appears to be based on Perugino's altar with the same subject and composition in the Musée de Peinture of Caen. There are several documents related to the commission for Perugino's panel, particularly that of April 11, 1499, and it seems reasonably certain, therefore, that it was painted earlier than Raphael's. But the fact that it is sometimes interpreted as having been painted later and having been based on Raphael's composition is indicative of the different stylistic characters of the two masters: to his very last years, Perugino's art continued on the basic principles of form of the late Quattrocento, while each successive work of Raphael's shows a development and expansion in spiritual and artistic expression.

In the comparison of the two works, note the common origin of the compositional scheme in Perugino's Christ Giving the Keys to St. Peter, in the Sistine Chapel; Raphael's more easily composed and clearly defined figures, which move forward from either side to the central group, as opposed to Perugino's formal arrangement in a friezelike relief; Raphael's tendency to dramatize the scene by giving greater prominence to the bachelors' active breaking of their rods at the right; the greater decorative and spatial unity of figures and background by means of the more elaborate perspective and the polygonal temple, as opposed to the planar design of Perugino's octagonal temple and background.

The Pierpont Morgan altarpiece in the Metropolitan Museum of New York demonstrates the difference between Raphael's Perugian and Florentine styles. It was probably painted in 1505 for the high altar of the convent of Sant' Antonio in Perugia, but appears to have been started at an earlier date, ca. 1503/4, which might be inferred from the clearly Umbrian and Peruginesque composition of the throne, the upper saints (Catherine and Cecilia), and the angels of the lunette (cf. Raphael's Coronation). The two figures of St. Peter and St. Paul were certainly done at a later date under Florentine influence (i.e., Fra Bartolommeo), and the assumption is that he finished the panel on a later trip back to Perugia (in December 1505, for instance, he is recorded there for a short time). A number of excellent predella scenes belonging to it are extant, such as the Christ Bearing the Cross, now in the London National Gallery, the Pietà, in the Isabella Stewart Gardner Museum of Boston, and the Christ in Gethsemane, in the Metropolitan Museum. The interesting motif of the fainting Virgin at the left of the Christ Bearing the Cross is the same used by Perugino in his contemporary Deposition from the polyptych of SS. Annunziata, in the Florence Galleria dell' Accademia, and used several times by Sodoma. Two single saints, St. Francis and St. Anthony of Padua, in the College Gallery of Dulwich, also belong to this altarpiece.

The Ansidei Madonna (the Madonna and Child Enthroned with St. John the Baptist and St. Nicholas of Bari), in the London National Gallery, is a second altarpiece from this same transitional period. A date which has been interpreted as 1506 is painted on the hem of the Madonna's garment, and the assumption is that Raphael had begun the work in Perugia in 1504 for the Cappella Ansidei in San Lorenzo dei Serviti, Perugia, and finished it two years later. One scene from the predella, St. John Preaching to the Multitude, survives in the Mersey Collection of London. The architecture and throne appear related to some of Perugino's altarpieces; the figures are more Florentine in character, yet the pose of St. John appears in Raphael's own *Sposalizio* composition.

The major part of Raphael's Florentine activity is taken up by countless drawings and studies, and by his famous Madonnas. The drawings reveal his growth from the small and intimate poetic expression of the Umbrian to a more broadly conceived Renaissance and universal form that came through the basic study and

understanding of the Florentine traditions. They show his careful studies from nature and the model, the sculpture of Donatello, the engravings and paintings of Pollaiuolo, the battle scenes of Leonardo and Michelangelo, as well as the new expression in Leonardo's portrait and devotional pictures. Psychologically, his position is somewhat related to that of Fra Bartolommeo. The fact that the majority of his fully executed paintings during the Florentine period are small Madonna and Child representations is not to be explained by this transitional state of mind alone, but also by the simple lack of large-scale commissions.

The Madonna panels represent compositonal variations (half-or full-length, seated or standing Virgin; the infant Christ Child and St. John in various playing motifs and gestures) that reflect the principles presented in Leonardo's Adoration of the Magi and developed in his Virgin, St. Anne and the Child. Their intimate and poetic character is a continuation of the Umbrian and Peruginesque type, yet becomes more human and recognizable and thus might be interpreted as tending toward the sentimental. The best known of these are: the Madonna Terranuova (ca. 1505), in the Berlin-Dahlem Museum, with the motif of the outstretched hand from Leonardo's Madonna of the Rocks; the Madonna della Granduca (ca. 1505), in the Palazzo Pitti; the two Cowper Madonnas of ca. 1505 and ca. 1508, in the National Gallery of Washington; the Madonna della Casa Tempi, in the Alte Pinakothek, Munich (ca. 1506-1508); the dated (1506) Madonna del Prato, in the Kunsthistorisches Museum of Vienna; the Madonna del Cardellino (ca. 1506), in the Uffizi; La Belle Jardinière, with the signature and date, *Raphaello Urb. MDVII*, in the Louvre of Paris; the Madonna di Casa Colonna, in the Berlin-Dahlem Museum (ca. 1506-1508); and the signed Holy Family with St. Elizabeth and the infant St. John (ca. 1507), from the Casa Canigiani, in the Alte Pinakothek of Munich. Many of the names by which the works are known are those of their former owners.

In the study of their style, note the clarity and luminosity of the color (in contrast to Leonardo's dark and richer coloration), the use of many glazes, the tendency toward a pyramidal composition, and the equal clarity of the figure design, which can perhaps best be seen in the many sketches of such varying poses and compositions. In the succession of works. the complexity of both figures and composi-

tions appears to increase, and those toward the end of the period, such as the Canigiani Holy Fmily, appear to be the most complex and stylized of the group (cf. the similar compositions developed by Fra Bartolommeo in the Palazzo Barberini of Rome, 1516, and Andrea del Sarto, ca. 1515, in the Louvre). This panel is signed and was painted for Domenico Canigiani and was seen in his house by Vasari. The flying angels which originally filled in the spaces on either side of Joseph had been painted out at a later date.

Raphael's maturer conception of the large and many-figured altarpiece at the end of the Florentine period can be seen in the Madonna del Baldacchino, i.e., the Madonna Enthroned with the Child and Saints Peter and Bruno, James and Augustine, in the Palazzo Pitti. It was painted about 1507/8, is unfinished, and is probably identical with that painted for the altar of the Dei family in Santo Spirito which Vasari says was left unfinished when he went to Rome. The comparison with the Sant' Antonio altar in the Metropolitan, as well as the Canigiani panel, will demonstrate the new relationship of figures to the space and a total monumental form. Note especially the spacious niche behind the throne and baldachin, the conversing angels in the foreground as a substitute for the Venetian music-making angels, and the general relationship as well as remarkable differences with the contemporary Venetian *sacra conversazione*. The fluttering angels at the top are repainted, but probably belong to the original composition.

The damaged fresco of the Holy Trinity, in the monastery of San Severo in Perugia, was probably begun late in 1505, when Raphael was in Perugia, continued ca. 1507/8, and left unfinished. The remainder, i.e., the six standing saints of the lower half, was completed in 1521 by Perugino. An inscription below, added later but probably correct, says that the Trinity above was done by Raphael in 1505 under the priorate of Don Ottaviano Stefano Volterrano (*Raphael de Urbino D. Octaviano Stephani Volterrano Priore Sanctum Trinitatem Angelos Astantes Sanctosque. Pinxit. A.D. MDV.*). Stylistically, Raphael's section of the fresco shows much the same duality of composition noted in the Sant' Antonio altarpiece and even persistent in the Madonna del Baldacchino, namely, the more decorative and Perugian manner of the lower section, as opposed to the heavy and more Florentine figures of the six seated saints on the upper level (Saints Maurus, Placidus, Benedict

on one side, and Saints Romuald, Benedict the Martyr, John the Martyr on the other). The total compositional scheme is based on Fra Bartolommeo's 1499 fresco of the Last Judgment in Santa Maria Nuova (Uffizi).

Another panel which, together with the Madonna del Baldacchino and the San Severo fresco, marks the transition from Raphael's Florentine to his Roman style, is the Entombment, in the Borghese Gallery of Rome, the predella to which, representing allegorical figures in grisaille of Faith, Hope and Charity, is in the Pinacoteca Vaticana. It is signed and dated 1507, and was commissioned by Atalanta Baglioni, in memory of her murdered son, Grifonetto, for the Baglioni Chapel of the church of San Francesco al Prato in Perugia.

Of some iconographical significance is the compositioned discrepancy between the Pietà (cf. the Oxford drawing) and the Entombment, as well as the attempt to combine the two and dramatize the theme through the physical movement of figures in the actual transportation of the dead Saviour to the Tomb (cf. the parallel in the Deposition theme, as opposed to the Crucifixion). Iconographically, the motif is related to Mantegna's engraving of the same subject; the interest in the abstract movement of figures may be related to the drastic compositons of Signorelli, but is certainly stimulated by the work of Michelangelo, as can be seen in the group of the fainting Virgin at the right (cf. the same group in Raphael's predella of Christ Bearing the Cross, in the London National Gallery), with the twisted figure of Mary Magdalene kneeling before her (taken from Michelangelo's Doni Madonna). Likewise, the figure of Christ bears a close resemblance to the design of the same figure in Michelangelo's marble Pietà in St. Peter's.

A series of superb drawings for the Entombment, in the Ashmolean Museum of Oxford and the British Museum of London, reveals the development process of the separate figures, from skeleton studies to clothed figures, the experimentation with compositional groups and, indeed, the basic iconographical theme. The well-preserved panel of St. Catherine of Alexandria, in the London National Gallery, was painted about the same time (1507) and again shows a related expression through the twisted figure.

The two important portraits of this period are the corresponding panels in the Palazzo Pitti representing Angelo Doni and

his wife, Maddalena di Givanni Strozzi, which are mentioned by Vasari as being, in his time, in the palazzo of their son, Giovanbattista. They were probably painted in 1506, hence within a few years after their marriage in 1503. On the reverse of the panels are paintings in grisaille of the myth of Deucalion and Pyrrha done by a later Raphael follower. In their full and plastically modeled half-length form, they are interesting stylistic documents in the history of portrait painting, particularly as it developed after Leonardo. The design of the Maddalena portrait is based on that of Leonardo's Mona Lisa (cf. Raphael's drawing in the Louvre, copied after it). The comparison of the two, however, reveals Raphael's clear and more refined draftsmanship, the simpler modeling of forms, and the lighter and more luminous coloration, with the particular use of many glazes, similar to his contemporary Madonna pictures.

Several controversial women's portraits are attributed to Raphael on the basis of their relationship with the Maddalena Doni, such as the Lady with a Unicorn in the Galleria Borghese, Rome, and the panel Portrait of a Lady (La Muta), in the Galleria Nazionale delle Marche in Urbino. The best of the early male portraits, besides the Angelo Doni, is the panel sometimes identified as Francesco Maria della Rovere, in the Uffizi Gallery.

The exact time of Raphael's arrival in Rome is not known. He is not mentioned among the artists of the Vatican until his appointment as *Scriptor brevium* on October 4, 1509. His work on the first room, from the inscription on the Parnassus, was finished by November 1511, and was probably begun in June, 1509. Generally, one assumes, however, that he came to Rome late in 1508. In November 1507, Pope Julius changed his living quarters from the Borgia Apartments, which had been so elaborately decorated for Pope Alexander VI by Pinturicchio, to the rooms upstairs, which had formerly been occupied by Nicholas V and which contained the chapel decorated by Fra Angelico. The decoration of these four rooms had been started in the fall of 1508 by a number of artists, including Perugino, Piero della Francesca, Sodoma, Bramantino and Peruzzi.

The Stanza della Segnatura, so-called because the hearings of the papal triibunal were held here and the official seal, *segno*, was affixed to the papal documents, was probably originally intended as a study and library, which is important to bear in mind in the analysis

406

of the content as related to the patron and the intellectual tastes of this particular period. As such, it is to be interpreted as a kind of *studiolo*, in the tradition of Duke Federigo's study, and forms an interesting contrast to the allegorical and intellectual content of Pinturicchio's decorations in the Borgia Apartments. It is the second of three rooms, beginning with the Stanza dell' Incendio, the Stanza della Segnatura, then the Stanza d'Eliodoro and leading into a fourth, considerably larger room, the Sala di Constantino, at the corner next to the Loggia. The rooms are nearly square (about 27 x 21 feet), of balanced proportions, covered by cross vaults and entered through doorways at the corners (cf. the architectural plan of Gozzoli's chapel in the Medici palace).

The decorative framework of the vault of this first room was painted by Sodoma, who is recorded at work on them in October, 1508. The four medallions and rectangular scenes in this design were executed by Raphael, and represent allegorical figures of Theology, Philosophy, Poetry and Justice, enthroned with angels holding tablets (cf. Michelangelo's sibyls). Between them are the corresponding rectangular scenes, the Fall of Man, Astronomy, the Crowning of Apollo after his victory over Marsyas, and the Judgment of Solomon. Corresponding to these again, and in the same order on the side walls below the vault, are the Disputà (i.e., Theology) and the School of Athens (Philosophy), the Parnassus (Poetry) and the Judicial Virtues (Justice). Below these, in grisaille, are the giving of the Civil and Canon Law (i.e., on either side of the window on the Justice wall), represented by Justinian giving the Pandects to Trebonianus, and Pope Gregory IX handing the Decretals to the jurist consistorium. This latter appears to be a group portrait in the manner of Melozzo da Forlì's portrait in the Vatican: Julius II as the enthroned Gregory, with Cardinal Giovanni de' Medici (later Leo X) to the left and Alessandro Farnese (later Paul III) to the right. On the opposite wall below the Parnassus are the two grisaille scenes (executed by Giovanni Francesco Penni) representing the stories of ancient Greek and Latin scriptures: Alexander depositing the poems of Homer in the tomb of Achilles, and Emperor Augustus preventing the burning of the *Aeneid*. Below the frescoes was originally a dado of inlaid wood by Fra Giovanni da Verona (cf. the intarsia decorations on the lower level of Duke Federigo's *studiolo*).

The Disputà del Sacramento was the first of the frescoes to be executed. It represents not a dispute, in the literal sense of the word, but a discussion, as the medieval scholastics understood the term, of the cardinal Mystery of the Church, represented in the Monstrance, by the learned church doctors and theologians (below) in the presence of the Trinity, the great prophets and saints (above). Of the many formal and iconographical problems, note the following factors:

1) The remarkable combination of many themes and motifs which are presented in one single unified composition, which can be studied by the comparison with the Glorification of Theology (i.e., St. Thomas Aquinas) as painted by Andrea da Firenze in the Spanish Chapel of Florence, the Last Judgment by Fra Bartolommeo in the Uffizi, and the Holy Trinity as painted by Raphael himself in San Severo, as well as in many altarpieces by Perugino.

2) The general animation of the ''discussion'' through varying gestures, poses and groupings, in contrast to the trancelike saints of the late Quattrocento and related both to the spiritual atmosphere of a *sacra conversazione* and the dramatic action of Leonardo's Last Supper or his Adoration of the Magi.

3) The iconographical significance given to various compositional means, not only in the figure animation but also through the division of upper and lower half (i.e., spiritual and worldly), the linear perspective with the Monstrance at the point of flight (cf. the use of the symbol at this point rather than the more realistic and human representation given by Leonardo in his Last Supper with much the same significance), the aerial perspective in the semicircular array of saints on clouds, the golden rays and group of figures straight down the center (i.e., the Trinity—God-Father, Christ and the Dove of the Holy Spirit) above the Monstrance, Christ accompanied by Mary and John, the Dove flanked by the four Gospels.

4) The realistic identification of figures, notably the Four Church Fathers at the corners of the altar (Gregory, Jerome, Ambrose and Augustine), the portraits of St. Thomas (fifth to the right of the altar), Pope Innocent III, St. Bonaventure (with the cardinal's hat), Pope Sixtus IV next to him, Dante, with his characteristic profile, and Savonarola (profile). The monk's head at the extreme left is probably Fra Angelico, and the new building of St. Peter's is visible

in the distance at the left. The gesturing figure leaning on the stone balustrade at the left is identified as Bramante, the tall youth pointing to the altar may be Francesco Maria della Rovere, nephew of Julius II, and the figure of the seated Pope Gregory the Great, to the left of the altar, has the beardless features of Julius II.

5) The evolution of Raphael's form, which can be followed, here as well as in the other murals, in the many sketches from the nude model, studies in drapery, nude and clothed figure compositions, experiments in light and shade, until a final and perfected composition was reached; the unbelievable degree to which Raphael had achieved that ideal of compositional perfection has led to the identity of the ''classic'' and ''artistic perfection'' through subsequent academic traditions (cf. Ingres).

6) Raphael's unique coloration, which has a rare luminosity in the local color patch and at the same time an even gray tone which gives a compositional unity to the wall and retains its surface decorative value. The recession of one figure behind another, and of the figure groups in three planes up the steps, is aided by the juxtaposition of complementary colors whose bright values are, in turn evenly distributed over the surface as a part of the total color pattern. In contrast to the darker, enclosed hall of the opposite School of Athens, this is open at the top and is accented by a brilliant gold, which might have been called for by the symbolic supremacy of the Christian subject over the accompanying pagan representations.

The School of Athens is the idealization of classical philosophy, as a counterpart to the medieval theology on the opposite wall, their concordance being strictly in keeping with the Renaissance ideals of the church and having its literary parallel in Dante's description of the ancient heroes in the caste (*Inferno*, Canto 4). Represented are Plato, with his *Timaeus*, and Aristotle, in the center, holding his volume of *Ethics*, as the two ancient apostles of the ideal and the practical (cf. their contrasting gestures and their physical characterizations as parallels to the Christian St. Peter and St. Paul). The figures are grouped to the left and right as representations of the theoretical and the empirical sciences (cf. the gesticulating Socrates, the warrior Alcibiades, and Pythagoras writing, with Empedocles looking over his shoulder, in the foreground at the left; to the right, the parallel group of Euclid demonstrating, Ptolemy with the crown,

and Zoroaster with the globe; the skeptic Diogenes reclines on the steps). The portraits of Raphael and Sodama are represented at the extreme right below.

The tall, youthful figure in white at the left is traditionally identified as Francesco Maria della Rovere. The seated figure of Heraclitus, leaning on the block in the left foreground, does not appear in the Milan (Pinacoteca Ambrosiana) cartoon. In view of the fact that the plaster sutures indicate this area to be a later addition and the figure has a definite Michelangelesque character, this has led to the observation that Raphael might have repainted it into a portrait of Michelangelo, whose partially completed Sistine ceiling was seen by the public for the first time on August 14, 1511.

In the composition, note the frieze arrangement of figures across the middle ground, with the two groups to the left and right in the foreground, the reclining Diogenes affording a connection between the two levels; the monumentality of the scene through the towering proportions of the interior, whose three superimposed vaults accent the two central figures. Although there is no direct model for the architectural setting, it may have been inspired by Bramante's plans for the huge vaults of the new St. Peter's or suggested by the triple barrel vaults used in Pinturicchio's Annunciation in the Borgia Apartments, or again by Raphael's own monumental use of architecture (an exterior and plastic form rather than an interior space) in the *Sposalizio* panel (Brera). The impressive monuments of ancient Rome may also have had an influence, i.e., the Basilica of Maxentius and the Baths of Caracalla (note also the classical poses of the niche figures of Apollo and Minerva on either side). As was noted in the development of the Disputà, there exist many sketches, as well as the Ambrosiana cartoon, in which the evolution of the form can be followed.

The two remaining walls, with the Cardinal and Theological Virtues (Fortitude, Prudence, Temperance) and the Parnassus, are designed around the windows; the first, more simply composed, with the three sibyl-like figures and accompanying putti (cf. Michelangelo's sibyls), the second, with some twenty-eight figures grouped around the viol-playing Apollo over the sparsely wooded Mount Parnassus. Many of the characters are easily identified, such as the blind Homer, with Dante and Virgil on either side of him, Sappho in the foreground, Horace, Ovid, Boccaccio, the Muses and

variously identified contemporaries. The date of 1511 is given in the inscription on the window ledge: *Julius II ligur. pont. max. ann. Christ. MDXI. Pontificat. sui. VIII.*

The next room, the Stanza d'Eliodoro, was probably begun in the summer 1511, after the completion of the Stanza della Segnatura; the Mass of Bolsena was finished before November 26, 1512 (from the inscription naming the ninth year of Julius' pontificate), and the liberation of St. Peter is inscribed 1514. On August 1 of that year, Raphael received the last payment. While the Segnatura theme is more spiritual in concept, the theme here is a more politically motivated Triumph of the Church. On the vaults are the four Old Testament scenes, probably painted by Baldassare Peruzzi, representing the Burning Bush, Jacob's Dream, God appearing to Noah, and the Sacrifice of Isaac. The general theme of divine protection and communication is carried out in the frescoes below them, although the original design seems to have called for another content (i.e., possibly scenes from the Apocalypse).

The Expulsion of Heliodorus (from the apocryphal book of 2 Maccabees 3: 14) depicts the expulsion of the King of Syria's treasurer, who sought to seize the gold from the temple, by a radiant horseman and two youths, and has its political significance in the papal victory over the schismatic forces. Pope Julius is represented at the left with a group of portrait figures, including the bearded Marcantonio Raimondi (identified by Vasari) and the self-portrait of Raphael, with the paper in his hand upon which the name of Giovanni Pietro di Foliari was later inscribed. Of stylistic interest, in contrast to the first Stanza, is the particular narrative emphasis on movement, figures receding into space at the left and coming outward at the right; the similarity of the horseman and Heliodorus group with the motifs used in Leonardo's designs for the Battle of Anghiari and the Sforza-Trivulzio monuments, the use of a succession of domes with reflections of light in achieving a deeper space effect and architectural emphasis on the center altar (cf. the School of Athens). There appears to be some variation in the quality of the painting, so that the group of the Pope and his attendants is considered to have been done by Raphael himself, whereas the righthand section was done with the help of assistants (e.g., Giulio Romano and Giovanni da Udine).

The Mass of Bolsena is based on the legend of the miracle

which occurred in the church of Santa Cristina in Bolsena: A German priest doubted the validity of the transubstantiation, and during the Mass one day, the Host overflowed and stained the corporal with the Saviour's Blood. The event was thereafter celebrated in the feast of Corpus Christi, established in the Papal Bull of Urban IV in 1264, which also founded the Cathedral of Orvieto. Pope Julius had visited the reliquary of the corporal kept in the Cathedral of Orvieto on September 7, 1506, and the representation here with himself and his suite before the altar and relic is again to be associated with his victories over the enemies and skeptics of the church, particularly after the Lateran Council of May 3, 1512. Note the similarity of the compositional problem with that of the Parnassus (i.e., over the window), the placement of the altar symmetrically in the center, as in the Disputà, the semicircular choir stalls around it, and the accent of the open arch behind (cf. the School of Athens), the genre figures peering over the choir stalls (note the same motif in Ghirlandaio, Andrea del Sarto), the contrast of action and rest on either side (i.e., the excited gestures of the people at the left, as opposed to the calm serenity of Pope, cardinals and the Swiss Guards at the right). The two figures immediately behind the kneeling Pope to the right are traditionally identified as Cardinal Riario and Cardinal Sangiorgio.

The liberation of St. Peter (Acts 2: 6) may have been associated with the Battle of Ravenna (April 11, 1512), which was decisive in the withdrawal of the French from Italy. More likely, however, it is to be interpreted in general terms of the liberation of the church from its oppressors, in keeping with the other frescoes of the room. The church of St. Peter in Chains (San Pietro in Vincoli) had long been the titular church of the della Rovere cardinals, especially Julius. Of particular note, aside from the continued use of the arch and vault as in the School of Athens, is the striking use of a bright yellow light and darkness, which is not only a matter of the story but compositionally a part of the location: the wall remains in a shadow about the window and is difficult to see when one faces the light. The brilliance of the yellow light in the scene is composed with the darkness of the night background and the shadow in which the wall is seen (cf. the recognition of this in the dark choir stalls of the Mass of Bolsena). Note further the recession of steps and the action of figures to the left and right, the moonlight scene and its own tradition (e.g., the Dream of St. Ursula by Carpaccio, the Dream of Con-

stantine by Piero della Francesca). In this situation there may have been a direct connection, since this wall had been decorated by Piero della Francesca before it was taken over by Raphael. The inscription, *Leo X pont. max. ann. Christ MDXIIII pontificat. sui ii.*, indicates the probable completion of the work in the second year of Leo's reign (Julius died February 20, 1513).

The Meeting of Pope Leo I and Attila (in 452 when Leo I, with the divine intervention of St. Peter and St. Paul, turned back the Huns from their invasion of Italy) is probably a substitute or variation of an original, similar theme involving Julius, but later changed to suit the new Pope, Leo X, who is represented with his suite at the left of the fresco. In keeping with the other walls, the content is probably asssociated with the Battle of Ravenna and the withdrawal of the French troops from Italy after 1512. The mural is a replacement for an earlier decoration by Bramantino representing a series of *condottieri*. In Raphael's composition, note the contrast of papal dignity and pagan chaos on the two sides, the Roman Campagna in the distance, with its Aqueduct, Colosseum and Basilica, rather than the Mincio area near Mantua where the meeting took place, and the general weakness of the execution, which indicates the increased use of assistants in the work. The atmospheric quality of the landscape in the background has frequently suggested Lorenzo Lotto as one of them.

The Stanza dell' Incendio was begun immediately after the Stanza d'Eliodoro, and depicts miracles from the lives of Popes Leo III and Leo IV as related to contemporary events, i.e., Leo X, whose characteristic features appear in each one of the papal representations. A letter of July 1, 1514, from Raphael to his uncle Simone Ciarla mentions the beginning of the work, and a note of June 6, 1517, to Duke Alfonso d'Este from Constabili, his ambassador in Rome, says that Raphael was almost finished. An inscription below the Oath of Leo III fresco names the fourth year of Leo's pontificate, March 19, 1517.

The decoration of the vaults had been painted by Perugino in 1507/8, and represents variations of Christ and God-Father in Glory with angels and saints (medallions). The most important of Raphael's frescoes below them, which were executed, for the most part, by pupils (especially Giulio Romano and Francesco Penni), from his designs, is the Fire in the Borgo. The subject (from the

Liber Pontificalis) refers to the miracle of Leo IV, who, with the sign of the Cross from the Vatican loggia, caused the extinction of a fire in the Saxon quarter (borgo) of the city which threatened the church of St. Peter's. Again, it refers to the defeat of the schismatists, as reflected in the earlier representations of the Stanzas. The burning city and fleeing figures at the left are probably taken from Virgil's description of the Fall of Troy (cf. the famous Aeneas and Anchises group at the left). Noteworthy are the general excitement and action of the figures, composed in three pyramidal groups across the foreground and repeated in the background, the general breaking-up of the architectural setting, as contrasted to the classic unity of the School of Athens, the relegation of the cardinal point of interest (i.e., the figure of Pope Leo in the loggia) to the background, which again emphasizes the element of dramatic excitement over the mystic symbol (cf. the balanced relationship of these two elements in the Disputà).

The remaining walls of the room represent the naval battle of Ostia, in which Leo IV defeated the Saracens in 849, and which probably refers to the contemporary efforts of the Pope in organizing a new crusade against the Turks. Pope Leo IV is represented with the features of Leo X, and is accompanied by Cardinal Bibbieena and Giulio de' Medici, the figures of whom were probably painted by Raphael himself, whereas the figures in the foreground are attributed to Giulio Romano. On the window wall is the Coronation of Charlemagne by Leo III, in which Francis I is represented as the emperor. The allusion is to the peace of October 1515 (i.e., the Concordat of Bologna), by which the French king commits himself to the protection of the Church. Opposite it is the Oath of Leo III, made on December 23, 800 (also taken from the *Liber Pontificalis*), by which he absolves himself of the false charges brought against him by his enemies. Below it is an inscription (*Dei non hominum est Episcopos iudicare*) referring to the old principle of *Unam Sanctam*, or supremacy of the Pope, which had been reiterated by the eleventh Council of the Lateran, December 19, 1516.

The last room, the Sala di Constantino, depicts almost purely historical scenes from the life of Constantine to illustrate the end of paganism and the supremacy of the Church in Rome. The contract for this was probably given to Raphael, but the execution was not carried out until after his death, and was finished by pupils before

September 1524. The last payment for the room was made on July 3, 1525. The most important fresco, and the best of the series, is the Battle of Constantine against Maxentius, which probably goes back to a drawing or rough sketch by Raphael himself. As a battle scene, it is interesting in being related to Leonardo's Battle of Anghiari, with its compact fighting groups, but is expanded into a panorama of a sweeping landscape with masses of small and actively moving figures. The other main scenes represent the Vision of the Cross, the Gift of Rome to the Papacy and the Baptism of Constantine, executed largely by Giulio Romano, Gianfrancesco Penni and Raffaellino del Colle.

Raphael's cartoons for the tapestries of the Vatican rank second only to the frescoes of the Stanzas in artistic importance. They were done between 1515 and the end of 1516, from the recorded payments of June 15, 1515, and December 20, 1516. The costly tapestries themselves were executed in Brussels, in the workshop of Pieter van Aelst. Of the original ten, which, for the most part, are based on Raphael's designs and were carried out in color under his supervision, seven are extant in the Victoria and Albert museum of London. They were painted in distemper on paper and mounted on canvas in the late seventeenth century. On the 26th of December, 1519, in honor of the Feast of St. Stephen, seven of the completed tapestries were hung in the Sistine Chapel.

They represent scenes from the lives of St. Peter, St. Paul and St. Stephen, and were originally hung below the Quattrocento frescoes on either side of the chapel in a concordance in keeping with the general narrative didactic system used throughout the decoration. To the left, in chronological sequence toward the altar, were: the Miraculous Draught of Fishes, the Death of Ananias, the Healing of the Lame Man, Christ Giving the Keys to St. Peter, and the Stoning of St. Stephen. On the opposite wall to the right were the parallel stories of St. Paul: the Conversion of St. Paul, the Blinding of Elymas, the Sacrifice at Lystra, the Preaching of St. Paul in Athens, and St. in Prison. Some of the tapestries have been cut down and the borders with frieze decorations lost. Their color has faded considerably and the original sheen of the gold is lost, so that the cartoon gives a better conception of their former appearance and style. A good many early copies in tapestry are extant in the museums of Berlin, Vienna, Dresden and Madrid.

The style parallels that of the Stanza d'Eliodoro, which was being painted at the same time. Several features might be particularly noticed, such a the enrichment of the Christ Giving the Keys theme (cf. Perugino's fresco in the Sistine Chapel) by the isolation of Christ from His devout disciples, and His gestures which combine a spiritual "distance" similar to the *Noli me tangere* with the charge to "Feed My Sheep." Note further the increased action in the large and muscular figures, their organization into monumental groups, the the breaking-up of the architectural forms and settings as a counterpart to this action, with much the same dramatic purpose as was noticed in the Fire in the Borgo fresco (cf. the Sacrifice at Lystra, the Preaching of St. Paul in Athens). Related to the style of the tapestries are the lost compositions (the Preaching of Christ, the Last Supper, and the Slaughter of the Innocents), which are known through the engravings of Marcantonio Raimondi.

Of Raphael's fresco decorations in the Villa Farnesina for Agostino Chigi, the first and most important is the Triumph of Galatea (from Poliziano's *Giostra*). The dating has been something of a problem, since in concept it appears to be earlier, i.e., ca. 1511/12, yet it may be later, possibly 1514, as can be inferred from an undated letter of Raphael's to Baldassare Castiglione in which he speaks both of the Galatea fresco and of his work on the building of St. Peter's. The composition and sections of the actual painting appear to be his own, but there is also evidence of Giulio Romano's participation, particularly in the Galatea figure. It is significant both as reflecting Raphael's own lyric, yet monumental interpretation of classical antiquity, inspired as it was by the Florentine humanists, and as a remarkable High Renaissance contrast to the similar motif by Botticelli (the Birth of Venus).

The second series in the Villa Farnesina is the Loggia of Psyche, which was executed for the most part in 1517 by Raphael's pupils, Giulio Romano and Gianfrancesco Penni. The fruit garlands that frame the scenes were painted by Giovanni da Udine. A letter of January 1, 1519, written by Michelangelo's friend, Leonardo Sellaio, speaks of the frescoes as being finished and worse than the last ones of the Stanzas, which reflects much of the well-known enmity between the two groups of artists (i.e., Michelangelo and Raphael). They represent the story of Psyche and Amor, from the legend told in the *Golden Ass* of Apuleius. The two main scenes on

416

the ceiling depict, in friezelike fashion, the Council of the Gods, with Jupiter sitting in judgment on the right, with Diana, Juno and Pallas on one side of him while Neptune, Vulcan and Mars are aligned on the other. Before him, Venus accuses Psyche, who is defended by Cupid while Apollo, Hercules and the host of other deities look on. The Wedding Feast features Jupiter flanked by Psyche and Cupid at the banquet table, extended into a frieze of standing gods and the dancing Venus at the left. These form the climax, as it were, of the legend itself, which is told in the series of ten spandrels and eight lunettes featuring the participating divinities in the Victory of Love in a total decorative scheme somewhat resembling that of Michelangelo's Sistine ceiling. For Raphael's skill in composing figures in space within the spandrel frame, note particularly the Cupid and the Three Graces, and the Mercury.

The frescoes of the loggia of the Vatican were probably begun in 1517 and completed in the summer 1519, almost totally by Raphael's pupils, chiefly Giulio Romano, Gianfrecesco Penni, Giovanni da Udine and Perino del Vaga. The fifty-two scenes in the vaults are taken mostly from the Old Testament (four scenes from the New Testament) and are strongly influenced by Michelangelo's motifs on the Sistine ceiling (note particularly the frescoes of God Separating Light from Darkness, the Expulsion from Paradise and the Last Supper). Historically important, and probably stimulated by the archaeological interests of Raphael, are the decorative motifs on the pilasters, comprising countless grotesques, battle scenes, centaurs, gods and goddesses, that are taken directly from ancient architectural and sculptural ruins (e.g., the newly discovered Baths of Titus). These were done not only in fresco and in color, but also in grisaille and bronze-color in imitation of sculptural relief, as well as in actual plaster relief.

The expansion of this archaeological interest into larger and more frankly pagan decoration can be seen in the frescoes of Cardinal Bibbiena's bathroom (1516ff.) in the Vatican, representing such scenes as the Birth of Venus, the Birth of Ericthonius, Venus and Adonis, Jupiter and Antiope.

Raphael's development as a portraitist during the Roman period can best be studied in the portraits of his two famous patrons. That of Julius II (Uffizi Gallery) was painted ca. 1511/12 and, according to Vasari, given to the church of Santa Maria del Popolo in Rome. A

417

copy of the same picture was probably painted by Titian for Duke Guidobaldo II (della Rovere) of Urbino in 1546, and is in the Palazzo Pitti of Florence. The characteristic features of the Pope are to be recognized in the various representations of him in the Stanza della Segnatura. The composition is a logical development of the earlier portrait of Angelo Doni, which in turn was based on Leonardo. Note the expansion from a half- to a three-quarter-length portrait; the same composition of head, shoulders and arms in a pyramid form turned to the right but more freely and plastically built into the space, hence the use of an armchair, rather than the picture frame or balustrade, as a support for the arms of the portrayed; Raphael's characteristic clarity and perfection of outline defining the forms, as compared to the Venetian richness and luminosity of color in the Pitti variation.

Perhaps Raphael's most famous portrait is that of Leo X (Uffizi Gallery), in which he is presented in the company of his two nephews of the College of Cardinals, Giulio de' Medici (later Pope Clement VII) at the left and Lodovico de' Rossi at the right. It was probably painted between 1517 and 1519, since Lodovico was not named cardinal until July 1, 1517, and died August 19, 1519. Concerning the iconography and style, note: the characteristic features of the Pope represented in the Stanze frescoes; in contrast to the portrait of Julius II, the expansion of the subject into a scene with the Pope seated at a table before a book (which has been identified with a fourteenth-century Neapolitan illuminated gospel in the Kupferstichkabinett of Berlin) and accompanied by two of his family, who are cardinals as well. Hence, it has elements of a group portrait, as in Mantegna's Gonzaga frescoes, the accompanying figures of which are composd as attributes of imperial dignity in a manner similar to the Early Christian and Byzantine court officials and *silentiarii* that are placed behind the enthroned emperor or consul. The same motif of accompanying cardinals is used in the fresco scene in the Stanza della Segnatura representing Pope Gregory IX handing the decretals to the consistory, which in turn was related to Melozzo da Forli's group portrait of Sixtus IV. The combination of personal character portrayal, the traditional requirements of group representation and an allegorical dignity that is achieved through the classic monumental form of Raphael's mature style makes this one of the most significant portraits of the Renaissance.

Among the other well-known portraits which might be mentioned are the Portrait of a Cardinal in the Prado of Madrid, painted 1510/11 (hence before the Julius portrait); the portrait (1512) of Tommaso Inghirami, Papal Librarian and Secretary to the 1512 Lateran Council (in the Palazzo Pitti), of which there is a replica, presumably by Raphael's own hand, in the Isabella Stewart Gardner Museum in Boston; the portrait of Raphael's friend, Baldassare Castiglione, in the Louvre (ca. 1515/16), which already shows a greater elaboration of decorative detail in the costume of the figure; the portrait of Jeanne d'Aragon, which was commissioned in 1518 by Cardinal Bibbiena, the papal legate to Brance, as a gift to Francis I and executed in great part by Giulio Romano, although the head, according to Vasari, was painted by Raphael himself. Of interest here is the prominence given to elaborate costume and the interior space, and the general courtly elegance, characteristic of the later manneristic style. The famous Donna Velata (Lady with the Veil), in the Palazzo Pitti, is, stylistically, a parallel to the Castiglione and probably represents the same model, the beautiful Fornarina (baker's daughter) mentioned by Vasari as Raphael's mistress, used in the Sistine Madonna and the St. Cecilia now in the Bologna Pinacoteca Nazionale.

Raphael's altarpieces, within the limitation of their respective forms, show a parallel development. A more concentrated and direct expression can be noted in those of smaller format: the Madonna Alba, 1508/10, in the National Gallery of Washington; the Madonna del Diadema, ca. 1510, in the Louvre; the Madonna della Sedia, ca. 1516, in the Palazzo Pitti; and the Madonna della Tenda, ca. 1516, in the Alte Pinakothek of Munich.

Of the larger altars, the Madonna di Foligno represents a remarkable contrast in spirit and form to his Madonna del Baldacchino painted only a few years earlier. The altar was commissioned by Sigismondo de' Conti, the secretary to Julius II, supposedly as a thank offering because his house had been saved after being struck by lightning, and was probably completed before the death of the donor in February 1512. Originally, it decorated the high altar of Santa Maria in Aracoeli, Rome, in the choir of which the donor was buried. In 1565, his niece, the abbess of St. Anna in Foligno, transferred the panel to the church of Sant' Anna in Foligno. The transfer of the painting to canvas was done after 1797, when it was

taken to Paris during the period of French occupation.

The compositon shows the same iconographical elements of the late Quattrocento which he had used in the Madonna del Baldacchino, but which are here recomposed with the artistic means of the High Renaissance, again under the influence of Leonardo. Note the Madonna enthroned on clouds and accented by a halo instead of a throne and baldachin, the more unified arrangement of adoring figures kneeling and standing to form part of an oval while still retaining the traditional separation of the Vision and the worshipers, i.e., Saints John the Baptist, Francis, Jerome and the donor. The asymmetrical pose of the Virgin is related to that used by Leonardo in the Adoration of the Magi; the pointing hand is taken from Leonardo's St. John and had been used in the Disputà. Significant, too, is the compositon of the figures in a unified space through light and perspective, as well as through the gaze and gestures of these adorers, including the angel in the center. Their eyes are directed toward the Vision which hovers over the space betwen them. Note the crossed diagonal paths on the ground leading to the distant atmospheric view of the town of Foligno (this landscape, however, was probably repainted later by Dosso Dossi). The active poses of the Virgin and Child are similar to those with which Raphael had experimented so many times in his drawings and Madonna panels, and had used in the fresco of the Virtues of the Stanza della Segnatura, and again, in more elaborate form, with the sibyls of the Cappella Chigi in Santa Maria della Pace, Rome.

The frescoes of these four sibyls (Cumaean, Persian, Phrygian and Tiburtine) with the prophets above (Hosea, Jonah, David and Daniel) and their attendant angels, were commissioned by Agostino Chigi as a kind of architectural decoration over the arch of his chapel facing the nave of Santa Maria della Pace and were probably executed in 1514. Although badly deteriorated, especially the prophets on the upper level (see the engravings made from them by Giovanni Battista Volpato), they show an obvious relationship with Michelangelo's figures in the Sistine Chapel, but, on the other hand, they reveal a thoroughly integrated character much more closely associated with his own Madonna and figure drawings done from models during this same period.

The seated figure of the prophet Isaiah in Sant' Agostino, Rome, though damaged and much restored, shows even more

strongly the direct influence of Michelangelo's prophets. This fresco, decorating a pier in the nave of the church, was commissioned by the apostolic Pronotary, Johann Goritz of Luxemburg, and painted between 1511 and 1512, therefore shortly after the initial opening of the Sistine Chapel. Goritz's name is given in the Greek dedication to St. Anne and the Virgin on the plaque at the top, while a passage from Isaiah (26:2), "Open ye the gates, that the righteous nation which keepeth the truth may enter in," is inscribed in Hebrew on the scroll. Copies of the two putti (one of which is preserved in the Accademia di San Lucca in Rome) were ordered by Julius II, which again indicates a dating before Julius's death in 1513.

The Sistine Madonna, in the Dresden Gemäldegalerie, doubtless the most famous single altarpiece of the entire Renaissance, is a logical development and simplification of the formal elements noted in the Madonna di Foligno, and was probably painted only a short time afterward. The actual date is uncertain; Vasari says it was painted for the monks of San Sisto in Piacenza, but the real intention was probably as an expression of papal blessing on the people of Piacenza for their acceptance of papal rule when the city came under the political control of the church in 1512. The church of San Sisto, moreover, had just gone through a period of extensive renovation (1499-1511). Significantly, St. Sixtus is given as Sixtus IV, who intercedes with the Virgin for the worshiper; St. Barbara occupies the similar position on the other side. Unusual is the fact that the canvas was undoubtedly painted by Raphael himself, which indicates a relatively early dating (i.e., ca. 1512-1514), since the later work was, for the most part, done by his assistants. The fact that Sixtus IV is represented as intermediary suggests the probability that the picture was ordered by Julius II (della Rovere); hence, again, the earlier dating, before his death in 1513. These same factors have also suggested the possibility that the altar was intended as a funeral *velarium* for Pope Julius before it was taken to Piacenza.

In the analysis of the style, note the simplification of the traditional Madonna and Saints (*sacra conversazione*) theme to a monumental three-figured group with only the two angels and the balustrade (which has also been interpreted as the lid of the Pope's coffin), giving a suggestion of an earthly realm; the continuity of the visionary image as it appears in the Vision of St. Bernard altars by

Filippino Lipi and Fra Bartolommeo, and the Virgin in Michelangelo's new studies for the tomb of Julius (1513); the clarity of the surface design, with the curtains, the outline of the figures against the luminous atmospheric heavens (enlivened with hazy heads of angels, as in the Foligno altar), and the graceful flow of the drapery; the solid forms, yet rich color of the figures, in their gold, red, blue, green and purple, against the light background, and framed by the green curtains; the contrasting inward and outward gestures and movement of the two side figures (cf. the contemporary Expulsion of Heliodorus). Between these and the curtains, the Madonna appears to move forward into the space. The illusion is further increased by the two angels leaning on the balustrade, looking up at St. Barbara and the Madonna (cf. this angel motif as used in the Madonna del Baldacchino, where they simply stand in front of the throne, and in the Madonna di Foligno, where the angel looks up at the Virgin). The same illusionism through perspective and association had appeared in Mantegna's ceiling decorations of the Bridal Chamber in Mantua. A similar psychological effect, i.e., an illusion of movement through the optical fixation of figures, was noted in the fresco Coronation of the Virgin by Fra Angelico in the monastery of San Marco.

The St. Cecilia altar, in the Pinacoteca Nazionale of Bologna, belongs to this same period as another *sacra conversazione*, related to the classical Galatea fresco on the one hand and to the devotional visions of the Foligno and Sistine Madonnas on the other. It was commissioned in 1514 by Lorenzo Pucci, Cardinal of SS. Quattro Coronati, for the Cappella di Santa Cecilia in the church of San Giovanni in Monte, Bologna, which was constructed by a Bolognese noblewoman, Elena Duglioli dall' Olio, in 1513, and where, according to Vasari, she was later buried. Represented, in a kind of *cantoria* compositon, are Saints Paul and John, Augustine, and Mary Magdalene on either side of St. Cecilia, with a remarkable still life of silent musical instruments (painted, Vasari says, by Giovanni da Udine) and the chorus of heavenly singers in the circle above.

The most important of Raphael's late altarpieces is the Transfiguration, in the Pinacoteca Vaticana. The panel was ordered by Cardinal Giulio de' Medici (later Pope Clement VII) for the cathedral of his archepiscopal see at Narbonne in January 1517, at the same time as he had ordered a Raising of Lazarus (now in the Na-

tional Gallery of London) from Sebastiano del Piombo. In the apparent competition and rivalry, Sebastiano seems to have finished his first, and his picture is referred to by Marc' Antonio Michiel in May 1519 as completed. Also, a letter of Sebastiano's to Michelangelo, dated April 12, 1520, mentions Raphael's nearly finished picture. In 1522, Giulio Romano appealed to the Cardinal through Catiglione for a payment for his work on the picture, and a Raphael pupil, Baviera, was paid for gilding the frame on September 18, 1524. At this time, it was placed on the high altar of San Pietro in Montorio, Rome. The character of the upper half of the panel indicates the execution by Raphael himself, whereas the manneristic gestures, dark shadows and sharp color contrasts of the lower section, although based on Raphael's drawing, reveal rather the style of Giulio Romano.

In keeping with Raphael's late style, however, and characteristic of the transition to the new mannerism of his school and followers, note the complexity of the composition, whereby the division of upper and lower parts (cf. his early Coronation of the Virgin) is retained as in the Disputà, but the two halves are composed together by the pyramidal form of the whole, as well as by the numerous gestures of the figures. In the presentation of the mystic vision (Matthew 27: 1-6), Raphael has introduced the episode of the epileptic boy (Mark 9: 17) to dramatize the scene, with the resulting excitement and gestures of the individual figures which are distorted further for compositional purposes (cf. Titian's Assumption in Santa Maria dei Frari, Venice). An interesting detail is the presence at the left of the mount of the two martyr saints Felicissimus and Agapitus on whose day Pope Calixtus III had set the Feast of the Transfiguration (August 6, 1457) in honor of the victory of the Christians over the Turks at Belgrade (1456). The revival of the theme in 1517 is probably associated with the renewed danger from invasion by the Turks, especially at Narbonne, that same year.

Raphael's ideas and character as an architect probably have their origin in Urbino and Luciano da Laurana's designs for the Palazzo Ducale there. His architectural conception of space is evident in his *Sposalizio* and can be traced through the Stanzas. The practical concern with architectural design appears in 1514 when as mentioned before, he was appointed directing architect of St. Peter's. His development in the Bramante tradition can be seen in

the Palazzo Vidoni-Caffarelli and the Villa Madama in Rome, and the Palazo Pandolfini in Florence, as well as in a number of unexecuted designs for St. Peter's in which the classic and well-articulated balance of monumental spaces and forms is evident.

Giulio Romano (Giulio Pippi, 1499-1546) is the most outstanding of Raphael's pupils and co-workers active in his shop, which in its scale, organization and division of labor involved many of the features of Peter Paul Rubens' famous workshop a century later (without, however, the driving personality which dominated the circle of the great Fleming). Giulio had assisted Raphael on most of the later decorative frescoes in the Vatican and Villa Farnesina, then was active in Mantua, from 1524 until his death, in the service of the Duke of Mantua, as architect and decorator: the Palazzo del Tè, the decorations of the Sala del Zodiaco and the Sala di Troia in the Palazzo Ducale.

Giovanni Francesco Penni (also Gianfrancesco Penni, called Il Fattore, ca. 1488-ca. 1540) was, according to Vasari, another favorite assistant of Raphael's, who had worked on the Constantine and Loggia frescoes and then with Giulio Romano on frescoes in the Massimi Chapel of SS. Trinita de' Monti in Rome, of which a detached fragment of St. Mary Magdalene is in the National Gallery of London.

Perino del Vaga (Pietro Buonaccorsi, 1501-1547) had assisted on the decoration of the Loggias and remained in Rome until 1527, when he went to Genoa to work on the fresco decoration of the Palazzo Doria (1528 ff.). He thus became the chief representative of Roman Mannerism in Genoa. Thereafter, he returned to Rome, where his most important work was the decoration of the Salone del Consiglio (Sala Paolina) in the Castel Sant' Angelo with fresco scenes from the history of Alexander the Great.

Raffaello dal Colle (ca. 1490-1566) came from Città di Castello and had assisted Raphael on the Farnesina frescoes, as well as the Loggia. He worked with Giulio Romano on altarpieces in the Raphael manner, before returning to Sansepolcro (a Resurrection in the Cathedral of Sansepolcro). The Madonna della Rosa and the

Madonna of the Oak of ca. 1519/20, in the Prado Museum of Madrid, have been attributed to Raphael, but are most likely to have been painted by Raffaello on Giulio Romano's designs.

Giovanni da Udine (1487-1564) had been a pupil of Giovanni Martini da Udine, then had worked with Giorgione before he went to Rome with a letter of recommendation from Domenico Grimani, a friend of his father's, to Baldassare Castiglione. Vasari describes his skill in still-life painting, which he learned from a Flemish ''Giovanni'' in Raphael's circle, and credits him with the execution of the still-life of musical instruments and the organ in Raphael's St. Cecilia compositon. Giovanni is also credited with many of the *grottesche* decorations, based on those newly discovered in the Baths of Titus, and worked with Raphael on the Farnesina Psyche and the Loggia. The general design for the decoration of the Sala dei Pontefici in the Vatican (ca. 1521 ff.) was probably done by Giovanni but executed largely by Perino del Vaga.

Marcantonio Raimondi (ca. 1475-1534) is important as an engraver active in Raphael's shop and as the means by which Raphael's compositional ideas and style were spread far beyond the confines of his immediate circle.

He was born in Bologna and had been a pupil of the painter and goldsmith Francesco Francia. In his earlier work, he was influenced by Albrecht Dürer, and indeed made direct copies of that artist's work. For a time he was in Venice and Florence, then appears in Rome after 1510. Chief among the many engravings based on Raphael's work, and probably executed under his supervision, are the Slaughter of the Innocents, the Judgment of Paris, and the Apollo and the Muses. After the Sack of Rome in 1527, he returned to Bologna, and continued there until his death.

Michelangelo (Michelaniolo di Lodovico di Lionardo di Buonarroto Simoni, 1475-1564) appears related, in his point of view, to that of Leonardo da Vinci, but in his development of dramatic expression he moved beyond the scientific limitations of the skeptic and analyst. Where Leonardo's production reveals the unlimited possibilities of expression in every conceivable phase of reality, Michelangelo saw those possibilities primarily in the human figure.

The tragedy of Leonardo lies in his breadth of vision and the inadequacy of an artistic medium to express it. The tragedy of Michelangelo lies in the magnitude of his own artistic conception and the inability of a society or patron to bring about its realization. The structural unity of his style is rooted in the craft and aesthetics of the sculptor and is the basic principle which he applied to painting and architecture as well. In his liberation of the spirit and personality from science, and in his almost unbounded, imperious ambition, he is a parallel to the great political visionaries among his contemporaries, such as Julius II and Charles V. As Leonardo was the focal point in the development of the High Renaissance, so does Michelangelo represent a concordance of aesthetic principles with those of the early Middle Ages—the Renaissance of Classic and Christian Antiquity—as well as the point of departure for the new art of the Baroque.

Michelangelo was born March 6, 1475, in Caprese, Casentino, the second of six sons born to Francesca di Neri di Miniato del Sera and Lodovico di Leonardo Simoni (1444-1534), a respected citizen who had been *Podestà* in Caprese and Chiusi. The family claimed to be descendants of the Ghibelline counts of Canossa, whose ancestor, Beatrice, was the sister of Emperor Henry II, a claim which was authenticated to Michelangelo by the Count of Canossa in 1520, but for which there is no convincing documentary evidence. The father first placed the youth in the Latin school of Francesco da Urbino; then, probably through the influence of his young friend, Francesco Granacci, an apprentice of Ghirlandaio's, Michelangelo entered the shop of Domenico and Davide Ghirlandaio in April, 1488. Various drawings are mentioned by Vasari and Condivi as having been made by Michelangelo after sketches by unknown old masters, after Ghirlandaio and Schongauer engravings (Temptation of St. Anthony) and of the scaffolding set up for the building of Santa Maria Novella. These are now lost, but are significant as indications of Michelangelo's varied activity and interests during these early years.

In 1489, probably in the spring, he entered the academy directed by the sculptor, Bertoldo di Giovanni (ca. 1420-1491) in the Medici gardens near San Marco, which was patronized by Lorenzo il Magnifico, for whose collection of classical sculpture Bertoldo was employed as custodian. Bertoldo, a pupil of Donatello, is known

chiefly for his bronze reliefs (a Battle Scene, ca. 1480-1490, in the Museo Nazionale del Bargello, Florence), medals and statuettes, and had little perceptible influence on the young sculptor. Michelangelo, at an early date, seems to have won the respect of Lorenzo de' Medici, and lived as guest at the Medicean household (1490-1492) in company with such scholars as Angelo Poliziano, Luigi Pulci, Pico della Mirandola, Marsiglio Ficino, and other humanists of the Platonic academy. It is in this social and intellectual environment that the basic principles of Michelangelo's Christian Platonism seem to have first taken root. Among the young painters and sculptors patronized at Lorenzo's academy, aside from Michelangelo and Francesco Granacci, were Giovanni Francesco Rustici, Pietro Torrigiani, Lorenzo di Credi, Giuliano Bugiardini, Niccolò Tribolo, Baccio da Montelupo and Andrea Sansovino. It was in an argument with the envious Pietro Torrigiani, as described by Vasari, that Michelangelo suffered the broken nose which marked him for life.

Lorenzo died in April 1492, and Michelangelo returned to his family home and began to work on a free-standing over-life-size marble statue of Hercules, which was probably finished by 1494 and sold by the Strozzi family in 1529 to Francis I of France. It remained in the garden of Fontainebleau, the *Jardin de l'Etang*, until some time before 1731. It is now lost, but its *contrapposto* character is known through a 1649 engraving by Israel Silvestre and similar poses in contemporary Quattrocento Hercules figures based on the classical Lysippus type, such as the small bronze by Bertoldo di Giovanni, in the J. W. Fredericks Collection. The Hague, and a Ghirlandaio school drawing in the *Codex Escurialensis*. At the same time, there was executed a slightly less than life-size wooden Crucifix for the prior of Santo Spirito in Florence (now lost). The influence of this new *contrapposto* form might be seen in the twisted figure of Christ in Perugino's fresco in Santa Maria Maddalena dei Pazzi, 1493, and is continued in other Crucifixion figures of the late Quattrocento and early Cinquecento in Florence. The execution of many anatomical studies and drawings during this period indicates Michelangelo's interest in the study of nature directly from the model, as well as from antiquity, and of the great realists of the Florentine tradition, i.e., Giotto, Masaccio and Donatello.

In October 1494, shortly before the expulsion of the Medici, Michelangelo left Florence and went to Venice via Bologna, and

then returned to Bologna to remain as the guest of Gianfrancesco Aldovrandi until the spring of the following year. He executed several statuettes for the shrine of San Domenico there, and had occasion to study particularly the reliefs and statues of Jacopo della Quercia on the main portal of San Petronio.

In the summer of 1495, Michelangelo returned to Florence and executed a San Giovannino and a Sleeping Cupid, the latter, according to Vasari, an intentional forgery of a classical figure which was sold as an original to a Roman collector of antiquities, Cardinal Raffael Riario. The discovery of the forgery was said to have aroused much admiration in the cardinal for Michelangelo's ability and brought about his invitation to Rome.

In June 1496, he arrived in Rome with letters of recommendation from Lorenzo di Pier Francesco de' Medici to Cardinal Riario. He remained until the spring of 1501. There were four recorded (Vasari and Condivi) works: a design for a painting of St. Francis Receiving the Stigmata (lost); a Cupid for Jacopo Galli (lost, though often identified with the Kneeling Cupid in the Victoria and Albert Museum, London); the Bacchus, in Florence; and the Pietà group, in St. Peter's.

In June of 1501, he returned to Florence. The influence of Leonardo's St. Anne, the Virgin and Child was shown in the various sketches of the Holy Family (Ashmolean Museum, Oxford, the Louvre, Paris, and the British Museum, London). He signed a contract with Cardinal Francesco Piccolomini in June 1501 for fifteen figures intended for the Piccolomini altar in Siena (only partially fulfilled—four figures delivered, and these mostly executed by helpers, possibly Baccio da Montelupo). He also worked on a bronze David in the manner of Donatello's David figure (now lost, but known through drawings), the twelve apostles for the choir chapels of the Cathedral of Florence (April 1503), the marble David (August 1501), and the Battle of Cascina fresco (August 1504) for the Sala del Consiglio of the Palazzo Vecchio. The marble Bruges Madonna and the painted tondo with the Holy Family (the Doni Madonna) belong to this period.

In March 1505, Michelangelo was called to Rome by Pope Julius II and given a contract for the marble tomb of Julius. He then went to Carrara, to select the marble to be used, and returned to Rome in December. During the interim, Julius had given up his

plan for the tomb in favor of the decoration of the Sistine Chapel ceiling. Michelangelo, incensed at the refusal of the Pope to receive him at the court, left Rome for Florence in April 1506.

From April to November 1506, he remained in Florence and executed several marble Madonna tondos (in the Bargello and the Royal Academy, London) and the St. Matthew; then he was reconciled with Julius at a meeting in Bologna, late in November. There, he received a contract for a seated bronze statue of Pope Julius, for which a wax model was made in April 1507, and the finished bronze set up over the main portal of San Petronio in February 1508. The figure was destroyed by the rival Bentivogli on their return to Bologna in 1511. Probable variations of this pose are to be found in Manganti's seated statue of Pope Gregory XIII (1578, Palazzo Pubblico, Bologna) and Michelangelo's prophet figures on the Sistine ceiling.

In March or April 1508, he returned to Rome, and received a contract from Pope Julius to decorate the ceiling of the Sistine Chapel. Work was begun in May 1508, and finished in October 1512. Julius died in February 1513, and in May there followed a second contract with his heirs for the completion of the tomb. A new contract and changed plans were drawn up in July 1516.

In September or October 1516, he was back in Florence and probably began his designs and models for the façade of San Lorenzo for Pope Leo X, on the basis of which a contract was signed in January 1518, then dissolved in 1520 for lack of funds. Considerable time was spent during 1516 and 1517 in Carrera, and during 1518 and 1519 in Pietrasanta, where new marble quarries were opened in competition with those of Carrera, getting marble for the San Lorenzo façade and the Julius tomb. During this period, he produced designs for the first-floor windows of the Medici palace in Florence (1513-1514), sketches for an altar and tomb in San Silvestro in Capite (1518) and the marble figure of Christ for Santa Maria sopra Minerva (1519-21) which was completed by Federigo Frizzi.

From November 1520, until the fall of 1534, Michelangelo was at work on the Medici Chapel in Florence. During the same period, many other designs and projects were started: these include sketches for the papal tombs of Leo X and Clement VII to be placed in San Lorenzo (June 1524); work on a new plan for the Julius

tomb; designs for a proposed statue to be placed at the entrance of the Palazzo Vecchio as a companion piece to the David (a Hercules and Antaeus group, 1525), which project was finally rejected in favor of a group by Bandinelli (Hercules and Cacus, completed in 1534); the plan of a ciborium (October 1525) for the choir of San Lorenzo, later given up (1531) in favor of a tribune over the main portal of that church.

In October 1528, Michelangelo was active on the building of fortifications for the city of Florence in its defense effort against Charles V and Pope Clement VII. In January 1529, he was made a member of the fortification commission, and on April 6 was appointed Procurator-General of Fortifications. He was sent to Ferrara by the Signoria to study the fortifications there, and was received with great respect by Duke Alfonso d'Este, for whom Michelangelo, at his request, later executed a Leda (in 1530), now lost but known through Michelangelo's drawings and numerous engravings made after it.

On September 25, 1529, fearing treachery, Michelangelo escaped from Florence to Ferrara and Venice, intending eventually to go to France. Five days later, he was proclaimed a "rebel" by the Signoria, but was pardoned and returned to Florence in November. After the fall of Florence (August 12, 1530), Michelangelo again received papal favor, and continued with the Medici tombs. During the ensuing years, Michelangelo prepared cartoons for a Venus and Cupid (completed in 1530) and a *Noli me tangere* (1531), which were painted by Pontormo; a marble Apollo for Baccio Valori, the papal commissioner at Florence; a design for a tomb for Cardinal Cibo; the reliquary tribune (1531-1533) over the main portal of San Lorenzo, with an Ascension of Christ, probably intended for the lunette; and renewed work on the tomb of Julius.

In Rome, in April 1532, Michelangelo became acquainted with the handsome young nobleman Tommaso Cavalieri, whose friendship he prized until his death, and to whom he dedicated many extravagantly ardent love sonnets, as well as drawings of an allegorical nature. Of these the Ganymede, Tityus, and the Fall of Phaethon, all of 1533, are the most important.

In the fall of 1534, or early the next spring, Michelangelo received the commission from Clement VII to paint the Last Judgment, which was finished by October 1541. During this same

period, he produced the marble bust of Brutus (1537/8) and developed the association with Vittoria Colonna, widow of the Marchese di Pescara, through whom Michelangelo became acquainted with the ideas of religious reform propounded by Cardinal Reginald Pole, Fra Bernardino Ochino and their group. The close platonic friendship with Vittoria lasted until her death in February 1547, and was reflected in his sonnets dedicated to her and in various designs for marble and painted works done probably for her: Christ and the Woman of Samaria, Christ Takes Leave of Mary, and several Crucifixion groups.

In 1541, shortly after the completion of the Last Judgment, he received a contract from Pope Paul III for the decoration of the Cappella Paolina. The next year, he renewed work on the Julius tomb, which he completed in 1545, and made designs for tombs of Cecchino Bracci and Paul III. During this time began Michelangelo's activity as an architect for Paul III, succeeding Antonio da Sangallo, who died in October 1546.

In January 1547, Michelangelo was named directing architect of St. Peter's; then follows the long struggle with his opponents, who attempted to carry through Sangallo's plan. Aside from the building of St. Peter's, many other architectural plans and designs for religious subjects occupied him in Rome until his death, February 18, 1564. The important architectural works of this period include the design for the completion of the façade and the court of the Palazzo Farnese; the plans (1546 ff.) for the court and palaces of the Campidoglio surrounding the ancient bronze equestrian statue of Marcus Aurelius; the design and model for the church of San Giovanni dei Fiorentini (1550-1559); a contract for the Porta Pia (1561); plans for the reconstruction of the Baths of Diocletian into the church of Santa Maria degli Angeli (1563). The two significant sculpture works left unfinished from this late period are the Pietà, in the Cathedral of Florence, and the Rondanini Pietà.

Michelangelo died on February 18, 1564, and was officially buried in the Chiesa degli Apostoli in Rome, but his body was secretly removed shortly afterward, and buried with all honors on March 11, 1564, in the church of Santa Croce in Florence.

Michelangelo's early drawings, how in the Louvre, the Vienna Albertina and the Munich Staatliche Graphische Sammlung, of figures in Giotto's Ascension of St. John in Santa Croce and of

431

Masaccio's Brancacci Chapel, as well as those now in the Musée Condé of Chantilly with studies from the actual model and classical Venus figures, reveal his interest in the strong, monumental form existent in old masters of the Florentine tradition, in classical antiquity, and in nature itself. These drawings were probably done while he was still in Ghirlandaio's shop. Note the use of cross-hatching, not common to previous drawings in Florence (cf. Pollaiuolo) and inspired, possibly, by the Schongauer Temptation of St. Anthony, the engraving which Michelangelo is said to have copied. Note, too, the study of the Venus statue from two sides, the arms left off so as not to detract from the modeling of the torso. The same combination of interests in the figure and its self-contained action appears to have been evident in the lost Hercules and the wooden Crucifux which he is recorded as having carved for the prior of Santo Spirito (cf., by contrast, the weak modeling and action in the recently discovered Crucifix in Santo Spirito, which is smaller in size but associated with the lost original and attributed to Michelangelo). It is assumed that this figure was responsible for the development of the new *contrapposto*-type Crucifix in Florentine painting and sculpture of the succeeding decades.

Other surviving works of this early period show similar characteristics. The Madonna of the Stairs, a low relief in marble, in the Casa Buonarroti of Florence, was executed in 1493, possibly on the basis of Donatello's flat relief of a seated Madonna in the Clouds, now in the Boston Museum of Fine Arts. Note particularly the heavy forms and verticle proportions of Michelangelo's composition, so that the figure has almost the solemn and prophetic quality of a classical sibyl. A similar mood can be seen in some of the seated woman figures found on classical grave steles. The stair and the figure leaning on a banister, as well as the lively genre figures, appear in Donatello's Dance of Salome, now in the Musée Wicar of Lille. Of significance is the appearance here of many motifs which reappear in later work, such as that of the nursing Child (in the Medici Madonna) and the contorted arm of the Child, used again as a motif in the figure of Day on the tomb of Giuliano in the Medici Chapel.

The Battle of Centaurs, a high relief in marble, in the Casa Buonarroti in Florence, was executed between 1492 and 1494. The content most probably represents the battle of Centaurs and Lapiths

at the wedding feast of Pirithous and Hippodamia (Ovid, *Metamorphoses*, 12. 210 ff.) or possibly the battle over the Abduction of Deidameia, or that over Deianira, both of which may have come from the *Fables* of Hyginus. The artistic form is not so much related to Bertoldo's bronze relief of fighting Horsemen, in the Bargello, as it is to the more vigorous and plastically modeled battle scenes on ancient Roman sarcophagi (e.g., the Battle of Romans and Barbarians, in the Camposanto of Pisa, or those in the Museo delle Terme, Rome).

The three sculptured figures on the Arca di San Domenico in Bologna were probably done while Michelangelo was in that city in 1494. The shrine itself, composed largely of a sarcophagus supported by four columns with angels, was originally executed by Fra Guglielmo da Pisa, after designs by Niccolò Pisano, in 1265/7. A contract was given in 1469 to Niccolò dell' Arca of Bari to complete the work, which still remained unfinished at his death in 1494. Late that year, Michelangelo was commissioned by Gianfrancesco Aldovrandi to add the missing figures. Michelangelo's Kneeling Angel repeats the same pose as that of Niccolò's corresponding figure on the opposite corner and common to that period (note the pair of candelabra-holding angels by Luca della Robia in the Cathedral of Florence), but reveals a much more massive, well-rounded and physically articulated form than the older and more typically Quattrocento style. Note the similarity in drapery and modeling to figures of Jacopo della Quercia and antiquity (e.g., the kneeling Nike figure in the Louvre). The stance and *contrapposto* of the St. Proculus bear a close resemblance to that used by Donatello in his bronze David, and later developed by Michelangelo in his own David in the Florence Accademia. The motif of the cloak over the shoulder recalls that of Donatello's St. George. The St. Petronius is modeled directly after the St. Petronius by Jacopo della Quercia, on the main portal of the same church.

The Bacchus in the Museo Nazionale del Bargello, Florence, is a life-size (6 ft. 7½ in.) marble ordered by Jacopo Galli, a Roman nobleman and collector in 1497, and finished probably the following year. Note the particularly strict adherence to the anatomical forms of nature and the actual model, the relaxed and heavy realism of content, its unclassical feeling when compared to ancient interpretations of the same theme (cf. the Bacchus in the Museo delle Terme,

Rome). In its relatively loose and rounded form, it is conceived, possibly, as a garden figure, to be seen from many points of view.

The Pietà in the Cathedral of St. Peter in Rome was probably begun in 1497, but the contract was actually signed on August 26, 1498, by Cardinal Jean de Villiers de la Groslaye, French envoy to the papal court, who intended to group for the Chapel of St. Petronilla, also known as the Chapel of the French Kings, in the old basilica of St. Peter's. The work was probably finished by the middle of 1500. The signature, *Michael Angelus Bonarotus Florent. Faciebat.*, on the band across the breast of the Madonna is said to have been Michelangelo's rebellious challenge to the fact that his name was unknown in Rome at the time.

The theme of the Pietà was particularly popular in Northern Late-Gothic sculpture, while not so frequently used in Italian sculpture until the later fifteenth century (e.g., Niccolò dell' Arca in Santa Maria della Vita, Bologna), as well as in painting (cf. Botticelli's contemporary Pietà, in the Munich Alte Pinakothek, and others by Perugino and Jacopo del Sellaio). The character of the theme, as well as the religious enthusiasm of the two widely different personalities, Michelangelo and Botticelli, may well reflect the influence of Savonarola's reform preaching. As to the artistic form of this chief example of Michelangelo's early Roman period, note the delicately carved detail and the highly finished technique, the small proportions of the Christ in contrast to the size of the Virgin, the simplicity and unity of the group composition in the draping of the Dead Body over the Virgin's knees, the dropping of His head and the expressiveness of Her natural pose and gesture, as in Leonardo's representation of the Madonna (Adoration of the Magi). Other features, such as the character of the heads and voluminous design of the drapery, suggest a relationship to Verrocchio (the Forteguerri monument).

A drawing for the bronze David (1502), now in the Louvre, indicates one of Michelangelo's early variations of the David theme, done shortly after his return from Rome. A request for a bronze David in the manner of Donatello's David was submitted by the French diplomat and art collector, Pierre de Rohan of Lyon, to the Signoria of Florence, in June, 1501. Michelangelo received a contract for the work on August 12, 1502, and it was finished by Benedetto da Rovezzano in October 1508. The last record of it was

its shipment to France, November 16, 1508. The several sketches in wax and clay in the Casa Buonarroti of Florence may possibly have been preparatory studies for this work, but this is doubtful.

The giant marble David (1501-1504) long stood before the Palazzo Vecchio as the defiant symbol of an independent Florence, the first clear statement of its greatest artist, and indeed an ideal symbol of the Renaissance itself. A contract was signed on August 16, 1501, with the Operai of Santa Maria del Fiore, by which Michelangelo agreed to carve a David out of the huge Carrara marble block which had been started by Agostino di Duccio, in 1463, as a giant prophet for one of the buttresses of the cathedral. Whether the block had been spoiled by Agostino, or by the stonecutter Bartolommeo di Pietro who worked for him, as suggested in the contract and stated by Condivi, is not clear; but the project and the block had been abandoned in the cathedral yard in 1464, and remained there until the task was given to Michelangelo. The work began September 13; it was listed as half finished on February 28, 1502, and was completed in April, 1504. The most prominent artists of Florence, including Leonardo da Vinci, Cosimo Rosselli, Piero di Cosimo, Botticelli, and others, were consulted (January 25, 1504), before it was ready, as to where it should be set up, i.e., before the cathedral, in front of the Palazzo della Signoria, or in the Loggia dei Lanzi. The decision to place it in the Loggia dei Lanzi was later reversed, possibly because of the artistic incompatibility of such a figure with the enclosure of the loggia, in favor of a place at the side of the entrance portal of the Palazzo della Signoria. The figure was finally put in place on September 8, 1504. Later, in 1873, the original statue was removed to the Accademia and replaced by a copy. Considering its exposure to the weather for so many years, the figure is in good condition except for repairs to the left arm due to the damage caused during the riots of 1527.

In relation to Michelangelo's revolutionary interpretation of the theme (1 Samuel 17), compare the fifteenth-century tradition of the David as represented by Donatello and Verrocchio—the adolescent boy—as opposed to Michelangelo's youthful giant of tremendous physical stature (14 ft. 3 in. tall), the choice of the tense and expectant moment before the attack rather than the accomplished deed, and the corresponding generalization of the David concept as a nude in contrast to the narrative realism of a clothed figure and its

435

related attributes (i.e., the severed head of Goliath, the sword, armor, etc.). The concept of David as a heroic figure has its parallel in the classical Hercules with which Michelangelo had worked just ten years before. Their relationship as symbolic personifications of Fortitude was apparently established here, since the Signoria commissioned Michelangelo in 1508 to execute a Hercules as a companion piece, but it was never carried out. The project was later taken on by Bandinelli in 1534, with his Hercules and Cacus.

With regard to problems of form, note the peculiar character of the stance, the strength and awkwardness of which may possibly be accounted for by the irregularities in the original block caused by the first sculptor; further, the combined *contrapposto* and twist of the body, the contrast of raised left arm with the sling and lowered right arm with the peculiarly clenched fist as motivating features to the sharp twist of the head and fixed stare of the eyes. Note, too, the tense, muscular structure of the figure, in contrast to the soft and relaxed form of the Bacchus. The tradition of the pose can be followed in Donatello's St. George (Or San Michele) and his prophet figures on the Campanile in Florence (particularly Job and Jeremiah). The lowered arm and clenched fist is a particular motif which can be traced through these figures and which received special attention in his drawing for the bronze David (Louvre).

The Bruges Madonna, in the Cathedral of Nôtre Dame in Bruges, was probably executed in 1503/4, and is mentioned in a letter of August 4, 1506, from Giovanni Balducci to Michelangelo, as the statue to be sent to a wealthy merchant, Alexander Mouscron, in Bruges. The statue was seen by Albrecht Dürer in the church of Nôtre Dame on his trip to the Netherlands in 1521 and noted in his journal. The group, with its vertical proportions, similar Madonna type and dignified repose, forms an interesting parallel and contrast to Michelangelo's Roman Pietà, and is often assumed to have been done while he was still in Rome. On the other hand, the dignity of the Madonna pose, the composition and action of the Christ Child suggest a relationshp with the Doni Madonna and the marble Pitti Madonna. These tend to argue for a later dating (ca. 1505).

Other sketches of the Madonna and Holy Family compositions (in the Musée Condé of Chantilly, the British Museum, London, and the Ashmolean Museum in Oxford) indicate considerable activity on this theme after his return to Florence, and acute awareness, if not

actual influence, of the work of Leonardo. To the same period belong the two unfinished marble tondo reliefs of Mary with the Child and the Infant St. John: One is the Pitti Madonna, in the Museo Nazionale del Bargello, Florence, which, according to Vasari, was commissioned by Bartolommeo Pitti and later came into the possession of Luigi Guicciardini. The other, in the Royal Academy of Fine Arts in London, is known as the Taddei Madonna. Their dates and chronology are again the subject of varying opinions, but it would appear that the Pitti tondo was done earlier, i.e., closer to the Bruges Madonna, whereas the Taddei Madonna is slightly later, i.e., 1505/6. More important, however, is the compositional interest in the combination of the monumental, sibylline character of the Madonna with the dramatic action of the cupidlike Child figures (cf. Raphael's contemporary drawings of Madonna and Child compositions). Parallels to this interest appear in the Doni Madonna and the later Sibyl figures of the Sistine Chapel (cf. the Delphic Sibyl).

The Holy Family, known as the Madonna Doni, in the Uffizi Gallery of Florence, is the only undisputed easel picture by Michelangelo extant. Again it is a tondo, painted for Angelo Doni, probably in 1503, for the occasion of his wedding with Maddalena Strozzi (1504). The elaborately carved frame, made at the time especially for the picture, bears the Doni-Strozzi coat of arms. The composition is based on similar tondos of the Holy Family and Madonna and Child by Signorelli, in the Uffizi. In comparison with Signorelli's Madonna, note the greater freedom of this figure group dominating the space, with the frieze of active classic nudes across the middle ground against a bare landscape, as opposed to Signorelli's half-clothed shepherds composed into the space. Note, too, the infant St. John behind the parapet to the right, the movement of the Madonna figure twisted about to the left to receive the Child over her shoulder from the crouching Joseph behind her, and especially the plastic clarity of the figures through their sharp drawing and clear color contrasts. A detail drawing of the Madonna head exists in the Casa Buonarroti.

The coloration of the Madonna Doni reveals Michelangelo's unique position as a sculptor and painter, particularly in this situation in Florence at the beginning of the sixteenth century, where color and light were developing as basic implements for the achievement of a unified composition and emotional mood (i.e., Leonardo

and Raphael). Where the contemporary interest was in the harmony of colors and the warm *sfumato* of light, Michelangelo's emphasis on the figure and form as the basic means of expression called for strong contours and clear colors with bright contrasts in blue, green, a deep gold-yellow and red-pink. Significantly, this painting is in tempera on wood. Shadows are not dark, but bright and luminous, and are paralleled in the use of cross-hatching in the drawings, to enhance the strong modeling of the forms. The shift to the cool colors and clear contrasts is one of the features of Michelangelo's composition in fresco, and is taken up later by the Mannerists.

Two panels in the National Gallery of London that are frequently attributed to Michelangelo belong to this period. One is the so-called Manchester Madonna, with the Virgin and Child, St. John and Angels, of ca. 1500; the other is the unfinished Entombment, which is presumably later, i.e., after the Doni Madonna and before the beginning of the Sistine ceiling.

The St. Matthew, in the Accademia of Florence, is an unfinished marble statue, executed in 1505, presumably intended as one of the twelve apostle figures contracted for by the *Arte della Lana* on April 24, 1503, to be placed in the choir chapels of the Cathedral of Florence. The contract was dissolved on December 18, 1505, because the work was not done, and Michelangelo was required to vacate the studio the guild had built for him. On his return to Florence in the summer of 1506, he seems to have taken up the work again, then left for Bologna to see Julius II. The peculiar twist of the figure is a variation of that used by Donatello in his Abraham and Isaac group on the Campanile of Florence. Note also the similarity to della Quercia's prophet figures on the baptismal font in the Baptistry of Siena.

The figure is of special importance at this time—and here again, the problem of chronology and dating presents difficulties in interpretation—because of its massive form and dramatic action concentrated within the single figure. He had finished the David. He had also been at work on preliminary studies for the tomb of Julius II with its chained slave figures, as well as the cartoons of the Battle of Cascina. The revelation of the famous Laocoön group, discovered on January 14, 1506, could only have strengthened and enriched his own expressive point of view, rather than given him a new direction.

The suggestion is often made that this figure was developed after the discovery of the Laocoön, but its execution in 1506, after the dissolution of the contract, seems improbable. It also seems clear that the idea of the twisted figure had already been suggested in his own work, which makes this late dating doubtful (cf. the twisted figure motif in Leonardo's drawings for the Trivulzio monument, as well as Michelangelo's Sistine ceiling).

The battle of Cascina is the subject of the lost cartoon for a large fresco which was to have been painted on the wall of the Sala del Consiglio in the Palazzo Vecchio, Florence, opposite Leonardo's Battle of Anghiari. The composition is known through the copy in grisaille of the total, by Aristotile da Sangallo, in the Leicester Collection, Holkham Hall, Norfolk, from numerous detail engravings, by Agostino Veneziano and Marcantonio Raimondi, and from Michelangelo's own sketches. A free sketch, from the original cartoon, made by an unknown artist—but often ascribed to Michelangelo—is in the Albertina Museum, Vienna.

Michelangelo was given the contract on August 14, 1504, after Leonardo had already begun work on his own wall. The call to Rome the following March found little more than the cartoon finished; this was then carelessly left for study and eventual destruction by copyists. It was mentioned several times in documents as having been seen and much praised in the Sala del Consiglio, then in the Sala del Papa near Santa Maria Novella, and later in the Palazzo Medici.

The content was a patriotic episode, taken from the Florentine wars with the Pisans, in which the Florentine soldiers were surprised by the Pisan army while bathing in the Arno river. The battle took place on July 29, 1364, outside Cascina, and is described in detail by Filippo Villani in his *Cronaca*. The theme is one of a long history of Renaissance battle pictures, from Uccello to Piero della Francesca and Leonardo. Note the choice of subject here, in contrast to that of Leonardo, who takes the most furious and realistic detail of warriors battling for the standard as the subject of his mural, while Michelangelo chooses the dramatic moment before the actual battle when the alarm has sounded and the soldiers scramble into action. The element of tension is similar to that of the David, although the action is transferred from a single standing figure to a moving group,

and the heroic character of a self-confident youth tensely facing his enemy is replaced by the pathos of men roused to action, yet terror-stricken by the threat of approaching danger.

The compositional idea is that used in the Battle of Centaurs relief, but also has its antecendents in Signorelli's frescoes of the Cappella Brizio (the Fall of the Damned) and possibly the figure compositions of Pollaiuolo (his engraving of fighting nudes). Note the contrast of Michelangelo's figures, each composed plastically in a three-dimensional space, as opposed to the fifteenth-century decorative flatness of Pollaiuolo's figures. Michelangelo used the general oval pattern of Signorelli's massed composition, but instead of crowding the innumerable figures into a intricate mass he has isolated each figure into a separate, clearly outlined and well-modeled individual form. There is no apparent interest in linear or aerial perspective as such, but the powerful muscular action of the figures, their compositon into rhythmic groups, and the decorative verve of figure outlines serve to build them into an integrated compositional unit. Many detail drawings of nudes reflect the most careful and realistic study of anatomy and foreshortening taken directly from the model.

Having finished the cartoon, and perhaps just begun the painting of the Battle of Cascina, Michelangelo was summoned to Rome to undertake the project for the tomb of Pope Julius II. The first plan and contract (March, 1505) called for a gigantic rectangular free-standing mausoleum to be placed in the new choir of the old St. Peter's, three stories high, with eight over-life-sized allegorical figures (Victories or Virtues) in niches at the corners, flanked by hermae on either side to which were attached chained slaves or captives. The chained slave motif is related to the traditional pose of the Christian St. Sebastian, and had been used by Leonardo to elaborate the mausoleumlike base of his equestrian Trivulzio monument (note the drawings in the Windsor Collection, which were probably done in 1506/7 but have frequently been dated earlier, i.e., ca. 1500). The motif may also have been inspired by the chained captives represented on late Roman sarcophagi and triumphal arches. These figures were interpreted by Vasari as symbolizing the provinces conquered by the Pope, and by Condivi as the Liberal Arts, fettered by the death of the art-loving pontiff. The second story was to have contained four seated figures at the corners, representing Moses, St.

Paul, and symbolic figures of Active and Passive Life (Vasari). Inside was to be a tomb chamber for the sarcophagus. The appearance of the third story is a matter of speculation; the crowning group apparently was to consist of symbolic figures of Heaven and Earth supporting either a bier or the litter with the seated Pope (i.e., the *sella gestatoria* similar to that represented in Raphael's Expulsion of Heliodorus).

The form and scale of the monument, with its projection of well over forty giant figures, was intended to outdo the imperial tombs of antiquity and remain an eternal tribute to this imperial-minded Renaissance spiritual and temporal ruler. Its form was a reversal from the traditional wall tomb, such as Donatello's tomb of Pope John XXII in the Baptistry of Florence, to the medieval shrine form used in that of St. Dominic in Bologna. The bronze tomb-monument of Sixtus IV, by Antonio Pollaiuolo, with its raised platform and allegorical figures in relief, may also have influenced the choice of plan.

After eight months' work in Carrara securing suitable marble and arranging for its shipment, the project was interrupted, presumably for lack of funds, and Michelangelo went back to Florence. He then went to Bologna (November 1506), where he executed the massive seated bronze figure of Julius for the façade of San Petronio (destroyed in 1511).

Michelangelo returned from Bologna in March 1508, and remained in Florence only a short time before he was summoned to Rome to undertake the decoraton of the Sistine Chapel ceiling. The contract was signed on May 10, 1508, and the scaffolding was set up immediately thereafter. Michelangelo's friend, Francesco Granacci, and a number of other helpers, including Jacopo di Sandro, Aristotile da Sangallo, Jacopo Indaco, Agnolo di Donnino and Giuliano Bugiardini, were employed at the beginning, but were soon discharged (according to Vasari) as Michelangelo proceeded to paint the entire work by himself. It must be assumed, however, that some of them must have been retained to assist with the medallions, architectural framework and decoration.

The first half of the ceiling—probably the central stories from the Drunkenness of Noah up to and including the Fall of Man, with their corresponding slaves, prophets and sibyls—was finished by August 17, 1510, when Julius left Rome for Bologna. Michelangelo

then stopped work because he had not been paid, and made trips in September and December to see Julius in Bologna to get money. In January of the following year, work was resumed, and the remaining central stories, prophets, sibyls, slaves and the two corner spandrels on the altar wall were completed when the first consecration was held on August 14, 1511. The remaining spandrels and lunettes with the predecessors of Christ were completed for the second consecration, on October 31, 1512.

The content involves, for the most part, Michelangelo's own interpretation of the Creation-Salvation theme, rooted in a thorough study of the Bible and Dante and developed out of the concordance of Old and New Testament cycles given on the walls of the chapel by Botticelli, Rosselli, Ghirlandaio, Perugino, Signorelli, Piero di Cosimo and Pinturicchio during the reign of Sixtus IV. The flattened vault of the ceiling was originally painted as a light blue sky with yellow stars, supposedly by Pier Matteo d'Amelia. In contrast to the narrative parallelism used in the histories of Moses and Christ, Michelangelo depicts the history of salvation before their leadership as told in Genesis and the story of Noah, a change similar to that made in his earlier reinterpretations of the David and battle themes. The breadth of theme, as well as the architectural placement and decorative plan, thereby form a completion and iconographic unity of the total chapel.

The difficulties and artistic development of Michelangelo's plan can be followed in his drawings. In the rather awkwardly proportioned room (40 m. long x 13.6 m. wide x 20.7 m. high, or ca. 132 ft. x 44 ft. x 67 ft.), the original plan (drawing in the British Museum) was to cover the flat vault with a system of circles and squares similar to the ceiling decorations in the Stanza della Segnatura. The twelve apostles were to be painted in elaborately designed thrones on the spandrels tapering to a point at the bottom of the triangular space and projecting up into the pattern of the middle ceiling zone. Michelangelo complained to the Pope about the meager appearance of the design, and was given a new contract, with carte blanche to paint what he wished. The second plan (drawing in the Detroit Institute of Art, formerly in the Wauter's Collection, Paris) shows the introduction of heavy painted arches across the vault connecting the enthroned figures on the spandrels and breaking up the flat circle-square patterns of the center zone. This resulted in a series of alter-

nating rectangular and octagonal fields along the center of the vault. The reverse of this same drawing has sketches which indicate that prophets and sibyls were already planned in place of the apostles. The designs for the first three central stories—the Drunkenness of Noah, Noah's Sacrifice and the Deluge—were probably executed in accordance with this plan.

In the final design of the fresco, the rectangular and octagonal spaces were changed to even rectangles which were alternated only in size, the smaller ones bounded by the transverse bands which connect the seated figures on the spandrels. The intervening spaces between these and the cornice are filled with medallions. The elaborately decorated thrones were simplified into a strict architectural framework, with pedestals for the *ignudi* and pairs of putti as caryatids on the supporting buttresses beneath them. The succession of designs, therefore, shows Michelangelo's own development from the original idea of a row of apostles corresponding to the figures of popes on the side walls, to an architectural framework by which he was able to overcome the unwieldy proportions and unify the room, and in which he was able to compose over 300 figures into a monumental story of Creation.

The story centers about the nine panels of alternating sizes, divided into three groups of three panels each: (1) God Separating Light and Darkness (Genesis 1: 1-5), the Creation of Sun and Moon (Genesis 1:14-18), and God Separating Land from Water (Genesis 1: 9-10); (2) The Creation of Adam (Genesis 2: 7), the Creation of Eve (Genesis 2: 21-22) and the Fall and Expulsion from Paradise (Genesis 3: 1-6 and 23-24); (3) Noah's Sacrifice (Genesis 8: 20), the Deluge (Genesis 7) and the Drunkenness of Noah (Genesis 9:21-23). The triptych arrangement thus divided the content into the Creation of the World, Creation of Man, and the Story of Noah. The division between the Creation (i.e., the first five scenes) and the Fall of Man roughly corresponds to the original division of the chapel into lay and clerical areas by the *concellata*.

In the corner spandrels appear four dramatic scenes from the Old Testament by which the Chosen People had achieved salvation through heroic men and women: David and Goliath (1 Samuel 17), Moses and the Brazen Serpent (Numbers 21: 4-9), Judith and Holofernes (Judith 13), Esther and Ahasuerus (Esther 6 and 7). The seven prophets (Jonah, Jeremiah, Daniel, Ezekiel, Isaiah, Joel and

Zachariah) and alternated with five sibyls (Delphica, Erythraea, Cumaea, Persica and Libyca) who, as pagan prophetess parallels to the Old Testament prophets, are often associated with the geographical divisions of Greece, Asia Minor, Italy, Asia and Africa respectively. The bronze-colored medallions likewise contain scenes anticipating the coming of Christ and the ultimate Salvation: the murder of Abner by Joab (2 Samuel 3: 27) and the Death of Joram (2 Kings 9: 24) on either end of the Drunkenness of Noah panel; the Death of Uriah (2 Samuel 2: 15-17) and the Destruction of Baal (2 Kings 10: 18-28) at the ends of Noah's Sacrifice; Nathan's Sermon (2 Samuel 12: 1-14) and the End of the Tribe of Ahab (2 Kings 10: 11 and 17) with the Creation of Eve, the Death of Absalom (2 Samuel 18: 9-14) and a missing medallion, with God Separating Land from Water; and Abraham's Sacrifice (Genesis 22: 2-12) and the Ascension of Elijah (2 Kings 2: 11) on either end of the God Separating Light and Darkness. Figures representing the genealogy of Christ, as listed in the first chapter of Matthew and somewhat reminiscent of Dante's praise of his ancestor Cacciaguida in the *Paradiso*, Canto 15, occupy the remaining spandrels and lunettes.

In the endless variety of problems, analogies and possibilities to be observed in the analysis of the work, note particularly the use of color as a means of modeling the forms, creating the illusion of space and unifying the room: the grisaille of the architectural framework, the strongly modeled ochre-brown flesh tones of the figures against the luminous blue of the heavens and backgrounds. Numerous preliminary drawings of single figures, as well as groups, have survived, but none of the cartoon. Many of the marks made in the wet plaster, in the process of transferring the drawing onto the wall by means of tracing with a stylus, rather than pouncing, are still to be seen. Traditions existed for the use of seated prophets (Donatello's St. John the Evangelist in the Cathedral of Florence) and sibyls listening to muses (Giovanni Pisano's figures on the pulpit at Pistoia). Their enlivenment as particular mediums of expression may have been stimulated by his study of the classical Laocoön group, as well as his own concentrated use of the individual figure (St. Matthew). Not only the alternation of prophet and sibyl, but also the variation of contrasting spiritual expression (e.g., thought and action, youth and age) indicate an interest in and dramatization of character portraits which he seems to have drawn directly from the

writings of these sages. The artistic language of figures alone, again suggestive of the Laocoön group, accounts in part for the substitution of the moving nudes (the *ignudi* on the pedestals) for the geometrical patterns intended in the first designs. The Laocoön idea, too, with its expressive struggle between the human figure and the serpent, may have stimulated Michelangelo's interest in the Bazen Serpent theme, which, characteristically, he reversed and substituted a more purely Christian spiritual struggle for the pagan physical torture of the classical group.

The curious fact that Michelangelo began the painting with the Drunkenness of Noah, instead of doing it last, as the historical sequence would suggest, is accounted for by the necessity of keeping the space about the altar free of scaffolding, so that the services in the chapel might be held as long as possible. Michelangelo may also have originally intended the series of stories to have begun with the story of Noah, rather than to end with it. The reverse reading of the historical sequence (i.e., from the entrance to the altar wall) reveals not only a gradual solution and development of the decorative problem, but also a climaxing of Michelangelo's own artistic drama. The first three panels seem to be enlargements of the designs made for the earlier (second) plan; in the succeeding ones, Michelangelo gave up the complex and many-figured composition for the single monumental forms more easily and forcefully comprehended from the distance of the floor below.

In the Drunkenness of Noah, note the contrast to the narrative form of Quattrocento renditions of the same theme (i.e., Gozzoli's fresco in the Campo Santo of Pisa), the influence of Jacoo della Quercia's reliefs on the San Petronio portal in Bologna (the relief composition, the motif of the digging figure), and especially Ghiberti's group on the Baptistry doors, whereby Michelangelo's monumental dramatization of the theme through the relieflike composition of the figures and their gestures becomes apparent.

The Deluge, from the chronological sequence of the story, should come before Noah's Sacrifice, but this was probably changed because of the need for a larger space for the more involved scene and composition. Its design seems to have been executed for one of the earlier plans (the second), as indicated by the composition of figures for an octagonal frame. Note again the terror of massed figures, related to the Battle of Cascina, and their organization into

groups (in contrast to the powerful linear perspective of Uccello's Deluge in the Chiostro Verde, and the flat pattern of the engraving, possibly by Bacchio Baldini, of the same subject) which recede into the distance by their diminishing size.

Noah's Sacrifice seems to be a correction of Botticelli's similar theme in the Old Testament sacrifice scene on the wall of this same chapel, with the altar block placed obliquely (cf. the classical relief of the Meleager sarcophagus, Villa Albani, Rome) and the figures composed around it. Jacopo della Quercia's Sacrifice of Cain and Abel (Bologna), rather than his Sacrifice of Noah, is also useful as a comparison to demonstrate again both Michelangelo's point of departure and his expressive power in the composition of figures. Note the compositional significance of the iconographically minor figure kneeling below in the act of blowing and kindling the sacrificial fire. The pose is a reversed variation of the kneeling youth on the right side of Filippino Lipi's (1496) Adoration of the Magi (in the Uffizi Gallery, Florence), and was used by Michelangelo as a characteristic means of dramatizing the action and composition, in keeping with the more external acts of bearing the wood and preparing the sacrifice.

The literal interpretation and dramatization of the Fall of Man was perhaps anticipated in della Quercia's relief of the same subject (Bologna), but the pair here is placed to one side of the tree and the theme combined with the Expulsion. Hence, the two related themes are compositionally combined in a continuous arc on either side of the massive columnar form of the Tree in the center. Note the contrasting poses of the seated and twisting Eve to the aggressive upward-spring Adam, the shaded face of Adam in lost profile (as in Leonardo's Judas of the Last Supper) and that of Eve in full light. The Expulsion group is related to that of Masaccio, but in the general intensification of the theme Michelangelo used larger, more plastic forms, and changed the use of gestures from that of a figure-bound attribute of shame to dramatic, outward-flung expression of pathos, which, with the commanding angel figure, was decoratively combined with Adam's seizure of the forbidden fruit on the other side. While there is no interest in ''landscape'' as such, the simplicity and complexity of the background design bring out the contrasting characters of Paradise and ''wilderness'' involved in the theme.

The compositional theme of the Creation of Eve is in the

446

Pisano-Ghiberti-Quercia tradition, and is particularly related to Jacopo della Quercia's Bologna relief. Note the change of the rectangular composition from the vertical to the horizontal, the simplified and more monumental figures, the diagonal pose of Eve between the towering God and the recumbent Adam, its expressive gesture of prayerful gratitude, and its effectiveness on the combined plastic and decorative style. Note, too, that the God-Father does not physically grasp the arm of the created Eve as she rises, as in the reliefs by Ghiberti and della Quercia, but rather uses the gesture of benediction to this miracle of creation.

The Creation of Adam was again based on della Quercia's relief of the same subject, horizontally composed, with the dual conception of God and Father in the figure sweeping in from the right toward the recumbent figure of Adam. As an anatomical study and expression, the Adam seems to be a recomposed synthesis of Michelangelo's own reclining Noah and the marble David.

The following scenes show a greater interest in the single figure and its movement. In the Separation of Land and Water, the object of the action is not shown, but the drama is concentrated in the single figure of God-Father with His combined gesture of command and benediction. With the larger space of the center panel of this last triptych—the Creation of Sun and Moon—the action is further dramatized by the oblique forward and rearward movement on either side of a central sphere. The final artistic climax of the entire series seems to be not merely the idea of Separation of Light and Darkness, but that of Creation itself: the self-created God-Logos emerging out of an indefinite chaos in the combined twist and upward thrust of the figure. Light and shade are not only iconographical attributes, but are used as an integral means of conveying the dramatic action of the figure through the contrast and the illusion of space. The difference between this and the rigid relief composition of the first panel—the Drunkenness of Noah—demonstrates the remarkable power and depth of expression which Michelangelo had achieved in this short time.

This recognition of the figure as creation itself, as the liberation of the soul from the body, is a familiar Renaissance and Neo-platonic theme. Its artistic possibilities appear to have been developed further, even to the point of Manneristic distortion, in the figure of the Libyan Sibyl just below it, opposite the powerful Jeremiah. The

remarkable red chalk drawing for it, in the Metropolitan Museum of New York, reveals the process of development, with its detailed study and power of anatomical construction, as well as this quality of expressive freedom for which the final fresco is so famous.

Both in time and in basic concept, the two gigantic projects of the Julius Tomb and the Sistine Chapel were closely related, the one a sculpture-decorated architectural form, the other an architectural space decorated with sculpture through the medium of fresco. After completion of the ceiling, Michelangelo returned to Florence, but was soon recalled to Rome by the heirs of Pope Julius after his death (February 21, 1513).

The new contract (May 6, 1513) involved a change to a three-sided structure with the smaller side against a wall and tabernacles on the two larger sides. Six, instead of four, seated figures on the second story, above them a huge visionary Madonna and Child (cf. the hovering figure in Raphael's contemporary Sistine Madonna), and below it the recumbent figure of the Pope on a catafalque with allegorical figures—this still comprised a total of some forty over-life-size figures (see drawings in the Berlin Staatliche Museen and the Uffizi). Finished at this time were the two slaves (1513, now in the Louvre) and the figure of Moses (1515/16); the latter, possibly already begun in 1506, was a development of the Quattrocento seated figure type (Donatello) and his own prophets of the Sistine Chapel (e.g., Joel).

The third contract (July 8, 1516) reduced the two longer side façades by half, and left the front with the sarcophagus and the figure of the Pope still as in the previous plan. After some delay, work was begun again in 1519, and continued to 1524, during which time the four unfinished ''Boboli'' slaves may have been worked upon (so called because they had been built into a Baroque grotto in the Boboli Gardens of Florence until they were transferred to the Florence Accademia).

After further threats of legal action by the heirs, notably Francesco Maria della Rovere, and first sketches for an entirely new plan of a wall tomb had been made (1525/26), a fourth contract was agreed upon (April 29, 1532). Its designated place was changed from St. Peter's to San Pietro in Vincoli; all the previous statues and marble ornaments made for it were to be usesd in the new and smaller tomb design. The Boboli slaves may possibly belong to this

period (1532/32) rather than to the earlier 1516 plan. The unfinished group of Victory with the vanquished barbarian, now in the Palazzo Vecchio of Florence, probably executed in 1532-1534, is sometimes assumed to belong to this same project. Again all this was interrupted by Michelangelo's assignment by Pope Clement VII to paint the Last Judgment (1534).

The final, fifth contract was signed on August 20, 1542, and resulted in the tomb as it stands today. Michelangelo was allowed to have pupils complete the work after his designs, notably Tommaso di Pietro Boscoli (sarcophagus and figure of the reclining Pope), and Raffaello da Montelupo (Madonna, prophet and sibyls of the upper story). Much of the marble already cut for the earlier plans was used, new volutes and half-figures were added, the Moses was used for the central figure, the two Louvre slaves discarded (later given by Michelangelo to Roberto Strozzi, who in turn gave them to Francis I of France, hence their present location in the Louvre) and replaced by Leah and Rachel as contrasting symbolic representatives, taken from Dante's *Purgatorio*, Canto 27, of the *vita activa* and *vita contemplativa*. These were begun by Michelangelo and finished by pupils. Final completion and end of the famous ''Tragedy of the Tomb'' (Condivi) came with its dedication in February 1545. It had indeed developed into a long and difficult personal tragedy as well, about which Michelangelo complained bitterly many times in his letters.

With regard to the problem of iconography, the Julius tomb appears as a parallel to the Sistine Chapel ceiling. There may have been literary sources—as yet unclarified—of a religious or philosophical nature which served as an inspiration; but, like the development shown in the chapel ceiling, the emphasis lay in the abstract expression of the form rather than in any single and unified iconographical system. The basic idea motivating the structure is obviously the person and memory of Pope Julius II as an omnipotent spiritual and temporal ruler, a Renaissance union of classical *Imperator* and medieval Pope. As to the further analysis of form, note particularly: the aggressive sideward twist and imperious gaze of Moses related to that of the earlier David; the tradition and variation in the seated pose of Moses as compared with Donatello's St. John and the Sistine Chapel prophets; the use of the chained slave motif as a development of Michelangelo's own St. Matthew relief and Donatello's figure of

Abraham in the Campanile group as well as the Laocoön, the aforementioned fettered figures on Leonardo's projected Trivulzio monument; the dramatic exploitation of these, with their expressions of contemplative pathos, in contrast to the active power of the seated Moses; their use, furthermore, as caryatids in a manner similar to the painted putti on the buttresses flanking the prophet and sibyl figures of the Sistine ceiling, but released, as free-standing forms, from the structural framework of the chapel to the "spiritual" framework of the tomb-catafalque.

Michelangelo's renewed activity for the Medici (Leo X) began in late 1516 with the development of drawings and a model for the façade of the Medici church of San Lorenzo in Florence. After several years' work on the selection of marble in Carrara for both the Julius tomb and the San Lorenzo façade, this contract was dissolved (March 12, 1520). New plans for the building and decoration of a Medici Chapel and a mausoleum for the Medici family were begun with Cardinal Giulio de' Medici that year. The unfinished chapel (the Sagrestia Nuova) was intended as a parallel to that of the opposite sacristy (Sagrestia Vecchia) of the church, designed by Brunelleschi and decorated with colored reliefs by Donatello, where the elder branch of the Medici family, including Giovanni d' Averado and the brothers Piero and Giovanni de' Medici (the father of Lorenzo Magnifico) were buried. The square room was completed and covered with a Pantheon-type coffered dome by Stefano di Tommaso after Michelangelo's design by January 1524.

The development of the total plan can be followed through Michelangelo's drawings. Originally there were four tombs planned, two for the elder Medici brothers, Lorenzo Magnifico (died 1492) and Giuliano (murdered 1478), and two for the younger nephews, Giuliano, Duke of Nemours (died 1516) and Lorenzo, Duke of Urbino (died 1519). These were to have been combined into a free-standing, four-sided monument, intended for the center of the chapel, similar to the original tomb of Julius. The plan then changed to a pair of balanced double wall tombs which were to be placed opposite each other on either side of the altar. Further change was necessitated by the addition of tombs intended for the two Medici Popes, Leo X (Giovanni de' Medici) and Clement VII (Giulio de' Medici), which, as another double wall tomb with an altar, was to occupy the third wall of the chapel opposite the apse. A fourth

plan composed a more unified single tomb arrangement flanking the altar wall with the double tomb of the Popes. This was used in the final plan, but with the change toward taller and thinner proportions.

The work was begun in March 1521; then it was dropped for lack of funds (September 1521) almost before it got under way, and was resumed again in January 1524. Between then and the second break, in the fall of 1526, the figure of the Madonna was begun, and models for the reclining figures (Night, Day, Morning and Evening, with the corresponding river gods intended for the base of each monument) appear to have been ready. The renewal of work, late in 1530, probably saw the finishing of Night and Day, and the beginning of most of the other figures, which were then left in the rough when Michelangelo went to Rome in 1534.

The completion and polishing of both the Giuliano and the Lorenzo tombs, as well as the rough execution of St. Cosmas, was done by Giovanni Montorsoli, St. Damian by Raffaello da Montelupo. The Cosmas and Damian, traditional patron saints of the Medici, were inteded for the niches on either side of the Madonna. The arrangement of the figures as they are today was made by Giorgio Vasari in 1565 in accordance with Michelangelo's own directions.

Aside from many drawings and the seven figures in the chapel by Michelangelo, there are several other unfinished figures which had been left over: the crouching youth (the Hermitage Museum, Leningrad), probably intended for the Lorenzo tomb; the David, in the Bargello, for one of the niches of the papal tomb; and the model for a river god on the Giuliano tomb (Accademia, Florence). The lunettes over the three tombs were probably to have been decorated with frescoes, for which two variations of the Resurrection of Christ and a Brazen Serpent exist among Michelangelo's drawings.

Among these drawings, too, are various studies for a lost painting in tempera of Leda and the Swan, which Condivi says Michelangelo painted for Duke Alfonso I d'Este of Ferrara, ca. 1530. A copy in the National Gallery, London, presumably by Rosso Fiorentino (1494-1540) after a Michelangelo drawing, shows a powerful female figure reclining in essentially the same pose as the marble ''Night'' of the Medici Chapel. Both inconographically and compositionally, it is based on similar figures to be found in

Roman sarcophagus reliefs and gems, and provides an interesting contrast to the Leda by Leonardo and the parallel themes of Venus and Danaë by Titian.

With regard to the style, Michelangelo was faced with a decorative problem not unlike that presented to Raphael in the Stanza della Segnatura—namely, a square room with four sides to decorate—but he used the plastic means of the sculptor, rather than the space-illusions of the painter. Donatello and the fifteenth-century sculptors usually had to deal with a given wall in a larger, already completed building, into which one was required to build a niche for a tomb. Michelangelo had the advantage of designing his own space and walls, and was restricted only by the given square foundation. The figures were placed before the wall, not recessed into it as with Quattrocento tombs, and hence were capable of being carved fully in the round, even though they are seen as a relief. The plastic effect thus achieved was combined and further strengthened, as in the architectural framework of the Sistine ceiling, by the strict architectural design on the wall behind. The bald, colorless effect of the present structure was not the original intention, as is shown by the suggestion of frescoes decorating the lunettes and the retention of Giovanni da Udine to decorate the upper sections of the walls. The pyramidal composition of the sculptured groups was based on the reclining figures of classical river gods, which were not completed beyond the working model stage, and continued up to the reclining sarcophagus figures and the upright seated figure in the niche at the top.

Along with the many interpretations of the content, the following factors may be noted: the pride of the Medici in the political and cultural heritage of their family was evident from the time of Lorenzo il Magnifico; their avowed destiny as the saviours of Italy, especially through this period of internal dissension and invasion by foreign powers (i.e., France and Spain), became an active part of their policy when they gained control of the papacy. The chapel and its tombs were to be a shrine dedicated to that heritage and destiny.

Michelangelo's interpretation of the theme took on his characteristic pessimism. Either through his own personal choice and interest in the abstract expression rather than subject matter, or because of more external circumstances involved in the execution, he managed to realize only the monuments of the two less impor-

tant, Lorenzo and Giuliano, and not the historically far more significant personalities of Lorenzo Magnifico and the martyred Giuliano. These monuments were crowned by seated figures, clothed as Roman *Imperatores*, in contrasting poses—the one heavy and relaxed, the other taut and aggressive—another variation of the medieval *vita activa* and *vita contemplativa* used so often before. Note the use of the helmet (as on Donatello's David) on the bowed head of the Lorenzo figure, casting a shadow over the face and increasing its reflective expressiveness. Contrast this with the aggressive, sharply twisted head of Giuliano, which catches the full light in profile.

Michelangelo's emphasis on movement and his recognition of its dramatic possibilities, not for the expression of physical strength alone, but for its spiritual pathos, is seen in iconographical changes over the traditional accompanying attributes. Instead of Christian Virtues or pagan allegorical scenes, he introduced powerful allegories of ever-flowing Time: positive Night and Day, and the transitional Evening and Morning. The river gods were logical extensions of this motive; their chief function is in their decorative movement, in keeping with the mood of the contrasting pyramidal reliefs, rather than traditional pagan or Christian symbolisms (i.e., the four Rivers of Paradise).

While the *Penseroso* (Lorenzo) gazes thoughtfully at the floor, the head of the opposing Giuliano is turned sharply to the right, apparently looking in supplication to the Virgin on the altar tomb. Contrast the twisted forms of the Virgin and Child with the straightforward position of the earlier Bruges Madonna: a quiet, balanced relief as opposed to the more agitated vertical movement composed on three sides of the block form. The head of the Madonna is extended forward, increasing the effect of its downward, negative stare. Likewise, the Child does not receive or answer the devotion of the beholder, but has His head turned around and buried anonymously in the breast of the Virgin. To this genuinely Christian pathos and pessimism, which was not only a part of Michelangelo's character but also seems to have been his interpretation of the "destiny" of the Medici house, the Resurrection intended for the lunette above appears to be a logical and crowning release. The chapel was presumably dedicated to the Resurrection (note the drawing in the Royal Library, Windsor).

The development of the design for the Biblioteca Laurentiana to

house the great Medici collection of books and manuscripts is closely associated with the Medici Chapel. Its actual construction was begun in the fall of 1524 and proceeded intermittently until Michelangelo left for Rome in 1534. The design for the famous entrance vestibule was probably done in 1526; the model for it, however, was not delivered until 1557, and then carried out under the supervision of Bartolommeo Ammanati and opened to the public in 1571.

Although Michelangelo's final plan for the Sistine Chapel was basically an architectural conception, the Medici Chapel was the first opportunity he had to develop the actual architecture as an integral part of the background and setting for the sculpture. Here in the library, especially the entrance vestibule with its monumental columnar forms and dramatic staircase, the expressive power of the sculptural forms is translated into the abstract language of architecture. The distortion of the forms, in terms of massive columns and corbels, wall panels and window niches, the restricted space, vertical proportions and the forceful staircase, makes this one of the significant milestones for the new architectural developments in Mannerism and the Baroque style.

Michelangelo was called to Rome in September 1534 by Clement VII for the purpose of decorating the end walls of the Sistine Chapel, with the Last Judgment on the altar wall and presumably the Fall of Lucifer intended for the entrance wall. Pope Clement died two days after he arrived (September 23, 1534) and the renewed contract was signed by the successor, Pope Paul III (October 13, 1534). By September 1535, the cartoons were finished. The two windows were walled up, the frescoes of the Assumption of the Virgin, the Nativity, and the Finding of Moses, by Perugino, along with Michelanglo's own lunette frescoes, were removed, and work on the wall itself began in May of the following year. An attempt by Sebastiano del Piombo to paint the mural in oil was given up in favor of the fresco. The upper part was finished in December 1540, the total wall completed October 31, 1541, and the official dedication took place on Christmas Day, 1541.

A later Pope, Paul IV, under pressure of the Counter-Reformation, sought to have the fresco removed because of the nakedness of the figures, but compromised with the decision to clothe them with loincloths, which were painted largely by Daniele

da Volterra (hence his nickname, *Il Brachettone*, "the Breeches Painter"). The changing and repainting of the St. Blaise and St. Catherine figures is also the work of Volterra. Aside from this, the fresco has suffered considerably from the dampness of the newly repaired wall, the cracking of plaster, and successive restorations.

The analysis of content will reveal Michelangelo's independent approach to the problems of tradition and iconography, as well as of artistic form, the chief source probably being the fantastic *Inferno* in Dante's *Divine Comedy*. Michelangelo was highly praised by his contemporaries, Pier Francesco Giambullari and Benedetto Varchi, for his knowledge and understanding of Dante, and had once proposed to Pope Leo a sepulchral monument to Dante for Florence (1519). Aside from the *Divine Comedy*, the parallels which are to be found in literature, such as the folk dramas of Feo Belcari (1410-1484) and the sermons of Savonarola, should be looked upon as parallel manifestations of the same spirit, rather than direct sources of inspiration.

Christ is enthroned as Judge, in the center, with Mary at His side, surrounded by the medieval seven choruses—Patriarchs, Apostles, Prophets, Church Fathers, Martyrs, Monks and Virgins. Of these, the monks are left out (as does Signorelli in Orvieto), and the sibyls added to the Virgin group. Many of the saints can be recognized by their attributes: St. Laurence and St. Bartholomew at the feet of Christ (the latter with a caricature self-portrait of Michelangelo on the skin he holds), Adam and Peter leading the Patriarchs of the Old and Apostles of the New Testaments in the immediate inside circle about Christ. On the outside circle, likewise receding through diminishing size and intensity, are the hosts of Virgins and Sibyls (left) and the Prophets and Confessors (right). In the two upper lunettes are swinging figures with symbols of Christ's martyrdom, the Cross and the Column. The middle zone depicts the Raising of the Blessed, at the left, and the Fall of the Damned, at the right. Below are the opening graves of the dead and the yawning mouth of hell, with Charon swinging his oar at the terror-stricken lost souls.

Of the many variations of the Last Judgment theme, two might be pointed out as being more closely related in spirit to Michelangelo's: that in the Campo Santo of Pisa, and Signortelli's decoration of the Cappella Brizio in Orvieto. Significant innovations

455

are the nudity of the figures, and hence Michelangelo's interest in the abstract movement and expression of the figures, rather than the use of nudity as an iconographical attribute (as in Signorelli); the absence of all scenery, background or even structural framework (as on the ceiling), which might contribute to a literal interpretation; the illusion of infinite space behind and around the forms through the use of a luminous atmospheric blue, in contrast to the warm flesh tones of the figures; the separation of figures and figure groups through this blue; the unity of the total wall by means of the individual movement of figures (as in the Battle of Cascina cartoon) and large moving patterns, particularly the oval upward movement of the Blessed and the downward movement of the Damned, and the wheel-like patterns of the hosts receding and revolving around the enthroned Christ. Independent figure compositions of classical origin may be noted in the Niobe group of the Sibyl (or Ecclesia) at the left and the Apollo-like pose of Christ.

The contract for the fresco decoration of the Cappella Paolina was given by Pope Paul III in the fall of 1541, shortly after the completion of the Last Judgment. Actual work was under way by July 20, 1542, and one fresco, the Conversion of St. Paul, was finished when Paul III visited the chapel on July 12, 1545. The frescoes have been considerably damaged and restored, partially by Michelangelo himself. This is especially true of the Conversion of St. Paul, which was damaged by a fire and the collapse of the roof in 1545. The second wall—the Crucifixion of St. Peter—was begun in March 1546, and finished in 1550. As with the Last Judgment, the naked figures were painted over with clothes and loincloths later in the sixteenth century.

The style represents a development of that of the Last Judgment, particularly in the use of the circular composition about a central space or form. Likewise, there was a greater intensity of action in the figures, and a tendency to compose them decoratively into groups, especially in the first fresco (e.g., the group at the lower right). In contrast to the Last Judgment, the overemphasis on the movement and decorative combination of forms accounts, in part, for the compositional weakness of the whole.

Several other pieces of sculpture, although well-documented through the sources and drawings, involve problems of completion of assistants. The Risen Christ, in Santa Maria sopra Minerva,

Rome, was commisisoned on June 14, 1514, by Metello Vari, Bernardo Cencio and Maria Scapucci. The original marble, which is now lost, was found defective. A second version was begun by Michelangelo in 1519-1520 and completed by Pietro Urbano in 1521, much to the dissatisfaction of the master. The Crouching Boy, in the Hermitage Museum, Leningrad (ca. 1524), and the Apollo (or David), in the Museo Nazionale del Bargello, Florence (ca. 1525/26), are largely the work of assistants and are associated with the Medici Chapel. The marble bust of Brutus, also in the Bargello, was executed in 1537-1538 for Cardinal Niccolò Ridolfi and was inspired, possibly, by the murder of Duke Alessandro de' Medici by his cousin Lorenzino de' Medici in 1537, a deed which was looked upon both as a crime and as a heroic blow aimed at the Caesarean tyranny of the hated Alessandro. The bust was not completed, but had been worked upon by Tiberio Calcagni, as is shown particularly in the drapery. The stylistic association with ancient Roman imperian portraits may be noted by the comparison with the various busts of Caracalla. Vasari says it was copied from an engraving.

The Pietà in the Cathedral of Florence was executed about 1550-1555 and intended by Michelangelo for his own tomb. Either because of defective material or, indeed, because of personal frustration, the work was smashed to pieces, probably by Michelangelo himself. The broken pieces were later given to Francesco Bandini, who had them patched together by Tiberio Calcagni, and an attempt was made by him to complete the work (note particularly the figure of Mary Magdalene). Vasari suggests that the face of Nicodemus is a self-portrait of Michelangelo. The group was placed in the cathedral in 1722.

Another late Pietà is that known as the Palestrina Pietà, in the Accademia of Florence. Although not recorded in any of the documents, it had long remained in the oratory of Santa Rosalia in the Palazzo Barberini in Palestrina, and is generally recognized to have been at least begun by Michelangelo and developed by another hand.

The Rondanini Pietà in the Castello Sforzesca of Milan was begun about 1555, and work continued until shortly before his death. A letter from Daniele da Volterra to Michelangelo's nephew, Leonardo, says that the master spent the entire day at work on this

457

group on February 12, 1564, six days before his death. A drawing in the Albertina Museum of Vienna shows the same vertical pose of Christ, related more to the Descent from the Cross theme than to the traditional Pietà (note other drawings in the Ashmolean Museum of Oxford). Changes in the design can be noted in the unfinished marble: the head, originally bent forward, was straightened up and modeled out of the shoulder of Mary, thereby increasing the thin vertical proportions of the group. The comparison of this final work with the earlier versions in St. Peter's and the Cathedral of Florence demonstrates again the elemental and sensitive form as well as spiritual depth of the unique universal genius that was Michelangelo.

The problem of Michelangelo as architect requires special consideration within the conceptual framework of the Renaissance artist. Whereas Leonardo's was basically a structural approach, i.e., that of the engineer, in the broadest sense, and Raphael's a theoretical one, in terms of space and its organization, Michangelo's approach remained consistently that of the sculptor. From the pyramid form of the Julius monument to the architectural framework of the Sistine ceiling and, again, the combination of monuments and architectural enclosure as conceived in the Medici tombs, Michelangelo arrived at a clear definition, in purely architectural terms, in the Laurentian Library.

Where the Rondanini Pietà reveals the lofty and mysterious inner spirit of the aging artist, the architectural designs of his late years express its external grandeur. This begins officially in 1546 when, after the death of Antonio da San Gallo, Michelangelo was commissioned by Pope Paul III (Alessandro Farnese) to complete the designs for the Palazzo Farnese, the new piazza and surrounding buildings of the Campidoglio, and the Cathedral of St. Peter. His designation as director of the St. Peter's project came on January 1, 1547.

Michaelangelo's essential contribution to San Gallo's design of the Palazzo Farnese, giving it both strength and movement, can be seen in the increased size of the cornice and columnar framework for the entrance on the façade, and the towering clusters of pilasters on the third story order of the courtyard. That of the Capitoline Hill is the concept of the hill as a form and space, enclosed by the three imposing masses of the Palazzo Senatorio, the Palazzo dei Conservatori

and the Palazzo Nuovo (Museo Capitolino). Their monumental effect is enhanced by the bronze equestrian statue of Marcus Aurelius, (identified then as the Christian Emperor Constantine, and moved there from the Lateran in 1538), the ovoid pattern of the pavement, and the flanking buildings set at a slight angle (note the total plan of the piazza in the etching by Etienne du Pérac, 1569).

Among the innumerable features of Michelangelo's conception of the colossal Cathedral of St. Peter are the reemphasis on Bramante's basic plan of a dome set on a Greek cross, but with a much more massive strength in the supporting piers of the crossing and a stricter organization of the secondary spaces and ambulatories into a simpler and more unified plan. The exterior was likewise simplified by the reduction of the secondary masses into a stronger and more unified sculptural form, articulated by clustered pilasters, Corinthian columns and heavy ribs to a crowning lantern at the top. The total form, with its imposing portico and entrance, was planned as the center of an open piazza. Its intended effect can best be seen today in a view of the dome and choir end. (Note the scale model by Giovanni Franzese in the Museo Petriano, Rome, and the 1569 engravings by Etienne du Pérac.) These ideas then became the new point of departure for the later development, culminating in Bernini's seventeenth-century transformation of the entire complex as Rome's greatest architectural monument.

4. Venice

IT HAS ALREADY BEEN NOTED that at the beginning of the sixteenth century, Venice was facing not only the increased hostility of the Turks, but a formidable alliance against her on the mainland as well. Her treacherous policies toward France and the papacy at the end of the fifteenth century caused the formation of the League of Cambrai opposing her in 1508; this consisted of France, Ferdinand of Spain, the Emperor Maximilian and the Pope, Julius II. After taking away most of the Venetian possessions in Lombardy, the Pope formed the Holy League (1511) between Spain, Venice and the papacy against the French; this enterprise successfully drove the French from Italy and restored to Venice most of her Lombard possessions. The rest of the century found Venice occupied with a continuous and losing fight against the Turks, which her victory at Lepanto in 1571 did not materially alter. The isolated position of Venice in relation to Italian affairs in general, the collapse of her colonial empire, and the fading of her commerce through the development of new trade routes, effected the continued decline of Venetian power and prestige throughout the second half of the century.

The development of painting in Venice and the surrounding schools follows closely in line with that of the late fifteenth century. It is less complicated by revolutionary problems of form or by the many political and social implications which characterized the art of the High Renaissance in Florence and Rome. Large decorative enterprises of historical or narrative character become less frequent; and while the traditional altar and *sacra conversazione* themes continue, the artist's individual choice and caprice in his personal interpretation of religious, genre or mythological subjects are given freer reign than in any period heretofore.

461

Giorgione (Giorgio da Castelfranco, ca. 1477-1510) takes a position as significant to the Venetian High Renaissance as that of Leonardo to the Florentine, with an art that is rooted in the local tradition of Bellini, yet recast with a new approach to nature and the painter's craft that tends more toward the lyric and poetic rather than the dramatic expression of the Florentine.

Giorgio, called Zorzi in Venetian dialect in the *Anonimo Morelliano*, was born about 1477 (Vasari, though he gives 1478 as the date in his second edition) in Castelfranco (the family name of Barbarelli is sometimes attributed to him). He apparently came to Venice at an early date, and may possibly have worked in the studio of Giovanni Bellini. Since the early sixteenth century there have been innumerable legends, speculations and attributions concerning the life, character and work of Giorgione. An inscription on the back of the Portrait of Laura, in the Vienna Kunsthistorisches Museum, gives the date of June 1, 1506, and the fact that the painting was done by *Maistro Zorzi de Chastelfr (ancho)* (i.e., Master Zorzi of Castelfranco), who was a colleague of Master Vicenzo Catena. The only other documentary records of him, however, are: the two payments of August 14, 1507, and January 24, 1508, by the Council of Ten to Giorgione for an unidentified picture for the audience chamber of the Palazzo Ducale; a payment on May 23, 1508, for a hanging for the picture (*la tenda di la tella facta per la camera di la audientia nuova*); a document of November 8, 1508, concerning payments for Giorgione's frescoes on the façade of the Fondaco de' Tedeschi and the judgment of a commission of three artists recommended by Giovanni Bellini—Lazzaro Bastinai, Vittore Carpaccio and Vittore Belliniano—estimating the value at 150 ducats; and, finally, the correspondence between Isabella d'Este and the Venetian, Taddeo Albano, of October 25 and November 7, 1510, in which the duchess inquires about a *Nocte*, possibly a Nativity by Giorgione, and Albano replies that Giorgione had died of the plague only a short time before.

Of the many attributions to Giorgione, only four have been traditionally recognized as certain and authentic. One is the Castelfranco Altar, which is traceable to its original location in Castelfranco and is mentioned by Ridolfi. The other three were recorded by Marcantonio Michiel as having been seen in Venetian collections between 1525 and 1532.

The first is the Madonna Enthroned with St. Liberalis and St. Francis, which was painted ca. 1505 for the Cathedral of St. Liberalis in Castelfranco at the request of the *condottiere*, Tuzio Costanzo, whose son, Matteo, died in 1504 and was buried in the family chapel of that church (note his coat of arms on the throne). The comparison with similar altarpieces by Giovanni Bellini (e.g., the San Giobbe altar or that in San Zaccaria) will show a tendency away from the older *sacra conversazione* type of altar toward a more impressive form, which in spirit and composition is more indirectly associated with the beholder. Notice the use of fewer figures, their logical composition into a pyramid with the Virgin towering on the throne, their look and gesture toward the spectator, the substitution of a larger space and delicate, luminous landscape for the architectural frame and vaulted interiors of Bellini, the soft, gray-yellow light illuminating the sky behind the red and dark green-robed Madonna, and, in general, the quiet simplicity and spiritual expression which, aside from the coloration, is not unlike the early Perugino.

The second is the so-called Three Philosophers, in the Kunsthistorisches Museum of Vienna (listed in the collection of Taddeo Contarini in 1525 by Marcantonio Michiel), variously interpreted as the classical Aeneas, Pallas and Evander, or as representatives of philosophical viewpoints associated with the contemporary academies and philosophic orders (i.e., Aristotelianism, Averroism, and the new naturalism or Neo-Aristotelianism popular in Padua at the time). Another interpretation is that of the traditional Three Ages of Man.

More significant, however, is the profane content as an artistic motif in itself, which is related to the mood of the *sacra conversazione* scenes. Its detachment from the religious devotional theme is in keeping with the general tendency toward the special emphasis on the genre detail (cf. the expansion of music-making angels to the "musicians" or "the concert," frequent in late Quattrocento and early Cinquecento painting, e.g., Giorgione-Titian). In the composition, note the dignified Renaissance figures (cf. the saints in Giovanni Bellini's San Zaccaria altar) placed asymmetrically to one side, the use of light to model the figures and space, their balance with the rock formations on the left side, the total design of figures, trees and rocks in the foreground against the lighter and more luminous land-

scape in the distance. The date of the painting is probably 1507 or 1508.

The third work is the so-called Tempest, also known as the Giovanelli landscape, formerly in the Palazzo Giovanelli and now in the Gallerie dell' Accademia of Venice, which is probably the finest and best-preserved of Giorgione's paintings. It was recorded in the Casa Vendramin by Marcantonio Michiel in 1530. Its content is again variously explained as the story of Adrastes, who comes upon the lovely Queen Hypsipyle as she suckles Opheltes (from the *Thebais* of Statius 4, 740 ff.), or as an allegory of *Fortezza* and *Carità* associated with the pastoral storm, or simply, as Marcantonio Michiel describes it, "a little landscape on canvas with a tempest, a gypsy woman and a soldier." Its interest appears to be chiefly in the painterly presentation of the landscape and *staffage* as such. In contrast to the Three Philosophers, note the greater emphasis on the space and recession of the river landscape with its ruins, bridge and architectural forms, the larger opening to it made by the trees of the foreground and middle ground, and the romantic subordination of figures to the space and stormy atmosphere.

The Sleeping Venus, in the Dresden Gemäldegalerie, although sometimes attributed entirely to Titian, is Giorgione's most famous canvas and is certainly the one listed as such by Marcantonio Michiel in the house of Jeronimo Marcello. The motif is not to be explained by classical mythology and literary associations, as is the case with Botticelli and the Florentines of the Medici circle, but more by the personal approach of the artist. With Giorgione, it appears to be a combined romantic interest in nature, whether the landscape or the nude model, and the artistic recognition of the emotional possibilities of light and color. The canvas is considerably damaged and repainted, and is assumed to have been left unfinished by Giorgione to be completed by Titian (i.e., the landscape). A cupid originally at the foot of the nude had later been painted out. Note the contrast in design and color, and the different character of the romantic expression in the Venus representations of Botticelli or Lorenzo di Credi.

Of the original appearance of the ruined frescoes of the Fondaco de' Tedeschi, one can have only a vague suggestion from the eighteenth-century etchings made by Zanetti (A.M. Zanetti: *Varie Pitture a Fresco de' Principali Maestri Veneziani*, Venice, 1760). A

mutilated, detached fresco fragment of a nude from the original façade is in the Gallerie dell' Accademia of Venice.

Two other well-known canvases are the Fête Champêtre, in the Louvre, Paris, and the Concert, in the Palazzo Pitti, Florence. Significant and not accidental is the continued association of music and musicians with the Venetian coloristic mode of expression. In the Louvre canvas, note the romantic associative relationship and artistic combination of musician figures, the nude, and the landscape (cf. the composition of the Three Philosophers, the landscape of The Tempest). The Concert, with the central figure playing the spinet (invented in 1502 by Giovanni Spinetti), can again be compared with the frequent groups of music-making angels and sacred conversation pictures of the late Quattrocento. The strong portrait character of these half-length figures, particularly the one in the center, has encouraged the attribution to Titian, as well as the possibility of a collaboration of Titian and Giorgione.

The many other attributions have been associated with these works as well as those of Bellini, Titian, Catena and early Cinquecento contemporaries. The Judith, in the Hermitage Museum of Leningrad, had once been ascribed to Raphael, and is related in type to the Madonna of the Castelfranco Altar. The pair of panels in the Uffizi Gallery of Florence representing the Trial of Moses and the Judgment of Solomon was once assumed to have come from Giovanni Bellini's shop (cf. Bellini's Sacred Allegory in the Uffizi), but they have also been attributed to Giulio Campagnola, as well as to Vicenzo Catena, and are not generally accepted as Giorgione's. The same is true of the Adoration of the Magi, in the National Gallery, London, and the Allendale Nativity, in the National Gallery of Washington, which is sometimes associated with the *Nocte* mentioned in Isabella d'Este's letter.

Although it has sometimes been questioned, the inscription on the back of the Portrait of Laura (the painting is on canvas attached to a wood panel) appears to be authentic, and the painting is significant, aside from the inscribed date of 1506, as representing an idealized portrait type similar to that used in the Judith and the Madonna of the Castelfranco Altar. A male counterpart is the bust Portrait of a Young Man, in the Berlin-Dahlem Museum, with the letters *V. V.* inscribed on the parapet probably indicating the initials of the unknown subject. There are two male portraits of con-

465

siderably greater maturity in terms of the Renaissance style, one the bust Portrait of a Man, in the Alte Pinakothek of Munich, and the other in the Frick Collection of New York. Both of these have been attributed to Titian at one time or another. The damaged Christ Bearing the Cross, in the church of San Rocco in Venice, is assumed to be the one mentioned by Marcantonio Michiel and Vasari, but it has also been identified as Titian's. Related to it is the Christ Bearing the Cross in the Isabella Stewart Gardner Museum of Boston. A final attribution, frequently given to Titian as well, is the Madonna with St. Anthony of Padua and St. Roch, in the Prado Museum of Madrid, which is related to the Castelfranco Altar.

Titian (Tiziano Vecellio, ca. 1476/7-1576), in an unbelievably long and productive career, represents the unfolding of the basic iconographical and stylistic principles of Giorgione through the succeeding generations of High Renaissance, Mannerism and, finally, a Baroque form that leads eventually into the art of Rubens and the seventeenth century. The many-sidedness of Titian's art as a painter is not necessarily due to the complexity of his character, as was the case with Leonardo and Michelangelo, but is rather to be explained by his financial and aesthetic responsibility to the many patrons who sought his work and whose tastes he was willing to satisfy (cf. the problem of patron and style in the fifteenth century). Being almost the same age as Michelangelo and outliving him, he is a parallel and in many ways an equally important link to the great styles of the Baroque period (Rubens, Rembrandt).

Tiziano Vecellio was born ca. 1476/7 (from a letter of Titian's to King Philip II of 1571, in which he gives his age as ninety-five) in Pieve di Cadore in the Dolomites, the son of Gregorio Vecellio, who had been a soldier and belonged to an old and well-known local family. There are many conflicting arguments about Titian's age. Sixteenth-century documents (a letter of 1564 from the Spanish ambassador in Venice, Garcia Hernandez, to Philip II gives his age as "about ninety"; another, of 1567, from the Spanish Consul, Thomas de Cornoça, to Philip II mentions him as eighty-five years old, and Vasari says he was born in 1480) all come from his late years and indicate that he was very old. Recent criticism has the tendency to place his birth date in the late 1480s, i.e., ca. 1488-1490.

With his brother Francesco, Titian appears to have come to Venice in his early youth. Lodovico Dolce says he studied with the mosaicist Sebastiano Zuccato (1467-1527; note panel of St. Sebastian with a Kneeling Patron in the Museo Correr, Venice, signed *Sebastianus Zucatus Pinxit).* and Vasari names Giovanni Bellini as his teacher. The fresco of a Hercules outside the Palazzo Morosoni is mentioned by Sansovino. The first definite record of him is in 1507/8, when he executed frescoes with Giorgione on the facade of the canal side of the Fondaco de' Tedeschi, which, like Giorgione's, were ruined by the damp sea atmosphere and are known only through Zanetti's etchings (cf. the Justitia). During the plague of 1510, Titian went to Padua and executed frescoes with campagnola in the Scuola del Santo (1511) and possibly in the Scuola del Carmine. In 1512, he refused an offer from the papal secretary Pietro Bembo to come to Rome and work for Julius II, then returned to Venice. The next year, he appealed to the Council of Ten, offering to paint a large battle scene without charge, but applying at the same time for the position of broker (*sensaria*) at the Fondaco de' Tedeschi. This the council granted, then revoked the privilege, probably because of the opposition of Giovanni Bellini, who also held such a position. Titian managed to get it, however, with the yearly income it provided, soon after the death of Bellini. The historical scene of the Battle of Cadore was begun on this occasion, but was not finished until ca. 1529 (destroyed in the fire of 1577).

Titian's standing as one of the foremost painters of Venice and the successor to Giovanni Bellini was quite well established at the death of that master. At the same time, he had active connections with the various courts and their ducal leaders outside Venice, who eagerly sought the altarpieces, portraits and mythological scenes from his brush. Among these were Alfonso of Ferrar and his wife, Lucrezia Borgia, whom Titan first visited in 1516, the young Federigo Gonzaga, as well as his mother, Isabella d'Este of Mantua, and his sister, Eleonora, the wife of Duke Francesco Maria della Rovere of Urbino. When Emperor Charles V visited Bologna (coronation February 25, 1530) and Mantua in 1530, Titian was introduced to him by Federigo as the best painter of the time. He received a number of important commissions, and thereafter (1533) was honored with many privileges and titles (Count of the Palatinate, Knight of the Golden Spur, and member of the imperial

household) and heard himself likened to Apelles, as Charles was compared to Alexander. He refused an offer to go to Madrid, but executed numerous commissions for friends and courtiers of Charles, then for the Roman house of Farnese, as well as for the Medici. His first meeting with the Farnese pope, Paul III, was in 1543, when the latter visited Ferrara and Bologna. In 1545, he was sent to Rome with great honor by Duke Guidobaldo, did the portrait of the Pope with Ottavio and Cardinal Alessandro Farnese, was quartered in an apartment in the Belvedere, and was visited there by Michelangelo, and shown about the Vatican and Rome by Vasari and Sebastiano del Piombo. That year, he was offered the sinecure of *Piombo* (Keeper of the Seal) at the papal court, which he refused, although he tried to get a similar position for his son Pomponio. Back in Venice, he was invited by Charles to Augsburg, for the Reichstag, where he went for eight months in 1548, doing a number of portraits of the Emperor, Chancellor Nicholas Perrenot Granvella, and Johann Friedrich of Saxony. Shortly afterward, he made a second trip there.

The remainder of his life, after 1550, was spent in Venice, living in princely splendor in the Biri Grande quarter. In 1525, he had married Cecilia (died 1530), the daughter of a barber, who bore him two sons, Pomponio and Orazio, and two daughters, one of whom died at an early age, and the other, Lavinia, identified as the model in many of his paintings. Her marriage is recorded in 1555 to Cornelio Sarcinelli of Serravalla. Titian's house was frequented by many of the Venetian intellectuals (e.g., his friends, Pietro Aretino and the architect Sansovino), and his production continued steadily until the very last years of his life. As an old man, he was visited by Henry III of France in 1574. He died on August 27, 1577, during the plague of that year, and was buried in Santa Maria dei Frari.

Titian's work divides itself into three periods, largely through the external circumstances of patronage and the social-political conditions governing taste and fashion mentioned before. The first period is that before his first official commission (1513) from the State (i.e., the Council of Ten in Venice), which stylistically parallels the brief activity of Giorgione and the aged Bellini. The second period (ca. 1513-1550) is dominated by active patronage of ducal, papal and imperial courts, as well as the church itself. The style, however, reveals two concurrent tendencies, the one toward the

468

large and monumental compositions that parallel the High Renaissance of Raphael and Michelangelo in Florence and Rome, the other toward the manneristic style of the following generation. To the first group belong the monumental altars and decorative projects; to the second, the portraits, mythological and allegorical representations. The last period (ca. 1550-1577) shows the artist freed from the social requirements of the previous style and represents a personal development of the earlier monumental form. The study and understanding of Titian is best afforded through the combination of the chronological sequence in style and the structural limitations of iconography and content.

Of the altarpieces, the earliest authentic work extant is the St. Peter Enthroned with the kneeling Jacopo Pesaro being recommended by Pope Alexander VI, in the Musée Royale des Beaux Arts in Antwerp. It was painted ca. 1503, probably in honor of the naval victory of Pesaro and the papal fleet over the Turks at Santa Maura on June 28, 1502. The banner held by the kneeling Dominican, titular Bishop of Paphos as well as naval commander, represents the coat of arms of the Borgia Pope Alexander. The inscription on the cartouche, *Ritratto di uno casa Pesaro in Venetia che fu fatto Generale di Santa Chiesa. Titiano F.*, appears to be a later addition. In the composition, note, in contrast to similar votive altarpieces by Bellini (i.e., that of the Doge Barbarigo or Doge Mocenigo), the awkward, unbalanced arrangement of figures, and the concentration on their plastic forms freed from decorative surroundings.

The St. Mark Enthroned with Saints Cosmas and Damian, Roch and Sebastian, in the church of Santa Maria della Salute, was originally painted for Santo Spirito in Isola, in commemoration of the end of the plague of 1510, which accounts for the choice of the physician and protector saints on either side before the patron saint of the republic. Its date, therefore, appears to be early 1511, though it has been frequently dated ca. 1504 because of its close relationship with the Antwerp altarpiece. In contrast to the earlier altar, however, note the vetical composition, the centralized position of the enthroned saint, and the unbalanced use of the row of columns. The comparison with Giorgione's Castelfranco Madonna shows a similar elimination of an architectural framework, but also larger and conversationally more active figures, as well as a more masculine, compact, though still largely Quattrocentist, grouping

469

(cf. the heroic pose of St. Mark, the emphasis on large and bright patches of color).

The Madonna della Ciliege (Madonna of the Cherries), in the Vienna Kunsthistorisches Museum, is an excellent example with which to demonstrate Titian's basic style, both in regard to Giorgione and to the traditional form of the small, intimate devotional altarpiece as it developed in the early Cinquecento (cf. the Raphael Madonnas of the Florentine period). It belongs still within Titian's first period, painted possibly about 1510, and represents, in its very human and naturalistic spirit as well as in its compositional integration, a parallel to Leonardo's Madonna of the Rocks. There is considerable disagreement as to its dating, which varies from an early 1506-1508, coinciding with Dürer's visit to Venice, to as late as 1516-1518.

In studying the composition, note, in contrast to Bellini's Madonna of the Trees, or Titian's so-called Gypsy Madonna painted ca. 1510 (sometimes dated as early as 1502), in the same Vienna museum, the broader and more horizontal proportions of figures and composition; the greater movement and triangular grouping of the Virgin and two Infants; the ''play'' motif with the cherry sprigs, whose bright red patches are also a part of the triangular composition in color; the recession and unity in tone and color—yellow-gold of the hair and flesh tones, green and red of the cherry branches, the rich red of the Madonna's gown, shining blue of the head-cloth, darker gold-brown of the tapestry and two male heads at the sides, and luminous blue of the sky. Aside from the unity of tone that was afforded through the use of light, as in Bellini, one significant feature to the coloration which is true of practically all his work is Titian's use of a darker reddish prime or under-painting (the so-called bolus ground). Upon the basis of this single tone the total choice and distribution of color, the modeling of the forms with white, and the successive glazes were built. Bellini also used such a prime (as did Dürer), but it was a very light and transparent yellow-ochre, hence the brilliance and luminosity of his panels, as opposed to the depth and coloristic richness of Titian's canvases. In contrast to the smooth surface of the panel, Titian preferred, especially in his later works, the rougher surface of canvas, which was also more suitable to the damp climate and the larger areas required for decoration. The rough surfaces made by coarse canvas and an increasingly freer

and more pastose application of paint cause a broken reflection of light from the picture, which, together with the countless glazes of the transparent oil color, the unifying color of the reddish prime, and the unifying tone of the light, are the basic features of Titian's and Venetian coloration after him.

The poor quality and state of preservation of the Madonna of the Cherries at the present time is due to restoration by Erasmus Engert in 1856, when the painting was transferred from the original canvas to wood, and the dark red underpainting was replaced by a flat and smooth white ground in the mistaken belief that the bolus ground was chemically defective. As a result, not only has the paint developed many cracks, but the color is hard, chalky and lifeless, and certainly unlike Titian.

This description of technical procedure, and the necessity of its thorough understanding when dealing with problems of conservation, points up one of the essential qualities of Titian, and indeed of the Venetian tradition, namely, the importance of the painting technique itself as a medium of personal expression. The coloristic tradition of Venice as a maritime city, with its century-old Byzantine and Oriental associations, is here redefined in terms of the individual expression with its emphasis on the freedom of the brushstroke, the flexibility afforded by the oil medium, and the rich and varied effects made possible by their combination with light and broken color. The parallel in Titian's work to the scientific study of nature seen in Leonardo, the sculptor's interest in form noted in Michelangelo and the organizational composure in Raphael, might be seen as the Venetian's inspired and equally personal emphasis on the painter's technical process and medium.

It is this point which distinguishes the short career of Giorgione and encourages his characterization as the "father of modern painting." Titian's Gypsy Madonna (La Zingarella) of circa 1510 in the Vienna Kunsthistorisches Museum has many qualities which are reminiscent of Bellini, Mantegna and the Quattrocento, particularly in its classical pose of the figures and its balanced horizontal-vertical design. The rounded and well-modeled forms and voluminous drapery, as well as the soft light that envelops both figures and landscape, are characteristic of Titian (cf. the Madonna of the Cherries) and reflect a feeling for nature and the model which is developed in his later Madonnas. Again, the close relationship in facial and figure

types with Giorgione's Sleeping Venus and the Madrid Madonna and Child with St. Anthony and St. Roch argues in favor of the attribution to Giorgione. The Concert, in the Palazzo Pitti, here attributed to Giorgione, is just as frequently ascribed to Titian, which demonstrates again the close affiliation of the two masters during the period 1500-1510.

The first and most important altarpiece of Titian's second period is the large (22 ft. 6 in. x 11 ft.) Assumption of the Virgin (L'Assunta), in the church of Santa Maria Gloriosa dei Frari in Venice. The panel was ordered in 1516 for the high altar of that Franciscan church, and was unveiled on March 20, 1518. It is signed *Ticianus MDXVI*. In the analysis of the style, note: 1) the clarity of the composition, with the traditional division of earthly apostles below, God-Father above and the ascending Virgin on the clouds between them; 2) the corresponding sharp contrasts of color, particularly the red gown and blue mantle of the swaying Virgin against the brilliant yellow-gold light of the background, which gives the figure and whole composition a striking clarity when seen in the vast space of the church for which it was designed; 3) the High Renaissance unity of composition (cf. Giovanni Bellini's Assumption) through the circular design of the angels, the organization of the moving figures into a pyramidal form (i.e., the Virgin and the apostles at either corner below), the corresponding repetition of color patches (i.e., the red in these same apostles to the left and right, repeated in the Virgin's robe and God-Father, likewise the blue from lower left, continued diagonally to the Virgin's mantle and that of God-Father again); 4) the composition of the figures in silhouette as a surface design, yet also in the third dimension (note the shadow with the kneeling St. Peter in the center, the twisting, in-the-round figure of the Virgin); 5) finally, the remarkable balance of physical, dramatic excitement and spiritual calm that has its parallel in the contemporary works of Raphael (i.e., the Sistine Madonna and the Transfiguration).

The famous Pesaro Madonna is a logical development and perfection of the forms suggested in the first two altarpieces (i.e., that of St. Peter, in Antwerp, and the St. Mark Enthroned, in Santa Maria della Salute, Venice). It was commissioned by the same Bishop Jacopo Pesaro on April 24, 1519, for the altar of the Conception, and dedicated on December 8, 1526, in Santa Maria Gloriosa dei Frari, Venice, where it still is. Payments are recorded

from 1519 to 1526. Represented are the Virgin enthroned, to one side; before her, on the step, is St. Peter with his key and the open book, looking down at the kneeling Jacopo. Behind him is an armored warrior, with a banner and the Borgia-Pesaro coat of arms, leading the conquered Turk (hence again commemorating the 1502 victory over the Turks at Santa Maura). To the right is St. Francis, looking up to the Child, with a gesture toward Benedetto Pesaro and the other members of the family. St. Anthony is behind at the right. In the composition, note the grandiose impressiveness of the space through the columns (cf. the same motif in the St. Mark altar) and the clouds, the subordination of the figures to it, the asymmetrical, yet balanced grouping of figures and design (cf. the Madonna and the banner), the theme of combined group portrait and votive picture (cf. Mantegna's madonna della Vittoria).

A simpler composition of about the same time (1520) is the Madonna in Glory with Saint Francis, St. Aloysius and the kneeling donor, which was formerly in the church of San Francesco, now in the Museo Civico of Ancona, and is signed, *Aloyxius Gotius Ragusinus fecit fieri MCXX Titianus Cadorinus pinsit* (cf. Raphael's Madonna da Foligno, in the Vatican Pinacoteca).

Titian's adherence to the old Venetian tradition, and at the same time his awareness of the new forms developed by his great Florentine-Roman contemporaries, can best be seen in the remarkable Averoldi polyptych in the church of Santi Nazzaro e Celso in Brescia, which is signed *Ticianus faciebat M.D.XXII.* In early Venetian fashion, probably at the request of the donor, the altar is composed in separate panels, the angel of the Annunciation on one side, the Virgin on the other; Saints Nazarius and Celsus accompany the kneeling patron, the papal legate Altobello Averoldo, at the lower left, and St. Sebastian is at the lower right. Most significant are the two shining muscular nudes of the resurrected Christ and St. Sebastian, which reflect the influence both of the classical Laocoön group, a caricature of which Titian had made in a drawing of three struggling apes (cf. the woodcut by Niccolò Boldrini), and the chained slaves of Michelangelo's tomb for Pope Julius II. Several pen-and-ink drawings for the St. Sebastian as well as the the Madonna and Child, in the Berlin Kupferstichkabinett and the Frankfurt Städelisches Institut, reveal Titian's loose and atmospheric pen stroke and vigorous action based on the study of the model.

The interest in the powerful and dramatic physical action of gigantic figures as such, whether inspired by Michelangelo or by antiquity, can be followed in a number of works whose choice of subject seems to be governed by that particular desire: the fresco of St. Christopher, in the staircase to the Doge's apartments in the Palazzo Ducale in Venice, which was probably commissioned by the Doge Andrea Gritti shortly after his election in 1523; the Christ Crowned with Thorns, of ca. 1542, in the Louvre, signed *Titianus F.*, formerly in the Cappella della Santa Corona in Santa Maria della Grazie in Milan; the three canvases of the Sacrifice of Isaac, Cain Slaying Abel, and David and Goliath, in Santa Maria della Salute, Venice, originally painted as ceiling decorations for Santo Spirito in Isola ca. 1542-1544; the two canvases representing Tityus and Sisyphus, in the Prado of Madrid, which belonged to a group of four (the others representing Tantalus and Ixion are lost) painted for Mary of Hungary, sister of Charles V, in 1548-1549.

The great compositions of Titian's late period show the enrichment of this dramatic expression with a deeply religious and personal, lyric pathos that in the history of painting has its counterpart only in the late work of Rembrandt. The first of these is the large holy Trinity—La Gloria—in the Prado Museum of Madrid, which is signed, *Titianus P.*, and was painted in 1551-1554 for Emperor Charles V. Iconographically, the work is unique in that it has elements of a Last Judgment and was referred to as such by the emperor. Note, in contrast to Michelangelo's Last Judgment, the more unified, though less complex, circular composition and the essentially mystic and emotional interpretation of the theme, rather than the drastic *terribilità* of the Florentine. It is also related to the numerous allegorical ''Triumph'' representations (cf. especially Raphael's Disputà as a Triumph of the Holy Sacrament). In addition, the work is essentially to be understood as a votive picture and, as such, represents the completion of a long development that can be followed from Masaccio's Holy Trinity, for example, through Piero della Francesca's Madonna with Duke Federigo, Raphael's Mass of Bolsena, and Titian's own earlier Pesaro Madonna.

In the analysis of the picture, note the circular composition of animated figures receding from the larger ones in the foreground to an atmospheric haze of angel heads behind the central group in the background; the persistence of a small strip of earthly horizon below

(cf. the Assunta and the concentration on the heavenly vision here, rather than the balance of heavenly and earthly figures noted in the earlier work); the recognizable allegorical significance of figures represented: prophets and patriarchs with the figures of Moses (with the law tablets), Noah (holding the ark and dove with the olive branch) and Mary Magdalene in the foreground; the Virgin at the left looking across to the supplicants on the opposite side, namely the white-shrounded Emperor Charles with his crown, the Empress Isabella behind him, Philip II and Queen Mary of Hungary.

Something of the emotional, in the deepest sense romantic, spirit of Titian's late style can be seen in the (signed) Fall of Man, in the Prado. It was painted ca. 1565-1570, and was considerably damaged in a fire of 1734. In the composition, note the gentle weaving of the two figures with the serpent (more suggestive of a cupid), trees and foliage in a pattern against the luminous sky. Note, too, the lyric pathos of Titian's interpretation of the theme, in contrast to the aggressive character of Michelangelo's Fall of Man on the Sistine ceiling.

The contrast of this late style with the more plastically integrated and Michelangelesque manner of Titian's earlier period can be seen in the Christ Crowned with Thorns, in the Alte Pinakothek of Munich. It was painted about 1570 or later, and is a variation of the same composition which he had done in the early 1540s for Santa Maria della Grazie in Milan (now in the Louvre). In the comparison, note especially the abstraction of the form in the interest of light and color; the same poses are used, e.g., the kneeling soldier in the right foreground, but the organic function (i.e., the arm around the neck of the next figure) has been stylized into a decorative pattern, and the plastic definition of the forms in the space is dependent almost solely on the color, as can be seen in the luminous blue jacket and yellow sleeves of this same figure, while the figure of Christ, with its rich broken gray and luminous flesh tones, recedes by contrast into the center of the group. Notice also the substitution of the lighted chandelier for the sculptured bust of Tiberius, used in the Paris version, as a part of the diagonal composition. The coloration is based on the technical method described in the early Madonna of the Cherries, i.e., the dominant reddish underpaint, the unified darkness of tone in which the lights are set, the rough canvas, the free and pastose handling of the brush stroke, the countless glazes and the

broken color. With these features, the remarkable reinterpretation of the subject can readily be seen in the comparison of the two representations of Christ: the Laocoön-like expression of physical struggle and pain, as opposed to the quiet resignation of the aged master.

Perhaps the most magnificent of all of Titian's compositions is the large Pietà in the Accademia of Venice. As a late and deeply personal statement, it is a striking parallel to Michelangelo's Rondanini Pietà and that in the Florentine Cathedral. The canvas was probably one of the last he had worked on, and was intended for his own tomb in the chapel of the Crucifixion in the church of Santa Maria Gloriosa dei Frari in Venice. It remained in his studio at the time of his death, and was then finished with pious reverence (from the inscription *Quod Titianus inchoatum reliquit Palma reverenter absolvit Deoq. dicavit opus*) by his pupil, Jacopo Palma il Giovane. On either side of the niche are represented monumental statutes of Moses and the Hellespontine Sibyl, and on the base of the latter is a tablet with the portraits of Titian and his son Orazio.

In the analysis of the work, compare the many variations on the Pietà, in the Pinacoteca di Brera; that of Crivelli, in the Boston Museum of Fine Arts, as well as Titian's own earlier versions, such as the Entombment of ca. 1525 in the Louvre; and that signed *Titianus Vecellius Eques Caesaris.*, painted in 1559 for Philip II and now in the Prado of Madrid. Note the tendency to compose the figures on planes in coloristic relief; the dramatization of the central group of Mother and Son through the impressive niche; the crossed diagonals of the Body of Christ continued in the taper-bearing angel, and the figures of Joseph of Arimathea (sometimes also identified as St. Jerome), the Madonna and Mary Magdalene; the quiet pathos of the central group, as opposed to the Baroque gesture and wail of the Magdalene; and the rich luminosity of light and color, with the striking accent of the green of Mary Magdalene's dress that coincides with her dramatic gesture.

Titian's activity in the field of narrative-historical painting is somewhat limited, partly due to the restricted possibilities of the logical medium (fresco) in the damp climate of Venice, and partly because of the different conditions of patronage, namely, the predominance of the individual commissioner, as compared with the church, state or corporation and the collective and social respon-

sibilities associated with each. The works that he did, however, are of considerable aesthetic and historical importance

Little is to be ascertained concerning the frescoes of the Fondaco de' Tedeschi (1508). The contemporary accounts praised Titian's color and realistic figures; the fragmentary etchings by Zanetti suggest a more complicated movement and composition in Titian's (i.e., in the Justitia) than in the frescoes of Giorgione. To Vasari, the allegory did not seem readily comprehensible.

The frescoes in Padua (1511) reveal a gradual development from Quattrocento narrative forms to the more dramatic style of the Cinquecento. The doubtful fresco in the Scuola del Carmine represents a spacious landscape with the Meeting of Joachim and Anna (note the well-rounded figures and their active gestures). Then follow the three frescoes (the final payment for which was made on December 2, 1511) depicting the Miracles of St. Anthony, in the Scuola del Santo: St. Anthony Grants Speech to the Newborn Child, the Healing of the Youth who had cut off his leg in repentance for having struck his mother, and the Raising of the Woman who had been killed by her jealous husband. Characteristic of the style is the domination of space and landscape over figures; the alignment of figures, in Quattrocento fashion, as a frieze across the foreground, but with a tendency to compose them into action groups. This is especially noticeable in the last-named scene, in which the more dramatic representation of the husband killing his wife is placed in the foreground while the miracle itself is placed in the background. Note, also, the later development of the same motif in the Slaying of St. Peter the Martyr.

Titian's most important example of historical painting is the Battle of Cadore, which was begun in 1513 (cf. Titian's letter of 1513 to the Council of Ten asking for the privilege of doing the decoration) and not completed until 1537-1539, under considerable pressure from the Council. It belonged with the long series of historical battle pictures by Quattrocento masters in the Sala del Gran Consiglio in the Palazzo Ducale, and was destroyed in the fire of 1577 (cf. the engraving by Giulio Fontana and the oil copy in the Uffizi). It represented the battle which took place March 2, 1508, when the Venetians, under Bartolommeo Alviano, defeated the Spanish imperial troops near Cadore, Titian's home town.

While the dramatic action of the massed figures, especially

those at the left, may be related to Michelangelo's Last Judgment and were probably executed at that later date, the basic composition undoubtedly belongs to the earlier period (i.e., ca. 1513). Note the integration of figures with the dramatically impressive mountain landscape, the motif of the bridge and the receding valley in the center, which appears to be characteristic Titianesque development of Giorgione's famous landscape of the Tempest, in the Accademia of Venice. The comparison of this form with the other great battle scenes of the High Renaissance (i.e., Leonardo, Michelangelo, Raphael) reveals Titian's distinctive solution of active figures designed into a towering space and landscape, which becomes a determining influence on later battle representations (Tintoretto, Rubens).

The large canvas decoration of Mary Ascending the Steps of the Temple is at once Titian's solution of the traditional narrative decorations so popular in Venice in the late fifteenth century (Gentile Bellini, Carpaccio) and a parallel to the monumental narrative of the High Renaissance as presented in Florence (Andrea del Sarto) and Rome (Raphael's tapestries). It was painted ca. 1534-1538 for the Sala dell' Albergo of the Scuola della Carità, which is not a part of the Accademia in Venice, and the canvas remains in its original position over two doorways. The crowd of spectators at the left is probably made up of members of the confraternity, of which Andrea de' Franceschi and Lazzaro Crasso, at their head, are identified by Ridolfi.

In the analysis of the style compared with the fifteenth-century versions of the same theme, such as those in the drawings of Jacopo Bellini, the panels of Cima da Conegliano in Dresden and of Carpaccio in the Pinacoteco di Brera, note: the monumental and decorative use of the architecture, which is combined with an unbalanced and moving composition; the festive grandeur of the scene, with the animated crowd below at the left, the dignified priests at the top of the steps, genre figures peering down from the windows in the background, and the seated egg woman below in the foreground; the remarkably human charm of the youthful Mary, with her brilliant blue dress against a shining gold halo, which is therefore increased both by the architecture and by the contrasts of these four groups of figures (cf. the similar use of genre figures by Andrea del Sarto).

A more animated and dramatic variation of this same type of composition may be seen in the Ecce Homo, in the Vienna

Kunsthistorisches Museum (signed *Titianus Eques Ces F. 1543*), which was painted by Titian for the Flemish merchant Giovanni d'Anna (Jan van Haanen) and was seen in his house by the French king, Henry III, in 1574. According to Ridolfi, the head of Pilate is a portrait of Pietro Aretino, and that of the turbaned figure at the right is a portrait of Sultan Suleiman II.

In the foregoing groups of devotional and historical paintings, the stylistic tendency was largely in the tradition of Giovanni and Gentile Bellini. The Battle of Cadore appeared to be a striking exception, in that the landscape background occupied the major part of the design, which in principle was the essential contribution of Giorgione to the Venetian tradition of the early Cinquecento. Categorical divisions, such as devotional, historical or landscape pictures, are arbitrary and lead, more often than not, to false interpretations, but there is a considerable number of Titian's works in which, as in the Battle of Cadore, the landscape is a dominant part of the design and in which the nature of Titian's development of the so-called Giorgionesque can best be followed. They point to the understanding, not only of his style as such, but also of the basic iconographical variations that appear to grow out of that style.

One of the first examples, again often disputed and attributed to Giorgione but now generally accepted as Titian's, is the *Noli me tangere* scene in the National Gallery of London. It appears to have been painted at an early date, shortly after the death of Giorgione (i.e., ca. 1511-1516), and is closely related to Giorgione's Venus. Possibly, he painted this at the same time as he was working over the unfinished Venus canvas, as the similarity of the architectural forms at the right of each picture would suggest. Important, and characteristic of Titian, is the impetuous gesture of the Mary Magdalene, clothed in bright crimson, and the design of the landscape (note the continuance of the design from her figure to the tree), which is composed with that of the figures, as seen also in the Venus composition by Giorgione. The artistic development and variation of this type of group composition can be seen in related iconographical themes, such as Pollaiuolo's Apollo and Daphne and Titian's contemporary Three Ages of Life of ca. 1510-1512 (now in the National Gallery of Scotland in Edinburgh, formerly in Bridgewater House, London), and in his later Venus pictures.

Many of these observations can be reinforced, and the

understanding of Titian's artistic intention clarified, through the study of X-ray photographs. The *Noli me tangere* was cleaned in 1957, and several painted additions to the figure of Mary Magdalene were removed. The X-ray photographs made at that time revealed not only these later additions, but also a number of changes made by Titian himself in the process of painting. These included an increase in the size of the tree and a change in its direction so as to enhance the movement and design of the Magdalene figure. The figure of Christ was originally striding away from her, rather than in the position of taking a slight step toward her, which then provided a more effectively integrated group and expression (cf. also the study of the drawings from this point of view).

A striking example of Titian's historical painting of the middle period is the Death of St. Peter the Martyr (1528-1530), which was commissioned by the confraternity of St. Peter the Martyr after a competition which Titian won over Pordenone and Jacopo Palma. The canvas was originally on the altar of that organization in San Giovanni e Paolo until it was burned in 1867, but is known from an early copy which is now on the same altar. There is also an engraving after the original by Martino Rota. The comparison of the style with fifteenth-century versions of the same theme (e.g., the one attributed to Giovanni Bellini, in the National Gallery of London) will demonstrate the grandiose manner of the High Renaissance, which in this case is exaggerated into the somewhat artificial mannerisms of the schools of Raphael or Michelangelo. Significant, however, is the prominence given to space and landscape over the figures, and the way in which the dramatics of the action are carried out in the impressive design of the trees (cf. the same motif and pose of the murderer standing over his victim as used by Titian in his Padua frescoes, i.e., the jealous husband slaying his wife, and the drawings for it in the Ecole des Beaux Arts in Paris). Toward the late period, the same composition of figure and landscape might benoted in the dramatic St. Jerome in the Desert (Pinacoteca di Brera), which was painted ca. 1550 for Santa Maria Nuova in Venice, and again in the Fall of Man (the Prado) which was discussed before.

Giorgione's fundamental approach to nature and the painter's medium, which Titian developed in the direction of the dramatic as well as the lyric and poetic, is the essential problem involved in the many mythological works which he produced. Indeed, their effec-

tiveness, in terms of color and compositon of forms, is so strong and universal that the literary and allegorical associations seem to be secondary and often insoluble problems (cf. the contrary relationship of form to content in the mythological paintings of the fifteenth century in Florence, i.e., Botticelli).

The most famous of these from the early, more Giorgionesque period is the so-called Sacred and Profane Love, in the Galleria Borghese, Rome. It was painted after Titian's return from Padua, probably 1512-1515, for the Venetian chancellor Niccolò Aurelio, whose coat of arms is represented on the marble fountain. The title of Sacred and Profane Love comes from the eighteenth century, and probably belongs to the original idea and content, whereby the sacred love is represented in the classic nude form at the right and the profane is the clothed figure opposite it. The various literary interpreations given to it follow, in general, that theme, i.e., Aphrodite counseling Medea to flee with Jason, Venus counseling Helen in favor of Paris, or even an allegory of Violente, the alleged mistress of Titian, being counseled by Venus. Some of the objects represented, e.g., the reliefs on the sarcophagus, the church and fortress with hunters and animals in the background, have been associated with recurrent themes of Christian and Platonic love.

In spirit and composition, the work is related to Giorgione's Fête Champêtre in the Louvre, with the characteristic difference that Titian has simplified and concentrated the expression more plastically on the single group of the nude and clothed figures, with the cupid between them and the open landscape receding on either side of the group. Note the related pose of the Venus to the standing nude in Giorgione's canvas, the indescribable richness and warmth of the coloration, with its accent in the luminous red, silver-gray and flesh tones of the figures and drapery in the foreground.

In line with this, and with Giorgione's Venus, is the long series of single nudes and pairs for which Titian is so famous, particularly among painters. Ignoring the many replicas and variations that come from his own studio as well as from his followers, the most important of these are: the so-called Venus of Urbino, in the Galleria degli Uffizi, which was painted for Guidobaldo della Rovere, later Duke of Urbino, ca. 1538, and mentioned in a letter to his chargé d'affaires, Girolamo Fantini, in March 1538; Danaë with Amor, in the Gallerie Nazionali di Capodimonte in Naples, painted ca. 1545

for Ottavio Farnese; Danaë with the Servant, the Prado Museum, painted in 1554 for Prince, later King, Philip of Spain; Venus with the Organ Player (of 1545-1548), in the Prado; and the late Jupiter and Antiope (ca. 1560, also known as the Venus del Pardo, since it had remained in the Prado palace of Madrid until 1624), now in the Louvre of Paris (cf. the many variations of the original motif of the Amor watching the sleeping Venus, e.g., the organ player, Jupiter, etc.).

The more elaborately composed mythological scenes of the middle period are likewise without a particularly dramatic literary content, and are to be understood from the sophisticated point of view of the court society, which flourished from the second quarter of the century and for which most of the works were painted. The first of these are the Worship of Venus and the Bacchanal, in the Prado, which were painted between 1518 and 1520 for Duke Alfonso I of Ferra. The subject matter is based on the descriptions of ancient paintings, which were supposedly in a gallery in Naples, written by the Greek Sophist, Philostratus, in his *Imagines* Book 6). The Bac- chanal—the fabled festival on the island of Andros—has an inscrip- tion on the scroll in the center: *Qui boit et ne reboit. ne sais que boire soit.*

In contrast to the Assunta which was done about the same time, both works reveal a strong emphasis on space, with sharply contrasting forms of towering trees and distant landscape into which the many figures are carefully woven. Note especially the Bacchanal, in contrast to the earlier and simpler theme of the Feast of the Gods begun by Giovanni Bellini and finished by Titian for the same Duke Alfonso, with its more prominent figures composed into groups both decoratively and in the receding space.

The Bacchus and Ariadne, in the London National Gallery, signed *Ticianus F.,* was also painted for Alfonso only a short time later (1522/23) for the same project, i.e., the decoraton of *camerino d'alabastro* in the Castello of Ferrara, which was a much more sophisticated version of Isabella d'Este's earlier *studiolo*. Its subject (from Ovid's *Ars Amatoria*) is a kind of dramatized Triumphal Pro- cession (cf. Mantegna), with Bacchus' chariot, drawn by cheetahs, leading the parade in a diagonal toward the open space and background. Compared with the others of this group, it shows a greater emphasis on the somewhat manneristic action of larger

figures rather than the carefully balanced groups of the Bacchanal. Note, also, the interest in the classical Laocoön group and Michelangelo, suggested in the Resurrection of Christ of 1522 in Brescia.

The late mythological scenes, in keeping with the religious painting of the same period, show a tendency toward a more dramatic content. The important and original ones, of which there are a number of replicas, were painted for King Philip II of Spain: one is the Perseus and Andromeda, in the Wallace Collection, London, which was probably painted in 1555, but promised by Titian in 1553, and was noted by Dolce as one of a group sent to Spain. Interesting here is the motif of the foreshortened figure descending from the top, which had been suggested in his early Worship of Venus (i.e., the putti above) and later used by Tintoretto in his Miracle of St. Mark (Accademia, Venice).

The two canvases (1559) in the National Gallery of Scotland in Edinburgh, representing Diana and Callisto and Diana and Acteon, are of parallel size and content, and may have been designed as companion pieces. In spite of their intended dramatic excitement, the figures are composed, on almost classic lines, more as a relief, rather than in the spacious groupings of the earlier works (cf. the same tendency developed in the later Christ Crowned with Thorns). A dramatic parallel to the late Pietà is the Rape of Europa (signed, ca. 1559-1562), in the Isabella Stewart Gardner Museum of Boston.

Without doubt, Titian is the greatest portraitist of the Renaissance, and, as such, is the sixteenth-century parallel to Rubens in the seventeenth. The many portraits by his own hand which have survived may be studied from the point of view of the historically important personages represented or in the chronological development of historical taste and personal style. The important historical characters included Emperor Charles V, Empress Isabella of Portugal, Pope Paul III, Philip II, the Duke of Alba, Nicholas Perrenot Granvella, Elector Johann Friedrich of Saxony, Pietro Aretino and Francis I of France. However, this latter portrait of Francis, in the Louvre, was probably not painted from life, and was given to the French King by Pietro Aretino ca. 1539.

The evolution of the portrait style can be followed from the early, Giorgionesque Portrait of a Man, of ca. 1508-1512, in the National Gallery of London, with a signature *T.V.* (Tiziano Vecellio) on the

parapet, to the portrait known as the Man with the Glove, in the Louvre, which came from the Gonzaga collection in Mantua, is signed *Ticianus F.* and is datable 1523/24. Another well-known portrait of about the same period is that of Vincenzo Mosti, in the Palazzo Pitti, which has an inscription on the back of the canvas (*Tommaso Mosti di anni XXV. l' anno MDXXVI. Titiano de Cadore pittore*) which appears to be a later addition. Tommaso Mosti was secretary to the Duke of Ferrara, but identification of the subject as Fincenzo, another member of the Mosti family at the court of Duke Alfonso, seems certain. The date is probably about 1520. The solid, pyramidal composition of the portrait, and the tendency to free the figure from the frame, roughly parallels the Raphael style of the same period (cf. the Cardinal, in the Prado, and the portrait of Balthasar Castiglione, in the Louvre).

The formality and dignity of the new tradition in portrait form later gives way to a greater variety of poses, costumes and background which are dependent on the caprice of the portrayed, rather than on the artist's choice. The most important examples are: 1) the standing Emperor Charles V with his dog, in the Prado, which was painted between December 1532 and February 1533 at Bologna; 2) Cardinal Ippolito de' Medici in a Magyar costume, after having fought against the Turks in Hungary, 1533, Palazzo Pitti; 3) Charles V seated, painted in Augsburg in 1548, Alte Pinakothek, Munich; 4) the allegorical portrait in the Louvre of Alfonso d'Avolos, Marchese del Vasto, who had been appointed commander of the Emperor's forces against the Turks in 1532. The allegory had been traditionally interpreted (now generally discredited) as representing his taking leave of his wife, seated with the crystal globe, and accompanied by Hymen and Amor; 5) the portrait, badly damaged in a fire of 1671, of Alfonso d'Avolos Addressing His Army (ca. 1540), in the Prado, the motif and pose of which is taken from classical Roman Caesar portraits (cf. the composition with that of the Ecco Homo, the Vienna Kunsthistorisches Museum).

For sheer artistic quality two portraits might be pointed out as among Titian's finest: the so-called La Bella, in the Palazzo Pitti (1536), and that known as the Young Englishman (ca. 1540-1545, also in the Palazzo Pitti), although the latter has been identified as Ippolito Riminaldi, the young Ferra jurist. La Bella had formerly and falsely been identified as the young Duchess of Urbino, Eleonora

Gonzaga or again as Isabella d'Este (cf. the known portraits by Titian of the Duchess of Urbino of 1536-1538, in the Uffizi, and of Isabella d'Este of about 1534-1536, in the Vienna Kunsthistorisches Museum). The subject is probably the same model as that used in the Venus of Urbino, in the Uffizi, and the Girl in Fur, in Vienna. The painting mentioned in a letter of May 2, 1536, from the Duke of Urbino to his agent, Leonardi, in Venice as "the lady in a blue dress" is most likely to be identified as La Bella.

The famous group portrait of the Farnese Pope, Paul III, and his two nephews, Ottavio and Cardinal Alessandro Farnese (Gallerie Nazionali di Capodimonte, Naples) was painted during Titian's stay in Rome in the fall of 1546. The compositional scheme and the symbolism associated with it afford an interesting comparison with Raphael's portrait of Leo X, whereby the courtly gesture which Titian has introduced in the full-length figure at the right is used as a part of the decorative and manneristic pattern (cf. the flat composition of the seated Pope, the curtain decorating the background).

The same comparison might be made between Raphael's portrait of Julius II and Titian's own version of the same composition in the magnificent Paul III, in the Naples Gallerie di Capodimonte, which was probably painted in Bologna on the occasion of the Pope's visit there in 1543 and is the first of several replicas and variations. Note the significant detail of the hand that is dropped on the thigh, rather than being allowed to protrude plastically on the arm of the chair. An imperial counterpart to the papal portrait may be seen in that of the seated Charles V, signed and dated 1548, in the Alte Pinakothek, Munich, and the famous equestrian portrait of Charles V in the Museo del Prado of Madrid. The Emperor is is mounted and clad in full armor as he appeared at the Battle of Mühlberg. It was painted in 1548 at Augsburg. As a compositional motif, it goes back to the Renaissance *condottiere* portraits, both in bronze and painted on walls (cf. Martini, Uccello, Castagno, Donatello, Verrocchio, Leonardo), and becomes the model for many such imperial representations of the seventeenth century (Velasquez, Rubens).

In reviewing Titian's late work two self-portraits are of special interest. One is the remarkable strong and freely painted self-portrait of ca. 1560-1562, in the Berlin-Dahlem Museum, which is probably the one Vasari saw in the artist's studio in 1566 and noted that

it had been painted four years earlier. The other is the late self-portrait, in the Prado Museum, Madrid (ca. 1570), whose features bear a resemblance to those of the aged, kneeling St. Jerome figure in the late Pietà (cf. Michelangelo's self-portrait in the Florentine Pietà).

Palma Vecchio (Jacopo d'Antonio Negretti, called Palma il Vecchio, ca. 1480-1528), is the third, though considerably less important, representative of the Venetian High Renaissance. He was born in about 1480 (from Vasari's statement that he died in 1528 at the age of forty-eight) in Serinalta, near Bergamo, and is recorded in Venice after 1510. His early training is uncertain, but he seems to have developed under the influence of the well-known late Quattrocentists, Giovanni Bellini, Alvise Vivarini or Cima da Conegliano. Compared with Giorgione's and Titian's, his style is much more conservative and restricted, without the universal appeal of those more widely known masters associated with the patrician society. He was a member of the Scuola di San Marco after 1513, is recorded in Serinalta in 1524, and wrote a testament of June 28, 1528, in which sixty-two of his pictures are catalogued, most of them unfinished.

Palma's most important work, and one of the finest of the Venetian High Renaissance, excluding Titian's, is the polyptych of Santa Barbara, commissioned after 1509 by the Confraternità dei Bombardieri (probably not finished until 1524), in the church of Santa Maria Formosa in Venice. It represents the patron of the order, St. Barbara, in the center panel, with separate figures of St. Sebastian and St. Anthony Abbot on either side, and half-length figures of St. John the Baptist, St. Vincent Ferrer and the Pietà above.

A number of other works, dating mostly between 1510 and 1528, include subjects and compositional motifs which parallel the fully rounded forms and space effects of the late Bellini and early Titian, e.g., the so-called Three Sisters, in the Dresden Gemäldegalerie, the Adam and Eve, of ca. 1510, in the Braunschweig Landesmuseum (cf. Dürer's famous engraving, 1504, of the same subject), the reclining Venus of 1520-1525, and the Meeting of Jacob and Rachel, both in the Dresden Gemäldegalerie. The traditional character of the *sacra conversazione* can still be seen in the

Madonna Enthroned with Saints George and Lucy (ca. 1525), in the church of Santo Stefano, Vicenza, and the altar of St. Peter Enthroned with Saints John the Baptist, Mark, Augusta, Justina, Paul and Tiziano Vescovo di Oderzo, from the parish church of Fontanelle, near Oderzo, and now in the Accademia of Venice. There is also a remarkably ''conversational'' mood to the mythological subjects, such as the Bathing Nymphs, of ca. 1525, in the Vienna Kunsthistorisches Museum. The parallel of late Quattrocento and Late Renaissance manneristic tendencies (cf. Lotto) can be seen in the Death of St. Peter the Martyr (ca. 1515), in San Pietro Martire, Alzano Lombardo, near Bergamo.

Sebastiano del Piombo (Sebastiano Luciani de' Lucianis, ca. 1485-1547) presents the first important connecting link of the sixteenth century between the schools of Venice and Rome, i.e., the particular language of light and color, as represented in the art of Giorgione, and the monumental figure, as represented by Michelangelo. As a problem of style, it is not only a part of the mannerism of the Raphael-Michelangelo schools, but also leads into the basic problems of the Baroque form toward the end of the century.

Most of the information about Sebastiano is based on Vasari's account and on the interesting exchange of letters between him and Michelangelo. He was born about 1485 in Venice, was a pupil of Giovanni Bellini, and then came under the influence of Giorgione. Vasari mentions his friendship with Giorgione and his working in the latter's shop. Shortly after the death of Giorgione, Sebastiano was invited to Rome by the banker Agostino Chigi. He arrived there in the spring of 1511, and began work for him in the Villa Farnesina.

With the exception of a short interlude in 1528/9, when he is recorded in Venice and was acquainted with Titian, Catena, Sansovino and Pietro Aretino, the remainder of Sebastiano's life was spent in Rome. There exists a considerable body of correspondence, between Sebastiano, Leonardo Sellaio and Michelangelo, which gives a remarkable insight into the various intrigues and jealousies of the papal court between the rival groups of Raphael and Michelangelo. Sebastiano's rivalry with Raphael was already noted in connection with the commission for the Transfiguration. Two letters of 1527 to Pietro Aretino describe the Sack of Rome. Although

he had been working with Michelangelo, he tried unsuccesfully to secure the commission to continue Raphael's decorations. In 1531, he was appointed papal *Piombo*, or Keeper of the Seal (left vacant by Fra Mariano Fetti), over Giovanni da Udine and Benvenuto Cellini, who also applied for the position; but he was required to divide the income with the Raphael pupil, Giovanni da Udine. He died in Rome on June 21, 1547.

The development of Sebastiano's style can be followed in a few important works, which, though strongly Michelangesque, still retain a markedly Venetian form of coloration and emotional expression. The earliest work (ca. 1507/8) is the group of four organ shutters, with St. Louis of Tours, St. Sinibald, St. Bartholomew and St. Sebastian, commissioned by the vicar Alvise Ricci for the church of San Bartolommeo di Rialto in Venice and still there. The reserved gestures, the figures set rather freely in illusionary niches, and the use of light reflect something of the dignity of the late Quattrocento, especially Giovanni Bellini. The influence of Giorgione, possible his collaboration, is clearly to be seen in the panel (ca. 1510) representing St. John Chrysostom Enthroned with Six Saints (Saints Liberalis, John the Baptist and an unidentified figure at the right, with Saints Mary Magdalene, Catherine and Agnes at the left), on the high altar of San Giovanni Crisostomo in Venice.

The first work in Rome, begun soon after his arrival in 1511, was the decoration of the lunettes of the Sala di Galatea in the Villa Farnesina. These represent eight scenes from Ovid's *Metamorphoses*: Tereus Pursues Procne and Philomela, the Curiosity of the Daughters of Cecrops, the Fall of Icarus, Juno and the Chariot Drawn by Peacocks, Scylla Shears the Purple Lock of Hair from the Head of Her Father Nisus, the Fall of Phaeton, Flora Receives the Breath of Cephir, Boreas Seizes Orithyia, and a colossal head. The large figure of Polyphemus, the legendary Cyclopean lover of Galatea, is intended as a companion to Raphael's fresco in the same room and was probably painted about the same time. The general emphasis is on the single figures, some of which appear to be rather inept variations of Michelangelo's ceiling decorations of the Sistine Chapel.

Aside from the initial impact of Michelangelo, as seen in the Villa Farnesino frescoes, the first and most remarkable combination of Venetian and Michelangelesque pathos can be seen in the famous

Pietà (ca. 1516), in the Museo Civico of Viterbo, which was commissioned by Giovanni Botonti da Viterbo for the church of San Francesco there. The frescoes which he was commissioned (1516) by Pierfrancesco Borgherini to paint in San Pietro in Montorio were not finished until 1524, and included two Prophets with Angels, St. Peter and St. Francis, the Transfiguration, and especially the well-known Flagellation. The figure of Christ, in this last, is based on a drawing of Michelangelo's (cf. figures in the Last Judgment). The large signed (*Sebastianus Venetus Faciebat*) panel, later transferred to canvas, representing the Raising of Lazarus, which he executed for Giulio de' Medici, in competition with Raphael's Transfiguration, in 1517-1519 (now in the National Gallery of London) also shows the probable use of Michelangelo drawings in the single figures (i.e., Lazarus). A rather complete description of the progress of the work is given in the correspondence of Sebastiano and Leonardo Sellaio with Michelangelo. The signed and dated (1520) Martyrdom of St. Agatha, in the Palazzo Pitti, Florence, was commissioned by Cardinal Rangone in Rome and combines the classic Roman Renaissance figure composition and glowing Venetian color with a drastically realistic subject not common to the High Renaissance, but popular in the Baroque style. The later, more grandiose and decidely manneristic style can be seen in the altar painted in oil on the wall, representing the Birth of Mary, in the Cappella Chigi in Santa Maria del Popolo in Rome. It was begun in 1532, and finished by Francesco Salviati after Sebastiano's death.

After Raphael's death, Sebastiano was the most important portraitist in Rome. The best-known of his portraits are: the so-called Christopher Columbus, in the Metropolitan Museum of New York, with the inscription *Haec est Effigies Liguris Miranda Columbi Antipodum Primus . Rate qui Penetravit in Orbem 1519* across the top and the signature *Sebastianus Venetus Facit* at the right; the Portrait of a Roman Lady, the so-called Dorothea, in the Berlin-Dahlem Museum; that of Andrea Doria, in the Palazzo Doria, Rome, 1526; Pope Clement VII (1526), in the Museo Nazionale di Capodimonte, Naples.

There are a considerable number of minor artists in Venice itself, as well as in the local schools of the Venetian terra firma, who belong to this period of the High Renaissance before the new epoch of Paolo Veronese, Jacopo Tintoretto and the Bassani.

Lorenzo Lotto (ca. 1480-1456) is perhaps the most unique and interesting of these, both because of his varied career in Venice, Rome, Ancona, Bergamo and other cities of the north, and because of his development of dramatic expression through decorative form which becomes one of the distinctive features of Mannerism.

He was born, probably in Venice, in about 1480 (from a statement in his will of 1546 in which he gives his age as "about sixty-six"), and was most likely a pupil of Giovanni Bellini, though there are influences of Alvise Vivarini and Antonello da Messina, as well as of Giorgione and Titian. He is recorded in Rome in 1508-1512, then worked in Bergamo 1513-1525, and lived mostly in Venice from 1525 until the late 1540s. After 1552, he was in Loreto, and died there in 1556.

Early altarpieces are the signed and dated (1506) Assunta with Saints Anthony Abbot and Louis of Toulouse, in the parish church of Asola, and the Recanati Polyptych with the Madonna Enthroned, flanked by Saints Gregory and Urban, bestowing the Scapular on St. Dominic, with Saints Thomas Aquinas and Flavian at the left, Saints Peter the Martyr and Vitus at the right, the Pietà above the central panel with half-length figures of Saints Catherine of Alexandria and Vincent Ferrer, Catherine of Siena and Sigismund on either side, in the Pinacoteca Comunale of Recanati. One predella scene—St. Dominic Preaching—survives in the Vienna Kunsthistorisches Museum.

The Recanati Polyptych is signed and dated 1508, and was ordered for the Dominican church of San Domenico di Recanati. The style shows the close relationship with the late Quattrocento tradition of Giovanni Bellini, with its interest in space and light (cf. the landscape background of the Assunta) and the architectural setting, figures modeled with light and the associated musical angels (cf. Bellini's San Giobbe altar), but it also reveals an interest in a distinct form of animation in the figures which suggests his later development. The St. Jerome in the Wilderness, in the Louvre of Paris, signed and dated 1506, has the seated figure of the saint subordinated to an extensive, rich and colorful landscape suggestive of Giorgione's contemporary Tempest (cf. the signed variation of the same subject by Lorenzo Lotto in the Castel Sant' Angelo in Rome).

The impact of Rome, and Lorenzo's independent reaction to it,

can be seen in the Entombment panel of 1512, in the Pinacoteca Civica of Jesi (cf. Raphael's Entombment in the Galleria Borghese, Rome), and the Santo Stefano altar of 1516, in the choir of San Bartolomeo in Bergamo. This large (central panel 5.20 x 2.50 m.) and elaborate altar was originally in the church of Santo Stefano al Fortino, commissioned by Alessandro Martinenghi, and later transferred to San Bartolomeo. The three scenes of the predella—the Martyrdom of St. Stephen, the Entombment, and the Miracle of St. Dominic—are in the Accademia Carrara of Bergamo. The central panel, with its crowd of ten saints (Saints Alexander, Barbara, James, Dominic, Mark, Catherine, Stephen, Augustine, John the Baptist and Sebastian) and many angels with active gestures and fluttering drapery in a large, Bramante-type domed interior, seems to be a composite of both Raphael (the Madonna di Foligno) and Correggio influences (the Madonna with St. Francis). The figures of St. Alexander and St. Barbara at the left are traditionally identified as portraits of the donor and his wife.

Lotto's extraordinary development of this action in his later work can be seen in parallel examples. One is the elaborate design, in both drapery and figure gestures, of the Assumption, in the church of Santa Maria Assunta in Celana (Bergamo), of 1527. Another is the Pietà, in the Pinacoteca di Brera of Milan, signed and dated 1545, painted for the monastery of San Paolo in Treviso (cf. Sebastiano's Pietà in Viterbo). The work in his late style is the large (6 x 4 m.) Assumption of the Virgin, in the Pinacoteca Civica of Ancona, which is signed and dated 1550 and came from the church of San Francesco delle Scale. The distortion of gestures and figures in the excited crowd of apostles and the suspended Virgin, for the sake of the design, and the restriction of the space, are typical features of Lotto's special form of Mannerism (cf. Titian's Assunta).

The combination of many features, such as the distorted action of figures, voluminous flow of drapery and an extensive interior space filled with light and luminous atmosphere, is to be seen in the canvas of Christ Taking Leave of His Mother, in the Berlin-Dahlem Museum. It was painted, along with a companion piece of the Nativity (a copy of which is in the Accademia of Venice), for Domenico Tassi of Bergamo and his wife, Elisabetta Rotta, who is represented keeling at the right. The signature and date—*Mo. Laurenttjo Lotto Pictor 1521*—is given on the letter in the

foreground. Note especially the dramatic, Pietà-like composition of the Madonna group in the center, the sculpturesque placement of the kneeling Christ, the donor at the right, Peter and Judas at the left, surrounded by light and receding into the extensive space of the loggia and garden in the background (cf. Antonello da Messina and Carpaccio).

The Renaissance elegance of the portrait (note that of Elisabetta Rotta in the Berlin painting) as enlivened by the expressive gesture can be seen in a considerable number of his signed works, such as the Gentlemen on a Terrace (1525), in the Cleveland Museum of Art, the Portrait of a Man (ca. 1535-1540), in the Palazzo Döria, Rome, the Physician Giovanni Agostino della Torre and His Son, Niccolò (1515), and the Family Group Portrait (Giovanni della Volta with his Wife and Children, 1547), both in the National Gallery of London.

Giovanni Cariana (Giovanni de' Busi, ca. 1485-ca. 1547) is related in style to Palma Vecchio. Although his family seems to have come from Bergamo, he is recorded as active in Venice from 1509 on. His chief authenticated works are the signed Group Portrait of the Albani Family (1519), in the Conte Roncalli Collection of Bergamo, the Resurrection with St. Jerome, St. John the Baptist and the kneeling donors, Ottaviano Visconti and his Wife (signed and dated 1520), in the Pinacoteca di Brera, Milan, a Madonna and Child with Donor (1520) and the signed portrait of Giovanni Benedetto da Caravaggio, in the Bergamo Accademia Carrara. There are, however, many others which reveal similar characteristics of the Venetian High Renaissance noted in the work of Giorgione, Titian and Palma Vecchio, such as the Visitation with Joseph and Zachary, in the Vienna Kunsthistorisches Museum (ca. 1510-1515), and the late Madonna and Child with the Infant St. John and St. Anthony Abbot, in the Munich Alte Pinakothek (note the use of light and the composition of the figure group into the fantastic landscape).

Rocco Marconi (recorded in Venice 1504-1529) may have been a student of Giovanni Bellini's, and is associated in style with Palma Vecchio as well as with Giorgione. His most important surviving

work is the Christ and the Adultress, signed *Rochus Marchonius* on the cartello of the column, in the Accademia of Venice.

Bonifazio De Pitati (also called Bonifazio da Verona, 1487-1553) came from Verona, was a pupil of Palma Vecchio, and was active as head of a shop producing decorative projects in Venice, especially after 1530. Stylistically, he belongs to the following generation, and represents a more direct and Venetian parallel to the early mannerists of Florence and Rome. At the same time, he reflects the continuation of the Venetian festive decoration tradition popular in the late Quattrocento (i.e., Gentile Bellini and Carpaccio), as can be seen in his best-known work, the Rich Man's Feast, in the Accademia of Venice (cf. the later development in Tintoretto and Paolo Veronese).

The development from his earlier style, more directly under the influence of Palma Vecchio, can be seen in the *Sacra Conversazione* (Palazzo Pitti, Florence) with the Madonna, St. Elizabeth, the Infant St. John and an elegantly dressed donor offering a globe to the Christ Child. The first signed and dated (1533) work is the Madonna dei Sartori, formerly in the Scuola dei Sartori, now in the Accademia of Venice, representing the Madonna Enthroned with the Child, John the Baptist, St. Barbara and St. Homobonus, patron saint of tailors and clothworkers. The later works, such as the Finding of Moses, in the Pinacoteca di Brera, Milan, and the Hail of Manna, in the Palazzo Ducale of Venice, show the interest in many-figured compositions, movement, and the rich and festive coloration characteristic of the Venetian Late Renaissance and Mannerism (cf. Tintoretto). The major project of the Bonifazio workshop is the elaborate decoration of the Palazzo dei Camerlenghi, beginning in 1529 and extending into the late 1540s, of which many of the canvases are in the Accademia of Venice.

Giulio Campagnola (ca. 1482-ca. 1515) is perhaps more important as an engraver then as a painter. He came from Padua, and apparently worked with Giorgione in Venice. The paintings sometimes associated with him are the frescoes in the Scuola del Carmine of Padua, particularly the Birth of Mary, Presentation of Mary in the Temple, and the *Sposalizio*. While, as an engraver, Giulio was strongly under the influence of Albrecht Dürer (his

Penance of St. John Chrysostom is a direct copy from Dürer), his interest in light and chiaroscuro through a system of stippling and graver flicks seems to be inspired by Giorgione (cf. John the Baptist, Christ and the Woman of Samaria). **Domenico Campagnola** (1500-ca. 1562) is his pupil and follower, as both painter associated with Titian (the frescoes in the Scuola del Carmine, Padua) and as engraver.

Pordenone (Giovanni Antonio de Lodesanis, ca. 1483-1539) is unique in his distortion of form for the sake of dramatic expression, and hence contributes another phase of the development of later Mannerism (Tintoretto). He was born in Pordenone (hence his name), near Udine, ca. 1483, which is based on Vasari's statement that he died at the age of fifty-six.

His earliest work is the 1506 fresco of St. Michael with St. Valerian and St. John the Baptist, in the church of Santo Stefano in Valeriano (Udine). It shows the influence of **Giovanni Francesco da Tolmezzo** (Giovanni Francesco dal Zotto, ca. 1450-ca. 1510), who had been a follower of Mantegna and Giovanni Bellini (a signed Madonna and Child in the Accademia, Venice; fresco decoration of the church of St. Anthony in Barbeano, 1489-1491).

From about 1506 until 1513, Pordenone was in Venice under the influence of Giorgione and the early Titian (frescoes in the Cappella del Castello of Collalto, the Transfiguration of 1511, in the Pinacoteca di Brera, the altarpiece of the Madonna with Saints John the Baptist, Catherine, John the Evangelist and Peter, in the church of Susegana, Treviso, the fresco of the Madonna della Loggia, 1516, in the Museo Civico of Udine).

In about 1515, he went to Rome and came under the influence of the Raphael school; this is evident in the fresco of the Madonna with St. Gregory and St. Jerome (ca. 1515), in the church of Alviano. He returned to Venice shortly afterward, and may have had some influence on Titian (the Assunta). After that, he was active on extensive and major fresco decorations in northern cities, such as those in the Cappella Malchiostro of the Cathedral of Treviso (1520), representing the Adoration of the Magi, the Visitation, Augustus and the Sibyl, and Saints; those representing Christ before Pilate, the Road to Calvary, Christ Nailed to the Cross, the Crucifixion (1521) and the Deposition, (1522) in the Cathedral of Cremona;

the frescoes representing scenes from the Life of the Virgin (Nativity, Flight into Egypt, Adoration of the Magi, Adoration of the Shepherds) and the Life of St. Catherine (Disputation, Torture and Martyrdom), along with St. Augustine, St. George and Prophets with Evangelists in the cupola, in the church of Santa Maria di Campagna in Piacenza (1529-1531). The gigantic scale and tumbling action of the figures in the St. Martin and St. Roch fresco (1528) in the church of San Rocco in Venice, and the Glorification of San Lorenzo Giustiniani altar in the Accademia of Venice (1532) show the fullest development of this almost Baroque style.

Giovanni Girolamo Savoldo (ca. 1480-ca. 1548) is the oldest of the three masters who represent a flourishing local sixteenth-century school of Brescia.

His earlier Madonna and Saints, of 1521, on the high altar of San Niccolò in Treviso, is clearly under the influence of Giovanni Bellini; his later (ca. 1535) Madonna in Glory with Saints Peter, Paul, Dominic and Jerome, in the Brera, has the broader and more monumental proportions of Titian. Savaldo's individual mode of coloration can be seen in the intimate and genrelike interpretation of devotional representations, as well as the frequency of romantic twilight and night scenes—*Giorgionismo*—e.g., the Adoration of the Shepherds, in the Galleria Sabauda of Turin, the Transfiguration, in the Uffizi, the St. Matthew and the Angel, in the Metropolitan Museum in New York.

Girolamo Romanino (ca. 1485-ca. 1562) appears, in his early work, to be largely in the Giovanni Bellini tradition, as seen in his 1510 Pietà (signed *Hieronvmi Rumani Brixiani Opus MDX Mense Decembri*), in the Accademia of Venice. Later, he developed the coarser massiveness of figures and strong color as revealed in the frescoes in the Cathedral of Cremona, 1519/20, representing Christ Crowned with Thorns, the Mocking of Christ, the Flagellation, and Christ before Pilate, and those in the Corpus Domini Chapel of San Giovanni Evangelista in Brescia, 1521, representing the Coronation of the Virgin, Mary Magdalene Washing the Feet of Christ, and the Raising of Lazarus.

The frescoes in the castle of Malpaga, Bergamo, where Bartolommeo Colleoni lived and held court until his death in 1475,

were commissioned ca. 1525 by Martinego Colleoni, and represent Pope Paul II Enthroned with Cardinals at Aracoeli, flanked by battle scenes (Battle of Bosco Marengo). He was assisted by **Marcello Fogolino** (active 1519-1548), who also painted the fresco in the large hall representing the Visit of King Christian of Denmark to Malpaga.

Moretto (Alessandro Bonvicino, 1498-1554) is much more delicate and refined in character, and is related in spirit to the lyric works of Titian, and perhaps to Lorenzo Lotto. One distinctive feature of his style is the delicate silver tone of his coloration (the Coronation of the Virgin, in Santi Nazaro e Celso, Brescia; the Madonna in Glory with Saints and Two Donors, on the high altar of San Giovanni Evangelista in Brescia).

Related to the style of Moretto is that of his pupil, **Giovanni Battista Moroni** (ca. 1520-1578), whose portraits rank with Titian's among the finest of the later Renaissance. Characteristic of these are the Portrait of a Tailor (ca. 1571), in the National Gallery, London, and two in the Metropolitan Museum of New York: the Prioress Lucretia Cataneo, and Bartolommeo Bongo.

5. Verona

ARTISTICALLY AS WELL AS POLITICALLY, Verona remained largely under the influence of the Venetians during the sixteenth century, though it continued the more conservative Mantegna tradition.

Girolamo dai Libri (1474-1555) followed the local Veronese tradition of Francesco Morone, but he was especially affected by Mantegna, as can be seen in his early Centrego Altar (1512), in the church of Sant' Anastasia in Verona, representing the Madonna Enthroned with Saints Augustine and Thomas Aquinas and half-length portraits of the donor and his wife at the bottom. A considerably freer composition, although still Mantegnesque (cf. the San Zeno altar) is the Madonna and Child with St. Anne (ca. 1518), in the National Gallery of London. This is the centerpiece of a triptych, of which one wing, with St. Roch, by **Paolo Morando**, is also in the National Gallery, and the other of St. Sebastian, is by **Francesco Torbido** (ca. 1482-1562; the Pala della Trinità altar for San Fermo Maggiore, Verona, 1523). A repainted signature, *Hieronimus. A. Libris. F.*, is visible at the bottom. The later works show a consistent interest in decorative detail combined with the use of light, the monumental figure, animated gestures and an atmospheric landscape background characteristic of the early Cinquecento, as seen especially in the (1526) altarpiece with the Madonna Enthroned, flanked by Saints Zeno and Lorenzo Giustiniani with half-length music-making angels, in the church of San Giorgio Maggiore (San Giorgio in Braida) in Verona.

Cavazzola (Paolo Morando, 1486-1522) is perhaps the most important of the Veronese painters of the High Renaissance through his emphasis on monumental form. The early work shows the influence of Domenico and Francesco Morone and Buonsignori, with

whom Vasari says he had studied (cf. the Madonna and Child, in the Museo Civico di Castelvecchio, Verona). The later work shows a more fully conscious Renaissance form, in both figure and composition, influenced by Raphael, as seen in the polyptych of the Passion (1517) and especially in the large altar of the Madonna in Glory with Saints Anthony and Francis, the Seven Cardinal Virtues and other saints, with half-length figure of the donor, Catarina de' Sacchi (1522), both in the Museo Civico di Castelvecchio of Verona. The canvas of St. Roch which belonged to the Girolamo dai Libri triptych, in the London National Gallery, has a still-legible date of 1518 and the signature *Paulus Morādus*.

Giovanni Francesco Caroto (ca. 1480-1555) follows the same pattern on a somewhat lower level. An early work in the Mantegna manner is the Madonna Cucitrice (1501), in the Galleria Estense, Modena, of which a later version is in the Accademia of Venice. A more dignified and independent character is seen in his fresco of the Annunciation (1508), in San Girolamo, Verona, whereas the later interest in a somewhat mannered movement of figures is seen in the altarpiece of the Madonna and Child with St. Anne and Saints John the Baptist, Peter, Roch and Sebastian, in the church of San Fermo Maggiore (1528) in Verona.

6. Milan

IN THE SIXTEENTH CENTURY Milan plays a minor role politically as well as artistically. Louis XII had control of Milan from 1500 until 1512, when the French were expelled from Lombardy by the Holy League. Maximilian, eldest son of Lodovico il Moro, was then set up as duke by the Pope and the Spaniards until 1515, when Francis I and the French again attacked Milan and captured Maximilian. The city was ruled by a French governor, the Constable of Bourbon, for six years; after several changes and the death of the last Sforza in 1535, Milan because a permanent Spanish possession until the Peace of Utrecht in 1713.

From the beginning of the sixteenth century onward, the local tradition that had developed at the end of the fifteenth century (Bramantino) gradually faded before the personality of Leonardo da Vinci and the academy of pupils that had collected about him, particularly during his second stay in Milan (1507-1513).

Ambrogio de Predis (Giovanni Ambrogio Preda, ca. 1455-ca. 1508) is the oldest of these. He came originally from the school of Foppa, possibly as a colleague of Zenale's, and had been mentioned as a miniaturist (1472). He had worked for Lodovico il Moro (1482) and in Innsbruck, for Emperor Maximilian I, on designs for medals and tapestries (1493). With his half-brother, Evangelista, he worked with Leonardo da Vinci on the Madonna of the Rocks project (1483-1506), and is generally credited with the painting of the two lute-playing angels on the wings of the London version. In 1502 and 1506, he is recorded at the imperial court, and is mentioned for the last time in 1508. His two important and authentic works are: the portrait of Francesco di Bartolommeo Archinto, Governor of Chiavenna during the time of Louis XII, in the National Gallery of London, which is signed and dated *1494, ANO. 20* with the

monogram *A M P R F* (Ambrogius Preda Fecit); and the portrait of Emperor Maximilian, in the Vienna Kunsthistorisches Museum, also signed and dated *Max. Ro. Rex. Ambrosius de Pdis Mlanen Pinxit. 1502.*

Giovanni Antonio Boltraffio (1467-1516) is the most closely identified of all the followers with the lyric, romantic spirit of Leonardo's style. The so-called La Belle Ferronière, in the Louvre, which is so frequently attributed to Leonardo himself, may well have been painted by Boltraffio. The same delicacy of characterization is seen in the youthful Narcissus, in the Uffizi Galleries, and the Madonna and Child, in the Poldi-Pezzoli Museum of Milan. His most important larger composition is the Madonna of the Casio Family (1500), in the Louvre.

Marco d'Oggiono (ca. 1475-1530) is a somewhat younger pupil whose use of typical Leonardo gestures and facial types becomes increasingly manneristic, as seen in the Fall of Lucifer and the Assunta (1524), in the Pinacoteca di Brera.

Francesco Melzi (1492-ca. 1570) was one of the youngest and most favored of the pupils who had accompanied Leonardo to Rome and France, and inherited the many notes and drawings that the master left behind in St. Cloud. (See his manneristic Vertumnus and Pomona, in the Staatliche Museen of Berlin, and the Leda, in the Galleria Borghese in Rome).

Bernardino Luini (ca. 480-1532) is the most gifted of Leonardo's followers, and the one who is most responsible for the establishment of the Leonardo style in a large and monumental form. His most extensive early work is the fresco decoration of the Casa Pelucca near Monza, now for the most part in the Pinacoteca di Brera, representing scenes from classical mythology (e.g., the Forge of Vulcan, and Bathing Nymphs) as well as from the Old Testament (the Story of Moses). The style has a lyric narrative quality associated in part with Bramantino and in part with the older tradition of Ambrogio Borgognone. The earliest of his works is probably the Entombment, of ca. 1507, in the church of Santa Maria della Passione in Milan, which has strong Borgognone characteristics. The influence of

Leonardo can be recognized in the mannered smile, the softer color texture (*sfumato*) and the tendency to integrate the composition through gestures of the figures. The later works retain the romantic attributes, but the compositions tend, unlike Leonardo's Last Supper, toward simple horizontal and vetical arrangements reminiscent of Perugino the Entombment of St. Catherine, in the Brera; the frescoes in the choir of Santa Maria dei Miracoli in Saronno, representing the Adoration of the Magi and the *Sposalizio*, ca. 1525; the frescoes of the Passion, in Santa Maria degli Angeli in Lugano, 1529; and those in the Monasterio Maggiore San Maurizio in Milan, with scenes from the Legend of St. Maurice, and the Passion, 1529-1530.

Gaudenzio Ferrari (ca. 1480-1546) is more firmly rooted in the older Lombard tradition as carried on by Borgognone, Zenale and Bramantino, which can be seen in the narrative style of the extensive frescoes of twenty-one scenes from the Life of Christ, in Santa Maria delle Grazie in Varallo (1507-1513). His later work reflects the mannered romanticism of the Leonardo school, and especially the decorative character of Luini and Correggio (cf. the cupola frescoes of Santa Maria dei Miracoli, Saronno, with hosts of music-making angels, 1535/6).

7. Ferrara

THE HOUSE OF ESTE continued to rule in Ferrara under Alfonso I, Ercole II and Alfonso II, through the sixteenth century until 1597 when, without heirs, it became extinct and the duchy was taken over by the church under Clement VIII. Pope Leo X had tried unsuccessfully, with the aid of the French, to wrest control of the city from Alfonso I; in return, Alfonso encouraged the sack of Rome in 1527. The active patronage of the arts by the court continued to the end of the century, not only in painting but particularly in literature (Ariosto, 1474-1533; Tasso, 1544-1595).

The flourishing local tradition that had developed in the Quattrocento, under Cosimo Tura and Francesco Cossa, gave way, in the following century, to a series of styles strongly conditioned by outside influences.

Lodovico Mazzolini (ca. 1480-ca. 1528) adhered more strictly to the older tradition of Cosimo Tura, Ercole Roberti and Lorenzo Costa, as can be seen in a considerable number of small-sized religious pictures: his early Nativity, in the Pinacoteca of Ferrarra, the numerous versions of Christ among the Doctors, in the Galleria Doria of Rome, the Staatliche Museen of Berlin and the National Gallery in London. A dated (1516) Holy Family in a Landscape is in the Alte Pinakothek of Munich.

Garofalo (Benvenuto Tisi, ca. 1481-1559) continued in the same tradition, having been a pupil of Domenico Panetti (1460-1512), who was a follower of Costa and later was influenced by Boccacino. He then came under the influence of the High Renaisance style, notably that of Palma Vecchio and Raphael. Characteristic works are: the Madonna Enthroned with Saints and Kneeling Donor (La Madonna del Pilastro), dated 1514, in the Pinacoteca of Ferrara; the

large fresco Triumph of the Church, 1523, from the refectory of the monastery of Sant' Andrea, now in the Pinacoteca of Ferrara; and the Madonna Enthroned with Music-making Angels and Saints John the Baptist and Lucy, Contardo d'Este (1523), in the Galleria d'Estense of Modena; see also the ceiling decorations (1519) of the Seminario Arcivescovile, Ferrara, influenced by Mantegna's Camera degli Sposi and Ercole Grandi's frescoes in the Palazzo di Lodovico il Moro in Ferrara. A number of Garofalo's works in the Galleria Borghese of Rome show this complex of interests from Raphael, Dosso Dossi and the Venetians: the Adoration of the Shepherds, Madonna and Child with Saints, and the Conversion of St. Paul (dated 1545).

Dosso Dossi (Giovanni de' Luteri, ca. 1482-1542) is the most important master of the school of Ferrara. He was probably born in Dosso, near Mantua, was apparently a pupil of Lorenzo Costa, and had worked in Mantua and Modena, as well as in the service of Alfonso I and Ercole d'Este in Ferrara, from 1514 until his death. His style is influenced largely by Giorgione or Titian and Raphael, somewhat romantic in character, and tends strongly toward the Mannerism of the Late Renaissance. The most important works are: Rest on the Flight into Egypt, in the Palazzo Pitti of Florence; the "Circe" representations from Ariosto's *Orlando Furioso*, along with several other allegorical subjects—Psyche Transported to Olympus, Apollo and Daphne, Diana and Callisto, and Gyges and Candaulus—in the Galleria Borghese of Rome; the Adoration of the Shepherds, also in the Galleria Borghese; the altar in the Cathedral of Modena (1522) representing the Madonna with Saints Laurence and Roch in the Clouds Appearing to Saints Sebastian, Jerome and John the Baptist; the Coronation with the Four Church Fathers (1532), in the Gemäldegalerie of Dresden. The Bacchanal, in the National Gallery of London (ca. 1514), has been associated with the series of decorations, which included the Bellini and Titian mythological scenes from Ovid's *Fasti*, painted for the *studiolo* of Alfonso d'Este in the Castello of Ferrara.

Battista Dossi (died 1548) is a younger brother of Dosso Dossi's who is recorded in Rome in 1522 and apparently had some contact with Raphael's studio. Although the two brothers seem to have

worked together—the Psyche Transported to Olympus is directly related to Raphael's Farnesina decorations—the panel of the Rest on the Flight into Egypt, in the Galleria Borghese, has been attributed to Battista because of its fresh color and more decorative style.

L'Ortolano (Giovanni Battista Benvenuti, ca. 1488-ca. 1525) is another pupil of Lorenzo Costa's whose name is recorded in Ferrara in 1512, 1520 and 1524. The most characteristic works, which are often confused with those of Garofalo, show a strong and expressive color and an atmospheric quality to the landscape: The Pietà, in the Galleria Borghese of Rome, painted for the church of San Cristoforo degli Esposti in Ferrara; the altarpiece with Saints Sebastian, Roch and Demetrius, formerly in the church of Santa Maria in Bondeno, near Ferrara, now in the National Gallery, London; and the Crucifixion, in the Pinacoteca di Brera, Milan.

8. Parma

THE DUCHY OF PARMA had been bought by the Visconti in the four-teenth century and continued in the possession of Milan until 1499, when it was conquered by Louis XII of France. After the treaty of Venice with Francis I for the retaking of Milan, Parma was re-annexed to Milan, with the consent of the Pope, in 1515. It was, however, conquered again by papal and imperial troops in 1521 and made part of the papal domains. In 1545, the Farnese Pope, Paul III, made Parma and Piacenza into duchies for his son, Pietro Farnese. The son of Pietro, Ottavio Farnese, married Margaret, daughter of Emperor Charles V, who claimed the duchies when Pietro was assassinated. With the aid of the Pope, Ottavio and the Farnese family remained in control through the end of the century, although strongly under Spanish influence.

Correggio (Antonio Allegri, ca. 1489-1534) is the outstanding master of Parma, and has long been considered one of the great per-sonalities of the High Renaissance.

He was born, probably in 1489, in Correggio, near Modena and Reggio nell' Emilia, the son of Pellegrino d'Antonio Allegri. The date of his birth is the subject of some speculation: a seventeenth-century mural inscription in the monastery of San Francesco in Correggio records his death in 1534 at the age of forty years (hence 1494), whereas a document of 1519 and the 1514 con-tract for the Madonna of St. Francis have led to the conclusion that he must have been twenty-five years of age when the contract was signed, and hence would have been born in 1489 or before. Concern-ing his life, little factual information is available, either in documents or in the older literature. His earliest instruction seems to have come from the shop of his uncle, Lorenzo Allegri, an otherwise unimportant local painter. Although there is no documentary evidence to prove the fact, it seems logical by stylistic comparison

and by the proximity of location that he had come into more or less direct contact with the leading artistic personalities of the neighboring towns during the significant first decade of the sixteenth century. These must have included Francesco de' Bianchi-Ferrari at Modena, Lorenzo Costa in Bologna, Giorgione and Titian in Venice, Leonardo and his circle in Milan, Mantegna at Mantua, as well as the significant works by famous late Quattrocento painters that Isabella d'Este had collected for the decoration of her *studiolo* (i.e., Mantegna, Costa, Bellini, Perugino and Leonardo, known by the drawing portrait of her). From the character of Correggio's work, he may well have served as an apprentice in Mantegna's shop before the latter's death in 1506, and could have continued in contact with Lorenzo Costa, who succeeded him as court painter.

There is, likewise, no evidence other than his decorative style to prove that he had been in Rome. A connection between the court at Mantua and the town of Correggio may be noted in the letters of Veronica Gambara, the wife of a local patrician, Gilberto da Correggio, and friend of Isabella, who fostered a local court culture of her own and mentions the painter Antonio at various times. The particularly lyric character of these artists, and the patrician culture with which they are associated, are significant in the understanding and interpretation of Correggio's style. His removal to Parma appears to have taken place in 1518 or 1519, in any case before 1520; at the same time, he married Girolama Merlini, and the major part of his subsequent activity was on the great decorative projects in that city. He died on March 5, 1534, in Correggio, and was buried in the church of San Francesco.

The first important and documented work of Correggio's is the famous Madonna with Saints Francis, Catherine, Anthony of Padua and John the Baptist, in the Gemäldegalerie of Dresden. The signature, *Antonius de Alegris P.*, is inscribed on the wheel of St. Catherine. According to the documents, the panel was contracted for on August 30, 1514, for the high altar of the abbey church of San Francesco in Correggio with an endowment that was established in the testament of Quirino Zuccardi on July 4 of that same year. The completion and final payment followed on April 4, 1515.

A study of the spirit and form of the altarpiece will reveal a collection of late Quattrocento and High Renaissance motifs that Correggio has fused into a new form which parallels Leonardo's Madonna

of the Rocks, the Sistine Madonna of Raphael and the Pesaro Madonna of Titian. In the various comparisons, note: 1) The relationship in general compositional scheme with Mantegna's Madonna della Vittoria, of 1496, in the Louvre, and the totally different spirit which, again, marks the oft-cited difference between the art of the Quattrocento as opposed to that of the Cinquecento. Chief among these are the greater life and vitality that motivate the action of the figures, the golden-yellow light that fills the space and accents the central figure (cf. the hard drawing, still figures and the detailed arbor niche of Mantegna). 2) The relationship with Leonardo's late style, paticularly the Madonna of the Rocks, which can be seen in the Leonardesque smile, the extended hand of the Madonna (also used by Mantegna), and the pointing hand of St. John the Baptist (cf. Leonardo's late St. John), which plays a compositional role similar to the pointing angel in the Louvre version. 3) The mystic spirit reflected in the two inside saints (Francis and Catherine), whose upward gaze is most closely related to the adoring saintly heads of Perugino, but whose naturalism reveals the same tendency to sentimentality noted in the Florentine Madonnas of Raphael. 4) The general illusionistic emotional appeal is close to that of the Sistine Madonna, as can be seen in the animation of the light about the Madonna with vague putti heads, the in-and-out movement of forms which Correggio relegates to the floating angels on either side at the top rather than the larger figures below. 5) Lastly, there is the attempt to animate the solid throne itself by inserting the moving putti at the corners on either side of the framed seated figure of Moses (cf. Michelangelo's putto-caryatids on the thrones of the sybyls and prophets of the Sistine ceiling, as well as the throne decorations of Lorenzo Costa).

The absence of documents and the uncertainty of Correggio's birthdate have caused considerable difficulty in interpreting a number of works which might belong to his earlier period. On the basis of the Madonna of St. Francis, and the assumption of the years 1489 as the approximate date of his birth, there are several paintings which have been assigned to his youthful years before 1515. Among these are the small Madonna in Glory, in the Uffizi Gallery, Florence, Christ Taking Leave of His Mother, in the National Gallery of London, and the canvas of Four Saints—Peter, Martha, Mary Magdalene and Leonard—in the Metropolitan Museum of

New York. The rigid drawing and figure composition of Mantegna and Lorenzo Costa are evident, but they have been softened and relaxed by a kind of Leonardesque movement and atmosphere.

Several early fresco projects, although badly damaged, have been variously attributed as belonging to the school of Mantegna but could very well have been done by Correggio. One is the fresco, transferred to canvas, now in the Galleria d'Estense of Modena, formerly in the church of San Quirino in Corregio, representing the Madonna and Child with Saints Francis and Quirinus, which has a restored scroll indicating a date of 1511. The others are the fresco decoration of the roundels, in the narthex (Madonna and Chid with Saints Joseph, Elizabeth and John the Baptist and the Entombment), and the Four Evangelists of the pendentives of Mantegna's mortuary chapel, in Sant' Andrea of Mantua.

Correggio's development of the decorative movement of figures and drapery, his use of light and naturalistic appeal to sentiment are clearly defined in the Dresden Madonna of St. Francis, but they are still subordinated to the classic restraint and monumental form of the High Renaissance. A number of important later works of the same iconographical type (i.e., the Madonna Enthroned with Angels and Saints, one of whom acts as chief intermediary) will show the emphasis on these decorative and emotional elements in the full spirit of the Manneristic style: the Madonna with St. Sebastian, executed ca. 1525 for the brotherhood of San Sebastiano in Modena, and the Madonna with St. George, done for the brotherhood of San Pietro Martire in Modena, ca. 1530-1532, both panels in the *Dresden Gemäldegalerie* (cf. the older *sacra conversazione* type of altarpiece).

Coreggio's large decorative projects may not rank artistically with those of Raphael and Michelangelo, but they are exceedingly important documents both to the spirit of the High Renaissance and to the succeeding Manneristic culture of the second third of the sixteenth century. As parallels to the early work of Michelangelo, the Roman products of Raphael and his school, and the later work of Titian, they, with their unique quality of decorative illusionism, form a permanent source of inspiration for the great decorative styles of the seventeenth century, i.e. the Carracci and their followers.

The first of these is the fresco decoration of one of the private chambers of the abbess, Donna Giovanna Piacenza, in the convent of San Paolo in *Parma*. The apartment comprised a series of six

rooms; besides Correggio's *camera*, the ceiling of one was decorated by Alessandro Araldi with an elaborate Gothic-type system of classical *grottesche* and Biblical allegories. Araldi (ca. 1460-1528) was a local follower of Lorenzo Costa and is recorded as active on various projects in Parma particularly from 1500 until 1521. From the date of 1514 on the fireplace, these ceiling decorations of the Araldi room must have been painted before that time. Correggio's frescoes are assumed to have been painted about 1518–1519, during which time there are records of the artist's presence both in Correggio and in Parma.

The frescoes cover the vaulted ceiling of the almost-square room whose walls were probably once decorated with tapestries. It is divided by painted ribs into sixteen sections involving an elaborate combination (largely in grisaille) of lunettes, oval openings with actively moving putti, garlands and trellis work, woven into a unified arbor decoration reminiscent both of the niche decoration in Mantegna's Madonna della Vittoria and the ceiling frescoes by Leonardo in the Sala dell' Asse in the Castello of Milan. The coat of arms of the abbess decorates the double rosette in the center of the vault.

Iconographically, the decorations are significant in that they represent the pagan and more worldly tastes of court life of the late fifteenth and early sixteenth centuries, in the tradition of Isabella d'Este and her *studiolo*, rather than the usual historical-devotional scenes common to the religious orders. The sophisticated and self-willed character of the abbess-patron is suggested in the relatively heroic figure of Diana, as Goddess of the Hunt, which dominates the room on the fireplace of the north wall, with the proverb *Ignem Gladio ne Fodias* (Do not poke fire with a sword) on its lintel. Various figures and motifs, which were probably taken from classical Roman coins, cameos or reliefs, continue the allegories in the lunettes over the four surrounding walls: Fortune, Bellona, the Three Graces, Virtue (Adonia); Genius, Tellus, Juno, Vesta; Saturn, the Temple of Jupiter, the Three Fates, Rhea Saving the Infant Jupiter; Diana Lucifera, Pan, Integrity and Chastity.

Significant to the style is the freedom with which Correggio was able to interpret what was apparently a highly sophisticated literary or iconographical program, related to the artistic attitude described in the work of Giorgione and Titian. The fascinating motifs of play-

ing putti, which move freely in the illusionistic space, are quite independent of the oval frames, and are closely related to the playing groups in Titian's Worship of Venus. The figures in the niches likewise show many recognizable compositions that are easily and brilliantly executed. These may have their basis in classical antiquity, but they appear to be related to contemporary work in Rome, as can be seen in the figure of Virtue (or Adonis), which closely resembles the Apollo in the background of Raphael's School of Athens (cf. the group of the Three Graces with Raphael's early panel of the same subject; the composition of Three Fates with Rapahel's sibyls in Santa Maria della Pace, or the Jurisprudence). Both the motifs and the skills with which Correggio has organized his figures and their action into a total architectural design make it difficult to believe that he had not actually seen the work of Michelangelo and Raphael in Rome.

Correggio's finest decorations are those in San Giovanni Evangelista in Parma, which were begun soon after the Camera di San Paolo, the first payment being recorded on July 6, 1520, and the last on January 23, 1524. They included a fresco, in the lunette over the door in the left transept, representing St. John on Mt. Patmos (cf. Andrea del Sarto's Madonna del Sacco in SS. Annunziata, Florence); a Coronation of the Virgin, accompanied by the Benedictine patron saints, Placidus and Maurus, and the two St. Johns. This was later destroyed when the choir was rebuilt in 1587, and a copy of Correggio's fresco was made in the new apse by Cesare Aretusi. Fragments of the original are still preserved in the Biblioteca of Parma (i.e., the figures of Christ and Mary) and in the National Gallery if London (several angels' heads). The cupola itself is decorated with the Ascension of Christ, with figures of Evangelists and Church Fathers groups on the pendentives below it (St. Matthew and St. Jerome, St. Mark and St. Gregory, St. Luke and St. Ambrose, St. John and St. Augustine). On the arches supporting the pendentives are grisaille figures of Aaron and the Blossoming Rod, Moses and the Burning Bush, Elijah and the Chariot of Fire, Daniel and the Fiery Furnace, Jonah and the Whale, Samson Carrying off the Gate of Gaza, the Sacrifice of Isaac, and Cain Kiling Abel. There are several copies of the apse fresco by Agostino and Annibale Carracci (i.e., in the Pinacoteca of Parma and the Museo Nazionale di Capodimonte in Naples) as well as the fresco by Aretusi. The

nineteenth-century water colors of the cupola by Paolo Toschi offer something of the earlier state, since the frescoes today are considerably damaged.

Concerning the style of the apse fresco, note the relationship in the artistic problems of movement and recession developed by Melozzo da Forli in SS. Apostoli in Rome; the similarity of the arbor design of the niche behind the masses of figures to that of Mantegna in the Modonna della Vittoria. In the study of the pendentive decorations, note the relationship of the Evangelist-Church Father groups to Michelangelo's Prophets and Sibyls of the Sistine Chapel, yet their manneristic distortion for decorative effect. In the cupola fresco, not the similarity of artistic problems of recession and illusionistic effect with Mantegna's ceiling fresco of the Camera degli Sposi in Mantua and the typical fifteenth- and sixteenth-century methods of solution; the recession through movement and design figures as well as anatomical foreshortening, the use of decorative clouds rather than the mathematical perspective of the balustrade, the concentration of attention and unity of the ceiling through the central ascending Christ, with its foreshortening and twisted revolving design.

Notable in this connection also is the relationship with Titian's Assunta, whereby the same features of Titian's composition are reformed to suit the requirements of a cupola decoration: cf. the twisted central figure with outstretched arms; the contrast, however subdued, of figure to the heavenly background which, like the Assunta, is animated by angels' heads; the excited gestures of apostles (these represented as idealized nudes rather than the dignified robed figures of Titian and the older tradition) below and around the ascending Christ; the compositional, and iconographical, use of a single earthly figure as a dramatic foil to increase the effect of the whole, namely the figure of St. John on Mt. Patmos, just below the Apostles Matthew, Mark and Luke in the clouds (cf. the similar use of the two angels in Raphael's Sistine Madonna). Some of the apostle figures have a remarkable resemblance to Michelangelo's decorative nudes on the Sistine ceiling, as can be seen, for example, in the figure of St. James the Less.

Even before the completion of the San Giovanni Evangelista fescoes, Correggio contracted, on November 3, 1522, to decorate the cupola, presbytery and apse of the Cathedral of Parma. Payments

are recorded on November 29, 1526, and November 17, 1530. In 1551, his heirs were requested to return part of the payments, since he died before completion of the work. These records, together with the character of the style, lead to the assumption that most of the work was done between 1526 and 1530, and left unfinished.

The figures with their accompanying angels decorating the pendentives represent Saints Bernard, Hilary, John the Baptist and Thomas. The fresco in the cupola is an Assumption of the Virgin (badly damaged; cf. the watercolor copies by Paolo Toschi). Regarding the composition, note the greater elaboration of detail and movement, the succession of illusionistic "cornices" using painted balustrades (cf. Mantegna) and rims of clouds. Most significant and characteristic of the mannerist psychology is the subordination of the main subject, i.e., the ascending Mary, to the decorative and exhilarating excitement of space and the massed figures of the total composition: an aesthetic excitement that receives its accent in the iconographically unimportant figure of the divine messenger in the center of the space descending to receive the Virgin.

Two famous late works, which are not so much manneristic as they are Baroque in character, are the altar panels known as "Day" (the Madonna with St. Jerome and Mary Magdalene, executed 1523-ca. 1528, for Donna Briseide Colla, and originally in Sant' Antonio in Parma, now in the Pinacoteca there) and "Night" (the Nativity, commissioned on October 14, 1522, by Alberto Pratoneri and set up in 1530 in the Pratoneri Chapel in San Prospero in Reggio Emilia, now in the Dresden Gemäldegalerie). Noticeable in both panels is the complexity of the composition, whereby the main subject remains the center of interest either through a pyramidal composition or through the accent of light (e.g., the Night scene), but where, also, a striking Baroque unbalance of the composition is effected by the heavy, twisted figure at the left (cf. the Laocoön-like figure of the shepherd in the "Night"). The same characteristics are to be found in the equally well-known altar, the Madonna della Scodella (1524–1530), in the Pinacoteca of Parma.

Correggio's smaller, more romantic and intimate house altars are closely related to his mythological scenes; hence, they are to be interpreted from much the same point of view as the religious-allegorical-mythological works of Giorgione and the early Titian. The best-known of the small devotional altars is the "night scene"

of the Virgin Adoring the Child, in the Uffizi Gallery (ca. 1523), which is an interesting sixteenth-century counterpart to Fra Filippo Lippi's altar of the same subject that was formerly in the Medici Chapel. The *Noli me tangere* (cf. Titian's version of the same theme), in the Museo del Prado of Madrid, was painted at about the same time.

In much the same romantic spirit are the later (ca. 1526–1530) mythological scenes, four of which apparently belong in pairs and in all probability were painted for Federigo Gonzaga of Mantua for the decoration of a single room: the Io and Jupiter, and the Ganymede, in the Vienna Kunsthistorisches Museum; the Danaë, in the Galleria Borghese of Rome, and the Leda and the Swan, in the Berlin-Dahlem Museum. According to Vasari, the Danaë and the Leda were given by the Duke Federigo to Emperor Charles V on the occasion of his coronation in Bologna. Significant to the style is the almost exotic sensuality (cf. the Io and the Leda canvases), the flowing grace of the figure compositions, the soft and most delicate coloration combined with a remarkable strength and monumental form. Note particularly, in the Leda and the Swan, the pyramidal composition of the central group and the diagonal recession of the landscape on either side (cf. Leonardo's Madonna of the Rocks). The figure of Ganymede is almost identical with the lower angel in the group around St. Bernard in the pendentive fresco of the cathedral.

Parmigianino (Francesco Mazzola, 1503-1540) is Correggio's most important follower in Parma and one of the great masters of Mannerism. He was born in Parma on January 11, 1503, and was influenced, probably, by Correggio, until about 1524, when he left for Rome, where he came under the influence of Raphael's followers. From 1527 until 1531, he worked in Bologna, and then again in Parma. He died in Casalmaggiore, not far from Parma.

The comparison of his early works, such as the Madonna with Saints John the Baptist and Jerome, of 1527 (also called the Vision of St. Jerome), in the National Gallery of London, with Correggio's Madonna, of St. Sebastian, or his Madonna of St. George, in Dresden, will show the persistence of many motifs, such as the pointing hand, the foreshortened dreaming figure and the compositional use of the animated figure, but it also reveals much of the hard drawing, the stylized and distorted use of the figure in a composi-

tional design oriented more toward the surface plane than in space. The heads are reduced in scale, the figures are longer in their proportions, and the panel itself has a greater emphasis on the vertical, rather than the balanced proportions characteristic of the High Renaissance. The coloration tends to be cool and detached, yet clear and positive in its definition of forms, in contrast to the soft and luminous quality of light and the warm color noted among the great masters of the High Renaissance. The development of these features can be seen in the Madonna dal Collo (the Madonna with the Long Neck), of ca. 1534, in the Uffizi Gallery of Florence.

The continued and often consistent evolution of this new style can be followed in this new generation, each working within the limitations of his own tradition in each of the great cultural centers: Jacopo Pontormo (1494-1557), Sebastino del Piombo (1495-1547), Giulio Romano (1499-1546), Benvenuto Cellini (1500-1571), Angelo Bronzino (1503-1546), Francesco Salviati (1510-1563), Giorgio Vasari (1511-1574) and Jacopo Tintoretto (1518-1594).

Appendix

The Popes at Rome 1261-1555

Pope	Accession
Urban IV (Jacques Pantaléon)	1261
Clement IV (Guy Foulques)	1265
No Pope	1268-71
Gregory X (Tebaldo Visconti)	1271
Innocent V (Pierre de Tarentaise)	1276
Hadrian V (Ottobono Fieschi di Lavagna)	1276
John XXI (Pietro Rebuli-Giuliani)	1276
Nicholas III (Giovanni Gaetano-Orsini)	1277
Martin IV (Simon Mompitié de Brion)	1281
Honorious IV (Jacopo Savelli)	1285
Nicholas IV (Girolamo Masci)	1288
No Pope	1292-94
Celestine V (Pietro Angelari da Murrone)	1294
Boniface VIII (Benedetto Gaetano)	1294
Benedict XI (Niccolò Boccasini)	1303
Clement V (Bertrand de Gouth)	1305

The Babylonian Captivity at Avignon, 1309-1377

No Pope	1314-16
John XXII (Jacques Duèze)	1316
Benedict XII (Jacques Fournier)	1334
Clement VI (Pierre Roger de Beaufort)	1342
Innocent VI (Étienne Aubert)	1352
Urban V (Guillaume Grimoard de Beauvoir)	1362
Gregory XI (Pierre Roger de Beaufort)	1370

The Great Schism, 1378-1417

Urban VI (Bartolommeo Prignano)	*1378*
Boniface IX (Pietro Tomacelli)	*1389*
Innocent VII (Cosimo dei Migliorato)	*1404*
Gregory XII (Angelo Coriaro)	*1406*

Martin V (Oddone Colonna)	*1417*
Eugene IV (Gabriele Condulmieri)	*1431*
Nicholas V (Tommaso Parentucelli)	*1447*
Calixtus II (Alfonso de Borgia)	*1455*
Pius II (Enea Silvio de' Piccolomini)	*1458*
Paul II (Pietro Barbo)	*1464*
Sixtus IV (Francesco della Rovere)	*1471*
Innocent VIII (Giovanni Battista Cibo)	*1484*
Alexander VI (Rodrigo Borgia)	*1492*
Pius III (Francesco Todeschini-Piccolomini)	*1503*
Julius II (Giuliano della Rovere)	*1503*
Leo X (Giovanni de' Medici)	*1513*
Hadrian VI (Hadrian Florensz)	*1522*
Clement VII (Giulio de' Medici)	*1523*
Paul III (Alessandro Farnese)	*1534*
Julius III (Giovanni Maria del Monte)	*1550*
Marcellus II (Marcello Cervini)	*1555*
Paul IV (Giovanni Pietro Caraffa)	*1555*

The Schismatic Popes at Avignon

Clement VII (Robert de Geneva)	1378
Benedict XIII (Pedro de Luna)	1394
Alexander V (Petros Filargis)	1409
John XXIII (Baldassare Cossa)	1410
Clement VIII	1423
Benedict XIV	1423
Felix V (Amadeus of Savoy)	1439

The Doges of Venice, 1311-1577

Giorgio (''Zorzi'') Marino	1311-13
Giovanni Soranza	1312-28
Francesco Dandolo	1328-39
Bartolommeo Gradenigo	1339-42
Andrea Dandolo	1343-54
Marino Faliero	1354-55
Giovanni Gradenigo	1355-56
Giovanni Dolfino	1356-61

Lorenzo Celsi	1361-65
Marco Cornaro	1365-68
Andrea Contarini	1368-82
Michele Morosini	1382
Antonio Venier	1382-1400
Michele Steno	1400-13
Tommaso Mocenigo	1414-23
Francesco Foscari	1423-57
Pasquale Malipiero	1457-62
Cristoforo Moro	1462-71
Niccolò Tron	1471-73
Niccolò Marcello	1473-74
Pietro Mocenigo	1474-76
Andrea Vendramin	1476-78
Giovanni Mocenigo	1478-85
Mario Barbarigo	1485-86
Agostino Barbarigo	1486-1501
Leonardo Loredan	1501-21
Antonio Grimani	1521-23
Andrea Gritti	1523-39
Pietro Lando	1539-45
Francesco Donato	1545-53
Marcantonio Trevisano	1553-54
Francesco Venier	1553-54
Lorenzo Priuli	1556-59
Girolamo Priuli	1559-67
Pietro Loredano	1567-70
Luigi Mocenigo	1570-77

The Medici of Florence

Cosimo (Pater Patriae)	1429-64
Piero (the Gouty)	1464-69
Lorenzo (the Magnificent)	1469-92
Piero (the Unfortunate;	
d. 1503)	1492-94
Alessandro (Il Moro)	
Duke of Florence	1530-37
Cosimo I	
Duke of Florence	1537
Grand Duke of Tuscany	1569-74

The Visconti and Sforza of Milan

The Visconti	
Matteo	1310-22
Galeazzo I	1322-28
Azzo	1328-39
Luchino	1339-49
Giovanni	1349-54
Matteo II	1354-55
Galeazzo II	1354-78
Bernabò	1354-85
Gian Galeazzo	1378-1402
Duke	1395

Giovanni Maria	1402-12
The Sforza	
Francesco	1450-66
Galeazzo Maria	1466-76
Gian Galeazzo Maria (d. 1494)	1476-80
Lodovico Il Moro (d. 1508)	1480-1500
Massimiliano	1512-15
Francesco Maria	1522-35

The Este of Ferrara

Niccolò III	1384-1441
Leonello	1441-50
Borso	1450-71
	(Duke, 1470)
Ercole I	1471-1505
Alfonso	1505-34
Ercole II	1534-59
Alfonso II	1559-97

The Montefeltre and Della Rovere of Urbino

Federigo I (da Montefeltro)	1444-82
Duke	1474
Guidobaldo	1482-1508
(Cesare Borgia,	1502-3)
Francesco Maria I (della Rovere)	1508-38

The Gonzaga of Mantua

Gian Francesco I	1407-44
Lodovico	1444-78
Federigo	1478-84
Gian Francesco II	1484-1519
Federigo II	1519-40

The Malatesta of Rimini

Giovanni Malatesta	1237-47
Malatesta da Verruchio	1247-1312
Malatestino	1312-17
Pandolfo	1317-26
Galeatto	1326-85
Carlo	1385-1429
Galeatto	1429-32
Sigismondo Pandolfo	1432-68
Sallustio	1468-69
Roberto	1469-82
Pandolfo (Pandolfaccio)	1482-1500

The Della Scala of Verona

Mastino I	1260-77
Alberto	1277-1301

Bartolommeo	1301-4
Alboino	1304-11
Francesco (Can Grande)	1308-29
Giovanni	1329-50
Mastino II	1350-51
Can Grande II	1351-59
Can Signorio	1359-75

The Angevin and Aragonese Kings
of Naples

The House of Anjou	
Charles of Najou	1266-85
Charles II (lo Zoppo)	1289-1309
Robert	1309-43
Joanna I (Giovanna)	1343-82
Charles III (of Durazzo)	1382-86
Ladislaus	1386-1414
Joanna II	1414-35
The House of Aragon	
Alfonso I	1435-58
Ferdinand I (Ferrante)	1458-94
Alfonso II	1494-95
Ferdinand II (Ferrandino)	1495-96
Frederick	1496-1501

The Holy Roman (German)
Emperors, 1220-1556

Frederick II	1220-50
(Hohenstaufen)	
Conrad IV	
Interregnum	
Rudolf I	1273-91
(Hapsburg)	
Adolf	1291-98
(Nassau)	

Albert I	1298-1308
(Hapsburg)	
Henry VII	1308-13
(Luxemburg)	
Louis IV	1314-47
(Wittelsbach)	
Charles IV	1346-78
(Luxemburg)	
Wenceslas	1378-1400
Rupert	1400-10
(Palatinate)	
Sigismund	1410-37
(Luxemburg)	
Albert II	1438-40
(Hapsburg)	
Frederick III	1440-93
Maximilian I	1493-1519
Charles V	1519-56

The Kings of France, 1226-1547

Louis IX (Capetian)	1226-70
Philip III	1270-85
Philip IV	1285-1314
Louis X	1314-16
Philip V	1316-22
Charles IV	1322-28
Philip VI (Valois)	1328-50
John	1350-64
Charles V	1364-80
Charles VI	1380-1422
Charles VII	1422-61
Louis XI	1461-83
Charles VIII	1483-98
Louis XII (Orléans)	1498-1515
Francis I	1515-47

TABLE OF IMPORTANT HISTORICAL EVENTS

1266	Charles of Anjou becomes King of Sicily through encouragement of papacy
1303	*Unam Sanctam* and the humiliation of Pope Boniface VIII by the French at Anagni
1309	Papal see removed to Avignon by Clement V
1314	Henry VII descends into Italy (cf. Dante's patriotic praise)
1315	Battle of Montcatini. Pisans defeat united Florentine and Neapolitan Guelfs
1327-29	Descent into Italy of Louis the Bavarian
1329-36	Florence acquires Pistoia and Arezzo
1347	Cola di Rienzi Tribune in Rome
1347-49	The Black Death
1354-55	Descent of Emperor Charles IV into Italy and renunciation of Italian claims
1356	Turks first set foot in Europe at Gallipoli
1377	Gregory XI ends Babylonian Captivity
1378-80	War of Chioggia. Venice recaptures Chioggia; destroys Genoese fleet and maritime power
1387	Marriage of Valentina Visconti to Louis, Duke of Orleans
1392	Francesco Carrara, lord of Padua under sovereignty of Milan
1395	Lombardy sold to Gian Galeazzo Visconti by Emperor Wenceslas
1396	Genoa under control of Charles VI of France, then taken by the Visconti
1399	Pisa sold to the Visconti of Milan
1409	Council of Pisa
1414-18	Council of Constance
1416	Venetian victory over the Turks at Gallipoli
1425	Reforms of Fra Bernardino of Siena
1431-49	Council of Basel
1433-34	Cosimo de' Medici exiled
1439	Council of Florence
1443	Alfonso of Aragon takes Naples
1447-50	"Ambrosian Republic" established in Milan
1453	Turks under Mahomet II take Constantinople
1454	League of Lodi formed against the Turks
1456	Defeat of the Turks at Belgrade
1463	Venice at war with the Turks
1469-92	Lorenzo il Magnifico
1479	Peace of Constantinople; end of Venetian war
1480	Turks attack Otranto
1487	Caterina Cornaro cedes Cyprus to Venice
1488	Council of Ten, under control of the Baglioni, established in Perugia
1492	Discovery of America by Columbus
1493	Accession of Maximilian I and expansion of the Hapsburg realm
1494	Descent of Charles VIII and the French to Naples
1494	Piero II de' Medici expelled; Republic set up in Florence which lasts until 1512
1496	French dispossessed in Naples; Maximilian's campaign fails
1498	Martyrdom of Savonarola
1499	First conquest of Milan by Louis XII
1500	Capture and banishment of Lodovico il Moro from Milan Fall of Milan and Naples to Louis XII
1501	End of Aragonese dynasty at Naples; the Two Sicilis come under Spanish rule
1501	Cesare Borgia conquers Romagna
1502	Guidobaldo da Montfeltro expelled from Urbino by Borgia
1503	Fall of Cesare Borgia
1508	League of Cambrai against Venice; i.e., Louis XII of France, Ferdinand of Spain, Emperor Maximilian and Pope Julius II

1511	Formation of the Holy League
1512	Battle of Ravenna: French win over the League of Julius II, Venice, Spain and England, but subsequent expulsion of the French from Italy
1512-27	Medici again in power in Florence
1515	Accession of Francis I and French expedition into Italy. Battle of Marignano. Reconquest of Milan
1516	End of war of Cambrai leaving France in possession of Milan and Spain of Naples
1519	Accession of Charles V as Holy Roman Emperor
1525	Battle of Pavia; Francis I defeated and captured
1527	Sack of Rome by Spanish-Austrian armies
1527-30	Republic again at Florence
1529	Peace of Cambrai between Francis I and Charles V; Francis renounces claims in Italy
1529	Charles V crowned Emperor at Bologna
1529-30	Siege of Florence by Spanish-Austrian armies; re-establishment of the Medici as dukes
1535	Sforza dynasty ends with Francesco II; Duchy of Milan appropriated by Charles V.
1545-63	Council of Trent
1556	Accession of Philip II of Spain

Index

W

Z